CLERICS AND CONNOISSEURS
An Irish Art Collection through Three Centuries

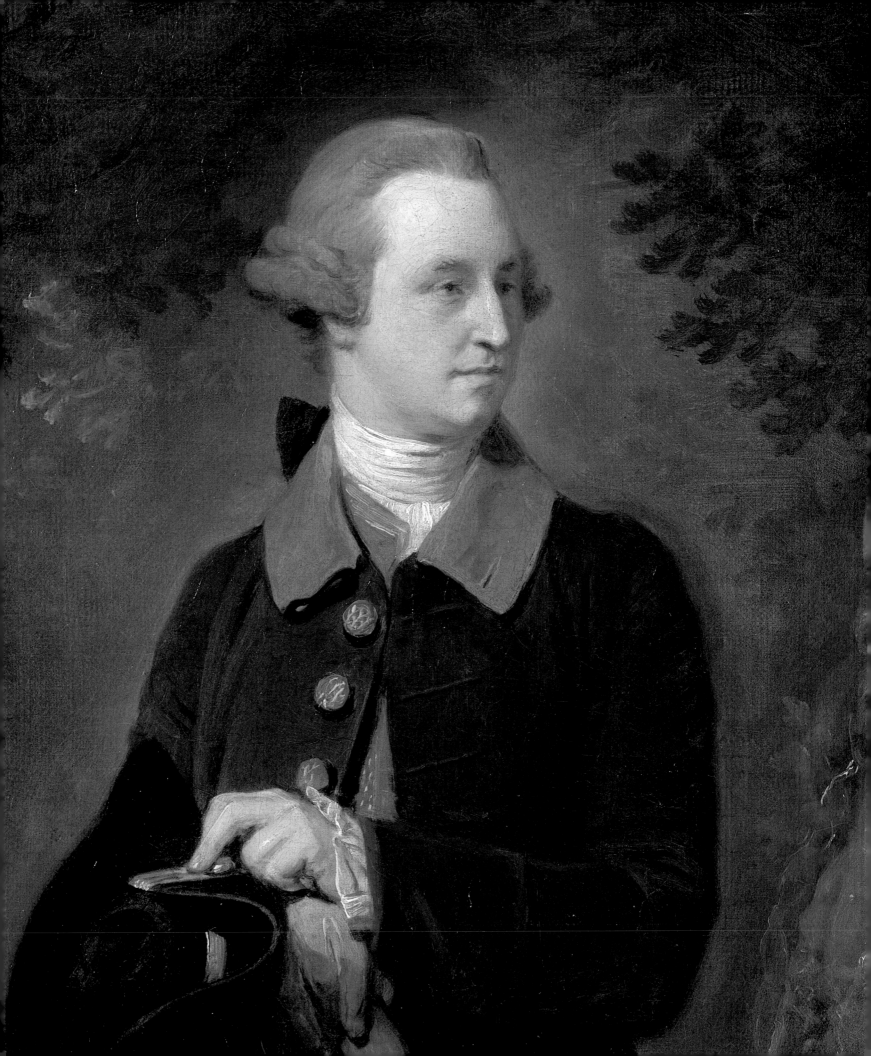

CLERICS & CONNOISSEURS

*The Rev. Matthew Pilkington, the Cobbe Family and the
Fortunes of an Irish Art Collection through Three Centuries*

Edited by Alastair Laing
with special contributions by Nicholas Turner

ENGLISH HERITAGE
AZIMUTH EDITIONS

The exhibition and the publication of this book were made possible through the generous support of

DONALD AND JEANNE KAHN
THE COBBE FOUNDATION
THE LONDON HISTORIC HOUSE MUSEUMS TRUST
THE IRELAND FUND
THE IRISH GEORGIAN SOCIETY
THE COBBE COLLECTION TRUST

This book was published to accompany the exhibition
Clerics and Connoisseurs:
An Irish Art Collection through Three Centuries
The Iveagh Bequest, Kenwood House, London
19 October 2001–27 January 2002

First published in Great Britain in 2001 by:
English Heritage
23 Savile Row, London W1S 2ET

Azimuth Editions Ltd
Unit 2a, The Works, Colville Road
Acton, London W3 8BL

Catalogue design by Anikst Associates
Typeset in Lexicon by Azimuth Editions Ltd
Printed in London by PJ Print

ISBN 1-85074-805-5 (cloth)
ISBN 1-85074-803-9 (paperback)

Library of Congress Catalog (data applied for)

Exhibition coordinators: Julius Bryant, Alec Cobbe,
Alastair Laing, Cathy Power
Managing editor: Karen Dorn
Catalogue editors: Alastair Laing, Sarah Yates, Frankie Leibe
Installation design: Alec Cobbe and David Mees Design Partnership

Cover illustration Detail of cat.57 (Guercino)
Frontispiece Detail of cat.46 (Zoffany)
p.7 Detail of cat.19 (Rombouts)
p.16 Detail of the Drawing Room, Newbridge House
p.198 Detail of the Saloon, Hatchlands Park

CONTENTS

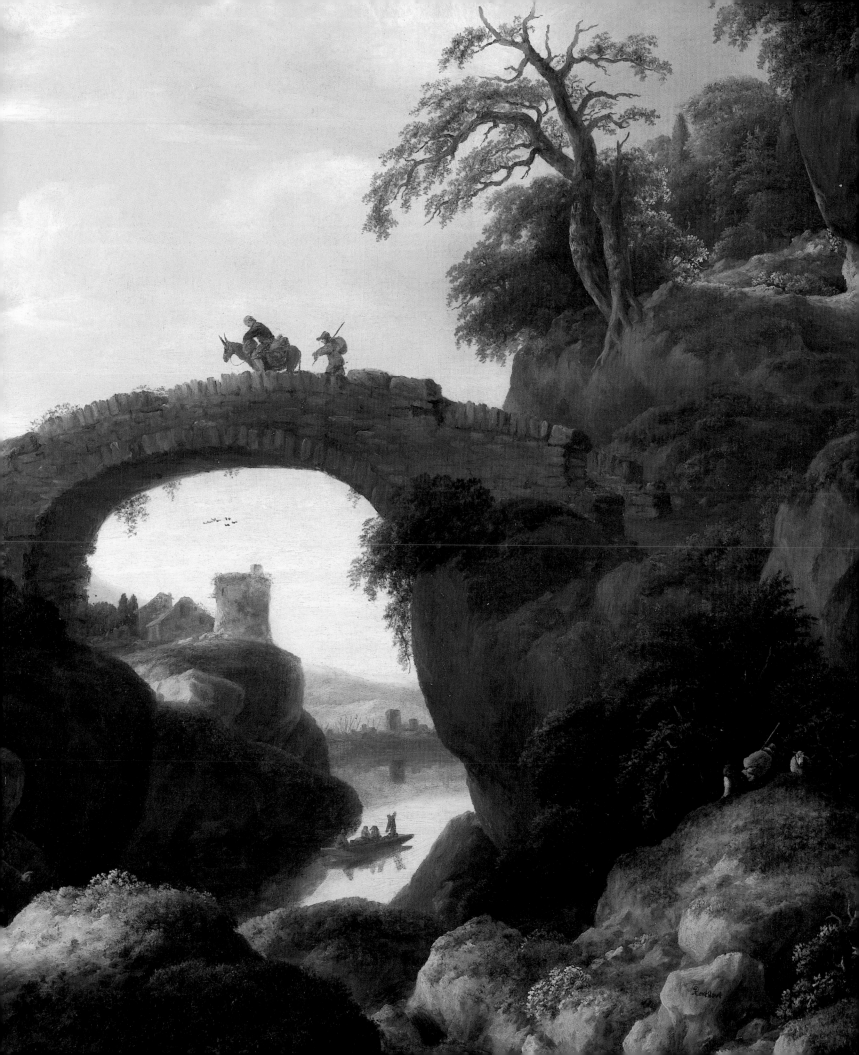

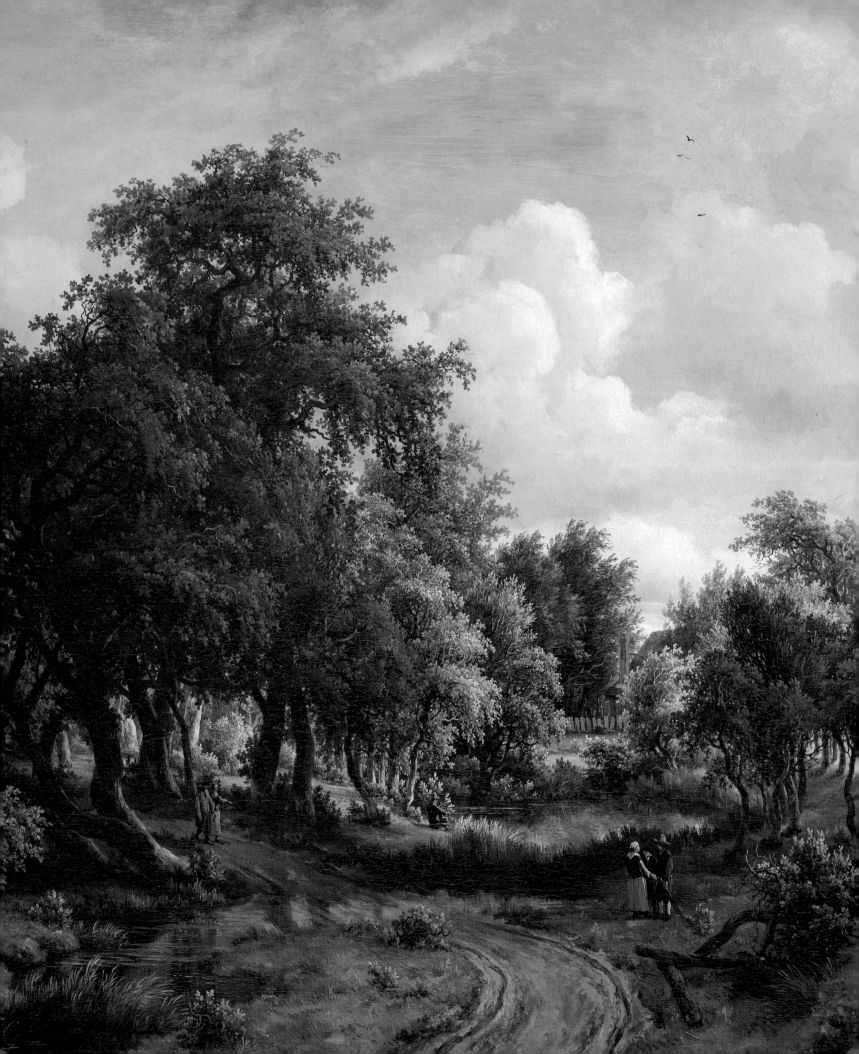

From its publication in 1770 to the early 19th century, the Rev. Matthew Pilkington's *The Gentleman's and Connoisseur's Dictionary of Painters* (figs 57–8) was the standard reference book for collectors in Britain. The first study of its kind written in English, it went through eight editions by 1857, as revised by Henri Fuseli, Allan Cunningham and others. As an affordable single-volume biographical survey of the history of art, it made collecting accessible to all, reducing the dependence on dealers, guides, gentlemen of taste and other self-appointed cognoscenti. Keen-eyed readers would have noted occasional references to paintings in the Cobbe Collection at Newbridge House, near Dublin, and may have wondered how such a pioneering work could have been compiled by an otherwise unknown scholar, identified on the title-page as the 'Vicar of Donabate and Portraine'.

The collection formed in the 1760s by Thomas and Lady Elizabeth ('Betty') Cobbe, with Pilkington's advice, provides an alternative to the familiar English country-house collections, accumulated over generations and enriched with souvenirs from Grand Tours of Europe. Assembled in the Dublin sale rooms, it became known as one of the best collections in Ireland, and nearly every loan exhibition held in Dublin for half a century from 1847 included examples drawn from Newbridge. Today Newbridge remains the most complete Irish house of the Georgian era and is opened to the public by Fingal County Council.

Growing up in Dublin and working in the family brewery, Edward Cecil Guinness, 1st Earl of Iveagh, must have known the Newbridge collection; certainly the Cobbe family were major lenders to the Irish Exhibition of 1872, which Edward Cecil co-organised, funded and underwrote against loss with his eldest brother on land behind their house on St Stephen's Green. In 1874 he made his first major purchase, Rembrandt's *Judas Returning the Thirty Pieces of Silver* (private collection; fig.55) from Lord Charlemont's celebrated collection in Dublin. As an exceptionally intact 18th-century Irish collection, the Newbridge paintings provide a revealing comparison with the 17th- and 18th-century artists Edward Cecil Guinness chose when he formed his own collection, largely through Agnew's of Bond Street, London, from 1887 to 1891, and with the selection he made for Kenwood shortly before his death in 1927. Most notable is the absence from the Iveagh Bequest at Kenwood today of 17th-century Italian paintings of mythological and religious subjects, in favour of a preponderance of British portraits. Iveagh was too much of a Victorian to resist the glamorous Gainsborough ladies and

Reynolds children that came on to the market in the 1880s. He was also too good a collector to risk buying Old Masters of uncertain attribution.

The Cobbe Collection is far more than an historic survivor, for it is alive and well and growing dramatically through the care of its honorary curator and conservator, Alec Cobbe, great-great-great-great-great grandson of Thomas and Lady Betty. As such, it is a marvellous example of how an ancestral collection can live in the present day, welcoming back old friends from their travels abroad, expanding their provenances, and making new introductions through appropriate additions.

This exhibition provides an opportunity to re-unite temporarily paintings from the Historic Cobbe Collection that have found new homes abroad and to present some major new discoveries. The 'Cobbe Hobbema' (cat.24) is the guest of honour, lent by the National Gallery of Art in Washington, DC. Sold from Newbridge in 1839 with a Gaspard Dughet (cat.40) for £1,500, it funded the replacement of every mud and thatch cabin on the Newbridge estate with a stone and slate house, providing, as Charles Cobbe noted in his diary in 1839, 'comfortable houses for the poor tenants, with comfortable beds, instead of the wet wad of straw so many now sleep on' (see pp.87–9). It was later acquired by the American business magnate J. Pierpont Morgan for £25,000 and has returned across the Atlantic for the first time since 1900. It is here re-united with the Dughet, lent from a private collection in Monaco. Discoveries made while preparing this catalogue include the recognition of Guercino's *Semiramis at her 'Toilette' Receiving the News of the Revolt of Babylon* (cat.57) as the lost prime version and the revelation of a previously unknown early painting by Poussin (cat.56) – both of which have been accepted by Sir Denis Mahon – and the identification of the design for Newbridge as by James Gibbs (fig.25) to whom the house had not previously been attributed.

Fifty years have passed since Kenwood set out on the ambitious path of presenting art-historical exhibitions to bring fresh perspectives to Lord Iveagh's collection. Subjects have varied from monographic retrospectives on British painters of the 18th century (notably Hudson, Hayman, Dance and Wootton) and their European rivals for British patrons away on the Grand Tour (including Vernet, Ducros, Batoni and Mengs) to more thematic studies of the period and in-depth explorations of single paintings in the Iveagh Bequest. Following the success of the recent exhibition on the collection formed by Sir Robert Walpole for Houghton Hall and its sale to Catherine the Great, *Clerics and Connoisseurs*

Detail of cat.24
(the 'Cobbe Hobbema')

develops the theme of collectors, to reveal the personalities and motivations that lie behind collections, beyond questions of taste and attribution. It also introduces the first exhibition at Kenwood to include artists of whom we hope to show more in the future: the painters of Ireland. Remarkably, this is the first time that an exhibition on an Irish theme has been presented at Kenwood, and, it would appear, only the second occasion at any other museum in England.

Complementing the Iveagh Bequest, *Clerics and Connoisseurs* raises issues about the historical position of the Anglo-Irish, and the social role of art and collecting in defining their self-image. After generations of political unrest, it seems fitting to address this sensitive subject in a museum in London founded on the Guinness family fortune. With a selection from the Cobbe family's private museum of antiquities (figs 1–2), the exhibition also raises more fundamental questions about the urge to collect, from curiosity about one's place in the natural and historic environment to the need to assert identity through heritage objects.

Many sponsors, lenders and scholars have made *Clerics and Connoisseurs* possible, but I would like to thank first and foremost Donald and Jeanne Kahn. Without their generosity, the exhibition and this handsome volume could not have been realised. Indeed, their support has enabled us both to produce the most substantial catalogue ever published to accompany an exhibition at Kenwood and to refurbish the exhibition rooms for the first time, making this a fitting 50th anniversary celebration.

Fingal County Council and the National Trust both agreed to denude the walls of Newbridge and Hatchlands Park of the Cobbe Collection without the prospect of any temporary substitutions. Among further supporters, particular thanks are due to the Irish Georgian Society, the Ireland Fund and its Trustees, the London Historic House Museums Trust, the Cobbe Collection Trust and its Trustees, and the Cobbe Foundation for their generosity.

Alastair Laing kindly agreed to serve as academic editor of this volume. In his Editor's foreword, he has acknowledged the many scholars for their contributions, but I would like to thank him and Mark Broch for their years of research on the collection, which provided the foundations for this exhibition, and for their new discoveries and ideas throughout the project. The team is most fortunate to have benefited from the expertise of Nicholas and Jane Turner. Kenwood's exhibition rooms have been redecorated for the occasion by the Alec Cobbe and David Mees Design Partnership. The catalogue was produced by Azimuth Editions with sensitivity and perseverance.

The commitment of the staff of English Heritage has been remarkable, and I would like to thank, in particular, the following for their help with painting conservation, photography and organisation of the exhibition and catalogue: Jonathan Bailey, Graeme Barraclough, Adrian Buckley, Estelle Cable, Rowena Diggle, Karen Dorn, Julie Ehlen, Dave Gribbin, Chris Higgs, Deidre Neill, Caroline Pegum, Cathy Power, Trevor Reynolds, Charles Walker and Amina Wright.

English Heritage's greatest debt is to Alec Cobbe who welcomed our invitation to develop this exhibition while collaborating with us in millennium year on the most substantial redecoration of the interior of Kenwood since the museum opened in 1928. Now that they are established, long may the links between Kenwood and Newbridge, as Anglo-Irish villas open to the public in London and Dublin, continue to flourish.

Julius Bryant
Director
Museums and Collections
English Heritage

'The collector is on the up … [he] is upgraded to a par
with the artist – and has certainly overtaken the patron –
in determining how we shall look at works of art.'
Editorial [by Neil McGregor],
The Burlington Magazine, December 1982

The rhetorical exaggeration of the epigraph to this piece (indited before the writer went on to become director of that temple devoted to the individual work of art, the National Gallery) was occasioned by nothing more sinister than the re-opening of Apsley House, its pictures rehung – insofar as was possible – as they had been in the 1st Duke of Wellington's day. The Wellesleys (previously Colleys), like the Cobbes, were an Anglo-Irish family – though George IV, when Prince of Wales, notoriously said of Wellington: 'What can be done with a Spanish Grandee grafted on an Irish Potato?' The Duke's collection of pictures, based as it was on Joseph Bonaparte's booty from Spanish palaces, may have been of a different order of magnitude from that of Thomas Cobbe, son of the Archbishop of Dublin, but their manner of hanging and display was much the same. Their essential characteristic is that they privilege the collection as an ensemble over the individual picture. It is that practice that this exhibition seeks above all to celebrate. For it is the spirit of the hang of the great Drawing Room at Newbridge House – the 18th-century Cobbe seat near Dublin – that has successively inspired the revitalisation of Hatchlands Park (an Adam house whose bequest to the National Trust had been hobbled by the departure of its indigenous, Goodhart-Rendel, collection) by the hanging of a revived Cobbe Collection there; the transformation of Kenwood through Alec Cobbe's rehanging of the pictures of the Iveagh Bequest in it; and now, the hanging of this exhibition there too.

Julius Bryant has thanked those who have so splendidly brought this exhibition to fruition, and Alec Cobbe will add his own mead of thanks after this. I should particularly like to thank those who have contributed to the making of this catalogue. First and foremost, Alec Cobbe himself, and his assistant, Mark Broch, who have supplied so much of the information and opened up so many of the lines of enquiry, upon which the contributors' entries are often based. Then Nicholas Turner, whose re-evaluations and discoveries have so greatly enhanced the revelations of this exhibition, and who has shouldered the task of writing so many entries, in addition to his own, for which no obvious author could be found. Then the authors of the various general essays, who

have lifted the horizons of this catalogue way beyond concern with just the one collection to which it is devoted – the Knight of Glin, Terry Friedman, Charles Sebag-Montefiore, Barbara Bryant, William Laffan and Christopher Rowell – and those authors not already cited whose other catalogue entries have likewise gone well beyond the individual picture to its wider context: Jaynie Anderson, Tabitha Barber, Linda Kelly, David Mannings, Sir Oliver Millar, Sally Mitchell, Axel Rüger, Francis Russell, Susan Sloman, Nicolette Sluijter-Seijffert and Arthur Wheelock.

The contributors have asked that the following individuals also be thanked for their help in either the preparation of essays and entries or the provision of photographs for comparative illustrations (often at extremely short notice): Angela Acheampong, Sir Jack Baer, Kathryn Barron, Alex Bell, Hugh Belsey, Giuseppe Bertini, Lorne Campbell, Anne Casement, Sophie Chessum, Anne Crookshank, Jane Cunningham, John Downham, Taco Dibbits, Harriet Drummond, Archibald Elias Jr, Jane Fenlon, Burton Fredericksen, Mario Di Giampaolo, Paul Grinke, Bella Hardy, Catherine Hassall, Martin Higgins, Angelo Hornak, Colin Johnston, Adrian Le Harivel, Ger Luijten, Sir Denis Mahon, Rosalind K. Marshall, Judith Mills, David Moore-Gwyn, Edward Morris, Athol Murray, Martin Royalton-Kisch, Stephen Ongpin, Flavia Ormond, Clare Rider, Clare Robertson, Mr and Mrs Stuart B. Schimmel, David Scrase, Jean-Pierre Selz, Luigi Spezzaferro, Simon Turner, Lady Cleone Versen, Nicholas White, Marieke de Winkel and Margret Wolters.

Finally, credit must go to our publisher and in-house editors, Julian Raby, Karen Dorn, Sarah Yates and Frankie Leibe (with warmest thanks to Jane Turner for her informal help and encouragement): confronted with a quantity of text twice the length of what was first envisaged, they have miraculously dealt with it in half the time originally allowed. That the catalogue has – if it has! – appeared in time is entirely due to their unflappability and determination to find solutions rather than raise obstacles.

Alastair Laing
Advisor for paintings and sculpture
The National Trust

The Picture Gallery or Drawing Room at Newbridge, its interior virtually untouched since 1828, provided a valuable inspiration when my and David Mees's design practice was advising English Heritage on redecoration schemes for Kenwood. While ideas for these were under discussion, I suggested to Julius Bryant, who was in Ireland for a couple of days, that he should visit Newbridge. Some months later he came up with the idea of this exhibition. Within a very short time, his idea had caught the enthusiasm of my friends Donald and Jeanne Kahn who had also stayed at Newbridge, and it must be said straight-away that it was their unstinting generosity and the immediacy of their commitment that ensured that this study of an Irish country house and its picture collection, the first to be published in England, would go ahead. I offer them my heart-felt thanks.

After my father's death in 1949, my mother, sister, brother and myself moved to Newbridge to live with my uncle. We had, of course, visited it many times before, but once we were living there I remember well how strongly the atmosphere of the place, from its upper nursery corridor to its basement passages, its yards, barns and stables and the web of lives existing there, struck an impressionable four-year-old. At that age, one perceived the whole as a single immutable world, and I can recall vividly the moment of realisation, a year or two later, occasioned by the visit of an interested 'grown-up', that all the dark pictures, which one took for granted as an inextricable part of the walls on which they were crowded, differed in something other than their subject-matter, that some pictures were 'fine' and others were not considered so. From that moment onwards, the subject of pictures, collections and their relationship to interior architecture has formed a significant thread of my life and a considerable portion of my professional activities. As I have said, this book was born during the rehanging of the Iveagh collection in Kenwood.

I was encouraged in my own earlier forays in purchasing pictures by my wife's aunt and uncle Renée and Langton Iliffe (a significant part of whose own collection of pictures was included in their gift of Basildon Park to the National Trust). By 1987 my growing collection of both pictures and musical instruments led to my leasing Robert Adam's Hatchlands Park from the National Trust and to my refurbishment of its fine interiors. The enlarged collection, since then, has had the advantage of great mid-18th-century rooms on both sides of the Irish Sea for its display. Though executed within four years of each other, Richard Williams's playful, inventive plasterwork in Newbridge makes a fascinating contrast to Robert Adam's unusually bold, but static Italianate schemes in Hatchlands.

Therefore, my very first acknowledgements on behalf of the collection, as it were, are architectural. I would like to express appreciation of the responsible and sensitive role played by Fingal County Council which, in 1985, as Dublin County Council, took over the ownership, maintenance and custodianship of Newbridge House and which, in conjunction with Dublin Tourism, has made such a success of its restoration and opening to the public. A happy aspect of the scheme for my family is that the unbroken 265 years of residence of the Cobbes continues. The same appreciation is expressed to the National Trust which preserves Hatchlands Park with the immaculate care and expertise bestowed on all its properties. The National Trust's contribution to the preservation of some of Britain's country houses is, with that of English Heritage, the envy of Europe.

For help with additional fundraising, I would like to thank personally, for their exceptional efforts, David Reid-Scott and Alan Hobart who befriended the exhibition from the moment it was brought to their attention, the Knight of Glin and Charles Sebag-Montefiore who gave of their enthusiastic support. Charles Sebag-Montefiore tracked down, in an astonishingly short time from within his own provenance library, the sale particulars of the 1812 disposal of pictures by Charles Cobbe, and by a fortuitous coincidence he possesses the receipt for the sale of the 'Cobbe Hobbema' (cat.24), shortly after it left Newbridge, to the Holford collection in Dorchester House. He has patiently responded to many a request to help with provenances, for which I offer my gratitude and likewise to John Guinness. The Marquess of Waterford kindly responded to queries relating to the Beresford family and allowed the reproduction of the large Astley picture of the *Earl of Tyrone and his Family*, as well as the *Portrait of Viscount Beresford* by Baron François Gérard. In matters relating to Irish paintings, the Knight of Glin, Sir Robert and Lady Goff, and Ken and Brenda Rohan have been pillars of support. Without the kind help of Francis Russell we could not have tracked down, let alone borrowed, the 'Newbridge Dughet'.

The architectural history of Hatchlands and its links with Robert Adam and Humphrey Repton are well documented, but we felt the publication should be furnished with a more detailed history of Newbridge whose architectural origins had remained obscure. It was the consequent re-examination

of Archbishop Cobbe's 'Plans for Houses' that first hinted at the possibility of James Gibbs's involvement in the designing of the house, and I thank Terry Friedman for his great patience and many telephone conversations before and after my discovery, in Oxford, of Gibbs's Newbridge design. The subsequent collaboration with him in our contribution for this book has been, for me, nothing short of an education. Archibald Elias Jr provided enlightenment of the relationship between the Archbishop and Matthew Pilkington, one of the keystones of the project. The Earl of Belmore was most helpful in making available for comparison interesting architectural records at Castle Coole. In Dublin, Freddie O'Dwyer shed valuable light on matters relating to George Semple and Joseph McDonnell in relation to the plasterwork at Newbridge. David Griffin at the Irish Architectural Archive, who was the first to identify the connection between Semple and the Archbishop, was a constant source of help, encouragement and information. The dedicated work of Peadair Bates in chronicling the history of Donabate and more particularly in sorting and cataloguing the Cobbe estate papers has been invaluable. I am also grateful to Rosemary Baird and Paul Spencer-Longhurst of the Barber Institute for providing a complete copy of the 1812 Cobbe sale catalogue, and to Sarah Newton, Christine Butler and Joanna Snelling of Corpus Christi College, Oxford.

The collection has benefited over many years from the wise council and friendship of Sir Hugh Roberts. For the present project it has received and, benefited from, the focussed attentions of a distinguished team of art historians. In particular, I should mention the enthusiastic commitment of Nicholas Turner, ably assisted by his wife Jane, whose task of cataloguing the majority of the Italian pictures (and some others), over one quarter of the exhibition, was, perhaps, the most sizeable of the project. The, sometimes late at night, whirring of faxes of discovery from the Turner household will be one of the pleasant memories of the preparation for this publication. Some pictures have been completely re-attributed in terms of artist or sitter, preparatory drawings have been identified in a surprising number of instances, and provenances newly discovered or considerably extended in many others. For her advice and constant support, everyone concerned is deeply grateful to Jane Turner.

I thank Sir Denis Mahon for his memorable 'Guercino' and 'Poussin' journeys to Hatchlands. Lord and Lady Egremont generously allowed their version of *Semiramis* to be an object of study and analysis during the research for the exhibition. Sir Oliver Millar very kindly inspected the Van Dyck *Portrait of a Man in a Ruff* and assessed the studio picture of the *Countess of Southampton*.

In 1998 Mary and the late Louisa Hely-Hutchinson, whose family had been close friends and neighbours of the Cobbes at Newbridge for over two centuries, decided that they would like their Hutchinson family portraits to join the Cobbe collection. This group, which I have known since childhood, includes a portrait of one of Archbishop Cobbe's closest friends and a fine portrait, previously unrecognised, by Batoni. I would like to express gratitude for these happiest of augmentations to the collection. I thank my cousin John Maxwell for his help in organising the photography of this group of pictures.

In the USA, I must thank Arthur Wheelock Jr, of the National Gallery of Art, Washington, DC, for his extremely courteous reception, some years ago, of an unexpected stranger, announcing his family's previous ownership of one of his pictures. Our discussions on that occasion led to our collaborative essay on a key aspect of the exhibition, the re-unification, for the duration, of the 'Cobbe Hobbema' with its former '*confrères*'. I am also most grateful to Mrs Russell B. Aitken, of New York, for allowing the reproduction of Gainsborough's *Portrait of Mrs Frances Champion*; although *Mrs Champion* did not make it across the Atlantic, she appears beside her husband in this book, re-united for the first time since the picture was sold by my grandfather in 1913.

Researches into Cobbe family history will always owe a considerable debt to Frances Power Cobbe (1822–1904), eminent writer and feminist. Her present-day biographer, Prof. Sally Mitchell, of the English Department at Temple University, Philadelphia, who has conducted the most detailed researches into her subject over a long period of years, now possesses a greater reservoir of knowledge concerning 19th-century Cobbes than does any other living person. This she has been always ready to share, and I would like to record my gratitude for the enrichment she has provided to the knowledge of members of our family.

Escaping family pictures have a habit of turning up in the art market at short notice and impecunious moments. I am greatly obliged to Johnny van Haeften, Simon Dickinson, Richard Green and Rafael Valls who have at various times been deeply sympathetic to the returning to the fold of various strays.

The contributors to the exhibition catalogue were chosen and the standards of scholarship set by Alastair Laing, whose

editorship and contributions are an enduring embodiment of the firm hand of friendship he has continuously extended to the collection and to me, ever since, as a fellow undergraduate at Corpus Christi, he came to stay at Newbridge in the summer of 1966. Working with him and his art-historical team has been a pleasure at all times.

It has also been a pleasure to work with the English Heritage team: Karen Dorn on the publication, whose ever-present calm inspired confidence at all times; Cathy Power, who shouldered the entire administration attendant on an exhibition of over one hundred pictures, executing it meticulously and with apparent effortlessness; and Deirdre Neill and Robin Brooks, who produced the admirable sound-guide. Overall, the calm, lucid and purposeful manner with which Julius Bryant has guided his idea to fruition has been remarkable. I would also like to thank Julian and Lorna Raby and the team of Azimuth Editions for their expert production of this book and for nobly accommodating one new item after another, despite ever-pressing deadlines.

It is fair to say that without my research assistant, Mark Broch, this book could not have been brought together in the short period allowed by the timing of the exhibition. He prepared a summary catalogue of the Historic Cobbe Collection, and, quite apart from his own entries, most of the catalogue and special essays in this book have benefited from his facility in surveying at speed large quantities of printed and manuscript material in libraries, record offices and the Internet. The discovery that two of the historic collection pictures were auctioned in Paris in 1764, only just before they would have been hung at Newbridge, was his and makes more acute the question of whether or not Pilkington travelled abroad. I would also like to thank my colleague, David Mees, who was deeply involved in the redecoration schemes at Kenwood, for his further help in designing the exhibition and his tolerance of the gradual capture of our office that the research for this catalogue effected. His acute, logical eye for grammar and punctuation in the texts produced at Hatchlands has, as ever, been enormously helpful.

The project was greatly assisted by the enthusiastic co-operation, at Fingal County Council and Newbridge, of Michael Lynch, Christy O'Halloran, Pascal Murphy, Brigid Dunn, Betty O'Brien and Fergus Lynch who helped me take multiple measurements all over the south front of Newbridge, and at the National Trust and Hatchlands, of Christopher Rowell, Keith Marshall and Lyn Marshall. To countless others in Ireland, the UK and elsewhere – too numerous to list individually – I offer my thanks for all their assistance on matters small and large.

My sister, Mary Bradshaw, and brother, Hugh Cobbe, were always ready to help with information, and I would like particularly to thank Hugh for his loans to the exhibition and for the liberal access he has provided over many years to his greater holding of Cobbe papers and accounts. My cousin the Rev. Mervyn Wilson has also helped me in family researches. My children, Frances, Tom, Rose and Henry, have kindly offered opinions on all manner of aspects of the book and exhibition, and these have been much valued. My greatest debt is to my wife, Isabel, whose extraordinarily wide range of general knowledge has continually come to my rescue, while her instinctive love and understanding of Irish culture has been an ever-present catalyst. During the year it has taken to accomplish the necessary tasks, I fear, one family plan after another was sacrificed to the need for research and compilation, and this she has borne with graceful patience.

Above all, I wish to acknowledge my mother, Joan Mervyn Cobbe, who instilled in us a sense of history, a discipline in which she took an honours degree at Bedford College, London University, just before the Second World War. I dedicate my own efforts towards this book to her and to the memory of my uncle, Thomas Leuric Cobbe, who between them preserved Newbridge through the most taxing years of the 20th century, during which large numbers of Irish country houses and their collections disappeared forever.

Alec Cobbe
Newbridge House, Co. Dublin
Hatchlands Park, East Clandon, Surrey

Dimensions are given in inches and centimetres (to the nearest 0.5 cm); height precedes width.

Entries for items in the exhibition are organised in two parts, the first for paintings from the Historic Cobbe Collection and the second for acquisitions made since 1960; within each part, entries are arranged by school and then in rough chronological order by artist. Some schools include works by foreign artists when the paintings were carried out during the relevant artist's stay abroad (e.g. Poussin and Dughet in Italy, Anthony van Dyck and Thomas Hickey in England).

Catalogue entries are signed with the initials of the following contributors:

A C	Alec Cobbe
A D L	Alastair Laing
A K W	Arthur K. Wheelock Jr
A R	Axel Rüger
D M	David Mannings
F R	Francis Russell
J A	Jaynie Anderson
J T	Jane Turner
L K	Linda Kelly
M B	Mark Broch
N S-S	Nicolette Sluijter-Seijffert
N T	Nicholas Turner
O M	Sir Oliver Millar
S M	Sally Mitchell
S S	Susan Sloman
T B	Tabitha Barber
W L	William Laffan

The following pictures in the exhibition are normally on display to the public at Newbridge House, Co. Dublin, courtesy of Fingal County Council and the Cobbe Collection Trust and its Trustees (open 1 April to 30 September, 10.00–1.00, 2.00–5.00 p.m. Tuesday to Saturday, 2.00–6.00 p.m. Sundays and Bank Holidays; 1 October to 31 March, 2.00–5.00 p.m. weekends and Bank Holidays):
1–2, 4–5, 7–10, 14, 17, 27, 38–9, 41–2, 44, 49, 53, 89, 92 and 102.

The following pictures are normally on display to the public at Hatchlands Park, East Clandon, Surrey, courtesy of the National Trust and the Cobbe Collection Trust and its Trustees (open 1 April to 31 October, 2.00–5.30 p.m. daily, except Monday, Friday and Saturday [but open Bank Holiday Mondays, and Fridays in August]):
3, 11, 15–16, 18, 20–23, 26, 28–9, 36–7, 43, 45, 46–7, 50, 52, 54–66, 68–88, 90–91, 93–101 and 103.

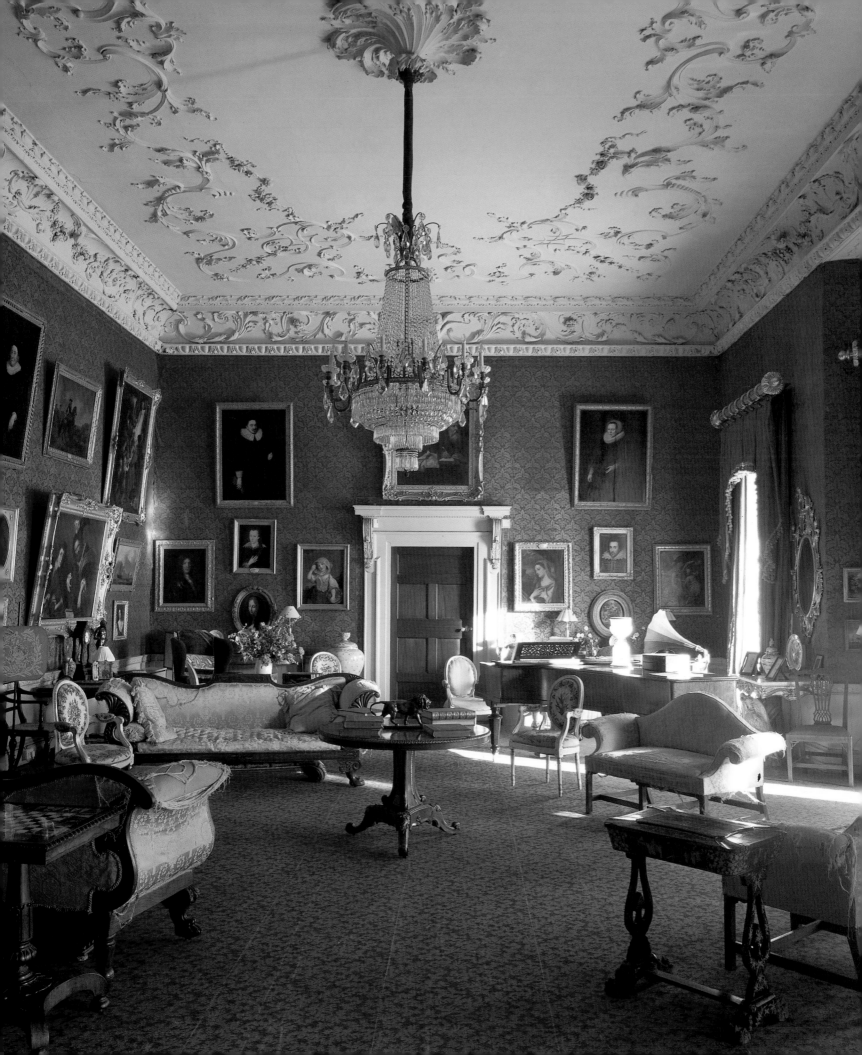

Part I

HISTORIC COBBE COLLECTION

Alec Cobbe

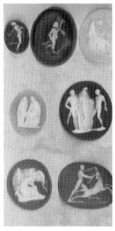

In the 16th, 17th and 18th centuries a 'Cabinet of Curiosities' was considered to be as essential a requisite for a cultivated gentleman as was a library or a picture gallery. The aim of early private museums, as opposed to later public art museums, was to encompass the material of the natural and manmade universe in one entity.

Collecting for the Cobbe family museum proceeded on this principle and was begun by Thomas and Lady Betty Cobbe in 1756, the year following their marriage, when an ostrich egg, inscribed in gilt letters *Laid At Dundalk 1756*, was acquired at Lord Clanbrassil's nearby menagerie. From 1757 significant sums were spent on shells in Dublin, Bath and London, while the acquisition of a 'calabash' and coral testifies to a growing taste for exotica, and of a 'solar microscope' to recreational enquiry. Display trays for the shells and other items in the museum were later fashioned out of disused packs of playing cards.

Thomas Cobbe took an interest in Captain Cook's discoveries in the South Seas, purchasing the three-volume edition of Cook's *A Voyage to the Pacific Ocean* (1784) in February 1785. A considerable corpus of South Sea objects from Cook's last excursion found its way to Dublin, and a small number of these into Thomas's museum, including a Tahitian head-rest and a selection of tapa (bark-cloth) inscribed for his daughter-in-law. A mineralogical survey of Newbridge carried out in 1792 seems to have inspired a group of rock and mineral specimens, most of them numbered, but the catalogue unfortunately is no longer extant. Most of the 18th-century exhibits, however, are of Chinese origin, and these include a spectacular ivory puzzle-ball (or 'Devil's work') and a child's pair of embroidered shoes, one containing a model of a foot to show how the toes were bound.

Thomas's heir and grandson shared his interest in curiosities, and Charles Cobbe's marriage to Frances Conway brought her 1795 collection of pressed seaweeds into the museum to join his of pressed grasses. Two of Charles's brothers seem also to have contributed significantly, Henry William Cobbe bequeathing in 1823 'All my curiosities … shells, coins, the cinnamon stick, the bronzes from Ithaca …' and Thomas Alexander Cobbe sending home from India examples of humming birds, insects, ivories and a group of deities he had commissioned to be made at Neemutch.

All these and much besides continue to reside in the Cobbe museum, but it is, perhaps, the display furniture itself that constitutes the greatest rarity today. An exceptionally fine Irish mahogany collecting cabinet of the mid-18th

fig. 1

Fig. 1 Coloured wax intaglios after Roman gems, possibly attributable to the Dublin wax modellers Patrick Cunningham (*d.*1774) or Samuel Percy (1750–1820)

Fig. 2 Thomas and Lady Betty Cobbe's original collecting cabinet (*c.*1760) standing against one of the Newbridge museum cabinets (*c.*1800)

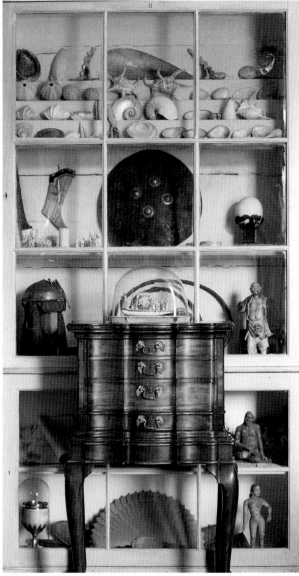

fig. 2

century (fig .2) possesses a secret drawer containing a dazzling group of brightly coloured wax intaglios after Roman gems (fig .1). The remaining furniture, providing display at eye-, waist- and ankle-levels, dates variously from the 1790s to the 1820s and is probably the earliest 'whole room' museum installation to survive in Ireland or Britain.

The Knight of Glin

Fig.3 Janet Finlay Cobbe,
Newbridge House,
watercolour, 6¾×12¼ in
(171×318 mm), after *c.*1870
(Alec Cobbe)

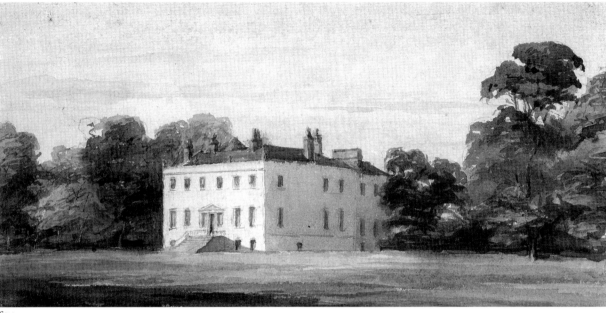

fig. 3

This essay sets out to put Newbridge in the context of the decline of the country house in Ireland and also to look at the contents of this remarkable fragile inheritance, which combines splendid interior decoration, a significant painting collection (including family portraits), the remaining original contents, as well as supporting family papers (figs 5 and 13–14).

Newbridge rated two plates in vol.v of the *Georgian Society Records* of 1913 and a mention in the catalogue.[1] It was on the eve of the First World War that the Rev. J. P. Mahaffy, later Provost of Trinity College, Dublin, and the driving force behind the first Georgian Society, visited the house. The owner, Thomas Maberly Cobbe, was to die a year later in 1914.

The photograph of the Drawing Room shows its superb Rococo plasterwork and the walls closely hung with paintings. An earlier photograph of *c.*1880 (fig.4) has the paintings in much the same hang, but without two Rococo mirrors, which are shown flanking the monumental door in the later Georgian Society plate. From comparing the two photographs, one senses that time had stood still in Newbridge during t he life of Thomas Maberly Cobbe. Indeed, John Cornforth, who reproduced a photograph of 1890 in his two seminal articles in *Country Life*,[2] commented that the Drawing Room was 'a room in which life seemed to have stopped about 100 years ago'.

Newbridge in those days had the atmosphere of a *bois dormant*, a house relatively untouched, and it has kept this atmosphere even today when it is open to the public. As Alec Cobbe wrote in a more recent article on the house in *The World of Interiors*:[3] 'Newbridge is one of those magnetic Irish houses where time makes no changes, save to allow a gradual dusty decline; open a bureau and you will find an invitation to dinner of the 1750s, and in a dressing-table drawer a never-kept appointment with a Dublin coiffeur of the 1840s.'

Newbridge is particularly remarkable in the fact that many of its original furnishings are still in the house or in the possession of the Cobbe family (fig.6). Particularly noteworthy are the oval Rococo mirrors in the Drawing Room (fig.9), which bear the label of James Robinson, Carver and Glass Seller of 7 Caple St, Dublin (fig.10), who was at this address between 1771 and 1778.

Robinson worked with Richard Cranfield on the Provost's House of Trinity College, Dublin, in the 1760s.[4] Cranfield was one of Dublin's most important craftsmen. In 1769 he made, after designs by James Mannin, the highly baroque President's Chair for the Dublin Society. The Newbridge oval mirrors are hung above 19th-century giltwood pier-tables by the Dublin firm of Murray's of Dawson St (fig.11; see also cat.17a).

Lady Betty Cobbe's invaluable account book lists the cost of a mahogany swan-necked bureau bookcase still in the house (fig.7) as £11.17.6d in 1762 (fig.8), but, maddeningly, the maker is not mentioned. Other accounts document the Drawing Room furniture as being by the Dublin firm of

Fig.4 Drawing Room, Newbridge House, photograph of *c*.1880 showing the pictures as hung in 1868 (Alec Cobbe)

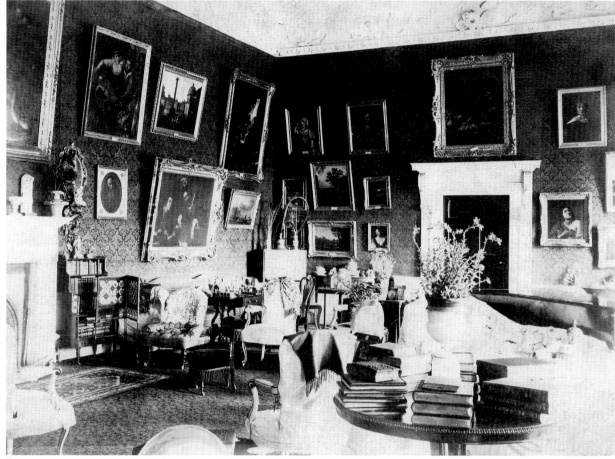

fig. 4

Mack, Williams & Gibton, the firm that also supplied the splendid crimson Regency curtains, which, along with the crimson wallpaper and carpet, make this room one of the most important surviving interiors in Ireland.

The second Georgian Society photograph shows the Dining Room with delicate Rococo plasterwork and incised Greek key pattern panels that elegantly match the key pattern on the friezes of the handsome pair of mahogany sideboards on either side of the pedimented Kilkenny marble mantel-piece. This Rococo plasterwork is also echoed by the delicately carved and gilded wooden festoons of the superb pier-glass, which is probably by Richard Cranfield, Dublin, and stands between the windows. Gervase Jackson-Stops suggested that the side tables might have been made by Christopher Hearn of 41 Fishamble St, Dublin,[5] whose name appears in the account books as the supplier of a great deal of furniture to the house in the 1750s and 1760s.

When the last generation of Cobbe children were brought up in this 50-roomed house there was little domestic help and no electricity. There were few visitors, a shooting lunch once a year and a weekly card party. Prying eyes were quickly dispatched by Uncle Tommy (Thomas Leuric Cobbe, son of Thomas Maberly) with a hint of menace and even, on occasion, a shotgun! An occasional visit by their neighbour, Lord Talbot from Malahide, with his houseguests, to see the house and pictures would generate a flurry of activity. Lacking the domestic assistance still present even half a century earlier (fig.12), dusters and tins of polish were thrust into the hands of the children, and the great red Drawing Room would be frantically cleaned.

The redolent atmosphere of this forgotten Irish house, with its encircling screen of trees and parkland (fig.3), instilled in Hugh and Alec Cobbe a curiosity and passion for all the papers that chronicled its past: bundles of letters

Fig.5 Cover of *Valuation of Heir Looms at Newbridge House, Donabate, Co. Dublin*, 18 November 1901 (Cobbe Papers: Alec Cobbe)

Fig.6 Irish 18th-century mahogany chair from Newbridge House (private collection)

tied up with faded red tape, merchants' receipts, the account books of the builder of the house, Archbishop Cobbe, and those of his son, Thomas, and his wife, Lady Betty. These papers tell some of the story of the picture buying in the 1750s. It was at this time that the Rev. Matthew Pilkington, the author of the famous *Dictionary of Painters* of 1770,[6] was the vicar of nearby Donabate. The church contains the amazing Rococo-stuccoed galleried Cobbe family pew by the plasterer Richard Williams, who was responsible for much of the work in Newbridge and who was married in the church to a nurse from Newbridge.

The second half of the 18th century saw the glory days of Newbridge. A century later, Frances ('Fanny') Power Cobbe, the stout and plain early feminist great-great-granddaughter of Thomas and Lady Betty, wrote a chatty and humorous book of memoirs,[7] which vividly describes Newbridge life in the late 18th century:

'I have often tried to construct in my mind some sort of picture of the society which existed in Ireland a hundred years ago, and moved in those old rooms wherein the first half of my life was spent, but I have found it a very baffling undertaking. Apparently it combined a considerable amount of aesthetic taste with traits of genuine barbarism; and high religious pretension with a disregard of everyday duties and a penchant for gambling and drinking which would now place the most avowedly worldly persons under a cloud of opprobrium. Card playing was carried on incessantly.

Tradition says that the tables were laid for it on rainy days at 10 o'clock in the morning in Newbridge drawing room; and on every day in the interminable evenings which followed the then fashionable four o'clock dinner … .

'As to the drinking among the men (the women seem not to have shared the vice), it must have prevailed to a disgusting extent upstairs and downstairs. A fuddled condition after dinner was accepted as the normal one of a gentleman, and entailed no sort of disgrace. On the contrary, my father has told me that in his youth his own extreme sobriety gave constant offence to his grandfather and to his comrades in the army.'

Life below stairs in the late 18th century was also described by Fanny. 'The tenantry lived in miserable hovels which nobody dreamed of repairing, but they were welcome to come and eat and drink at the great house on every excuse or without any excuse at all – a custom that is still sighed after as "the good old times".'

Fanny Cobbe was herself a humane woman and always ensured that men coming from the Cobbe estate at Glenasmole in the Dublin Mountains on business for 'the Master' were served with the largest plateful of meat and jugs of beer '… but should not be left in the servants' hall *en tête-à-tête* with whole rounds and sirloins of beef, of which no account would afterward be obtained'.[8] Her father, Charles, sold two of the most important pictures in the collection, the Gaspard Dughet (cat.40) and the Hobbema (cat.24), to build

fig. 5

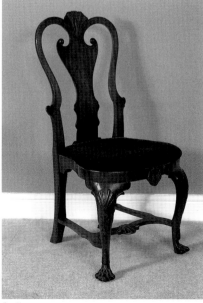

fig. 6

Fig.7 Irish 18th-century kneehole bureau-cabinet (Newbridge House)

Fig.8 'A bureau wt Glass doors – £11.17s.6d', entry for fig.7 made on 8 December 1764 in Thomas and Lady Betty Cobbe's account book for the years 1756–65 (Cobbe Papers: Hugh Cobbe)

Fig.9 Irish 18th-century oval giltwood mirror by Robinson's of Caple St, Dublin, over an Irish 19th-century giltwood pier-table by Murray's of Dawson St, Dublin (Drawing Room, Newbridge House)

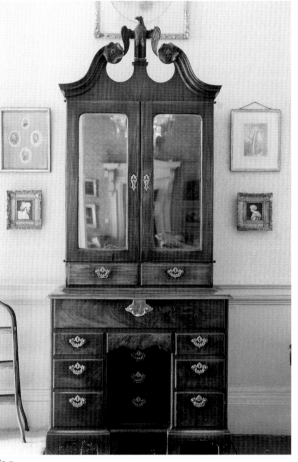

fig. 7

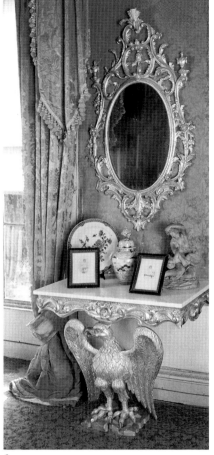

fig. 9

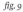

fig. 8

80 dry, sound, stone and slate cottages for these tenants in the Dublin Mountains (see fig.89), with no increase in rent for the new homes (see pp.87–9).

Fanny's memoirs are also extremely good value for their glimpse of late 19th-century people and places. She recalls, for instance, a number of visits to country houses. She particularly liked Garbally, the home of her cousin, the Earl of Clancarty, a splendid house in Co. Galway: 'We stayed nearly a week and I must say I have never enjoyed society in the same way before. I liked everybody and if I had been the Duchess of Draggletail nobody could have been more civil to me.'[9] She also relates the romantic tale of the astronomer William Parsons, 3rd Earl of Rosse, who met his heiress wife by going

incognito as a handy craftsman to a foundry in Yorkshire owned by his future father-in-law.

The late 18th-century life at Newbridge so amusingly described by Fanny came to an end in 1795 when Lady Betty shut up the house and abandoned her husband's liberal lifestyle thanks to the influence of his cousin, the Methodist Countess of Huntingdon. The constant visits of her smart Beresford relations ceased (Lady Betty [*née* Beresford] was the sister of George de la Poer Beresford, 1st Earl of Waterford), and the Countess persuaded Lady Betty and her husband to retire to a quiet life in Bath. Her husband's diary, with its droll stories and complaints of his gout, are among the Cobbe family papers.

Dating from April/May 1802 are a couple of interesting letters from Thomas Cobbe to a friend in Dublin, in which he announced his intentions of selling his father's famous library through the Dublin auctioneer James Vallance

Fig.10 Trade label of
Robinson's of Caple St,
Dublin (on reverse of
mirror in fig.9)

Fig.11 Trade label of
Murray's of Dawson St,
Dublin
(Glin Castle, Furniture
Archive)

(*fl.*1765–1808), as he was worried that it would deteriorate.
He continued: 'Pictures and China are Articles that will not
suffer by lying by, but Bed furniture is apt to decay if not
well looked after.' He proposed to 'forward the disposal of
the Chintz beds at Newbridge, which are Capital in their
way', and suggested, 'Others of an Inferior Quality, might be
put in their places'. Otherwise, 'every-thing else shall remain
as it stands, for Pictures and China require very little atten-
tion, and I will never let the house. It will retain the character
of not being stripped quite naked to the Walls.'

Two of the beds that were mentioned by Thomas appear

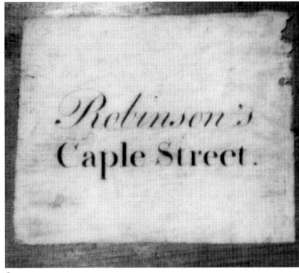

fig. 10

in the invaluable account book, for in April and November
1763 we find 'Mr. Hearn for ye tent (bed) – £34', and 'Mr
Hearn's bill in full for ye bed – £52.12.7d —'. Hearn was
Christopher Hearn, 'Upholder', whom we have already met,
but he had by then moved to George's Lane, Dublin. His
grandiose beds are by far the most expensive of the furnish-
ings that appear in the account book. They reflect a common
18th-century concern that goes back to the elaborate royal
State Beds of Louis XIV and William and Mary, but sold they
were, and Mr Cobbe replaced them 'with others of an Inferior
Quality', as he instructed,[10] although the replacements were
nonetheless quite elaborate.

The decline of the Irish country house and its collections
is a sad and gloomy phenomenon.[11] Descriptions of Irish
houses after the ill-fated Union of 1800 frequently illustrate
the rapid collapse of these estates. Tourists such as Prince
Pückler-Muskau, with his particular interest in landscape

parks, who came to Ireland in 1828 and visited many country
houses, both grand and less grand, reveal that many of them
were already on a downward turn. The prince gave a marvel-
lous description of the ramshackle Bermingham in Co.
Galway: 'the rain (for alas it does rain) runs merrily through
my windows, and falls in romantic cascades from the win-
dowsill to the floor, where the old carpet thirstily drinks the
stream. The furniture is rather tottery …'.[12]

A few years later, in 1843, the novelist William Makepeace
Thackeray gave a tragic description of a demesne near
Thomastown, Co. Kilkenny:[13] 'There was one place along

fig. 11

this rich tract that looked very strange and ghastly – a huge
pair of gate pillars, flanked by a ruinous lodge, and a wide
road winding for a mile up a hill. There had been a park once,
but the trees were gone; thistles were growing in the yellow
sickly land, and rank thin grass on the road. Far away you saw
in this desolate tract a ruin of a house: many a butt of claret
has been emptied there, no doubt, and many a merry party
come out with hound and horn. But what strikes the English-
man with wonder is not so much, perhaps, that an owner of
the place should have been ruined and a spendthrift, as that
the land should lie there useless every since. If one is not
successful with us another man will be, or another will try,
at least. Here lies useless a great capital of hundreds of acres
of land; barren, where the commonest effort might make it
productive, and looking as if for a quarter of a century past no
soul ever looked or cared for it. You might travel five hundred
miles through England and not see such a spectacle.'

Fig.12 Housemaid
at Newbridge House,
photograph, *c*.1900

A less familiar description, by an art-loving doctor from Philadelphia towards the end of the century in 1887, paints a sad picture of Drumboe Castle, the Irish estate of Sir Samuel Hayes in Co. Donegal: '… walked around the castle, the stables, etc., and found that the 'great place', that had filled my imagination with thoughts of splendour and plenty for many years, is merely a large white house, without beauty of either architecture or site. How different from what I had imagined. We rang the bell, and were admitted into the vestibule, the master being absent in Dublin. It was unattractive and dusty, and was occupied by a table containing a few indifferent books, various kinds of common gloves, a stuffed tiger in a glass case, the *crania* of some animals killed in the

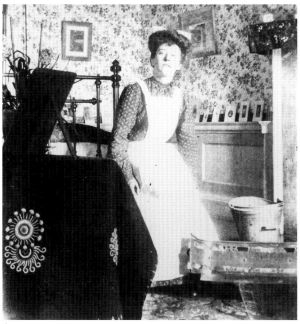

fig. 12

chase, a hat-stand like a tree trained to a wall, … filled with shabby hats. We penetrated into the hall, containing a rusty . stove; stairs covered with a soiled, cheap, threadbare carpet, economically worn to the bone. We were permitted to enter the library and parlour, I judged in one, a room 20 × 35 feet.

'In the centre a table filled with curios, none of interest, a few common-place ornaments around, a couple of old substantial cabinets and the like. One side of the room covered by a book-case, filled with books in time-stained bindings – standard volumes printed in but one language; works chiefly of utility, but few volumes of fancy or imagination. At the other end of the library a conservatory filled with plants in

bloom … this was the luxuriant house of an Irish baronet … we walked through the garden. Rhododendrons in particular grow high here, 10–12 feet, and bloom in great confusion. The gardener being off duty, we were not admitted among the flowers. Visited the shell house, the object of former wonder, and found it a little octagonal room about 7 feet wide, the inside encrusted by Lady Hayes with shells from the Donegal coast; then we lay down onto the grass, under the branches, and thought of home.'[14] A few pages later our doctor exclaimed 'of all the misfortunes I can imagine none worse than inheriting an Irish estate'.[15]

Even very grand houses such as Dromana, Co. Waterford, so dramatically sited over the River Blackwater, degenerated into ramshackle glory, as described in 1836 by an Englishwoman: 'The house is (like all things in Ireland) full of contrasts – such a grand drawing-room, such tumble-down offices, 16 lamps in the chandelier, and pack-thread for bell-ropes; a beautiful gold paper, and no curtains to the six windows; an eagle before the windows, a stuffed seal in the hall, some great elk horns over the staircase, lots of family pictures, an old theatre turned into a workshop, the remains of what must have been very fine hanging gardens, connected by stone steps, down to the river.'[16]

The Famine, together with the land wars of the 1880s, saw the inevitable slow collapse of the world of the landlord. Some of the most telling accounts are to be found in the diaries of the Scottish-born Elizabeth Smith of Baltiboys, Co. Wicklow.[17] In 1849 she related that it was not only the poor who were affected by the Famine but the rich as well. At the great Palladian house of Russborough, a combination of the Famine and Lord Milltown's compulsive gambling brought financial collapse to the family, causing his horses and stud to be sold at auction. Luckily the great collection of paintings and furniture survived, though Mrs Smith remarked that Lady Milltown took no pleasure in them other than to see that the house was occasionally dusted.

Russborough brings us back to the history of Irish collections. Geraldine, widow of the 6th Earl, left the Milltown paintings, other works of art, and the superb Rococo mirrors in 1897 to the National Gallery of Ireland, in whose care they still are today. In 1997 Sergio Benedetti mounted an exhibition at the National Gallery charting the history of the Milltown collection.[18] That and the present exhibition, devoted to Newbridge and the Cobbe Collection, are the only serious academic studies of the contents of Irish country houses ever mounted.

Fig.13 House account book with merchants' receipts for 1787 (Cobbe Papers: Alec Cobbe)

The story of picture collections in Ireland is a tale of auctions and dispersal. Indeed, some of the contents of Newbridge – paintings and furniture – were sold during the time of Thomas Leuric Cobbe, but the greatest loss was the monumental pilastered and pedimented dolls' house, which is now in Leixlip Castle. Undoubtedly the greatest Irish picture collection was that formed by the 1st Duke of Ormonde and his Duchess in the Restoration period,[19] much of which was sold in the early 18th century when the 1st Duke's grandson (the 2nd Duke) was attainted. The Irish State has wisely bought back some of the collection, which remains on display at Kilkenny Castle, together with some additional portraits and paintings.

Stackallen, Abbeyleix, and Lyons.[20] To these must be added the Wood collection, originally exhibited at Fota and now at the University of Limerick. It is extremely exciting to see such an infusion of Irish works of art returning to this country.

The North of Ireland offers a different picture, with a major collection of works of art in Baronscourt, and the notable contents at Caledon, Clandeboye and Glenarm. The North of Ireland National Trust administers with great care and attention the great houses of Castle Coole, Florence Court, Castle Ward, Mount Stewart and the Argory, with their vitally significant collections. Florence Court has recently received back the bequest of its original contents through the generosity of the late Countess of Enniskillen.

fig. 13

Important collections of paintings that still survive in the South of Ireland include those at Curraghmore, Birr, Westport, Lissadell, Glin, and the remaining O'Brien portraits still hanging at the Dromoland Castle Hotel. The portraits in the Malahide collection, now belonging to the National Gallery of Ireland, are only partially hung in their original location. Houses in the South with some or most of their remaining contents are relatively few – Kilruddery, Ballinlough, Castletown, Bantry, Tullynally, Lismore, Castle Leslie, Clonalis, Carriglass, Dunsany, Howth and Strokestown. Important collections, recently formed, have given new life to some of our most architecturally significant houses, such as Charleville,

The historic house situation in the South of Ireland is confusing, as there is no equivalent of the National Trust. The Irish State has taken in charge some very important properties such as Castletown, Kilkenny Castle, Fota, Emo, Glenveigh, Rathfarnham and Muckross House in Killarney, in partnership with local trustees, and, most recently, the Guinness house at Farmleigh in the Phoenix Park. Local authorities administer houses such as Malahide, Newbridge and other properties such as Ardgillan and Belvedere. The semi-state Heritage Council grant-aids important buildings at risk and formulates policies on all aspects of heritage, including archaeology and the natural as well as the built

environment. The Irish Georgian Society assists owners
in the conservation of historic properties, large and small,
urban and rural. An Taisce has the same wide remit as the
Heritage Council and is currently submitting a policy docu-
ment to the government on the establishment of a properly
structured, non-state, property-owning organisation,
i.e. an Irish National Trust.

fig. 14

This fascinating exhibition, devoted to the history of
Newbridge, its architecture, collections and family history,
also provides a vital insight into the delicate balance needed
to ensure the survival of such a house. Housekeeping,
conservation of its fabric and artefacts requires sympathetic
and knowledgeable curatorial skills, and particularly so as
the house is open to the public. Many other properties face
the same issues, and an overall body, such as a National Trust,
is needed to bring the various strands together; expertise
should be available to all historic properties in the Republic.
This is essential if all our remaining houses and collections
are to be efficiently looked after, in the manner of the excel-
lent blueprint offered by the British National Trust.

Well aware of the lack of easily accessible information, the
Irish Georgian Society is organising a one-day seminar in

Castletown, concentrating on all aspects of country house con-
servation. This event has been very heavily oversubscribed – a
state of affairs that speaks for itself.

This 'Housekeeping in Historic Houses' seminar is the
most recent indication of the longstanding concern of the
Irish Georgian Society about the future of Ireland's country
houses and their collections. It is now eight years since the
IGS produced a film, *The Irish Country House*, and, with Irish
Historic Properties, hosted a conference on the 'Future of
the Irish Country House'.[21] This conference was opened by
the then Taoiseach, Albert Reynolds, who said, 'The most
efficient way of protecting and preserving our great houses
is to help the owners, as far as possible, to keep and maintain
them, and these should be the basic policy objectives.'

This was a landmark statement, but, while much has
been achieved for conservation in the way of new legislation
by successive governments, 'basic policy objectives' are by
no means fully in place. Newbridge, however, is an excellent
example, with the Cobbe family working with Fingall
County Council so that the contents of Newbridge (owned
by the family) remain in the house. It is to be hoped that the
arrangement continues, as it would be tragic to see Newbridge
become another virtually empty husk.

In the same speech, Albert Reynolds rightly stated that
'the latent hostility or bureaucratic and commercial indif-
ference is tending to give way to a growing realisation and
sense of pride that the many splendid monuments of the
past ... are jewels that now belong to an independent, demo-
cratic Irish nation.'

Newbridge is just such a jewel and should be continuously
polished!

JAMES GIBBS AND THE DESIGN OF NEWBRIDGE HOUSE

Alec Cobbe and Terry Friedman

Fig.15 Newbridge House, Co. Dublin

The designing and building histories of Irish Georgian country houses are, with few exceptions, notoriously difficult to pin down. Until recently, the architectural origins of Newbridge House (fig.15), though better served with documents than most, had remained speculative.[1] Among the papers of the Rev. Charles Cobbe (1686–1765), Archbishop of Dublin (fig.16), who erected the house sometime between 1747 and 1752, is an unexecuted plan for Newbridge (fig.24) recently identified as a close copy of a palatial scheme by James Gibbs (1682–1754) for Milton House near Peterborough. This identification led to the discovery in Oxford of a preliminary design by Gibbs for Newbridge as built (fig.25) and establishes him as its architect.

James Gibbs (fig.17) had been sent as a young man to the Scots College in Rome to study for the priesthood, but he turned instead to architecture, becoming a pupil of the papal architect Carlo Fontana (1638–1714) and so the first British architect to receive a professional training abroad. On returning home in 1708, he formed an important friendship with a leading Irish aristocrat, Sir John Perceval (1683–1748), later 1st Earl of Egmont (fig.18), whom he had met in Rome, which very nearly led Gibbs to establish a career in Ireland, but circumstances kept him in London. Newbridge House seems to be his only realised Irish work.

A number of personal circumstances may have led the Rev. Charles Cobbe to consult Gibbs. Cobbe had arrived in Ireland in 1717 as chaplain to his kinsman, Charles Paulet, 2nd Duke of Bolton (see cat.44), who came as Lord-Lieutenant in that year. The Cobbe and Paulet families had been closely connected since the sale to the Paulets by Charles's grandfather of the Cobbe lands in Hampshire in 1638 (see p.38). Relations with the 2nd Duke must have been particularly close, as he had stood surety in a bond of £32,000 for Charles's father, Thomas, on the latter's appointment in 1698 as Receiver-General for Hampshire. It seems likely, furthermore, that the Duke was godfather to the young chaplain, who was the first member of the Cobbe family to bear the name Charles in records going back to the 15th century. Between *c.*1728 and 1740 the Duke's son, Charles, 3rd Duke of Bolton (1684–1754), commissioned Gibbs to design his house and several garden buildings at Hackwood Park, Hampshire. The Duke and his brother, Lord Nassau Paulet (who was appointed auditor-general of Ireland in 1723), subscribed to Gibbs's *A Book of Architecture* (1728).[2]

An even more important connection was established through Lord Egmont, to whom the aspiring architect wrote on 3 December 1707: 'I believe … there will come to Rome very few that will leave such a notable character behind them

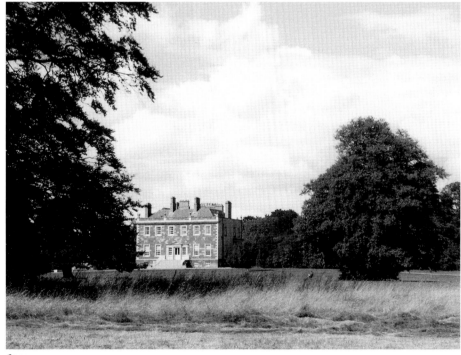

fig. 15

Fig.16 Andrew Millar
after Francis Bindon,
*Portrait of Charles Cobbe,
Archbishop of Dublin*,
mezzotint, 14 × 9½ in
(35.5 × 24 cm), 1746

Fig.17 James McArdell
after J. Williams, *Portrait of
James Gibbs*, mezzotint,
13 × 10 in (35 × 25 cm)

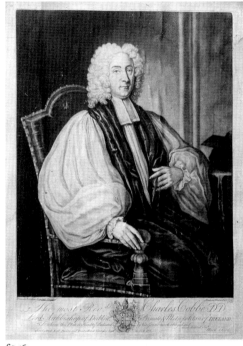

fig. 16

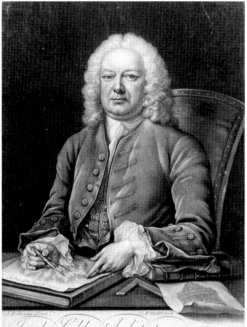

fig. 17

as your worthy person has done. When you went away I am sorry I did not go along with you …. The reason why I did not beg of you to take me along with you was that I might stay some short time longer to perfectionate myself in this most miserable business of architecture. However … if I can be any way serviceable to you here, or in England, I will be very proud to have the honour to be enrolled amongst the very lowest of your servants.'[3]

Soon after settling in London, Gibbs wrote again to Lord Egmont, on 10 February 1709: 'I have indeed a great many very good friends here, and that of the first rank and quality in England … but their promises are not a present relief for my circumstances . … So truly, I think it best not to lose certainty for good hopes, and embrace your most kind favour and prefer your most honourable patronage and protection.'[4] But, two days later he informed Perceval that John Erskine, 6th Earl of Mar, on hearing of his 'design to go to Ireland', offered him a sinecure commission as an officer at Sterling Castle and architectural work in London, but 'if you thought fit he would give me leave to come over [to Ireland] and see your honour in the summer time for a month or two, if I could be any way serviceable in my way'.[5] The Irish expedition was cancelled and there is no evidence that Gibbs worked for Perceval, though the two men remained friends.[6]

In 1730, Cobbe, by then Bishop of Dromore, married Dorothea, Lady Rawdon (1691–1733), widow of Sir John Rawdon Bt, of Moira, Co. Down, who had two Rawdon sons then aged eight and ten years old. In the following year Cobbe was translated to the Bishopric of Kildare and Deanery of Christ Church. This was an important promotion, as the position usually signified the holder as 'heir-apparent' to the Archbishopric of Dublin. In 1733 later Dorothea died giving birth to Charles's second son, Thomas, and he never remarried.

In 1741 Cobbe's eldest stepson and ward, Sir John Rawdon (1720–93), came of age and on returning from travels in Italy married John Perceval's daughter, Helena (*d*.1746).[7] This, too, provided a valuable architectural connection. For example, the Earl dined with his daughter and son-in-law on 17 January 1742, having been paid a visit by Gibbs on the previous day.[8] Rawdon and his wife spent the latter half of that year in Ireland settling affairs and accounts with his stepfather, the Bishop, who had managed the Rawdon estates during Sir John's minority. Helena was painted by the Irish artist James Latham (see cat.4), to join Sir John's Grand Tour portrait in Cobbe's family gallery (see cat.3), and towards the end of their stay Cobbe was enthroned as Archbishop of Dublin in a ceremony in Christ Church Cathedral on 10 March 1743. During much of 1744 and again in 1745 Cobbe

Fig.18 John Smith after Godfrey Kneller, *Portrait of Sir John Perceval, 1st Earl of Egmont*, mezzotint, 1704

Fig.19 Thomas Cave, *Survey of the Lands of Newbridge, Lanistown and Donabate* (detail of Newbridge House), 1736 (Cobbe Collection)

was in London. He seems to have stayed with his stepson and daughter-in-law, and he and Perceval were visiting and dining with each other as members of the Rawdons' inner family circle.[9] It seems likely during one of these London visits that Perceval, who took a keen interest in building projects in Ireland, could have recommended Gibbs as architect for the Archbishop's intended new house, to replace the middle-sized, gable-ended Stuart house (fig.19) that existed on the estate when he bought it.[10]

As Archbishop of Dublin, Cobbe had amassed considerable estates,[11] as well as annually increasing unspent cash reserves. He occupied a position fourth in precedence in the government of Ireland and could expect to succeed as Archbishop of Armagh and Primate of All Ireland, the ultimate goal of any career-minded Irish prelate, as the Primacy was potentially the most powerful position in the land, second in precedence only to the changing Lord-Lieutenants.

By this time Gibbs had become one of the most admired and widely imitated of Georgian architects.[12] His reputation rested largely on the success of his two London church masterpieces, St Mary-le-Strand (1714–24) and St Martin-in-the-Fields (1720–27), the Radcliffe Library at Oxford (1736–49) and, above all, on the 150 engraved plates of designs in *A Book of Architecture*, published in 1728 and again in 1739, which he recommended as 'of use to such Gentlemen as might be

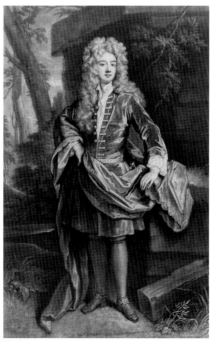

fig. 18

concerned in Building, especially in the remote parts of the Country, where little or no assitance for Designs can be procured [and] which may be executed by any Workman who understands Lines, either as here Design'd, or with some Alteration, which may be easily made by a person of Judgment' (Introduction).

The unsigned sheet found among the Archbishop's surviving papers (fig.24) consists of Gibbsian plans for an ambitious mansion of eleven by seven bays measuring 148 by 168 feet. The drawing, which was probably originally

fig. 19

accompanied by elevations and sections that do not survive, is a near copy of Gibbs's design for Milton House outside Peterborough (fig.23), the seat of John, 2nd Earl Fitzwilliam. The designs for Milton House (figs 20–23), containing twelve 'noble Apartments', were proposed in 1726, then abandoned on the Earl's death in 1728 (before work had begun), but they were included in Gibbs's *A Book of Architecture* (p.XIII, pls 48–9). One of eight preliminary designs prepared by Gibbs specifies the room distribution: a 'Great Hall … two storys high', 'salon or great dining roome towards the Garden', 'two great staircases', 'back stairs for all the appartments', 'parlour or common eating roome', 'Library, or billiard roome', chapel and bedchambers with closets; at cellar level 'a common Roome', 'Servants Hall', 'Stewards Hall', 'Stewards parlor', 'waiting roome', kitchen, housekeeper's and servants' rooms, confectionary, wine cellar, butler's pantry and strong beer cellar.[13] The house was approached on both main fronts by elaborate staircases leading to monumental temple porticoes (fig.20). Such an imposing plan would surely have been urged by Perceval, who in 1722 had written to Bishop Berkeley concerning the building of Castletown, Co. Kildare: 'I am glad for the honour of my country that Mr Conolly has undertaken so magnificent a pile of a building special care must be [taken] to procure good masons since this house will

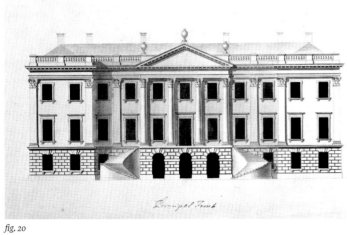

fig. 20

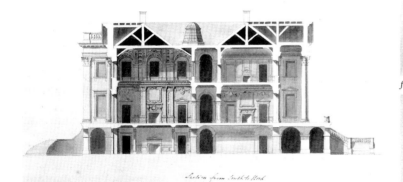

fig. 21

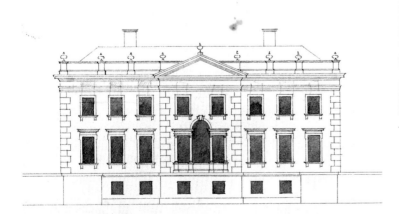

fig. 22

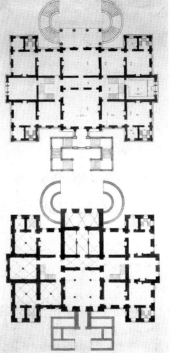

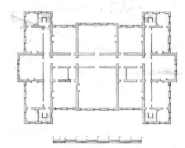

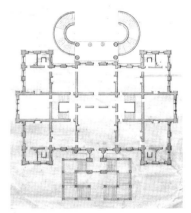

fig. 23

fig. 24

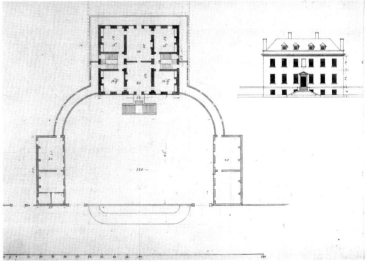

fig. 25

Fig.20 James Gibbs, *Principal elevation (unexecuted) for Milton House, Northamptonshire*, pen and ink and grey wash, *c.*1726 (Northampton Record Office, Fitzwilliam Milton Estates and Sir Philip Naylor-Leyland, Bt); later proposed for Newbridge

Fig.21 *Section (unexecuted) for Milton House, Northamptonshire*, pen and ink and grey wash, *c.*1726 (Northampton Record Office, Fitzwilliam Milton Estates and Sir Philip Naylor-Leyland, Bt)

Fig.22 James Gibbs, *Side and principal front elevations (unexecuted) for Milton House, Northamptonshire* (detail of side elevation), pen and ink and grey wash, *c.*1726 (Northampton Record Office, Fitzwilliam Milton Estates and Sir Philip Naylor-Leyland, Bt, no.78)

Fig.23 James Gibbs, *Principal and cellar floor plan (unexecuted) for Milton House, Northamptonshire*, pen and ink and grey wash, *c.*1726 (Ashmolean Museum, Oxford, Gibbs Collection, vol.I, no.19)

Fig.24 James Gibbs (perhaps office of), *Cellar and ground floor plan (unexecuted) for Newbridge House*, pen and ink and grey wash, 17½ × 10 in (45 x 26 cm), undated (Cobbe Papers: Alec Cobbe)

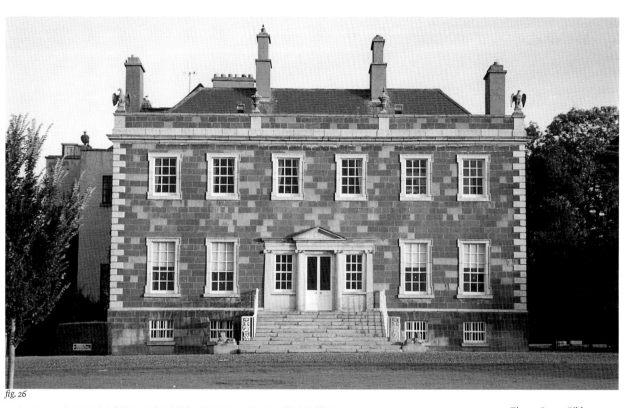

fig. 26

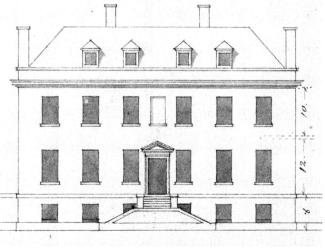

fig. 27

Fig.25 James Gibbs, *Preliminary ground plan and front elevation for Newbridge House*, pen and ink and grey wash, undated (Ashmolean Museum, Oxford, Gibbs Collection, vol.II, no.54)

Fig.26 South front of Newbridge House

Fig.27 Detail of fig.25 showing house elevation

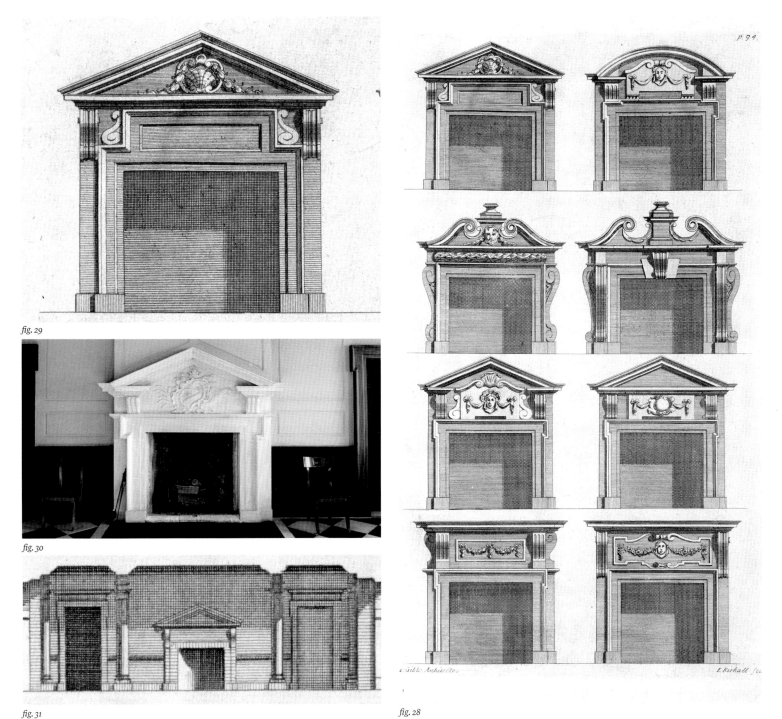

fig. 29

fig. 30

fig. 31

fig. 28

Fig.28 James Gibbs,
A Book of Architecture
(London, 1728), pl.94

Fig.29 James Gibbs,
A Book of Architecture
(London, 1728), pl.94
(detail)

Fig.30 The Hall,
Newbridge House

Fig.31 James Gibbs,
A Book of Architecture
(London, 1728), pl.49
(detail)

Fig.32 James Gibbs,
*Rules for Drawing the several
Parts of Architecture*
(London, 1753), pl.XLV

be the finest Ireland ever saw, and by your description fit for a Prince, I would have it as it were the epitome of the Kingdom.'[14]

In considering a comparably palatial scheme for himself, Cobbe clearly envisaged a seat that would truly symbolise the influence and power of the head of the Church of Ireland. Had it been built, it would have elevated Newbridge to one of the grandest Palladian houses in Ireland.

The resubmission to one client of a previously redundant scheme intended for another is not unique in Gibbs's oeuvre. Among the Londonderry Papers in Belfast is a large set of undated Gibbs plans, elevations and sections for a substantial country house perhaps intended to have been built at Mount Stewart, Co. Down, a property acquired by Alexander Stewart in 1744.[15] Also Milton-like in both plan and elevation, it is closely based on Gibbs's 1739 design for Hampstead Marshall, Berkshire, the partial construction of which was cut short by the death of the client, William, 3rd Earl of Craven, on 10 August 1739.[16] Interestingly, the Stewarts and Rawdons were near neighbours in Co. Down.

The draughtsmanship and handwriting of some of the Stewart drawings are consistent with the many surviving Gibbs drawings, either in his own hand or that of his long-time draughtsman, John Borlach.[17] However, this is not the same hand as the Newbridge plan (fig.24), which in addition employs a different, triple-ruled, scale. One explanation may be that Gibbs's involvement in designing and building the Radcliffe Library between 1736 and 1749, which left little time for private commissions, led to the Newbridge plan having been prepared by another, unidentified draughtsman.

Towards the end of 1746 a cloud appeared on the horizon of Cobbe's hitherto steadily ascendant ecclesiastical career. Dr John Hoadly, Archbishop of Armagh, had died in July. Despite being immediately recommended for the succession by the Lords Justices to the Lord-Lieutenant, Cobbe became aware of a rumour that George Stone, Bishop of Derry, had 'friends at Court whose Interest is powerful and prevailing insist on his having no other Archbishoprick than the Primacy I should with pleasure give place to an experienced English Prelate, and readily give my assistance to him on his coming as a stranger into this country. But to have a Junior step before me will I fear make me appear insignificant in the World and render me useless hereafter.'[18] In April 1747 Cobbe's fears became a reality when Stone, 22 years his junior, was indeed appointed to the See of Armagh.

This public rebuff must have been extremely demoralising, and it is understandable that Cobbe's grand architectural

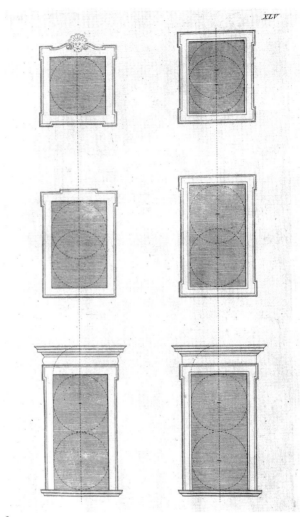

fig. 32

scheme was not carried forward. Nevertheless he had owned his lands now for over a decade, his financial advantages continued to be very considerable, his two sons were approaching manhood and he himself was 61 years old. If he were to realise his dynastic intentions in building a family seat, he could scarcely afford to lose further time. That Newbridge was then in residential use by the Archbishop is clear, for on 11 August 1747 the Rev. John Wesley 'waited on the Archbishop at Newbridge, ten miles from Dublin. I had the favour of conversing with him two or three hours.'[19]

A survey of the Newbridge lands dated August 1747,[20] the earliest of the Cobbe surveys to single out Newbridge from its surrounding townlands, would seem to indicate that building there may have been imminent. A distinct peak in

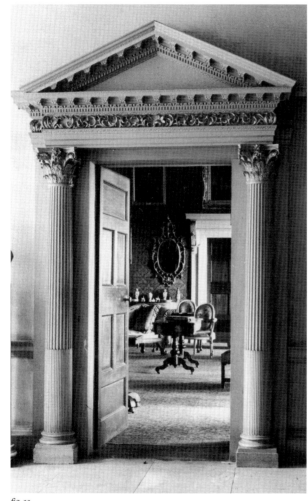

fig. 33

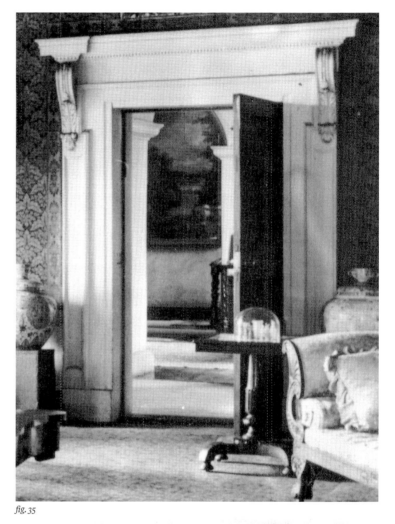

fig. 35

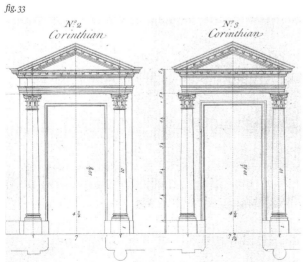

fig. 34

fig. 36

the table of the Archbishop's annual expenditures in the year 1749/50, the highest in a span of 20 years between 1735 to 1755,[21] suggests that the higher expenses of fitting out a new house are likely to have fallen then, a possibility strengthened by a 1749 reference in the Archbishop's account book: 'Newbridge now in own hands.'[22] A further survey of Donabate lands dated 1752,[23] which shows what remained of them after substantial incorporations into the Newbridge park, also implies that the house was near to completion and landscaping was in progress.

The chosen design was a further plan and elevation by Gibbs that survives, hitherto unrecognised, among the architect's collection of drawings bequeathed by him in 1754 to the Bodleian Library and now housed in the Ashmolean Museum at Oxford (fig.25).[24] The identification is conclusive, as the elevation shares parity of dimension with the built elevation of Newbridge in almost every single like-for-like feature (figs 26–7).[25]

The plan shows that, as first conceived, Gibbs intended a four-floored villa with quadrant corridors connecting the central block to two flanking outbuildings around a forecourt. Apparently only the main house was built. The pavilions are not shown in Frizell's survey of 1776,[26] but evidence of possible foundations, currently under investigation, suggest that these features may have been executed. The main elevation embodies Gibbs's encomiums in his Introduction to *A Book of Architecture*: '… it is not the Bulk of a Fabrick, the Richness and Quantity of the Materials, the Multiplicity of Lines, nor the Gaudiness of the Finishing, that give the Grace or Beauty and Grandeur to a Building; but the Proportion of the Parts to one another and to the Whole, whether entirely plain, or enriched with a few Ornaments properly disposed.'

However, the austerity of this front resulted in several modifications. The parapet was broken by piers; quoins were introduced at the corners, and the entrance door and flanking windows were consolidated in a tripartite, pedimented, Ionic *ensemble*, combined with a broad flight of steps. This arrangement is frequently found in Georgian Ireland, one of the earliest dated examples being Richard Castle's Tyrone House, built in 1740 for Sir Marcus Beresford, later 1st Earl of Tyrone.[27] This or something similar led to an almost universal Irish archetype. The Newbridge arrangement, however, appears chaste and correct by comparison, suggesting that the idea, as in the case of almost every feature of Newbridge's interior architecture, was subjected to the discipline of Gibbs or of his published works. The upper middle blind window

in fig.27 was not retained in building, where the identical fenestration is slightly adjusted to a more even rhythm across the front (fig.26). That Gibbs himself was involved with these adjustments, which in the latter case results in an odd composition of two window apertures set over the tripartite ensemble, is suggested by the similar treatment of the side elevations in some of the Milton designs.[28] Design no.78, in particular, with its corner quoins and solid parapet broken by piers and urns (fig.22), may have been the catalyst for these further refinements of the Oxford design for Newbridge. Moreover, the earlier Milton-inspired design, though rejected, clearly remained influential in Gibbs's thinking. Further telling evidence of his presence in the refinement of the Oxford design is the overall use of shouldered window jambs without keystones, which he recommended in *Rules for Drawing the several Parts of Architecture*, published in 1732 and again in 1738 and 1753 (fig.32).

In the interior of Newbridge, the influence of Gibbs is equally pervasive. The Archbishop seems to have set a rigorous procedure that when a design supplied by the architect could not be employed, then his published works were to be used as sources, and this continued in the alterations made by his son and heir, Thomas Cobbe, in the 1760s, long after Gibbs's death. The architecture of the Entrance Hall could have developed from the earlier, Milton-like proposal for Newbridge, with a treatment akin to pl.49 in *A Book of Architecture*, where a tall, pedimented chimneypiece is flanked by doors with shouldered architraves (figs 30–31). For the detailing of the chimneypiece itself, an example in pl.94 was followed closely (fig.28–29), but substituting the Cobbe arms in a Rococo cartouche under the pediment. The scroll-framed chimneypiece in the Library derives from pl.LI (centre) in *Rules for Drawing*, where Gibbs commented: 'There may be drawn a great variety of them, and all good in their kind, if the Draughtsman have a good taste' (p.35). The black Kilkenny marble chimneypiece in the Dining Room, perhaps based on a lost drawing, relates to an unpublished pattern found in Gibbs's Kelmarsh Hall, Northamptonshire (1728–32).[29]

The plasterwork of the Library ceiling (fig.37),[30] with its profile medallions of Flora, Ceres, Mars and Mercury, emblems of the seasons, fruit and flower garlands and leafy ribbons contained in polylobed compartments, can be related to two drawings in the Gibbs Collection at Oxford (fig.38).

The wooden balusters of the Newbridge staircase are taken, with some modifications, from pl.LXII (top left) in *Rules for Drawing*, the plainer of the two examples specified

fig. 37

fig. 38

by Gibbs as 'of a more delicate form, being divided into
twelve parts, and subdivided to form the Mouldings. These
are fittest to be done in Wood or cast in Metal' (p.41).

Gibbs's published designs continued to be employed,
perhaps on the advice of Charles Cobbe, now in his late 70s,
by Thomas and Lady Betty Cobbe in the addition to the house
(*c.*1762–4). *Rules for Drawing* provided models for the monu-
mental Corinthian doorcase leading into the Drawing Room
(pl.XXXVIII, nos 2–3) and for those within (pl.XLVII: 'A Rule for
drawing the Scroll for the Support of Cornices over Doors',
p.33) in combination with pl.105 in *A Book of Architecture* (figs
33–6). The chimneypiece is a close copy of pl.96 (right).

During the years when the nucleus of Newbridge was
being built (*c.*1747–52), Gibbs was busy completing the
Radcliffe Library and in deteriorating health. Cobbe, there-
fore, was obliged to employ a Dublin architect to supervise
his work. This was almost certainly George Semple (1700–
?1782). His name was first associated with Newbridge by
David Griffin, who drew attention to a passage in Semple's
A Treatise on Building in Water (1776),[31] where the architect
writes that in 1751 he was 'engaged in the conduct of the
building a new house for his Grace the Lord Archbishop
of Dublin'.[32]

By this time Archbishop Cobbe was promoting two
Semple projects in Dublin: the 100-foot high granite spire of
St Patrick's Cathedral (1749–50)[33] and, as the senior member
of the governors, the building of Dean Swift's St Patrick's
Hospital (1749–57).[34] It was in Cobbe's archiepiscopal resi-
dence, in May 1751, that it was proposed to Semple that he
should build his most famous work, the Essex Bridge over the
Liffey in Dublin (1753–5, demolished 1873).[35] The Hospital
and Semple's closely related designs for Headfort House, Co.
Meath (1760), with their repetitive use of block-rusticated, or
Gibbs-surround windows, while also showing the influence
of *A Book of Architecture*, do not resemble Newbridge.[36]

Following the completion of Gibbs's central block at
Newbridge, other refinements were added, including urns
and eagles crowning the south parapet, and the Drawing
Room wing to the north (see pp.63–4), as well as a number
of garden features.[37]

THE COBBE FAMILY OF HAMPSHIRE
AND IRELAND

Alec Cobbe

Charles Cobbe (1686–1765), a younger son, moved to a new country, was enthroned as archbishop of its capital and built what became the family's principal seat, Newbridge House in Co. Dublin (figs 3 and 15). It is inevitable that accounts of the family history have tended to begin with him (see cat.7). However, in the middle of the 19th century, Frances ('Fanny') Power Cobbe (1822–1904), the noted writer, feminist and philanthropist (see cat.49), and two of her four brothers, the historian Thomas Cobbe (1813–82) and the clergyman Henry Cobbe (b.1817), liked to research the earlier phases of the f amily's history in Hampshire. In her autobiography, quoting

Robert Cobbe was, therefore, very likely an early ancestor. Records of Hampshire and Winchester from the early 13th century do indeed show successive Robert and John Cobbes. The earliest individual from whom lineal descent is securely documented is a William Cobbe of Steventon (b. c.1450),[5] whose probable father was John Cobbe of Steventon (fl.1464), recorded as a 'tythingman' there in 1464 (fig.42).[6]

William's son, another John Cobbe (fl.1524), seems to have acquired tenure of the manors of Swarraton and The Grange, near Micheldever, Hampshire,[7] and there began an association with them that was to last through five generations.

fig. 39

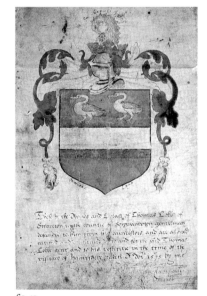

fig. 40

Fig.39 I. Hewetson, *The Grange*, etching and aquatint; from Rudolph Ackermann's monthly magazine, *The Repository of Arts*, 6 (1825)

Fig.40 Confirmation of arms to Thomas Cobbe, watercolour on vellum, 1575 (Cobbe Papers: Hugh Cobbe)

from Charles Dickens's *Bleak House*, she wrote: 'my ancestors were rather like those of Sir Leicester Dedlock, "chiefly remarkable for having done nothing remarkable for so many generations".'[1] Her historian brother (and my great-great-grand-father), Thomas Cobbe, in a 'charming and well argued' essay written in 1860,[2] chose to trace the origin of the arms of our Hampshire ancestry to a Robert Cobbe (fl.1346), who was a deponent in a dispute on a matter of chivalry at the siege of Calais, a few weeks after the Battle of Crécy (1346), in a court at which King Edward III and the Black Prince were present.[3]

Thomas argued that the Cobbe arms, confirmed in 1575 to the then head of the family as 'descended to him from his ancestors' (fig.40),[4] derived from those of the two commanders at Crécy, Thomas de Beauchamp and William de Bohun (fig.41), that arms of esquires in the feudal period were frequently derived from those of their overlords, and that

Both manors belonged to the Abbey of Waverley and at the Dissolution were granted by Henry VIII to his friend and confidant Sir Anthony Browne, who gained huge tracts of land at this time. In 1567 Thomas Cobbe (c.1510–80) purchased the Grange and Swarraton manors from Sir Anthony's son, the 1st Viscount Montagu,[8] who by a curious historical coincidence also owned Hatchlands in Surrey. Thomas Cobbe's estate amounted to about 2,000 acres. This was all part of Frances Power Cobbe's 'Dedlock' period of five generations of Hampshire squires.

Michael Cobbe (1547–98),[9] who had married an heiress, Joan Welborne, built or rebuilt the Grange some time before 1594 (see fig.39 for the Neo-classical house later built on the same site), while his half-brother, Richard Cobbe (d.1597), became an early Fellow and subsequently Vice-President of Corpus Christi College, Oxford. Richard bequeathed to

Corpus Christi his library (fig.43.1–2) and £10 a year for the purchase of books, which was the college's only regular library income for the next 200 years.[10] There were further land transactions in 1598, these between the Cobbes and Henry Wriothesley, 3rd Earl of Southampton, the dedicatee of William Shakespeare's *Rape of Lucrece*, and very possibly the 'W. H.' of the Sonnets.[11]

The Cobbe family held the Grange and Swarraton until the years immediately preceding the Civil War, when another Michael Cobbe (1602–47) and his younger brother, another

fig. 41

Richard Cobbe (1607–58), the grandfather of Archbishop Cobbe, sold the properties in 1638/9 to Lord Henry Paulet, a younger brother of John Paulet, 5th Marquess of Winchester (fig.44). However, they retained a landholding at Barton's Farm, near Winchester. Michael Cobbe looked after the estates of the 4th Earl of Southampton, while important connections were established between the Cobbes and Paulets, following the marriage of the younger brother Richard to Honor Norton (1616–1703), whose sister Elizabeth Norton married Lord Henry's son Francis Paulet. The Norton sisters, co-heiresses on the death of their brother, promulgated an intimacy between the two families that seems to have been unaffected by their taking opposite sides in the Civil War. The Paulets were staunchly Royalist – defending Basing House against Cromwellian troops until it had been razed to the ground, with the loss of £200,000 of family property – while

Richard Cobbe became Knight of the Shire for Hampshire and represented the county in the Commonwealth Parliament, along with Richard Cromwell, son of the Protector.

An inventory of Richard Cobbe's house in the parish of St Michael, near Winchester, at the time of his death in 1658, reveals a well-to-do establishment, consisting of a Hall, a Little Parlor, a Great Parlor, a Great Chamber over the Parlor, a Lodging Chamber, an Outer Chamber, a Men's Chamber, a Study and a Gallery.[12] The Great Chamber contained the only three pictures in the house; as there are exactly three pictures in the Cobbe Collection today originating from Richard's marriage to Honor Norton, it may be supposed that these are they. If Cobbe portraits existed at this time, they would most likely have been inherited by Richard's elder brother, Michael. Curiously, however, the latter, though with an ample family of his own, had stated in his will that his brother Richard should have 'the best things in or out of the house'.

The house in the parish of St Michael, leased from Winchester College with 'about 307 yeares yet to come', was to be the home of Richard's descendants for several generations. Richard also had a large family. His eldest son, another Richard Cobbe (1645–1717) and a bachelor, seems to have resided at New Barton's Farm, while his second son, Thomas Cobbe (1648–1703), lived in the Winchester house, where the future Archbishop Cobbe grew up. Thomas, through his marriage to Veriana Chaloner (fig.45), acquired a thoroughly Cromwellian family circle. Veriana's father, James Chaloner, who had married Ursula Fairfax, had been one of the judges at the trial of Charles I. Her uncle Sir Thomas Chaloner, whose portrait by Anthony van Dyck shows an alert and nervous disposition (fig.46), signed the King's death warrant. James Chaloner's sister, Frances, had married Ursula Fairfax's brother, Sir William Fairfax, resulting in a double relationship between the two families. Sir William's son Thomas Fairfax (see cat.1) would later be the first near relation of the Cobbes to receive appointment in Ireland, becoming Governor of London-derry some time after 1680 until 1689 and Governor of Limerick from 1703 until his death in 1712.

A cache of letters from Lord Fairfax, commander-in-chief of Cromwell's army, to the Archbishop's grandfather James Chaloner, was discovered at Newbridge in the mid-19th century, much to the delight of the trio of historian siblings.[13] Sir Thomas Chaloner had been perhaps fortunate in dying of natural causes in 1660, the year of the Restoration, though the Chaloners seemed to have preserved their property on account of the part Lord Fairfax played in effecting the

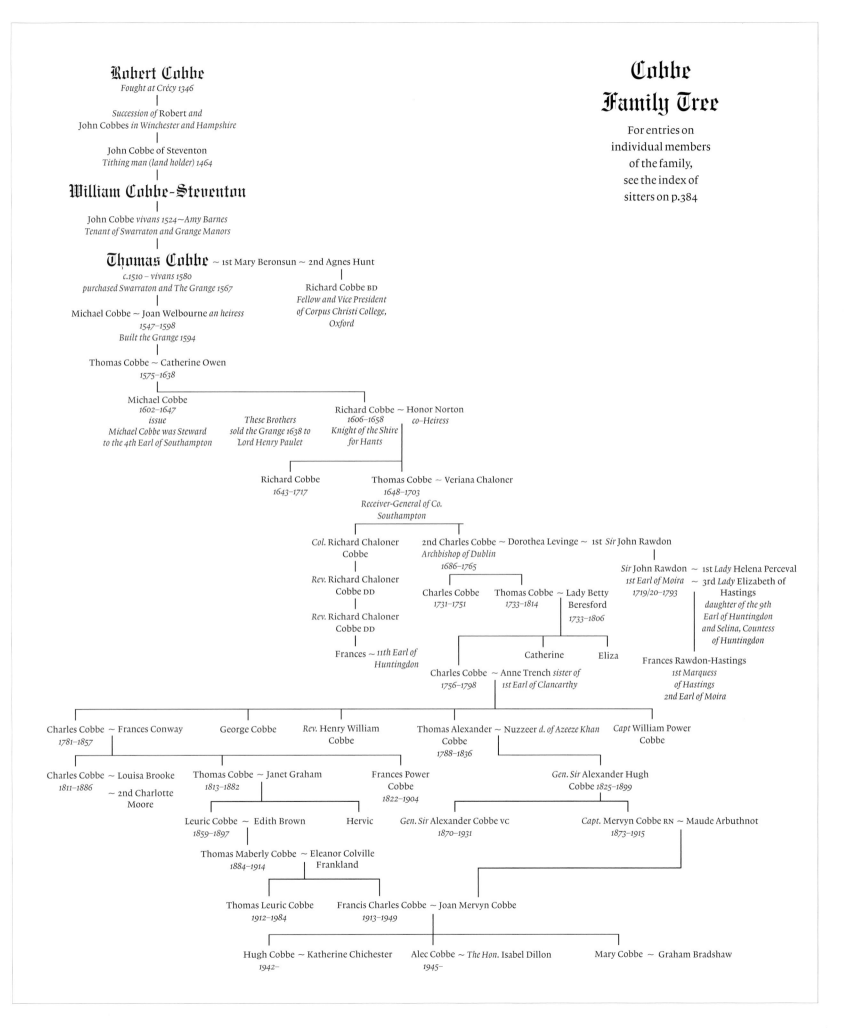

Robert Cobbe
Fought at Crécy 1346

Succession of Robert *and*
John Cobbes *in Winchester and Hampshire*

John Cobbe of Steventon
Tithing man (land holder) 1464

William Cobbe-Steventon

John Cobbe *vivans 1524* ~ Amy Barnes
Tenant of Swarraton and Grange Manors

Thomas Cobbe ~ 1st Mary Beronsun ~ 2nd Agnes Hunt
c.1510 – vivans 1580
purchased Swarraton and The Grange 1567

Richard Cobbe BD
Fellow and Vice President
of Corpus Christi College,
Oxford

Michael Cobbe ~ Joan Welbourne *an heiress*
1547–1598
Built the Grange 1594

Thomas Cobbe ~ Catherine Owen
1575–1638

Michael Cobbe
1602–1647
issue
Michael Cobbe was Steward
to the 4th Earl of Southampton

These Brothers
sold the Grange 1638 to
Lord Henry Paulet

Richard Cobbe ~ Honor Norton
1606–1658 *co–Heiress*
Knight of the Shire
for Hants

Richard Cobbe
1643–1717

Thomas Cobbe ~ Veriana Chaloner
1648–1703
Receiver-General of Co.
Southampton

Col. Richard Chaloner
Cobbe

2nd Charles Cobbe ~ Dorothea Levinge ~ 1st *Sir* John Rawdon
Archbishop of Dublin
1686–1765

Sir John Rawdon ~ 1st *Lady* Helena Perceval
1st Earl of Moira ~ 3rd *Lady* Elizabeth of
1719/20–1793 Hastings
daughter of the 9th
Earl of Huntingdon
and Selina, Countess
of Huntingdon

Rev. Richard Chaloner
Cobbe DD

Charles Cobbe Thomas Cobbe ~ Lady Betty
1731–1751 *1733–1814* Beresford
1733–1806

Rev. Richard Chaloner
Cobbe DD

Frances ~ *11th Earl of*
Huntingdon

Catherine Eliza

Frances Rawdon-Hastings
1st Marquess
of Hastings
2nd Earl of Moira

Charles Cobbe ~ Anne Trench *sister of*
1756–1798 *1st Earl of Clancarthy*

Charles Cobbe ~ Frances Conway
1781–1857

George Cobbe

Rev. Henry William
Cobbe

Thomas Alexander ~ Nuzzeer *d. of Azeeze Khan*
Cobbe
1788–1836

Capt William Power
Cobbe

Charles Cobbe ~ Louisa Brooke
1811–1886
~ 2nd Charlotte
Moore

Thomas Cobbe ~ Janet Graham
1813–1882

Frances Power
Cobbe
1822–1904

Gen. Sir Alexander Hugh
Cobbe *1825–1899*

Leuric Cobbe ~ Edith Brown
1859–1897

Hervic

Gen. Sir Alexander Cobbe VC
1870–1931

Capt. Mervyn Cobbe RN ~ Maude Arbuthnot
1873–1915

Thomas Maberly Cobbe ~ Eleanor Colville
1884–1914 Frankland

Thomas Leuric Cobbe
1912–1984

Francis Charles Cobbe ~ Joan Mervyn Cobbe
1913–1949

Hugh Cobbe ~ Katherine Chichester
1942–

Alec Cobbe ~ *The Hon.* Isabel Dillon
1945–

Mary Cobbe ~ Graham Bradshaw

**Cobbe
Family Tree**

For entries on
individual members
of the family,
see the index of
sitters on p.384

Restoration. One of the Newbridge letters shows Lord Fairfax instructing the Archbishop's grandfather on how to conduct a defence of his actions to a Restoration inquiry.

These Cromwellian connections seem not to have stood in the way of Thomas Cobbe receiving high office in the administration of Hampshire: he was a Commissioner of Customs, and in 1698 he was appointed to the potentially lucrative post of Receiver-General of Taxes for the county. Nor do they seem to have affected the relationship of the Cobbes with the Royalist Paulets. His appointment as Receiver-General may

The appointment as Receiver-General of Taxes ended in financial disaster for Thomas Cobbe, and for his brother Richard. According to family tradition, a subordinate embezzled Thomas of one year's taxes. This seems to have occurred sometime before 1702, when Richard's house and assets, valued at £6,000, were seized and sold, and the funds paid into the Exchequer. But in 1702 and 1703 the 2nd Duke of Bolton, Richard Cobbe and two others were called upon to pay the further sum of £3,748.[15] Somehow, the lease of the house at New Barton's Farm seems to have been re-acquired

fig. 43.1

fig. 43.2

have been the result of the influence of Lord Charles Paulet, who was among those who had gone to the Netherlands to invite William of Orange (see cat.27) to take the English throne with his wife, Princess Mary Stuart. Lord Charles (who succeeded as 2nd Duke of Bolton in 1699) and Thomas's elder brother, Richard Cobbe, were two of the signatories to the required bond of surety to the king for the staggering sum of £26,000.[14] Relations between Thomas and the Paulets must have been close, and Lord Charles was probably god-father to the young Charles Cobbe – the future archbishop and the first recorded member of the family to have borne that name.

and continued in the hands of Col. Richard Chaloner Cobbe (1683–1759), who was Thomas's eldest son and the future archbishop's brother. These events occurred while Charles was at the impressionable age of six to eight years old. Although his father's honour was stoutly defended and vindicated in the House of Lords by the Duke's brother, Lord William Paulet (whose portrait hangs at Newbridge; Cobbe Collection, no.117), the worry and distress for the whole family must have been immense. This also explains the young Charles Cobbe's determination to set the family affairs to rights in the establishment of a new landed estate in a new country.

fig. 44

Fig.44 Wenceslaus Hollar,
Portrait of John Paulet,
5th Marquess of Winchester,
etching, *c.*1640

Fig.45 English School,
Portrait of Veriana Cobbe,
née Chaloner, watercolour
on vellum, 3 × 2½ in
(76 × 63 mm), 1698
(Cobbe Collection, no.142)

Fig.46 Anthony van Dyck,
Sir Thomas Chaloner,
oil on canvas, *c.*1637
(Hermitage, St Petersburg)

fig. 45

Although the descendants of Col. Richard Chaloner Cobbe and his wife, Mary Cobbe (*née* Godolphin), including their eldest son, the Rev. Richard Chaloner Cobbe (1728–67), and his wife, Ann Cobbe (*née* Fern), continued to live in Hampshire until that side of the family died out in the first half of the 19th century, Charles established the family in Ireland and thus began a new phase in its history. It is from him that the 19th- and 20th-century members of the family descended, and the landholdings that he acquired and house that he built provided the centre of activity and security for eight generations of his posterity. This began with a further act of kindness by the Paulets to their beleaguered cousins. When the 2nd Duke of Bolton was appointed Lord-Lieutenant of Ireland in 1717, he brought Charles, his 32-year-old godson, who had been educated at Winchester and New College, Oxford, to Dublin as his chaplain. The Duke was not a success in Ireland, being described by Jonathan Swift, who admittedly satirised anyone he could, as 'a great booby at Court', and was recalled in the autumn of 1719. Cobbe, however, who was clearly a man of ability and who by January 1718/19 had been appointed Dean of Ardagh, saw his future in Ireland.

In 1720 Cobbe was appointed to the Bishopric of Killala in 1720, which he held until 1726, when he was translated to the See of Dromore. Here, he met the recently widowed Dorothea, Lady Rawdon (*c.*1691–1733), who resided at Moira, a few miles away from Dromore, and who was the daughter of Mary, Lady Levinge (see cat.95), and the immensely rich and powerful Lord Chief Justice Sir Richard Levinge (1656–1724), who had also recently died. In 1730 Charles married Dorothea, who had two very young sons, John and Arthur Rawdon, by her late husband. Charles and Dorothea also had two sons, Charles Cobbe (1731–50) and Thomas Cobbe (1733–1814; see cat.13), but Dorothea died in 1733 at the birth of the second. The following year Cobbe was sworn of the Privy Council. Shortly after his marriage, Charles had been promoted to the Bishopric of Kildare and the Deanery of Christ Church, where in 1742 he played a significant part in the arrangements for the first performance of Handel's *Messiah*. In the latter episode, he had to reconcile Jonathan Swift, with whom he was on friendly terms, to the involvement of the Vicar's Choral of St Patrick's Cathedral, of which Swift was dean. Both Cobbe and his two sons seem to have been of a musical disposition, as their names appear on subscription lists of music by William Boyce and John Travers during the 1740s.

Charles Cobbe's character was noted by the Earl of Egmont (see fig.18) when they dined together in London in 1744; by this time, under the Viceroyalty of the 3rd Duke of Devonshire, Cobbe had been promoted to Archbishop of Dublin (March 1742/3) and his stepson Sir John Rawdon (1719/20–93; see cat.3) had married Egmont's daughter Helena Perceval (*d.*1746; see cat.4): 'He [Cobbe] is a genteel, well bred man and not to be prevailed on in matters he t hinks not right, but frank and open in his behaviour to all. He came from Ireland to settle his two sons at Winchester School. … The Archbishop married Sir John Rawdon's mother and is very fond of Sir John and my daughter Rawdon.'[16]

fig. 46

This evenness of character seems, in some measure, to have been a key to his success in his progress through the ecclesiastical hierarchy, though he did not attain the highest office (see p.33). Open practice of the prohibited Roman Catholic religion was permitted on his estates, and John d'Alton recorded that 'it is creditable to this prelate … that when a bill was introduced in the House of Lords, of a very severe penal nature against the Roman Catholic clergy, in 1757, he and the Protestant Primate of Armagh spoke most strenuously against it, and, although it was read a third time in that house, they contested it to a division on every

fig. 47

reading'.[17] It is unlikely, however, that he would have
been aware that he was employing a Catholic architect for
Newbridge in James Gibbs (see fig.17), who took care to
conceal his religion from clients in England.

The Archbishop seems to have been a conscientious,
though elderly father. He was 61 years old when the building
of Newbridge began and 64 when his elder son, Charles,
died in France *en route* for a Grand Tour. The cause of Charles's
death is unknown, but as it took place at the spa of Montpellier,
it was probably due to ill health. The Archbishop was nearly
70 years old when in 1755 his second and sole surviving child,
Thomas, married Lady Elizabeth ('Betty') Beresford (1736–
1806; see cats 9 and 48). Ten years later, after having been
Archbishop of Dublin for nearly a quarter of a century, he
'departed this Life, at his Palace in Cavan St., full of years and
Honours … the Eldest Bishop in the Christian Church'.[18]

The acumen possessed by the Archbishop does not seem
to have been inherited by his son Thomas Cobbe, who with
Lady Betty had three children: Charles Cobbe (1756–98) and
Catherine Cobbe (1761–1839), who are shown together in
the double portrait by Strickland Lowry (cat.12), and Eliza
Dorothea Cobbe (1764–1850). By his marriage settlement,
Thomas was endowed, at the age of 22, with a large estate of
around 35,000 acres, providing a rental income of around
£3,000 to £4,000 per annum, with further income from a

capital sum given him of £18,000. His marriage and financial
advantages placed Thomas among the highest echelons of
Dublin society. While his father was still living, he enlarged
Newbridge House to accommodate a growing collection
of pictures (see pp.63–72), and in 1768 he built a substantial
townhouse in Dublin, probably to the design of George
Semple.[19] This was in the eminently fashionable and recently
renamed Palace Row, just three or four doors away from
Lord Charlemont's formidable house (see fig.53), designed
by William Chambers and then still under construction, the
grandeur of which had given the street its new name. Thomas
Cobbe became MP for the borough of Swords and represented
the interest of his brother-in-law, the Hon. and Rt Hon. John
Beresford (1738–1805; see cat.10), though in 1803, after the
Act of Union, they fell out over a matter of some £1,200,
connected with the winding-up expenses of the borough.

It was electioneering for the borough of Swords that seems
to have caused severe financial difficulties for Thomas's only
son, Charles Cobbe, who had married Anne Trench (fig.47),
sister of the 1st Earl of Clancarty. By 1774 Charles, who main-
tained a separate establishment in Dublin in Gardener's Row,
had run up debts amounting to £10,000. It is unclear if any-
thing other than electioneering expenses was the cause of his
insolvency, but when Charles predeceased his father at the
age of 42 in 1798, the situation had considerably worsened.

Fig.48 Robert Home,
*Portrait of Thomas Alexander
Cobbe*, oil on canvas,
49×39 in (122.5×99 mm),
early 19th century
(Cobbe Collection, no.125)

Fig.49 Anglo-Indian
School, *Portrait of Nuzzeer
Begum, Wife of Thomas
Alexander Cobbe*, miniature
on ivory, 4¼×3¼ in
(106×82 mm),
early 19th century
(Cobbe Collection, no.177)

In that year, his mother wrote: 'our sons debts are not more than double what they were at the time that was writen during … [his] life'. This second financial embarrassment in the history of the family was to have its consequences. When their elder daughter Catherine (see cats 12 and 86), an acknowledged beauty and later noted by Joseph Farington for her free speech, became engaged to the Hon. Henry Pelham, Thomas and Lady Betty were obliged in 1788 to sell an entire estate in Co. Louth, as well as their 'beautiful' house in Palace Row, to provide for her marriage portion and to settle the debts 'horridly contracted by their son'.[20] In the room at the end of the north corridor at Newbridge may still be seen an iron staple set in a beam across the ceiling, to which was attached a swing 'on which Miss Catherine Cobbe was wont to depend, the better to enable her maid to lace her bodice'.[21] The second daughter, Eliza Dorothea, was a lady of greater character still. In contrast to the beauty of her sister, she was 'equally noted for her ugliness, which she strove rather to enhance by her costume'.[22] This did not prevent her marrying Sir Henry Tuite, Bt, in 1784, four years before her elder sister's marriage. On that occasion, she drove her bridegroom from the townhouse in Palace Row to Newbridge, 'in a carriage and four greys presented to her as an appropriate wedding gift by Sir Henry. On the road she passed successively all the carriages of her friends and relatives, and was found waiting on the hall door steps to receive them on their arrival'. She was described by a nephew as the 'most gentlemanly old lady' he had ever known.

Thomas and Lady Betty lived in a high style that, even without their son's debts, would have dented their finances: 'multitudinous clans of Trenches and Moncks, in addition to

fig. 49

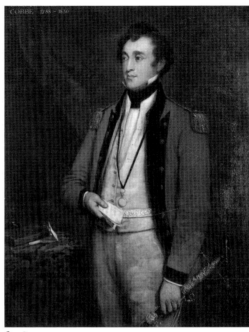

fig. 48

Lady Betty's Beresford relations, … adopted the habit of paying visitations at Newbridge. Arriving by coachloads, with trains of servants, they remained for months at a time. A pack of hounds was kept, and the whole *train de vie* was liberal in the extreme.'[23] Fortunately, at the onset of pecuniary embarrassments, 'Lady Betty came under the influence of her husband's cousin, the Methodist Countess of Huntingdon, and ere long renounced the vanities and pleasures of the world, and persuaded her husband to retire with her and live quietly at Bath, where they died and were buried in Weston churchyard.'[24] The move to Bath took place at the end of 1785 or during 1786, when Thomas Cobbe is recorded as having taken a house in St Catherine's Place, which had recently been vacated by the Master of Ceremonies, Thomas Dawson. Thereafter Thomas returned to Ireland for five or six months of the year, latterly without Lady Betty, but perhaps until 1798 accompanied by his son and daughter-in-law. This pattern was interrupted by a number of long periods away from Ireland, including one lasting from August 1796 to une 1801. Between August 1802 and January 1810 Thomas spent scarcely 16 months at Newbridge. During these years Lady Betty, who died in 1806, suffered from illness. In 1810 he gave the entire estate to his grandson and heir, Charles Cobbe (1781–1857; see fig.50 and cat.14), and remained wholly at Bath until his death four years later.

fig.50

Fig.50 Irish School, *Portrait of Charles Cobbe*, miniature on ivory, 2 × 1⅜ in (50 × 32 mm), 18th century (Cobbe Collection, no.162)

Charles, the eldest of five brothers, had served in the Indian campaign under Col. Arthur Wellesley, later 1st Duke of Wellington, to whom he had been recommended by Col. Beresford (see cat.101), and who had helped him purchase his commission.[25] He took part in Wellesley's crucial victory at Assaye. Arriving at Newbridge with a determination to put to rights the financial insecurities of his childhood, he brought about a new and long era of attentive and conscientious direction of the Irish estates. Newbridge was run down as a result of the somewhat erratic management of his grand-father, whose behaviour was characterised by Frances Power Cobbe as 'being generous before you are just' to the poor people who were living in 'miserable hovels which nobody dreamed of repairing; but then they were welcome to come and eat and drink at the great house on every excuse or without any excuse at all'.[26] In a stewardship that lasted for more than half a century, Charles embarked on a steady cam-paign of repairs and improvements on the extensive estate. Having sold two of the best pictures in the family collection to rebuild 80 cottages (for which see pp.87–9), he found that for another part of the estate in Co. Wicklow he absolutely had not the resources to improve it to his standards, and for this reason alone he sold it, though he immediately regretted having done so. At a time when rural communities were hard pressed in the years approaching the Irish Famine, he was conscientious almost to a fault, and, during the terrible

Famine itself, neither death from malnutrition nor hardship was suffered on the Cobbe estate.

Charles's next younger brother, Thomas Alexander Cobbe (1788–1836), joined the East India Company and made his career in India (fig.48), considerably assisted by the fact that his cousin Francis Rawdon-Hastings (1754–1826), 2nd Earl of Moira and later 1st Marquess of Hastings, was appointed Governor-General of Bengal in 1813. Thomas Alexander made there an unusual marriage to Nuzzeer, a Kashmiri *begum* of great beauty (fig.49), by whom he had ten children. His career brought him such wealth that his elder brother ruefully remarked in his diary that each of his brother's ten children, for whom he inevitably stood *in loco parentis* during their education in Europe, had an income higher than his own. Charles's diary gives further evidence of his brother's tremendous financial advantages: in one month Thomas Alexander remitted the sum of £10,000 to be invested, and just one month later Charles was asked to take care of a con-signment of indigo with a value of £60,000. In 1836 Thomas Alexander decided to retire from India and to return to England with his wife. Charles was enjoined to take a house and gather his nephews and nieces in it to welcome their parents. He accordingly came over from Ireland, rented a house in the Royal Crescent, Bath, and went to meet the boat – only to find that his brother had died *en voyage*. The *begum* soon returned to India, where she preferred to live, taking up

Fig.51 *'Arise! Sir Alexander Cobbe. – The King knighting the Lieutenant-General V.C. at the Palace yesterday.'* (Cobbe Papers: Alec Cobbe)

residence in Calcutta's most fashionable square. Thomas Alexander had been generous in sending items over to his brother for the family museum in Newbridge (see p.18). The ship on which he had set out to return was loaded with Indian goods and artefacts, with which he doubtless had intended to create his own oriental museum, but Charles decided to consign them all to Christie's, where they were disposed of in a two-day sale.

Two of Thomas Alexander's children pursued military careers with great success. His eldest son, Henry Clermont

ARISE! SIR ALEXANDER COBBE.—The King knighting the Lieutenant-General V.C. **at the Palace yesterday.**

fig. 51

Cobbe (1811–55), was colonel commanding the 4th Regiment in the Crimean campaign, was mentioned in Lord Raglan's dispatches and was killed at Sebastopol. Another son, Alexander Hugh Cobbe (1825–99), was promoted to general and was knighted. Alexander Hugh's son, another Alexander Cobbe (1870–1931), was awarded the VC in Somaliland in 1902 (fig.51): 'During the action at Erego, on 6th October, 1902, when some of the Companies had retired, Lt: Col: Cobbe was left by himself in front of the line, with a maxim gun. Without assistance he brought in the maxim, and worked it at a most critical time. He then went out under an extremely hot fire from the enemy about 20 yards in front of him, and from his own men (who had retired) about the same distance behind, and

succeeded in carrying in a wounded Orderly. Colonel Swayne, who was in command of the force, personally witnessed this officer's conduct, which he describes as most gallant.'[27] Alexander became, like his father, a general and a knight.

Charles's own children were less ambitious, though his only daughter, Frances Power Cobbe, was to become a renowned figure (as already mentioned at the beginning of this essay; see also cat.49). The eldest son, Charles Cobbe Jr (1811–86), was a straightforward country squire, while the second son was the historian Thomas (mentioned at the beginning of this essay), who was also a barrister-at-law. Charles's other sons included Henry, the youngest son and a clergyman (also mentioned at the beginning), and the much favoured third son, William Cobbe (*b*.1816), who joined a scandal-provoking religious sect in the West Country, known as the Agapemonites, whose leader, Henry Prince, arranged his marriage to the sister of a fellow sect-member. Thomas's attempts to extract his brother William from the sect by legal action came to nothing, and William remained a member of it until his death.

Thomas's historical studies gave him a taste for early Saxon names, and he named his two sons Leuric (1859–97) and Hervic (1861–after 1949). Since Thomas's elder brother, Charles, was childless, Leuric stood as heir apparent to the estate, but for some reason he succeeded in quarrelling with both his father and his uncle, as a result of which he emigrated to the United States, first to Iowa, where he married, and then to Los Angeles, where he settled. His uncle, meanwhile, having enjoyed a happy marriage to Louisa Caroline, *née* Brooke (1813–82), which endured for 43 years until her death in 1882, shocked his family by marrying, exactly one year later, at the age of 72, a well-to-do, young woman in her late twenties named Charlotte Moore (*d*.1901), later known as Lottie. The interval of just a year was considered, in the Victorian age, tantamount to open admission that there had been an affair within the lifetime of his late wife. When Charles himself died three years later, in 1886, Leuric, on receiving news that seemed to have materially changed his situation, left Los Angeles for New York, where he found a telegram informing him that he had been effectively disinherited. He never returned to the British Isles and died ten years later in Los Angeles. His family then moved to San Francisco. From his daughter Vere, I have heard an eyewitness account of the great earthquake of 1906: she watched the resulting destruction from her bedroom window, until she and her family had to leave the house before it was consumed by the ensuing flames.

fig. 52

Frustrating as it must have been for Leuric, Lottie was, on the whole, a conscientious custodian of Newbridge. She used her money to reroof the house, and she kept the pictures and furniture in good order, adding items here and there. She befriended Leuric's only son, Thomas Maberly Cobbe (1884–1914), and introduced him to young ladies she considered suitable, one of whom, Eleanor Frankland, a cousin of the Zouche family, he later married.

The knighted general and other Cobbe relations were habitually invited to house parties, and a collection of glass plate photographs is preserved that records the various pursuits of this and, later, my grandmother's time (fig.52). Lottie might have lived until the 1940s, but for her contracting consumption; as it was, she died in 1901, and Thomas Maberly inherited at the age of 17. His unexpected death in 1914 led to Newbridge being inherited again by someone of a very young age, this time my uncle, Thomas Leuric Cobbe (1912–84), who was then only two years old. His mother Eleanor (my grandmother) and her second husband, Cyril Corbally, took care of Newbridge until he reached his majority in 1933.

Thomas Leuric's long reign thereafter of over 51 years (accompanied in the latter 35 years, after my father's death, by my mother, elder brother, sister and myself), together with his reclusive character and his reluctance to allow change, had the effect of preserving the house in aspic for most of the 20th century. We had a lamp-lit childhood, and I remember vividly the day when the farm horses on the demesne were replaced by a tractor. Electricity did not arrive until the mid-1960s, at the instance of my mother, when I was in my early twenties. On my uncle's death in 1984, our family trustees negotiated the arrangements that presently pertain with the local authority, Dublin (now Fingal) County Council. From almost every point of view, these have proved to be successful.

COLLECTING IN IRELAND IN THE 18TH CENTURY:
THE HISTORIC COBBE COLLECTION IN CONTEXT

Charles Sebag-Montefiore

Both private and public collections of Old Master paintings in Britain and Ireland in this 21st century still benefit from the artistic patrimony of the Grand Tour of the 18th century. No less than their British contemporaries, Irish Grand Tourists travelled through France and Switzerland to Italy, returning with paintings, sculpture and other works of art for the new houses they were having built. One Irish 18th-century Grand Tourist, whose collecting was to be of major significance for the future National Gallery of Ireland in Dublin, was Joseph Leeson (1711–83) of Russborough, Co. Wicklow, created 1st Earl of Milltown in 1763.

Leeson, who inherited the family brewing fortune in 1741, made a first tour to Florence and Rome in 1744–5 and a second tour to Rome, with his son and nephew, in 1750–51. On his first

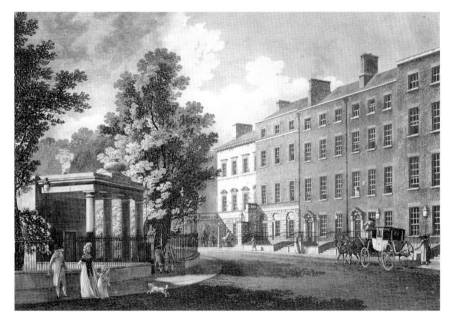

Fig.53 James Malton, *Charlemont House in Palace Row, Dublin*, mezzotint, 1793; the Cobbe townhouse was adjacent to the last house on the right

trip, in 1744, he commissioned Batoni to paint his portrait, one of the earliest portraits by Batoni of any British or Irish sitter. This picture must have pleased him, for on his second visit, in 1751, he or his son commissioned portraits of his wife and son (all three portraits – like the rest of the Milltown Collection – now in the National Gallery of Ireland).

A highlight of Leeson's collections was the beautiful *Holy Family with Seven Figures*, painted by Nicolas Poussin in 1649. In contrast, he acquired three rare caricatures painted by Reynolds in 1751, one, the *Parody on Raphael's 'School of Athens'*, a comic depiction of British and Irish visitors to Rome, and three smaller groups of figures, which include himself, his

son and Lord Charlemont. Leeson's collection also included four paintings by Panini (two capriccios and two *Views of the Roman Forum and Colosseum*); three paintings by Vernet, of which one was a commission by Leeson for a copy of *The Death of Regulus* by Salvator Rosa; pastels by Rosalba Carriera; a group of 17th-century Florentine pictures by Cesare Dandini, Francesco Furini and Lorenzo Lippi; and an important bronze, *The Four Labours of Hercules*, from the workshop of Tacca.

Leeson began to build Russborough to the designs of the fashionable architect Richard Castle in 1741, some six or seven years before Archbishop Cobbe began to rebuild Newbridge to designs by James Gibbs. Russborough was completed about 1750 and contains elaborate stucco ceilings attributed to the Lafranchini brothers, fine mantlepieces, inlaid floors and mahogany doors. The earliest printed list of the picture collection appears in vol.3 of Neale's *Views of Seats* (1826), and this was followed by a stand-alone *Catalogue of Pictures belonging to the Earl of Milltown at Russborough* (Dublin, 1863). Purely a hand-list, with no preface or details of provenance, it does nevertheless provide a room-by-room list of the pictures. After the death of the 6th and last Earl of Milltown, in 1897 his widow offered the collection to the National Gallery of Ireland, which took possession of the collection in 1902.

Milltown was elected a member of the Society of Dilettanti in 1754, two years before James Caulfeild, 4th Viscount and 1st Earl of Charlemont (1728–99), perhaps the most distinguished Irish patron and collector of the 18th century. Lord Charlemont spent the eight years between 1746 and 1754 abroad, mostly in Italy, but he extended his travels to Greece and Asia Minor owing to his strong interest in Classical antiquity. In 1748, with other amateurs such as Charles Watson-Wentworth (later 2nd Marquess of Rockingham), Charlemont was a subscriber to *The Antiquities of Athens* by James Stuart and Nicholas Revett. Described by Sir John Summerson as 'one of the three most important architectural travel books of the century', this was the first accurate survey of the surviving Classical buildings of Athens. Charlemont commissioned views of Tivoli from Thomas Patch, sat twice to Batoni (one portrait at the Yale Center for British Art, New Haven, CT) and possibly once to Mengs: the resulting portrait by the latter (National Gallery, Prague), even if not of Charlemont, is an astonishing allegorical work showing a British or Irish sitter inspired by the architecture of Vitruvius and Palladio.

Charlemont's Dublin town house, designed by William Chambers, who, like Gibbs, never visited Ireland, was built between 1763 and 1776 at the centre of the north side of Rutland

Fig.54 Gerrit van Honthorst, *'The Duettist': A Musical Party with a Lute Player*, oil on canvas, 51¾×71½ in (135×182 cm), late 1620s (National Gallery of Ireland, Dublin)

Square (fig.53). The grandeur of his scheme resulted in the renaming of the terrace as Palace Row. Soon, the street housed two other owners of significant picture collections: the Earl of Farnham (presumably Robert Maxwell [*d*.1779], 2nd Baron Farnham, who was created 1st Earl of Farnham in 1783), and Thomas Cobbe, who had built, in 1768, a four-bayed house with a 60ft frontage on the corner of the square.

Charlemont's house was to contain one of the best collections of paintings in the city. From Italy, he sent home paintings, marbles, bronzes, books, medals and prints. A letter written to him by John Parker (an English historical painter and Charlemont's agent) on 26 July 1755 gives the shipping list for that month and conveys the exciting nature and scale of activity: 'The [objects] were packt up by me and [Vierpyl] in two large cases, one full of books only, the other,

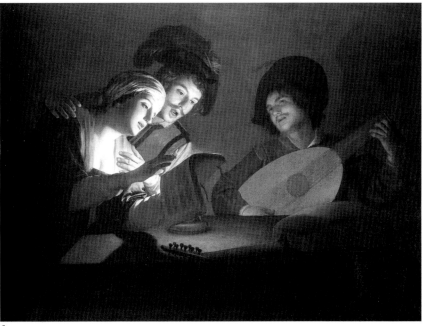

fig.54

besides books, contained in a case at the bottom your marble mosaic table, the case of medals and the walnut-tree case with drawers for the medals. In the other case, the Farnese globe and under it the basso relief MinervaAnd Mr. Murphy's other cases, in the large one, the Etruscan vases, boxes of lava, etc.; other cases containing Mr. Murphy's clay heads and two bronze heads, Caesar and Brutus. All your lordship's marble busts – viz, Swift, Homer, Brutus the elder and younger, antique faun, modern faun; girl's head from Alessandria, and Agrippina in separate cases.'

In 1756 John Parker bought an oil painting for Charlemont from the Barberini collection in Rome: *'The Duettist': A Musical Party with a Lute Player* was then believed to be by Caravaggio, but is today recognised as a composition by Gerrit van Honthorst (fig.54). In 1892 the picture was sold at auction with the rest of Charlemont's collection, and its whereabouts remained unknown until it appeared recently on the London art market. With admirable aptness, the National Gallery of Ireland acquired it in 2001.

Among Charlemont's other paintings by Old Masters were *Judas Returning the Thirty Pieces of Silver* by Rembrandt (private collection; fig.55) and works by or attributed to Titian, Tintoretto, Dughet, Zuccarelli and Van Dyck. He was one of Hogarth's last patrons, owning *The Gate of Calais*, also known as *The Roast Beef of Old England* (Tate Britain, London), *The Lady's Last Stake* (Albright–Knox Art Gallery, Buffalo, NY) and an unfinished *Portrait of Charlemont* painted by Hogarth *c*.1759 (Smith College Museum of Art, Northampton, MA). Charlemont, who had known Reynolds in Rome in 1751, proposed him in 1766 as a member of the Society of Dilettanti, to which Reynolds was duly elected in May of that year. Charlemont's patronage continued: in 1774 he bought from Reynolds *Venus Chiding Cupid for Learning to Cast Accounts* (Iveagh Bequest, Kenwood House, London).

The collection of Lord Farnham at his country seat, Farnham House, Co. Cavan, also derived from the Grand Tour. Besides antiquities from Pompeii and Herculaneum, it contained *The Miracle of the Loaves and Fishes* and *Christ Washing the Disciples' Feet*, both by Tintoretto, a *St John the Baptist in the Desert* by Guercino, ten Venetian views by Guardi and works by Carlo Dolci, Salvator Rosa, Zuccarelli and Netscher.

Many other notable collections were formed in 18th-century Ireland. The 2nd Earl of Bessborough (1704–93) travelled in Italy, Greece and Constantinople in 1736–8. He was one of the founder-members of the Society of Dilettanti in 1736 and was a noted collector of marbles, gems and other works of Classical antiquity. He was a friend of Jean-Etienne Liotard, who painted him and his family, and in Bessborough House, Kilkenny, hung pictures by Northern artists, including Jordaens, Snyders and Seghers. The collection of Ralph Howard at Shelton Abbey contained fine examples by Vernet and Richard Wilson. The Earl-Bishop of Bristol and Derry gathered a remarkable collection in Rome for his house at Ballyscullion, although it did not all reach Ireland, and what did was subsequently transferred to Downhill Castle, where much of the collection was destroyed in a fire in 1851.

Fig.55 Rembrandt
Harmensz. van Rijn, *Judas
Returning the Thirty Pieces
of Silver*, oil on panel,
31½ × 40¼ in
(80 × 102 cm), 1629
(private collection)

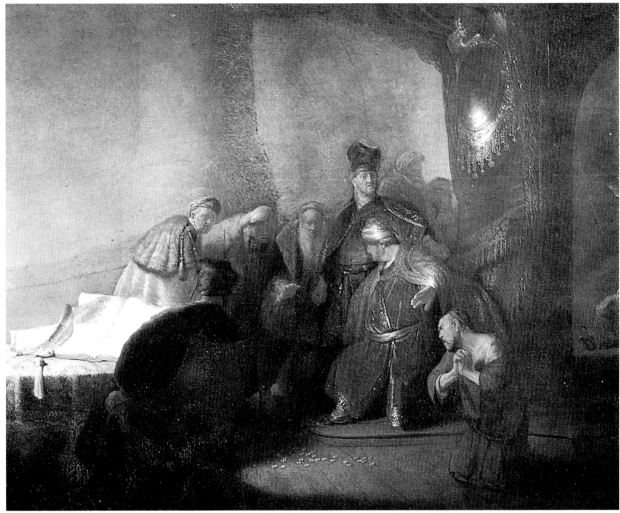

fig. 55

It is a tantalising fact that, relative to 18th- and 19th-century England and Scotland, so few Irish collections of paintings and sculpture were the subject of separate catalogues. In consequence, much detailed information remains to be discovered about Irish collectors and collections of this period. For example, Richard Robinson (1709–94), who was appointed Archbishop of Armagh and Primate of All Ireland in 1765, was a notable patron of Irish architecture. He was painted four times by Reynolds. One version, painted in 1779, was acquired in 1943 by the Barber Institute, Birmingham; another, much praised by Horace Walpole, is in the Musée des Beaux-Arts, Bordeaux. He also owned a version of Angelica Kauffman's *Andromache and Hecuba Mourning the Ashes of Hector* (The Courts, Holt, Wiltshire; currently missing). It is likely that he furnished

his house with only Continental paintings, but the evidence has yet to come to light.

In his *Tour of Ireland* of 1780, Arthur Young noted a few collections. Given the fact that Young's principal interest was in agriculture, it is possible that the few descriptions of houses in his book were supplied to him rather than written by him, but this is conjectural. In Dublin, Young mentioned, with extreme brevity, three houses: those of the Duke of Leinster, Lord Charlemont and Robert Fitzgerald. Young described more extensively the pictures at Dunkathel, Co. Cork, built for Abraham Morris, a wealthy Cork merchant. These included works by or attributed to Romanelli, Guido Reni, Carracci and Sebastiano del Piombo, as well as works by Northern artists such as Rubens and Egbert van Heemskerck, and copies

of works by Titian and Raphael. At Castle Oliver, Young recorded five pictures by Sebastiano Ricci, two by Luca Giordano and six heads by Nogari. Other collectors and pictures are mentioned, but the details are all too slight.

Sir Compton Domville lent pictures by Annibale Carracci and Carlo Maratta to exhibitions in Dublin in 1814 and 1830. Other lenders to Dublin exhibitions in this period included the Earl of Listowel (as Viscount Ennismore), Richard Fox, Henry Harrington, Robert Latouche, the Duke of Leinster, Viscount Lifford, William John Moore, James Penrose, James Roche, Henry Charles Sirr and John Sweetman.

Dublin became a centre for sales of pictures by auction: in 1845 John Littledale, auctioneer of 11 Upper Ormond Quay, needed 18 days to sell, in a total of 1,440 lots, the vast collection of paintings, bronzes, china, statuary and other works of art formed by the Irish architect Francis Johnston. Many of the pictures were bought from earlier Irish collections, including those of Dr Bernard Bishop of Derry, Sir George Caulfeild, the Marquess of Ely, the Harrington Gallery, Godfrey Hoffman, Thomas Potter, Dr Tuke and, strangely, a few pictures claiming a provenance from the Milltown collection.

One effect of this energetic flow of paintings and other works of art into and within Ireland was the call for the establishment not only of an academy of painting but also of a National Gallery. In 1766 the Society of Artists considered the establishment of a permanent picture gallery in its new premises in William Street, Dublin and this plan was given new momentum during the Viceroyalty of the 4th Duke of Rutland (1754–87), appointed Viceroy in 1784. Peter de Gree, a Flemish artist, was appointed Keeper to form a collection, but the early death of the Duke in 1787 prevented the project from proceeding.

Charles Cobbe (1686–1765; see cat.7), chaplain to his cousin Charles Paulet (1661–1772), 2nd Duke of Bolton and Lord-Lieutenant of Ireland (see cat.44), was appointed Archbishop of Dublin in March 1743. He had acquired Newbridge House in 1736 and rebuilt it between 1747 and 1752 (see figs 13, 15 and 26). His youngest and only surviving son, Thomas Cobbe (1733–1814; see cat.13), formed the core of the Newbridge collection: in 1764 he built onto the house a large drawing room to serve as a picture gallery to contain the growing collection (see figs 66–7).

It is not known whether Archbishop Cobbe himself collected any of the Old Master pictures surviving in the Historic Cobbe Collection. He undoubtedly inherited family portraits, and his wife, the widow Dorothea Rawdon (c.1691–1733),

had commissioned portraits of her elder children by her first husband (Cobbe Collection, no.89) and her parents (Cobbe Collection, nos 98 and 100; see also cat.95). Archbishop Cobbe's eldest stepson, Sir John Rawdon (1719/20–93), later Earl of Moira, on his return from his Grand Tour, evidently gave him his pastel portrait painted in Florence by Charles Martin (cat.3), and the Archbishop would seem to have commissioned from James Latham the portrait of the Sir John's bride, Lady Helena Perceval (cat.4). The Archbishop almost certainly commissioned the portraits by John Astley of his daughter-in-law, Lady Betty (cat.9), and of his chaplain, the Rev. Sir Philip Hoby, Bt (cat.8). Given that the local Vicar of Donabate and private secretary to the Archbishop was the Dublin art luminary, the Rev. Matthew Pilkington (1701–74), it is not unlikely that he may have begun a small collection. The pronounced religious character of a number of works in the collection may well point to some collecting activity on his part.

No evidence has come to light to show that the Archbishop's son Thomas Cobbe made the customary Grand Tour, though it is clear that Thomas's half-brothers, Sir John and Arthur Rawdon, both of whom had travelled to Italy, provided a strong influence on his collecting activities. Thomas acquired an expensive picture from Moira in 1763, and in the following year paid for the costs of restoration of some Arthur's pictures. Moira had been elected a member of the Society of Dilettanti in 1741, several years earlier than either Milltown or Charlemont.

It is highly likely that Thomas Cobbe was influenced by Pilkington, author of the influential reference book *The Gentleman's and Connoisseur's Dictionary of Painters* (see pp.52–62). The vicar and amateur art critic may have seen in Thomas an opportunity to further his activities as a 'purveyor' of pictures. His employer, the Archbishop, may well have approved and funded the project, as references to purchases in Thomas Cobbe's own ledgers account for only a small proportion of the total number of pictures bought.

The household account books at Newbridge cover family expenditure almost continuously from 1723 to 1900, and give a certain amount of information on the formation of the collection. Unfortunately, the one missing volume covers the years 1765–83, coinciding all too closely with the date of the construction of Thomas Cobbe's new picture gallery. The immediately preceding volume gives scant details to identify individual pictures. However, one can see a steadily increasing rate of acquisition throughout the 1760s until 1765.

Family tradition relates that Pilkington was sent to Holland and Italy to acquire pictures for Newbridge: if he did take an extended period abroad, it would have been in 1756–8, when there is a gap in his signature of the annual vestry meetings at Donabate. There is no record of his presence in Italy, but he could well have visited the Netherlands and France. A fact that may throw some light on the question is that one of the most interesting genre pictures in the historic collection, *A Lady in an Interior, with a Servant Washing her Foot* by Johannes Voorhout (cat.26), was acquired at a Paris auction (bidder not known) in January 1764, very shortly before the completion of the newly built Newbridge Drawing Room and Picture Gallery.

Of Irish collections, pictures in the Cobbe Collection and Pilkington's own are most frequently alluded to in the *Dictionary*, which may suggest that the author, in passing, was using it both to promote his own pictures and to justify his purchases for Cobbe. An instance of the latter is in his entry for Meindert Hobbema, in which the splendid Cobbe *Wooded Landscape* (cat.24) is described, and in which Pilkington refers to a high price recently obtained in London for another of Hobbema's paintings.

Cobbe's collection was predominantly Northern, with a large number of landscapes by, for example, Cornelis Decker, Klaes Molenaer, Barent Gael, Jacob van Ruisdael and Gaspard Dughet. His most celebrated purchase was the *Wooded Landscape* by Hobbema, signed in full and dated 1663. The earlier provenance has not been established, but in 1839 Thomas Cobbe's grandson Charles sold it and a painting by Dughet (cat.40) for £1,500 to the dealer Thomas Brown, in order to raise money to rebuild the houses on the family's Glenasmole estate (see pp.87–9): the houses were later known as 'Hobbema Cottages' (see fig.89). Later in 1839, Brown sold the Hobbema for £3,000 to Robert Stayner Holford (1808–92), a discerning millionaire collector of paintings, rare books and manuscripts, who lived at Dorchester House, Park Lane, London, and Westonbirt in Gloucestershire. Holford's son, Sir George Holford, sold the picture privately in 1901 to J. Pierpont Morgan. In 1935, the latter's son, J. P. Morgan Jr, sold it to Andrew Mellon, who gave it to the National Gallery of Art, Washington, DC, as part of his huge foundation gift to the new gallery in 1937.

In addition to the Hobbema, three other notable pictures have been sold from the collection. As noted above, the *Wooded Valley Landscape* by Gaspard Dughet was sold by Charles Cobbe with the Hobbema in 1839; it also passed into the Holford collection. Although now in a private collection in Monaco, it still retains its 18th-century Newbridge frame (see p.88). A later generation sold the Ruisdael *Landscape with Cornfields*, last recorded with the dealer Marshall Spink, and the Gainsborough *Portrait of Mrs Frances Champion* (cat.45*), which until recently was in the Kimbell Art Museum, Fort Worth, TX, but is now in a private collection in New York. In the present generation, the period of dispersal has abated, and indeed the Cobbe Collection is being spectacularly enriched (see Part II of this catalogue).

MATTHEW PILKINGTON AND *THE GENTLEMAN'S AND CONNOISSEUR'S DICTIONARY OF PAINTERS* OF 1770: A LANDMARK IN ART HISTORY

Barbara Bryant

Pilkington's *The Gentleman's and Connoisseur's Dictionary of Painters* (figs 57–8) marked a dramatic turning-point in the study of art history. The *Dictionary* was the first biographical treatment of painters' lives in the English language.[1] Recent scholars occasionally mine Pilkington to assess the fluctuating reputations of artists such as Rembrandt or Reynolds or to assess the taste for Old Masters.[2] However, this key compendium has not been studied in its own right with Pilkington in the spotlight. If scholars are increasingly to use Pilkington's

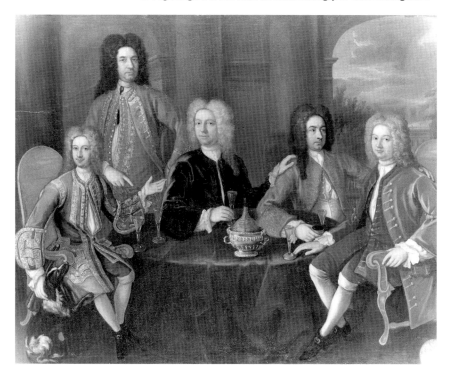

Fig.56 James Worsdale, *The Dublin Hell-Fire Club*, oil on canvas, 82¾×108½ in (210×275 cm), *c*.1735 (National Gallery of Ireland, Dublin); painted by Pilkington's friend Worsdale, this group portrait of the famous drinking club includes Lord Santry, Simon Luttrell, Col. Henry Ponsonby, Col. Richard St George, Col. Clements (some or all of whom were known to Pilkington)

Dictionary, we need to be confident that he wrote as an informed participant in the mid-18th-century art world and not as an isolated hack. This essay will consider Pilkington himself, the *Dictionary*'s standing at the time of publication and, finally, its later incarnations through reworkings by editors such as Henry Fuseli.

PILKINGTON, THE MAN

To posterity Matthew Pilkington (1701–74) led two seemingly separate lives: the first as a would-be poet and wit in the Dublin of the 1730s, craving attention in the public arena despite having taken holy orders, flattering aristocrats, cajoling his older friend Jonathan Swift into providing introductions in London, running with the playwrights and hacks of Smock

Alley and looking for the main chance wherever it might be found. The ultimate disgrace surely came with his scandalous divorce in 1738 from his wife Laetitia, who then took her revenge by penning her own vindication, her massively entertaining *Memoirs* (1748–54; fig.59),[3] written while she lived in London. Matthew's second self could not have been more different: a diligent scholar, in the service of the eminent Archbishop Cobbe, and then his son Thomas, advising as they formed the painting collection at Newbridge. This Matthew could be found tucked away in his study, translating and collating art-historical works on painters and painting from previous centuries, and using that material to create his own magnum opus, *The Gentleman's and Connoisseur's Dictionary of Painters*, published in 1770. Such was the disjunction between the two Matthews that his entry in the original *Dictionary of National Biography* (1896) warned readers not to confuse him with another individual of the same name, and even though this mistake was corrected by 1912,[4] the double nature of Pilkington's life has naturally led to its own confusions and obfuscation. But it is essential to see the man behind the publication to understand the importance and impact of the *Dictionary*.

Pilkington's forebears were English, making their home in Ireland (Meath) by the mid-1600s. The birth of Matthew coincided with the new century. His clockmaker father (*faber automatarius*) provided a good education; Matthew progressed to Trinity College in Dublin as a scholar, ultimately receiving an MA in 1725 and taking holy orders. A minor post at St Andrew's, Dublin, did not prevent him from writing poetry (published collections 1730, 1731, 1734; fig.60).[5] He married early, and perhaps ill-advisedly, in 1725, to Laetitia van Lewen (1712–50), daughter of an eminent Dutch-born physician who specialised in childbirth. Matthew's clerical path seemed due more to circumstances than to natural inclination, with his keenest efforts directed towards writing poetry[6] and the cultivation of his local hero, Jonathan Swift, Dean of St Patrick's Cathedral. Swift, who described the pair as 'a little, young, poetical parson, who has a littler, young, poetical wife',[7] joked with Laetitia and hunted for old books in the shops of Dublin with Matthew. As to Pilkington's children, the eldest was farmed out to his parents, and he later questioned the legitimacy of the others.

For a time in the early 1730s Pilkington mixed in Dublin's social and artistic circles, and he was initially happy with Laetitia, his partner in ambition. The literary and theatrical world attracted them, as did the entertainers who worked

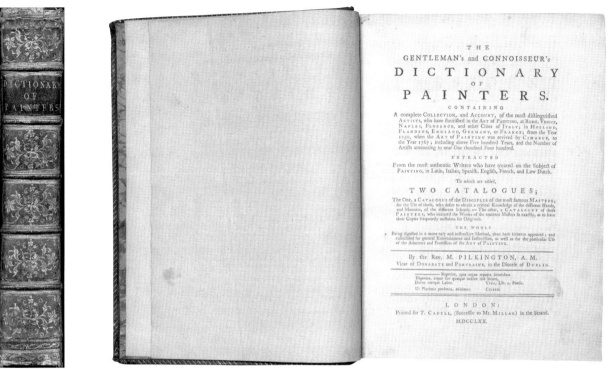

fig. 57 fig. 58

Fig.57 Spine of the first edition (1770) of *The Gentleman's and Connoisseur's Dictionary of Painters* by Matthew Pilkington

Fig.58 Title-page to the first edition of *The Gentleman's and Connoisseur's Dictionary of Painters* (London: Thomas Cadell, 1770) by Matthew Pilkington

therein, such as actress Mary Barber. Another boon companion was James Worsdale (*c*.1692–1767),[8] portrait painter (formerly Kneller's assistant) and dramatist, whose ballads and farces entertained audiences in Dublin and London. In 1735, he painted the Dublin Hell-Fire Club (fig.56; National Gallery of Ireland, Dublin),[9] a modest evocation of the milieu in which he and Pilkington moved. Worsdale's disreputable character, famed for what Vertue called his 'bare face mountebank lyes',[10] was to loom large in the lives of both of the Pilkingtons for some time to come. Another friend with a taste for the *outré* was the middle son of the Prime Minister, Sir Edward Walpole (1706–84), then in Dublin as Secretary to the Lord-Lieutenant of Ireland. Walpole collected paintings, patronising Samuel Scott and Hogarth, whose *Night Encounter*, depicting Walpole and the 2nd Viscount Boyne,[11] revealed a decadent substratum of life in the 1730s. Unfortunately no portraits of Matthew Pilkington are known to exist; for Laetitia's portrait, however, he turned to the young Irish-born Nathaniel Hone (1718–84), who produced a conventional image showing a concern for social niceties.[12]

Pilkington yearned to mix with the literary lions of London and to that end, through another contact, Dr Patrick Delany, he contrived a recommendation from Swift to John Barber (1676–1741), official printer to the City of London, then about to take up his term as Lord Mayor. Swift wrote of Pilkington: 'he is some Years under Thirty, but has more Wit, Sense, and Discretion, than any of your London-Parsons … . He hath a great Longing to see England … .'[13] Pilkington became Barber's chaplain for the duration of the Lord Mayor's term (1732–3), which allowed him to live in London (away from Laetitia, who nonetheless travelled over for a long visit) and to enjoy further introductions from Swift to Pope, Gay and others. Pilkington's unflattering 'character' of Barber ('His intimate-Friends, he treats like his Dependants; his Dependants, like his Footmen; and his Footmen, like his Slaves'),[14] written for Swift, revealed his talents for duplicity, as did the complicated episode in which Pilkington was arrested with others for dealing in 'treasonable' poems ascribed to Swift. In the event, Pilkington obtained early release, it was surmised, by implicating his friends.[15] Essentially this time in London allowed Pilkington to survey the literary and artistic scene there. Exactly what he did that year we can only speculate; he made the most of established friendships in the circle of Worsdale and Walpole and embarked on others such as that with the actress Mary Heron. Barber, the Lord Mayor, had himself formed an art

collection on travels abroad,[16] and Pilkington must have known it. Pope supposedly tried to shake Pilkington off when he visited Twickenham,[17] and whether Pilkington gained entry to such high-level clubs as the 'Virtuosis at the Kings Armes',[18] a tavern in New Bond Street, remains an open question. Certainly this is what he aspired to. The widening art world focused on London: the greatest collections were housed in the urban palaces of the aristocracy,[19] and auctions held by Christopher Cock and dealers such as Andrew Hay provided yet more to see.[20] But for Pilkington, his London sojourn proved abortive, and return to Dublin followed, with some years during which he urged his wife into compromis-

Matthew Pilkington's eventual salvation in June 1741 lay in an appointment from Charles Cobbe, the Archbishop of Dublin. In the wake of the scandal, Cobbe nonetheless felt certain enough of Pilkington to offer him the living of the parish of Donabate and Portraine associated with his seat, Newbridge. One can assume Archbishop Cobbe found Pilkington an attractive character – entertaining, witty and amusing. Pilkington retired to Newbridge to serve the Cobbe family, including perhaps carrying out some secretarial duties (the 'pen-making' referred to by Laetitia)[25] and advising on the formation of their collection. Here also it would seem he began to contemplate his new career as an art histo-

fig. 59

ing situations, on occasion with Worsdale, finally succeeding in proving her adultery in 1737. Still dabbling in the theatre in 1738, Pilkington reworked Worsdale's *A Cure for a Scold*, dedicated to Sir Edward Walpole,[21] at the same time as his soon-to-be-divorced wife was writing poetry for Worsdale. An ecclesiastical divorce followed that year, along with a large dose of public humiliation (fortunately most of the clergy sided with him).[22] Their old friend Swift quickly denounced them: 'he proved the falsest Rogue, and she the most profligate whore in either Kingdom.'[23] Laetitia left for London branded an 'adventuress', surviving by her pen and personality, eventually producing her *Memoirs*, recognised as a landmark publication by Virginia Woolf, by feminist critics and by literary experts.[24]

rian (though it was not until 30 years later that his magnum opus was to appear). The publication of the first volume of Laetitia's *Memoirs* in 1748 placed Pilkington in a poor light as a husband and family man, but the furore subsided, and when she died in 1750 at the early age of 38, it effectively freed Pilkington to re-invent himself. One month later, aged 49, he married for the second time, Miss Nancy Sandys, whom he called Ann.

Renovations initiated at Newbridge by Archbishop Cobbe and his recently married son, Thomas, led to the creation of a splendid Drawing Room (see pp.63–72 and figs 66–7), completed in 1764. Family tradition maintains that Pilkington went abroad to buy paintings for the Cobbes, as stated by Frances Power Cobbe in her catalogue of the collection in

Fig.60 Title-page of
Matthew Pilkington's
Poems on Several Occasions
(London, 1731)

1868 and in her memoirs of 1894.[26] His European travels cannot be proven, but his involvement in the art world can. There is a comment recorded (again by Frances Power Cobbe) that, in answer to the Archbishop's question as to why his vicar had turned art-critic, Pilkington replied: 'Your Grace, I have preached for a dozen years to an old woman who *can't* hear [the Archbishop's elderly unmarried sister, Elizabeth] and to a young woman who *won't* hear [his daughter-in-law, Lady Betty Cobbe]; and I now think I may attend to other things!'[27] Here we begin to see what the years of poetry writing and dramatic tinkering had gained for Matthew Pilkington – an easy way with words. But more importantly

for Cobbe in the 1750s and early 1760s, lending him greater expertise and credibility. It seems Pilkington lived primarily in Dublin[29] for easy access to the auction houses and collectors, but one can imagine him engaged in scholarly work and writing in his quiet retreat on the Newbridge estate (fig.62) during his retirement years. Indeed, by the 1750s Pilkington was actively involved in the Dublin art market, as satirised in Beaumont Brenan's farce *The Painters' Breakfast* ('a dramatick satyr') in 1756, discussed so well by the Knight of Glin.[30] The disreputable trade in fakes and false provenances provides the background to characters such as the connoisseur Formal, the duped collector Sir Bubble Buyall and, as

fig. 60

it provides a date in the early 1750s for his new career, when he was in his early fifties, some 12 or so years on from his appointment in 1741.

In the 1750s a campaign of picture-buying by the Cobbes began, as recorded in family accounts, with Pilkington named in December 1761 (fig.61) as the source of a battle painting by Jan Wyck (cat.27),[28] and by family tradition he advised and purchased abroad for the Cobbes. There is also the intriguing question of just how much Pilkington may have favoured purchases of religious subject paintings. This direct involvement in acquiring paintings led to his interest in questions of connoisseurship and quality, no doubt spurring on his art-historical researches. Furthermore, such work supported his role in the formation of the collections

Archibald Elias has observed, Pilkington in the guise of the Rev. Mr Busy,[31] offering up dubious attributions to gullible purchasers. Buying paintings became a fashion in Dublin of the 1750s and 1760s with great collectors of the day, some gathering their treasures from the Grand Tour, including the Earl of Charlemont, the Earl of Farnham, the Marquess of Waterford, Francis Johnston and the Earl of Moira (Thomas Cobbe's half-brother).[32] And with this wave of interest in painting came a consequent thirst for reliable information.

THE DICTIONARY

Pilkington signed his preface to *The Gentleman's and Connoisseur's Dictionary of Painters* on 2 December 1769 in Dublin. He paid immediate homage to his famed exemplar,

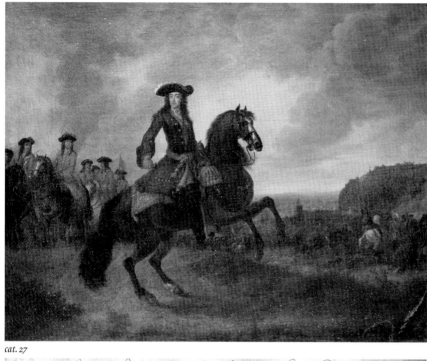

cat. 27

fig. 61

tions, which could neither improve the taste or judgement of a lover of the Art, nor scarcely keep the attention of a judicious inquirer awake'. Here is a hint of Pilkington the poetic and dramatic wordsmith, whose life among theatrical folk had lowered his boredom threshold. He later refers to 'the tediousness which I have experienced' in trawling through earlier lives of painters. Entertainment and instruction were equal goals to Pilkington, and the easy language of the entries provides a refreshing antidote to more ponderous art theorising of the era.

As a literary man, Pilkington had gained a wide knowledge of the literature of art; and, since little of that was in English, he must have had a facility in languages, as he absorbed the writings of Vasari, Bellori, Félibien, van Mander and Houbraken (none of whose works existed in translation),[33] as well as De Piles and Du Fresnoy (whose works existed in English versions), all of whom Pilkington cited in his substantial list of sources. Were it not for Pilkington's own involvement in the art market, the *Dictionary* might be considered purely an exercise in compilation. But there is also continual reference in his entries on painters to colour, handling and use of light and shade,[34] so much so that one can only conclude that he had many years' familiarity with looking at works of art in sale rooms, collectors' homes in Ireland, London and probably abroad (if not Italy, then more accessibly, the Low Countries). It is also significant that he formed his own small but choice collection of Old Master paintings (discussed below).

The genesis of the *Dictionary* certainly belongs in part to Pilkington's long-established friendships with artists and collectors. There is even some evidence that he wrote a life of Hogarth in the 1760s, which he withheld from publication at the time of the artist's death in 1764 because of strong feelings over 'Party & Politicks' at the time.[35] Did Pilkington share Hogarth's scorn for faked-up 'Old Masters' by the 'fizmongers' of the era, perhaps seeing reliable information as a way around the growing problem of fakes, which he himself must have encountered in the sale rooms? They parted company on the notion of the connoisseur, anathema to Hogarth, but Pilkington's selected audience. In the book's title Pilkington targeted these connoisseurs, evoking the spirit of the Grand Tourist and collection builder of the mid-18th century.

The idea of the connoisseur had developed through the writing of Jonathan Richardson, whose key text,[36] 'The Science of a Connoisseur' in *Two Discourses* (1719), established the notion of the man of taste and judge of paintings who

Vasari, with a subtitle invoking a pre-Renaissance master: 'from the Year 1250, when the Art of Painting was revived by Cimabue to the Year 1767'. Thus Pilkington's history of painters over 500 years began with Cimabue and ended with near-contemporary painters. His refreshingly brief preface has a few autobiographical nuggets, referring to his 'early admiration of the Art of Painting, and an eager inclination to improve myself in the knowledge of it'. Somewhat disingenuously he wrote that it 'cannot appear an improper employment for the leisure hours of an Ecclesastick; particularly of one, who being wholly unambitious, and pleased with his profession and retirement, has been always more studious to improve his mind, than his fortune'. He saw himself as providing a useful service in digesting the foreign literature on the subject and extracting material that was 'either instructive or Entertaining', avoiding what he called 'a tedious account of the artists...encumbered with a load of descrip-

Cat.27 Jan Wyck, *William III at the Siege of Namur*; Pilkington acquired this picture as *William III at the Battle of the Boyne*, possibly in the auction rooms in Dublin

Fig.61 'A Picture from Pilkington done by Wycke – £6.16s.6d', entry for cat.27 made on 11 December 1761 in Thomas and Lady Betty Cobbe's account book for the years 1756–65 (Cobbe Papers: Hugh Cobbe)

Fig.62 Charles Frizell, *A Map of Newbridge, Desmesne of Thomas Cobbe, Esq.* (detail of the church and Matthew Pilkington's residence, Glebe House), pen and wash, 1776 (Cobbe Papers: Hugh Cobbe)

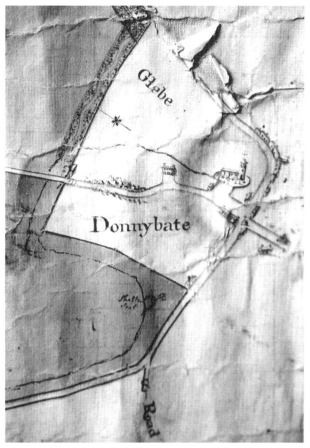

fig. 62

could rank and grade paintings, but the language of this text is quaint and sometimes laboured. With reference to actual works of art, Richardson and his son produced *An Account of Some of the Statues, Bas-Reliefs, Drawings and Pictures in Italy, &c.* (1722; 2nd edn 1754), the *de rigueur* companion for the Grand Tourist, as well as for the armchair connoisseur. But these modest publications did not attempt to be comprehensive in any way. Another book, Thomas Martyn's *English Connoisseur* (London, 1766; Dublin, 1767), drew together locations of works of art in a systematic way, presenting this information in lists. The botanist-connoisseur Martyn disseminated these lists because 'The only way, by which we can ever hope to arrive at any skill in distinguishing the styles of the different masters in painting is the study of their works o … .'[37]

Other English language precedents dated back to the late 17th century[38] and formed the essential background to the breakthrough represented by the publication of the *Dictionary*. In 1685 William Aglionby's *Painting Illustrated in*

Three Dialogues included 11 translated lives from Vasari; Richard Graham, an artist himself, provided 'A Short Account of the Most Eminent Painters both Ancient and Modern …' in 1695 for Dryden's translation of Du Fresnoy's poem *De Arte Graphica; or The Art of Painting* (later edns 1719, 1750), but he excluded Northern artists. In 1706 the Highgate gentleman Bainbrigg Buckeridge, probably the most significant predecessor of Pilkington, included 'An Essay towards an English School of Painters', with biographical sketches, as an appendix to the translation of Roger de Piles's *The Art of Painting and the Lives of the Painters* (later edns 1744, 1754).[39] Also with a biographical element was Henry Bell's *Historical Essay on the Origins of Painting* in 1728 (re-issued in 1730 as *The Perfect Painter …*), which, however, ended with the life of Giotto. James Wills, like Pilkington a retired clergyman but unlike him also a painter, penned an English verse translation of Du Fresnoy's *De Arte Graphica; or The Art of Painting* in 1754. One can see that the continental theorists dominated such writings, often used as a vehicle for appendices dealing with the native school. George Vertue spent a lifetime aiming to rectify this lack of a history of British art and artists,[40] but it was left to Horace Walpole to reshape that material, again with the express intention of making the writing entertaining to read, when in 1762 he began publication of *Anecdotes of Painting in England* (4 vols, 1762–71).

What did not exist in English was a large-scale compendium of major and minor painters of all national schools from the early Renaissance onwards. This is the gap Pilkington set out to fill: 'For some years I waited, in expectation, that an author so qualified would have schemed such a work, as this which I present to the public.' The first edition of the *Dictionary* comprised approximately 1,400 biographies of painters in one volume. It included 'An Explanation of Technical Terms', and appended at the end of the volume were what Pilkington called 'two catalogues', one listing disciples of 'the most famous Masters', the other a catalogue of imitators. Such features obviously assisted in the distinguishing of hands that was so essential to the connoisseur. Pillkington wrote all the entries, and he acknowledged his sources in a separate list at the front of the book as well as within each entry. The alphabetised treatment made for ease of use, and the author presented his material in a straightforward manner, beginning with the speciality of the artist and his date of death. Often, if these dates were a matter for conjecture, he reviewed what previous authors had said, attempting 'with the utmost exactness I could exert, to rectify their chronological mis-

Fig.63 Anonymous artist, *View of Samuel Rogers's Dining Room*, watercolour, 8¾×13¾in (22×35cm), *c*.1840–50 (collection of Mr and Mrs Stuart B. Schimmel); this amateur watercolour shows the large oil sketch by Tintoretto (left of fireplace above three small pictures) – formerly owned by Pilkington and mentioned in his *Dictionary* – as a highlight of Rogers's famous collection at 22 St James's Place

fig. 63

takes'. Longer entries then gave the artist's date and place of birth, continuing with a chronological account of his life, his patrons, possibly an anecdote, characterisation of his style, and then reference to a few specific paintings and their locations, their qualities as works of art, and, even, revealingly, the status of the artist's work in the marketplace. Such a summary provided all that Pilkington's audience of connoisseurs and gentlemen might require.

Pilkington's early years writing poetry (fig.60) and drama, and also no doubt his facility at sermonising, make his prose style accessible and readable. He also valued brevity, reliability and the occasional item of human interest. Perhaps, given Pilkington's susceptibility to women, it is not surprising that he was scrupulously thorough in including women artists in the *Dictionary*, with accounts (as one might expect) of 'Mary Beal' and 'Elizabetha Sirani', but also of lesser-known figures such as 'Henrietta Worten' and 'Violante Beatrice Siries' and many others. If the strengths of his coverage emerge clearly, native-born British artists are under-represented, with no entry, for instance, on either Richardson or (the Irish-born) Jervas. Wholly new in Pilkington's *Dictionary* were the references to specific collections and works of art, linking the

biographical facts with the paintings, more in the spirit of an art historian than a biographer, thereby providing a way to study a painter's output in the original for those set upon such a course.

In this quest for locations, Pilkington drew upon his own knowledge of the past 40 years, but he also benefited from the recent innovation of the published collection catalogue, such as that for the Earl of Pembroke's collection at Wilton, which appeared in 1731 and is considered the 'earliest printed catalogue of any English private collection'.[41] References to catalogued works from that collection appeared frequently throughout the *Dictionary*. In addition, however, Pilkington frequently cited paintings he knew from first-hand experience, including his own, but also those of his patrons, the Cobbes, as in the entries on 'Monnix' (cat.18), 'Rontbout' (cat.19), 'William Van DeVelde' (cat.29) and 'Hobbema' (cat.24). He also cited Irish collections that he presumably knew well,[42] such as those of William Montgomery, the Earl of Moira and the Viscount and Viscountess Kingsland, who lived adjacent to the Newbridge estate at Turvey, along with references to many English collections, ranging from that of the Duke of Portland to that of the Duke of Marlborough. Thus

Pilkington's *Dictionary* remains an essential source for the study of the history of taste. As a barometer of prevailing fashions, one can see that the Italian schools predominate, but Pilkington provided as much on the early masters as on the more mainstream 16th- and 17th-century schools, and in northern Europe as well. He valued the Dutch and Flemish artists, as he proclaimed in a substantial entry on 'Gerhard Douw', singling out 'those imperfect connoisseurs', including 'gentlemen of fortune, who travel to Paris, and any part of Italy, there are some few who return without any real refinement of taste, to their own country; and being possessed with vanity, conceit, or affectation, bring back with them no more real knowledge of the art of painting, than they exported.' He continued that ' … persons of the finest taste in Italy, prize the best of the Flemish masters … for their sweetness of colour, for the charming effect of their chiaroscuro, for their delicacy of pencil, for their transparence, and their true imitation of nature … many of the most elegant collections and cabinets in Italy, particularly the celebrated Florentine collection, are repositories for the works of some of the Flemish masters, such as Douw, Tenirs, Hobbema, Mieris, Berchem, Vanderwerf, Ruysdal, Brueghel, Rubens, Vandyck, Rembrant, Ostade, and others.'

Hobbema, for example, then represented by a stunning example in the Cobbe Collection (referred to by Pilkington; cat.24), did not enjoy a high reputation in the mid-18th century; indeed, he stood at a low ebb, not even appearing in Houbraken.[43] Therefore it would seem that Pilkington himself had urged his patron to seize the opportunity to possess a work so underappreciated and undervalued. Interestingly, Pilkington did not curry favour with Cobbe by including all of his works in the *Dictionary* – the painting by Jan Wyck (cat.27), for example, which Pilkington acquired for him, is not referred to in the entry on that artist. But the example of the Hobbema underlines that Pilkington, far from following fashion slavishly (Walpole famously denigrated such Northern masters),[44] had formed his own distinctive approach from close study of originals, providing an alternative to the essentially Italianate Grand Tour taste.

Pilkington's own collection, previously unanalysed, provides an insight into his own taste as well as that of the 1750s, when the Cobbe Collection was formed. This taste is evident in his own choice cabinet collection of paintings, featuring, not unexpectedly in light of the above discussion, some distinctive works by (or attributed to) Northern masters – a landscape by Paul Bril (with, it was said, the figures by one of the Caracci), a genre scene (termed by Pilkington a 'droll') of a sick woman in bed by Egbert van Heemskerck and a moonlit river scene by Dirck Camphuysen. Bril's painting, from the description provided by Pilkington, sounds like a major work on large scale; the taste for this artist was also at a formative stage.[45] Pilkington also possessed several watercolours of East Indian birds by Jean-Baptise Monnoyer, which carried the impressive provenance of the 'old Duke of Ormond[e]', whose collection at Kilkenny in the earliest years of the century was still alive in the memory of connoisseurs. A portrait of *Princess Elizabeth of Bohemia* by Cornelis Jonson represented the earlier, half-native, school. But the star of Pilkington's collection must have been what he considered to be Tintoretto's oil study, measuring over 4 feet across, for the *Miracle of the Slave*, the major work now in the Accademia in Venice. The oil study, also from the distinguished Ormonde collection, travelled a particularly influential path once it left Ireland after Pilkington's death in 1774, as it passed to George IV at Carlton House, then into the hands of the Irishman Henry Tresham, then John Hoppner and William Young Ottley,[46] before entering Samuel Rogers's illustrious collection (fig.63).[47] Indeed, the quality of Pilkington's own collection, as readers of his *Dictionary* could detect, helped to establish his credentials as a scholar and connoisseur even to later audiences. Well into the 19th century, it was a selling-point for a painting to have a provenance that included Matthew Pilkington, as is evident in sale catalogues of the period.[48]

Pilkington secured publication with Thomas Cadell, a well-established firm in London with connections with the Royal Academy. Perhaps he found his publisher on the strength of his earlier literary life, or indeed through contacts in the art world; he claimed their dealings were 'friendly and Genteel'.[49] The book cost £1.1s, more than other art publication of the day;[50] as an attractive quarto volume (figs 57–8), it was destined for the serious reader, and indeed it entered the collections of many of the great bibliophiles of the day, including Horace Walpole and Richard Bull.[51]

There is a final point to consider about the initial publication of the *Dictionary*: the dedication to the 'President and Council of the Royal Academy of Painting in London', founded less than two years before in 1768; in making direct appeal to the newly formed national institute, Pilkington aligned his book with the centre of the art world. He sought nothing less than the most important audience, in the spirit of one well aware that his book would fill a long-standing gap. Sadly, if he ever sent a copy to the Academy itself, it is no

longer in the Library.[52] But this public gesture made a direct address to Joshua Reynolds as President, who may well have kept the *Dictionary* by his side as he wrote his *Discourses*.

The *Dictionary* remained the only such work in English for more than 30 years and an essential source on myriad minor painters as well as major ones. A review in the 'Catalogue of Books for 1770' in the *Gentleman's Magazine* commented: 'This is a very elaborate work, extracted from a multitude of

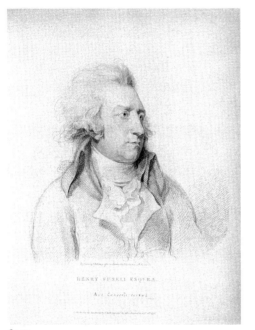

fig. 64

authors, and calculated to direct the reader to works of the most distinguished artists. It is a work of merit, but is capable of great improvement.'[53] A fuller account in the *Monthly Review* in July 1770 provided extracts from some of the more vivid entries, whetting the reader's appetite for amusing stories, but concluded that Pilkington focused too much on 'their Works, and a description of the manner in which they practised their art'[54] rather than on anecdotal lives of the artists. Indeed it was just this concern for the stylistic characteristics of individual artists that represented the innovation of the *Dictionary*. But not all of the readers who constituted Pilkington's audience were ready for such an approach. The book skimped on the British School, and in this area future editors made up for its deficiencies. Recent artists were also thinly represented, with only those who died in the 1740s and 1750s sure of inclusion; Carle Van Loo, who died in 1765, is one of the latest to be found.

Pilkington died just four years after publication so had no opportunity to bring out further, extended editions. The *Dictionary* endured in his exact form until just before 1800, relied upon by a wide range of collectors, dealers, connoisseurs, artists and bibliophiles.[55] In an era when the art market expanded dramatically, the *Dictionary* provided a comprehensive listing, with essential information in readily accessible form, along with an appendix of masters and imitators. It thus facilitated the process of connoisseurship in the late 18th century by allowing the process of stylistic analysis and assessment of an artist's manner to take place on an informed basis for the first time.

THE EDITIONS

Until 1798 only two re-issues appeared, but in this year an important new edition brought the *Dictionary* back into the public eye. The main text remained unchanged, but appendices were added by John Wolcot[56] ('Peter Pindar') comprising 'anecdotes of the latest and most celebrated artists, including several by Lord Orford'. These new lives, including those of Reynolds, Richard Wilson and George Barret, seemed to be an effort to update Pilkington and Walpole's *Anecdotes* at the same time. A further addition was James Barry's 'Reflections on the Present State of the Art of Painting in England', presented as a letter to the Dilettanti Society and dubbed by Farington the 'Phillipic of Barry against the Acad:'.[57] This inclusion ignited a controversy within the Royal Academy and perhaps also intentionally directed attention to this new edition of the *Dictionary*. The uproar resulted in Barry's resignation as Professor of Painting and his expulsion from the Academy.

Henry Fuseli, Barry's immediate successor as Professor of Painting, also became inextricably allied with Pilkington's publication, still seriously diminished by less than full coverage of recent painters. Upon taking up the professorship, with its academic responsibilities in the front of his mind, Fuseli turned anew to Pilkington's work (in its edition of 1798) in preparation for his first lecture delivered in 1801. He may have realised that he had an excellent opportunity to rework the book to his own undoubted advantage,[58] but it seems that the impetus for a new revised edition came from a consortium of publishers headed by his friend, the bookseller Joseph Johnson.[59] How long Fuseli worked on the project, which he sometimes referred to as a '*riformato*' of Pilkington, is not known, but it is no doubt relevant that shares in the copyright changed hands in 1804,[60] and that by

May that year Fuseli was already deep into work, asserting his own superior position: 'Now that driveller whom I have undertaken to edit, Pilkington, chaine [*sic*] me to this Spot; I am however so far advanced in his Castration and my own effusions, that he will probably Visit the Printer in two or three weeks.'[61] Fuseli's new post of Keeper of the Academy lent him even greater authority, giving the edition a distinct selling-point, as the publishers astutely realised. Fuseli impressed his stamp on the book by extensively revising entries on artists close to his heart, such as Correggio (an artist whose appeal had grown by 1800), but in very many

have been confused to find reference to 'a large landscape by Paul Bril, in his best manner … in the possession of the author of this book'. The unusual mixture of two eras of taste, *c*.1770 representing the moment of the Academy's foundation and *c*.1800 representing the widened horizons of a booming art world, indeed bears out Fuseli's reference to the 'piebald Compound' of the *Dictionary*.[63]

An *Illustrative Supplement* appeared along with Fuseli's volume, as a speculative venture on the part of an editor[64] who was unnamed but keen to curry favour with William Pitt, the dedicatee, and Benjamin West, the President of the

fig. 65

cases he was content to leave most of Pilkington's wording intact and cut paragraphs here and there to shorten the whole in order to insert new entries. He introduced some footnotes to indicate conflict or to expand what Pilkington wrote and always made certain that his own material was marked by 'F.'. He sometimes made changes for change's sake,[62] but, apart from negligible fiddling, Fuseli incorporated the extra entries from the edition of 1798 into the main body and added his own recent selection as a separate list. He jettisoned the list of masters and disciples, so essential to the connoisseur and gentleman, and not surprisingly the title of the book became more straightforwardly *A Dictionary of Painters*, thus encapsulating the changed taste of the times for information of a purely art-historical nature. Yet Fuseli retained (one wonders why) several of the references to Pilkington's own collection; any reader in 1805 might well

Royal Academy. Remarkably, a full catalogue of West's work (hitherto unrecorded)[65] appeared as an appendix, as did Fuseli's portrait (fig.64), together with a short life.

Johnson published Fuseli's edition in 1805, by which time the Academy had elected the artist as Keeper. He then resigned his professorship and took up the residence in Somerset House that went along with the keepership. With new publications on art and artists appearing regularly, and with the advantages of working in the Academy itself, Fuseli almost immediately embarked on a revised edition, prepared from 1806 onwards (fig.65). His new version of Pilkington's *Dictionary* in 1810 added more than 300 artists, particularly of the Spanish school. Compressing the layout increased space, and material from the previous edition was interspersed into the main body of text. It is at this stage that the character of the book moves increasingly away from Pilkington's view of

older art, as recently deceased artists are incorporated, with far more of those of the native school, for whom Fuseli was indebted to *Anecdotes of Painters* (1808) by Edward Edwards. Fuseli reckoned he was 'a clever little fellow, and had given him by this work assistance in preparing a new Ed. of Pilkington's lives'.[66] Fuseli's motives throughout seem entirely opportunistic, but his editions had a good press[67] and *Pilkington's Dictionary*, as it was still known,[68] did not see further improvement until 1824.

In 1816 the first serious rival to Pilkington's *Dictionary* appeared with the publication of Michael Bryan's *Biographical and Critical Dictionary of Painters and Engravers*. Unlike Pilkington, Bryan (1757–1821) was no amateur. He belonged to the London art world, as a professional connoisseur and dealer who had played an important part in the sale of the Orleans collection. However, his *Dictionary* inevitably relied on Pilkington, though with differing emphases. In addition, the inclusion of engravers doubled its size.[69]

Throughout the 19th century there was continual revision of the *Dictionary*, which remained, however, inextricably linked with Pilkington, no matter who edited or revised it. In 1824, the edition published by Thomas McLean, now titled *A General Dictionary of Painters*, carried a dedication to Sir Thomas Lawrence, the President of the Royal Academy, indicating its ties with the establishment, but there was a more egalitarian spirit in this edition, reduced in size and expense for a wider audience.[70] The unsigned preface injects some human interest as it told of Pilkington: 'Ardently intent, however upon acquiring some knowledge of a subject of which he was an enthusiastic admirer, Mr Pilkington, though an ecclesiastic, and residing in a country parish in Ireland, set about collecting all the information he could procure respecting the history of his favourite art, and the lives of its most distinguished professors of the different schools.'[71]

It was entirely fitting that Allan Cunningham (1784–1842), dubbed the 'Scottish Vasari', took on the task of revamping the *Dictionary* after his own extended biographies of major figures appeared in *Lives of the Most Eminent British Painters, Sculptors and Architects* from 1829 to 1833. His version of *Pilkington's Dictionary of Painters* in 1840 bore a dedication to his friend David Wilkie, who had turned so often to older art as a source of renewed inspiration for his own style. Interestingly, Cunningham returned to the editions of the *Dictionary* before Fuseli, to whom he paid tribute but was not swayed by in his assessments, thereby making clear that he was editing Pilkington rather than Fuseli. In the entry on

Giorgione, for instance, Cunningham repeated virtually word for word Pilkington's assessment, adding merely one line at the end on locations of works. Fuseli's version he eschewed completely, which one can probably interpret as Cunningham rejecting Fuseli's less objective entry. But it is interesting to consider the implications of that earlier assessment of the 1760s presented anew to an audience of the 1840s. Giorgione was, at this time, far less well known because many of his authentic works had yet to be rediscovered.[72] Cunningham further provided a general history of modern painting and added new entries on recently deceased artists, such as William Hilton and Thomas Stothard. The *Dictionary* provided an appropriate commemorative resting-place for the reputations of esteemed artists of their day, with each edition adding new names to the canon.

The last editor to revise Pilkington's *Dictionary* was, like Cunningham, a professional writer, specialising in biography. In 1852 there appeared a new edition by Richard Alfred Davenport (1777–1852), commissioned by the publishers Tegg, correcting and revising the edition of 1840. It did not differ substantially from Cunningham's work, though Davenport added some new names, as did another edition of 1857 re-issued by the same publishers, but still with Davenport's preface dated 1851. This indeed proved to be the last edition of Pilkington's *Dictionary*.

Pilkington's work became the standard by which all other dictionaries of painters had to be judged. Well into the 19th century, and long after the man himself was forgotten, his *Dictionary* lived on, and, bizarrely, so did many of his actual phrases, some of which remained unchanged for upwards of 60 years. Although Pilkington had talents as a witty writer of style, these are not obvious in the restricted format of dictionary entries. His abilities as a writer served more as a way of freeing him from the ponderous language of some of his predecessors, allowing him to provide readable, brief biographies. His consummate achievement consisted in assembling a wide range of sources, drawing from them key data on artists of all major national schools and presenting the results in an accessible fashion. Once Pilkington had fixed his canon in print in 1770, all that remained for nearly 100 years was to edit, to add or to embellish.[73]

THE NEWBRIDGE DRAWING ROOM:
A PICTURE GALLERY FOR A GEORGIAN VILLA

Julius Bryant

In 1837 Samuel Lewis's *Topographical Dictionary of Ireland* described 'the extensive demesne of Charles Cobbe Esq' at Newbridge. The 'noble mansion' was said to contain 'several valuable paintings by the old masters, which were collected on the continent by the Rev M. Pilkington, author of the Dictionary of Painters, who was vicar of this parish; the drawing room contains several of the paintings described by him.'[1]

The Newbridge Drawing Room (fig.66) is the only example in Ireland to survive from the 18th century of a wing added to

Fig.66 The Drawing Room at Newbridge House, Co. Dublin

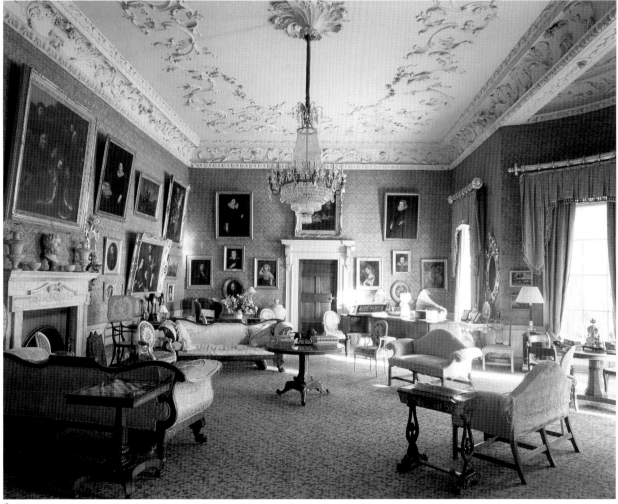

fig. 66

a house for the enjoyment of art. One of the best-preserved mid-Georgian interiors in the country, it provides a rare opportunity to study an Irish collection in its historic context. Most of the paintings that were collected in the 18th century by Thomas Cobbe (1733–1814; see cat.13) remain *in situ*, along

with the original Irish Georgian furniture, picture frames and the Regency curtains, carpet and Grecian Revival rosewood furniture. Compared to great Irish houses such as Castletown, Powerscourt, Russborough and Malahide Castle, it is remarkably intact. Florence Court in Northern Ireland has recently seen the return of many of its contents, including souvenirs from the 2nd Earl of Enniskillen's Grand Tour of 1792,[2] but Newbridge remains exceptional in not having been denuded of its contents and then refurnished. It can also

claim to be home to the best-documented 18th-century Irish collection outside the National Gallery in Dublin, where the Milltown collection from Russborough hangs today.[3]

The Dublin architect and engineer George Semple (1700–?1782) built Newbridge House (see figs 3 and 15) between 1747

and 1752 to the designs of James Gibbs (1682–1754) for Rev. Charles Cobbe (1686–1765), Archbishop of Dublin (see pp.27–36 and cat. 7).[4] Cobbe purchased the original estate in 1736 and became Archbishop of Dublin in 1743. Less than ten miles from Dublin, Newbridge served as a villa for the Archbishop whose principal palaces were in Cavan Street, Dublin, and at Tallaght, Co. Dublin. More than a working widower's rural retreat, Newbridge became the seat of his dynastic ambitions. In the years just prior to the Archbishop's death in 1765, he and his son and heir, Thomas Cobbe, added the large drawing room, 45 ft in length, adjoining the rear of the house. Here Thomas could entertain Dublin society with his fashionable aristocratic wife, Lady Betty Cobbe (1736–1806; see cats 9 and

aristocracy[6] have revealed them to be the primary homes of the greatest British collections of their day, but not one survives intact.[7]

Scholarship has also expanded the research resources by assembling images of interiors from more modest houses, recorded as the settings for 'conversation-piece' group portraits by Hogarth, Hayman, Devis and their contemporaries.[8] Unfortunately, these may be little more reliable than the painted backdrops employed by Victorian studio photographers, for there are few that relate to otherwise recorded or surviving rooms. More accurate are amateur watercolours, painted for pleasure in the 19th century to record domestic ambiences, but again the actual interiors

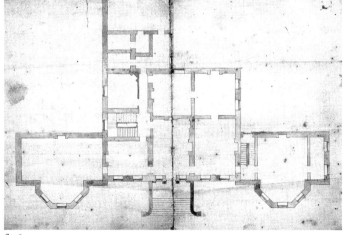

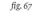

fig. 67

48), eighth and youngest daughter of the 1st Earl of Tyrone and sister of the 1st Marquess of Waterford (see cat. 46). The new room would also serve as a picture gallery for the collection they formed from the mid-1750s with the advice of the Archbishop's secretary, the Rev. Matthew Pilkington (1701–74). The Vicar of Donabate is better known as the author of the first dictionary of artists in English, *The Gentleman's and Connoisseur's Dictionary of Painters* of 1770 (see pp.52–62).

The history of the collecting and display of paintings in the Georgian era has traditionally been told in terms of great English houses, such as Houghton, Holkham, Corsham and Kedleston, and of collections formed in Italy on the Grand Tour.[5] However, few great country house collections remain undisturbed, because of sales, inheritance through marriage of other collections and the transfer of the finest paintings from families' London townhouses to their country seats. Recent studies of the London townhouses of the Georgian

are mostly lost. To advance the study of the collecting and display of paintings in Georgian Britain, further documented examples are needed.

An aspect of the collecting and display of paintings that has yet to be studied – and one that provides a more relevant context for the scale of Newbridge and the Cobbe collection – is the addition of wings to middle-size houses, particularly villas, to display collections of paintings, books and sculpture. The best-known example is Stourhead, which was given wings for a library and a picture gallery between 1794 and 1802. Half a century before Isaac Ware (1704–66) noted in his study *A Complete Body of Architecture* (1756): 'We see an addition of a great room now to almost every house of consequence This is an essential point in the practice of modern architecture. The builder sees every body wants a large room.'[9]

Ware was speaking from personal experience, as architect of Chesterfield House in Mayfair. On 31 March 1749 his client,

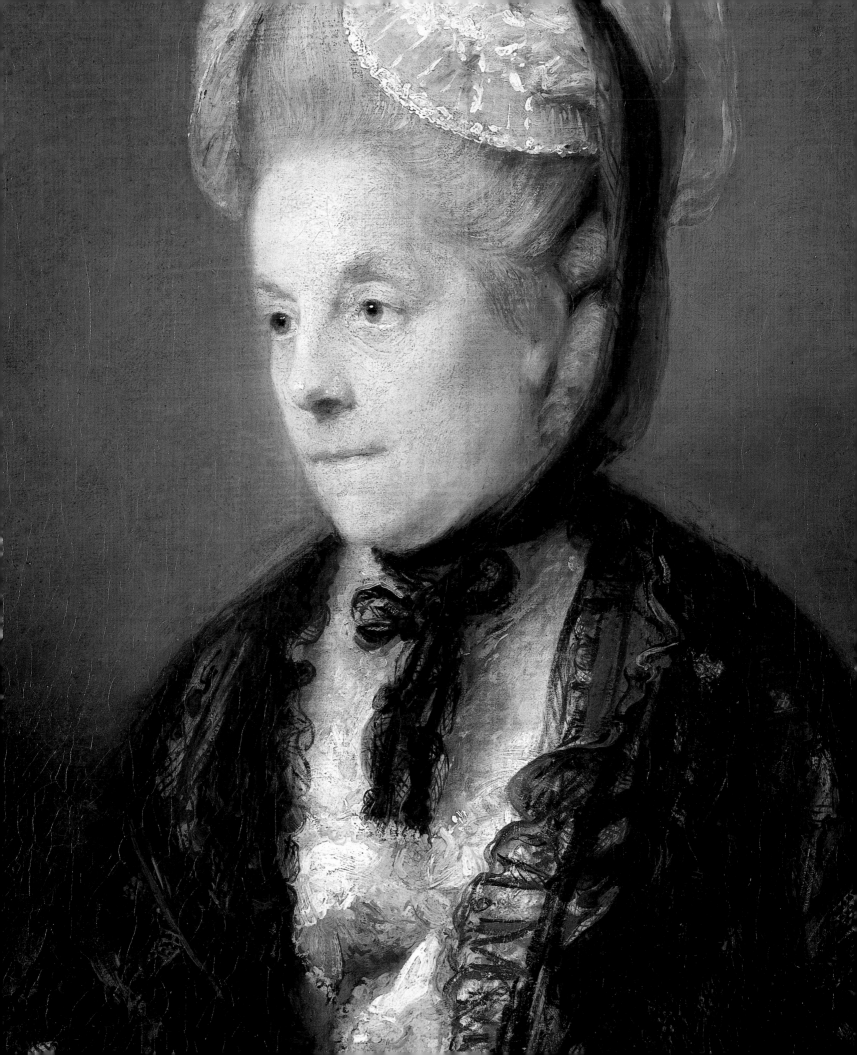

Fig.68 Drawing Room at Newbridge, photograph of *c.*1907, showing the Ruysdael (formerly Cobbe Collection, no.19) hanging at eye-level to the left of the chimneypiece; its pendant (in a matching frame) was the Strozzi (cat.38)

opposite page Detail of cat.47 (Thomas Hickey, *Portrait of Mrs Elizabeth Nind*)

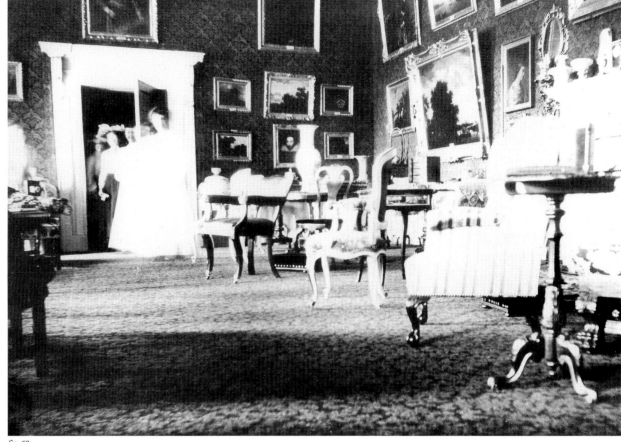

fig. 68

Philip Dormer Stanhope, 4th Earl of Chesterfield, wrote declining the offer of a painting by Teniers, 'both my picture-rooms being completely filled – the great one with the capital pictures, the cabinet with *bijoux*.'[10] The following year he completed the addition of a gallery, 77 ft long, at his villa at Blackheath, which he also filled with paintings.[11] The room survives and, like the Newbridge Drawing Room, is lit by a central window bay facing the chimneypiece. This purpose-built wing for Lord Chesterfield's villa provides maximum wall space for paintings, spreads light into the room diagonally from three directions, avoids dark piers (which would otherwise require pier-glasses) and removes the risk of hanging paintings opposite windows, and hence of reflections. Unlike Newbridge, Chesterfield's gallery also had the benefit of window bays at each end, to afford additional sidelight and the 'finest prospects' towards Greenwich and London.[12]

Even the most celebrated Georgian villa, Lord Burlington's Chiswick House in London, was built to replace a wing to his Jacobean ancestral home, two years after the west wing was destroyed by fire in 1725. Here he displayed his collection of paintings on the *piano nobile*, with his library in the rustic storey. Burlington's main gallery was top-lit and octagonal, like the celebrated tribuna in the Uffizi Gallery, Florence, to afford an even wash of light and to avoid dark corners. The reconstruction of Burlington's picture hang at Chiswick has revealed the main rooms of this wing to have been lined with paintings.[13] Three miles away stands Marble Hill House, the Anglo-Palladian villa built beside the Thames at Twickenham between 1724 and 1729 for Mrs Howard, mistress of King George II. Here the unique set of five *capricci* painted in Rome in 1738 by Giovanni Paolo Panini (1691–1765) was installed as architectural fittings (as an overmantel and four overdoors). A year later, in 1739, Mrs Howard had a two-storey cottage built alongside for her porcelain collection and library, which was linked to the house by the architect Matthew Brettingham (1699–1769) in 1750–51.[14]

Fig.69 Charles Frizzell, *A Map of Newbridge, Demesne of Thomas Cobbe Esq.*, pen and wash, 1776 (Cobbe Papers: Hugh Cobbe)

The library or 'Great Room' designed by Robert Adam (1728–92) and his brother James (1732–94) as an extension to Kenwood, near Highgate, between 1764 and 1767, has paintings fitted as part of the interior decoration, as in the 'Great Room' at Marble Hill. The Adam brothers' finest room was designed, according to Robert, 'both for a library and a room for receiving company'.[15] They confined the book collection of their patron, Lord Chief Justice Mansfield, to apse ends,

The creation of the Drawing Room and the evolution of the collection of paintings for Newbridge are well documented, chiefly through the house account books that survive, with one exception, for the years 1723 to 1900, with one exception.[16] A widower since the birth of his second son, Thomas, in 1733, Archbishop Cobbe completed the building of Newbridge in 1752. Two years before, his eldest son, Charles (1731–50), had died aged 20 at Montpellier in France *en route*

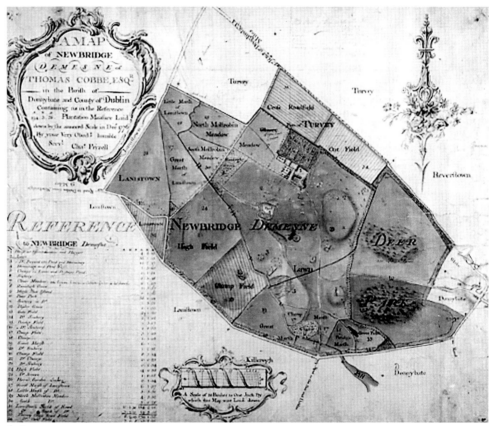

fig.69

leaving an ample mirrored saloon where company might gather beneath six specially commissioned paintings by Antonio Zucchi (1726–96).

As with the saloon at Chiswick and the 'Great Room' at Marble Hill, this decorative use of paintings as backdrop to receptions highlights, by contrast, the character of the Newbridge Drawing Room. Midway between the grandeur of a 'Great Room' or saloon and the intimacy of a collector's cabinet room, the Newbridge Drawing Room could serve as a more informal gallery for connoisseurs who enjoyed living with their pictures.

for a Grand Tour. Archbishop Cobbe arranged an advantageous marriage to Lady Betty for his surviving heir, then aged 22. Educated at Winchester, Trinity College, Dublin, and at Oxford, Thomas does not appear to have followed in his late brother's footsteps and visited the Continent; in the absence of a Grand Tour, he would have developed his eye as a connoisseur in the Dublin sale rooms,[17] with Pilkington ever ready to advise. If the Vicar of Donabate had failed to interest the Archbishop in collecting, he succeeded with his son.

Thomas Cobbe married in 1755. An undated plan at Newbridge (fig.67), probably from around 1762, reveals the

initial scheme by the Archbishop, his son and daughter-in-law, to flank the entrance with a pair of wings along the south front. The plan can be attributed to George Semple, builder of the house, as the central polygonal bay windows in each pavilion resemble his design for Headfort House, Co. Meath.[18] At that time, the site of the present drawing room was devoted to a pair of rooms, one with a lobby, the other with a more substantial waiting hall, which opened onto a walled yard and would have thus been offices. The earliest known plan of the wing as built, shown on a map of 1776 (fig.69), confirms the present location of service buildings to the north of the house, adjoining the five-acre walled garden.

The decision to settle for just one wing and to locate it behind the house suggests a cautious approach to expenditure. To the original Newbridge lands of 56 Irish acres (Irish acres being larger than English), 60 Irish acres of the village of Donabate had been added by 1763; the demesne extended to 194 acres by 1776. The more discrete location of the new wing also left the modest entrance façade unrivalled, preserved the view from the sitting room, and afforded the new drawing room a fine prospect across the lawn towards the deer park and Donabate. Furthermore, it provided the opportunity to rebuild the offices that are incorporated beyond the drawing room in the wing, with their own entrance from the service yard.

To preserve a homogeneity of style, Semple turned to James Gibbs's *Book of Architecture* (London, 1728) as a source of designs for chimneypieces and doorways (see figs 28–36). Within the new wing, the Drawing Room is introduced by an antechamber with niches for Classical sculpture, and is then entered through a pedimented Gibbsian doorway flanked by Corinthian columns (fig.33). As John Cornforth has noted, the large bow window may have been inspired by one in the saloon at Leinster House, Dublin, designed by Richard Castle. The first decorative scheme for the Drawing Room was probably completed in 1764 (the year before the Archbishop's death), since seven payments to 'Williams ye stucco man' totalling £21.3.1½ are recorded between 4 November 1763 and 3 November 1764, and quantities of extra porcelain ware were purchased in 1764, suggesting plans for entertaining.[19] The Rococo plasterwork ceiling is a sea of scrolling leaves and floral garlands encircled by dragons and birds fighting over baskets of fruit.

Richard Williams of Dublin also decorated the ceiling of the family pew in the gallery of the Protestant church at Donabate, on the edge of the Newbridge demesne (see fig.62).

Furniture was supplied in 1762 and 1763 by the Dublin cabinet-maker Christopher Hearn.

The one gap in the account book, covering the years 1765 to 1783, raises tantalising questions that may be answered some day only through archaeological investigation of the room. On 3 April 1783 payment of £33 is recorded to a 'Mr Sullivan, upholder', a role equivalent today to an interior decorator and supplier of curtains and hangings. On 12 May 1783 'Mr Dunne, paper man' (the Dublin paper stainer and housepainter James Dunn) was paid £18.11.6½. Thomas and Lady Betty also furnished their townhouse in Palace Row, Dublin, which Thomas built in 1768.

The sale of the Dublin townhouse in 1788 to meet their son's debts and their eldest daughter's marriage settlement may explain the arrival of the three pier-glasses by James Robinson of Caple Street, Dublin (see figs 9 and 10). Substantial activity was recorded in the accounts in 1791. This includes payments to 'Cranfield' for picture frames and, on 20 August 1791, a further payment of £11.4.0 'To Mr Dunn's papermen on gratuity for finishing the rooms well'. The crimson flock paper in the Drawing Room today is laid in squares (rather than in long sheets) and may date from this time.[20] On 9 July 1791 Mary Lowe, a metal sash-maker of Marlborough St, Dublin, was paid £20.17.8 for installing the present narrow metal glazing bars, presumably to give the room more light. Payment for the restoration of pictures is also recorded in 1791, and further frames were purchased from Cranfield in 1793. Much of the collection was reframed, using four mouldings: two for portraits (see p.78, types VIII and IX), a third type for classical landscapes (p.78, type VII) and specially carved and pierced frames for the subject paintings (figs 76–84). In the absence of any record of payments for paintings from 1783, this expenditure on frames between 1791 and 1793 suggests a rehang of the collection.

In the 1790s Thomas Cobbe's collecting interests expanded into the museum room that he established at Newbridge (see fig.2) with his daughter-in-law, Anne Cobbe (see fig.47), wife of his only son Charles, who died 1798 at the age of only 42. Consequent shortage of space was probably the main reason for Thomas's decision to sell his father's library in 1800, after concluding that none of his family was likely to live at Newbridge for many years. Ten years later he gave Newbridge to his newly married grandson Charles and remained in Bath (where he had also lived since 1786) until his death in 1814.

Grandson Charles (see fig.50 and cat.14) moved back to Newbridge from Bath with his new wife, Frances Conway;

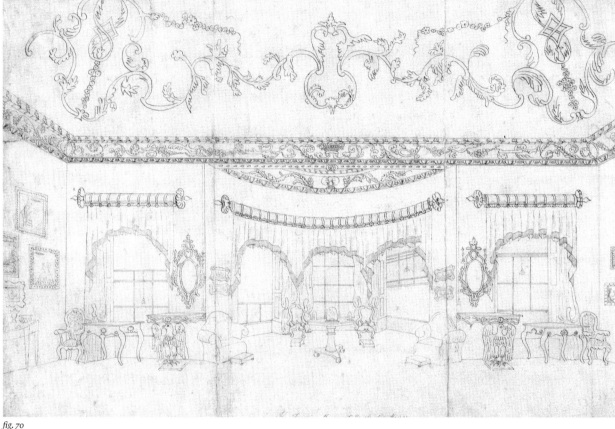

fig. 70

here they remained until she died in 1847 and his own death ten years later. Evidently, they reviewed the collection and found the house to be too damp. Payments are recorded in 1810 to give the Drawing Room a new grate, ten 'window buttons' and window stools. According to their daughter, Frances Power Cobbe (writing in 1868), some of the Newbridge paintings 'being injured by damp were cut up or destroyed and many were sold in 1812'[21] (two fragments of paintings survive in the collection: cat.41 and Cobbe Collection, no.116). About sixteen pictures were sold at auction in Dublin, and the following February, Charles and Frances invested in 'two bottles of varnish for pictures'. In the absence of any record of Thomas Cobbe's original hang of the collection, the extent to which it was denuded by this sale cannot be determined. The rejuvenation of the Drawing Room continued, for payments for furniture were made in 1821 to Woods & Son and to the most fashionable cabinetmakers and upholsterers in Regency Dublin, Mack, Williams & Gibton, who were also paid for curtains in 1828. Both their curtains and couches

survive today (with a labelled chess table), as does the carpet supplied on 25 March 1823 by Beck & Co. of Bath for £68.14s. A finishing touch was the Empire-style border to the wallpaper, for which payment was made in April 1829.

An inventory of Newbridge taken in 1821 records 102 paintings on the ground-floor, but does not identify them individually. There were 31 in the 'Large Drawing Room', 4 just outside in the inner hall, 17 alongside the stairs in the middle hall, 14 in the study and 36 in the sitting room (the former library). Surprisingly, there were none in the dining room or entrance hall, while the housekeeper was fortunate enough to have ten; there were even five more hanging in the nursery bedroom.

The earliest evidence of the arrangement of paintings in the drawing room is an outline drawing (fig.70), probably made by Charles Cobbe's wife, Frances, around 1840. She appears to have used the new *camera lucida* purchased that year (for £2.10, presumably after she found she needed to replace the one purchased in 1830 for £1.10). Only the east

sides of the end walls are included, but care has been taken to annotate each painting with its attribution. In 1868 their daughter, Frances Power Cobbe, completed the first catalogue of the collection. Her numbering system, found also on the printed card labels that she added to the pictures (see fig.75), continues to be used today (see Concordance). Together with study of the picture frames and Victorian photographs of the room (fig.68), this evidence has informed Alec Cobbe's diagrammatic reconstruction of the picture hang from 1868 (fig.71).

After the sale in 1812, the only losses were the Hobbema (cat.24) and Dughet (cat.40), which were sold in 1839 to fund some 80 estate workers' cottages (see pp.87–9). On 23 November 1839 Charles Cobbe noted in his diary: 'I have filled up the vacancies on my walls occasioned by the loss of the two pictures which have been sold, and I felt some satis-

The reconstruction of the hang illustrates how the paintings were grouped broadly by national school, balanced in a strongly symmetrical arrangement and spaced apart, unlike the closer frame-to-frame, dado-to-cornice displays favoured on the Continent. Unlike the often cited Cabinet Room at Felbrigg Hall, Norfolk, which was designed by James Paine in 1751 for a Grand Tour collection of landscapes, still *in situ*, at Newbridge the smaller landscapes are arranged along the lower tier for study, with historical portraits above. The taste of Thomas and Lady Betty Cobbe suggests the shopping list of their day, with mainly 17th- and 18th-century Dutch landscapes and interiors, as well as Italian subject paintings. Their accounts record only one quarter of the total number of pictures purchased, and the average price was less than £5 per picture. The main structure came from the pairing on the west wall of the Ruysdael with the Hobbema to left and right

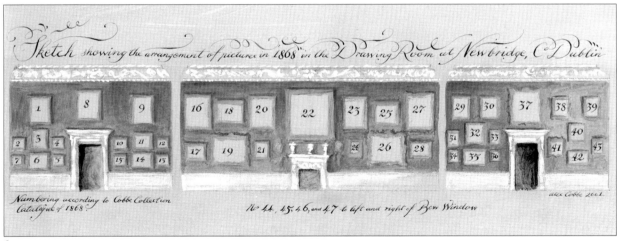

fig. 71

faction in thinking that my room (by the new arrangement) looks even more furnished than before.'[22]

The reference to the collection two years before in Lewis's *Topographical Dictionary of Ireland* (quoted at the beginning of this essay) confirms its recognised status in Ireland. Certainly, for half a century, beginning with the loan of the Ruysdael (Cobbe Collection, no.19) to the Dublin exhibition of 1847, the Cobbe family lent to nearly every major exhibition in Ireland. The fame of the collection would have been further enhanced by the publication of Frances Power Cobbe's memoirs in 1894. The paintings were in good hands, for when Walter Armstrong, Director of the National Gallery of Ireland, visited in 1896, he found only two works in the Drawing Room in need of restoration.

of the chimneypiece. The choice of the painting of *Fisherfolk Preparing the Catch on the Beach*, attributed to Jan de Bondt (*d*.1653; Cobbe Collection, no.22), for the overmantel seems a weak focal-point today and suggests either a substitution around 1812 for a damaged painting (possibly the Chiari copy after Guido Reni, of which cat.41 is a fragment) or the deliberate avoidance of a position where paintings inevitably suffer from heat.

The north end wall, facing the entrance, was devoted mainly to Italian biblical subjects, including *St John the Baptist* (cat.39) by Guercino; the *Madonna Annunciate* (cat.42) by Chiari; the *Holy Family* (Cobbe Collection, no.33) and *An Angel's Head* (cat.37), both then thought to be by Albani. Hung as overdoors were *An Alchemist* (Cobbe Collection, no.37) and the *Portrait of*

Oliver Cromwell by Robert Walker (Cobbe Collection, no.30). The latter had been inherited rather than purchased by Thomas Cobbe, whose family were Parliamentarians in the Civil War. The south wall was mainly taken up by Dutch landscapes, below the portraits considered to be by Rembrandt and Velázquez (cat.17). No family portraits hung in the room. The even quality of the paintings was consistently high, with only two copies, one of which was believed to be by Rubens's son.[23]

In brief, the Newbridge Drawing Room was conceived for the enjoyment of art, with original works of exceptional quality arranged for close study and comparison. Neither a grand saloon nor a cabinet, the Drawing Room with its mixed hang suggests that the optimum viewing of the finest works was valued over any strictly decorative or didactic arrangement. Unlike many picture galleries of Europe and many great English houses built in the 18th century, the paintings were not there primarily for show to impress from afar, interspersed with copies of popular masterpieces. They were to be enjoyed informally, along with the social pastimes appropriate to a drawing room, such as the art of conversation, cards, chess, backgammon, reading aloud and sewing, to judge from the furniture recorded in the 1821 inventory and still in the room today.[24] Initially the collection may have been appreciated while Lady Betty Cobbe played on her spinet, for she was a patron of Ferdinand Weber, the supplier of instruments, for thirty years from 1756 (see fig.72).[25]

Dr Gustav Waagen, Director of the Royal Gallery in Berlin, toured English art collections in 1835 and 1850. Had he visited Ireland, he would have noted in his subsequent publication, *Treasures of Art in Great Britain* (1854), several major collections that were to be dispersed in the 20th century. On a visit to Panshanger, however, he found the way in which the English chose to display their paintings to be worthy of note: 'The drawing-room, especially, is one of those apartments which not only give great pleasure by their size and elegance, but also afford the most elevated gratification to the mind by works of art of the noblest kind. … I cannot refrain from again praising the refined taste of the English for thus adorning the rooms they daily occupy, by which means they enjoy, from their youth upward, the silent and slow but sure influence of works of art.'[26]

Thomas and Lady Betty Cobbe's new wing, though to all intents and purposes a large picture gallery, was always termed a 'drawing room'. Writing in 1894, Frances Power Cobbe recalled how 'the drawing-room with its noble proportions and its fifty three pictures by Vandyke, Ruysdael, Guercino, Vandervelt and other masters, was the glory of the house. In it the happiest hours of my life were passed.'[27] Her fond memory of her childhood at Newbridge is the perfect illustration of Waagen's observation. More recently the Drawing Room and its paintings have had a formative influence on Alec Cobbe. His upbringing at Newbridge has inspired a career that has led to his advising on the rehanging and redecoration of interiors at Petworth (see fig.92), Burghley, Hatchlands, Goodwood, Harewood, Kenwood and elsewhere. Perhaps therein lies the most visible legacy of a drawing room in a wing attached to a Georgian villa, nearly ten miles from Dublin.

MUSICAL INSTRUMENTS
IN 18TH-CENTURY NEWBRIDGE
Alec Cobbe

Fig.72 Spinet (detail) by Ferdinand Weber of Dublin, third quarter of the 18th century (Hatchlands Park)

Fig.73 Yellow, 'Chinoiserie'-style Meissen teapot, porcelain, h. 4 in (10 cm), *c.*1740 (Cobbe Family Museum)

Archbishop Cobbe kept a musical household, helping to arrange the first performance of Handel's *Messiah* and later subscribing to William Boyce's oratorio *Solomon*. His children and stepchildren were brought up to have an interest in music. Lord Egmont observed that Sir John Rawdon's chief interests were music and painting, while the Archbishop's two sons were active subscribers to publications of music; Thomas, who may have played the violin, was a subscriber at the age of 12 to Boyce's trios. It was only fitting that Thomas's wife, Lady Betty Cobbe, should also have been encouraged to pursue an interest in music.

Ferdinand Weber, Dublin's leading maker of keyboard instruments and organs, a link that would last for nearly thirty years. A detailed record of the tuning and movement of her instruments between Newbridge and the townhouse in Dublin, preserved in a transcript of Weber's account book (now in the National Museum, Dublin), shows that she possessed two harpsichords, a spinet (fig.72) and, from 1774, a pianoforte, all almost certainly made by Weber.

Weber served his apprenticeship with one of the Dresden Court organ builders, Johann Hahnel, in Meissen, Saxony, from 1728 to 1735. By 1749 he was in Dublin. His few sur-

fig. 72

fig. 73

In May 1756, the Archbishop presented his young daughter-in-law with an account book. It would seem that, to adapt to the Cobbe family's interest in music, she had embarked on a series of harpsichord lessons very shortly after her marriage. One of the first entries in her book (10 May 1756) is a payment to Henry Walsh for 'seven months teaching on the harpsichord'. Years later, in 1765, Walsh rose to the position of organist of St Patrick's Cathedral, and in 1768 he gave Ireland's first recorded public performance on 'that much admired instrument, the pianoforte', one month before that of Johann Christian Bach in London.

Another early entry in Lady Betty's accounts (29 October 1756) is to Mr Weber for 'tuning etc, bringing the harpsichord to town'. This betokens the beginning of an association with

viving instruments retain somewhat more of a Germanic character than do those of his London contemporaries, Jacob Kirckman and Burkat Tschudi, also immigrants from the German tradition. His account book shows that he exploited his familiarity with the famous porcelain factory in his hometown and carried out a thriving secondary business of importing, via Leipzig and Rotterdam, a wide variety of porcelain wares. Around 1774 he sold a 43-piece coffee service, 'Gold edge, purple flowers', to Lady Betty's brother, the Earl of Tyrone, later 1st Marquess of Waterford. A charming yellow Meissen, 'Chinoiserie' tea service surviving at Newbridge must also have been supplied by Weber (fig.73).

THE FRAMING AND RESTORATION
OF THE HISTORIC COBBE COLLECTION

Alec Cobbe

The Historic Cobbe Collection is served by reasonable records contained in the family papers. They are not as complete as might be wished; payments and payees are recorded, for instance, but few bills survive. There is, furthermore, a gap of 18 years in the accounts during the second half of the 18th century (April 1765 to April 1783). Thomas Cobbe's accounts are also somewhat erratic and probably record only a proportion of the total activity of acquisition, framing and repair.

It is clear, however, from the records that have been preserved that the framing and restoration of the collection were placed in the hands of Dublin's leading specialists in these fields, Richard Cranfield (1731–1809) and James Chapman (*d*.1792) respectively. Further information is provided by the trade labels of Cornelius Callaghan, which survive on both 18th- and 19th-century frames (fig.74.1 and 74.2). Another framer involved with the collection in the Regency period was Joshua Kearney, who also carved the curtain poles in the Drawing Room in 1828. A possible candidate for further work would be Gervas Murray, who in 1841 carved the eagle console-tables in the Drawing Room (see fig.9) and whose trade label also survives among the Cobbe Papers (fig.74.3).

FRAMING

The earliest reference to a frame in the Cobbe Papers is in the handwriting of Thomas Cobbe's mother, Dorothea, and relates to the portrait of her father, Sir Richard Levinge, commissioned in 1723 (Cobbe Collection, no.100), for which the payment of £6.18s to the little-known artist Ralph Holland is recorded on 8 April 1724. Two days later 'his man' was paid £2.17s.6d for the frame, which survives with the picture today.[1] A number of further pictures seem to have retained the frames, of various dates, in which they were acquired, though these are the exceptions.

Most of the pictures in the collection have gilt frames of the later 18th century, which were specially commissioned by Thomas and Lady Betty Cobbe and which lend coherence to the collection as a whole. These fall into two categories. Firstly, there are livery frames, of varying complexity, which occur either on whole series of pictures or on only a few examples. Of these, there are ten models (see p.77). Secondly, there are Rococo carved frames of individual design for what presumably were considered to be the finest pictures. In the case of the pair of village scenes by Barent Gael (cats 21–2), the frames were carved to match (figs 76–7). The earlier trade label of Cornelius Callaghan, 31 Brittain St, Dublin, is dated 1784. The same firm was patronised by Thomas Cobbe's grandson Charles, sometime after 1810 for the more important new frames introduced into the Drawing Room. This kind of trade loyalty, stretching over different generations, is apparent in many of the areas covered by the Newbridge accounts. Thus payments to Richard Cranfield for sconces in 1759 and for picture frames in 1791 and 1793 suggest that he was responsible for the more elaborate carved and gilt picture frames, which were possibly commissioned during the 18 years not covered by the account books. Comparison of the Newbridge frames with those carved by Richard Cranfield for Trinity College, Dublin, in the Provost's House and the Public Theatre, reveals stylistic similarities.[2]

The grandest frame from the 18th century to survive on a Newbridge picture was that on the Gaspard Dughet (cat.40), sold in 1839, but still on the picture in 1990 (see p.88).[3] It is likely that the Hobbema landscape, now in the National Gallery of Art, Washington, DC (cat.24), was once framed similarly. Other very fine frames survive on the copy of Rubens's *Descent from the Cross* (fig.78) and on the Dutch interior scene by Johannes Voorhout (cat.26; fig.84), which were hung as

fig. 74.1

fig. 74.2

fig. 74.3

fig. 74.4

Fig. 74.3 Trade label of Murray, 2 Duke St, Dublin, presumably Gervas Murray, looking-glass manufactory, listed in 1836 at 55 Great Britain St, Dublin

Fig. 74.4 Trade label of Del Vecchio, Dublin, *c.*1830

Fig. 75 Frame labels reflecting the numbering of Frances Power Dobbe's 1868 catalogue

pendants in the 1868 scheme (see fig. 71). The frame (fig. 79) on the *Head of an Angel* by Albani (cat. 37) compares closely with that on the 17th-century Italian School painting of *Anacreon Repelling Minerva* in the Provost's House, Trinity College, Dublin, though both the Newbridge picture and its frame have been cut down, probably in 1812.

Other payments in connection with picture frames are to Mrs Beatty, possibly the wife or widow of Richard Beatty of 24 Henry St, Dublin. There are rare instances of composition frames also dating from the 18th century, such as that (fig. 80) on Balthazar Beschey's *St Hilary and St Francis in a Cave* (cat. 36), where its purchase note of 1764 is inscribed in Thomas Cobbe's handwriting on the reverse of the frame. Composition frames from the 18th century (fig. 81) also appeared on the set of four landscapes by George Barret (Cobbe Collection, nos 52–5).

The inheritance of the house by Charles Cobbe in 1810 saw a new, but modest, campaign of reframing. Some pictures and their frames were cut down, but others were reframed completely. Three of these (cats 38 [Follower of Strozzi] and 39 [Studio of Guercino] and Cobbe Collection, no. 37 [Pseudo-Roestraten]) bear the label of Cornelius Callaghan of no. 24, Clare St, Dublin, a firm used, as has been seen, by Charles's grandfather. Photographs show that the frame of the painting by Salomon van Ruysdael (see fig. 68) that was sold in 1913 (Cobbe Collection, no. 19) was identical to the Callaghan

frame of the picture by a follower of Strozzi (fig. 82). Although there is an account entry for Callaghan in respect of a looking-glass in 1841, no payments to the firm for these frames has yet been identified. It is possible that they were included as part of a larger furnishing payment to another firm. The enclosure of the livery frame (type I) on the beach scene attributed to Jan de Bondt (Cobbe Collection, no. 22) may well have been carried out by the carver and gilder Joshua Kearney (fig. 83), who was paid £16.11s.9d for a single picture frame in February 1819. All these Regency frames were produced in wood with composition ornaments (figs 79–80). The original maple frame on a watercolour *Portrait of an Unknown Sitter* of *c.*1830 (Cobbe Collection, no. 187) bears the label of Del Vecchio, a Dublin supplier of fancy goods (fig. 74.4).

LABELS AND BOOKPLATES ON FRAMES

Evidence for the earliest numbering system for the collection exists in the form of labels affixed to the backs of a few of the pictures or frames. Apparently written in the hand of Frances Cobbe (*née* Conway), these must reflect an early 19th-century inventory, presumably made sometime after her husband Charles's succession to the estate in 1810. The inventory itself is not extant, but the surviving number, where known, is referred to in the exhibition and summary catalogue entries as 'early 19th-century inventory, no. – '.

In 1868 the collection was recatalogued by Frances Conway Cobbe's daughter, Frances Power Cobbe, and a new numbering system was applied to the pictures. At this time, buff-coloured printed card labels were affixed by small pins to the bottom members of the frames. These have been preserved (fig. 75), and a replacement system of gilt cartouches is in the process of being introduced, since the 1868 numbering

fig. 75

Fig.76 Specially carved
Rococo frame on cat.21

system is still in use today (with the sequence of numbers being continued for recent acquisitions).

Of the eight types of Cobbe family bookplates found in use in the Newbridge library, three appear historically on the backs of pictures in the collection (nos 1, 2 and 4 below):

1. The Rococo bookplate of Thomas Cobbe (1733–1814)
2. Same bookplate, with 'Thos' altered to 'Chas' (1781–1857)
3. Newly designed classical bookplate of Charles Cobbe (1781–1857), with swags of husks
4. Bookplate of Charles Cobbe (1781–1857), similar to (2), but without the swags and with the pelican and coronet moved down
5. Another newly designed bookplate of Charles Cobbe (1781–1857), with the shield at an angle, set within drapery
6. Bookplate of Louisa Caroline Cobbe (1813–82)
7. Bookplate of Frances Power Cobbe (1822–1904)
8. Bookplate of Alec Cobbe (b.1945), the same as (1) and (2)

PICTURE RESTORATION AT NEWBRIDGE

Restoration of items in the collection began shortly after the very first picture purchases in 1756, when £1.14s.½d was paid for 'mending a picture'. In 1762 the larger sum of £7.5s.2d was paid to James Chapman for his bill for 'cleaning pictures'. The detailed Chapman accounts surviving in Trinity College,

Dublin, dating from 1766, show prices for cleaning a single picture varying between 6s.6d, 11s.4d, 13s, £1.2s.9d and £1.9s.3d. The Cobbe accounts for 1764 record a further £5.1s.10d paid 'for cleaning Mr. Rawdon's pictures'; the payee is unrecorded but is likely to have again been James Chapman.

As Prof. Anne Crookshank has noted, picture restoration prices in Dublin rose significantly in the 19th century. Michael Gernon, the restorer employed by Charles Cobbe to put the collection in order during the first quarter of the 19th century, charged £15.7s.6d for 'repairs to 5 Pictures & Frames' in April 1822. Charles Cobbe took a responsible view on conservation matters. He refused, on occasion, to lend pictures to the Royal Irish Institution on account of a report that the rooms were damp,[4] and he was not best pleased when a large *Raising of Lazarus*, which he had given to Swords Church, suffered a catastrophic rubbing-over at the hands of the vicar, Mr French, who used a mixture of onion and salt, after which the painting had to be sent to Dublin, presumably to Mr Gernon, to be rectified and returned in September 1823.

Gernon was a key figure in the 1839 sale of the paintings by Hobbema and Dughet, for which he acted as intermediary, presumably on commission, between the dealer Thomas Brown and owner Charles Cobbe. His trade stamp survives on the reverse of the stretcher and frame of Gainsborough's *Portrait of Mrs Townley Balfour* (cat.97).[5]

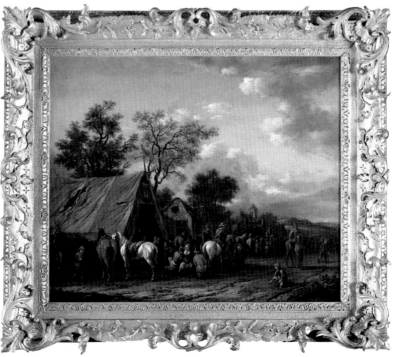

fig.76

Fig. 77 One of two matching frames on cats 21–2 (Gael)

Fig. 78 Frame of a copy after Rubens's *Descent from the Cross* (Cobbe Collection, no.27)

Fig. 79 Frame on cat.37 (Follower of Albani)

Fig .80 Frame on cat.36 (Beschey)

Fig.81 Frame of one of the series of four landscapes by George Barret (private collection)

Fig.82 Frame by Cornelis Callaghan on cat.38 (Venetian follower of Strozzi)

Fig.83 Frame on the *Scene of Fisherfolk Preparing the Catch on a Beach*, attributed to Jan de Bondt (Cobbe Collection, no.22)

fig. 77

fig. 78

fig.79

fig.80

fig.81

fig.82

fig.83

Type I

Type II

Type III

Type IV

Type V

Type VI

Type VII

Type VIII

Type IX

Type X

TABLE OF FRAME TYPES

Type I This model appears to be from the early 18th century and occurs on the market piece by a follower of Beuckelaer (cat.35) and the beach scene attributed to Jan de Bondt (fig.83), though the latter was later enclosed with additional mouldings. It may be that the two pictures were acquired from the same earlier collection of which this livery frame was a feature.

Type II shouldered and unshouldered 'egg and dart' outer moulding, with sanded flats and gadrooned inner edges, and with rosettes at the corners. This model, which is typical of many Irish collections, occurs on portraits of the 1740s and 1750s, for instance on the *Portrait of the Rev. Richard Chaloner Cobbe* by John Lewis (Cobbe Collection, no.109).

Type III a wide plain moulding with an inner edge decorated with running husks. This frame occurs on many of the early and mid-18th-century three-quarter-length portraits, an example being that of *Dorothea, Lady Rawdon* (Cobbe Collection, no.97). On a number of these, the plainer parts of the gilt moulding were overpainted in black, as in the *Portrait of Charles Cobbe, Archbishop of Dublin* (cat.7). This was probably done after 1868, at the time that five, so treated, were hung in the Dining Room.

Type IV very similar to type III, but with a different inner moulding consisting of shells and acanthus leaves. It occurs on only two pictures, the *Portrait of Sir Kenelm Digby* after Anthony van Dyck (Cobbe Collection, no.9) and the Newbridge studio version of the *Portrait of Mary, Lady Levinge* (Cobbe Collection, no.98), where the outer mouldings are painted black.

Type V a simple running moulding. It was applied to small pictures, including a landscape by George Barret (cat.11), two boor scenes by Egbert van Heemskerck and two landscapes on copper, formerly attributed to Ruisdael (Cobbe Collection, nos 48 and 50).

Type VI a narrow gadroon-edged running moulding. This frame occurs on a *View of Leiden* attributed to the Monogrammist WD (Cobbe Collection, no.67(ii)). Although only one example survives, the model would doubtless have also been used on the now frameless pendant to this picture (Cobbe Collection, no.67(i)), and possibly elsewhere.

Type VII an ornamental 'egg and dart' running moulding. This model occurs on medium-sized cabinet pictures, exclusively landscapes of the Dutch school, for instance those by Decker (cat.16) and Molenaer (cat.20). Exceptionally, it also occurs, with mouldings scaled up, on one larger picture, the *Vegetable Market in Trajan's Forum* by Mommers (cat.18).

Type VIII a gadroon-edged running moulding. Apart from its occurrence on landscapes by Abraham Begeyn (cat.23), Rosa da Tivoli (Cobbe Collection, no.17) and a follower of Berchem (Cobbe Collection, no.63), this model is found on commissioned portraits of the 1750s and 1760s.

Type IX There are only three examples of this frame, occurring on two 17th-century Dutch portraits from the circle of Ravesteyn (Cobbe Collection, nos 112 and 113) and on an anonymous early 18th-century *Portrait of Lord William Paulet* (Cobbe Collection, no.117).

Type X Although it survives in only one example, the *View of a Mediterranean Port*, attributed to Alessandro Grevenbroeck (Cobbe Collection, no.7), it has the appearance of a livery frame type.

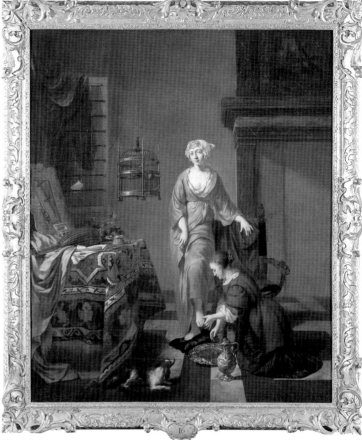

fig.84

Fig.84 Carved and gilt Rococo frame on cat.26

'THROUGH ANCESTRAL PATTERNS DANCE':
THE IRISH PORTRAITS AT NEWBRIDGE HOUSE
William Laffan

Cat.7. James Stewart,
*Portrait of Charles Cobbe, later
Archbishop of Dublin*

'*Amid great chambers and long galleries lined
With famous portraits of our ancestors*'
William Butler Yeats[1]

Repeatedly in his poetry, William Butler Yeats turned to the motif of the ancestral as part of his exploration of the faded glory of Anglo-Irish life. Considering the portraits (mostly of his friends) in *The Municipal Gallery Revisited*, he explored the nature of portraiture, its commemorative function, its exemplary power and, perhaps above all, the limits of what it can represent. These are themes that have been taken up by recent scholarship on the meaning, and indeed the efficacy, of portraiture. Part of the difficulty of reconstructing the context in which portraits were commissioned, and of determining how they were viewed, is the lack of literary record, combined with the sheer complexity of feeling attendant upon the 'taking of a likeness'. The group of portraits at Newbridge House, of the interrelated families of the Cobbes, Rawdons and Beresfords, is one of the few such collections to remain almost intact. In it, we can follow the different strands of descent and civility that are intrinsic to the family's growth and consolidation. At the same time, the survival of occasional references in the family account books to payments to artists gives an extremely rare chance to support with documentary evidence the connoisseurship that has largely predominated in the study of Irish art of the period.

Significant, from the viewpoint of the Cobbe family's history in Ireland, are three portraits: those of Archbishop Cobbe (cat.7) and his patron and presumed godfather, Charles Paulet, the 2nd Duke of Bolton (cat.44), and that of Major-General Thomas Fairfax (cat.1). Cobbe accompanied the 2nd Duke of Bolton to Dublin in 1717, after the latter's appointment as Lord-Lieutenant of Ireland, to serve as his chaplain. The family's Irish connections, however, go back to the late 17th century, when Fairfax, who was (doubly) the Archbishop's first cousin once removed, was Governor of Londonderry (1680–89) and later of Limerick (1703–12). He died in Dublin in 1712, just five years before Charles Cobbe's arrival there. His portrait, acquired for Newbridge in recent years, was probably painted in Ireland during the 1680s.[2]

Charles Cobbe is portrayed as Bishop of Kildare and Dean of Christchurch in a work by James Stewart (*fl. c*.1750), an artist about whom almost nothing is known.[3] Cobbe is shown in characteristically modest fashion, wearing white rochet and black chimere. The image ultimately derives from the tradition of ecclesiastical portraiture established in the

Low Countries in the 17th century and, perhaps more specifically, from George Vertue's engravings of famous 17th-century Protestant bishops produced from the 1720s to 1740s, a print series that enjoyed wide circulation. The portrait displays the reticence and lack of frivolity so central to the reformed church's self-image. Compared, for example, with Hogarth's slightly later *Portrait of Thomas Herring, Archbishop of York* (Tate Gallery, London), there is no spark of character or individuality. A *terminus post quem* for the *Portrait of Bishop Cobbe* is provided by the painted coat of arms of Kildare, the see to which Cobbe was raised in 1734 and from which he was translated to Dublin in 1743. Indeed, perhaps to commemorate his enthronement as Archbishop (the pinnacle

cat.7

of his career), Cobbe was painted again, and this second portrait, attributed to Francis Bindon (*c*.1700–1765), is also at Newbridge (Cobbe Collection, no.111). Bindon, the son of the MP for Ennis and an Irish pupil at the academy of Sir Godfrey Kneller (1646–1723), was an architect as well as a painter and made something of a speciality of painting leading members of the established church. As well as painting Jonathan Swift, Dean of St Patrick's Cathedral, on numerous occasions, he painted portraits of Cobbe's colleagues, Hugh Boulter, Archbishop of Armagh (Cobbe Collection, no.82), and Archbishop King, Cobbe's predecessor but one in the See of Dublin. Bindon's portrait of Cobbe was engraved in

Cat.1 Irish School, *Portrait of Major-General Thomas Fairfax*

Cat.44 English School, *Portrait of Charles Paulet, 2nd Duke of Bolton*

cat.1

cat.44

mezzotint by Andrew Miller (*c.*1700–1763) in 1746 (see fig.16), perhaps as a move to win support for his candidacy for the See of Armagh after the death of Dr John Hoadly in that year.[4]

The portraits of the Duke of Bolton and the Archbishop stand slightly apart from the rest of the collection. Portraiture can be seen here as being used to confer legitimacy on the family. Between 1716 and 1724, years that included Bolton's Lord-Lieutenancy, half of the appointments to Bishoprics in Ireland went to Englishmen – and with them vast wealth and power. This practice, to which Archbishop King took great exception, was famously attacked by Swift who noted that: 'Excellent and moral men had been selected upon every occasion of vacancy. But it unfortunately has uniformly happened that as these worthy divines crossed Hounslow Heath on their road to Ireland, to take possession of their bishoprics, they have been regularly robbed and murdered by the highwaymen frequenting that common, who seize upon their robes and patents, come over to Ireland and are consecrated bishops in their stead.'[5] While no such criticism could be levelled at Cobbe, it is certainly true that as an Englishman holding high office in Ireland, he must have been highly aware of the importance of appearance and decorum. In Swift's *A Tale of a Tub* (1704), his satire on corruption in religion and learning published a decade before he became Dean of St Patrick's, the issue of clothing is central, and Stewart's sober portrayal of Archbishop Cobbe as the epitome of everything an Anglican cleric should be can be seen as making a statement as to the legitimacy of his office and,

indeed, as to his suitability for promotion. The implicit claim to Bolton, the Lord-Lieutenant, as a close family friend, gives the family a link with Dublin Castle, the locus of English rule in Ireland. The portraits of the Duke and the Archbishop, showing the sitters as personifications of respectively temporal and spiritual authority, can be construed as founding portraits of the two men who were responsible for the fortunes of the Cobbes in Ireland and who created the necessary wealth for the series of intermarriages and the dynastic ambitions of the following generations.

In contrast to these founding images, the remainder of the portraits seem to show their sitters first and foremost as members of the extended family. Through portraiture, marriages were commemorated and likenesses recorded for posterity. The earliest reference in the Newbridge account books to a family portrait is dated 8 April 1723. It is in the hand of the Archbishop's wife, Dorothea, and notes: 'To Mr Holland for my father's picture 6-18-0, to his man for the frame 2-17-6'. This work, still at Newbridge, portrays the Archbishop's father-in-law Sir Richard Levinge, Lord Chief Justice of Ireland (Cobbe Collection, no.100). Little is known of the artist Ralph Holland (*fl.* early 18th century), although, interestingly, like Bindon, he also seems to have painted Archbishop King (Trinity College, Dublin), and shortly after the reference in the Newbridge account books, he is referred to in King's correspondence with Francis Annesley.[6] At the same time that she ordered the portrait of her father from Holland, Dorothea may have commissioned the artist to

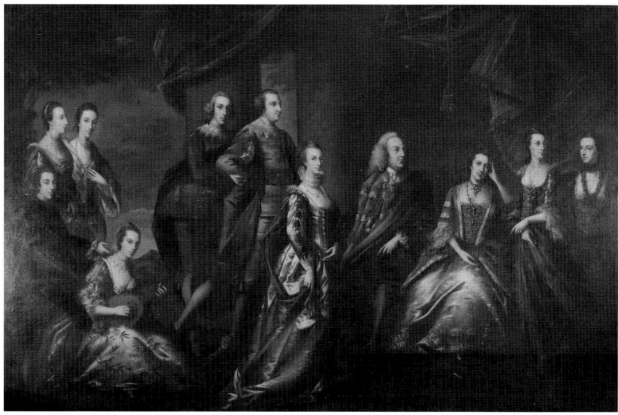

fig. 85

paint the *Portrait of Mary Levinge, Countess Ferrers* (cat.2), a representation of her sister, which is probably a secondary version of another portrait.

The largest group of the family portraits at Newbridge charts the generation after the Archbishop. His wife, Dorothea, had previously married Sir John Rawdon, by whom she had two children: John, later the 1st Earl of Moira (see cat.3), and Arthur. On 3 December 1725 Dorothea recorded a further payment of the unusually high sum of £23.15s for 'my sons pictures to Mr Verney'.[7] A painting of John and Arthur Rawdon as children is recorded in the 1868 catalogue (no.89), but was sold about 1960. Alec Cobbe recalls it as a large work showing the children in the costumes of Roman centurions. The Rawdon children grew up with their stepfather and guardian, Archbishop Cobbe, and were close friends with their stepbrothers, Charles and Thomas Cobbe, from Dorothea's marriage to the Archbishop (who managed the Rawdon estates during their minority). Both John Rawdon and Thomas Cobbe (see cat.13) were keen collectors, and the account books record the exchange of pictures

between the two. The works portraying their wives, in-laws and friends chart the history of Irish painting from the late Baroque of James Latham (1696–1747) to the refined Neo-classicism of Hugh Douglas Hamilton (*c*.1736/40–1808).

The Archbishop's stepson Sir John Rawdon married first Lady Helena Percival, the daughter of Lord Egmont (see fig.18), whose diary gives a vivid account of the wedding in 1741.[8] The fine *Portrait of Lady Helena Rawdon* by James Latham (cat.4) is likely to commemorate the event and can be dated to some time between the autumn of 1742 and the spring of the following year, when the newly married couple were in Ireland. It may have been hung with Sir John's portrait (cat.3), which was executed a few years earlier in Italy by Charles Martin (*fl*.1728–52). The Latham portrait was wrongly described in the 1868 catalogue as showing *Isabella, Lady Levinge*, but the correct identification as a depiction of Lady Helena is supplied by the inscription on a mezzotint after it by John Brooks (*c*.1710–after 1756). As Friedman and Cobbe have noted elsewhere in this catalogue (pp.28–9), the marriage of the Archbishop's stepson and ward to Lady

Helena may have been a key moment in the architectural history of Newbridge, with her father, Lord Egmont, bringing the architect James Gibbs (1682–1754) to the attention of his new in-laws.

The *Portrait of Lady Helena Rawdon* is a typical half-length by Latham, bold in conception, but executed, particularly in details such as the pearl earrings, with a refined delicacy. Latham was the leading Irish portrait painter of the first half of the 18th century. He was born in Tipperary in 1696 and may have studied with Garret Morphey (1680–1715/16). He is recorded as a member of the Antwerp guild of painters between September 1724 and September 1725, immediately after which date it seems he was in Dublin. Although a visit to London is highly probable, there is no documentary evidence for it. The great majority of his portraits can be dated to the last 15 years of his life. A further work in the collection, which is close to the style of Latham and may very well be by him or a close follower, shows the Archbishop's close friend Samuel Hutchinson, Bishop of Killala (cat.5).

Lady Helena died young in 1746, and six years later John Rawdon, who became the 1st Earl of Moira in 1762, married Lady Elizabeth Hastings, daughter of the 9th Earl of Huntington. His second wife is the subject of a fine portrait with a favourite dog (cat.6) by John Lewis (fl.1740–57). Again, this may well be an engagement or marriage portrait: it is signed and dated in the 1750s, but the last digit of the date is illegible. Interestingly, the artist had connections with the family of John Rawdon's previous wife, having been a tenant of Lord Egmont.[9] Lewis is one of the most interesting figures in mid-18th-century Irish painting. For most of the 1750s he was Thomas Sheridan's scene painter at the Smock Alley Theatre in Dublin, where his innovative designs were acclaimed. Like most scene painters, he was also an accomplished landscape artist. Perhaps executed when the Dublin theatre was not in season, the portrait shows Lady Elizabeth with an alert gaze that adds a sense of movement to the somewhat wooden pose. While the features are somewhat primitive, the dress is nicely realised in creamy impasto. Lewis often painted more than one member of the same family, and two further works of his survive at Newbridge. Dating from 1755, they show the *Rev. Richard Chaloner Cobbe* and his wife, *Mary Cobbe, née Godolphin* (Cobbe Collection, nos 96 and 102). When the portraits were painted, Chaloner Cobbe, the nephew of the Archbishop, was a Prebendary of St Patrick's Cathedral. The invitation to paint Lady Elizabeth would have been a prestigious commission for Lewis, as most of his

sitters were of more humble mercantile origin or members of the Dublin theatrical world.

It seems reasonable to assume that the Archbishop commissioned the portraits of his ward's wives, Lady Helena and Lady Elizabeth, and of his clerical nephew, Richard Chaloner Cobbe. The style of these portraits by Latham and Lewis would, by the middle of the century, have been seen as rather old-fashioned. A lighter, more modern touch is apparent in a group of works depicting the Archbishop's daughter-in-law,

fig. 86

Lady Elizabeth ('Betty') Cobbe, and her Beresford family relatives. Five years after Sir John Rawdon married Lady Elizabeth Hastings, his half-brother Thomas Cobbe, son of the Archbishop, married Lady Betty, and it is tempting to see her taste behind many of the works commissioned of her family. Elizabeth was the daughter of Marcus Beresford, 1st Earl of Tyrone, and she is shown standing next to her parents in the group *Portrait of the Tyrone Family* by John Astley (1724–87), now at Curraghmore (fig.85). Astley also produced for Newbridge a separate half-length version of Lady Betty, derived from (or, perhaps, preparatory to) the Curraghmore portrait (cat.9). Among the more colourful artists to have worked in Ireland in the middle years of the century, John

fig. 87

fig. 88

Fig.87 Hugh Douglas Hamilton, *Portrait of the Hon. and Rev. William Beresford, 1st Baron Decies (1743–1819)*, watercolour and pastel, oval: 9 × 7¼ in (23 × 18.5 cm), before 1764 (Cobbe Collection, no.153)

Fig.88 Hugh Douglas Hamilton, *Portrait of Elizabeth Fitzgibbon, Lady Decies (d.1807)*, watercolour and pastel, oval: 9 × 7 ¼ in (23 × 18.5 cm), before 1764 (Cobbe Collection, no.154)

Astley studied under Thomas Hudson (1701–79), at the same time as Joshua Reynolds (1723–92), before travelling to Italy between 1748 and 1752. He was in Ireland for about three years after 1756, producing both half-lengths and large group portraits, such as the Curraghmore picture and a *Portrait of the Molyneux Family*, which is dated 1758 (Ulster Museum). The following year, Astley returned to England. The Curraghmore group portrait – and hence the Newbridge version of Lady Betty – dates from shortly after her marriage. In the smaller work, particularly, are apparent the 'bright flickery highlights which enliven his work and make his embroidery vibrate'.[10]

Anthony Pasquin gives an amusing account of Astley's character. 'He thought that every advantage in civil society was compounded in women and wine: and, acting up to this principal of bliss, he gave his body to Euphrosyne and his intellects to madness. He was as ostentatious as the peacock and as amorous as the Persian Sophi; he would never stir abroad without his bag and his sword; and when the beauties of Ierne sat to him for their portraits he would affect to neglect the necessary implements of his art and use his naked sword as a moll-stick.'[11] During his time in Ireland, he reput-

edly earned the vast sum of £3,000. The attribution of one other portrait in the collection, previously given only tentatively to Astley, can now be confirmed. It shows *Rev. Sir Philip Hoby, Bt* (cat.8), the chaplain to Archbishop Cobbe, and bears close similarities to Astley's *Portrait of a Gentleman*, signed and dated 1753, formerly on the London art market.[12]

One of the features of the family portraits at Newbridge is the group's emphasis on Lady Betty's Beresford relations. Portraits of three of her siblings shown in Astley's group portrait survive in the collection. Her eldest brother, the 2nd Earl of Tyrone and later, was painted by John Zoffany (1733–1810) around 1780 (cat.46), before his elevation in 1789 as 1st Marquess of Waterford, while the Irish artist Robert Hunter (*fl.*1750–1803) portrayed her brother John Beresford (cat.10). Hunter was perhaps the most successful portrait painter working in Ireland in the second half of the 18th century. It is likely that he was born in Ulster and studied under Justin Pope (*fl.*1743; *d.*1771). Initially influenced by Stephen Slaughter (1697–1765), he developed a mature style that is a somewhat provincial reflection of Reynolds, many of whose poses he borrowed. Among his sitters were his friend Samuel Madden, founder of the Royal Dublin Society (Trinity

College, Dublin), Tom Conolly of Castletown (private collection), and the 2nd and 3rd Viscounts Powerscourt. The Cobbe and Powerscourt estates marched together in the Dublin Mountains, and, as a latter-day reflection of the friendship that existed between the two families in the 18th century, Hunter's unusually monumental double *Portrait of Lady Powerscourt (2nd Wife of the 1st Viscount) and her Daughter* (fig.86) was acquired for Newbridge following the Powerscourt sale in 1984. In 1765 Hunter painted the *Portrait of John Wesley*, the founder of the Methodist church, who was then on a visit to Dublin (Wesley Chapel, City Road, London). Perhaps Hunter's finest work is the *Portrait of a Gentleman of the La Touche Family* (National Gallery of Ireland, Dublin), which shows an informal elegance and displays the artist's ability as a landscape painter. After about 1785, Hunter seems to have largely retired from painting.

In the Newbridge portrait, Beresford is shown in Hunter's favoured half-length format, gazing out of the picture to the left. The pose rather suggests that the portrait may have been accompanied by a pendant showing his wife. Although a suitable pendant is not recorded in the collection, Beresford's first wife, Anne Constantia de Ligondes, was portrayed in a fine pastel (Cobbe Collection, no.72). The account books for 30 May 1756 record in Lady Betty's hand: 'paid Mr Pine for Miss Legondys picture £2.16s.10 ½d'. This most probably refers to Simon Pine (*fl*.1742–72), who spent at least a decade working in Dublin, rather than to his brother Robert Edge Pine (?1720/30–1788).

The limits of portraiture, perhaps particularly in the hands of minor artists such as Hunter, are apparent in the *Portrait of the Hon. and Rt Hon. John Beresford*. While a comparison with the portrait of the same sitter in the National Gallery of Ireland by Gilbert Stuart (1755–1828) shows that the likeness is accurate, Hunter captured little of the strength of his character. Beresford was without doubt one of the most remarkable Irishmen of the period. Like his sister's husband, Thomas Cobbe, he had a strong interest in architecture. Perhaps his greatest achievement, in his position as Commissioner of the Revenue, was commissioning the Custom House in Dublin from James Gandon (1741/2–1823). An ardent supporter of the Act of Union, he fought a duel with the Lord-Lieutenant Lord Fitzwilliam (who had favoured Catholic emancipation), while his behaviour in the suppression of the 1798 rebellion was particularly savage. Little of the strength of character of this complex man can be gleaned from the decorous civility of Hunter's portrait.

Two further portraits (figs 87 and 88) show Lady Betty Cobbe's younger brother, William Beresford, and his wife, Elizabeth. Following the usual pattern, in which the eldest brother inherited the title and the next made a career for himself in government service, William entered the Church. He was successively Bishop of Dromore, Bishop of Ossory and Archbishop of Tuam, before being created Baron Decies. Beresford and his wife are portrayed in two elegant pastels by Hugh Douglas Hamilton. The artist was the best of the many fine pastellists who studied at the Dublin Society Schools, and in his large-scale works executed in Italy he extended greatly the possibilities of the technique. It seems reasonable to suppose that these two works were executed before Hamilton left Dublin for London in 1764.

A year later the account books provides us with the only documentary evidence regarding the rather puzzling painter Strickland Lowry (1737–85). On 18 January it notes: 'to Mr Lowry the painter £4.11s', and on 4 April: 'Mr Lowry for ye pictures of the children £9.2s'. This clearly relates to the fine double portrait of the eldest of Thomas and Lady Betty Cobbe's children, Charles and Catherine (cat.12). They are set in a wooded landscape, each with a favoured pet. Originally from Cumberland, Lowry worked in Staffordshire and Shropshire, as well as in Dublin and Belfast. He is the most likely author of the unusual *trompe l'oeil* showing a mezzotint of *The Spartan Boy* by Nathaniel Hone the elder (1718–84) (National Gallery of Ireland, Dublin). A portrait dated 1780 of a member of the Lurgan volunteers (Ulster Museum) shows that he retained connections with Ireland until late in his career. The secure documentation of the Cobbe picture helps reconfirm the attribution to Lowry of *A Conversation-piece with the Bateson Children* (Ulster Museum), which is unsigned but dated 1762.

The *Portrait of the Charles Cobbe and his Sister Catherine Cobbe as Children* shows an unsuspected mastery of landscape, and although portrayed in full-length and on a small scale, the figures avoid the doll-like quality of portraits by Arthur Devis (1708/12–87). Lowry here seems to have directly influenced Robert Hunter, who painted the children's uncle, John Beresford. Hunter's *Portrait of Christopher O'Brien* (Dromoland Castle), executed the year after Lowry's work, echoes the pose of the young Charles Cobbe, while his green costume and even details such as the shoe buckles are repeated almost identically. Intriguingly, after Lowry's death, Sir John Rawdon, by now Lord Moira, provided the artist's widow with a pension.[13]

While Thomas Cobbe concerned himself with the collection of Old Master pictures, it seems that his wife, Lady Betty, may have commissioned the portraits, and particularly those of her own Beresford family. The difference between the acquisition of works by the great masters and that of family portraits has been well articulated by Lippincott: 'Valuing likeness and decorum [buyers of portraits] could make their judgements on the basis of their knowledge of the sitter's appearance and social and family status, whereas collectors seeking ideal beauty were dependant on the shaky new "science" of connoisseurship.'[14] This distinction is apparent in a letter from Maria Edgeworth to Lady Rawdon, preserved in the Granard Papers in the Public Record Office in Belfast. Speaking of the Irish artist Adam Buck (1759–1833), she noted: 'we have lately had a man of genius in the art of painting upon a visit in this country. I should rather say in the art of taking portraits, which can scarcely be called the art of painting".[15] There is something of a paradox here. The Cobbe portraits were among the family's most cherished possessions, but, of all the pictures at Newbridge, they were the least appreciated, at least in terms of artistic merit.

Almost all of the family portraits are relatively small, with half-lengths predominating. The portraits of the Archbishop, in particular, are modest works by minor artists (Cobbe Collection, nos 111, 120 and 139). There is nothing of the scale of the contemporary patronage of the Hon. Frederick Hervey (later Earl of Bristol), Bishop of Derry, who was painted by Pompeo Batoni (1708–87), Elisabeth-Louise Vigée Le Brun (1755–1842) and Angelica Kauffman (1741–1807), as well as by Hugh Douglas Hamilton. A further instructive comparison can be made with the portraits of Richard Robinson, whose career rather neatly matches that of Charles Cobbe. Like the Archbishop, he came to Ireland, in 1750, as chaplain to the Lord-Lieutenant, in this case the Duke of Dorset. He succeeded Cobbe in many of the same sees, including Killala and Kildare, and had a keen interest in architecture, commissioning the fine mansion Rokeby Hall, Co. Louth. Robinson was portrayed by Sir Joshua Reynolds on three occasions and also commissioned portrait busts of himself from John Bacon (1740–99) and Joseph Nollekens (1737–1823).

This does not accord with the practice – or indeed the character – of Archbishop Cobbe. Likewise, among the younger members of the families, portraiture can be seen as a quite personal attempt to record the features of loved ones. The artists commissioned tended to be either local to Dublin or English visitors of relatively modest talents. It is interesting that no works were commissioned from the great English portraitists of the day.

The Cobbe tradition of family portraiture continued into the 19th century. On 25 March 1839, Charles Cobbe, the grandson of the young boy portrayed by Strickland Lowry, noted payments in his account book to George Francis Mulvany for his portrait (cat.14). However, as we know from Frances Power Cobbe's 1868 catalogue of the collection, the entire collection of paintings, both Old Masters and family portraits, had subsequently suffered dreadfully from neglect and decay.

In his note on the Irish artist Charles Jervas (c.1675–1739), Horace Walpole gave a rather touching account of the fate of many family portraits: 'it is almost as necessary that the representations of men should perish and quit the scene to their successors, as it is that the human race should give place to rising generations. And indeed the mortality is almost as rapid. Portraits that cost twenty, thirty, sixty guineas and that proudly take possession of the drawing room, give way in the next generation to those of the new-married couple, descending into the parlour, where they are slightly mentioned as "my father's and mother's pictures". When they become "my grandfather and grandmother", they mount to the two pair of stairs; and then, unless dispatched to the mansion house in the country or crowded into the housekeeper's room, they perish among the lumber of garrets, or flutter into rags before a broker's shop at Seven Dials.'[16]

Happily this has been the case with the Cobbe family to a very limited extent only. Very few portraits have been disposed of, and indeed in the present generation Alec Cobbe has actively sought to acquire representations of Rawdons, Beresfords (see cat.101) and other collateral ancestors. Preserved in the splendour of Newbridge House, the family portraits provide an eloquent, if partial, glimpse into the Cobbe family's history, its successful careers, friendships and marriages. From the image of 'the Archbishop with an upraised hand', we see the family as it chose to be depicted across a century, but, like the elderly Yeats standing alone in the Municipal Gallery, only four houses down from the Cobbes' former townhouse in Parnell Square, we may wonder how much of the family's humility and pride has really been captured by the artist's brush.

'A BETTER PICTURE TO THE CHRISTIAN EYE':
THE SALE OF MEINDERT HOBBEMA'S *WOODED LANDSCAPE* FROM NEWBRIDGE

Arthur K. Wheelock Jr and Alec Cobbe

Although Meindert Hobbema is recognized today as one of the finest Dutch landscape artists, his paintings were not mentioned in a single literary source during his lifetime. The earliest published comment of his work appears in Johan van Gool's 1751 lexicon of Dutch artists.[1] By this time, Hobbema's reputation was firmly established, and his paintings were already being sold in England.[2] Evidence of the growing esteem in which 18th-century British collectors held the work of Hobbema is found in Matthew Pilkington's 1770 *Dictionary of Painters* (see pp.52–62). In his entry on the artist, Pilkington – who was both Vicar of Donabate and private secretary to Thomas Cobbe's father, Archbishop Charles Cobbe – singled out for discussion the signed and dated painting of a *Wooded Landscape* of 1663 in the Cobbe Collection (cat.24).

Pilkington not only noted the rarity of paintings by this artist in British collections, but also, in what reads as a justification to Cobbe of an unusually expensive purchase, commented on the high prices they commanded: 'The works of Hobbima are now exceedingly scarce, and industriously sought for; and his paintings were so highly prized a very few years ago in London that one of them was sold for above an hundred pounds; and it is probable that the works of this celebrated artist are as estimable at this day. Not many of his pictures have appeared in this kingdom, although he has often been dishonoured, by having many mean performances ascribed to him. But, one of the most genuine landscapes of Hobbima, perfectly well preserved, is in the possession of Thomas Cobbe, Esq; in Dublin, which has been often examined with singular pleasure; …'.[3]

In 1835, when John Smith published the Cobbe painting in *A Catalogue Raisonné of the Works of the Most Eminent Dutch, Flemish and French Masters*, he indicated that it was the pendant to a landscape of the same dimensions and date, presently in the National Gallery of Ireland, Dublin (see

Cat.24 Meindert Hobbema, *Wooded Lanscape* (sold from the Cobbe Collection in 1839; now National Gallery of Art, Washington, DC)

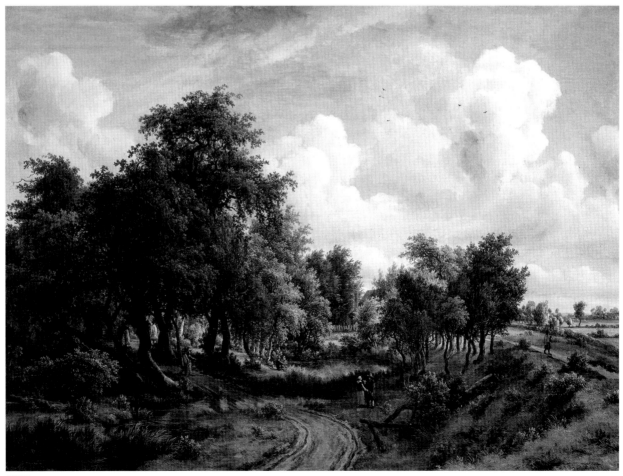

cat.24

Cat.40 Gaspard Dughet,
Wooded Valley Lancscape
(sold from the Cobbe
Collection in 1839; now
private collection,
Monaco)

Fig.89 One of the
'Hobbema Cottages' as it
appears today

Fig.90 Schedule of costs
for the rebuilding and
repairing of mountain
cottages (Cobbe Papers:
Hugh Cobbe)

Fig.91 Design for moun-
tain cottage presumably
drawn by Frances Power
Cobbe (Cobbe Papers:
Hugh Cobbe)

cat.40

cat.24a).[4] Smith's statement must be treated with some scep-
ticism, especially since little is known about 17th-century
landscape pendants. However, in the 18th-century collection
of Thomas Cobbe the Hobbema did have a pendant. This was
the *Wooded Valley Landscape* by Gaspard Dughet (cat.40), and
the two pictures were clearly among the stars of Thomas
Cobbe's acquisitions. They almost certainly hung in the cen-
tre positions, at eye-level, on either side of the chimneypiece
in the Drawing Room at Newbridge, which Cobbe had com-
pleted by 1764.

Unlike the 'Cobbe Hobbema', the 'Cobbe Dughet' has
retained its original Newbridge 18th-century frame (see
above), and it can be no coincidence that it is quite the most
elaborate example of those surviving. It is likely to have been
provided by the celebrated Dublin carver and gilder Richard
Cranfield, who figures as frame supplier in Thomas Cobbe's
account book (see pp.74–5). As with the matching frames on

the pendant village scenes by Barent Gael (cats 21–2; see also
figs 76–7), it is possible that the Hobbema and Dughet were
framed identically.

In 1810 Thomas Cobbe gave the Hobbema painting, along
with the paintings collection and the entirety of the Cobbe
estates, to his grandson Charles. By this time, Thomas had
been residing mainly in Bath for some years, and the estates
had fallen into disrepair. Thomas, as landowner, though
sympathetic to the hardships of his mountain tenants ('the
mountaineers are shut up in their Cottages, frequently by
snow, & roads, in winter, Impassable')[5] had operated on the
'truly Irish principle of being generous before you are just'.[6]
The living conditions of small-holders throughout Ireland at
that time were often wretched; lime-washed mud cabins,
with earth floors and ill-maintained thatched roofs, were
prevalent. In decay, they made damp and unhealthy
dwellings 'which nobody dreamed of repairing'.[7]

fig.89

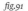

fig.90

repairing Tenants dwelling houses in the Mountains' (fig.89).[9]

The programme continued, despite the lack of the necessary funds, and in 1839, in a gesture of extraordinary humanity, Charles sold the pinnacles of the Cobbe Collection, the

fig.91

Hobbema together with the Dughet, to raise extra money to complete the project. Charles's deliberations on the decision are recorded in his journal: 'I cannot reconcile it to my mind to leave so much value on Walls where they have such bad light and are so little seen, and when such a sum is laid out on … mountain property in comfortable houses for the poor tenants, with comfortable beds, instead of the wet wad of straw which so many now sleep on, would present a better picture to the Christian eye'.[10]

The Dublin picture restorer Michael Gernon, who had been looking after the collection since 1822, acted as intermediary between Cobbe and the London dealer Thomas Brown, and £1,500 was paid for the two pictures. Within five months, Brown had sold the Hobbema alone for £3,000 to Robert Stayner Holford.[11] The Dughet was also bought by Holford.

In the years leading up to the catastrophic Famine in Ireland (1845–9), Cobbe's strenuous efforts to improve the living conditions of his tenants and labourers provides a refreshing contrast to the ruthless evictions pursued by some landowners in the name of 'improving' their estates. As a result of his conscientiousness, no hardship was suffered on the Cobbe estate during the Famine years. In 1894, Charles's daughter Frances described the episode of the 'eighty stone and slate Hobbema Cottages',[12] concluding her account with these heartfelt sentiments: 'Be it noted by those who deny every merit in an Anglo-Irish landlord, that not a farthing was added to the rent of the tenants who profited by this real act of self-denial'.

Charles Cobbe, however, did dream, and he dreamt of not merely repairing, but of rebuilding the majority of dwellings on his estates. This was a gargantuan task, as the Cobbe lands amounted to around 35,000 acres, and, on account of the disastrous debts left at his father's death in 1798, funds were in extremely short supply. By steady and thrifty management, however, his project commenced, and by 1835 he had regenerated most of the housing on his lands in the north of the county, an the majority of the cabins in the mountains south of Dublin had come up for review. Detailed accounts, specifications and lists survive, indicating which houses were to be rebuilt and which were to be repaired (fig.90).[8] In the latter stages, Charles Cobbe's copy of Arthur Creagh Taylor's *Designs for Labourers' Cottages, … Suited to Irish Estates* (Dublin, 1841) provided prototypes for his daughter Frances Power Cobbe to elaborate in pencil drawings (fig.91). Between 1835 and 1845 a total of £5,470 was 'expended on building and

CATALOGUE OF
THE HISTORIC COBBE COLLECTION

1

IRISH SCHOOL

Late 17th century

Portrait of Major-General Thomas Fairfax (1633–1712)

Oil on canvas, 28¾ × 24 in (73 × 61 cm)
INSCRIPTIONS on the reverse: inscribed on label,
in ink, *Thomas Fairfax / (Son of Sir William Fairfax by
Frances Chaloner) / born 1633 died 1712 / Major General,
Governor of Limerick*
Cobbe Collection, no.432

1 I am grateful to Lt-Col. John Downham, Director of
the Regimental Museum of the Queen's Lancashire
Regiment, for his kindness in providing information
about the military career of the sitter.

Thomas Fairfax was the son of Sir William
Fairfax and Frances Chaloner. His mother
was the sister of James Chaloner, Archbishop
Cobbe's grandfather, who had married Sir
William's sister Ursula Fairfax. The sitter was
therefore (doubly) a first cousin once removed
of Archbishop Cobbe.

Described by his friend John Evelyn, the
diarist, as 'a soldier, a traveller, an excellent
musician, a good natured and well-bred
gentleman', Fairfax pursued a distinguished
career as a soldier.[1] In 1655 he served in
the Cromwellian army in Jamaica and,
continuing as a soldier after the Restoration,
was appointed in 1675 Lieutenant- Deputy
Governor of Virginia. In 1680 he was in
Ireland, where he became the Governor of
the City and County of Londonderry. By 1689
he was in Lancashire, and, as Colonel of the newly formed Castleton's Regiment, he was
despatched by William III to the Low Countries, where he served until the peace of Rijswijck
in 1697. He left the Regiment in 1703 to take up the appointment of Governor of Limerick and
died in Dublin in 1712.

AC

2

IRISH SCHOOL (?)

Early 18th century

Portrait of Mary Levinge, Countess Ferrers (d.1740)

Oil on canvas, 50 × 38¾ in (127 × 98.5 cm)
Irish 18th-century black-painted frame
with gilt inner slip (type IV)
Cobbe Collection, no.93
HISTORY 18th-century Newbridge collection; recorded
by Frances Power Cobbe in 1868, no.93, in the Drawing
Room Corridor; recorded in the Dining Room in 1901
(Valuation 1901a, p.33) and 1914 (Valuation 1914, £25);
thence by descent
LITERATURE Cobbe 1868 (1882), no.93

1 The conflicting dates come from GEC and
from [Anonymous] 1853, pp.5–6.
2 Crookshank and Glin 1978, p.14, and Belfast 1990,
no.303.
3 Sale, Christie's, London, 14 October 1992, lot 14.

Mary Levinge was the eldest daughter of Sir
Richard and Lady Levinge (see cat.95) and the
sister of Dorothea, who married firstly Sir
John Rawdon and then, in 1730 as her second
husband, Charles Cobbe, later Archbishop of
Dublin (see cat. 7). (There are further Levinge
family portraits in the Cobbe Collection,
nos 81, 84, 97, 98 and 100.)

In either 1700 or 1704,[1] Mary married
Washington Shirley (1677–1729), second son
but eventual heir of Robert Shirley, 1st Earl
Ferrers, whom he succeeded in 1717. Lady
Ferrers was mother to three daughters,
co-heirs to their father, one of whom was the
celebrated Selina, Countess of Huntingdon
(for whom see under cats 6 and 48).

The artist of this portrait (formerly attrib-
uted to Willem Wissing [1656–87], a Dutch
artist active in England) is unknown. It could be a secondary version of another portrait,
possibly commissioned by the sitter's sister Dorothea, who in the mid-1720s is known to have
ordered an image of her father from the little-known Irish artist Ralph Holland, to whom she
recorded a payment of £6.18s. 'to Mr Holland for my father's picture' in her account book.[2]
Lady Ferrers sits in a conventional, contemplative pose, her rather harshly executed blue wrap
falling in a bold sweep across her lap. Facially, her appearance is very similar to the miniature
portrait of her by Christian Richter III (1676–1730), inscribed on the reverse *1722, London*,
recently on the London art market,[3] although her costume is probably slightly earlier,
c.1715–20.

TB

3

CHARLES MARTIN
fl. Florence 1728–52

Portrait of Sir John Rawdon, 4th Bt, later 1st Earl of Moira, FRS (1719/20–93)

Pastel on paper laid down on canvas, 26 × 23 in
(66 × 58.5 cm)
inscriptions on the *verso* of the paper: signed
and dated, in crayon, *Charles Martin fecit 1739*
Cobbe Collection, no.70
HISTORY 18th-century Newbridge collection;
recorded by Frances Power Cobbe in 1868, no.70, in the
Study; recorded in the Study in 1901 (Valuation 1901b,
p.16) and 1914 (Valuation 1914, £25); thence by descent
EXHIBITIONS Dublin 1872, no.42 (as by Rosalba)
LITERATURE Laing/Cobbe 1992, p.7, no.70 (as by
Martin after Rosalba)

1 Walpole/ed. Yale 1948, vol.13, pp.202–3, letter to
Richard West of 27 February 1740.
2 Wicklow MSS, quoted in Ford and Ingamells 1997,
p.644.
3 See Kieven 1975, pp.13 and 23, n.8.
4 Inscribed on the back, *Earl of Moira / done by Rosalba
from a Syracusan woman*; see Sani 1988, no.244, p.308
and fig.214.
5 Wortley Montagu/ed. Halsband 1965, letter of
22 June 1752.
6 Mrs Crewe's Irish Journal (unpublished MS.), quoted
by kind permission of Mary, Duchess of Roxburghe.

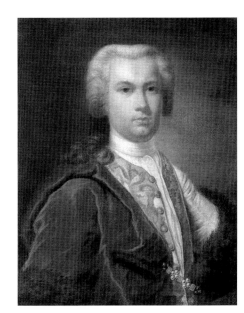

'Not in Waterhouse' is a rare distinction for an
18th-century British painter, but this pastel
would appear to be the first identified original
work by Charles Martin, a painter in pastels of
whose origins and end there are no details, and
who was previously known, if at all, for a walk-
on part in Horace Walpole's letters from Italy.[1]
The latter described how, at Florence in
February 1740, Martin took offence at an eld-
erly Florentine nobleman, declaring that he
was no gentleman, and challenged him to a
duel. Walpole saw the 'little figure [Martin],
pale but cross, with beard unshaved and hair
uncombed, a slouched hat, and a considerable
red cloak, in which was wrapped, under his
arm, the fatal sword', awaiting his opponent at
the spot named for the event. The nobleman,
however, failed to appear, declining to fight
with one who was 'no cavalier'.

Martin may, in fact, have been Irish, to judge from the remark made to Ralph Howard (later
Viscount Wicklow) by another Irishman settled in Florence, Dr James Tyrrell, whose activities
and correspondence there were almost exclusively on behalf of his compatriots; Tyrrell referred
to Martin as 'our Tuscan Raphael in the crayon way'.[2] Ralph Howard had commissioned
from him a pastel copy of Raphael's *Madonna della Sedia*. It is also possible that Charles was the
brother of Letitia Martin, who was married to the architect Alessandro Galilei, when he was in
England, in 1718, and returned to live with him in Florence until her death there in 1731.[3]

Sir John Rawdon evidently favoured pastel, for he obtained a version of the bust of a *Young
Tyrolean Woman* (Victoria & Albert Museum, London)[4] from Rosalba Carriera (1675–1757), to
whom the present portrait used to be ascribed. His connection with the Cobbes was a close one
(see pp.28–9 and 41–2). His mother, Dorothea Levinge, had married Charles Cobbe, the future
Archbishop (see cat.7), six years after the death in 1730 of her first husband – and his father –
Sir John Rawdon. But she died in 1733, giving birth to Charles Cobbe's second son, Thomas
(see cat.13), leaving Charles with two sons and two stepsons (to whom he was as devoted as if
they had been his own children). (A portrait of the two stepsons as children was once also in
the Cobbe Collection, no.89.)

The younger Sir John Rawdon married three times. His first wife was Lady Helena Perceval
(see cat.4), who died in June 1746; later the same year he married the Hon. Anne Hill (*d.*1751),
only daughter of the 1st Viscount Hillsborough. The year after his second wife's death, he
married Lady Elizabeth Hastings (see cat.6), elder daughter of the 9th Earl of Huntingdon.
Spence's observation of the facility with which he transferred his affections, when circum-
stances dictated, evidently continued to hold true. Thanks, no doubt, to these alliances, he was
raised to the peerage, as Baron Rawdon in 1750 and as the Earl of Moira in 1762. Were it not for
the fact that all three marriages were so evidently advantageous, one might have thought that
he simply suffered from too great a desire to please. For Lady Wortley Montagu, while calling
him sarcastically 'that good Creature', said that he was of 'unlimited complaisance He
hardly ever open'd his mouth but to say – What you please, Sir – At your service – Your humble

servant – or some gentle expression to the same effect.'[5] Rawdon's interest in pictures, about which Lady Mary was equally scathing (asserting that 'I dare swear he purchas'd his Title for the same reason he us'd to purchase Pictures in Italy: not because he wanted to buy, but because somebody or other wanted to sell'), endured however, and his half-brother Thomas Cobbe's account books record exchanges of pictures between the two.

Towards the end of his life – to judge from a diary entry by Frances Anne Greville, Mrs John Crewe, describing a dinner at his Dublin house in 1785 – he evidently kept up a great state, and in the old fashion: 'The plate clattered, the servants in and out of livery stood on tiptoe, the wines went round and round on silver salvers, the compliments were plentiful and stupid on every side of the table, and dullness never appeared in greater splendour! … daughters, toadeaters, and clergymen, play'd their respective parts to admiration …. At this house they preserve the old Irish custom of drinking Claret out of a Silver jug ….'[6]

His eldest son by his third wife, later 2nd Earl of Moira, became the friend and confidant of the Prince of Wales (later George IV); and it was evidently through his influence that Thomas Cobbe's daughter, Catherine, the Hon. Mrs Henry Pelham (see cat.86), was made one of the four Bedchamber Women to Princess Caroline after her marriage to the Prince.
ADL

4

JAMES LATHAM
Tipperary 1696–Dublin 1747

Portrait of Lady Helena Rawdon, née Perceval (d.1746)

Oil on canvas, 29 × 24 in (73.5 × 61 cm)
Newbridge 18th-century gilt livery frame
(type II without shoulders)
Cobbe Collection, no.83
HISTORY 18th-century Newbridge collection; recorded
by Frances Power Cobbe in 1868, no.83, in the Library;
recorded in 1896 in the Library, where seen by Walter
Armstrong, Director of the National Gallery of Dublin,
and restored on his advice for £2.10s (Cobbe 1896, fol.5r);
recorded in the Library in 1901 (Valuation 1901b, p.11)
and 1914 (Valuation 1914, £10); thence by descent
LITERATURE Cobbe 1868 (1882), no.83

1 Spence/ed. Klima 1975, pp.245 and 284, letters of
27 January and 1 June 1740.
2 Perceval/ed. Historical Manuscripts Commission
1923, vol.3, p.277.

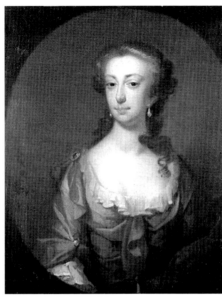

Lady Helena Perceval was second daughter of
John Perceval, 1st Earl of Egmont (see fig.18),
the Irish diarist, politician and colonist (and
former pupil of James Gibbs in Rome). She met
her future husband, Sir John Rawdon (see
cat.3), shortly after he returned from his Grand
Tour of 1739–40, on which he was reported by
Joseph Spence to have been sent – presumably
by Charles Cobbe – 'to wean him from [being]
in love over head and ears in Ireland' (despite
which he was also said to have become 'prodi-
giously in love in every town [in Italy] he
makes any stay at').[1] On 12 May 1741 Egmont
recorded Rawdon coming to Charlton to ask
for Helena's hand in marriage. The diarist
described him as: 'very personable and good-
natured, as well as sober and prudentHe
came last year from his travels abroad, and
gives a good account of them. His amusements are the same as my daughter's, music and
painting, &c., which will naturally make them delight in home.'[2]

Helena's father, Lord Egmont, took a deep interest in architectural projects in Ireland, and
his daughter's marriage to Sir John brought him in close contact with Archbishop Cobbe, who
spent much of 1744 in London, staying with his stepson and daughter-in-law. It seems certain
that, on learning of Cobbe's plan to build at Newbridge, he encouraged Cobbe to consult
James Gibbs (1682–1754), and he may have brought the two together.

ADL, AC

5

ATTRIBUTED TO JAMES LATHAM
Tipperary 1696–Dublin 1747

Portrait of Samuel Hutchison, Bishop of Killala

Oil on canvas, 29½ × 24¼ in (75 × 61.5 cm)
Irish 18th-century gilt livery frame (type II)
Cobbe Collection, no.270
HISTORY the Hely-Hutchinson family at Lissen Hall,
Seafield and Newport House; by descent to Mary and
Louisa Hely-Hutchinson; given by them to the Cobbe
Collection in 1998

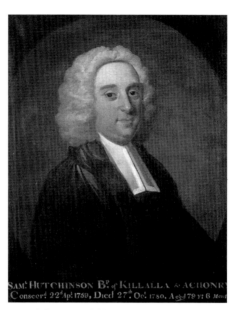

Samuel Hutchinson was brother of Sir Francis Hutchinson Bt. He was Bishop of Killala and Achonry by 1761 and was clearly a close friend of Archbishop Cobbe. His name appears on Cobbe's list of those to whom he lent books in 1761, while prior to this, when Hutchinson's ecclesiastical career was less advanced, he issued a card of invitation: 'Dean and Mrs Hutchinson present their compliments to his Grace the Ld Archbishop of Dublin & Mrs Cobbe & to Sr Philip Hoby & Dr Cobden & his Lady & desire the favor of them to dine with them on Friday next being July 3d.' The 'Mrs Cobbe' referred to would have been the Archbishop's unmarried sister Elizabeth, here accorded the dignification customary for spinsters. After her brother lost his wife, she kept house for him, until her death in 1750.

Dr Cobden was a fellow prelate and a close friend of the Archbishop. He published a book of poems, and some of his verse appears with unpublished details in the Archbishop's manuscript book of poetry. Sir Philip Hoby was the Archbishop's chaplain (see cat. 8).

Hutchinson's daughter Sophia married in 1753 the Rev. Edward Synge DD of Syngefield, and his brother Francis's baronetcy later devolved upon his grandson by this marriage, Sir Samuel Synge Hutchinson.

Another portrait attributed to Latham, depicting Bishop Hutchinson's father, also called Samuel Hutchinson (*c*.1667–1749), is also in the Cobbe Collection (no.271).
AC

6

JOHN LEWIS

fl. 1740–57

Portrait of Elizabeth Rawdon, née Hastings, later Countess of Moira (1731–1808)

Oil on canvas, unlined, 50¼ × 39¾ in (127.5 × 101 cm)
Newbridge 18th-century black painted frame with gilt
inner slip; remains of leather hanging-loop pinned
down on reverse
INSCRIPTIONS signed and dated at lower right, *J. Lewis* /
... 1751 (?); on the reverse of the canvas: inscribed in white
chalk, *14 / Below*; and an early 19th-century inventory
label illegibly inscribed in brown ink
Cobbe Collection, no.92
HISTORY 18th-century Newbridge collection; recorded
by Frances Power Cobbe in 1868, no.92, in the Drawing
Room Corridor; recorded on the Principal Stair Case in
1901 (Valuation 1901b, p.19) and 1914 (Valuation 1914,
£10); thence by descent
LITERATURE Cobbe 1868 (1882), no.92

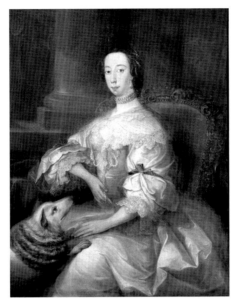

Lady Elizabeth Hastings, the third wife of
Sir John Rawdon (see cat.3), was the daughter
of Theophilus Hastings (*d*.1746), 9th Earl of
Huntingdon, and Lady Selina Shirley (1707–
91), the celebrated Methodist Countess of
Huntingdon, whose evangelical sect (known
as the 'Lady Huntingdon Persuasion' or the
'Countess of Huntingdon Connexion') was
to exert such a strong influence over Lady
Betty Cobbe (see cat.48). The sitter's maternal
grandmother was Mary, Countess of Ferrers
(see cat.2). On the death of her brother Francis
Hastings, 10th Earl of Huntingdon, in 1789,
the barony passed to Elizabeth.

The present portrait was apparently
painted around 1751 (the last digit of the date
is uncertain), which would have been the year
before Lady Elizabeth married Sir John, who
was created 1st Earl of Moira in 1762, a decade after their marriage. The couple had two sons
and two daughters. The elder son, Francis Rawdon-Hastings (1754–1826), was created Baron
Rawdon in 1783, succeeded his father as 2nd Earl of Moira in 1793 and in 1817 became the 1st
Marquess of Hastings, in recognition for his military success in India, where he served as
Governor-General of Bengal and commander-in-chief of the British forces. The second son
was Colonel John Rawdon. The elder daughter, Anne, married Thomas Bruce (*d*.1814), 1st Earl
of Ailesbury, and the younger daughter, Selina, married George Forbes (*d*.1837), 6th Earl of
Granard.

AC

7

JAMES STEWART
fl. c. 1750

Portrait of Charles Cobbe, as Bishop of Kildare, later Archbishop of Dublin (1686–1765)

Oil on canvas, 49¾ × 39¾ in (126.5 × 110 cm)
Newbridge 18th-century black painted frame
with a gilt inner slip (type III)
Cobbe Collection, no.71
HISTORY 18th-century Newbridge collection; recorded
by Frances Power Cobbe in 1868, no. 71, in the Study;
recorded in the Dining Room in 1901 (Valuation 1901a,
p.33) and 1914 (Valuation 1914, £25); thence by descent
EXHIBITIONS Dublin 1872, no.86; Dublin 1967, no.25a
LITERATURE Cobbe 1868 (1882), no.71; Cornforth 1985a,
p.1732, fig.2; Stewart 1995, vol.2, p.683; vol.3, p.75

1 Archbishop Cobbe's *Manuscript Book of Poetry*, a light-
hearted verse by Dr Barker (Cobbe Papers: Alec Cobbe).
2 He was described by Lord Egmont, a father-in-law of
his stepson John Rawdon, as 'a genteel, well bred man
… not to be prevailed on in matters he thinks not
right, but frank and open in his behaviour to all'
(Perceval/ ed. Historical Manuscripts Commission
1920–23, vol.3, p.301).
3 I am grateful to my cousin the Rev. Mervyn Wilson,
who recently effected the rejoinder of two manuscripts
in his possession, from Archbishop Cobbe's library,
with the Archbishop's remaining archive. One of these
is a copy, in Cobbe's hand, of 'Lord Falconberge's
instructions at Whitehall in order to his Embassy at
Turin, Genoa, Florence and Venice, 1670'.
4 No catalogue of the sale survives, though Thomas
Cobbe's letters on the subject to his agent, William
Shanley, mention that a catalogue of the library existed
in Newbridge.
5 *Pue's Occurrences*, Dublin, April 1765.

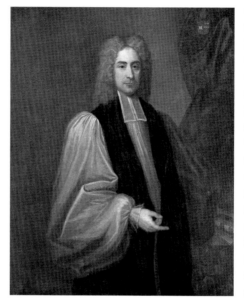

Charles Cobbe, fourth son of Thomas Cobbe
and Veriana Chaloner (fig.45), travelled to
Ireland in 1717 as chaplain to his godfather,
Charles Paulet, 2nd Duke of Bolton (see
cat.44), who was appointed Lord-Lieutenant
of Ireland in that year. 'Chaplain to the Lord
Lieutenant' was a good start to any Irish cleri-
cal career, and in the following year Cobbe
was appointed Dean of Ardagh and appears
to have thrown himself into his decanal
duties so energetically that he was chided for
neglecting to visit his family in Winchester.[1]
His ecclesiastical career, which successively
delivered the bishoprics of Killala in 1720,
Dromore in 1726, Kildare in 1731 and finally
the Archbishopric of Dublin in 1743, was to
establish the family in Ireland for the next two
and a half centuries, though he did not attain
the highest honour, the Archbishopric of Armagh. Cobbe appears to have been a fair-minded
and even-handed prelate,[2] loyal to the Church and Crown, but liberal both in opposing penal
legislation against Catholics and in permitting open practice of the prohibited religion on his
estates. At Dromore, Cobbe met his wife, the widowed Dorothea, Lady Rawdon, *née* Levinge,
who had two young sons, Sir John and Arthur Rawdon. They married in 1730 and had two sons,
Charles and Thomas, the latter born in 1733, when Dorothea died, presumably in childbirth.

Educated at Winchester and Trinity College, Oxford, he took his DD at Trinity College,
Dublin. He was something of an architectural patron, for as well as going to one of the most
important architects of his time, James Gibbs (1682–1754), for the design of Newbridge, he
presided over several major building projects in Dublin – the new spire for St Patrick's
Cathedral, the rebuilding of Essex Bridge, the principal thoroughfare across the Liffey in
central Dublin, and, as the first 'chairman of trustees', the building of Swift's hospital. In each
of these projects, the architect George Semple (1700–?1782) was employed, and Semple, it
seems certain, was also made responsible for the execution of Gibbs's designs for Newbridge.

Cobbe commissioned portraits of his family and may equally have been interested in Old
Masters. He employed, as his private secretary, the art-loving Rev. Matthew Pilkington and,
through him, probably initiated the purchase of Old Masters for Newbridge, a practice con-
tinued so notably by his son. But, above all, in his extra-mural activities, he was a man of letters.
He copied and collected manuscripts on diverse subjects,[3] befriending Jonathan Swift and
copying, in his own hand, the latter's autobiography. Cobbe's copy was further annotated by
Swift's secretary and so became an important additional source to Swift's own manuscript.
These, together with his books, came to constitute a considerable library, one that was
deemed, by the end of the 18th century, to be of such value that it was, regrettably, disposed
of in a sale in 1800 by James Vallance, the Dublin auctioneer, on the instructions of his son.[4]

Cobbe died 'full of years and honours' at the age of 79 in April 1765, 'the eldest bishop in
the Christian Church',[5] and was interred at Donabate.
AC

8

JOHN ASTLEY

Wem, Shropshire 1724–Duckenfield 1787

Portrait of the Rev. Sir Philip Hoby, Bt (1716–66)

Oil on canvas, unlined, 25 × 20 in (63.5 × 51 cm)
Irish 18th-century gilt livery frame (type VIII)
INSCRIPTIONS on the reverse: inscribed on label,
in brown ink, *No 75 Sr Philip Hoby Bart by -*
Cobbe Collection, no.104
HISTORY 18th-century Newbridge collection; early
19th-century inventory, no.75; recorded by Frances
Power Cobbe in 1868, no.104, on the Stairs (First Wall);
thence by descent
LITERATURE Cobbe 1868 (1882), no.104

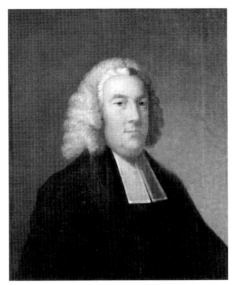

The sitter was chaplain to Archbishop Cobbe (see cat.7) who bequeathed to him a snuff-box. His duties were presumably exercised in residence, as he was included *en famille* in an undated invitation to dine sent to the Archbishop by Dean Hutchinson. The latter was elevated to the See of Killala (see cat. 5). The present portrait was painted during Astley's three-year sojourn in Ireland (1756–9), probably at the same time as that of the Archbishop's daughter-in-law, Lady Betty Cobbe (cat. 9).

Sir Philip Hoby (1716–66), of Bisham in Berkshire, received his BA at Oxford in 1732 and his MA in 1739. Having succeeded his brother Thomas as 5th and last Baronet in 1744, Hoby was appointed Chancellor of St Patrick's in Dublin and Dean of Ardfurd in 1748, positions that he held until his death in 1766. Having no male heir, Sir Philip bequeathed his estates to Sir John Mill Bt.

AC

9

JOHN ASTLEY
Wem, Shropshire 1724–Duckenfield 1787

Portrait of Lady Elizabeth ('Betty') Cobbe, née Beresford (1736–1806)

Oil on canvas, 24 ⅛ × 20 ⅛ in (61 × 51 cm)
Inherited by Alec Cobbe unframed; copy of Irish
18th-century gilt livery frame (type VIII) has been
made by John Davies of Norfolk
INSCRIPTIONS on the reverse, on the stretcher: inscribed
in white chalk, *LADY COBBE 119 (wife of General Sir Alexander
Cobbe v.c.);* numbered, *119;* inscribed by Alec Cobbe, *Lady
Betty Cobbe. d. of Earl of Tyrone. sister of / 1st Marquess of
Waterford / M. 1751 Thos. Cobbe of Newbridge;* and bookplate
of Alec Cobbe
Cobbe Collection, no.121
HISTORY 18th-century Newbridge collection, which
it left before 1868; inherited by Anne and Wendy,
daughters of Gen. Sir Alexander Cobbe, VC; inherited
from them by Alec Cobbe

1 According to Primate Marcus Beresford, Archbishop
of Armagh (*d.*1885).
2 The present portrait of Lady Betty may have been
started as a head study for the large family group por-
trait by Astley for Curraghmore (fig.85) and thereafter
finished off as an individual work for the sitter.
3 'Memorandum of the Lady who had the dream or
vision which will be related in the following pages,
copied from the original manuscript in the Beresford
family', the first of four items in a manuscript notebook
in three different hands. The book apparently belonged
originally to Lady Betty's daughter, Catherine, The Hon.
Mrs Pelham, in whose hand the 'Memorandum' is
written, presumably copied from Lady Betty Cobbe's
manuscript. The book was later given by Mrs Pelham's
daughter to Frances Power Cobbe; it also contains a
second version of the story, together with introductory
remarks, ascribed to Primate Marcus Beresford,
Archbishop of Armagh, copied by Mary Lloyd for
Frances Power Cobbe (Cobbe Papers: Hugh Cobbe).
4 Letter from Frances Power Cobbe, from her home
Hengwrt, Wales, 3 October 1889; the letter continues,
'My story was given me by my cousin Catherine Pelham
.... I believe it to have been *Mrs Pelham's* writing'
(Cobbe Papers: Alec Cobbe).

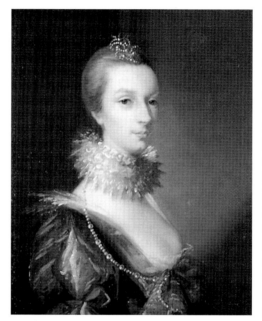

Youngest daughter of the Earl and
Countess of Tyrone, there seems little
doubt that Lady Elizabeth ('Betty') was a
considerable character, 'represented to
have been of a very sprightly disposition,
talented and agreeable',[1] possessing good
taste and a predilection for good pictures.
It must have been in recognition of the
latter that her eldest brother George,
trustee of her marriage settlement and
later 1st Marquess of Waterford, seems to
have presented her with his portrait by
Zoffany (cat.46), retaining only a pastel
copy for himself. She had a strong sense of
family, assembling in the portrait collec-
tion at Newbridge a cohort of Beresfords,
which included her other brothers and
their wives. Among her purchases is a
cameo of the Marquess of Stafford,
acquired solely on account of its resemblance to one of her brothers.[2]

During the first half of her married life, Lady Betty led a fashionable existence, beautifying
Newbridge, sharing her husband's interest in music and collecting pictures, and commencing
the collection of shells and curiosities still contained in the family museum (see fig.2). By 1768,
when they had done all they had wished to Newbridge, she and her husband built a large
townhouse in Palace Row, Dublin, and entertained lavishly. Newbridge, meanwhile, being
close to Dublin, meant that family relations came to stay for months at a time. (For details
about Lady Betty's later life, see cat.48.)

Lady Betty was celebrated as the chronicler of the 'Beresford Ghost story', an incident in
which her grandmother, Lady Beresford, was awakened in the night by an apparition of her
cousin the 2nd Earl of Tyrone, who informed her that he had died a few days previously. There
followed discussions about religion and Lady Beresford's future life, which foretold that a
cruel second husband would make her life a misery, and that death would come to her in her
forty-seventh year. She asked the ghost to make some permanent sign so that she could be sure
she had not merely suffered a bad dream. He touched her wrist, causing a withered mark,
which he bade her to show to no one. Lady Beresford appeared next morning with a black band
of velvet round her wrist, which she wore for the rest of her life. Naturally, events unfolded as
the Ghost had prophesied. The story was 'forbidden amongst the Lords of Curraghmore',[3] and
for that reason, perhaps, excited general curiosity. According to Frances Power Cobbe, Lady
Betty 'had the greatest horror of the story and would never speak of it, and when some Lady-
in-Waiting to Queen Charlotte wrote and asked her to tell it, she replied that she was "sure the
Queen would not intrude into the private affairs of her subjects" and that she had "no inten-
tion of gratifying the impertinent curiosity of a Lady-in-Waiting".'[4]

AC

10

ROBERT HUNTER
fl. 1750–1803

Portrait of the Hon. and Rt Hon. John Beresford (1738–1805)

Oil on canvas, unlined, 24 × 19½ in (61 × 49.5 cm)
Newbridge 18th-century gilt livery frame (type VIII)
INSCRIPTIONS on the reverse: inscribed on label, in
brown ink, *No 73 John Beresford Esq brother to Marquis
of Waterford*
Cobbe Collection, no.105
HISTORY 18th-century Newbridge collection; early
19th-century inventory, no.73; recorded by Frances
Power Cobbe in 1868, no.105, on the Stairs (First Wall);
recorded in the Study in 1901 (Valuation 1901b, p.16)
and 1914 (Valuation 1914, £25); thence by descent
LITERATURE Cobbe 1868 (1882), no.105; Crookshank
1989, p.180, no.10

1 The ceiling of the house's hall as been described by
William Garner as 'one of the most daringly conceived
and freely modelled Rococo ceilings in Dublin' (see
Turner [ed.] 1996, vol.33, p.95).
2 See Mannings 2000, no.1282, illus.

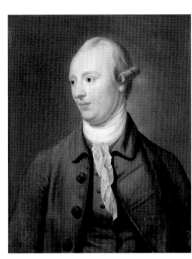

The Hon. John Beresford was the second son of the
1st Earl of Tyrone and brother of the 1st Marquess of
Waterford (see cat.43) and Lady Betty Cobbe (see cats 9
and 48). In 1767 he married his sister's intimate friend
and companion, Anne Constantia de Ligondes
(*d*.1770), who had been living in the Cobbe household
and who had changed her religion following the
death of Archbishop Cobbe. Beresford built a villa
at Malahide, not far from Newbridge, and named it
Abbeville, after his wife's hometown in northern
France. From 1755 he occupied a Dublin house
of great magnificence at 20 Lower Dominick St,
designed and fitted with extravagent plasterwork
by Robert West (*d*.1790), which the stuccoist had
originally intended for himself.[1] In 1774, four years
after his first wife's death, Beresford married, secondly, Barbara Montgomery (?1757–88), one
of the sisters portrayed by Joshua Reynolds (1723–92) as *Three Ladies Adorning a Term of Hymen*,
politely known as *The Three Graces* (1774; Tate, London).[2]

Beresford was active in Parliament and hungry for power. His opportunity came with his
appointment as one of the Commissioners of Revenues, for which he received a remuneration
of £8,000 per annum. During his long-held tenure as Commissioner, he became one of the
most powerful men in Ireland. When the rebuilding of the Dublin Custom House was con-
templated, to Beresford's eternal credit, he invited James Gandon (1741–1823), a London-based
pupil of William Chambers (1723–96), to produce designs for the new building. He further
dissuaded Gandon from accepting an offer, conveyed by Princess Dashkov, of a post and com-
missions to build in St Petersburg, and, despite considerable opposition in Dublin, he finally
procured for Gandon a guarantee that the project would place. The controversial aspect of
Beresford's scheme was to move the site of the Custom House further to the east, which would
allow it to be a more spaciously laid-out building. This was not without self-interest, as that
region of Dublin was being developed jointly by Beresford and his brother-in-law (Elizabeth
Montgomery's husband), Luke Gardiner (later 1st Viscount Mountjoy), who stood to benefit
considerably from the move. Gandon's new Custom House took ten years to build (1781–91) and
cost between £200,000 and £400,000. Upon completion, Beresford was 'sumptuously lodged
in it', while a large room under the north portico, looking out on a crescent put up by Beresford
and named Beresford Place (now demolished), was shown off as 'Mr Beresford's ballroom'.
Gandon's Custom House is one of the most beautiful riverside buildings in Europe, and
the architect went on to make further outstanding contributions to Dublin's architecture,
designing the Four Courts and the King's Inns.

Despite the aesthetic debt that Dubliners owed to Beresford for his taste and foresight in
bringing Gandon to Ireland, he was not a popular public figure, and the harshness of the punish-
ments he administered following the 1798 rebellion further reduced his standing. He was a
leading proponent of the Act of Union and retired to Abbeville, which Gandon had altered by
the addition of a stableyard and dairy. The Abbeville dining table survives at Newbridge.
AC

11

GEORGE BARRET
Dublin *c.* 1728/32–London 1784

River Landscape at Sunset

Oil on canvas, unlined, 5¾ × 8¼ in (14.5 × 21 cm)
Newbridge 18th-century Irish gilt livery frame (type v);
19th-century red hanging-string attached to two
brass rings
INSCRIPTIONS on the reverse of the canvas: inscribed
on label, in brown ink, *No 53 / Small Landscape / by Barrett*;
on the stretcher: inscribed in brown ink, *Bt / for 16.3*;
bookplate of Thomas Cobbe; on the frame: inscribed
in pencil, *By Barrett*
Cobbe Collection, no.66
HISTORY 18th-century Newbridge collection (acquired
for £0.16s.3d); thence by descent (not mentioned by
Frances Power Cobbe)

1 Manuscript letter in the National Art Library, Victoria
& Albert Museum, London (L3532-1976).
2 Crookshank and Glin 1978, p.112.
3 Wynne 1994, p.139.

Cat.11 (reverse)

In a letter of 1775 quoting prices to a client, Barret noted: 'I have painted pictures from 10 ft down to 5 ins.'[1] Indeed, at the beginning of his career, while he was still living in Dublin, the artist received patronage from Thomas Cobbe for both large and, as here, almost miniature landscapes. Barret's early facility in different modes of landscape painting brought him rapid success. Probably through his friend Edmund Burke, he was introduced to Viscount Powerscourt, and he painted extensively in the Dargle Valley. His earliest style – an elegant reflection of Francesco Zuccarelli (1702–88), who had recently arrived in England – is exemplified by his *Italianate Landscape* of 1755, recently acquired by the National Gallery of Ireland. It has been plausibly suggested that the sombre tone and romantic mood of his landscapes of about 1760 show the influence of Burke's *A Philosophical Enquiry into the Origin of our Ideas of the Sublime and the Beautiful*, published in 1757.[2]

Thomas Cobbe commissioned an important set of four landscapes from Barret (Cobbe Collection, nos 52–5). It is possible that the artist came into contact with Cobbe through his friend Lord Powerscourt. The Cobbe family owned land adjoining the Powerscourt estate in Co. Wicklow and, like Lord Powerscourt, were patrons of the architect Robert Mack.

The present gem-like landscape study is in complete contrast to the set of formal works commissioned by Cobbe. Two figures with their backs to the viewer look out over the expanse of a lake while the sun sets, casting subtly captured reflections on the water. Like the set of four larger landscapes, this small view is generically Claudian in composition: early in his career Barret executed copies of two landscapes by the French master, almost certainly for the Rev. Samuel Madden.[3] However, in contrast to the four more highly finished works that formerly hung in the Study at Newbridge, it is tempting to hypothesise that this small oil sketch was executed *en plein air*. While this practice was unusual at this date, it was not unknown. Richard Wilson (1713/14–1782), later to be Barret's great rival in London, showed himself painting at an easel in his *View of Tivoli*, commissioned in 1752 by Joseph Henry of Straffan, Co. Kildare (National Gallery of Ireland, Dublin). Certainly the Cobbe sketch's freedom of execution and sparkling chromatic range could support this theory. Already apparent at this early date is Barret's mottled application of paint to delineate leaves, a technique that was famously attacked by Wilson as 'spinach and eggs'.

WL

12

STRICKLAND LOWRY
Whitehaven 1737–Worcester *c.* 1785

Portrait of Charles Cobbe (1756–98) and his Sister Catherine Cobbe (1761–1839)
as Children in a Landscape

Oil on canvas, unlined, 25½ × 21 in (65 × 53 cm)
Newbridge 18th-century gilt livery frame (type VIII)
INSCRIPTIONS on the reverse of the canvas: inscribed
on label, in brown ink, *No 76 / Chas & Cathe. Cobbe /*
children of Thos Cobbe
Cobbe Collection, no.87
HISTORY 18th-century Newbridge collection (according
to Thomas and Lady Betty Cobbe's account books,
payments for a picture that is probably identical with
this portrait were made on 18 January 1765, to 'Mr Lowry
the painter', for £4.11s, and on 4 April 1765, 'Mr Lowry
for ye pictures of the children', £9.2s); early 19th-century
inventory, no.76; recorded by Frances Power Cobbe in
1868, no.87, in the Library; recorded in the Study in 1901
(Valuation 1901b, p.16) and 1914 (Valuation 1914, £30);
thence by descent
LITERATURE Cobbe 1868 (1882), no.87; Dublin, London
and Belfast 1969–70, p.61; Cornforth 1985a, p.1734,
fig.7

1 Undated letter from Catherine Pelham to Charles
Cobbe, franked in Cheltenham and indistinctly
dated (1833?) (Cobbe Papers: Alec Cobbe). The Charles
Beresford referred to in the letter was probably her
cousin the Rev. Charles Beresford, fourth son of the
Hon. John Beresford (see cat.10); in the early years of the
19th century the Rev. Charles was a personal assistant
to Archbishop Cobbe, and his brother John Claudius
(the third son) ran a bank in Beresford Place. Catherine's
marriage portion may have become embroiled in a
financial dispute over £1,200 (in retrospective borough
expenses) that arose between her father, Thomas Cobbe,
and her uncle, the Hon. John Beresford.

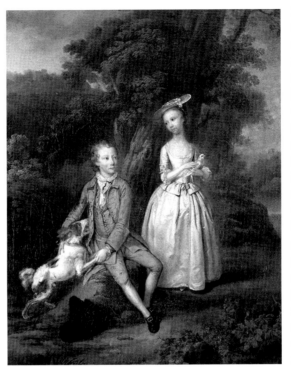

This double portrait represents
Charles and Catherine, the two
eldest of the three children of
Thomas and Lady Betty Cobbe.
Charles Cobbe (see also fig.47) died
in 1798, at the age of 42, leaving his
wife, Lady Anne Trench (*d.*1835; see
fig.48), and parents with enormous
debts and five sons to raise. His
financial difficulties were said to
have resulted from electioneering
for the borough of Swords, of
which Charles was MP. However,
by the age of 18, he had already run
up debts amounting to £10,000
(surely due to gambling), and by
the time of his early death this
figure had more than doubled. In
1788 Thomas and Lady Betty were
forced to sell an entire estate in
Co. Louth, as well as their house
in Palace Row, Dublin, in order to
settle their son's debts and to provide a marriage settlement for their daughter Catherine at
the time of her engagement to the Hon. Henry Pelham (1759–97). Correspondence late in
Catherine's life with her nephew, another Charles Cobbe (see cat.14), expressed concern with
respect to this marriage portion, which amounted to £5,000. She wrote that the money had
been lent to John Hatch (see cat.43), and, after his death, 'his heir Mr Synge paid it off when my
share being unfortunately entrusted to Mr Charles Beresford, he appropriated it to his own
use, for which I pray God to forgive him'.[1] (For additional biographical information about
Catherine, her husband and children, see cat.86.) For further details about the picture and
its little-known author, Strickland Lowry, see p.85.

AC

13

IRISH SCHOOL

Late 18th century

Portrait of Thomas Cobbe (1733–1814)

Pencil and watercolour on vellum, oval,
4¼ × 3½ in (11 × 9 cm)
Ebonised and gilt oval slip frame
INSCRIPTIONS on the reverse of the frame: on paper
backing, in brown ink, *This belongs to Honble Mrs Pelham /*
Thomas Cobbe Esq of / Newbridge County Dublin only /
surviving son of Docr. Cobb(e) / Archbishop of Dublin & /
Lady
Rawdon; inscribed by Joan Mervyn Cobbe, *JMC 1967*; and
also by her, on a label attached to the frame, *For my Son,*
Richard Alexander Charles Cobbe [i.e. Alec Cobbe] */ on my*
decease. / Jan 4 1967 / Joan M Cobbe
Cobbe Collection, no.147
HISTORY Catherine Cobbe, the Hon. Mrs Henry
Pelham, daughter of the sitter; thence by descent
LITERATURE Cobbe 1970, no.8

1 Young 1780, vol.2, p.180.
2 Letter to William Shanley, dated 14 April 1800
(Cobbe Papers: Hugh Cobbe).

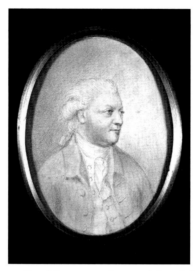

Thomas, second son of Archbishop Cobbe, was born
in 1733. Because his mother died in childbirth, the
Archbishop's unmarried sister, Elizabeth, joined the
household. Thomas seems to have been of a musical
disposition and probably played the violin, as he sub-
scribed to Boyce's *Trio Sonatas* at the age of 12 years.
The Archbishop sent both his eldest stepson, Sir John
Rawdon (see cat.3), and his eldest son, Charles (*b*.1731),
on European travels, when each had respectively
attained the age of 19. Charles never returned, dying
in 1751 at the famous spa, Montpellier, where he had
presumably fallen ill *en route* for Italy. Thomas's
prospects in life were, by this unfortunate circum-
stance, considerably altered. After his education at
Trinity College, Dublin, and matriculation in 1754
at Oxford, his father might well have been reluctant
to allow his – now only – surviving child to embark on a Grand Tour; he seems to have lost no
time in encouraging his marriage to Lady Elizabeth Beresford (see cats 9 and 48), the youngest
daughter of the Earl and Countess of Tyrone, which took place in the spring of 1755.

An indulgent marriage settlement was conferred on the 22-year-old: the entire Newbridge
estate north and south of Dublin, together with lands in Co. Carlow and Co. Louth. The
estates were accompanied by considerable capital sums and allowances. Thomas immediately
instigated a system of accounts, from which the history of Newbridge chattels has benefited
considerably. It seems almost certain that he was tutored, or at least encouraged, in the visual
arts, perhaps to make up for the absence of European travel, by his father's private secretary,
the Rev. Matthew Pilkington, an influence that bore rich fruit in the creation of a picture
gallery and a considerable art collection at Newbridge House.

Thomas Cobbe maintained a wide circle of friends and relations, lived well, and left the
management of his property to an agent, William Shanley, whom Arthur Young encountered
at Curraghmore.[1] Cobbe served as an unremarkable MP for Swords, representing the interests
of his brother-in-law, John Beresford (see cat.10), with whom he later fell out. From the 1780s
he resided chiefly at Bath and, due largely to the debts of his only son, Charles, the Newbridge
estates dwindled in size during his long life. In 1800 he disposed of his father's library and the
chintz beds at Newbridge, not so much for the money but because they were costly items and
he feared they would deteriorate while the house was unoccupied. Fortunately, because
'Pictures & China are articles that will not suffer by lying by', these escaped his sudden burst
of rationalisation.[2] His son predeceased him in 1798, leaving him with five grandsons whose
careers occupied him during his latter years. He handed Newbridge over to his eldest grand-
son, Charles (see cat.14), in 1810 and died at Marlborough Buildings, Bath, in 1814.

There is, surprisingly, no life-size portrait of Thomas Cobbe in the collection, though his
wife and children were all painted at various stages. His likeness survives in only three works:
the present drawing, an oval gouache taken later in life and a silhouette by Hamlet of Bath
(*fl.*1779–1815). I am grateful to Susan Sloman for suggesting that cat. 13, probably by an ama-
teur hand and inscribed on the reverse by his daughter, Catherine (see cats 12 and 86), may
have been taken from such a portrait on the scale of life, now lost to the collection.

AC

14

GEORGE FRANCIS MULVANY
Dublin 1809–Dublin 1869

Portrait of Charles Cobbe, DL (1781–1857)

Oil on canvas 29½ × 24½ in (75 × 62 cm)
Contemporary composition and gilt frame,
supplied by the artist
INSCRIPTIONS signed and dated at lower right,
G. F. Mulvany / 1839
Cobbe Collection, no.88
HISTORY 19th-century Newbridge collection (Charles
Cobbe's account book records a payment of £5 'To
Mulvany for Picture adv.' on 25 March 1839 and a further
payment of £9.14s 'To Mr. Geo Mulvany for Picture &
frame' on 1 May of the same year); recorded by Frances
Power Cobbe in 1868, no.88, in the Library; recorded in
the Library in 1901 (Valuation 1901b, p.11) and 1914
(Valuation 1914, £10); thence by descent
LITERATURE Cobbe 1868 (1882), no.88

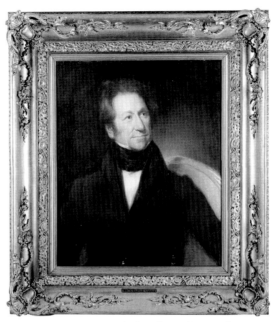

The eldest son of Charles Cobbe, MP
(see cat.12), and Anne Trench (see
fig.47), the sister of William Trench,
1st Earl of Clancarty, Charles was
only 17 when his father died. He was
educated at Winchester and at the
age of 18 – thanks to the efforts of
his grandfather Thomas Cobbe
(see cat.13) and his second cousin,
Viscount Beresford (see cat.101) –
he went to India, having obtained
a commission as lieutenant in the
19th Light Dragoons. The money to
purchase his lieutenancy was lent
to him by Colonel Arthur Wellesley,
later the Duke of Wellington. Cobbe
returned to England after seven
years in the field, his 'health much
broken'.[1] In 1809 he married Frances
Conway (1777–1847), only daughter of Capt. Thomas Conway of Morden Park, Surrey. The
following year he inherited the Newbridge estate from his grandfather, who had retired
permanently to Bath.

For nearly 50 years, as squire of Newbridge, Charles 'laboured incessantly to improve the
condition of his tenants and of the country at large, and actively performed all the duties of
a country gentleman, a guardian of the poor and a magistrate'.[2] He is best remembered for
having sacrificed the two most important paintings of the collection that he had inherited,
the landscapes by Hobbema and Dughet (cats 24 and 40), to fund the building of 80 stone and
slate cottages for his mountain tenants (see pp.87–9). The sale of the Hobbema and Dughet
took place in November 1839, only eight months after the present portrait was commissioned
from George Francis Mulvany, who received an advance from the sitter in March of 1839 and
final payment in May.

Mulvany came from a family of artists: his father was the landscape and figure painter
Thomas James Mulvany (1779–1865), who was the first Keeper of the Royal Hibernian
Academy, Dublin, and his uncle was John George Mulvany (*d.*1838), RHA. In 1862 George
Francis Mulvany was appointed the first director of the newly established National Gallery
of Ireland, a post he held until his death in 1869.

AC

15

ATTRIBUTED TO HERMAN VAN SWANEVELT
Woerden *c.* 1600 – Paris 1655

Landscape with Muleteers and Cattle

Oil on panel, 12 × 16 in (30.5 × 40.5 cm)
Newbridge 18th-century gilt livery frame (type VII),
remains of pinned-down leather hanging-loop
on the reverse
INSCRIPTIONS on the reverse of the panel: bookplate
of Thomas Cobbe; bookplate of Alec Cobbe; on frame:
inscribed in graphite, *17 by 13*; by Thomas Cobbe, in
brown ink, *J Artois*; in another hand, also in brown ink,
6 foot bare; on label, also in brown ink, *No. 9*
Cobbe Collection, no.15
HISTORY 18th-century Newbridge collection; recorded
by Frances Power Cobbe in 1868, no. 15, in the Drawing
Room; recorded in the Drawing Room in 1901
(Valuation 1901a, p.26) and 1914 (Valuation 1914, £40);
thence by descent
LITERATURE Cobbe 1868 (1882), no.15; Laing/Cobbe
1992, p.3, no.15

1 Cobbe 1868, no.6: 'Sunset. Painter – Jacques d'Artois,
died 1665 [*sic*]'.
2 The attribution is also supported by Christopher
Wright, communicated in a letter dated 19 December
1997 to Alec Cobbe. For comparable compositions, see
the *Landscape* in the Galleria Doria Pamphilj, Rome (see
Waddingham 1960, fig.31b); a *Landscape* with the London
dealer Fischman in 1956 (a photograph of which is in the
Rijksbureau voor Kunsthistorische Documentatie, The
Hague); and a *Landscape* (formerly?) in the collection of
the Marquess of Linlithgow, Hopetoun House (see
Waagen 1854–7, vol.2, p.319).
3 See Waddingham 1960, p.39; Amsterdam, Boston and
Philadelphia 1987–8, p.489; and Montreal 1990, p.182.
4 Museum Bredius, The Hague (inv.no.115).
5 See Amsterdam, Boston and Philadelphia 1987–8,
p.489, and Turner (ed.) 2000, pp.347–8.
6 See Stechow 1966, pp.149–52, who grouped the Dutch
Italianate artists into three generations.
7 See Montreal 1990, p.182.
8 Compare Breenbergh's *flight into Egypt* of 1634 in the
Alte Pinakothek, Munich (inv.no.1647), and van
Poelenburch's picture of the same subject from 1625 in
the Centraal Museum, Utrecht (inv.no.839); see also
Amsterdam, Boston and Philadelphia 1987–8, no.69
(van Polenburch), and p.407, fig.2 (Breenbergh).
9 See Stechow 1966, pp.152–64, and Turner (ed.) 2000,
p.347.

In this picture the artist evokes an idealised vision of the countryside outside Rome, with its gently rolling hills dotted by ancient ruins and bathed in the warm light of the Mediterranean sun. The composition is divided into two distinct areas. The path extending from the foreground leads up a slope on the left, curving around a massive rock. On the path stand a man with his dog and a muleteer pointing something out to the woman next to him. To the right of the path runs a stream that separates the foreground from the sunny pasture and ancient ruins beyond. On the pasture there are two figures with a small herd of cows and sheep, and in the far distance one can make out the faint outline of hills.

Throughout the picture the artist makes clever use of light to structure the composition. Much of the foreground is cast in shadow, as the sunlight coming in from the left is blocked out by the massive rock. Only the figures in the lower left corner catch a few rays, as do the trees that flank the winding path. The pronounced contrast between the shaded foreground and the brightly lit pasture further back accentuates the depth of the space. The recession is further underscored by the sudden change in scale between the large trees in the foreground and the smaller ones next to the ancient ruins.

When the picture entered the collection of Thomas Cobbe in the 18th century, it was attributed to Jacques d'Artois (1613–86), an attribution that was maintained by Frances Power Cobbe in her catalogue of the collection of 1868.[1] However, d'Artois, a Flemish artist from Brussels, painted mostly landscapes based on his native Flanders and not Italianate scenes such as the present painting. The more recent attribution to Herman van Swanevelt, on the other hand, seems much more plausible: there are several other works by him that follow a similar compositional pattern,[2] and van Swanevelt excelled in, and was celebrated for, his depictions of the idyllic Roman *campagna*, complete with ancient ruins and small figures and animals.

In the more recent literature, much has been made of the close connection between Claude Lorraine (1604/5–1682) and van Swanevelt, and authors generally agree that they must have influenced each other.[3] However, in the present picture, van Swanevelt seems to have taken his inspiration not from Claude's classical landscapes, with their more horizontal compositions and arcadian subjects, but rather from the works of a number of other Northern painters who were living in Rome at the time that he was there.

Van Swanevelt came to Rome in 1629, and his first dated Roman picture is an Old Testament scene of 1630.[4] He stayed until 1641, when he moved north. From 1644, after he had become *peintre ordinaire* to the King of France, he spent the remainder of his career in Paris.[5] When he arrived in Rome, two of the most important and celebrated landscape painters were Cornelis van Poelenburch (1594/5–1667) and Bartholomeus Breenbergh (1598–1657). Both artists had moved to Rome in the second decade of the 17th century and were among the earliest members of the association of Dutch painters in Rome, the so-called Schildersbent. They belong to the first generation of Dutch Italianate painters.[6] Influenced by Paul Bril (*c.*1554–1626) and Adam Elsheimer (1578–1610), they began to specialise in idealised depictions of both the ancient

ruins in Rome and the countryside outside the eternal city. According to Joachim van Sandrart (1606–88), van Swanevelt spent much of his time 'haunting the ancient ruins and deserted places of Rome and Tivoli', which gained him his nickname 'Eremiet' (Dut.: 'hermit') from his fellow artists in the Schildersbent.[7]

The present picture seems to take much of its inspiration from the diagonal compositions, the dramatic light effects and the portrayal of ancient ruins of Breenbergh and van Poelenburch.[8] Indeed, it has been argued that van Swanevelt represents an important link between this first generation of Dutch Italianates and the second generation, consisting of artists, such as Jan Both (c.1618–1652), Jan Baptist Weenix (1621–60/61) and Nicolaes Berchem (1620–83), who came to Rome in the 1640s.[9] The Cobbe painting is a good example of the type of small cabinet picture of Italianate scenes in which Northern collectors of the 17th and 18th centuries took great delight.

AR

16

CORNELIS (GERRITSZ.) DECKER
fl. Haarlem 1643–78

River Landscape

Oil on panel, 14½ × 19¼ in (37 × 49 cm)
Newbridge 18th-century gilt livery frame (type VII)
INSCRIPTIONS signed and dated at lower left, *C. Decker /
1651*; on the reverse of the panel: inscribed in black ink,
By Decker / at Ribton's Sale / 1764 4. 11. 0; bookplate of
Thomas Cobbe; inscribed on label in brown ink, *N 44 /
LandsCape / by Decker's*; printed label from 1872 Dublin
exhibition; another printed label, *1160*; bookplate of
Alec Cobbe; and on the frame: inscribed in graphite,
19¼ by 14¾; in brown ink, *6 foot 6 ½*; on label, in brown
ink, *4 / Landscape by / H. Dankers*
Cobbe Collection, no.4
HISTORY 18th-century Newbridge collection (acquired
at the Ribton sale, Dublin, 1764; an account book entry
for 12 March 1764 records a payment of £22.2s. for
'Ribton's bill in full for 5 pictures'); early 19th-century
inventory, no.44; recorded by Frances Power Cobbe
in 1868, no.4, in the Drawing Room; thence by descent
EXHIBITIONS Dublin 1872, no.100 or no.177 (two land-
scapes by Decker are recorded as being lent by Charles
Cobbe, although the contemporary catalogue at
Newbridge records only one)
LITERATURE Cobbe 1868 (1882), no.4; Stewart 1995,
vol.1, p.181, vol.3, p.75

1 Miedema 1980, pp.601, 603, 605, 932, 1033 and 1041.
For a discussion of the artist's life and work, see also
Saur, vol.25, pp.125–6.
2 See, for example, his *Interior of a Weaver's Workshop*,
in the sale, Philips, London, 8–12 December 1987, lot 3.
3 It is commonly assumed that his last work is the *Edge
of an Oak Forest*, dated 1666, in the Statens Museum for
Kunst (see *Cat. Copenhagen* 1951, p.69, no.161).
4 Stechow (1966, p.32), who did not find him worthy of
a separate discussion, grouped Decker with 'a host of
imitators of [Salomon van Ruysdael's] own and his
nephew's [Jacob van Ruisdael's] style, such as Dubois,
Van Borssum, Claes Molenaer …, the Rombouts, and
many others.'
5 This quality has led one writer to refer to him as the
'*Planken-Maler*' ('painter of wooden planks'); see Bol
1969, p.209. Examples include the *Landscape with a Sandy
Path*, signed and dated 1649 (oil on panel, 15 ¾ × 20 ⅞
in [40 × 53 cm]), in the Narodní Galerie, Prague (inv.no.
O-9116), and the *Landscape with Farms*, signed and dated
1650 (oil on panel, 18¼ × 25 in [46.5 × 63.5 cm]), in the
Hermitage, St Petersburg (inv.no.944).
6 Dublin 1872, nos 100 and 177.

In this painting Cornelis Decker
depicted a somewhat intimate view of
a small, hilly patch of land with a little
stream running through it. Seen from
a slightly elevated vantage-point, the
setting is surrounded by bushes, trees
and a few farm houses, which prevent a
glimpse into the deeper recesses of the
landscape. A few small figures – a child
taking flight from a dog across the little
bridge and a goatherd surrounded by
her goats – populate the scene.

The focal-point of the composition
is the large tree in the centre, silhouetted against the cloudy sky. The scene is otherwise struc-
tured by the artist's clever use of light; the dark bushes in the left foreground function as a
repoussoir, setting off the sun-drenched clearing beyond, while on the right a subtler rhythm
between brightly lit and shaded areas describes the recession of the space.

Nothing is known about the origins of Cornelis Decker. He first appears in the records of
the painters' guild in Haarlem between 1642 and 1644, and in 1646 he is mentioned as a pupil
of the Haarlem landscape painter Salomon van Ruysdael (1600/03–70).[1] However, somewhat
surprisingly, there are already dated works by him from the 1630s,[2] which suggests that
Decker may have had an earlier teacher and that he was already a trained painter by the time
he entered van Ruysdael's workshop. His last works date from the mid-1660s.[3]

Decker's oeuvre consists to a large extent of landscapes that draw heavily on the works of
Salomon van Ruysdael and Jan van Goyen (1596–1656).[4] Decker's numerous river and canal
views, in particular, with their diagonally receding compositions, enlivened by small fishing
boats and farm buildings, windmills and small villages along the banks, betray van Ruysdael's
influence. The present painting, however, belongs to another group of works, which show
picturesque wooded settings with sandy paths, large trees and derelict farm buildings. These
scenes seem to be influenced by painters such as Salomon's nephew Jacob van Ruisdael
(*c*.1628/9–1682) and Meindert Hobbema (1638–1709). Here Decker's particular talent reveals
itself in the close observation and faithful description of weathered fences and other wooden
surfaces.[5] These works, very much like the present picture, usually feature pronounced light
effects, with bright, almost spot-lit areas contrasting sharply with other parts of the land-
scape, which both help to structure the composition and lend the scene a certain degree of
monumentality and drama. Decker's landscapes are often populated by a few small staffage
figures, representing peasants, herdsmen and travellers. Occasionally the staffage is the work
of the Haarlem painter Adriaen van Ostade (1610–85). Finally, Decker also produced a few
paintings of weavers' workshops, which are related to the work of Gillis Rombouts (1630–1672
or before).

This type of finely executed small-scale landscape was popular with collectors in the 18th
century, and Thomas Cobbe acquired a number of such works for the collection (e.g. cats 15,
21–3 and 28). Interestingly, in 1872 two landscapes by Decker are recorded as being lent by
Charles Cobbe to an exhibition in Dublin,[6] but the contemporary inventory of the collection
at Newbridge mentions only one work by the artist (for a possible explanation see cat.20).
AR

17

DUTCH SCHOOL (?)

c. 1640

Portrait of a Lady

Oil on canvas, unlined, 35¼ × 27½ in (89.5 × 70 cm)
Newbridge 18th-century carved and gilt frame
INSCRIPTIONS on the reverse of the canvas: Charles
Cobbe bookplate (4); on the frame: inscribed on label,
in ink, *36*; and bookplate of Alec Cobbe
Cobbe Collection, no.1
HISTORY 18th-century Newbridge collection; recorded
by Frances Power Cobbe in 1868, no.1, in the Drawing
Room; recorded in the Drawing Room in 1901
(Valuation 1901a, p.27) and 1914 (Valuation 1914, £50,
described as 'A Spanish Lady'); thence by descent
LITERATURE Cobbe 1868 (1882), no.1; Laing/Cobbe 1992,
p.3, no.1

Cat.17a. *Interior of the Drawing Room, Newbridge* (detail),
pen and ink, 11¾ × 18¾ in (300 × 475 mm), *c.*1842
(Cobbe Collection, no.203)

1 See Kinderen 1950, figs 99, 120, 132b, 131f and 133f.
2 Rijksmuseum, Amsterdam (on loan from the van
Weede Family Foundation).
3 The attribution was first proposed by Simon
Dickinson and was taken up by Laing/Cobbe 1992, p.3,
no.1.
4 A further attribution to the Bruges painter Jacob van
Oost I (1603–71) has been suggested by Drs Jan Kosten of
the Rijksbureau voor Kunsthistorische Documentatie,
The Hague.
5 Valuation 1901a, p.27.

The sitter's dark complexion prompted
an early 'country-house' attribution of this
portrait to Diego Velázquez (1599–1660).
However, her black dress, three-fold flat lace
collar and lace cuffs were extremely fashion-
able in Amsterdam around 1640;[1] a near
identical lace collar is worn by the daughter
of one of the richest men in Amsterdam in
the *Portrait of Maria Trip* (1639) by Rembrandt
(1606–69).[2] In the 1980s the present painting
received an attribution to Abraham van den
Tempel (1622/3–72), a Frisian artist who
moved around 1640 to Amsterdam, where he
was influenced by the fashionable portrait
painter Bartholomeus van der Helst (*c.*1613–
1670) and also by Jacob Backer (1608–51),
in whose studio he trained.[3] More recently,
Christopher Wright has suggested that it
was painted by the Flemish portrait artist Justus Sustermans (1597–1681), who was born and
trained in Antwerp and who in 1620 migrated to Italy, where he died in Florence.[4]

The *Portrait of a Lady* is the first entry in Frances Power Cobbe's *Catalogue of Pictures* of 1868
and hung at the upper level to the right of the entrance door of the Drawing Room. It is also
shown in that position in a pen-and-ink drawing of the room of *c.*1842 (cat.17a). By 1868,
the Velázquez attribution had been abandoned in favour of a mere indication of date, 'temp.
Charles Ist'. However, by 1901 it had regained an association with the Spanish School.[5]

MB

18

HENDRICK MOMMERS
Haarlem *c.*1623–Amsterdam 1693/7

A Vegetable Market in Trajan's Forum

Oil on canvas, unlined, on original fixed stretcher,
31½ × 37 ½ in (80 × 95 cm)
Newbridge 18th-century gilt livery frame (type VII);
remains of pinned-down leather hanging-loop
INSCRIPTIONS signed at lower left on plinth of
fountain, *Mo*; on the reverse: bookplate of Thomas
Cobbe on back of frame across to stretcher; inscribed
on label, in ink, *No 26*; on the frame: inscribed in
graphite, *3 f 2 ¼ by – 2 f 8 ½*; and in brown ink, *12 foot 9*
Cobbe Collection, no.25
HISTORY 18th-century Newbridge collection (acquired
before 1770); recorded by Frances Power Cobbe in 1868,
no.25, in the Drawing Room; recorded in the Drawing
Room in 1901 (Valuation 1901a, p.26, no.17) and 1914
(Valuation 1914, £42); thence by descent
LITERATURE Pilkington 1770, p.400: 'A good picture of
this master's [Monnicks or Monnix] hand, is in the pos-
session of Thomas Cobbe, / Esq; in Dublin'; Cobbe 1868
(1882), no.25; Laing/Cobbe 1992, p.4, no.2

Cat.18a. The piazza as it appears today

1 Pilkington 1770, p.400.
2 One offered by the London dealer J. Bruinse, *c.*1928
(photograph in the Rijksbureau voor Kunsthistorische
Documentatie, The Hague); the second included in a
sale, Achenbach, Berlin, 25 January 1939, illus. in *Die
Weltkunst*, 22 January 1939 (photograph also in the RKD,
The Hague); another in sale, Weinmüller, Munich, 16
December 1953, lot 1644, pl.33.

This picture was described by Matthew
Pilkington as 'a good picture' by the
hand of 'Monnicks, or Monnix', whereas
it is, in fact, by Hendrick Mommers.[1]
Pilkington confused Mommers and
Pieter Moninckx (1606–86), probably
on account of the first two letters of
their surnames, which appear as a sig-
nature on the picture. He therefore
ascribed to Moninckx the characteris-
tics of Mommers's pictures. Although
Moninckx made a few drawings of
Rome, his surviving, signed paintings
are of other subjects and entirely unlike
the work of Mommers. Interestingly, Pilkington's confusion regarding the subject-matter
of Moninckx's works survived in the biographies of his successors well into the 19th century.

Hendrick Mommers was born in Haarlem and completed his apprenticeship with Nicolaes
Berchem (1620–83) in 1647, when he became a master of the Haarlem guild. It is not known
when exactly he travelled to Italy. The vegetable market here is typical of his work, and there
exist at least three other market pictures by Mommers in which Trajan's Column and the
church of S Maria di Loreto form the background.[2] These would almost certainly have been
painted after Mommers's return to Haarlem, and his repeated use of the same urban motif
illustrates the 17th-century Dutch taste for genre scenes in Italianate topographical settings.

The composition shows the ancient Forum of Trajan as seen from the east; the Column
was dedicated in AD 113 to commemorate the Emperor's Dacian conquests. It was enclosed in
Imperial times by the Basilica Ulpia, the Latin and Greek libraries and the Temple of Trajan.
The remains of these buildings were invisible when Mommers visited what was then a pleasant
piazza surrounded by 16th- and 17th-century buildings, with the column surmounted by a
statue of St Peter, which replaced that of Trajan in 1588. Much of the piazza was demolished in
the 20th century in the excavation of Trajan's Forum. Of the view seen here, little more than
the column and the church of S Maria di Loreto now survive (cat.18a).
MB

19

ATTRIBUTED TO GILLIS ROMBOUTS
Haarlem 1630–Haarlem 1672 or before

Landscape with a Bridge

Oil on panel, 28⅞ × 22¾ in (73.5 × 58 cm)
Newbridge 18th-century gilt livery frame (type VII)
INSCRIPTIONS signed at lower right on the rock,
Rontbovt; on the reverse of the panel: bookplate of
Thomas Cobbe; printed label from 1872 Dublin exhibi-
tion; another printed label, *1157*; and on frame: inscribed
in graphite, *2 f 5 by 23 Inch*; in brown ink, *9 foot … a half*;
on label, in brown ink, *40*; on another label, also in brown
ink, *40 Landscape with Bridge / By N. Rontbout*, over a mainly
illegible label, also inscribed in brown ink, *Donabate*;
and printed label from 1957 Dublin exhibition
Cobbe Collection, no.40
HISTORY 18th-century Newbridge collection (acquired
before 1770); recorded by Frances Power Cobbe in 1868,
no.40, in the Drawing Room; recorded in the Drawing
Room in 1901 (Valuation 1901a, p.26) and 1914 (Valuation
1914, £30); thence by descent
EXHIBITIONS Dublin 1872, no.169 (as by 'N. Rontbout');
Dublin 1957
LITERATURE Pilkington 1770, p.521: 'N. Rombout … An
excellent landscape painted by this master, in his best
style, is in the possession of Thomas Cobbe, Esq; it rep-
resents a view of a bridge between two hills; and in per-
spective under that grand arch, is an agreeable pros-pect
of a river, a distant range of hills, and an antique tower
on the border of the stream, which has a fine effect. The
name of Rontbout is inscribed on this picture.'; Burke
1852, p.2; Cobbe 1868 (1882), no.40; Stewart 1990, vol.2,
p.626; vol.3, p.75; London 1996b, p.34

1 Pilkington 1770, p.521; Cobbe 1868, no.40.
2 See Wurzbach 1906–11, vol.2, p.466.
3 Thieme–Becker, vol.28, p.556.
4 Ibid., and Bénézit, vol.11, p.867.
5 Slive 1995, p.205.
6 See, for example, Jan Both's *Mountain Pass with a Large
fir Tree*, of *c*.1647–50, in the Detroit Institute of Arts
(inv.no.89.31; see Amsterdam, Boston and Philadelphia
1987–8, no.14); Herman van Swanevelt's *Landscape with
fishermen* (see Wadingham 1960, fig.28); Adam
Pynacker's *Stone Bridge*, of *c*.1654, in the collection of the
Earl of Crawford & Balcarres, Scotland (see Harwood
1988, pp.68–9, no.43, and Amsterdam, Boston and
Philadelphia 1987–8, p.396, fig.1), as well as his *Italianate
Landscape with a Bridge*, of *c*.1653, in the Dulwich Picture
Gallery, London (inv.no.183; see Harwood 1988, pp.61–2,
no.32, pl.32 and colour pl.VIII).

This painting of a mountainous landscape takes
us to an imaginary place in Italy. The foreground
depicts a rocky and impassable setting populated
by a few minute figures. With a stone bridge sus-
pended between them, they frame the view into
the distant landscape with a river and further
hills with buildings on top. The artist has used
the warm sunlight to great dramatic effect. The
immediate foreground is cast into darkness, which
contrasts sharply with the illuminated patches on
the rocky bottom of the valley. The bridge and the
rocks to either side are cast in shadow, thereby
creating a powerful silhouette against the bright
sky. This contrast also enhances the depth of the
sunlit landscape beyond.

In the early records of the Cobbe Collection,
the picture, signed *Rontbovt*, was catalogued as being by a certain 'N. Rontbout'.[1] This is most
certainly a misunderstanding, as the only 'N. Rontbout', or Rombouts, is Claes or Nicolaes
Rombouts, a glass painter active in Louvain and Brussels between 1480 and 1519.[2] The present
picture was almost certainly painted by a member of the Rombouts family active in Haarlem
in the 17th century. Gillis Rombouts was a landscape painter who worked in the style of Jacob
van Ruisdael (*c*.1628/9–1682).[3] He became a master in the Haarlem guild in 1652. What is pre-
sumed to be his son Salomon Rombouts may have been born in 1652 and died before 1702,[4]
though other authors have suggested that Salomon was active in Haarlem between 1652 and
1663 (which would suggest that he was Gillis's brother rather than his son).[5] In any event,
because of their stylistic similarities, it is extremely difficult to distinguish between the works
of these two artists. Moreover, their signatures, which most often omit the first name, do
not differ sufficiently to come to any reliable conclusions. To date the only suggested attribu-
tion for the Cobbe picture was made on the mount of the photograph at the Rijksbureau voor
Kunsthistorische Documentatie in The Hague, where the picture is attributed to Gillis
Rombouts, the designation maintained here.

While some of the dramatic light effects (which clearly derive from Jacob van Ruisdael) are
typical of the works of both Gillis and Salomon Rombouts, the present picture is unusual in
representing an Italianate setting, whereas most of their works repeat the Northern or Dutch
subjects preferred by van Ruisdael and Meindert Hobbema (1638–1709). The distinct lighting
and strong contrasts have in the past also led to confusion between the works of the Rombouts
and Cornelis Decker (see cat.16). Furthermore, the motif of the bridge as it has been used in this
picture is not very characteristic of the Rombouts: it is far more reminiscent of Dutch Italianate
painters such as Jan Both (*c*.1618–1652), Herman van Swanevelt (*c*.1600–1655) and, most strikingly,
Adam Pijnacker (*c*.1620-1673).[6]

Although the authorship of the picture is uncertain, its merits are apparent. The careful
observation of the details and light effects, coupled with the unusual and dramatic composi-
tion, must have convinced Thomas Cobbe that the picture would be an interesting addition
to his fine collection of Dutch Italianate pictures (see cats 15, 23 and 28).

AR

20

KLAES MOLENAER
Haarlem 1630–Haarlem 1676

Travellers Resting near Cottages

Oil on panel, 13 × 15 in (33 × 38 cm)
Newbridge 18th-century gilt livery frame (type VII);
remains of pinned-down leather hanging-loop on
reverse
INSCRIPTIONS signed at lower right, *K Molenaer*; on
the reverse of the panel: bookplate of Thomas Cobbe;
inscribed on label, in brown ink, *N 60 / Landscape / by
Molenaer*; and bookplate of Alec Cobbe; on the frame:
inscribed in graphite, *15 ½ by 13 ¾*; and in brown ink,
5 foot & a half
Cobbe Collection, no.10
HISTORY 18th-century Newbridge collection; early
19th-century inventory, no.60; recorded by Frances
Power Cobbe in 1868, no.10, in the Drawing Room;
recorded in the Drawing Room in 1901 (Valuation 1901a,
p.26) and 1914 (Valuation 1914, £25); thence by descent
EXHIBITIONS Dublin 1872, no.100 or no.177 (erroneously
attributed to Decker; according to Frances Power
Cobbe's catalogue, this picture was among the paint-
ings that were lent to the 1872 exhibition, the catalogue
for which lists two paintings from Newbridge as by
Decker)
LITERATURE Cobbe 1868 (1882), no.10; Laing/Cobbe
1992, pp.1 and 3, no.10

As with most of the landscape artists represented in the Cobbe Collection, Klaes Molenaer was born and worked in Haarlem. The popularity of the Haarlem school resulted from the influence and success of the greatest contemporary Dutch landscape painter, Jacob van Ruisdael (1628/9–82), whose *Landscape with Cornfields* was part of the Cobbe Collection (no.11) from the 18th century to the 1960s.

Klaes Molenaer was born in 1630, the son of Claes Jansz. Molenaer and a nephew of the genre and portrait painter Jan Miense Molenaer (*c*.1610–1668), whose wife Judith Leijster (1609–60) was a pupil of Frans Hals (1581/5–1666). Signed early works by Klaes Molenaer are known from 1647, which, as guild regulations did not allow apprentices to sign their work, suggests that he was by then already a master. These early landscapes show knowledge of the work of Jan van Goyen (1596–1656), then resident in The Hague, while later works are reminiscent of Salomon van Ruysdael (1600/03–70) and his nephew Jacob van Ruisdael. In addition to landscapes such as the present work, with its typical woolly foliage, Molenaer painted ice and fair scenes, as well as views of the Dutch towns of Delft, Scheveningen (near The Hague) and Egmond-aan-Zee. His treatment of architectural features is distinctive.

MB

21

BARENT GAEL

Haarlem ? 1630s–Amsterdam 1687 /1703

Village Inn

Oil on canvas (probably unlined and stretched over an independently fixed backing canvas; a batten was fixed to the upper edge of the stretcher after the backing canvas had been stretched, but *prior* to the stretching of the original canvas, which retains its tacking edges and is thus stretched over the upper edge batten), 21 × 25 ¼ in (53.5 × 64 cm)
Newbridge 18th-century carved, pierced and gilt frame, attributed to Richard Cranfield
INSCRIPTIONS signed and dated at lower left, B. GAEL/ *1669*; on the reverse of the stretcher: Charles Cobbe bookplate (2); inscribed in brown ink, *8 foot 9 inches each*; and numbered on label, 47
Cobbe Collection, no.6
HISTORY 18th-century Newbridge collection; recorded by Frances Power Cobbe in 1868, no.6, in the Drawing Room; recorded in the Drawing Room in 1901 (Valuation 1901a, p.26, no.23) and 1914 (Valuation 1914, £80 for the pair); thence by descent to Hugh Cobbe; sale, Christie's, London, 16 December 1998, one of a pair in lot 81; bought by Johnny Van Haeften; from whom purchased by Alec Cobbe
LITERATURE Cobbe 1868 (1882), no.6

1 Houbraken 1718–21, vol.3, p.256: '*wels aart van schilderen hy al vry wel wist na te bootsen*'.
2 Thieme–Becker, vol.13, p.36.
3 The year of Gael's death is not entirely clear. Bénézit (vol.5, p.783) suggests that he died either in 1687 or in 1703; Wurzbach (vol.1, p.564) said that he was still active in 1687; while Bol (1969, p.239) gives 1698 as the year of his death.
4 Walter Liedtke, in his recent entry on Carel Fabritius's *View of Delft with an Instrument Seller's Stall*, in the National Gallery, London (inv.no. NG 3714; see New York and London 2001, no.18, p.250, n.2), has observed the popularity of this name for inns in the Netherlands in the 16th and 17th centuries. See also the beer keg featuring a white swan on the sleigh in Aelbert Cuyp's *Ice Scene in front of the Huis te Merwede near Dordrecht*, of the 1650s, in the collection of the Earl of Yarmouth, Brocklesby (see Amsterdam, Boston and Philadelphia 1987–8, no.23, pp.298–300, and Washington, DC, London and Amsterdam 2001–2, no.32), where the swan represents the symbol of Dordrecht's main brewery.

Barent Gael was probably born in Haarlem in the 1630s. In his short account of the artist, Arnold Houbraken (1660–1719) mentioned that Gael was a pupil of the Haarlem landscape painter Philips Wouwerman (1619–68), 'whose manner of painting he could imitate very well'.[1] In Haarlem, Gael also painted staffage figures for Jan Wijnants (1631/2–1684) and other local artists.[2] Shortly after 1660 he seems to have accompanied Wijnants to Amsterdam. His last dated painting is from 1681, and he died in Amsterdam sometime between 1687 and 1703.[3]

Cats 21 and 22, two well-preserved – and probably unlined – paintings, are both entirely characteristic of Gael's oeuvre, which consists mainly of similar depictions of Dutch villages (besides a small number of winter scenes). Although Gael had trained with Wouwerman, the Cobbe works seem much closer in composition and figure style to the paintings of Adriaen van Ostade (1610–85) and his brother Isaac van Ostade (1621–49). In some passages the handling of the paint also recalls the style of Wijnants.

The present picture shows a large tent in the foreground, with a number of people gathered in front of it. Beyond the tent a row of buildings extends along the diagonally receding road towards the back. In the distance one can make out the gently rolling dunes characteristic of the Dutch countryside close to the North Sea coast. In front of the tent and the buildings groups of people – peasants, soldiers and horsemen – have gathered to rest and to enjoy each other's company. The absence of any performances, such as singing, dancing or music-making, and further stalls and tents (*cf*. cat. 22) suggests that the subject of the picture is relaxation before an inn rather than a village fair. In this case the tent on the left is perhaps a makeshift tavern, apparently named 'The (White) Swan', according to the sign above the entrance.[4] Both subjects – the village inn and the village fair – were very popular in the 17th century, and many of Gael's contemporaries painted similar scenes.

AR

22
BARENT GAEL
Haarlem ? 1630s–Amsterdam 1687/1703

Village Fair

Oil on canvas (as for cat.21), 21 × 25 ¼ in (53.5 × 64 cm)
Newbridge 18th-century carved, pierced and gilt frame,
attributed to Richard Cranfield
INSCRIPTIONS signed B. GAEL; on the reverse: bookplate
of Thomas Cobbe
Cobbe Collection, no.14
HISTORY 18th-century Newbridge collection; recorded
by Frances Power Cobbe in 1868, no.14, in the Drawing
Room; recorded in the Drawing Room in 1901
(Valuation 1901a, p.26, no.23) and 1914 (Valuation 1914,
£80 for the pair); thence by descent to Hugh Cobbe; sale,
Christie's, London, 16 December 1998, one of a pair in
lot 81; bought by Johnny Van Haeften; from whom pur-
chased by the Pelican and Coronet Company
LITERATURE Cobbe 1868 (1882), no.14

1 For examples of works conceived as pendants, see the
pair in the sales at Christie's, London, 3 December 1997,
lot 126, and at Dorotheum, Vienna, 19 June 1979, lot 47.
2 See essay by Mariët Westerman in Washington, DC,
and Amsterdam 1996–7, pp.58–9.

Although the similar dimensions and
complementary compositions of cats 21
and 22 suggest that they were conceived
as a pair, to be hung side by side, unfortu-
nately there is no provenance information
about the pictures prior to their presence
in the Cobbe Collection in the 18th century,
and, given the large number of very sim-
ilar works by Gael as well as their generic
character, it is impossible to come to a
definitive conclusion as to whether or not
they originally belonged together.[1]

Cat.22 shows a sandy road diagonally
receding in the opposite direction from the previous scene, which is one of the reasons why it
seems possible that the two pictures were conceived as pendants. Here the road is lined with
several houses, and in the distance one can make out a number of stalls and tents, as well as the
town's church. In the foreground people have gathered in front of an inn to enjoy themselves.
Watched by the rest of the crowd, a young couple is dancing to the music played by the fiddler
at the back. Further down the road there is a large crowd of people strolling and chatting
between the tents and stalls. In contrast to its pendant, this picture does indeed show a village
fair. Typically, *jaarmarkten* (annual fairs) and *kermissen* (fairs that had a religious origin) were
the venue for performances of travelling groups of actors and of members of the local rhetori-
cians' chambers, the so-called *rederijkers*, as well as for quacks and charlatans. The tradition of
these depictions, which were intended as showcases of the comic world with its human foibles
and follies,[2] goes back to 16th-century Flemish prints and paintings, for example the pictures
of peasant fairs by Pieter Bruegel the elder (?1525/30–69) and his son.
AR

23
ABRAHAM BEGEYN
Leiden 1637/8–Berlin 1697

Landscape with Muleteers Watering their Animals

Oil on canvas, unlined, 28½ × 25 in (72.5 × 63.5 cm)
Newbridge 18th-century gilt livery frame (type VIII);
remains of pinned-down leather hanging-loop on
reverse
INSCRIPTIONS signed and dated at lower left, *AB*[in
ligature]*egein f / 1662*; on the reverse, on the stretcher:
Charles Cobbe bookplate (2); and on the frame:
inscribed on label, in brown ink, *Charles Cobbe Esq /
Newbridge Donabate*; printed label from 1872 Dublin
exhibition; another printed label, *1153*; another label,
printed in blue, *689*; with yet another label, inscribed
in brown ink, *Mr Cobbe*
Cobbe Collection, no.32
HISTORY presumably anonymous [Hennin] sale,[1]
Remy, Paris, 17ff. January 1764, lot 44: '*Des figures &
Animaux, plusieurs s'abreuvent à une Fontaine: ce Tableau qui
est chaud de coloris, est peint par A. Begein en 1662; il est sur toile
& porte deux pieds deux pouces de haut, sur deux pieds de large*'
(bought for *72 livres*); 18th-century Newbridge collec-
tion; recorded by Frances Power Cobbe in 1868, no.32, in
the Drawing Room; recorded in the Drawing Room in
1901 (Valuation 1901a, p.26) and 1914 (Valuation 1914,
£40); thence by descent
EXHIBITIONS Dublin 1818, no.35; Dublin 1832, no.44;
Dublin 1872, no.165
LITERATURE Burke 1852, p.2 (as by Bergham); Cobbe
1868 (1882), no.32; Laing/Cobbe 1992, p.5, no.32; Stewart
1995, vol.1, p.43; vol.3, no.74

1 For Hennin, see cat.26.
2 MacLaren and Brown 1991, vol.1, p.18. For further
evidence of the Italian sojourn, see Begeyn's painting of
the *Harbour of Naples*, dated 1659, in the Musées Royaux
des Beaux-Arts, Brussels (inv.no.10; see *Cat. Brussels* 1984,
p.17).
3 Saur, vol.8, p.273.
4 For Berchem's painting, see Montreal 1990, pp.66–7,
no.10, and for Begeyn's painting, see n.2 above.
5 Turner (ed.) 2000, vol.3, p.20.
6 Thornton and Tomlin 1980.
7 Obreen 1877–90, vol.4, p.116, as 'Mr Bega in de
Suijlinxstraet'.

For this scene of life in the Italian countryside, Abraham Begeyn chose a rather dramatic loca-tion. The elegant gentleman and woman on horseback, the muleteers and their animals have all gathered around a fountain for a brief rest in the afternoon sun. The setting is framed on the left by the remains of a column on a pedestal and on the right by trees and possibly rocks. Immediately behind the group one can make out the edge of the plateau on which they have stopped, from which there is a spectacular view into the deeply receding landscape, complete with hills, water, rich vegetation and a high mountain in the distance. The focal-point of the composition, however, is the stage-like plateau in the foreground with the colourful figure of a woman on horseback; she counterbalances the immense depth of the landscape, into which the eye would otherwise be drawn. To heighten the dramatic effect, the artist used the dark column and the shadow it casts across the immediate foreground as a *repoussoir*. The scene is otherwise bathed in the warm and hazy light of the Mediterranean sun. Begeyn knew this type of landscape and its golden light from first-hand experience of a trip to Italy *c*.1659/60.[2] However, he could not have created the present composition, with its set-ting, light effects, inclusion of ancient ruins and, in particular, the figures, were it not for the influence of the Haarlem painter Nicolaes Berchem (1620–83) and other Dutch Italianate painters such as Jan Asselijn (after 1610–1652) and Johannes Lingelbach (1622–74).[3] Unfortunately, nothing is known about Begeyn's training before he registered with the painters' guild in his native town of Leiden in 1655. He may have been Berchem's pupil at some time prior to that date or, alternatively, he may simply have been profoundly influenced by his style. The immediate impact of Berchem's work as a source and model is clear from a compari-son of two closely corresponding compositions, Berchem's *Liberation of the Slave*, dated 165(8?), in an English private collection, and Begeyn's *Harbour of Naples*, dated 1659, in the Musées Royaux des Beaux-Arts, Brussels.[4] Berchem had a vast number of pupils as well as followers, and his influence lasted until long after his death.[5]

By 1672 Begeyn was working in Amsterdam and shortly thereafter moved to London, where he painted some pictures for Ham House.[6] It is not known how long he stayed in London, but by 1681 he is documented in the records of the painters' confraternity in The Hague.[7] Seven years later he was appointed court painter to Friedrich III, Elector of Brandenburg, and he lived in Berlin until his death in 1697. Besides his Italianate landscapes and port scenes, Begeyn also produced paintings of plants with reptiles and insects in the manner of Otto Marseus van Schrieck (1619/20–78) and Melchior d'Hondecoeter (1636–95). His dated pictures span almost his entire career between 1653 and 1690. The Cobbe picture, dated 1662, was painted when Begeyn was still working in Leiden and is one of the most beautiful examples in the collection of the small-format Italianate landscapes (see cats 15, 16 and 28) of which 18th-century collec-tors such as Thomas Cobbe were particularly fond.
AR

24

MEINDERT HOBBEMA
Amsterdam 1638–Amsterdam 1709

Wooded Landscape

Oil on canvas, 37⅜ × 51⅜ in (94.5 × 130.5 cm)
INSCRIPTIONS signed and dated at lower right,
meijndert hobbema F 1663
National Gallery of Art, Washington, DC,
Andrew W. Mellon Collection, inv.no.61
HISTORY 18th-century Newbridge collection (possibly
acquired for Thomas Cobbe , before autumn 1764, by
Matthew Pilkington); by descent to Charles Cobbe; sold
by him in 1839 to the dealer Thomas Brown; sold by the
latter in 1840 to Robert Stayner Holford, MP, Dorchester
House, London, and Westonbirt, Gloucester-shire; by
inheritance to his son, Lt-Col. Sir George Lindsay Holford,
KCVO; J. Pierpont Morgan, New York, in 1901; M. Knoedler
& Co., New York; by whom sold in 1935 to the A.W.
Mellon Educational and Charitable Trust, Pittsburgh,
PA; National Gallery of Art, Washington, DC, 1937
EXHIBITIONS London 1840, no.22; London 1851, no.49;
Manchester 1857, no.767; London 1862, no.3; London
1887, no.59; London 1900, no.24; New York 1909, no.48;
New York 1914
LITERATURE Pilkington 1770, p.288; Smith 1829–42,
vol.6, p.149, no.100, vol.9, pp.724–5, no.18; Waagen
1854–7, vol.2, pp.202–3; Thoré-Bürger 1857, p.291;
Thoré-Bürger 1859, pp.28–44; Waagen 1860, vol.2,
p.444; Michel 1865, pp.18, 50 and 52; Thoré-Bürger 1865,
p.291; Cundall 1891, pp.56–8 and 157; Cobbe 1894, vol.1,
pp.23–4; Hofstede de Groot 1907–27, vol.4, pp.412–13,
no.171; Bode 1913, vol.3, p.21; Broulhiet 1938, pp.68, 275
and 424, nos 347 and 373, pl.581, p.97, no.61 (illus. of
signature); Stechow 1959, pp.3–18, fig.13; Stechow
1966, p.77, fig.151; Walker 1976, p.295, no.397, illus.;
Amsterdam, Boston and Philadelphia 1987–8, p.349,
sub no.45, n.2; Ingamells 1992, pp.155–6; Wheelock
1995, pp.61 and 117–19, illus.

Cat.24a. Meindert Hobbema, *Landscape with Cows and
Travellers*, oil on canvas, 41½ × 50½ in (105.5 × 128 cm),
1663 (National Gallery of Ireland, Dublin)

1 A simpler version is in the Wallace Collection, London.
2 Hofstede de Groot 1908–27, vol.4, no.136 and
Broulhiet 1938, no.304.
3 Waagen 1854–7, vol.2, p.203.

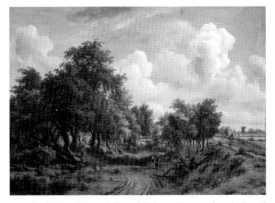

Born in Amsterdam on 31 October 1638,
Hobbema is recorded in 1660 as one
of the students of Jacob van Ruisdael
(1628/9–82). In 1668 van Ruisdael served
as a witness at his marriage to Eeltien
Vinck, a kitchen maid to Lambert
Reynst, burgomaster of Amsterdam.
Perhaps because of this, Hobbema
was appointed wine-gauger of the
Amsterdam *Octroi* a few years later.
Despite this well-paid position,
Hobbema died a pauper. Having
outlived his wife and five children, he was buried at the Westerkerk, Amsterdam, in 1709.

The date inscribed on this well-preserved masterpiece, 1663, establishes it as one of the
artist's earliest mature paintings. Here, he has freed himself from the overt dependence on
compositions by Jacob van Ruisdael that is so evident in his earlier works. The landscape is
more open and spacious, the painterly touch more delicate and varied, and the palette consid-
erably lighter than in his paintings from previous years. Hobbema's composition also draws
the viewer into the forest with soft pools of light that both accent the distant foliage and
silhouette the tree trunks. He used this technique with great effectiveness to enhance the
spatial recession of the small trees growing along the side of the dike at the right.[1]

In 1835, when John Smith published the Cobbe painting in *A Catalogue Raisonné of the Works
of the Most Eminent Dutch, Flemish and French Masters*, he indicated that it was the pendant to a
landscape of the same dimensions and date, formerly in the collection of Sir Alfred Beit and
now in the National Gallery of Ireland, Dublin (cat.24a).[2] The Dublin picture, which in 1835
was owned by the Rt Hon. Edward John Littleton (1791–1863), 1st Baron Hatherton, has a full
signature in which the letter 'M' is capitalised. Unfortunately, no earlier provenance exists to
confirm that the two paintings were ever together. Compositionally, both paintings can stand
by themselves as independent creations. Smith's statement, therefore, must be treated with
some scepticism, especially since little is known about 17th-century landscape pendants.

In the 18th-century Newbridge collection, however, the Hobbema did have a pendant. This
was the *Wooded Valley Landscape* by Gaspar Dughet (cat.40), and the two pictures were clearly
among the stars of Thomas Cobbe's acquisitions. They almost certainly hung in the centre
positions, at eye-level, on either side of the chimneypiece in the Drawing Room at Newbridge
until 1839, when Charles Cobbe was compelled to sell both in order to fund the rebuilding of
the tenants' cottages on the Newbridge estate (for a detailed discussion of the sale and other
details about the present picture, see pp.87–9).

As one contemplates the idyllic vision of the world depicted in Hobbema's *Wooded Landscape*,
it is easy to imagine the attachment that Charles Cobbe must have felt towards this sensitive
rendering of a lush forest, bathed in golden sunlight, with men and women strolling along
secluded paths, occasionally stopping to converse or rest by a pool of water. Such qualities were
highly praised by a number of 19th-century critics. For example, in 1854 Gustav Waagen wrote:
'Seldom has the power of art in expressing the effect of the low afternoon sun in the light
clouds of the sky, on tree, bush, and meadow, been exhibited with such astonishing power,
transparency and freshness as in this picture.'[3]

AKW

25
EGBERT (JASPERZ.) VAN HEEMSKERCK THE ELDER
Haarlem *c.* 1634/5–London 1704

Self-portrait

Oil on panel, 30¾ × 23½ in (78 × 59.5 cm) [measurements include a one-inch addition along the edges] Newbridge 18th-century carved and gilt frame (type VIII); remains of pinned-down leather hanging-loop on reverse
INSCRIPTIONS on the reverse of the panel: Charles Cobbe bookplate (2); on reverse of frame across panel: printed label from Dublin 1872 exhibition; on the frame: printed label, *1162*; printed label from Dublin 1957 exhibition; inscribed on two labels, in brown ink, *Charles Cobbe Esq.* / *Newbridge Donabate*; and on another label, in brown ink, *38 Hemskirck* / *By Himself.*
Cobbe Collection, no.38
HISTORY 18th-century Newbridge collection; recorded by Frances Power Cobbe in 1868, no.38, in the Drawing Room; restored in 1896 for £2.10s at the advice of Walter Armstrong, Director of the National Gallery in Dublin, described by Charlotte Cobbe as 'Portrait of "Heemskerk" / "Good and interesting picture" / £2.10s.od.' and mentioned in the Drawing Room; recorded in the Drawing Room in 1901 (Valuation 1901a, p.26, no.3) and in the Library in 1914 (Valuation 1914, £150); thence by descent
EXHIBITIONS Dublin 1957, no.75
LITERATURE Cobbe 1868 (1882), no.38; Stewart 1990, vol.1, p.319; vol.3, p.75

1 Identification on the mount of the photograph in the archive of the Rijksbureau voor Kunsthistorische Documentatie, The Hague.
2 Dublin 1957, no.92.
3 Turner (ed.) 1996, vol.14, p.291. Bénézit (vol.6, p.847) is incorrect in distinguishing Egbert the elder and Egbert Jaspersz. as two separate artists. There is no other known record in the literature of an artist from Haarlem with this name and the dates 1610–80; moreover, Egbert Jaspersz. could not have been the son of Egbert the elder, since 'Jaspersz.' is a patronymic abbreviation for Jasperszoon (i.e. 'son of Jasper').
4 See also Bredius 1925, pp.111–14 and Raines 1987, pp.119ff.
5 Frances Power Cobbe stated erroneously that he died in 1740.
6 For a detailed discussion of this subject, see London and The Hague 1999–2000.
7 As early as the late 1630s, Jan Lievens did this for his *Self-portrait* in the National Gallery, London (inv.no.NG 2864), which was probably influenced by the Flemish portraiture that he had encountered in Antwerp.
8 Museo del Prado, Madrid (inv.no.2179).
9 Musée du Louvre, Paris (inv.no.1747), and the Iveagh Bequest, Kenwood House, London (inv.no.57); see also London and The Hague 1999–2000, nos 79 and 83.
10 On the subject of the collecting of artists' self-portraits in the 17th century, see the essays by Ernst van de Wetering and Volker Manuth in London and The Hague 1999–2000, pp.22-7 and 46–53.

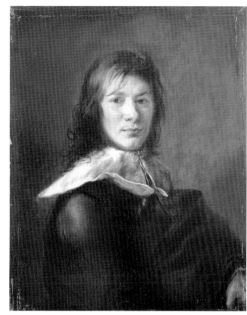

This painting has been recognised as a self-portrait by the painter and draughtsman Egbert van Heemskerck the elder.[1] It shows a dashing young man, probably around 30 years old, at half-length. He is seated against a plain brown background, with his head turned towards the viewer at whom he gazes directly. He does not wear any hat or beret, and his long hair falls loosely onto the white collar he is wearing over his black garment. In the bottom right one can just make out the thumb of the man's – possibly gloved – left hand (discounting the later additions to the hand on the strip that has been added to the picture).

The identification of the sitter has not always been entirely clear. In Frances Power Cobbe's catalogue of the collection of 1868, he is identified as Egbert van Heemskerck the younger. The catalogue of the exhibition with works from Irish collections held in Dublin in 1957 erroneously identifies the sitter as Maerten van Heemskerck (1498–1574).[2] However, judging by the costume the young man is wearing, it seems clear that the picture must have been painted around the mid-1660s. This, of course, rules out Maerten, but to determine which 'Egbert van Heemskerck' is depicted requires some careful attention, as there are several artists by that name mentioned in the literature.

Egbert Jaspersz. van Heemskerck, more commonly known as Egbert van Heemskerck the elder, was a painter from Haarlem who specialised in low-life genre scenes in the style of David Teniers (1610–90) and Adriaen Brouwer (1605/6–38).[3] Born around 1634/5, he went to Italy in 1655 before moving to Amsterdam, where he is documented between 1661 and 1674. He then moved to England, where he lived in London and Oxford.[4] Here, John Wilmot, the 2nd Earl of Rochester (1645–80), is said to have been his patron. Most of his oeuvre consists of scenes of the Temptation of St Anthony, Witches' Sabbaths, satirical subjects and Quaker meetings. Egbert died in London in 1704. He is the author and subject of the present portrait, which must have been painted during his years in Amsterdam. His son, also named Egbert van Heemskerck, was active as a painter as a young man but later became an actor. Since he died only in 1744,[5] in the 1660s he would – if yet born – have been too young to be the sitter in the present painting. In some cases, it is difficult to distinguish the works of the first two artists, presumed to be father and the son.

It seems somewhat surprising that van Heemskerck used a rather old-fashioned style for his portrait: the dark colouring and placement of the sitter against a plain brown background recall the self-portraits of Rembrandt (1606–69).[6] Although Rembrandt clung to this format until the end of his life, by the 1640s other artists from his circle had begun to adopt a lighter palette and more vivid backgrounds, often enlivened by architectural motifs or views into a landscape.[7] Van Heemskerck, however, did not adopt the fanciful costume that Rembrandt and some of his followers preferred (see cat.103), but instead chose the fashionable attire worn by young gentlemen of his time. Less surprising is the fact that he did not depict himself with

the tools of his trade, such as a palette or an easel. While some artists did include specific references to their profession, there is also a long tradition of painters depicting themselves in the guise of elegant gentlemen – a practice that harks back to the 1498 *Self-portrait* by the German master Albrecht Dürer (1471–1528).[8] Like Dürer, Rembrandt hardly ever alluded to his profession in his self-portraits, with two known exceptions, the self-portraits of 1660 in the Louvre, Paris, and that of *c.*1665–9 in the Iveagh Bequest at Kenwood House.[9] Unfortunately, it is not known for whom artists' self-portraits such as the present one were intended, but it is likely that the picture was either painted for one of van Heemskerck's patrons or destined for a collector of this type of painting.[10]

AR

26

JOHANNES VOORHOUT
Uithoorn 1647–Amsterdam 1723

A Lady in an Interior, with a Servant Washing her Foot

Oil on canvas, unlined, on original fixed stretcher,
55 × 46 in (140 × 117 cm)
Newbridge 18th-century carved and gilt frame,
attributed to Richard Cranfield
INSCRIPTIONS signed at lower left, *Johannes Voorhout pinx.*
Cobbe Collection, no.16
HISTORY anonymous [Hennin] sale, Remy, Paris, 17ff. January 1764, lot 77: '*Une Dame debout, appuyée sur le dos de son Fauteuil, une Femme de Chambre lui lave un pied; elles sont dans une Chambre proche d'une Table sur laquelle il y un Tapis de Turquie un Miroir & autres ustensiles de Toilette: ce Tableau est peint par Jean-Voorhout, Elève de Jean Van Noort, sur toile, de quatre pieds deux pouces de haut sur trois pieds cinq pouces de long*' (bought for 30 livres); 18th-century Newbridge collection; recorded by Frances Power Cobbe in 1868, no.16, in the Drawing Room; recorded in the Drawing Room in 1901 (Valuation 1901a, p.27) and 1914 (Valuation 1914, £200); thence by descent
EXHIBITIONS Dublin 1872, no.85; Dublin 1957, no.112
LITERATURE Cobbe 1868 (1882), no.16; Donahue Kuretsky 1979, pp.26 and 87, fig.92; Cornforth 1985b, pp.1808–9, fig.2; Laing/Cobbe 1992, pp.1 and 4, no.16; Stewart 1995, vol.2, p.741; vol.3, p.75 (both as Vourhont)

Cat.26a Jacob Ochtervelt, *The Footwashing*, oil on canvas, 73.5 × 60.5 cm, *c.*1671–3 (present whereabouts unknown)

1 Vermeer had done the same with the windows closest to the corner in his *Glass of Wine*, of *c.*1658–9, in the Gemäldegalerie, Berlin (inv.no.912c), and his *Woman with a Balance*, of *c.*1663–4, in the National Gallery of Art, Washington, DC (inv.no.1942.97), for both of which see New York and London 2001, nos 70 and 73.
2 Present whereabouts unknown (formerly with D. Katz, Dieren, 1934–9); see Donahue Kuretsky 1979, pp.26 and 87, no.79, fig.91.
3 Ibid., p.26.
4 I am grateful to Marieke de Winkel, Amsterdam, who communicated these observations to the author in conversation in April 2001.

This large genre scene by the Amsterdam painter Johannes Voorhout depicts a rare subject in Dutch painting. In an elegant interior, a young woman is having her feet washed by her maid. With her gaze fixed on the viewer, she is standing in the middle of the room with one foot raised and supported by a chair. The kneeling maid is washing her mistress's feet using a silver ewer and basin set that is particularly remarkable for its Auricular style (which, by the time the picture was painted, was about half a century old). The scene has been set in a grand interior – the *faux* fireplace and painting in the background suggest that the room is rather tall – and the elegant accessories (the mirror, pearls, lute, comb and brush) on the table point to the young woman's affluence. The cage hanging from the ceiling seems to contain an expensive exotic bird. Next to the cage, behind the table, one can see the open wing of a window with curtains draped over it.

Paintings of interiors of this kind – a box-shaped room with a tiled floor, a fireplace in the back and windows along the left wall – belong, of course, to a very rich tradition in Dutch painting of the 17th century. Probably most readily associated with painting from Delft, this type of interior is best known through the works of Pieter de Hooch (1629–84) and Johannes Vermeer (1632–75). Other artists who used similar arrangements include Nicolaes Maes (1634–93) and Gabriel Metsu (1629–67). Interestingly, however, Voorhout does not reveal the windows as the principal light source, even though the light is clearly coming from the left. From the little speck of light on the curtain in the upper left corner of the picture, it appears that the lower shutters are closed and that light is only coming in through the upper register.[1]

The present author is aware of only one other example of this rare subject, a picture by Jacob Ochtervelt (1634–82), in which the mistress is shown in a surprisingly informal pose, wearing a formal satin skirt but with her breasts bared (cat.26a).[2] Although Donahue Kuretsky suggested that the treatment in the present picture was more decorous, it seems that the mistress's dress is no less informal.[3] Her nightgown casually wrapped around her body, and the chemise underneath, clearly reveal more of her *décolletage* than would be appropriate in a less private setting – and young women did not normally bare their feet in public. Also, the woman is wearing a so-called *cornette*, a type of headgear that was typically worn around the house.[4] Yet at the same time, the woman's elegant (and selfconscious) pose and her direct gaze are in sharp contrast to the character of the scene; she is fully aware of the viewer who is observing her during this private moment. Whether this 'formality' infuses the scene with the 'solemnity of a ritual' that befits a historical or biblical drama is debatable, but the depiction certainly teeters uneasily between the privacy of the moment and an ostentatious, formal display of wealth and luxury.[5] Since the subject is so uncommon in Dutch art, it is equally difficult to determine whether the picture contains any moralising message. Indeed, while the luxury

5 For the interpretations of the scene as having the 'solemnity of a ritual', see Donahue Kuretsky 1979, p.26.
6 For the interpretation of the moralising symbolism, see Laing/Cobbe 1992, p.1.
7 For further details on Voorhout and his relationship with Jan van Noordt, see De Witt 2000, pp.20–22; see also Thieme–Becker, vol.34, p.543.
8 Houbraken 1719–22, vol.3, pp.176–9 (esp. p.177).
9 Lugt, no.1342.
10 I am grateful to Mark Broch for providing me with this information.
11 Laing/Cobbe 1992, pp.1 and 4.

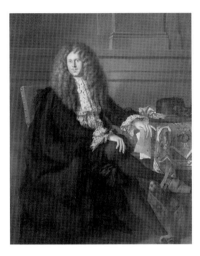

Cat.26b Johannes Voorhout, *Portrait of a Gentleman*, oil on canvas, 68 × 53 in (172.5 × 134.5 cm) (present whereabouts unknown)

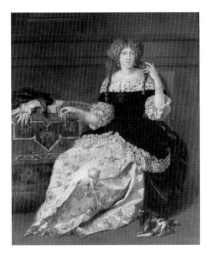

Cat.26c Johannes Voorhout, *Portrait of a Lady*, oil on canvas, 68 × 53 in (172.5 × 134.5 cm) (present whereabouts unknown)

objects on the table may perhaps be seen as reminders of human vanity and the ultimate futility of earthly riches, and while the risqué portrayal of the mistress might possibly hint at moral corruption, it seems more likely that these are no more than faint overtones in what is essentially an elegant domestic scene.[6]

Johannes Voorhout was a history, genre and portrait painter. Born the son of a watchmaker in Uithoorn, he first studied with the minor artist Constantijn Verhout in Gouda between 1664 and 1669, before joining the workshop of the Rembrandt's pupil Jan van Noordt (1624–after 1676) in Amsterdam.[7] In 1673 he fled from the French invasion and settled in Northern Germany for a few years, first to work with another former pupil of Rembrandt, Juriaen Ovens (1623–78), in Friedrichstadt and then as an independent master in Hamburg. Around 1676 he returned to Amsterdam, where he spent the rest of his career. The style of the painting and the figures' costumes suggest that it must have been painted some time after Voorhout's return to Amsterdam, towards the end of the 17th century.

Arnold Houbraken said, somewhat disparagingly, that Voorhout's works were not much in demand because of the large quantities that he produced.[8] However, relatively few are identifiable today, and among them the present picture must rank as his masterpiece. Other rare surviving works include a pair of signed portraits, formerly on the London art market (sale, Christie's, London, 20 February 1986, lot 144), depicting a fashionable lady and gentleman (cat.26b–c). Individual motifs seen in cat.26 appear in both of these works: a table covered with the self-same Turkish carpet, for instance, features prominently in each portrait, while in that of the lady the same dog is to be found, identically posed, but in reverse.

The Cobbe picture by Voorhout is one of the most remarkable works to survive from the collection of Thomas Cobbe. Prior to its arrival in Ireland, it was sold in Paris on 17 January 1764. On the strength of an annotation in a copy of the sale catalogue, Lugt tentatively identified this sale as that of one 'Hennin'.[9] The sale of M. Hennin or Henin, who was Conseiller du Roi, Maitre et Doyen de la Chambre des Comptes, had already taken place, without anonymity, on 9–25 May 1763, and consisted primarily (as D'Argenville's description of his *Cabinet* in the 1757 edition of his *Conchyliologie* would lead one to expect) of shells, items of natural history, scientific instruments etc – and only 17 lots of paintings.[10] The *experts* for that sale were Helle & Remy, but for the sale on 17ff. January 1764 (in which cat.26 appeared), it was Remy alone: it seems likely that it was also put together by him. The picture must have come very soon after the sale to Newbridge, where the stuccowork in the Picture Gallery or Drawing Room was completed by 1764.[11] The frame (see fig.84) is one of the richest examples on any picture from the collection made for Thomas Cobbe, and the painting was evidently intended to be one of the focal-points of the new decorative scheme.

AR

27

JAN WYCK AND STUDIO
Haarlem 1640–Mortlake 1702

William of Orange at the (?) Siege of Namur
[traditionally known as 'William III at the Battle of the Boyne']

Oil on canvas, unlined, 29 × 39 in (73.5 × 99 cm)
Irish 17th- or 18th-century carved and gilt frame
Cobbe Collection, no.62
HISTORY 18th-century Newbridge collection (bought
directly from Matthew Pilkington in 1761; Thomas
and Lady Betty Cobbe's account book records the trans-
action on 11 December 1761: 'A picture from Pilkington
done by Wycke £6.16.6'); recorded by Frances Power
Cobbe in 1868, no.62, in the Study; recorded on the
Principal Staircase in 1901 (Valuation 1901b, p.19) and
in 1914 (Valuation 1914, £5); thence by descent
LITERATURE possibly Pilkington 1770, p.703: '... the
most remarkable works of this / master, are, the repre-
sentation of the battle of the Boyne, between William
III. / and James II; the siege of Namur'; Cobbe 1868
(1882), no.62

1 Photograph available in the Courtauld Photographic
Survey (x), Witt Library, London.
2 Inv.no.988; see *Cat. National Gallery of Ireland* 1981,
p.183.
3 D'Auvergne 1696, p.171.
4 Gibson 2000, pp.3–13, no.2, illus.
5 Ibid., no.4, illus.

Although identified as depicting the
Battle of the Boyne by Frances Power
Cobbe in her manuscript catalogue
of 1868, the picture actually shows
William III before Namur, with the
citadel, silhouetted on its rocky out-
crop, clearly visible in the distance. The
work was bought by the Cobbes in 1761
from Matthew Pilkington (see fig.61),
who, in his *Dictionary* of 1770, described
Wyck's battle-pieces, especially his ver-
sions of the Battle of the Boyne and the
Siege of Namur, as his most remarkable productions. This particular work is probably a studio
repetition, the original perhaps that in a private collection,[1] while another version is in the col-
lection of the National Gallery of Ireland, Dublin.[2]

Wyck, who left the Netherlands and settled in England around 1672, worked in a number of
genres, but he was particularly respected as a battle painter and is largely associated with views
celebrating William III's military successes. William was keen to promote himself as Europe's
Protestant saviour against French expansionism. Namur had fallen to the French in June 1692.
It was strengthened with a garrison of over 16,000 men and was believed impregnable – until
its miraculous retaking by the allied forces over a period of two months in 1695. William, noted
for his personal bravery, had been in the thick of the battle. He saw the victory as a great blow
to French prestige and one of the greatest successes of the Nine Years' War. To contemporaries,
Namur was 'rank'd among the most Famous Sieges Register'd in History'.[3]

In the Cobbe painting, the King is presented as a courageous and victorious military hero,
his horse rearing in the foreground, while a panoramic view of the battle-stage and surround-
ing country opens up behind him. There is no evidence, however, that Wyck ever received direct
royal patronage; works such as this were presumably bought or commissioned by William's
supporters and were not deliberate promotions by the King for his campaigns, in contrast, for
example, to the battle-pieces by Adam Frans van der Meulen (1632–90) intended to glorify the
victories of the French king Louis XIV.

Wyck painted two larger and more detailed views of the Battle of Namur, each without the
dominant figure of the King. That at Brodick Castle, Isle of Arran,[4] has been misidentified in the
past as the Battle of Lerida; while the background of the view at the National Army Museum,
London,[5] has been left incomplete. Exactly how Wyck gathered his topographical details is
not known.

TB

28

GERARD HOET
Zaltbommel 1648–The Hague 1733

Landscape with Travellers on a Path

Oil on panel, 16 ½ × 13 ½ in (42 × 34.5 cm)
Newbridge 18th-century gilt livery frame (type VII)
INSCRIPTIONS signed at lower left, *G. Hoet f.*; on the
reverse of the panel: inscribed, *By Hoet, 1: 5: 0.*; Charles
Cobbe bookplate (2); inscribed on label, in brown ink,
No 45 / Landscape / by Gerard Dowe
Cobbe Collection, no.31
HISTORY 18th-century Newbridge collection (acquired
for £1.5s.0d); early 19th-century inventory, no.45;
recorded by Frances Power Cobbe in 1868, no.31, in the
Drawing Room; recorded in the Drawing Room in 1901
(Valuation 1901a, p.26) and 1914 (Valuation 1914, £10);
thence by descent
LITERATURE Cobbe 1868 (1882), no.31; Laing/Cobbe
1992, p.5, no.31

1 Gerard Hoet, *Catalogus of naamlyst van schilderijen:
met derzelver pryzen zedert een langen reeks van jaren zoo in
Holland als op andere plaatsen in het openbaar verkogt:
benevens een verzameling van lysten van verscheyden nog in
wezen zynde cabinetten*, 2 vols (The Hague, 1752).
2 See, for example, his *Apollo and Daphne*, in the
Dulwich Picture Gallery (inv.no.176), and the pair of
*Arcadian Landscapes with Nymphs and Satyrs by Classical
Ruins*, sale, Christie's, London, 31 October 1997, lot 13.
3 Examples include the *River Landscape with Two
Horsemen*, in the Rijksmuseum, Amsterdam
(inv.no.A4118), the *Evening Landscape*, in the Royal
Collection (inv.no.314), and the *River Landscape with
Horsemen and Peasants*, in the National Gallery, London
(inv.no.NG 6522), for all of which see Washington, DCO,
London and Amsterdam 2001–2, nos43–5.

Extending from the foreground, a sandy path
winds along the edge of the forest on the right.
From the path one looks down into the lower
countryside, with a river or lake surrounded
by trees and a village and hills in the distance.
On the path in the foreground a young man
has sat down for a rest and is cutting a piece of
bread or cheese from a loaf he is holding. Close
by, two women are absorbed in conversation.
Other figures can be seen between the trees to
the right.

Gerard Hoet the elder was a draughtsman,
painter and writer. His son, Gerard Hoet II
(*d.*1760) is best known for his fierce pamphlet
war with Johann van Gool (1685–1763) over the
latter's criticism of art dealers, as well as for his
useful two volumes on paintings in Dutch col-
lections and those sold at auction between 1684 and 1752.[1] Born in the province of Gelderland,
Hoet the elder trained with his father Moses Hoet (*d.* after 1665) and with Cornelis van
Poelenburch (1594/5–1667) in Utrecht. In 1672 he moved to The Hague, but, after a short inter-
lude in Paris and Brussels, he returned to Utrecht, where in 1697 he founded a drawing academy.
In 1713 he published a handbook on drawing entitled *Ontslote deure der tekenkunst* (Leiden, 1713).
From 1714 until his death in 1733 he lived in The Hague.

Hoet the elder was a versatile artist who produced genre scenes, a few portraits, classicising
decorative schemes, larger history paintings (complete with elaborate classical architectural
settings) and designs for biblical illustrations. Influenced by van Poelenburch, he also painted
similar Italianate landscapes with historical scenes taken from the Bible, mythology and clas-
sical texts.[2] The present picture with its small genre figures is rare in Hoet's oeuvre. While the
setting and the lighting seem more reminiscent of Italianate scenes, such as those painted by
van Poelenburch and his colleague Bartholomeus Breenbergh (1598–1657), than of a Dutch
environment, it is possible that the landscape was inspired by the scenery along the Rhine
between Nijmegen and Cleves, a landscape with which Hoet is likely to have been familiar
since he was originally from Gelderland. In the previous generation, Aelbert Cuyp (1620–91)
had travelled to the region in 1651–2 and subsequently painted a number of pictures, albeit on
a much grander scale, that take their inspiration from this scenery.[3] The composition of the
scene in the present painting bears certain resemblances to Cuyp's settings. Cuyp, who had
never been to Italy, was the artist who pioneered the portrayal of Dutch landscape – most often
the land and waterways around his native Dordrecht – suffused with the hazy golden light
he had adopted from those painters, most notably Jan Both (*c.*1615–1652), whose work had
been influenced by first-hand experience of landscape of the Roman *campagna* and Mediterranean
light. For Hoet, however, the strongest influence was his teacher, van Poelenburch, who
had lived in Rome between 1617 and 1625. Hoet's figures, and more specifically their faces, are
strongly reminiscent of those usually painted by his teacher (see cats 70–72).

AR

29

WILLEM VAN DE VELDE THE YOUNGER
Leiden 1633–Greenwich 1707

Ships under English Flags at Sea, a Squall Approaching

Oil on canvas, 10¼ × 14 in (26 × 35.5 cm)
Newbridge 18th-century carved and gilt frame; remains
of pinned-down leather hanging-loop on reverse
INSCRIPTIONS on the reverse: signed by the artist, *W. V.
Velde J*(?) [exposed by a 'window' in the 18th-century
lining canvas]; inscribed on label, in brown ink, *N 47 / Sea
Piece Storm / by Vandervelde*; remains of the bookplate of
Thomas Cobbe; Charles Cobbe bookplate (4); on the
stretcher: the bookplate of Alec Cobbe
Cobbe Collection, no.5
HISTORY 18th-century Newbridge collection (possibly
the 'small Dutch picture' entered as costing £2.5s.6d in
the account book in February 1762 or the 'picture of a
Ship at Sea' listed for the same amount in February 1764
but subsequently deleted; early 19th-century inventory,
no.47; recorded by Frances Power Cobbe in 1868, no.5,
in the Drawing Room; recorded in the Drawing Room
in 1901 (Valuation 1901a, p.27) and 1914 (Valuation 1914,
£10); thence by descent
LITERATURE Cobbe 1868 (1882), no.5

Cat.29a Willem van de Velde the younger, *A Hoy
Close-hauled in a Strong Breeze*, black chalk and grey wash,
heightened with white, on grey paper, 9 × 11 ⅜ in
(230 × 290 mm), *c*.1700 (National Maritime Museum,
Greenwich, London)

1 For another similar work, see Robinson 1990, vol.2,
p.1120, no.549 (19 × 24.5 cm).
2 Robinson 1958–74, vol.2, p.53, no.1305, illus.
3 Fragments of Thomas Cobbe's bookplate survive,
bridging both original and lining canvas. It was subse-
quently pasted over with his grandson Charles Cobbe's
bookplate. Both were relocated on the reverse of the
picture in a recent restoration, revealing the full
signature.

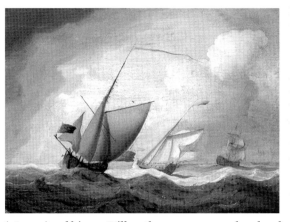

Painted towards the end of Willem van de Velde the younger's career, this small canvas shows a *hoy* in the foreground and two merchant vessels under English flags in agitated waters. The ships sail in a strong breeze from the left, and the painter has contrasted the brightly lit patch of sea and sky in the middle ground with the stormy clouds of a gathering squall at the left, which overcasts the *hoy* and the foreground.

Willem van de Velde the elder (1611–93) and his son Willem the younger were already acknowledged as the leading marine artists of the Netherlands before they emigrated from Amsterdam to Greenwich in the winter of 1672/3. Their move was prompted by the collapse of the Dutch art market following the invasion of the Northern Netherlands by Louis XIV in the spring of 1672. The van de Veldes introduced the practice of marine painting to the British Isles and were immediately patronised by King Charles II and his brother the Duke of York. Each artist was granted an annual stipend of £100, and they were allowed to set up their studio in the Queen's House, Greenwich. The royal decree employed Willem the elder to execute *plein-air* drawings, which were subsequently 'put into Colours' by Willem the younger, who, like his brother, the landscape and genre painter Adriaen van de Velde (1636–72) who remained in the Netherlands, was considerably more gifted than his father. Willem the younger, assisted by a number of pupils, continued to direct the van de Velde studio after his father's death in 1693, adopting a more fluid and painterly virtuoso technique, which found its most apt expression in scenes of shipping in strong or stormy winds, executed as drawings, in pen and ink or chalk, or as small oil sketches, such as the present work.[1] Van de Velde the younger's late preoccupation with atmospherical and stormy effects was to prove a seminal influence on the development of J.M.W. Turner (1775–1851).

The open brushwork of cat.29 gives it the character of an oil sketch. However, notwithstanding the spontaneous character of the work, the composition had been carefully worked out in a preparatory chalk drawing by the artist, which is preserved in the National Maritime Museum, Greenwich (cat.29a).[2] Though the drawing contains only a single vessel, the *hoy*, which was painted more or less as drawn, it also features the broader arrangement of clouds, water and lighting that make up the composition of the finished painting. There are some *pentimenti*, notably in the direction of the pennant, which was altered downwards. This tallies with van de Velde's normal practice, and it is likely that both picture and drawing were executed in the studio.

The picture may have been acquired in 1762, and, before Thomas Cobbe's bookplate was attached to the back, the picture had been lined, possibly by James Chapman, who was paid £7.5s.2d in May 1762 for 'cleaning pictures'. If the lining were by him, he was a sensitive operator when measured against the standards of the time, for not only is the stretcher fitted with small keys to adjust the tension, but a 'window' was cut in the lining canvas, so that van de Velde's signature would not be covered. The liner was more sensitive than his client's servant, who pasted the Cobbe bookplate across the window, obscuring the signature.[3]
MB

30

CORNELIS VAN DE VELDE
b. c. 1672/82; *fl.* Greenwich 1699–1729

A Calm with Ships near the Shore

Oil on canvas, 20¼×30½ in (51.5×77.5 cm)
English carved and gilt frame (*c.*1700) with shell orna-
ments at centres and corners; remains of pinned-down
leather hanging-loop on reverse
INSCRIPTIONS signed at lower right, *W. V. Velde J*(?)
[similar to signature on reverse of cat.9]; on the reverse,
on the stretcher: inscribed on 18th-century label, in
brown ink, *32*; and Charles Cobbe bookplate (2)
Cobbe Collection, no.28
HISTORY 18th-century Newbridge collection (acquired
before 1770); recorded by Frances Power Cobbe in 1868,
no.28, in the Drawing Room; recorded in the Drawing
Room in 1901 (Valuation 1901a, p.26, no.21) and 1914
(Valuation 1914, £150); thence by descent
LITERATURE Pilkington 1770, pp.637–8: 'William
Vandervelde, called the Young … one fine picture of a
Calm, is in the possession of Thomas Cobbe Esq';
Cobbe 1868 (1882), no.28; Cobbe 1894, vol.1, p.10;
London 1996b, pp.33–4

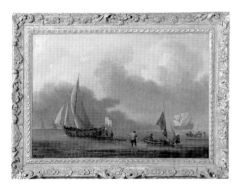

Cat.30a Cornelis van de Velde (?), *A Calm with Ships near
the Shore* (Cobbe Collection no.424)

1 Pilkington 1770, pp.637–8.
2 Cobbe Collection, no.18; Cobbe 1868 (1882) no.18.
3 Robinson 1958–74, vol.1, p.26.
4 For these two versions, see Robinson 1990, vol.1,
pp.501–2, nos 575(1) and (2).
5 Robinson 1990, no.575(2), formerly in the collection
of Capt. Eric C. Palmer.

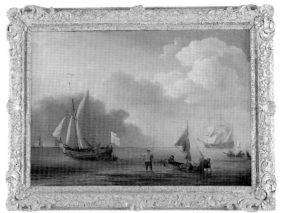

This picture is probably the 'Calm
… in the possession of Thomas
Cobbe Esq' cited by Matthew
Pilkington as a 'capital' example of
Willem van de Velde the younger's
works in the *Dictionary of Painters* of
1770.[1] Frances Power Cobbe, how-
ever, identified Pilkington's refer-
ence with the painting of *Shipping
near a Port* (Cobbe Collection, no.18),
which is now given to Willem van
Diest (1610–after 1663) or Adriaen
van Diest (1655–1704).[2]

Stylistically, the present composition can be dated to the early 1670s, shortly after Willem
van de Velde the younger (1633–1707; see cat.29) moved from Holland to Greenwich and was
employed by Charles II and the Duke of York. It is likely, however, to have been painted by Willem
the younger's son Cornelis after a composition by his father. According to 18th-century critics,
Cornelis was considered to be as talented as his father, whose compositions he is known to have
repeated.[3] He also maintained the family studio in Greenwich after his father's death. Owing
to the similarity of their techniques, Cornelis's work has generally been difficult to isolate. In
cat.30 – which is well-preserved in both handling and details – the sureness of hand in the ele-
ments of shipping, combined with the tidy execution of water and sky suggest Cornelis as the
author, perhaps under the supervision of his father, who may himself have signed the canvas.

In addition to the Cobbe *Calm*, two further versions of this composition are known.
They bear dates variously read as 1671, 1673 or 1678, and both may also have been painted by
Cornelis.[4] The dates would seem to confirm that their common prototype was painted in the
1670s. One of these further versions was acquired for the Cobbe Collection in 1997[5] (cat.30a)
and offers an interesting comparison with the picture in the historic collection. The two differ
in several respects, most notably in the left foreground *kaag*, which sails under an English flag
here, but under a Dutch flag in the recent acquisition; further differences can be seen in the
rigging, positioning of sails, figures and lighting.

It is interesting that both versions now in the Cobbe Collection, despite their different his-
tories, are framed in comparable early Georgian carved and gilt frames with shell ornaments at
the corners and centres; this may indicate that Willem the younger's studio had a standing
arrangement with a framer for its prolific output.

MB

31–34

ORAZIO GREVENBROECK
b. Milan 1678?–active early 18th century

Three Port Views and a River View in Winter

Each picture: oil on copper, 6⅞ × 13½ in (17.5 × 34.5 cm)
Newbridge 18th-century carved and gilt frames
INSCRIPTIONS Cat.31: signed at lower left, *O …
Greuenbroeck*; on the reverse of the panel: bookplate of
Thomas Cobbe; on the frame: inscribed in brown ink,
Mr Cobbe. Cat.33: on the reverse of the panel: Charles
Cobbe bookplate (2); on the frame: inscribed in brown
ink, *Mr Cobbe*. Cat.34: on the reverse of the panel: Charles
Cobbe bookplate (2); on the frame: inscribed in brown
ink, *Mr Cobbe*
Cobbe Collection, nos 44–7
HISTORY 18th-century Newbridge collection; presum-
ably the group of four pictures offered at auction by
Thomas Jones, Eustace St, Dublin, 14–16 July 1812 (from
the property of 'His Grace the late Archbishop Cobbe'),
lot 115: 'Four Venetian Views, on copper, marked
Treuenbroeck' (bought by Shanley, presumably the
family agent, for £22.15s); recorded by Frances Power
Cobbe in 1868, nos 44–7, in the Drawing Room; recorded
in the Drawing Room in 1901 (Valuation 1901a, p.26,
no.1) and 1914 (Valuation 1914, £30); thence by descent
LITERATURE Cobbe 1868 (1882), nos 44–7

1 See Zani 1819.
2 Bodkin acquired two of these from Sandymount,
Dublin, in 1918 and the other two from Dublin dealers.
The four were possibly together before their dispersal
and re-union by Bodkin; see Bodkin 1934, p.3, pl.2; all
four in sale, Phillips, London, 10 May 1983, lots 12 and 13
(each lot including two landscapes).
3 A single loose sheet from the sale catalogue (anno-
tated with the prices realised and the Newbridge
pictures marked 'C') survives among the family papers
(Cobbe Papers: Alec Cobbe). A copy of the complete
catalogue (annotated with the names of the buyers) is
in the Barber Institute Library, Birmingham.

32

33

Pilkington's *Dictionary* does not men-
tion any painter called Grevenbroeck,
though there are five known artists of
this name: Martinus, Jan or Giovanni,
Orazio, Alessandro and Charles-
Leopold, all of whom may well have
been related to one another. Orazio, to
whom the Cobbe pictures are attribut-
able, is likely to have been the son of
Jan van Grevenbroeck of Dordrecht,
who was listed in Rome as 'Giovanni
Fangrevenbruck' from 1667 to 1669
and who was documented in Milan in
the 1680s. Orazio is reported to have
been born in 1678 in Milan and to
have been the son of Jan.[1] A Charles-
Leopold Grevenbroeck, who may have
been the son of Orazio, was active in
Paris as painter to Louis xv in the 1730s
and 1740s and exhibited marine and topographical views in sets of four at the Paris Salons of
1738 and 1741 respectively. The works of Jan, Orazio and Alessandro – the last of whom may
have been Orazio's brother and to whom another work in the original collection may be attrib-
uted (Cobbe Collection, no.7) – all bear resemblances; however, until further information
comes to light, the relationships between them will remain unclear.

The present four cabinet pictures (two of which are shown here; see pp. 180–81 for all
four) are closely related to another set of four very similar landscapes, two of which are signed
Oratio Grevenbroeck. These were formerly in the collection of Prof. Thomas Bodkin, Dublin.[2]
Like the Cobbe pictures, the Bodkin set depicts sunlit and nocturnal views of harbour towns
and mountainous and winter landscapes, with compositional elements corresponding to the
present views. All eight pictures are painted on copper plates of identical size.

Two years after having inherited Newbridge, in his rationalisation of the picture collection
which had suffered from neglect, Charles Cobbe decided to consign a number of paintings to
the Dublin auctioneer Thomas Jones. On 16 July 1812 (the third of the sale, described as includ-
ing the property of 'His Grace the late Archbishop Cobbe'), among works attributed to Paul
Bril, Backhuijsen, Moucheron, Tintoretto and Poussin, were four 'Venetian Views, on copper,
marked Treuenbreck'. According to an annotated copy of the sale catalogue, they were acquired
for £22.15s by a certain 'Shanley'.[3] This is most likely to have been the family agent, Capt.
William Shanley, which may explain why the pictures appear to have returned to Newbridge.
Another possibility, however, is that there were originally eight views by Grevenbroeck in
the Cobbe Collection and that those included in the 1812 sale are identical with the four later
owned by Prof. Bodkin.

MB

35

FOLLOWER OF JOACHIM BEUCKELAER
Antwerp *c*.1534–Antwerp *c*.1574

Market Scene

Oil on canvas, 50 × 40 in (127 × 101.5 cm)
Newbridge 18th-century carved and gilt livery frame
(type I)
INSCRIPTIONS on the reverse of the canvas: Charles
Cobbe bookplate (2); inscribed on the stretcher, in white
chalk, *No 4*; and on label, in brown ink, *No. 4*
Cobbe Collection, no.23
HISTORY 18th-century Newbridge collection; recorded
by Frances Power Cobbe in 1868, no. 23, in the Drawing
Room; recorded in the Drawing Room in 1901
(Valuation 1901a, p.27) and 1914 (Valuation 1914, £10);
thence by descent
LITERATURE Cobbe 1868 (1882), no.23

1 Cobbe 1868, no.23.
2 For more information on Aertsen, see the whole issue
of the *Nederlands Kunsthistorisch Jaarboek*, vol.11 (1989);
Turner (ed.) 1996, vol.1, pp. 168–9; and Saur, vol.1, pp.
452–3.
3 See, for example, Aertsen's very early *Meat Pantry of
an Inn, with the Virgin Giving Alms* of 1551 in the North
Carolina Museum of Art, Raleigh, NC (see Amsterdam
and Cleveland 1999–2000, no.1) and *Kitchen Scene with
Christ in the House of Martha and Mary* of 1553 in the
Museum Boymans–van Beuningen, Rotterdam.
4 For more information on Beuckelaer, see the compre-
hensive catalogue of the monographic exhibition on
the artist, Ghent 1986–7; see also Turner (ed.) 1996,
vol.3, pp.887–8; and Saur, vol.10, pp.274–5.
5 See, for example, his series of *The Four Elements* of
1569–70 in the National Gallery, London.
6 See especially Emmens 1973 (with further literature);
Ethan Matt Kavaler's essay on the different interpreta-
tions in Ghent 1986–7, pp.18–26; and Keith Moxey's
essay 'Interpreting Pieter Aertsen, the Problem of
"Hidden Symbolism"', in *Nederlands Kunsthistorisch
Jaarboek*, vol.11 (1989), pp.29–40.
7 See Moxey 1976.
8 The symbolism is based on the double meaning of
the Dutch verb *vogelen* ('to [hunt] bird[s]' and vulgar 'to
copulate'). For further discussion of the erotic connota-
tions of birds in painting, particularly in 17th-century
Holland, see de Jongh 1968.
9 Similar opinions were expressed to the author, orally
by Lorne Campbell of the National Gallery, London, and
in written communication by Margret Wolters of the
Rijksbureau voor Kunsthistorische Documentatie, The
Hague, both in April 2001.

Because of its subject-matter, this picture has tra-
ditionally been attributed to the Flemish painter
Pieter Aertsen (1507/8–75).[1] It shows a man and a
woman displaying their wares: a variety of food-
stuffs, including pumpkins, cabbages, grapes,
apples, dead rabbits and birds and a live cockerel
and chicken. The woman places her hand casually
on the man's shoulder, as if to get his attention,
while he looks straight at the viewer. Behind the
couple are the base of a large column and part of a
building, while further into the background the
scene opens up to a view of a village with small
figures going about their daily tasks.

These types of market as well as kitchen scenes,
which frequently include views of towns or land-
scapes in the background, became popular in
Flanders in the 16th century. Pieter Aertsen is usually credited with developing this genre of
painting, in which half- or full-length food sellers and maids are depicted attending to rich
displays of food items and kitchen utensils.[2] Often biblical scenes in the background add an
extra – apparently moralising – layer of meaning to these displays of abundance.[3] This genre
was developed further by Aertsen's pupil and nephew Joachim Beuckelaer, whose earliest
works date from 1560 and many of whose compositions rely on Aertsen's example.[4] Beuckelaer
also frequently included biblical episodes in the background, and he often added architectural
details that derive from the multi-volume treatise on architecture by Sebastiano Serlio (1475–
1553/4), which had been translated into Dutch by Pieter Coecke van Aelst (1502–50). Beuckelaer's
most spectacular works include large canvases with life-size figures surrounded by abundant
selections of fruit, vegetables, game, live animals and kitchen accoutrements.[5] The meaning of
these works and their potentially moralising messages have been the subject of much debate
in the literature.[6] The inclusion of biblical scenes must indeed have served as an illuminating
contrast to the displays of abundant riches and their enjoyment. In some cases, certain of the
gestures and actions of the maids and young men are clearly sexually charged and point to the
sort of morally questionable behaviour of which the viewer was encouraged to be wary. How-
ever, other authors have suggested that these scenes are simply illustrations of interesting
everyday objects and activities.[7] While the present picture does not contain any biblical scene,
and the exchange between the man and the woman seems more friendly than amorous, the
display of the live cockerel and chicken (and the man holding another bird by its beak) may
perhaps be interpreted as containing erotic overtones.[8]

The present picture entered the collection in the 18th century as ascribed to Aertsen. More
recently, however, it has been suggested that it may have been painted by Beuckelaer. This
attribution seems to be equally unlikely for a number of reasons. The handling of some of the
still-life details, such as the baskets, as well as of the background scene have little in common
with that of Beuckelaer's works. Moreover, the figures' anatomy, and more specifically, the
length of their arms and the way they are attached to their bodies, appear somewhat awkward
and less accomplished. All of this suggests that the picture must have been painted by one of
several (possibly even 17th-century) followers of Beuckelaer.[9]

A R

36

BALTHAZAR BESCHEY
Antwerp 1708–Antwerp 1776

St Hilary and St Francis in a Cave

Oil on panel, 11½ × 14¼ in (29 × 36 cm)
Newbridge 18th-century gilt composition frame
INSCRIPTIONS on the reverse of the panel: bookplate of
Thomas Cobbe; inscribed in brown ink, *by - - Beschey / at
Antwerp*; inscribed on label, in brown ink, *No 46 / Hermits
/ by -*; inscribed in white chalk, *3*; bookplate of Alec
Cobbe; on the frame: inscribed in brown ink, *Bought at
Booker's Sale / March 1764 / For £3 - 10 - 0*; also in brown ink,
Num:; inscribed on another label, in brown ink, *Beschey -
Cobbe Collection, no.13*
HISTORY 18th-century Newbridge collection (according
to the inscription on the reverse of the frame of this pic-
ture, it was bought in March 1764 at 'Booker's sale' for
£3.10s by Thomas Cobbe; an account book entry for 22
March 1764 records a payment of £5.15s.6d for 'Two pic-
tures from Booker's sale'); early 19th-century inventory,
no.46; recorded by Frances Power Cobbe in 1868, no.13,
in the Drawing Room; recorded in the Drawing Room
in 1901 (Valuation 1901a, p.27) and 1914 (Valuation 1914,
£20); thence by descent
LITERATURE Cobbe 1868 (1882), no.13; Laing/Cobbe
1992, p.3, no.1

Cat.36a Gerrit Dou, *Praying Hermit*, oil on panel,
13¼ × 10⅞ in (33.5 × 27.5 cm), 1664 (Amsterdam,
Rijksmuseum)

1 Amsterdam, Rijksmuseum (inv.no.C128; see
Sumowski 1983, vol.1, no.252).
2 Inv.no.127696; oil on panel, 13¼ × 11¼ in
(35.5 × 28.5 cm), signed *B. Beschey* (see *Cat.Warsaw* 1969,
no.84).
3 Sale, Antwerp, 1 July 1776, second item in lot 143
(bought by Solvers for 56.10 fl.).

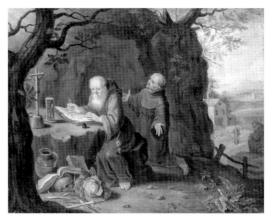

This picture by Balthazar Beschey of
St Hilary and St Francis writing and
praying in the mouth of an overgrown
cave was purchased by Thomas Cobbe
in March 1764. Beschey, an Antwerp
gentleman-painter, dealer, connois-
seur and, from 1754, Director of the
Antwerp Academy, assiduously stud-
ied the achievements and techniques
of previous artists. He painted pictures
in their various manners and encour-
aged this practice in his students.
 In the present work, the figure of St
Hilary seems to have been derived from the *Praying Hermit* of 1664 (cat.36a) by Gerrit Dou
(1613–75).[1] Dou's hermit, meditating over the crucifix held in his folded hands, was used again
by Beschey in a more literal, mirror-imaged interpretation, which is now in the National
Museum at Warsaw.[2]

 The sale of the contents of Beschey's studio and his art collection in Antwerp in July 1776,
organised shortly after his death, included another work of this subject by the artist, the
description of which in the sale catalogue helps to clarify the identity of the friars in the pres-
ent picture: '*Hilarius schrijvende ende Franciscus biddende in de Spelonke: deze zyn schoon ende teer,
helder van couleur*' ('Hilarius writing and Francis praying in the cave: these are beautiful and
tender, bright of colour').[3] The same lot included a companion work of the hermit saints
Anthony and Paul. It is possible that the Cobbe composition, purchased a dozen years before
this sale, was also originally accompanied by a pendant of Sts Anthony and Paul.

 The description of the first picture in the artist's studio sale gives a name to the hermit
seen writing in the Cobbe panel, but it is not immediately apparent which figure of that name
is intended. The conspicuous cabbage and leeks evoke the notoriously vegetarian diet of St
Hilarion (*c*. AD 291–371), the founder of the anchoritic life in Palestine. The massive tomes,
one of which the figure is seen writing, however, suggest St Hilary of Arles (AD 403–49), who,
though he ended as an archbishop, began as a monk in the pioneering ermitical community
founded on the island of Lérins by his kinsman St Honoratus, whose life – among other things
– he wrote. He did not, however, reach old age.

 The cave at the entrance to which the two figures in the Cobbe picture are shown would
be that on the mountain of La Verna, on which St Francis created a hermitage and where he
experienced the miracle of the stigmata – here only suggested (as in the painting of *St Francis
in Ecstasy* by Giovanni Bellini [*c*.1430–1516] in the Frick Collection, New York) by the rays of
'MESSER LO FRATE SOLE'.

AR

FOLLOWER OF FRANCESCO ALBANI
Bologna 1578–Bologna 1660

Head of an Angel

Oil on canvas, 14½ × 11 in (37 × 28 cm)
Newbridge 18th-century carved and gilt frame,
attributed to Richard Cranfield
INSCRIPTIONS on the reverse, on the stretcher: inscribed
in brown ink, *Angel's Head from Albano's Ecce Homo*; and
Charles Cobbe bookplate (2)
Cobbe Collection, no.34
HISTORY 18th-century Newbridge collection; recorded
by Frances Power Cobbe in 1868, no.34, in the Drawing
Room; recorded in the Drawing Room in 1901
(Valuation 1901a, p.26, no.5) and 1914 (Valuation 1914,
£5); thence by descent
LITERATURE Cobbe 1868 (1882), no.34; Laing/Cobbe
1992, p.5, no.34 (as Italian school, 17th century)

Cat.37a Francesco Albani, *Ecce Homo*, oil on canvas,
56½ × 75¾ in (144 × 193 cm), c.1635 (Galleria Colonna,
Rome)

Cat.37b Francesco Albani, *Annunciation 'dal bell' angelo'*
(detail of the Angel Gabriel), oil on canvas, 14¼ × 11½ in
(36.5 × 29.5 cm), 1632 (S Bartolomeo di Porta Ravegnana,
Bologna)

As noted in the old inscription on the stretcher,
the present painting is related to the head of the
left-hand angel of Francesco Albani's *Ecce Homo*, of
which the primary version is the painting of c.1635
now in the Galleria Colonna, Rome (cat.37a).[1] In
the 1648 inventory of Cardinal Girolamo Colonna
(1604–66), this composition was listed as an over-
door in the '*Stanza di sopra*'.[2] Colonna had been
made a cardinal by Pope Urban VIII two decades
earlier, and in 1632 he was appointed Archbishop
of Bologna. Probably as a result of his stay in that
city, he favoured the work of Emilian artists.
Besides paintings by Albani, he added works by
Guercino (1591–1666) and Guido Reni (1575–1642),
among others, to the family art collections.

The Colonna picture is horizontal in format
(56¾ × 76 in [144 × 193 cm]) and shows the figures
half-length behind a parapet, with Christ, in the centre, flanked to each side by a winged angel.
The angel to the left looks up at Christ, combining both awe and anguish in his expression. His
companion, on the opposite side, stares outwards at the spectator, urging us, by extending his
right hand towards Christ, to contemplate his suffering; as the angel does so, he wipes tears
from his face with a cloth.

Although the angel in the Cobbe Collection picture is seen in head and shoulders only,
without any indication of his wings or clasped hands, the scale and profile of the head seem
to be the same in both works. According to Alec Cobbe, the painting was apparently cut down,
no doubt from a full-scale version of the composition, probably towards the end of the 18th
century when it was at Newbridge. Despite the remarkable similarities between the Cobbe and
Colonna paintings, there are important differences, especially in the colouring and handling
of the paint. In the Colonna *Ecce Homo*, the angel's drapery is more agitated, with a mantle
pinned at the shoulder with a slightly different, jewelled clasp, over a light-coloured tunic
with loose, billowy sleeves.

These discrepancies in the figure's drapery suggest that the Cobbe angel corresponds,
instead, to a lost version of the subject, which in 1668 was recorded (as by Albani) in the inven-
tory of Duke Jacopo Salviati (d. c.1668) in his family palazzo on the Via della Lungara, Rome.[3]
This second version is strikingly close in composition, but with three angels instead of two (an
extra one on the right side). Its present whereabouts are unknown, but its appearance is pre-
served in three engravings, one in I. M. Silos, *Pinacotheca sive romana pictura et sculptura* (Rome,
1678), no.CCXLIV, another by Stéphane Picart[4] and the last by Gilles Rousselet (1610–86).[5] The
configuration of the drapery on the corresponding angel's shoulder, on the far right of the
print, in reverse, is identical to that of the Cobbe painting – from the jewelled clasp with a
dangling pearl, to the armband round the upper sleeve, and to the actual loops and folds of the
clothing. Even the stray wisps of hair on the angel's neck are present in the reproductive
engraving.

The ex-Salviati version of the *Ecce Homo* also later entered the Colonna family collection. It
has previously been assumed that this was following the marriage in 1718 of Caterina Maria
Zeffirina Salviati (1703–56) and Don Fabrizio Colonna (1700–55),[6] but an inventory dated 17

1 Puglisi 1999, no.77, illus.

2 Getty Provenance Index, inv.no. I-815, fol.43, item no.44: 'Un' quadro di un' Ecce Homo con cornice indorata è doi Angeli di mano del Albano'.

3 Ibid., inv.no. I-34, fol.3, item no.34: 'Un Ecce homo, in tela raggiunta, mezza figura, con tre Angioli piangenti. Mano dell'Albano; alta palmi 5.1?, e larga 6.4'. The picture was also recorded in the collection of Duke Salviati by Malvasia 1678, vol.2, p.197.

4 Bibliothèque Nationale, Paris, Cabinet d'estampes, Bd 31, fols 25 and 27.

5 Ibid., fol.26.

6 Puglisi 1999, p.167.

7 Getty Provenance Index, inv.no. I-35, fol.3, item no.38: 'Uno detto, rappresentante Nostro Signore in mezzo degli Angeli. Di Francesco Albani.'

8 Getty Provenance Index, inv.no. I-117, fol.1, item no.1: 'Sopra la porta [della Stanza de' quadri], Ecce Homo, dell'Albani', and fol.3, item no.76: 'Apresso, Ecce Homo, dell'Albano' [in the Stanza di sopra].

9 Getty Provenance Index, inv.no. I-631, fol.22, no.129: 'Un Quadro sopra la Porta, misura d'Imperatore per traverso = Ecce Homo con trè Angeli piangenti = Opera stimatissima di Francesco Albani Bolognesi', and fol.31, no.190: 'Un Quadro nel mezzo di 5, e 7 per traverso = Ecce Homo in mezzo a due Angeli = Opera insigne di Francesco Albani'.

10 Puglisi 1999, p.167. The picture was not included in the inventory of 12 August 1818 for Principe Maffeo Barberini Colonna di Sciarra.

11 Example in the Witt Library, London.

12 Zeri 1966, p.42.

13 Puglisi 1999, no.69, illus.

14 Ibid., no.62, illus.

April 1749 of the collection of Cardinal Duke Alamanno Salviati (b.1669) shows that it was then still in the possession of the Salviati family.[7] It must have passed to Caterina after the death of Alamanno. Both versions of the *Ecce Homo* appeared in Fabrizio Colonna's inventory (made some time after 1740),[8] and again in the 1783 inventory of Filippo III Colonna (b.1760).[9] By 1818 the second version of Albani's *Ecce Homo* had left the family.[10] In fact, it is likely that it had been sold even earlier, for what is presumably the same picture surfaced in the sale of Capt. James Poole (c.1760–1814) at Christie's, London, 14 March 1806, lot 89, where it was described as: 'a most astonishing picture … long celebrated as one of the finest ornaments of the Colonna Palace, from which it was purchased'. Although bought in for 940 guineas in March, it was offered again by Christie's two months later, on 24 May 1806, lot 58, when it was purchased by the dealer F.C. de Bligny (fl.1801–13) for £315.

Catherine Puglisi has suggested that the ex-Poole version might be identical with the copy of the *Ecce Homo* with three angels that turned up in 1997 in the church of St Thomas, Garstang, Lancashire. While this is not impossible, the reportedly poor quality of the latter (not seen by the present writer) makes it unlikely that it could have been confused with the 'celebrated chef d'oeuvre of Albano' sold by Capt. Poole, which, as Alastair Laing has kindly pointed out, was reproduced in an early 19th-century illustrated Bible.[11] It is more likely that the ex-Poole version was that seen in an American collection by Federico Zeri some time before 1966.[12] Another copy, like the present work after the angel's head only, was offered for sale at Christie's South Kensington, London, 9 December 1993, lot 57, illus.

The Cobbe canvas depicts the same model, with his mass of soft ringlets, as the one who appears in other works by Albani, such as the *Annunciation 'dal bell'angelo'* of 1632 in the church of S Bartolomeo di Porta Ravegnana, Bologna (cat.37b),[13] and the *Holy Family with Two Angels* of c.1630 in the Accademia di S Luca, Rome.[14]

NT

VENETIAN FOLLOWER OF BERNARDO STROZZI
Genoa 1581–Venice 1644

The Concert

Oil on canvas, 42 × 54 in (106.5 × 137 cm)
Early 19th-century Irish gilt composition frame by
Cornelius Callaghan
INSCRIPTIONS on the reverse of the canvas: Charles
Cobbe bookplate (2)
Cobbe Collection, no.26
HISTORY 18th-century Newbridge collection; recorded
by Frances Power Cobbe in 1868, no.26, in the Drawing
Room; recorded in the Drawing Room in 1901
(Valuation 1901, p.26, no.22) and 1914 (Valuation 1914,
£60); thence by descent
EXHIBITIONS Dublin 1816, no.22; Dublin 1832, no.5
LITERATURE Cobbe 1868 (1882), no.26; Stewart 1995,
vol.2, p.447; vol.3, p.74; Mortari 1995, p.170, sub no.401

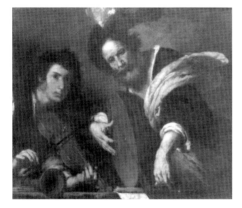

Cat.38a Bernardo Strozzi, The Concert, oil on
canvas, 40 × 48 ⅞ in (101.5 × 124 cm), c.1631–5
(reproduced by gracious permission of Her Majesty
The Queen, Hampton Court)

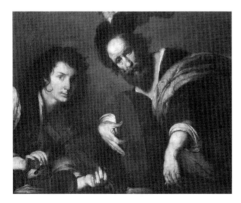

Cat.38b Bernardo Strozzi, The Concert, oil on canvas,
39½ × 48½ in (100.5 × 123 cm), c.1631–5
(Trustees of the Chatsworth Settlement, Chatsworth
House, Derbyshire)

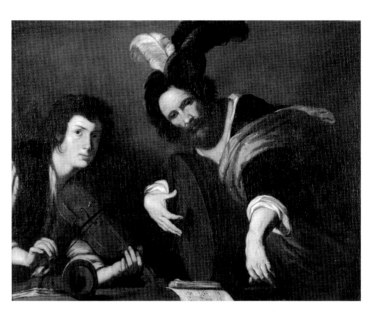

The Concert is one of the most famous compositions of Bernardo Strozzi's entire oeuvre. Two musicians – one young and clean-shaven, the other elderly, bearded and wearing a plumed hat – stare intently outwards, as if inviting the viewer to take part in the music-making that is about to begin. Since the older musician is in the process of tuning the bass string of his lute, and the younger man is perhaps playing a sample note on his violin, the third person on whom they are focusing their attention may well be their concert director. On the table, beneath the violin player, is a tenor shawm.

So felicitous an invention was this composition that numerous versions were made – by Strozzi, his studio and followers.[1] Each of these is slightly different from the others. These variations allow one to demonstrate that the Cobbe Collection picture depends on the painting of this subject in the collection of Her Majesty The Queen at Hampton Court (cat.38a), which is by the master himself and is the finest of the extant versions.[2] After the Hampton Court picture, the next closest is Strozzi's own repetition, with variants, at Chatsworth House, Derbyshire (cat.38b).[3]

The precedence of the Hampton Court picture may be determined by a formal comparison between it, the version in the Cobbe Collection and that at Chatsworth. Simply taking one detail, the position of the left hand and wrist of the younger minstrel holding the neck of the fiddle appears slightly crooked in the version at Chatsworth, but is straight in both the Hampton Court and the present picture. However, in cat.38, the position of the fingers of his left hand is not as convincingly rendered, and his right wrist is bent too far back. By contrast, Strozzi's understanding of the fingering used by musicians, as exemplified in the Hampton Court painting, was derived from first-hand observation in drawings, such as the sheet of Studies of Hands in the Palazzo Rosso, Genoa,[4] which was associated with the Hampton Court picture by Homan Potterton. There are also several surviving studies by Strozzi of the bearded model who posed for the lute player,[5] though none is in exactly the same position as the figure in The Concert.

On the grounds of both style and execution, the Cobbe Collection picture cannot be by Strozzi or by his studio. Strozzi was a daring and original colourist, applying his paint with lavish impasto, mingling the hues unusually in his handling of the flesh. None of these Strozzi-like quirks of technique can be found in the present picture, which depends on a different pictorial tradition, that prevalent in Venice towards the end of the 17th century. The muted, almost sombre palette and thinly painted neutral background suggest the work of a

1 Eight of these are listed by Mortari 1966, p.137, and sixteen different versions by Homan Potterton in London 1979, p.93 (under 'Versions'). Mortari mistakenly identified the Hampton Court version as having previously been at Chatsworth, and it is also likely that the versions listed separately by Potterton as in the Leuchtenberg collection, Munich, and the Museum of fine Arts, Moscow, are one and the same.

2 Levey 1964, no.656; London 1979, no.23, illus.

3 Leeds 1954, no.40, illus.

4 Motari 1966, fig.454.

5 For instance, the *verso* of a double-sided drawing in the Louvre, Paris (inv.no. RF 38819; see Genoa 1995, no.109, illus.), and a study in the National Gallery of Scotland, Edinburgh (inv.no. D 4917; see Genoa 1995, p.316, illus.), for one of the disciples at the Supper at Emmaus.

number of artists active in Venice in this period, such as Johann Carl Loth (1632–98) and Antonio Zanchi (1631–1722).

A Venetian origin for the Cobbe picture is further suggested by the early history of the Hampton Court picture. Strozzi probably painted it shortly after 1631, when he moved from Genoa to Venice; Michael Levey has proposed a date of just before 1635. It seems to have remained in Venice, latterly in the possession of the Sagredo family, in the Palazzo Sagredo, before being sold by the Sagredo heirs in 1752 to Joseph Smith (*c*.1674–1770), the British Consul at Venice. A decade later it passed into the ownership of King George III of England (*reg*.1760–1820), along with the whole of Consul Smith's first collection, which was sold to the British monarch because of Smith's financial difficulties.

NT

39

STUDIO OF GIOVANNI FRANCESCO BARBIERI, CALLED IL GUERCINO

Cento 1591–Bologna 1666

St John the Baptist

Oil on canvas, 24 × 22 in (61 × 56 cm)
19th-century gilt and composition ornamental frame
by Callaghan of Dublin
INSCRIPTIONS on the reverse, on the stretcher: Charles
Cobbe bookplate (2); inscribed on label, in ink, *No 40*;
and bookplate of Alec Cobbe; on the frame: printed
framer's label, *Cornelius Callaghan, Carver Gilder No 4 Clare
Street Dublin* (an entry in the account book for 15 January
1841 records a payment to Callaghan for a looking-glass)
Cobbe Collection, no.41
HISTORY 18th-century Newbridge collection; recorded
by Frances Power Cobbe in 1868, no.41, in the Middle
Bedroom (as 'St John the Baptist Painter – Giovanni
Francesco Barbieri, commonly called Guercino da
Cento, d 1666. A replica of this picture is in the Vatican');
recorded in the Drawing Room in 1901 (Valuation 1901a,
p.26, no.6) and 1914 (Valuation 1914, £21); thence by
descent
LITERATURE Burke 1852, p.2; Cobbe 1868 (1882), no.41
(as Guercino); Cobbe 1894, vol.1, p.10; Laing/Cobbe 1992,
p.6, no.41, illus. (as 'by or after Guercino')

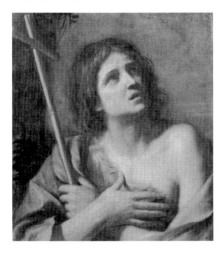

Cat.39a Guercino, *St John the Baptist*, oil on canvas,
33¼ × 21½ in (86 × 55 cm), late 1650s or early 1660s
(Pinacoteca Vaticana, Rome)

1 Inv.no.352; see Salerno 1988, no.351, illus.
2 Ibid., no.92, illus.
3 Ibid., no.349, illus.

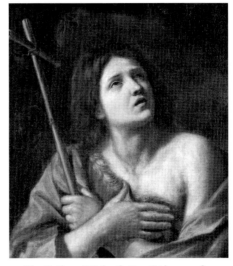

This is a good studio version of Guercino's
painting of the youthful St John the Baptist,
now in the Pinacoteca Vaticana, Rome
(cat.39a).[1] There are few significant differences
of detail, though the general quality of brush-
work is weaker in the Cobbe picture, for
example in the treatment of the hands. The
Vatican picture cannot be identified with cer-
tainty either in the list of Guercino's commis-
sions, which appears in Malvasia's life of the
painter (for which see cat.57), or among the
payments the artist received for his canvases,
which are registered in his Account Book.
The date of neither picture is thus recorded.
Nevertheless, on the grounds of style, both
must belong in the late 1650s or early 1660s.

The Vatican *St John the Baptist* is one of a group of 126 pictures that was bought in 1750 by
Pope Benedict XIV (1675–1758) from the Pio family of Rome and presented to the Pinacoteca
Capitolina. Originally, it may have belonged to Cardinal Carlo Francesco Pio di Savoia (1622–
89), who was Bishop of Ferrara from 1655 to 1662 and was responsible for moving his family
from Ferrara to Rome in the 1650s, settling there himself in 1662. In 1817, it was one of a small
group of pictures that was moved to the Vatican Galleries to make way for Guercino's vast
altarpiece of the *Burial and Reception into Heaven of St Petronilla*, which was returned from Paris
by the French in that year.[2]

The composition of both the Vatican and the Cobbe pictures depends in design on the
larger-size, half-length *St John the Baptist* in the Pinacoteca Capitolina, Rome.[3] This shows the
same youthful model looking upwards to the right, with an identical expression of reverence
on his face. The Capitoline picture must have been painted around the same period as the other
two, the principal compositional difference being in the position of the reed cross, which rests
against the crook of the saint's arm rather than being held in one of his hands. Formerly in the
Sacchetti collection, the Capitoline picture likewise cannot be documented with certainty in
any of the early source material for Guercino's work.

NT

40

GASPARD DUGHET, CALLED GASPAR POUSSIN
Rome 1615–Rome 1675

Wooded Valley Landscape, with Two figures in the Foreground
[traditionally known as 'Solitude']

Oil on canvas, 38 × 53 in (96.5 × 134.5 cm)
Newbridge 18th-century carved and gilt frame,
attributed to Richard Cranfield
Private collection, Monaco
HISTORY 18th-century Newbridge collection; thence
by descent to Charles Cobbe; sold by him in 1839 to the
dealer Thomas Brown; sold by the latter in 1840 to
Robert Stayner Holford, MP (1808–92), Dorchester
House, London, and Westonbirt, Gloucestershire; by
inheritance to his son, Lt-Col. Sir George Lindsay
Holford, KCVO (1860–1926); his posthumous sale,
Christie's, London, 17–18 May 1928, lot 133 (bought by
Kohnstam)
LITERATURE Waagen 1854–7, vol.2, p.195, no.3; Bryan
1903, vol.3, p.97; Benson 1927, vol.1, no.138, p.25 and
pl.CXXIII; London 1980, p.55, *sub* no.56; Boisclair 1986,
p.214, no.136 (as '*localisation inconnue*')

1 Benson 1927, vol.1, no.138, p.25 and pl.CXXIII (as *Under
the Greenwood Tree* [!]).
2 Waagen 1854–7, vol.2, p.195, no.3.
3 Boisclair 1986, pp.213–14, no.135 and fig.175.
4 Vertue/ed. Walpole Society 1930, p.11.
5 London 1980, pp.55–6, no.56 and p.82, illus.;
Boisclair 1986, p.365, no.G.181.
6 The painting was exhibited at Kenwood House (see
London 1980, pp.37–8, no.5, and p.59, illus.) and is in
Boisclair 1986 (p.210, no.126 and fig.167). For the engrav-
ing, see Boisclair 1986, no.G.145 (p.361, not illus.). It
should not be confused with Boydell's republication of
Vivares's engraving of the landscape in the Walpole
Collection (now in the Hermitage, St Petersburg; see
Boisclair 1986, nos G.10 and G.219, after her no.288),
entitled *The Cascade*, which had been published only
four months before.
7 See London 1980, pp.44–5, no.21 and p.66, illus.; and
Boisclair 1986, p.274, no.341 and fig.374.
8 See Anne French's remarks in London 1980, pp.30–31
and fig.10, and pp.93–4, nos 87–90, and pp.110–12, illus.;
taken up by Boisclair 1986, pp.96 and 101, n.109.
9 Boisclair 1986, p.96.
10 London 1980, pp.94–5, no.91, and p.112, illus. Not
only did Lady Farnborough's husband own the fine
Panoramic Landscape of Tivoli that he left to the National
Gallery (Boisclair 1986, pp.274–5, no.342, and fig.377),
but her sister, Sophia Hume, Countess Brownlow, made
a copy in oils of a *View of Ariccia* (?) that was later left to the
National Gallery by the Rev. Holwell Carr (Boisclair
1986, pp.276–7, no.348, and fig.383); the inscription
transferred to the lining canvas of the copy auctioned at
Christie's South Kensington, London, 2 July 1997, lot
427, appears to state that she had owned the original.

This was the 'admir-
able work' by Gaspard
Dughet (who was
known as Gaspar
Poussin, after his
brother-in-law Nicolas
Poussin [1594–1665])
that was sold by Charles
Cobbe in 1839 with the
similarly sized picture
by Hobbema (cat.24), 'to
enable himself to erect
good dwellings for his
tenants' (Frances Power
Cobbe; see pp.87–9). It
was sold to the dealer
Thomas Brown, who
almost immediately sold it on to Robert Stayner Holford.[1] Gustav Waagen saw it at Dorchester
House (Holford's London residence) in 1850/51 and described it as one of four Dughets there
'of unusual transparency, power and freshness'.[2] The loss was always keenly felt at Newbridge,
since a 'Gaspar' was almost a prerequisite of any self-respecting country-house collection in
the British Isles. It was only in 2000 that Alec Cobbe, as it were, 'replaced' it with a Dughet of
comparable size, if not equal luminosity (cat.59).

The early history of the present work is not known, but its fine Rococo Irish frame indicates
that it was an acquisition of Thomas Cobbe's, so that it must have arrived at Newbridge at
much the same time as another version of the same composition was acquired by Frederick,
Prince of Wales.[3] That picture must have been one of the 'paintings, landskips by Gasper, &
Nicolas Poussin figures – 4 of them, large & fine', shown to George Vertue in the second room
of Leicester House by the Prince in 1749 (the belief that such pictures were collaborations
between the brothers-in-law was common in the 18th century).[4] Later, when it had passed to
his son, King George III, it was engraved in reverse by Wilson Lowry (1762–1824) and published
by John Boydell in 1786, with the Richard Wilson-inspired title of 'Solitude',[5] and with the
same-sized *Landscape with a Waterfall* engraved by John Browne (1741–1801) as a pendant, enti-
tled '*Cascade*'.[6] In the collection itself, however, it was superbly framed by Paul Petit as a pen-
dant to the *Landscape with figures by a Pool*,[7] which was never engraved. Both pairings seem,
nonetheless, to have been factitious, although '*Solitude*' and '*Cascade*' do seem to have been
painted around the same time, unlike the much later *Landscape with figures by a Pool*. John Sell
Cotman (1782–1842), many of whose soft-ground etchings pay respectful homage to Dughet,[8]
seems to have owned – and possibly had himself made – a pair of painted copies of '*Solitude*'
and '*Cascade*' that featured in his posthumous sale at Norwich on 16 May 1861 and that had
doubtless been done from the prints.[9] The watercolour copy of '*Solitude*' owned by Amelia
Hume, Lady Farnborough (1762–1837), now in the National Gallery of Scotland, Edinburgh,
was, *per contra*, evidently made directly from the Royal version of the picture in 1821.[10]

The late Marie-Nicole Boisclair, who knew only the Royal version of '*Solitude*' at first hand,
dated it to 1653/4.

ADL

41

GIUSEPPE BARTOLOMEO CHIARI (?) AFTER GUIDO RENI

Lucca or Rome 1654–Rome 1727

Head of Helen of Troy

Oil on canvas, 25 × 19 in (63.5 × 48 cm)
Newbridge early 19th-century gilt moulding livery
frame, original leather hanging-loop pinned-down
on reverse
INSCRIPTIONS on the reverse, on the stretcher: inscribed
on label, in brown ink, *No 77 / Head of Helen / by Giuseppe
Chiari / Copy from Guido*
Cobbe Collection, no.21
HISTORY 18th-century Newbridge collection (part
of the whole composition presumably acquired by
Thomas Cobbe, but not included with the other sur-
viving parts in Thomas Jones's sale of pictures, all
purportedly having belonged to 'the late Archbishop
Cobbe', at Dublin in 1812); early 19th-century inventory,
no.77; recorded by Frances Power Cobbe in 1868, no.39,
in the Drawing Room; thence by descent
EXHIBITIONS Dublin 1872, no.1159
LITERATURE Cobbe 1868, no.39; Laing/Cobbe 1992,
p.43, no.21; Stewart 1995, vol.2, p.596, vol.3, p.75

1 Inv.no.539; see Pepper 1988, pp.269–70, no.116, pl.107.
2 For the best account of the tangled history of this
commission, together with a full bibliography and a
listing of both drawn and painted copies – to which one
should add one in stucco, by Charles Stanley, at Langley
Park (see cat.96) – see entry by O. Bonfait in Paris 1988–9,
pp.326–9, no.128, and p.29, illus. (in colour).
3 See Zeri 1965, p.27, no.134, and Vicini 1998, p.64,
illus. (in colour).
4 This discovery was made by Jane Turner, who called
attention to the three fragments in the Cobbe sale of
14–16 July 1812, all described as copies by G.B. Chiari
after Reni: (lot 84) 'Portrait of a Black, from Guido'
[i.e. the page-boy at lower left]; (lot 144) 'Cupid, after
Guido' [i.e. the figure of Cupid at lower right] and
(lot 145) 'Hymen, ditto' [i.e. the torch-bearing, winged
cherub at upper right].

When Frances Power Cobbe compiled her manuscript catalogue of the pictures at Newbridge House in 1868, she reported this head to be the sole surviving fragment of an original painting by Guido Reni (1575–1642), a replica of which she thought to be in the Capitoline Gallery in Rome: 'This head formed part of a large picture containing full length figures of Helen, Paris, [and] a huge attendance. Having been injured by damp, the head of Helen was unhappily alone cut out and preserved.'

The actual original by Reni, one of the most celebrated pictures of its day, but relegated in the 19th century to the picture-store of the Louvre (cat.41b),[1] was painted in Rome and Bologna between 1627 and 1631 for Philip IV of Spain. Refused by a new Spanish ambassador to the Holy See, it was bought by Queen Marie de Médicis of France, whose exile resulted instead in its being acquired by Louis Phélypiaux de La Vrillière as one of the first of the large pictures to adorn the gallery of his *hôtel* in Paris, whence it was removed to the new Musée National at the time of the French Revolution.[2]

The first of the many copies of the whole painting was painted by Giacinto Campana (1600–?1650) for Bernardino Spada, Cardinal-Legate to Bologna and intermediary of the aborted sale of the original to Marie de Médicis, and was retouched by Reni himself. It is still in the Galleria Spada, Rome.[3]

Frances Power Cobbe's statement that the present head was the sole survivor of another such replica of the original was only partially true. The picture had indeed decayed and been cut up, but the head of Helen was not the only surviving fragment. At least three further portions of the picture, all from its outer edges, were also rescued, but they were sold – as by 'G.B. Chiari after Guido' – in the 1812 auction of pictures from 'Archbishop Cobbe's' collection.[4] It therefore seems very likely that, as Alec Cobbe has long maintained, this full-size copy of Reni's original was the centrepiece of Thomas Cobbe's collection, as the overmantel in the Drawing Room. What is surprising is that Pilkington fails to mention such a major work in his *Dictionary*, under either Chiari or Reni (another such copy was one of the pictures given pride of place in the collection at Stourhead, by being hung in the Saloon); perhaps its acquisition postdated 1770. The other three fragments are untraced, but that this head was indeed cut down from a copy of – most probably Campana's copy in the Galleria Spada rather than of Reni's original then in the Hôtel de la Vrillière – is evidenced by painted-over traces of the shoulder of Paris, and by his right eye and cheek on the turn-over edge.

The head of Helen (cat.41a) was, however, also held to be of such beauty that it was copied on its own. An early instance of this in a British collection is to be found at Ham House, Richmond (Surrey). Since the 19th century, the background of this has been overpainted, and it has been relegated to serve as an overdoor to the Green Closet, but it was already recorded as a freely hanging picture in the 'Estimate' of the Duchess of Lauderdale's pictures at Ham in 1683. Neither artist nor copyist was named. In the case of the present picture, Chiari was first

Cat.41a Detail of the head of Helen from fig.41b

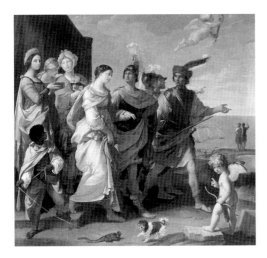

Cat.41b Guido Reni, *The Abduction of Helen*,
oil on canvas, 100×104 in (253×265 cm), 1628–9
(Musée du Louvre, Paris)

cited as the copyist only in the early 19th century, so that the ascription seems unlikely to rest on an old tradition, and too much faith should not be placed in it. Chiari was, moreover, the most faithful pupil and perpetuator of the style of Carlo Maratta (1625–1713), rather than of Reni. He did, however, serve a 20-year apprenticeship, before becoming an independent master, so he would have had ample opportunity to execute copies such as this; moreover, his own paintings do betray something of a return to Renian sweetness and grace from the tougher classicism of Maratta's maturity.

ADL

42

GIUSEPPE BARTOLOMEO CHIARI
Lucca or Rome 1654–Rome 1727

OR ANOTHER FOLLOWER OF CARLO MARATTA
Camerano 1625–Rome 1713

The Madonna Annunciate

Oil on canvas, unlined, the original canvas hardly extending around front edge of stretcher (painter's loom?), 28 ½ × 23 in (72.5 × 58.5 cm)
Irish early 18th-century carved and gilt frame (*c*.1700); 18th-century tape hanging-loops on reverse of stretcher; remains of a leather hanging-loop, replaced by brass ring and screwing socket, on reverse of frame
INSCRIPTIONS on the reverse: Charles Cobbe bookplate (4); on the frame: inscribed in black paint, *401*
Cobbe Collection, no.39
HISTORY 18th-century Newbridge collection; recorded by Frances Power Cobbe in 1868, no.39, in the Drawing Room; recorded in the Drawing Room in 1901 (Valuation 1901a, p.26) and 1914 (Valuation 1914, £10); thence by descent
LITERATURE Cobbe 1868 (1882), no.39; Laing/Cobbe 1992, p.6, no.39, illus. (as follower of Maratta, possibly Agostino Masucci)

1 See Turner (ed.) 1996, vol.20, p.806, illus.
2 Pio 1724/ed. Enggass 1977, pp.145–6, 254–5, 313–5.
3 Clark 1967, pp.3–23.

Carlo Maratta and his followers were responsible for a great variety of paintings of the Madonna such as this: small-scale, private devotional images ostensibly suffused with piety, yet of a size and format particularly suited to the tiered hang of a picture gallery. This image, with the small figure of the Archangel Gabriel in the sky behind the Madonna, clutching a lily while looking back at the heavens in a posture of submission to the Divine Will, derives from a composition by Maratta known in several versions. Among these are paintings in the Hermitage, St Petersburg, and the Galleria Corsini, Rome.

This particular picture was traditionally ascribed to Maratta's faithful pupil and follower, Giuseppe Bartolomeo Chiari, as is evident from the manuscript catalogue of the Cobbe pictures at Newbridge House compiled in 1868 by Frances Power Cobbe. At least one other picture more likely to be by Chiari was formerly at Newbridge: a copy after Guido Reni's *Abduction of Helen* now in the Louvre, Paris. (For the history of that copy, of which only one fragment, the *Head of Helen*, survives in the Cobbe Collection, see cat.41.) Unfortunately, Frances Cobbe's observations are not always wholly reliable. She catalogued the *Head of Helen*, for instance, as an autograph work by Reni himself, even though three other segments of the copy were more plausibly attributed to G. B. Chiari in 1812, when Charles Cobbe auctioned these and other items from the collection of his grandfather Thomas Cobbe.

It has been suggested more recently (see Cobbe/Laing 1992) that *The Madonna Annunciate* may be by the Roman painter Agostino Masucci (1691–1748), who laid claim to the mantle of Maratta after the death of Chiari in 1727. This attribution is supported by the picture's smooth finish, subtle colouring and classical balance, and by the serenity of the Madonna's expression, as well as more individual features: the elegant but rubbery hands, for example, invite comparison with other works by Masucci, such as the *modello* (*c*.1742; Minneapolis, Minneapolis Institute of Arts)[1] for the *Annunciation* for the chapel of St John the Baptist in the church of S Roch, Lisbon.

According to the biography of Masucci in Nicola Pio's *Vite*[2] – for which Masucci himself produced a group of 32 portrait drawings of artists as illustrations (now in the Nationalmuseum, Stockholm)[3] – he was 'nourished first by the perfect milk of Maratti, and then saturated with the divine nectar of Raphael'. When he entered the ageing Maratta's studio, he rose quickly to become a particular favourite, capable of imitating his master 'with assurance and feeling'. His oval canvases of the *Life of the Virgin* (1721–5) in the nave of S Maria in via Lata, Rome, have been admired as some of the loveliest and most tender religious paintings made in Rome in the first half of the Settecento. The particular traits of Masucci's work (all present in the Cobbe picture) – lucid composition, smooth handling of paint, impeccable draughtsmanship and delicate spiritual temper (in contrast to the more emotive works of his rivals) – explain why by the late 1720s he had clearly emerged as the undisputed heir of the classical Marattesque tradition.
NT

43

POMPEO BATONI
Lucca 1708 – Rome 1787

Portrait of a Gentleman [traditionally identified as John Hatch]

Oil on canvas, 29¼ × 24¼ in (74.5 × 61.5 cm)
Copy of Newbridge 18th-century carved and gilt livery
frame made by John Davies of Norfolk
Cobbe Collection, no.272
HISTORY John Hatch; presumably by descent to his
daughter, Lady Dorothea Synge Hutchinson, wife
of the 3rd Baronet; by descent to Mary and Louisa
Hely-Hutchinson; transferred by them to the Cobbe
Collection in 1998

1 Clark 1985, no.81.
2 Ibid., no.174.
3 Ibid., no.179.
4 Ibid., no.181.
5 Ibid., nos 192 and 193.
6 Ibid., no.241.
7 Ibid., no.255.

This unpublished portrait is an addition of some interest to the sequence of portraits of Anglo-Irish visitors to Rome on the Grand Tour by the greatest exponent of Grand Tour portraiture. Batoni's earliest extant portrait of a sitter from the British Isles is the *Portrait of Joseph Leeson* (later 1st Earl of Milltown), dated 1744, now in the National Gallery of Ireland;[1] in 1750–51 he painted further portraits for Leeson. Irish sitters of the early 1750s included James Caulfeild, later 1st Earl of Charlemont, arguably the outstanding patron of his generation in Ireland; Ralph Howard, later 1st Earl of Wicklow, Thomas Dawson, later 1st Viscount Cremorne, and Joseph Henry of Straffan, also discriminating patrons; and Robert Clements, later 1st Earl of Leitrim, son of the architect Nathaniel Clements. For three decades Batoni continued to paint the Anglo-Irish: his *Portrait of Valentine Quin* (later 1st Earl of Dunraven) is perhaps the most memorable of these later portraits, but other sitters included the Headforts, Adam's patrons at Headfort; Lord Carlow, later 1st Earl of Portarlington; and Mrs James Alexander, wife of the builder of Caledon.

Sitting to Batoni was not, by Roman standards, a cheap option. His early British patrons can, for the most part, be grouped in clusters: the Leesons and their associates, including the *nouveaux-riches* Fetherstonhaughs of Uppark, all linked by their patronage of Joseph Vernet (1714–89) and their appearance in the group of satirical conversation-pieces that the young Joshua Reynolds (1723–92) painted in Rome; a number of landowners from east Kent, whose neighbour, Lady Guilford, obtained portraits of no fewer than four relations; and others connected by looser dynastic ties but who depended on the same *cicerone* for advice. There is, therefore, a *prima facie* case for supposing that the sitter in this portrait was connected in some way with Batoni's other Anglo-Irish patrons. The picture is of his most modest standard format, but, despite its apparent simplicity, is compellingly autograph in handling.

That the portrait dates from not long after 1755 seems likely, not only on stylistic grounds, but also because of the very flamboyant way in which the black ribbon is arranged: this is paralleled in a sequence of portraits of the 1750s, but in few later portraits. The former include the ex-Killadoon *Portrait of Robert Clements* of 1753;[2] the Birdsall *Portrait of Henry Willoughby* of 1754;[3] the *Portrait of Robert ffrench* of the same year;[4] the *Portrait of Frederick, Lord North* (London, National Portrait Gallery) and its erstwhile companion, the *Portrait of William, 2nd Earl of Dartmouth*;[5] and, finally, the *Portrait of John Lombe*, probably of 1756. On the other hand, the use of a feigned oval – treated like a slip lit from the left – is unusual before the early 1760s, when it occurs, for example, in the *Portrait of Sir Humphrey Morice* of 1761–2 in the Wadsworth Atheneum, Hartford,[6] and the *Portrait of Augustus, 3rd Duke of Grafton* of 1762 in the National Portrait Gallery.[7]

The present portrait was identified as being of John Hatch by the time of his grandchildren. Hatch was called to the Bar in Dublin in the Hilary term, 1748, and by the 1760s he was in a

position to build Lissen Hall, near Swords, in Co. Dublin. He was Seneschal of the Manor of St Sepulchre and owned property in Dublin, demolishing a house in St Stephen's Green in 1775 to create Harcourt St between the site of this and his farm of St Sepulchre. By 1780 he had retired from the Bar and in 1787 was elected, with Charles Cobbe, in the government's interest for the borough of Swords in the Irish House of Commons. There is no evidence that Hatch's fortune was inherited, unlike that of most men on the Grand Tour: moreover, there is no known reference to a visit to Italy, where Batoni would have painted his portrait.

The picture was eventually inherited by Hatch's granddaughter Sophia, the Hon. Mrs Coote Hely-Hutchinson, daughter of Dorothea Hatch. Dorothea had married her first cousin – on her mother's side – the Rev. Sir Samuel Synge Hutchinson, 3rd Bt (*d*.1846) (whose brother Francis married her sister Barbara). Sir Samuel assumed the surname Hutchinson after succeeding to the Hutchinson estate on the death in 1813 of his mother's brother, the Rev. Sir James Hutchinson, 2nd Bt. The latter had been the heir of his elder brother Francis, who was created a baronet in 1782 and died without issue in 1807. As Alastair Laing has pointed out, this must be the Francis Hutchinson recorded in Venice, from 12 May to 4 June 1757, with three companions (including a Thomas Condai [?], who might be identified as Thomas Conolly of Castletown, who was painted in Rome in 1758 by Anton Raphael Mengs [1728–79]). In view of the relative frequency of the name, it is also conceivable that he is the Hutchinson, identified as an Irishman, recorded at Pisa in 1755. A date of *c*.1757 is certainly plausible for the portrait, and it is possible that in old age Mrs Hely-Hutchinson – who outlived her husband by 54 years – was confused about the identity of the sitter: her great-uncle Francis Hutchinson or her grandfather John Hatch, neither of whom she can have met and to both of whom she was heiress.

FR

44
ENGLISH SCHOOL
c. 1714–22

Portrait of Charles Paulet (or Powlett), 2nd Duke of Bolton (1661–1722)

Oil on canvas, 48¾ × 39⅜ in (124 × 100 cm)
Newbridge 18th-century gilt livery frame overpainted
in black, apart from inner moulding
Cobbe Collection, no.95
HISTORY 18th-century Newbridge collection; recorded
by Francis Power Cobbe in 1868, no.95, in the Centre
Hall; recorded in the Dining Room by 1901 (Valuation
1901a, p.33) and 1914 (Valuation 1914, £50); thence by
descent
EXHIBITIONS Dublin 1872, no.95
LITERATURE Cobbe 1868 (1882), no.95; Stewart 1995,
vol.1, p.387; vol.3, p.75

1 Sale, Christie's, London, 17 October 1986, lot 99.

This portrait was formerly ascribed to
Sir Godfrey Kneller (1646/9–1723) but is
stylistically closer to the work of Michael
Dahl (1656/9–1743), although this is less
evident in the painting of the drapery.
The face is based on a pattern – but with
the wig arranged slightly differently –
used in at least two other portraits of the
2nd Duke of Bolton, one of which, in
Muncaster Castle, is ascribed to Charles
Jervas (*c.*1675–1739), and the other, for-
merly on the art market,[1] to a follower of
Kneller; the latter is perhaps a version
of the Muncaster Castle picture, or of an
unknown original of both of them. As
in this portrait, both show the Duke in
Garter robes (but in a different pose). All
three must have been painted between
December 1714, when Bolton was installed
as a Knight of the Garter, and his death in 1722, although the Newbridge picture omits the
white staff of office included in the other two – evidently his staff as Lord Chamberlain, an
office he held from 1715 to 1717.

Contemporary or near-contemporary profiles of Bolton tend to be negative and dismiss-
ive: Bishop Burnet thought he made no figure at court, Swift considered him a 'great Booby',
while Tom Hearne described him as a 'most lewd, vicious man, a great dissembler and a very
hard drinker' (GEC). In fact Bolton found great favour at court, under both William & Mary
and Queen Anne, as well as under George I, and held influential positions both in England and
Ireland. From 1697 to 1700 he was one of the Lords Justices of Ireland and from April 1717 to
1719 was Lord-Lieutenant of Ireland.

Connections of marriage and trusteeships had existed between the Paulet and Cobbe fami-
lies for some time, and the Duke, when Lord Charles Paulet, had acted in 1696 as guarantor to
Archbishop Cobbe's father, Thomas Cobbe, for his position as Receiver-General of Hampshire
in a bond with the Crown for the stupendous sum of £26,000 (see pp.40–41). When a financial
catastrophe occurred in connection with the post and the bond was drawn upon, the Duke's
brother Lord William Paulet defended Thomas Cobbe's honour in the House of Commons.
The Marchioness of Winchester's kindness to Thomas Cobbe's widow (the 1st Duke of Bolton's
father had been Marquess of Winchester, and it was a title retained by the family) was recorded
by Frances Power Cobbe (1868). Charles Cobbe, later Archbishop of Dublin, who was Thomas
Cobbe's son and almost certainly the Duke's godson, came to Ireland as his godfather's chap-
lain in 1717.

TB

45
THOMAS GAINSBOROUGH
Sudbury 1727–London 1788

Portrait of Col. Alexander Champion (d.1795)

Oil on canvas, unlined, 29 × 24½ in (73.5 × 61.5 cm)
English 18th-century carved and gilt frame (original
to the picture)
INSCRIPTIONS on the reverse of the canvas: numbered
in black chalk, *41* [partly visible through to the front]
Cobbe Collection, no.86
HISTORY inherited by Mrs Charles Cobbe (*née* Frances
Conway) from her step-parents, Col. and Mrs
Champion, Bath; recorded by Frances Power Cobbe in
1868, no.86, in the Library; recorded in the Library in
1901 (Valuation 1901b, p.11) and 1914 (Valuation 1914,
£10); thence by descent
LITERATURE Cobbe 1868 (1882), no.86; Cornforth 1985a,
p.1737, fig.14; Laing/Cobbe 1992, pp.2, 7–8, no.86, illus.;
London 1996b, p.34

1 [Anonymous] 1914a, p.121; see also [Anonymous]
1914b, p.165, letter LXXIII.
2 Gainsborough/ed. Hayes 2001, pp.46–7, no.27.
3 Hodson 1927, p.328.
4 [Anonymous] 1824, vol.2, p.86.
5 Davies 1935, p.128.
6 Weitzman 1929, p.153, n.4.
7 Ibid., p.228.
8 McEvansoneya 1999, p.162.
9 Kitz 1984, p.125.
10 Of William Hamilton's copy (private collection; see
London 1996a, no.176, illus.), now attributed to Luca
Cambiaso (1527–85), Horace Walpole is reported to have
said: 'Mr. Hamilton's Correggio…it is divine, and so is
the price, for nothing but a … nabob can purchase it.'
11 Millar 1969, vol.1, no.797.

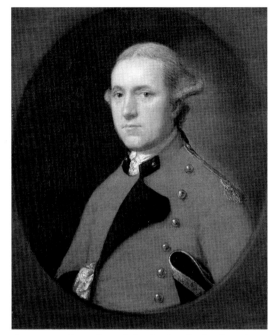

Col. Champion is depicted within a feigned oval, wearing a bright red jacket with gold epaulettes, his black tricorn hat tucked under his left arm. A hint of brown hair peeps out from under his powdered wig. At the time his portrait was painted, he was Lieutenant-Colonel in the 1st Bengal European Regiment.

The Champions, the Cobbes and the artist Thomas Gainsborough were all associated with the city of Bath during the second half of the 18th century (cat.45a), and although Col. Champion was in India almost continuously between *c*.1755 and 1775, his portrait must have been painted in Bath. That of his wife (cat.45*) must have been painted in London between 1775 and 1778. Local newspapers in Bath recorded the names of people arriving in the city for the winter social season, and the notice of the arrival of a 'Col. Champion and Lady' in the *Bath Chronicle* of 10 September 1767 may be associated with this portrait. Col. Champion apparently left India 'for Europe' on 6 February 1766'.[1]

By 1767 Gainsborough was established in the fashionable new upper part of Bath, at No.17 The Circus, and was enjoying a period of prosperity and good health. In a letter dated 13 September 1767, he playfully referred to some earlier difficulties on the 'Voyage' of his career, but fancied now that he was able to 'see Land' and was so busy that he required 'all the sail' he could muster.[2] His charge for a standard 'head' or 'three-quarters' portrait of this size was twenty guineas, a healthy increase on the modest five guineas he charged on first arriving in Bath in the autumn of 1758.

Col. Champion saw 20 years of active service in India, rising to the rank of Commander-in-Chief, Bengal, on 18 January 1774.[3] At the Battle of Buxar, in 1764, he reported his 'complete victory over the King and Vizier of Hindostan … their army consisted of 50,000 men, of whom they had 6000 killed on the field …'.[4] He appears to have been an efficient soldier, but one who was sometimes less than scrupulously honest, especially in his dealings with native Indians: 'a character long known among Indians to want every happy distinction', according to one contemporary.[5] When Warren Hastings was appointed Governor-General of Bengal in 1774, he congratulated Champion on his recent victory in the Rohilla War, but relations between the two men rapidly deteriorated, Champion bitterly resenting the fact that he was not accorded the rank of Brigadier-General nor given the political power his predecessor had enjoyed. Later, when the tide turned against Hastings, a Select Committee of Inquiry investigating the Governor's supposed mismanagement summoned a Capt. Rayne in the belief that he would speak against Hastings simply because he was a nephew of Col. Champion.[6]

Although Col. Champion visited Bath in 1767, when, like most visitors, he probably stayed in lodgings, he first rented a house of his own in the city in 1775. The Champions left India for England on a boat that sailed from Calcutta in February 1775.[7] Bath City Rates Books (Bath

Cat.45a Inscriptions and bookplates of Col. Alexander Champion, Mrs Champion, Thomas Leman, Frances ('Fanny') Conway and Charles Cobbe, successive owners of Samuel Johnson, *A Dictionary of the English Language*, 2 vols (London, 1786) (Alec Cobbe)

Cat.45b Joseph Nollekens, funeral monument to *Col. Alexander Champion* (Bath Abbey)

Record Office) show that by June 1775 Col. Champion was the ratepayer for No.29 Royal Crescent, a house previously occupied by the Hon. Rev. Frederick Hamilton (1728–1811), nephew of the Hon. Charles Hamilton, creator of the Painshill landscape garden, who lived at No.14. Both Hamiltons had Irish roots, the Rev. Frederick being the son of Archibald Hamilton of Riccartoun and Pardovan, Co. Linlithgow, and Confey Castle, Co. Kildare, and the Hon. Charles being son of the 6th Earl of Abercorn. The Champions' house was situated at the far (western) end of the Crescent, that nearest Marlborough Buildings, where, in 1790, Thomas Cobbe took a newly built house on moving from a smaller property in Catherine Place. Next door to the Champions, at No.28 Royal Crescent, was Philip Thicknesse, one of the most despised men in Bath (owing to his querulous nature and vicious satirical writings), but a long-term friend of Thomas Gainsborough and the author of the first biography of the artist.

John Warren, an Irish artist living in Bath in 1776, wrote home to his Dublin mentor Andrew Caldwell: 'I saw Mr Champion's House & was much please'd with the dining Room, etc, … Mr Hamilton has probably given you a description of the general Design … There is a Copy from the picture of Corregio's that was lately brought from Italy, by a Mr Hamilton ….'[8]

The Champions' copy of Correggio may have been after the version of the composition of *Venus, Cupid and a Satyr* in the possession of the Hon. Charles Hamilton. The latter was itself a copy – either of the original by Correggio now in the Louvre[9] or, more likely, of the famous copy brought to England in 1771 by William Hamilton, who described it as 'a picture of Correggio, excelled I believe by none'.[10] Warren's letter indicates that a variety of works of European art soon mingled with the rich array of Indian artefacts to be found in Col. Champion's house. In 1777, not long after Warren's visit, Champion commissioned a picture of his two dogs (Cobbe Collection, no.51) from Thomas Hickey (1741–1824), another Irish artist who was living and working in Bath and who may have been responsible for another portrait of Champion in the Cobbe Collection (Cobbe Collection, no.103). The same year Hickey signed and dated a portrait of the Colonel's mother-in-law, Mrs Elizabeth Nind (cat.47). It seems highly likely that the Champions' collection and intimate knowledge of India influenced Hickey's determination to move there in 1780.

In 1788 Col. Champion was a godparent (together with Thomas Cobbe and Lady Elizabeth Luttrell) to Thomas Cobbe's grandson, Thomas Alexander Cobbe (1788–1836), fourth son of Anne Power Trench (see fig.47) and Charles Cobbe (1756–98). Born on 31 August 1788 and baptised on 17 January 1789 at St Swithin's, Walcot, Bath, the Colonel's namesake Thomas Alexander went to India (see fig.48), where he married Nuzzeer Begum (see fig.49), daughter of Azeeze Khan of Cashmere. His godmother Lady Elizabeth Luttrell was sister to the Duchess of Cumberland, who sat to Gainsborough as Mrs Anne Horton in Bath in 1766, and both sisters appear in Gainsborough's famous oval canvas of the *Duke and Duchess of Cumberland in a Landscape* of 1783–5 (Royal Collection).[11]

Alexander Champion died on 15 March 1793 and is commemorated by a memorial by Joseph Nollekens in Bath Abbey (cat.45b), immediately to the north of the great west door.
ss

45*

THOMAS GAINSBOROUGH
Sudbury 1727–London 1788

Portrait of Mrs Francis Champion (d.1818)

Oil on canvas, 29½ × 24¾ in (75 × 62.9 cm)
Collection of Mr and Mrs Russell B. Aitken, New York
[represented in exhibition by a photograph only]
HISTORY inherited by Mrs Charles Cobbe (*née* Frances
Conway) in 1818 on the death of the sitter (then Mrs
Leman), her stepmother; recorded by Frances Power
Cobbe in 1868, no.85, in the Library; recorded in the
Library in 1901 (Valuation 1901b, p.11); at Newbridge
until 1913; with Lewis & Simmons and Agnew's,
London, July 1913; Mrs Daniel C. Jackling, San
Francisco, CA, 1933; Andre de Coppett, New York, by
1939 and until 1953; with M. Knoedler & Co., New York,
May 1953; with Newhouse Galleries, New York, 1955;
Kimbell Art Museum, Fort Worth, TX, 1955–89, from
which de-accessioned at auction, Sotheby's, New York, 2
June 1989, lot 99; sold again at sale, Sotheby's, New
York, 20 May 1993, lot 79; and again at Sotheby's, New
York, 30 January 1997, lot 53; private collection, USA
EXHIBITIONS Dublin 1872, no.194; San Francisco 1933,
no.9; New York 1939, no.135; New York 1942, no.382;
New York 1953, no.4
LITERATURE Cobbe 1868 (1882), no.85; Armstrong 1898,
p.198 (as '*Portrait of an Unknown Lady*'); Meehan 1901,
p.164; Armstrong 1904, p.271 (as '*Portrait of an Unknown
Lady, Said to be a Mrs. Champion*'); [Anonymous] 1913a, p.5;
[Anonymous] 1913b, p.6; Howe 1933, p.12, illus., and p.15;
Waterhouse 1953, pp.18–19; Waterhouse 1958, p.59,
no.129; *Cat. Kimbell Art Museum* 1972, pp.134–5, illus.;
Cat. Kimbell Art Museum 1981, p.39, illus.; Stewart 1990,
vol.1, p.261

1 [Anonymous] 1914b, p.104, letter XXX.
2 *Gentleman's Magazine*, vol.62, pt 2 (September 1792),
p.868.
3 C. Hoare & Co., Museum and Archive, Ledger
no.73/345.
4 Hodson 1927, p.328.
5 [Anonymous] 1914b, p.87, letter XXV.
6 [Anonymous] 1916, p.191, no.400.
7 Hodson 1927, p.328.

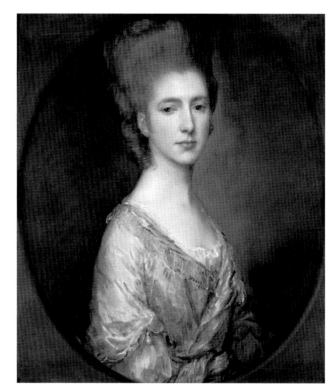

The classically beautiful Frances Champion, born Frances Nind, was described by a contemporary as a 'little woman'.[1] Her portrait – one of the finest of Gainsborough's 'head' or 'three-quarters'-length female portraits of the mid-1770s – is very similar in style and concept to the *Portrait of Elizabeth Linley* (Phildelphia Museum of Art, George W. Elkins Collection), usually dated to 1775. Since Gainsborough left Bath in the autumn of 1774 and since Frances and her husband, Col. Thomas Alexander Champion (see cat.45), took up residence in Bath only in 1775, the portrait must have been painted at Schomberg House, Pall Mall, London, where the artist lived from 1774 until his death. It was perhaps painted to celebrate Mrs Champion's entrée into Bath society in 1775: its presence in the Champions' sumptuously furnished house in Royal Crescent may have prompted Thomas Hickey to paint Mrs Champion's mother, Mrs Elizabeth Nind, in a consciously Gainsborough-esque style two years later, in 1777 (cat.47).

Although painted about eight years later than the portrait of her husband by Gainsborough, that of Mrs Champion is similarly composed within a feigned oval, and the two paintings probably always hung as pendants before 1913, when the present work was sold by Thomas Maberly Cobbe for the then extraordinary sum of £10,000.

According to a brief obituary notice that appeared in the *Gentleman's Magazine* at the time of her death in January 1818, Frances Champion was said to have been the daughter of William Nind, Barrister-at-law of Beaufort Buildings in the Strand, London, but this may be incorrect (see cat.47). She was, in any case, closely connected with a businessman named Thomas Conway, possibly a builder or property speculator, of the Strand, London, by whom she was apparently 'adopted' or at least financially supported in her youth. Conway was also described as 'of Beaufort Buildings',[2] and in April 1766 he appears to have purchased a substantial part of the Beaufort property in the Strand for £10,000.[3] A number of Strand properties, including houses in Beaufort Buildings and York Buildings, were occupied by various members of the Nind family.

Frances Nind and Thomas Alexander Champion were married in Calcutta, India, on 11 February 1759.[4] It is clear that she was a popular figure in India, to judge from the correspondence of Richard Barwell (1741–1804), a trader and property developer who amassed a huge fortune in India (where his father had served as a former Governor of Bengal). Mrs Champion

was evidently much admired by Barwell, who offered to help her stepfather. In a letter of September 1766, from Barwell addressed to Mrs Champion 'To the care of Mr. Thomas Conway, York Buildings [Strand]', he promises to try 'to advance the interest of Mr. Conway' in India.[5] The same letter speaks of the distress of all her 'Indian Devotees' on hearing that she is detained in England.

From Barwell we also learn that she was a keen collector of Indian artefacts. In a letter of 1774, to Robert Conway of Beaufort Buildings, he asks Conway to tell Mrs Champion that he has procured for her the coins she desired.[6] A group of Indian paintings that eventually made their way into the Cobbe family museum at Newbridge (see p.18) are among the items collected by Mrs Champion.

Following Alexander Champion's death in 1793, Mrs Champion remarried. Her second husband was the Rev. Thomas Leman, of Wenhaston Hall, Suffolk, Chancellor of Cloyne, whom she wed on 4 January 1796, in St Swithin's, Walcot. The witnesses to the marriage were Anne Cobbe (see fig.47) and Ralph Leycester (an associate of the Champions in India and another sitter to Gainsborough).

It is possible that a William Champion (1759/60–1780), described as a native of Wiltshire, was a son of Alexander and Frances Champion; he was killed in a duel in Calcutta in 1780.[7] Thus, apparently without surviving children of her own and recognising her debt to the Conway family, Frances Champion took the young Frances Conway (1777–1847), daughter of Capt. and Mrs Thomas Conway of Morden Park, Surrey, into her family. This Frances Conway married, in 1809, Charles Cobbe (1781–1857), and it was as a result of this marriage that the two Gainsborough portraits of the Champions and the Hickey portrait of Mrs Nind came into the Cobbe Collection.

SS

46
JOHN ZOFFANY
nr Frankfurt 1733–Kew 1810

Portrait of George de la Poer Beresford, 1st Marquess of Waterford (1735–1800)

Oil on canvas, 35¾ × 28 in (91 × 71 cm)
Newbridge 18th-century carved and gilt livery frame
(type VIII)
INSCRIPTIONS on the reverse: inscribed on label, in
brown ink, *Charles Cobbe Esq. / Newbridge Donabate*; on
another label, also in brown ink, *73 Full length Portrait of
George / 1st Marquis of Waterford*; and printed label of the
Dublin 1872 exhibition
Cobbe Collection, no.73
HISTORY 18th-century Newbridge collection; recorded
by Frances Power Cobbe in 1868, no. 73, in the Study;
recorded in the Study in 1901 (Valuation 1901b, p.16)
and 1914 (Valuation 1914, £21); thence by descent to
Hugh Cobbe; sale, Christie's, London, 12 July 1996, lot 21
(bought by Richard Green); acquired by Alec Cobbe,
December 1997
EXHIBITIONS Dublin 1872, no.306 (the attribution was
then given as 'Lobeni', a misreading of a former label on
the reverse of the picture; Alec Cobbe remembers read-
ing this label as 'Zobeni')
LITERATURE Cobbe 1868 (1882), no.73; Cornforth 1985a,
p.737, fig.15; Stewart 1995, vol.1, p.419, vol.3, p.75

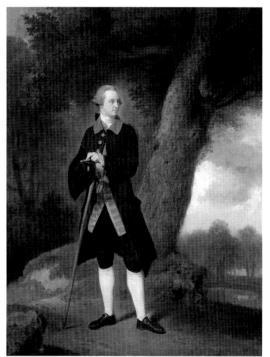

George de la Poer Beresford, 1st
Marquess of Waterford (1735–1800),
was the elder son of Sir Marcus
Beresford, 4th Bt, who was successively
created Viscount and Earl of Tyrone in
1720 and 1746, on account of his mar-
riage in 1717 to Lady Catherine Poer or
Power (*d*.1769), daughter and heiress
of James, 3rd Earl of Tyrone of the cre-
ation of 1672, and Baroness de la Poer
in her own right. The Poer family
had held immense estates in what was
to become the county of Waterford
since the late 12th century, while the
Beresfords had settled in northern
Ireland under King James I in the early
17th century. The Beresfords were,
inevitably, committed Protestants,
while the loyalties of Lady Catherine's
family were more complicated: her
grandfather, the 1st Earl of Tyrone,
had died as a Jacobite prisoner in the
Tower of London in 1690. Prodigiously rich by Irish standards, the 1st Marquess followed his
father's example by himself marrying an heiress, Elizabeth, only daughter of Henry Monck of
Charleville. His elevation to Marquess of Waterford in 1789 must be seen in the context of the
attentions of William Pitt the younger (1759–1806) to those who supported his ministry. It is
therefore revealing that Tyrone – as he was at the time that Zoffany portrayed him – chose to
be shown in Windsor uniform, of which the right to wear was in the personal gift of King
George III and was, of course, regarded as a considerable honour.

The Marquess selected a London architect, James Wyatt (1746–1813), to work at the family
seat of Curraghmore, and it is therefore not surprising that he turned to a painter based in
London for this portrait, which was presumably intended for presentation to his sister Lady
Betty Cobbe, of whose marriage settlement he was a trustee. The picture is evidently of about
1780 – the Windsor uniform itself was initiated only in 1778. Zoffany had first achieved fame
as a painter of 'portraits-in-little' and small group portraits early in the previous decade.
Significantly, in view of the sitter's relationship with the court, Zoffany had quickly secured
royal patronage, and painted his most ambitious work, *The Tribuna* (Royal Collection), for
Queen Charlotte. This sensitive portrait exemplifies the painter's talents on a confined scale,
the realistic, informal, but not unflattering pose, the skilful use of what can only be a very
generic parkland setting to suggest the subject's consequence, and, not least, the precision
and control of the execution.

FR

47
THOMAS HICKEY
Dublin 1741–Madras 1824

Portrait of Mrs Elizabeth Nind (d. after 1780)

Oil on canvas, 30 × 25 in (76 × 63.5 cm)
By 1868, and until recently, fitted inappropriately into a Newbridge 18th-century shouldered livery frame (type II); replaced by a copy, by John Davies of Norfolk, of another Newbridge 18th-century livery frame (type VIII), which is more in keeping with the date of the picture
INSCRIPTIONS signed and dated *1777*; on the reverse of the canvas: inscribed on label, in brown ink, *… 14 Mrs Nind*, over another label, also in brown ink, *Cobbe / Newbridge*; fragment of printed label from the Dublin 1872 exhibition; inscribed on another label, in brown ink, *… / Study to its present location on November 1901. to make room for the / large likeness of Charles Cobbe which is / now over the Chimney Piece / Francis C. H. Moore*
Cobbe Collection, no.114
HISTORY inherited by Mrs Charles Cobbe (*née* Frances Conway) from her step-parents, Col. and Mrs Champion, Bath; recorded by Frances Power Cobbe in 1868, no.114, on the Stairs (Second Wall); recorded in 1896 in the Study, where seen by Walter Armstrong, Director of the National Gallery of Dublin, and restored on his advice for £2.10s (Cobbe 1896, fol.4r); removed from the Study in 1901 and replaced on the Stairs; recorded on the Principal Staircase in 1914 (Valuation 1914, £60); thence by descent
EXHIBITIONS Dublin 1872, no.242
LITERATURE Cobbe 1868 (1882), no.114; Laing/Cobbe 1992, p.8, no.114, illus.; Stewart 1995, vol.3, p.75

1 PCC 1742, Middx 11/ 719. In the preparation of this catalogue entry, I have been greatly assisted by Mrs Angela Acheampong, whose mother was a member of the Nind family. I am most grateful to her for sharing the results of her extensive genealogical research with me and for making a number of helpful suggestions.
2 Information kindly supplied by Dr Clare Rider, Archivist to the Honourable Society of the Inner Temple.
3 PCC 1751, Middx Mar 151.
4 [Anonymous] 1914b, no.25.
5 PCC 1780, Middx Jul 370.
6 Victoria Art Gallery, Bath (inv.no.P1959.9).
7 Bath Record Office, City Rates Book, commencing 24 June 1772 and 25 December 1773. For his help, I am indebted to Colin Johnston, Archivist, Bath Record Office.
8 Breeze 1984, pp.83–5.
9 Dublin Corporation; see Breeze 1984, pp.92–3, n.18.

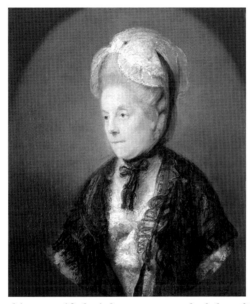

Mrs Elizabeth Nind was the mother of Mrs Frances Champion and the mother-in-law of Thomas Alexander Champion, both of whom were painted by Thomas Gainsborough (cats 45* and 45). According to Mrs Champion's brief obituary (see p.142), Elizabeth Nind was not, as Frances Power Cobbe believed, married to a clergyman, but to William Nind, a barrister-at-law of Beaufort Buildings in the Strand, London. A William Nind of the Strand was living in 1742. He was the son of another William Nind (*c.*1682–1742), a brasier and ironmonger in the Strand. The younger William was left 'one shilling and no more' in his father's will as a result of having 'greatly misbehaved himself'.[1] It is not certain, however, that the perpetrator of this unspecified misdemeanour was the father of Mrs Champion and husband of the Mrs Elizabeth Nind depicted by Hickey. No William Nind appears to have been admitted to any of the four Inns of Court (a necessary qualification for a barrister) at the time in question.[2]

It is possible that Mrs Nind's husband and Mrs Champion's father was a John Nind (1712–*c.*1751) – who had a wife named Elizabeth and a daughter named Frances – who was baptised at St Martin-in-the-Fields on 26 March 1740. In 1749 this John Nind occupied premises in York Buildings, George Street, Strand. His will shows that his wife and daughter were still living in 1751.[3] If this John Nind of York Buildings was the husband of the Mrs Nind who sat to Thomas Hickey, his death about 1751, when his daughter was only 10 or 11 years old, might have been the reason for Frances being taken under the protective wing of the Conway family. A letter from Richard Barwell in India to Frances (then Mrs Champion) is addressed to her 'care of Mr. Thomas Conway, York Buildings' in September 1766.[4] A Mrs Elizabeth Nind of Bath is mentioned in the will of 1780 of Sarah Nind of Lisson Green, London.[5]

Hickey's *Portrait of Mrs Elizabeth Nind* is one of the best surviving examples of his work from the period 1776–80, when he was resident in Bath. Philip Thicknesse, in his *New Prose Bath Guide for the Year 1778* (p.49) includes under 'Artists resident at Bath', 'Mr. HICKEY, near the PUMP ROOM'. He further noted: 'We have seen very few of this Gentleman's Portraits, but enough to venture to pronounce him a Man of Genius … We are sorry, however, to observe, that Artists, of Eminence in their Profession, think it necessary to put their Names upon Boards in Public Places; Places where only the names of Hairdressers, Milliners and Mountebanks, ought to appear.' If Mrs Nind's portrait hung at her daughter and son-in-law's house at No.29 Royal Crescent, as seems very likely, Thicknesse would probably have seen it, since he lived next door (see cat.45). The only example of Hickey's Bath work to remain in the city is his signed and dated *Portrait of William Dawson, Master of Ceremonies at the Upper Rooms*, also of 1777.[6] A William Dawson, probably this same person, occupied the house in Catherine Place, Bath, to which Thomas Cobbe moved in 1786.

It is not known precisely which property Thomas Hickey occupied near the Pump Room in Bath, but a Michael Hickey was a ratepayer in Abbey Churchyard (where the Pump Room is

situated) from autumn 1772 until late 1773.[7] This Michael Hickey may have been the 'Hickey Taylor' who advertised in the *Bath Chronicle* on 29 November 1770 from a Cross Bath address, and he may have been a relative of the artist. Abbey Churchyard was a prime trading position in Bath: it was here that Gainsborough worked between 1760 and 1766, before moving to The Circus. It has been noted that a Mr Hickey was a ratepayer at Bellmont, Bath, between 1777 and 1778,[8] but Bellmont was not the most convenient location for an aspiring portrait painter, and Thicknesse's assertion that the artist lived near the Pump Room is likely to be correct. It is possible that Hickey lived under one roof and worked under another, as Gainsborough did for part of his stay in Bath.

The painterly handling of Mrs Nind's portrait and the placing of the figure on the canvas, within a feigned oval and against a dark, shadowy background, owe a great deal to Gainsborough. That artist's portrait of his sister *Mrs Sarah Dupont* (Art Institute of Chicago) is similarly conceived, as are several other Gainsborough family portraits. Mrs Nind's downward glance, perhaps designed by Hickey in anticipation of a high hanging position for the portrait, is not derived from the work of Gainsborough. He, as is well-known, wished portraits of this size to be hung at eye-level and positioned his sitters accordingly, either looking straight out at the viewer (see cat.45*) or to one side (see cat.97). Hickey's familiarity with the work of Gainsborough predates his residence in Bath: Gainsborough's full-length *Portrait of John, 4th Duke of Bedford*, presented to Trinity College, Dublin, by the sitter in 1768, was copied by Hickey in Dublin.[9]

By the time the Champions and Mrs Nind settled in Bath in 1775, Gainsborough had left for London. Although Mrs Champion travelled to London to sit for her portrait, which was destined to hang as a pendant to her husband's picture, it was more convenient for the elderly Mrs Nind to sit locally, and Thomas Hickey, newly arrived from Ireland, was an obvious choice. Considerations of practicality doubtless also influenced Thomas Alexander Champion's decision to ask Hickey rather than Gainsborough to paint his two dogs (Cobbe Collection, no.51), although Gainsborough's skill in this subject-matter was unsurpassed. As mentioned under cat.45, the experience of seeing extraordinary Indian artefacts at the Champions' house, and hearing first-hand accounts of India from the family, may have played a part in Hickey's plan to move to India in 1780. In the event, the ship on which the artist sailed was captured off Spain, and Hickey spent three years in Lisbon before setting off again for India, reaching Calcutta in March 1784.

SS

48

ENGLISH SCHOOL (?)

18th century

Portrait of Lady Elizabeth Cobbe, née Beresford (1736–1806)

Oil on canvas, 30 × 25 in (76 × 63.5 cm)
Newbridge 18th-century gilt livery frame (type VIII);
remains of pinned-down leather hanging-loop on
reverse
INSCRIPTIONS on the reverse, on frame: inscribed on
label, in brown ink, *No 67 / Lady Betty Cobbe / by Angelica
Kauffman / Oct 1806*
Cobbe Collection, no.80
HISTORY 18th-century Newbridge collection; recorded
by Frances Power Cobbe in 1868, no.80, in the Study;
restored in 1896 for £2 on the advice of Walter
Armstrong, Director of the National Gallery in Dublin,
described by Charlotte Cobbe as 'Lady Elizabeth Cobbe
(née Beresford) / wife of Thomas Cobbe Esq / by Angelica
Kauffmann / £2.0.0.' and mentioned in the Study;
recorded in the Study in 1901 (Valuation 1901b, p.16) and
in the Drawing Room in 1914 (Valuation 1914, £300);
thence by descent
LITERATURE Cobbe 1868 (1882), no.80; Mayer 1972, illus.
(as by Angelica Kauffman); Cornforth 1985a, p.1735,
fig.9 (as by Kauffman)

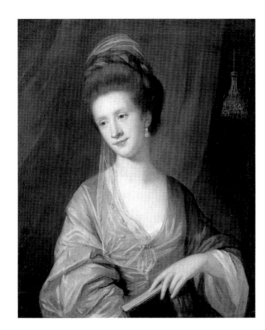

In contrast to the confident poise displayed in her portrait by Astley (cat.9), which was painted shortly after her marriage in 1755, Lady Betty Cobbe is here shown as a young woman in pensive mood, book in hand, perhaps an allusion to the beginnings of a religious phase of her life that would lead her to retreat from Irish society and live quietly in Bath.

After many years of fashionable life at Newbridge – extending the house, collecting pictures and entertaining on a lavish scale – Lady Betty became increasingly religious, coming under the influence of her husband's first cousin, the celebrated Countess of Huntingdon, who had founded a Presbyterian chapel in Bath. In late 1785 or 1786, Lady Betty and her husband took the first of a succession of houses in Bath, where they spent most of the remainder of their lives.

The present portrait was unattributed in Frances Power Cobbe's catalogue of 1868. Following the visit to the collection in 1896 of Walter Armstrong, then Director of the National Gallery of Ireland, the picture was referred to in accounts and inventories as by Angelica Kauffman (1741–1807), though, as Dr Bettina Baumgärtel has pointed out, this cannot be the case. While painted in oils, the portrait has some affinities with the pastel of Lady Betty's closest friend and sister-in-law, Anne Constantia de Ligondes, the Hon. Mrs John Beresford (see under cat.10), which is presumed to be the work commissioned by Lady Betty in 1756 from 'Mr Pine', perhaps Simon Pine (*fl.*1742; *d.*1772). The present painting, however, has recently been attributed by Francis Russell to the Scottish painter Katherine Read (1723–79), who specialised in pastel portraits and who made a full-size portrait in oils of Lady Betty's only son, Charles, of which a fragment survives (Cobbe Collection, no.116).

AC

49
FLORENCE GRAHAM
fl. 1861–91

Portrait of Frances Power Cobbe (1822–1904)

Crayons on paper, 11 × 9 in (28 × 23 cm)
Composition and gilt frame
INSCRIPTIONS signed, numbered and dated at centre
right, in pencil or black crayon, *F. Graham / 104 /* [18]*97*;
on the *verso:* inscribed on label, *Miss Frances Power Cobbe /
by / Miss Florence Graham / 15a Cromwell Place / S.W.*;
printed label, in red and black ink, *W.E.* (red) / *2101*
(black) / *Earl's Court* (red); and bookplate of Alec Cobbe
Cobbe Collection, no.124
HISTORY 19th-century Newbridge collection; thence
by descent

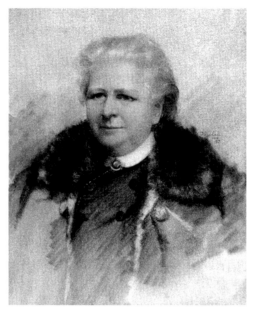

Frances Power Cobbe (1822–1904), whose
handwritten catalogue from 1868 docu-
ments the Cobbe family collection, was a
suffragist, essayist, journalist, theologian
and social reformer. By the last quarter of
the 19th century she had become the most
important British woman writer of intel-
lectual prose. Her essays are marked by
impassioned earnestness, careful research,
concrete details and a biting edge that
compelled public attention. A central
figure in the circle of London intellectuals
who engaged in the period's significant
debates, she published in prestigious
journals, as well as in popular monthly
magazines. On her 80th birthday, admirers
presented a message signed by almost 400
scientists, bishops, politicians, reformers
and authors, from both sides of the
Atlantic, including Florence Nightingale, Dr Elizabeth Blackwell, Henry James, Mark Twain
and former US President Grover Cleveland.

The youngest child and only daughter of the Charles Cobbe (who succeeded to the Newbridge
estate in 1810), Frances Power Cobbe lived almost entirely at Newbridge for the first 35 years of
her life. 'It is hardly to be measured', she wrote in 'A Day at the Dead Sea' (1863), 'how much the
best and tenderest family feelings amongst us are due to the old house, wherein all associations
are centred, wherein each member of the race feels pride, where the pictures of our forefathers
hang side by side on the walls, and their dust rests together in the vault hard by.'

During her early years, the house was often filled with brothers, cousins and visitors, but
after leaving school in 1838 she had time and the initiative to occupy herself in ways that pre-
pared her for intellectual eminence and that now provide a record of the family and estate. Her
self-education began with a crisis of faith. Dissatisfied with her father's evangelical Christianity,
she began to study comparative religion. Her first books, published anonymously in 1855 and
1857, explored intuitive morals – that is, universal and non-sectarian moral principles derived
from individual conscience rather than from scriptures or organized religion. Studded with
quotations in Latin and Greek as well as in French, the books were generally reviewed as the
work of a well-educated, but unconventional clergyman.

In the following decade Cobbe became widely known as an advocate of women's rights.
She was the first to propose, at the 1862 London meeting of the National Association for the
Promotion of Social Science, that women be eligible for university degrees. Although *The Times*
(11 June 1862) said that hers was 'the most interesting paper of the day', other newspapers and
weekly magazines ridiculed the idea. Essays such as 'What Shall We Do With Our Old Maids?'
supplied memorable phrases as well as provocative ideas. 'Criminals, Idiots, Women and
Minors' pointedly named those citizens who had few civil rights. Her 1878 campaign against
domestic abuse, culminating in the article 'Wife-Torture in England', secured passage of
the act that allowed magistrates to grant an immediate separation order to a woman whose
husband assaulted her.

But women's causes were not the only focus of her interest. In 1871, long before Freud, she wrote 'Dreams as Illustrations of Unconscious Cerebration'. She also published on science, politics, the Poor Laws, travel and religion, and engaged in a long-running battle with leading physicians over the use of animals in experiments. Within two decades after her death, however, Cobbe's name was almost forgotten. One problem was genre: 19th-century British women novelists and poets are valued for their imagination, emotion and realistic depiction of female lives, but the women who published non-fiction prose remain invisible. Furthermore, as the *Daily News* suggested in 1893, 'It is the fate of social reformers worthy of the name to find their writings gradually becoming more or less obsolete.'

Both the fame and the neglect lay far in the future when Frances Power Cobbe was a young woman at Newbridge. 'The Town Mouse and the Country Mouse' (1875) describes the 'eventlessness' of life on a substantial estate. Yet the corresponding benefit, she continued, was the opportunity for a young mind of 'working out its problems for itself' and 'devouring the great books of the world'. In addition, she filled time in ways that preserve information that might otherwise have been lost.

Her observations of Anglo-Irish life in the 1830s and 1840s were set down in the autobiography published in 1894. On a simpler but more practical level, she sketched scenes that record the appearance of Newbridge in the 1840s, catalogued the books that were in the house in September 1852, and created a large, illuminated genealogical album containing the arms and heraldic devices of families connected to the Cobbes, the last requiring significant historical and archival research. Although her elder brothers Thomas (a barrister with antiquarian hobbies) and Henry (a clergyman) shared in the work, she herself happily inspected manuscript sources in the British Museum, where records show that she was formally admitted to the Reading Room on 2 June 1851 while visiting London cousins.

The catalogue of Newbridge paintings was produced after she had left home, during a summer visit in 1868. Her first trip to Rome in 1857 had spurred an interest in art. Visiting museums and churches, Murray's guidebook in hand, she copied inscriptions, made notes and produced rough sketches to aid her memory. She also met the American sculptor Harriet Hosmer (1830–1908), whose monumental *Zenobia* (c.1857; Wadsworth Atheneum, Hartford) was shown in London in 1862. Five years later, Hosmer accompanied Frances Power Cobbe on a visit to Newbridge. Hosmer's interest may well have prompted Frances's decision to produce a record of the paintings and family portraits. In addition, she had developed 'Twelve Canons of Art and Literature', in an article published earlier in the summer of 1868. Silently taking issue with Keats's claim that 'Beauty is truth, truth beauty', she asserted their difference. Literature, she wrote, arises from 'love of the true' but art from 'love of the beautiful', and the only aim of art is 'excitement of the imagination'. It is unsurprising that Frances Power Cobbe should have had herself portrayed by a female artist, but the reason for the choice of the little-known Miss Graham, who had four subject paintings exhibited at the Royal Academy between 1883 and 1898, is less apparent. She may have been the sister of Frances Power Cobbe's sister-in-law Janet Finlay Graham, who was herself an amateur artist (see fig.3) and who was married to the historian brother, Thomas Cobbe.

SM

Part I

COLOUR PLATES OF
THE HISTORIC COBBE COLLECTION

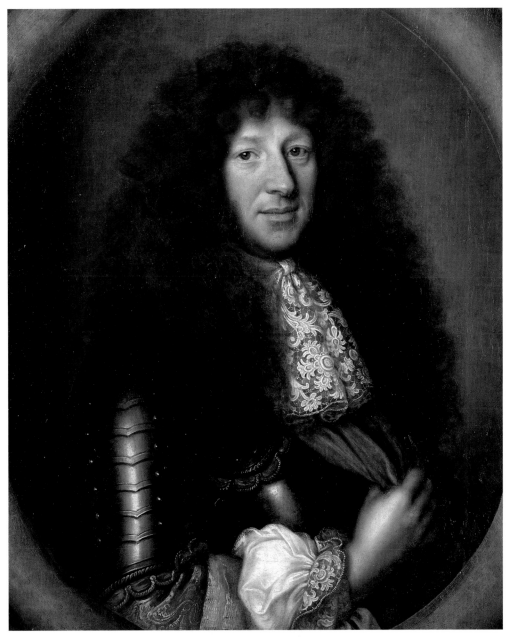

CAT.1 IRISH SCHOOL, LATE 17TH CENTURY *Major-General Thomas Fairfax*

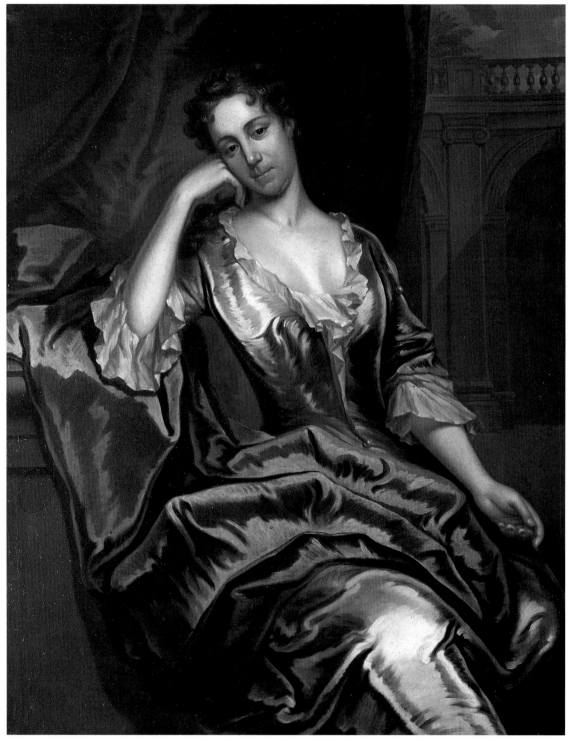

CAT.2 IRISH SCHOOL (?), EARLY 18TH CENTURY *Mary Levinge, Countess Ferrers*

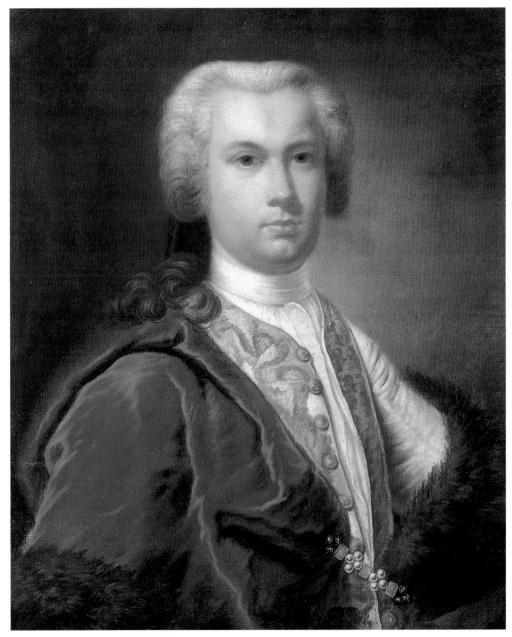

CAT.3 CHARLES MARTIN *Sir John Rawdon*

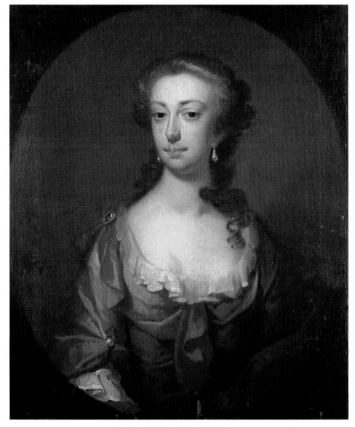

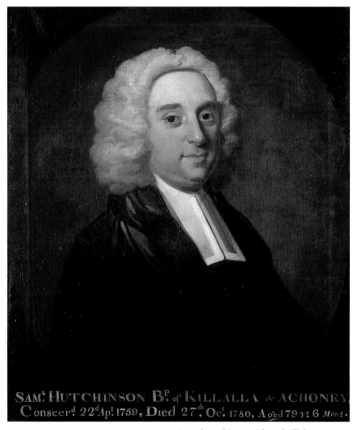

CAT.4 JAMES LATHAM *Lady Helena Rawdon, née Perceval*

CAT.5 ATTRIBUTED TO JAMES LATHAM *Samuel Hutchinson, Bishop of Killala*

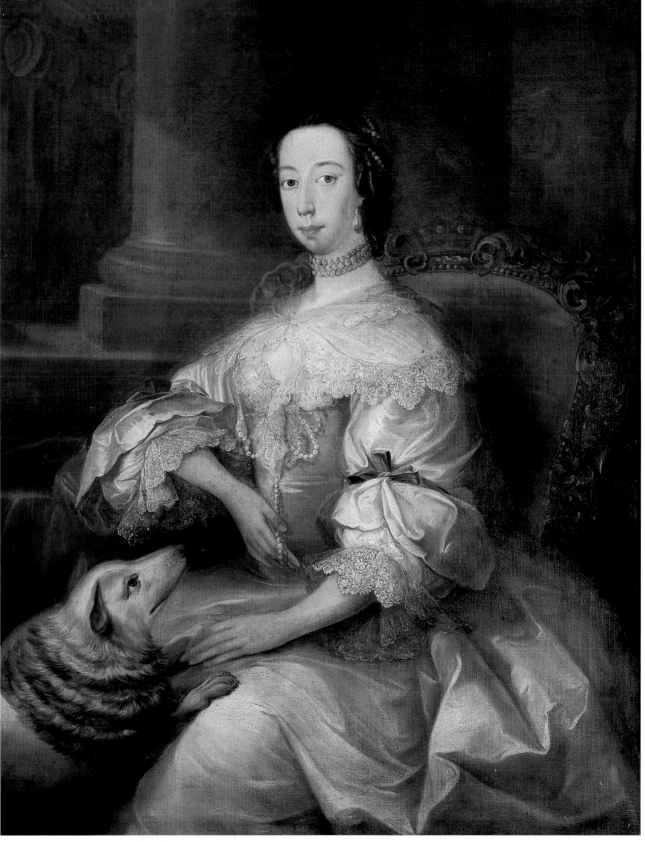

CAT.6 JOHN LEWIS *Elizabeth Rawdon, née Hastings*

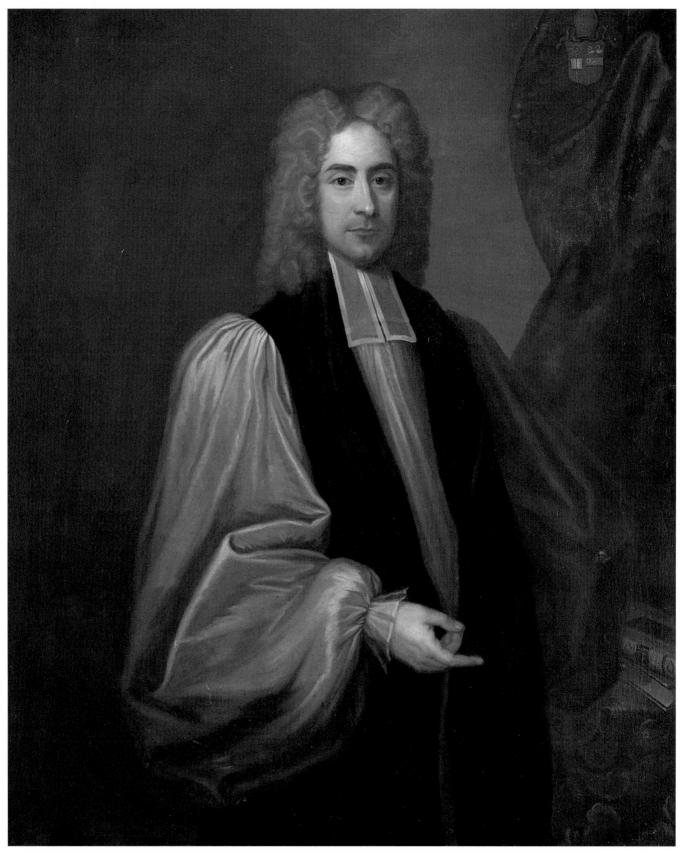

CAT.7 JAMES STEWART *Charles Cobbe, later Archbishop of Dublin*

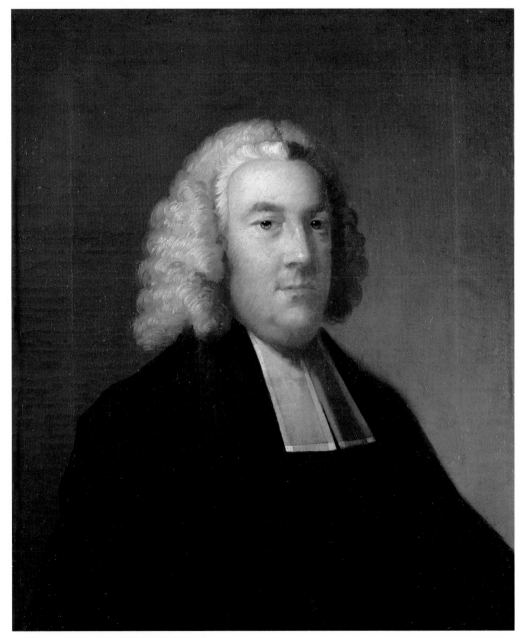

CAT.8 JOHN ASTLEY *Rev. Sir Philip Hoby, Bt*

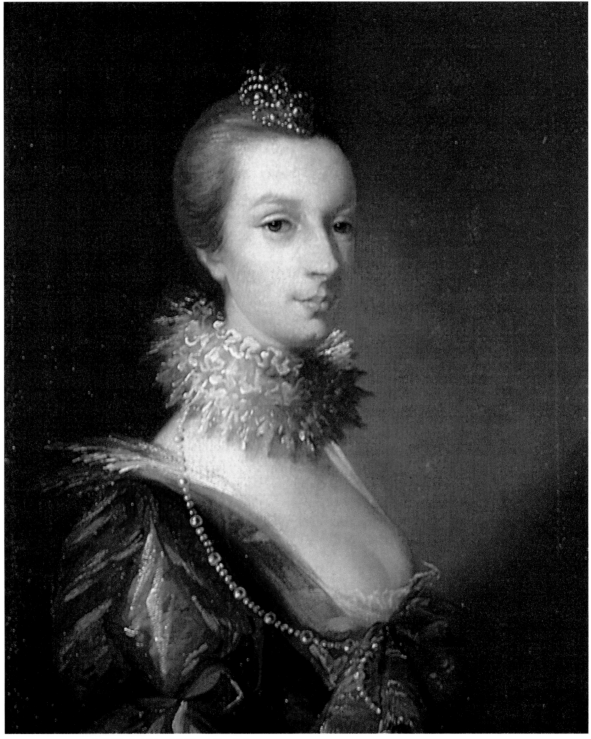

CAT.9 JOHN ASTLEY *Lady Elizabeth ('Betty') Cobbe, née Beresford*

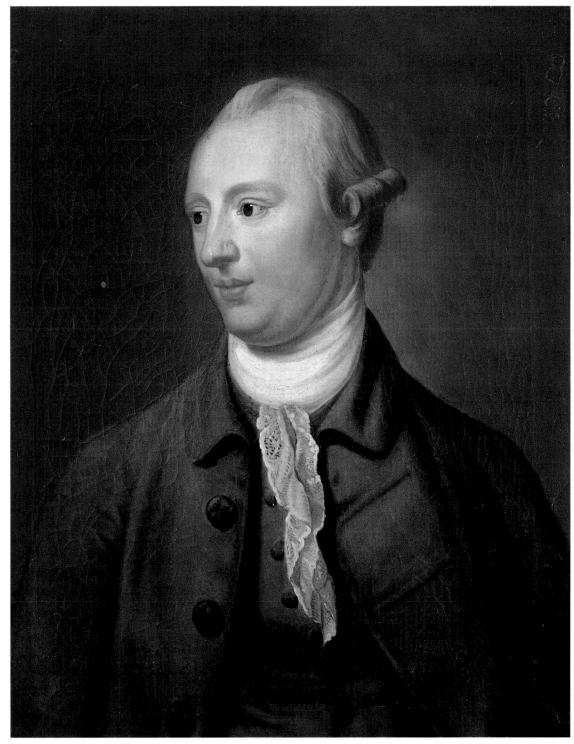

CAT.10 ROBERT HUNTER *The Hon. and Rt Hon. John Beresford*

CAT.11 GEORGE BARRET *River Landscape at Sunset*

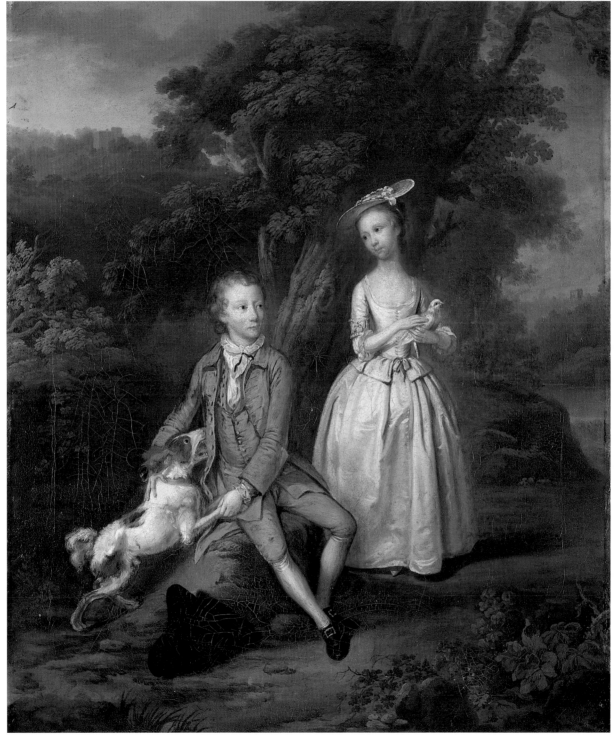

CAT.12 STRICKLAND LOWRY *Charles Cobbe and his Sister Catherine Cobbe as Children in a Landscape*

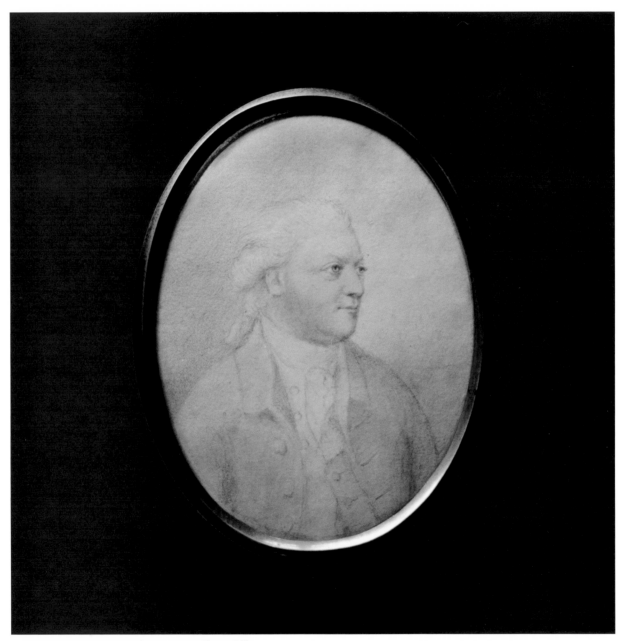

CAT. 13 IRISH SCHOOL, LATE 18TH CENTURY *Thomas Cobbe*

CAT.14 GEORGE FRANCIS MULVANY *Charles Cobbe*, DL

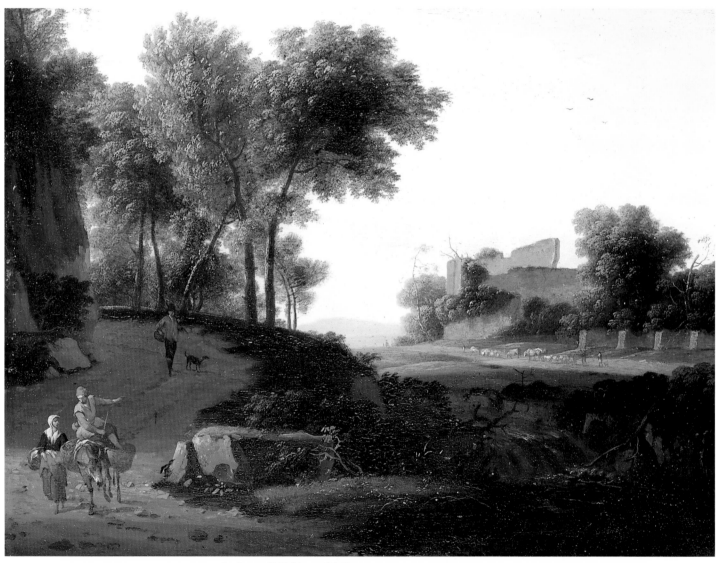

CAT.15 ATTRIBUTED TO HERMAN VAN SWANEVELT *Landscape with Muleteers and Cattle*

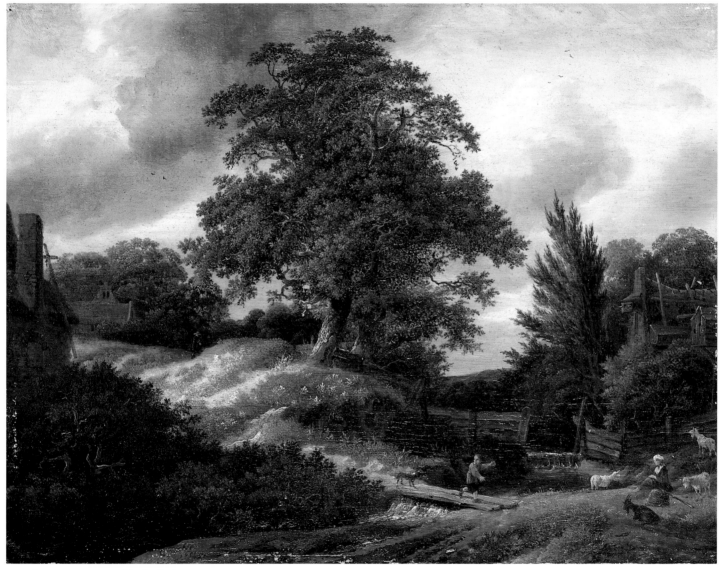

CAT.16 CORNELIS DECKER *River Landscape*

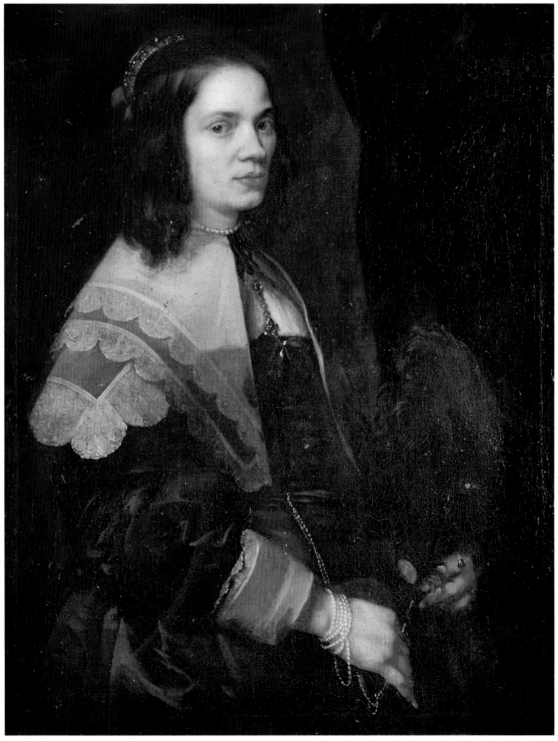

CAT.17 DUTCH SCHOOL (?), *c.*1640 *Portrait of a Lady*

CAT.18 HENDRICK MOMMERS *A Vegetable Market in Trajan's Forum*

CAT.19 ATTRIBUTED TO GILLIS ROMBOUTS *Landscape with a Bridge*

CAT.20 KLAES MOLENAER *Travellers Resting near Cottages*

CAT.21 BARENT GAEL *Village Inn*

CAT.22 BARENT GAEL *Village Fair*

CAT.23 ABRAHAM BEGEYN *Landscape with Muleteers Watering their Animals*

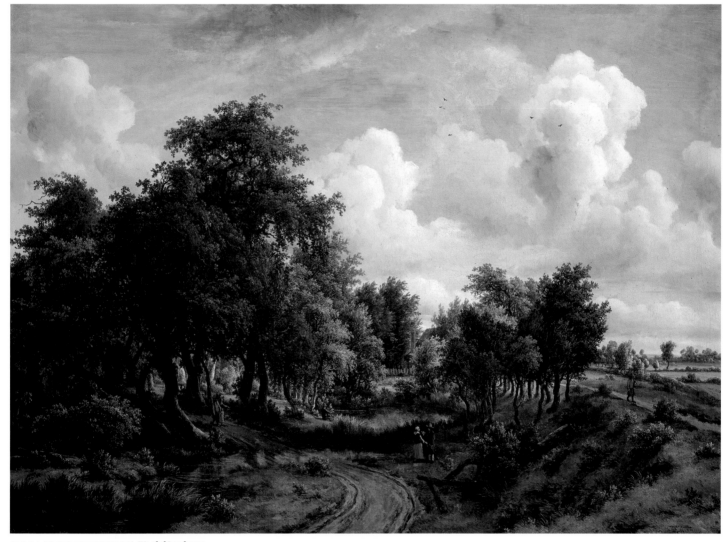

CAT.24 MEINDERT HOBBEMA *Wooded Landscape*

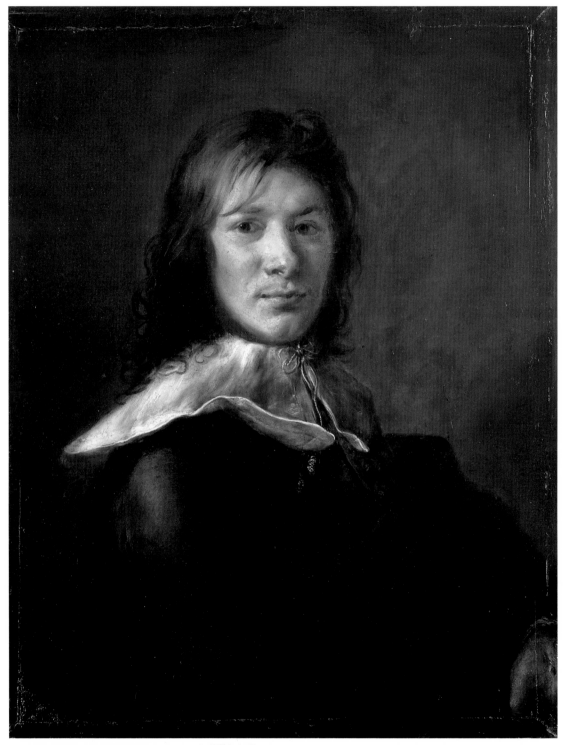

CAT. 25 EGBERT VAN HEEMSKERCK THE ELDER *Self-portrait*

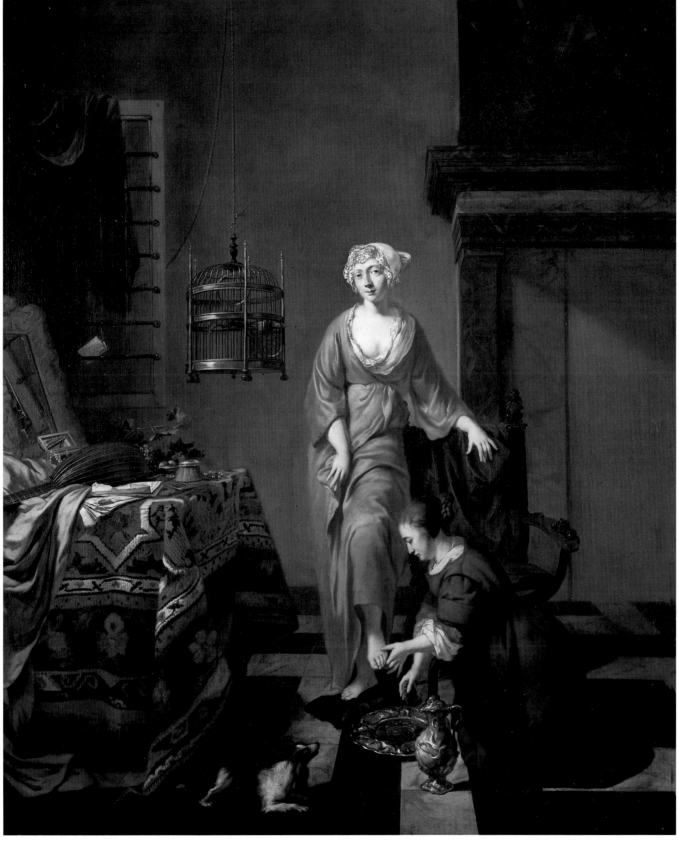

CAT.26 JOHANNES VOORHOUT *A Lady in an Interior, with a Servant Washing her Foot*

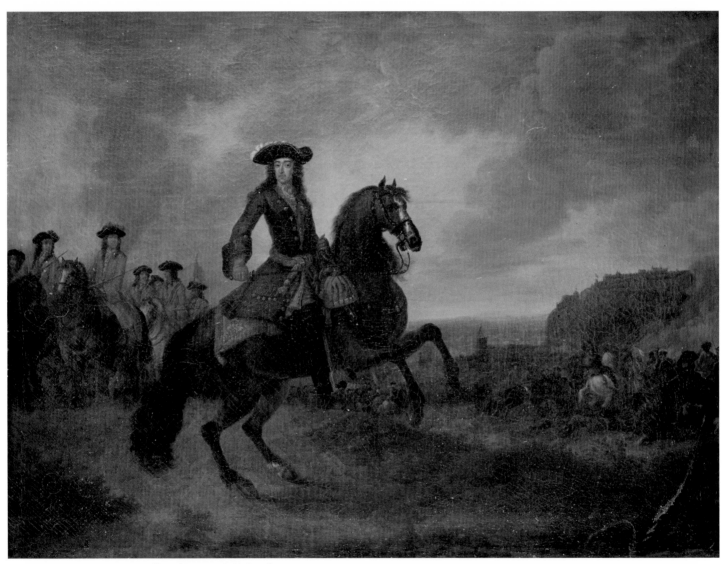

CAT.27 JAN WYCK AND STUDIO *William of Orange at the (?) Siege of Namur*

CAT.28 GERARD HOET *Landscape with Travellers on a Path*

CAT.29 WILLEM VAN DE VELDE THE YOUNGER *Ships under English Flags at Sea, a Squall Approaching*

CAT.30 CORNELIS VAN DE VELDE *A Calm with Ships near the Shore*

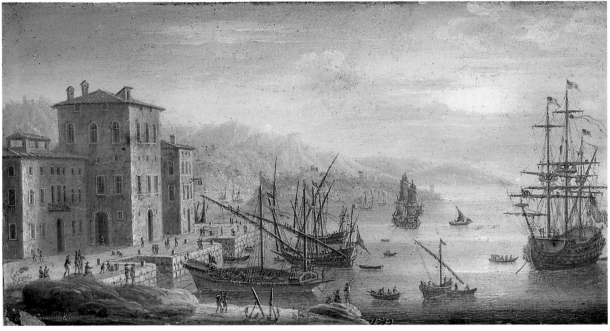

CAT.31 ORAZIO GREVENBROECK *View of a Port at Sunset*

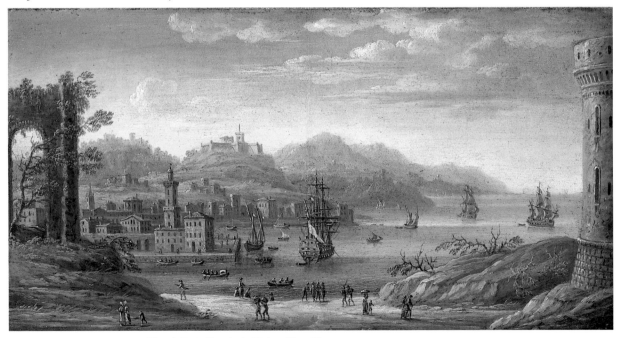

CAT.32 ORAZIO GREVENBROECK *View of a Port with an Ancient Ruin and Round Tower*

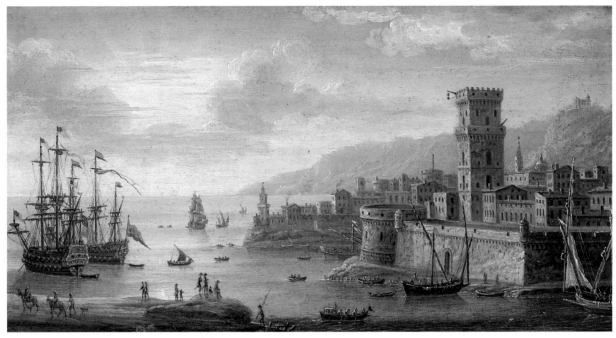

CAT.33 ORAZIO GREVENBROECK *View of a Fortified Port at Sunset*

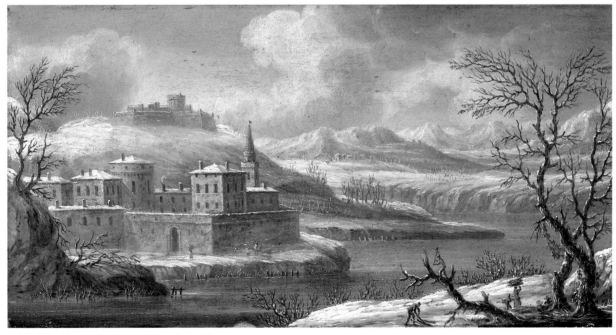

CAT.34 ORAZIO GREVENBROECK *River View in Winter*

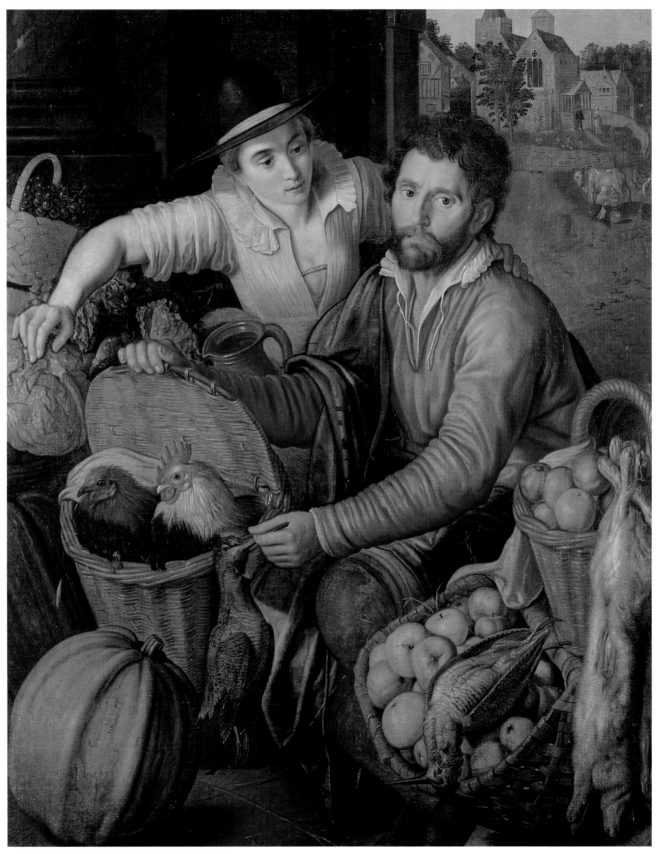

CAT.35 FOLLOWER OF JOACHIM BEUCKELAER *Market Scene*

CAT.36 BALTHAZAR BESCHEY *St Hilary and St Francis in a Cave*

CAT.37 FOLLOWER OF FRANCESCO ALBANI *Head of an Angel*

CAT.38 VENETIAN FOLLOWER OF BERNARDO STROZZI *The Concert*

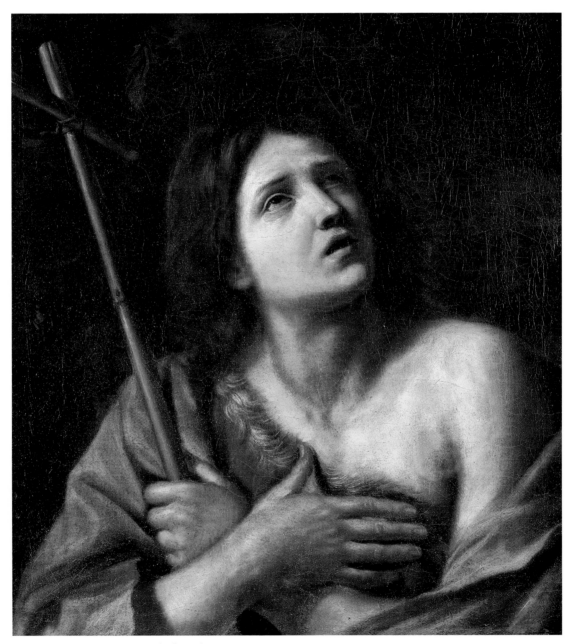

CAT.39 STUDIO OF GUERCINO *St John the Baptist*

CAT.40 GASPARD DUGHET *Wooded Valley Landscape with Two Figures in the Foreground*

CAT.41 GIUSEPPE BARTOLOMEO CHIARI (?) AFTER GUIDO RENI *Head of Helen of Troy*

CAT.42 GIUSEPPE BARTOLEMEO CHIARI OR ANOTHER FOLLOWER OF CARLO MARATTA *The Madonna Annunciate*

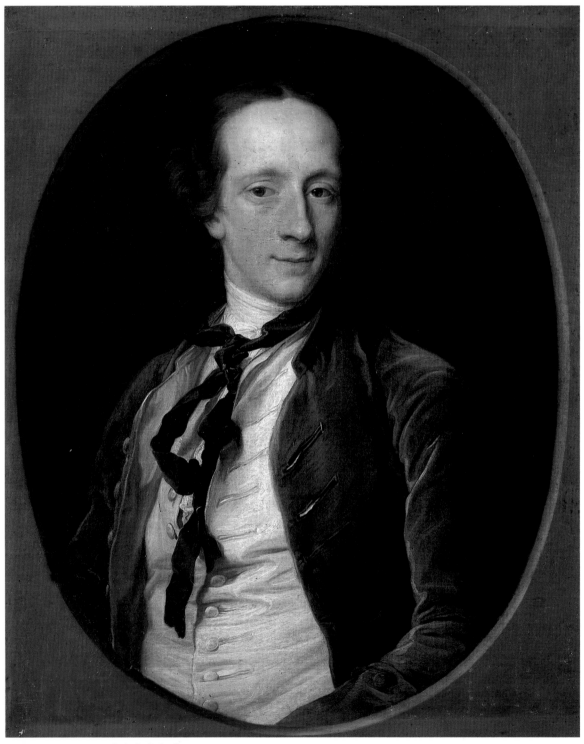

CAT.43 POMPEO BATONI *Portrait of a Gentleman*

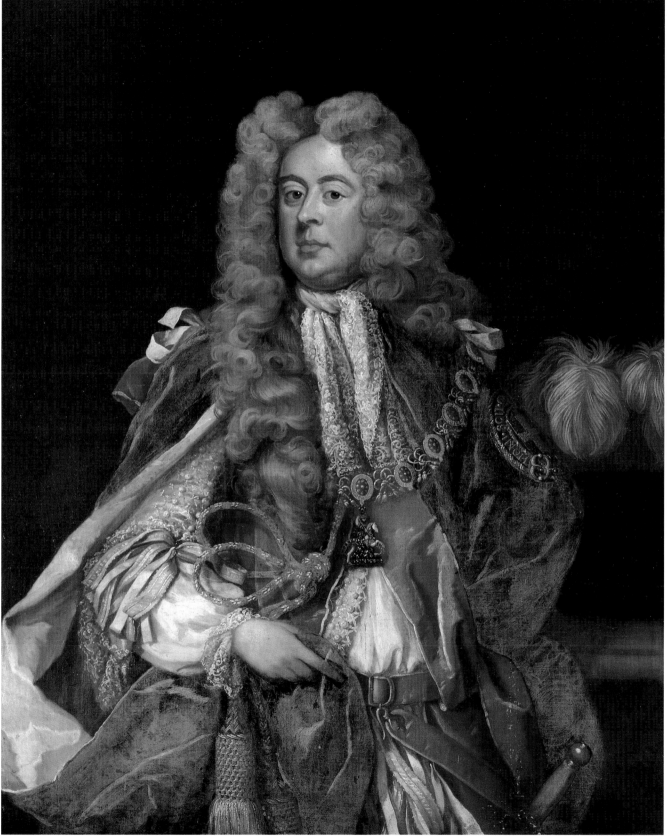

CAT.44 ENGLISH SCHOOL, *c.1714–22* *Charles Paulet (or Powlett), 2nd Duke of Bolton*

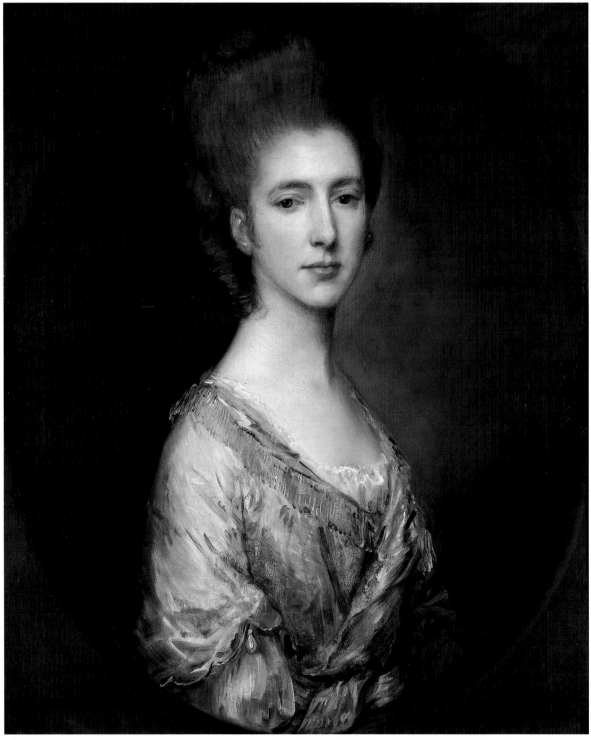

CAT.45* THOMAS GAINSBOROUGH *Mrs Frances Champion*

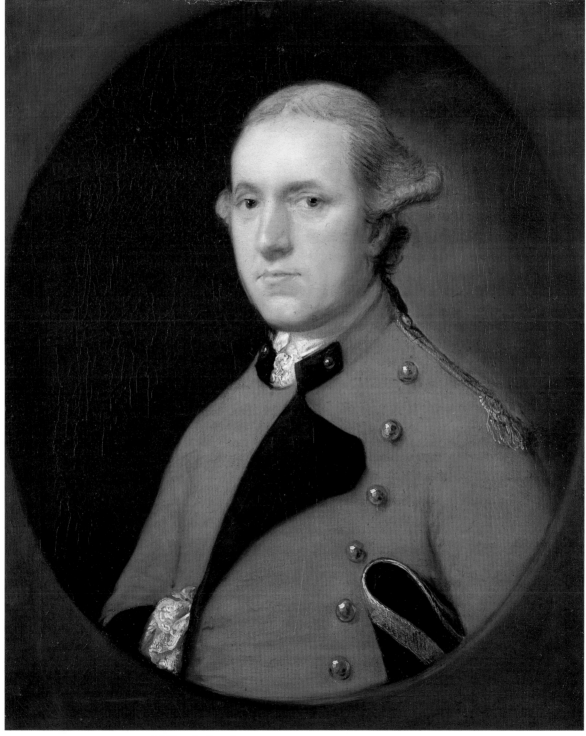

CAT.45 THOMAS GAINSBOROUGH *Col. Alexander Champion*

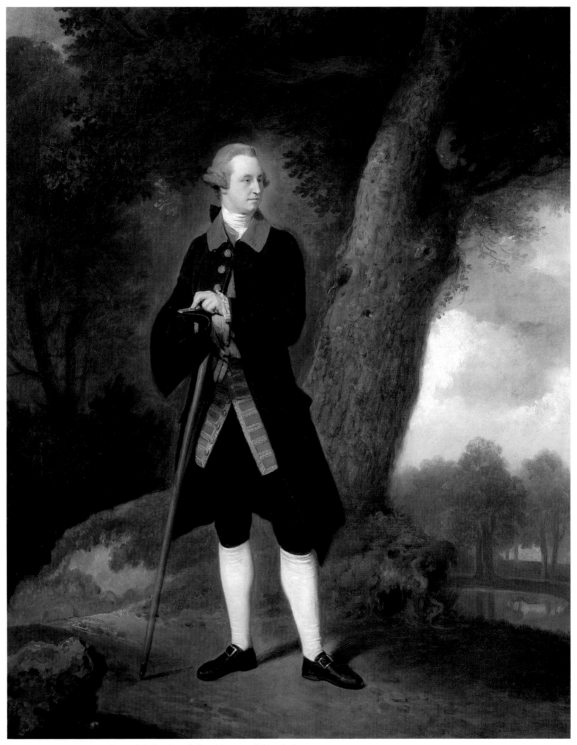

CAT.46 JOHN ZOFFANY *George de la Poer Beresford, 1st Marquess of Waterford*

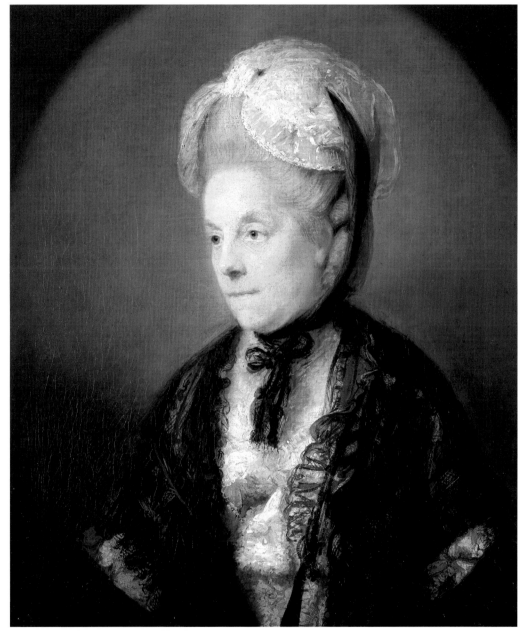

CAT.47 THOMAS HICKEY *Mrs Elizabeth Nind*

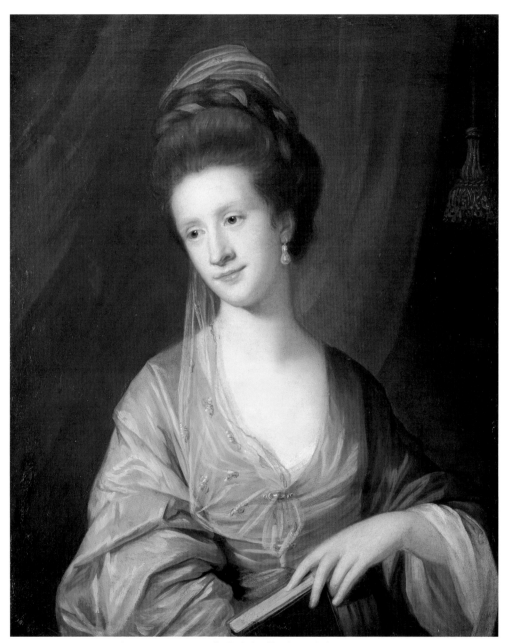

CAT.48 ENGLISH SCHOOL (?), 18TH CENTURY *Lady Elizabeth Cobbe, née Beresford*

CAT.49 FLORENCE GRAHAM *Frances Power Cobbe*

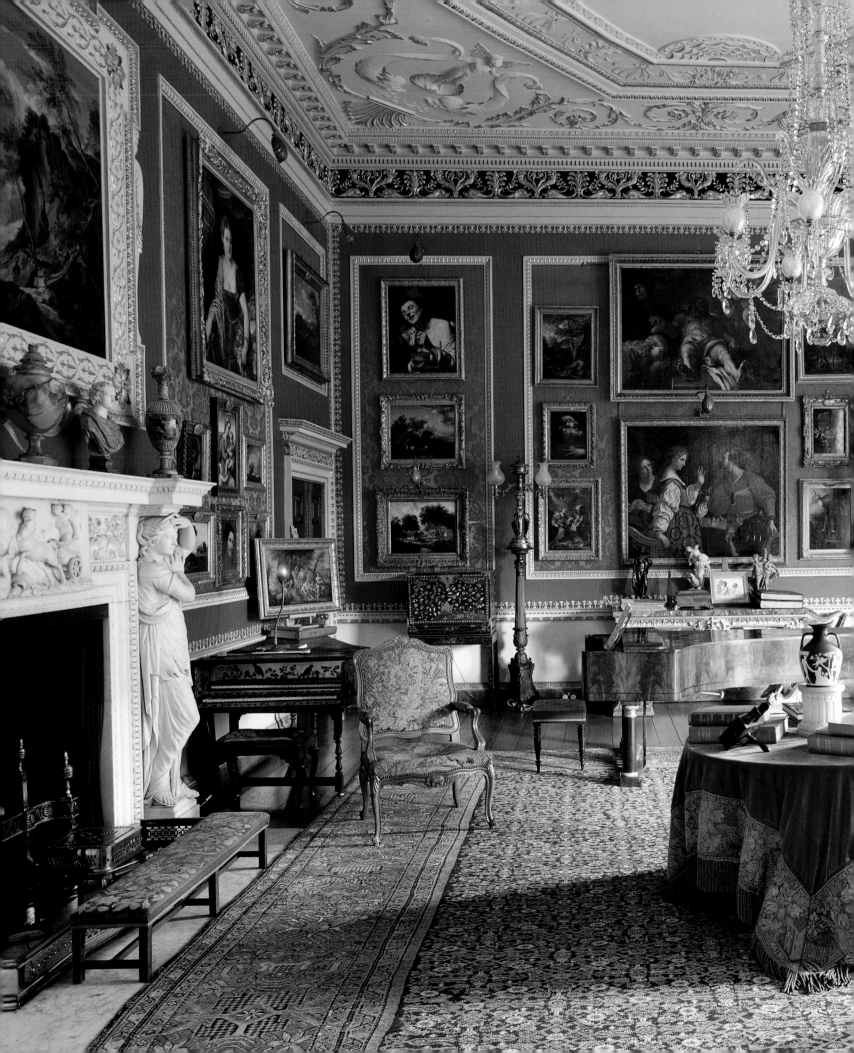

Part II

ADDITIONS SINCE 1960

There are not many people who, having inherited all or part of a collection of Old Master paintings whose nucleus goes back to the 18th century, would not simply have rested content with that or, at most, would have sought only to recover previous 'escapes' (as Capt. Spencer-Churchill did with those of the Northwick collection). Very few, however, would have embarked on collecting pictures of the same kind so vigorously that their collection came to surpass the original both in quality and quantity. So *démodé* has the collecting of Old Master paintings become in this country (as opposed to in the United States) that more kudos appears to be won through pocketing a vast sum for an inherited picture sold at auction than by bearing off the prize of a major painting contested and won at just such an auction. Not that one should overrate the role of the collector ('a useful, but over-glamourized hobby, which has always met with far too much fawning adulation', in the perhaps over-compensatory words of that great historian of patronage and collecting, the late Francis Haskell), but a culture in which the buying and collecting of Old Master paintings and drawings becomes largely the business of public museums and galleries is one from which those bodies themselves will in time come to suffer. Paintings – as often created for private delectation as for public display – will come to be seen only as educative or representative. Moreover, curators, who in the past (not to speak of the days when they themselves could afford to buy pictures of reasonable quality) had their taste refined by regular contact with private collectors and collections and who, in turn, played a part in the formation or sifting of these (sometimes to the ultimate benefit of their own institutions), will lose that sense of the collecting impulse; their acquisitions will instead become merely reactive or fillers of imagined art-historical gaps.

What I first remember Alec Cobbe collecting was not pictures, but books of pictures. While we were both at Corpus Christi College, Oxford, Blackwell's opened a huge new second-hand department, including a section for art books, in Ship Street. Having gone there myself and found a worthy copy of a volume from the Pelican History of Art, I was astonished to find Alec staggering back under the weight of great, but almost textless, tomes on the pictures of the Royal Collection and the Imperial Picture Gallery in Berlin. The illustrations to these books were, however, superb photogravure engravings, rich in both detail and tone in a way that subsequent methods of photographic reproduction have never equalled. Alec delighted in them and in the embodiments of the histories of great collections that they represented. Later, he did buy old

paintings to hang in his rooms in the Broad, including a large dark landscape bought on the Quays in Dublin that he thinks may have been by George Barret, but – in classic undergraduate fashion – these were sold to pay his debts when he went down, including a particularly large bill at Blackwell's.

Staying in the summer vacation of 1964 with Alec at Newbridge, I realised how strong a presence the collection there – particularly the hang of its harmonious Drawing Room – was to him and how bitterly he regretted both the 19th century's and his grandfather's and uncle's more recent sales from it. But there was no thought then of repairing those losses. When he began to collect again, it was old keyboard instruments, an area in which he perceived that much greater rarities could be obtained with the funds that he could then command. It was only after he had given up medicine and started to train as a picture restorer – which introduced him to a variety of private collections and trained his eye to detect the innate quality of a dark or damaged picture in the sale rooms – that he began to perceive the possibility of again collecting pictures, this time in earnest. The advantage of being a picture restorer (as well as a painter, as Alec is) is that it brings one close to the physical qualities of a painting and enables one to appreciate its intrinsic merit, where the trained art-historical eye might see only the implied inferiority of a lesser artist's name.

Two pictures had, in fact, survived from the early wreck of his own collection, given to him *in lieu* of payment for some of his own paintings by Mr and Mrs Julian Peck of Rathbeale Hall (for whom, a decade later, he was to decorate the entrance hall of Prehen House): a *Salome with the Head of John the Baptist* from the circle of Titian and a supposed *Portrait of Swift's 'Vanessa'*. Nothing major in themselves, they nonetheless exemplify what were to become two of the strands of his collecting: Old Master paintings, acquired because of an innate reflection of a great name (regardless of actual attribution), and Irish portraiture.

These gifts remained isolated, however, until 1976, when Alec acquired a *Portrait of a Gentleman*, assigned to the circle of Adriaen Hanneman, from Roberson & Co, the historic London firm of colourmen that was then in the process of closing down and whose important archive he helped steer towards the Hamilton Kerr Institute, Cambridge, of which he was one of the founding team. A few years later, he started to buy minor Old Master and Irish pictures from Dublin dealers, such as Ronald McDonnell in Kildare St and the Cynthia O'Connor Gallery. From the former, he bought what

he describes as three 'black' paintings for about £100 each. When a finished drawing of a variant version of one of these 'black' works, the *St Jerome in the Wilderness* (cat.53, which had been attributed after cleaning to the circle of Maerten de Vos), appeared recently at auction in America, Alec's picture was immediately recognised as a rare instance of a gallery picture by the mid-16th-century Italian artist Bernardino Campi, the only known work by him in the British Isles.

More ambitious – and visible – purchases began in 1982, with the acquisition of Cornelis van Poelenburgh's *Christ on the Road to Emmaus* (cat.72) from Agnew's, which had the additional attraction for Alec of having previously been in the historic country house collection of Lord Suffield, at Gunton Park, and thus potentially before that at Blickling Hall (in view of the marriage of the 2nd Baron Suffield to

Lady Caroline Hobart, one of the three daughters and co-heirs of the 2nd Earl of Buckinghamshire).

Not long after, in May 1984, Alec made his first purchase at a major London sale room, a *Southern Landscape with Muleteers*, by a follower of P. A. Rysbrack. The picture was bought more for its effect in an interior than in its own right, for Alec had by this time revived single-handedly the 18th-century profession of *tapissier* and was also beginning to hang his own collection on the walls of Yattendon Manor over red silk damask discarded from the Wallace Collection. He had already bought the odd picture at his local sale room, Dreweatt Neate in Newbury, but this acquisition marked a new confidence. Buying from dealers (other than those from whom he had made his earliest purchases in Dublin) would have meant buying pictures that had already been 'done up'

fig.92

Fig.93 Pieter Nason,
*Portrait of a Man in Oriental
Dress [traditionally called
Sir John Chardin]*, oil on
canvas (present where-
abouts unknown)

Fig.94 Hugh Douglas
Hamilton, *Selene and
Endymion*, oil on canvas
(present whereabouts
unknown)

fig. 93

fig. 94

and already freighted, however incorrectly, with identi-
fications and attributions. Buying at auction afforded much
greater scope – for recognising the merits of an as yet
unrestored picture under the accretions of dirt and old or
perished varnish, for seeing some quality that had been
missed in the inevitably hasty process of cataloguing for
auction, or for buying a picture simply for its intrinsic quality
alone. The supposed *View out from Vallombrosa* (cat.85), for
instance, was acquired in a sale of pictures from the John
Tillotson collection at Christie's in February 1985 with an
attribution to F.-X. Fabre, and it has oscillated between that
name and an alternative attribution to J.-J.-X. Bidauld in
the minds of both owner and experts ever since. Another
such picture bought at Christie's in 1985, a replica of Angelica
Kauffman's *Self-portrait* in the Uffizi, has not fared so well.
Despite bearing what is apparently the artist's signature with
the date 1787 and in spite of being borrowed for the Kauffman
exhibition at Brighton and York in 1992–3, expert opinion
has subsequently turned against it, and only the Uffizi picture
is admitted as autograph. Nonetheless, there is the fact that
Angelica did not deliver the Uffizi picture until the year after

it was painted, quite possibly in order to make a copy of it.
The Cobbe version is, allowing for its less than perfect state
of preservation, of arguably autograph quality, and experts
can always change their mind!

It was with the acquisition of Guercino's *Semiramis at her
'Toilette' Receiving the News of the Revolt of Babylon* (cat.57) and
Lambert Sustris's *Judith with the Head of Holfernes* (cat.52) at
auctions in the autumn of 1985 that Alec's collecting took
on a different dimension. In each case, the picture was
bought for its intrinsic quality and appeal; only subsequently,
thanks to the research conducted by Nicholas Turner for
his cataloguing of them for this exhibition, has their true
importance been recognised. The *Semiramis* was sold as by
Guercino's studio in the belief that the original was the pic-
ture formerly in the Northbrook Collection, not seen since
its sale at Christie's in 1919. But that was known only from an
old photograph, and its provenance from the great Cornaro
collection in Venice had been wrongly assumed. The *doyen* of
Guercino studies, Sir Denis Mahon, who in 1949 published
the lost Northbrook picture as that painted in 1645 for
Cardinal Federigo Cornaro, now accepts that the Cobbe

picture is the prime version of the 1645 composition, painted by Guercino, aided by his brother, Paolo Antonio Barbieri. The Sustris was already recognised as such – though it had been exhibited in 1981 with an attribution to Paris Bordone, having previously been ascribed to Titian – but, surprisingly, it was never given its due as one of the most beautiful of Sustris's productions from his Augsburg period. Its provenance could be traced to the mid-17th century, as it descended through a Swedish family at Österby, though it was Mark Broch's discovery of an obscure reference in the literature that suggested that this picture may once have belonged to the great Augsburg banker-collector Anton Fugger. Five paintings by Sustris in France, all formerly in Louis XIV's collection, appear to have formed part of the Fugger sale in 1650, the same year that Anton Grill and Vollrat Tham, ancestors of the picture's first documented owners, left Germany for Sweden with their picture collections. Equally fascinating is the previously unexplored relationship between the Cobbe Sustris and a painting of the same subject by his master Titian, which helps settle the complex and hotly debated question of the dating of the latter work.

Alec's other acquisitions can be followed in the individual catalogue entries in Part II. Here I should like simply to identify what I see as his chief characteristics as a collector.

First and foremost is the fact that he is entirely his own man. Unusually for a collector who has no formal art-historical upbringing or training other than what now forms part of the education of a picture restorer (a term Alec prefers to 'conservator'), he buys entirely with his own instincts, without the advice of any art historian or museum curator or, indeed, of any preferred dealer or auction-house expert. That is not to say that he rejects the subsequent help of any of these: the present catalogue is proof enough of that. He comes to them, however, to have his intuitions confirmed or to have his knowledge of his acquisitions deepened, as happened with the Titian (cat.51) and the Poussin (cat.56). In pursuing research, he has been greatly assisted by a young Dutch art historian, Mark Broch, who was employed as his assistant and carried out invaluable groundwork for the catalogue both of the complete collection and of the present exhibition.

For Alec, the prime aspect of a picture is the power of the image rather than the bravura handling of paint. It is for that reason that he is unafraid of buying an anonymous picture, obviously misattributed or dismissed as a copy, of which Reynold's autograph replica of *Mrs. Siddons as the Tragic Muse* (cat.96), now vindicated by David Mannings, is a good

instance, the Honthorst *Allegory of Taste* (cat.69) another. This practice roots him firmly in the tradition of the collection at Newbridge and of the collectors of the age in which it was formed, for whom a copy of a great Old Master was as, if not more, prized than an original by a lesser hand. (Only one of the eight paintings installed by the great collector Henry Hoare 'the Magnificent' in the Saloon at Stourhead was an original.)

Subject-matter is also of lesser importance for him. Eclectic in what he buys – history-paintings both religious and secular, portraits, landscapes, sketches and finished pictures, large and miniature – he is also eclectic in how he hangs them. The overall effect of the hang – ever mindful as he is of the Drawing Room at Newbridge – takes precedence over the individual picture. When hanging other people's collections (fig.92), as *tapissier*, his proposals are presented as seductively coloured and lettered sketches, giving hints both of each picture and of its frame, though so far as I know, he has never done so for either Yattendon or Hatchlands. With a collection that is constantly expanding as his is, there is, as at Petworth in the 3rd Earl of Egremont's day, no fixed hang, but rather a succession of hangs based on the same principles of organisation – large, striking pictures as focal-points, with the subsidiary pictures grouped around them, or arranged in 'columns' or as 'predellae'. Most recently, one such rehang at Hatchlands was precipitated by the re-evaluation of the Guercino and the desire to see how perceptions of it would be altered by giving it just such a focal position (see fig.98).

The framing of pictures has also been important to Alec. The distinctive Irish Rococo frames of Newbridge (see pp.74–9) have had a particular resonance for him, and a number of pictures in the collection have been reframed in reproductions of them, motivated by Alec's awareness of the unity that a so-called 'livery' frame can give a collection. However, his taste ranges much more widely than these Newbridge frames alone might have prompted. For instance, there has been for him almost as much satisfaction in matching – 'incorrectly' but with remarkable aptness – the 'Sansovino' frame from a Veronese picture formerly in the Orléans Collection to his *Madonna and Child with Saints* by Alessandro Allori (cat.55) and then tracking down exactly which Veronese in the Orléans Collection that frame had actually been on, as there has been in establishing that his Allori, with its numerous *pentimenti*, may be the prime version of an often-repeated composition by the artist and that, furthermore, the picture had its own distinguished provenance. This last process of discovery began a few years ago with my recognition of Alec's picture

in a drawing by Panini, which suggested that it might have been in some cardinal's collection in 18th-century Rome. Nicholas Turner's archival research for this catalogue then demonstrated, among other things, that it was Cardinal Valenti Gonzaga who owned the picture. One wonders, however, if Panini's drawing might not have been as much of a capriccio – an ideal hanging scheme for the cardinal rather than a record of one – as Alec's own imaginary sketch for the cover of the Collection catalogue at Hatchlands (done in 1992, before he knew of the Panini drawing), showing the same picture over a similar large, fictive opening.

Like all but the richest collectors, Alec has occasionally been forced to sell one or two of his more valuable acquisitions to meet the sudden demands of school fees or taxes. I remember with particular regret a fine 17th-century portrait of a man in oriental dress, called, with no great justification, *Sir John Chardin*, but tantalisingly close in character to the portraits of Pierre Mignard, though now generally accepted as the work of Pieter Nason (fig.93). The Mignard expert would not accept it as such, and this, combined with the doubts over the sitter's identity, may have discouraged Alec, who selected it as his sacrificial victim when the need arose. In that, at least, it did not disappoint, fetching a healthy sum in the sale room despite the uncertainties hanging over it. A picture that he sacrificed for a different reason was Hugh Douglas Hamilton's important *Selene and Endymion* (fig.94). The Cupid in this had been extensively damaged and badly restored. Despite having removed the previous restoration and having restored it much more sympathetically, too little of the original figure remained; Alec could never blot this from his mind, and so he reluctantly sold the painting.

Repeated mention of Newbridge prompts me to end with the obvious observation that that collection – and its losses – remains the lodestar of Alec's collecting. Some of those losses, such as the Hobbema (cat.24), now in the National Gallery of Art in Washington, DC, he recognises can never be recovered. Even were some of those still in private hands to come on to the market again, they would most likely be beyond his financial resources. Such was the disappointing case with the Gainsborough *Portrait of Mrs Frances Champion* (cat.45*), for which Alec was outbid at auction when it was de-accessioned from the Kimbell Museum, Fort Worth, and it would quite possibly be so of the *Wooded Valley Landscape* by Dughet (cat.40), which last came up at auction in 1928 and which, until recently, was unidentified and so untraceable. He has, however, bought back a number of pictures sold more recently by his siblings (or their trustees), either directly to him or at or after auction, such as the pair of village scenes by Barend Gael (cats 21–2) or the Zoffany (cat.46). In other cases, he has acquired pictures specifically as 'replacements' for Newbridge or Hatchlands (for the Drawing Room of the former or for the collection of the latter) of what he has been unable to recover: e.g. the picture of *A Smalschip and Rowing Boats in a Calm* from the studio of Willem van de Velde the younger to replace at Newbridge an almost identical (and identically framed) painting in Thomas Cobbe's collection, which was singled out for mention by Pilkington in his *Dictionary*, but which (though still in the collection) is now considered to be by his pupil Willem van Diest (Cobbe Collection, no.18); or the Bath-period Gainsborough of another Irish sitter, *Letitia Leigh, Mrs Townley Balfour* (cat.97), to serve as a 'pendant' at Hatchlands to the Gainsborough portrait of Mrs Champion's husband, *Col. Alexander Thomas Champion* (cat.45), which remains in the collection; or a new Dughet (cat.59), bought in place of the one sold in 1839 with the Hobbema (cat.24) to build proper houses for the tenantry. For the large *River Landscape with a Ferry-boat* by Salomon van Ruysdael and the smaller *Landscape with Cornfields* by Jacob van Ruisdael, both formerly in the Cobbe Collection (nos 19 and 11) and both sold in the last century, it will be as difficult to find worthy replacements as for the Hobbema.

No collection can ever be entirely reconstituted – many of the pictures in the original collection at Newbridge had anyway simply decayed, and been cut up or sold by 1812, according to Frances Power Cobbe – and so much has been added to the Cobbe collection that it would be pointless to repine over its losses. What is remarkable is that this old-*cum*-new Cobbe collection of paintings not only continues to give character to Newbridge. Along with Alec's even more remarkable collection of old and composer-associated keyboard instruments, the Cobbe Collection pictures have also breathed fresh life into another house, Hatchlands, a National Trust property that had been denuded of its historic collection (pictures from which now grace such galleries as the Kunsthistorisches Museum in Vienna and the Norton Simon Museum in Pasadena). Indeed, Hatchlands, inverting the salutations, might say to the Goodhart-Rendel and Cobbe collections what Colt Hoare imagined the portraits of his ancestors and family saying to visitors to Stourhead: *ave atque vale!*

A GREAT ADAM ROOM REMODELLED AS A PICTURE GALLERY: THE SALOON AT HATCHLANDS

Christopher Rowell

During the winter of 1987–8, the principal rooms at Hatchlands Park, East Clandon, Surrey,[1] were transformed by Alec Cobbe and his atelier in collaboration with the National Trust. A year later, in a feature article in *Country Life*, Gervase Jackson-Stops wrote of the Saloon (fig.98): 'Filling the room again with a dense hang of pictures – some from Newbridge, some from his own collection, and some from the National Trust, Alec Cobbe has created the impression of a great Adam room remodelled by a Regency connoisseur.[2] The panels have been hung with crimson damask, always a favourite background for Old Masters in the 18th and early 19th centuries; while the walls have been painted red to match.'[3] Jackson-Stops explained the thinking behind the metamorphosis of this – the grandest room at Hatchlands – into a gallery redolent of the most palatial Italianate interiors of the heyday of British collecting: 'The layer upon layer of

denser and ever more elaborate arrangements, and by the gradual refinement of its decoration.

It is hardly surprising that the Hatchlands Saloon is now reminiscent of its Irish counterpart at Newbridge, but whereas the Newbridge Drawing Room (fig.66) was built by Thomas Cobbe (and redecorated *c.*1828) specifically as a repository for pictures, the Hatchlands Saloon was originally a dining room with a very different scheme of decoration. Adam's drawings (Sir John Soane's Museum, London)[5] are dated 1759 and inscribed 'Great Dining Room (fig.95)'; the 'With Drawing Room' (the equivalent of the present Saloon) was then directly above. Adam's interiors at Hatchlands (*c.*1759) are among his earliest, and the plasterwork of the ceilings both here and in the adjoining Library (then the 'Drawing Room') is in high relief. The inspiration is clearly Italian (Adam had just returned from a prolonged Grand Tour), but more *Seicento*

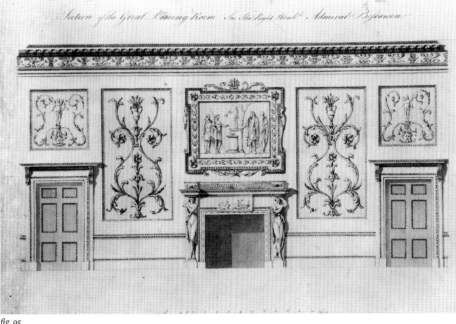

fig. 95

history that Hatchlands represents has been the key to its present redecoration. Had it been as pure an Adam house as Osterley or Syon, complete with its original contents, there might have been a real argument for returning to a mid-18th-century scheme based on analysis of paint layers, and comparison with other documented neo-Classical interiors. But a more eclectic approach was obviously called for.'[4] This approach has continued for 15 years, and the Saloon has been further enriched by the acquisition of new pictures, by

and less overtly Neo-classical than his later and more famous style, which drew on ancient Roman and *all'antica* grotesque decoration. The layout of the Saloon ceiling, with its octagonal central panel and pairs of figures in the corners, is (like the Library ceiling) partly inspired by the Villa Pamphilj (now Doria-Pamphilj), Rome.[6] The Hatchlands ceilings were originally plain white,[7] which would have increased the impression of sculpture in plaster (and again this is in stark contrast to the elaborately painted ceilings of Adam's later

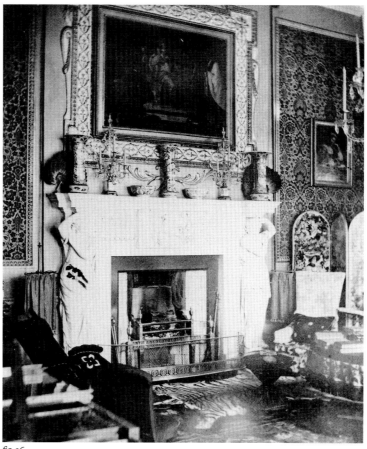

fig. 96

Fig.96 The Saloon,
Hatchlands, photograph,
*c.*1880 (Alec Cobbe)

style). A nautical theme runs through the rooms: in the Saloon, dolphins, seahorses and shells are combined with the more usual urns and arabesques. This was clearly a requirement of Adam's patron, the naval hero, Admiral the Hon. Edward Boscawen (1711–61), whose victories at Louisburg (1758) and Lagos Bay (1759) were in their day as famous as Nelson's. The inscription on the Admiral's tomb (1765; designed by Adam and carved by Rysbrack) in St Michael's, St Michael Penkevil, Cornwall, proclaims that Hatchlands was built 'at the expense of the enemies of his country'.

Adam's scheme for the walls of the Admiral's Great Dining Room was more conventional, with two huge capriccio paintings of Roman ruins in the central panels of the end walls, arabesques in the other panels, and a *trompe l'oeil* bas-relief within the overmantel frame (as in the Gallery at Croome Court). The designs are comparable to those for the Music Room (1765) at Harewood,[8] and they were apparently partly executed.[9] The plaster panels and overmantel reflect Adam's

drawings and the statuary marble chimneypiece (fig.96) also equates with Adam's design, with minor variations. The craftsmen may have been those employed on the interior of Shardeloes, Buckinghamshire (1761–3),[10] where Adam also collaborated with the Buckinghamshire architect Stiff Leadbetter, and, if so, they would have included the famous plasterer Joseph Rose. The Saloon chimneypiece, with its draped caryatids carved with considerable *finesse* almost in the round, is probably by Michael Spang (*d.*1762), given that the caryatids are almost the twins of those supporting his chimneypiece in the Drawing Room at Kedleston (1759).[11]

What of the original contents of Admiral Boscowen's Dining Room? We know that the Admiral, while taking charge of the architectural commission, gave his wife 'discretion as to furniture' for the 'Great Dining Room' (i.e. the present Saloon) and the room above,[12] but his untimely death in 1761 seems to have terminated her plans. This is confirmed by Horace Walpole's account: 'Hatchland [*sic*] Park build by

Fig.97 The Saloon, Hatchlands, photograph, 1953 (*Country Life*)

Admiral Edward Boscawen, & not finished when he died, nor yet furnished (1764). It is a plain brick good house; the Chimnie-pieces & ceilings are designed by Mr Adam, & are uncommonly beautifull. On the Staircase is a pretty little China room.'[13] Nonetheless, the pair of massive gilt tables at either end of the Saloon, with eagles supporting the heavy marble tops (fig.97), may perhaps have belonged to the Boscawens. As for pictures, the Admiral was certainly capable of recognising connoisseurship in others. In 1757, while staying at Holkham and admiring Lord Leicester's 'fine collection of pictures', he wrote of his fellow guest, the 2nd Earl of Egremont, that he 'knows the hands and seems to understand them',[14] but we can only surmise that Boscawen's first-floor Great Drawing Room may have been intended to contain a collection of pictures.

We know little more about the collecting proclivities of the Sumners, who occupied Hatchlands from 1770 and who around 1800 commissioned the architect Joseph Bonomi (1739–1808) and the landscape designer Humphry Repton (1752–1818) to make improvements to the house and park.[15]

A photograph of the Saloon of *c*.1880 (fig.96) indicates that there were at least some Old Master pictures at Hatchlands (the overmantel and the smaller *Sibyl* to the right are apparently of the Italian *Seicento*) and that they were hung upon cut velvet or flock wallpaper within an exotic *fin de siècle* setting of Japanese Imari, feather fans and tiger skin, all presumably spoils of the Sumners' activities as East India nabobs. The polished steel fire basket shown in the photograph still survives *in situ* and could well have been designed by Adam for the Boscawens. Otherwise, the set of eight Piranesian early 19th-century bronze colza-oil *torchères*, now split between the Saloon and the Dining Room, could be remnants of the Sumners' collection.

In 1888, Hatchlands changed hands for the last time before its acquisition by the National Trust. The purchaser was Stuart Rendel (1834–1913), a partner in the northern engineering firm of Armstrong, who was ennobled as Lord Rendel of Hatchlands in 1895. Despite his extensive alterations to Hatchlands, the Saloon was largely untouched, apart from the raising of the bay window-sills to their original

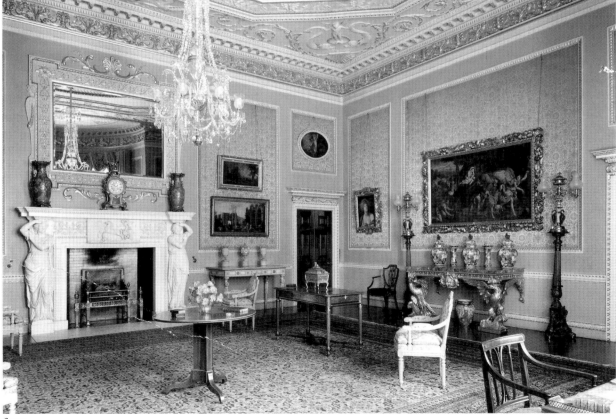

fig. 97

height (they had been converted into French windows by the Sumners). Adam's ceiling was gilded and coloured (for the first time), the walls were painted green, and green silk damask was hung in the wall panels. The curtains were of yellow silk hung in a continuous drapery around the bay. Judging by the *Country Life* photographs (fig.97), the rooms were somewhat sparsely furnished, but there were what Christopher Hussey described as 'some excellent paintings', mainly landscapes, but also Italian, French and Flemish 17th-century subject pictures, some of which were provided (in the Staircase Hall) with elaborate white-painted rococo plaster frames.[16] Among them was Salvator Rosa's *Justice Returning to the Skies Leaving her Scales and Fasces with the Shepherds* (private collection).[17] The Saloon pictures included two pairs of landscapes (to the right and left of the chimneypiece), ovals over the doors, and Italian paintings in elaborate 17th-century-style frames on the end walls. A panel of mirror glass was fitted into Adam's plaster overmantel.

Lord Rendel's grandson, the architect H. S. Goodhard-Rendel (1898–1959) made no changes to the Saloon and kept Hatchlands much as it had been in his grandfather's time. He gave the house and park to the Trust in 1945 and moved out shortly before his death, leaving Hatchlands almost empty. It was let to a series of tenants (including the Manager of *The Times* and a girl's school) before being opened regularly in 1982. The Saloon was redecorated by the National Trust in the early 1980s in an evocation of Lord Rendel's scheme of 1888, but lacked contents worthy of its architecture. In 1984, Martin Drury (then the National Trust's Historic Buildings Secretary) suggested to Alec Cobbe that Hatchlands might be an appropriate setting for his pictures and keyboard instruments, a thought that was reiterated by the present writer two years afterwards. By April 1988, the somewhat depressing, frigid, and almost empty Saloon had become a veritable picture gallery in the great Anglo-Italian tradition.

On first visiting Rome in 1814, the poet and connoisseur Samuel Rogers wrote ecstatically: 'Doria Palace. Colonna Palace. Compared to these in extent & splendour what are the houses of England? The small gallery that runs round the gallery of the Doria, hung with red silk & full of pictures, more captivating in my eyes than even the splendid hall of the Colonna – 209f by 35f – full of pictures & marbles!'[18] Such was the inspiration for the revival of the Hatchlands Saloon, whose Italianate Adam plasterwork, influenced by the Villa Doria-Pamphilj, was enhanced by the deep blue picking-out of the dolphin cornice and acanthus central oval, by hanging

the panels with crimson silk, and by painting the walls to match. As Gervase Jackson-Stops observed, this combination of red, blue, and Victorian gilding introduced 'a rich Carlton House note, along with the porphyrised skirting board'.[19] However, the style of the picture hang – with a symmetrical profusion of smaller pictures clustering around or beneath the larger ones – also derives from the gallery tradition. Whereas at Carlton House, the Prince Regent sometimes placed paintings singly within the panels,[20] as had previously been the case at Hatchlands, the present arrangement of the Saloon is inspired by Continental picture galleries and their early 19th-century English equivalents. This approach is entirely in keeping with the scale of the room: in the past the comparatively few pictures seemed dwarfed by the architecture; today, the sculptural plasterwork and the massive chimneypiece are enhanced (as Adam originally intended) by filling the panels – in this case with ordered patterns of pictures and their frames.

About a fifth of the 50 or so pictures in the Saloon are from the Newbridge collection, the remainder was purchased by Alec Cobbe. The overmantel is a 17th-century copy[21] of Salvator Rosa's *Landscape with Jacob's Dream* at Chatsworth, which was acquired by Alec Cobbe to replace Lord Rendel's mirror glass. The panels to either side are dominated by the two pictures in the upper register: Johannes Voorhout's *A Lady in an Interior, with a Servant Washing her Foot* (cat.26), one of Thomas Cobbe's 1760s purchases and Voorhout's masterpiece, on the left; and Lambert Sustris's *Judith with the Head of Holofernes* (cat.52) on the right. The cabinet pictures beneath are mainly Dutch landscapes from the Newbridge collection (with 18th-century Irish frames like the Voorhout), although there are also pictures bought by Alec Cobbe: the *Head of a Bearded Man, Seen Full Face*, attributed to Bernini (cat.58), in the left panel, and the Spanish School *Study of the Head of a Man* (cat.68) in the right panel. The west end wall is held by Alessandro Allori's *Madonna and Child with Sts Catherine of Alexandria and Francis of Assisi* (cat.55). Its magnificent frame – acquired to display the Allori in the Hatchlands Saloon – may be the original frame of the supposed Veronese *Venus and Adonis*, which was purchased with the Orléans collection by the Duke of Bridgewater.[22] The frame became redundant when the supposed Veronese was later reduced in size, but its subsequent history is unclear until it emerged at a London auction in 1987.[23] The Allori altarpiece is balanced in the panel to the right by the late 17th-century Venetian *Pietà*, attributed to Giovanni Segala (cat.65). The opposite (east) wall (fig.98) is

Fig.98 The Saloon, Hatchlands, photograph, 2001

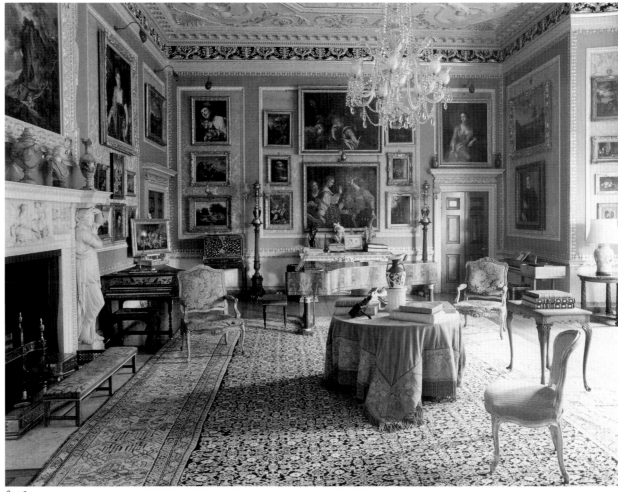

fig. 98

now arranged to give due prominence to Guercino's *Semiramis at her 'Toilette' Receiving the News of the Revolt of Babylon* (cat.57), and Giordano's *Lamentation over the Dead Christ* (cat.62) hangs above. Among the larger pictures flanking the bay window is Maso da San Friano's *Portrait of Ottavio Farnese, 2nd Duke of Parma and Piacenza* (cat.54) to the left, below, while columns of small pictures frame the window itself. The overdoors include (to the left of the chimney) Hendrick Mommers's view of *A Vegetable Market in Trajan's Forum* (cat.18) and Carlo Dolci's large oval *St John the Baptist* (cat.61).

There is no picture rail, which enhances the Saloon's 18th-century character; the fixings are disguised by gilt roundels and the pictures identified by gilded tablets painted with inventory numbers (both in traditional style and designed by Alec Cobbe). The gilt fillet is a copy of one of Robert Adam's

fillets at Harewood. The brass shell picture-lights, inspired by Edwardian lights in the Ballroom at Knole, Kent, are in tune with the scallop shells of Adam's ceiling. With bronze and marble statuettes, Old Master drawings and keyboard instruments complementing the rich hang of pictures, the Saloon represent the essence of Alec Cobbe's aims both as a collector and as the inheritor of his family's distinguished record in the connoisseurship of pictures and their display. That the Saloon has become a *salone* and picture gallery is entirely consistent with the Roman source of Adam's architectural inspiration.

p.211 Detail of cat.51
(Titian, *Portrait of a Patrician Lady and her Daughter*)

p.212 Detail of cat.52
(Lambert Sustris, *Judith with the Head of Holofernes*)

p.213 Detail of cat.55
(Alessandro Allori, *Madonna and Child with St Catherine of Alexandria and St Francis of Assisi*)

p.214 Detail of cat.56
(Nicolas Poussin, *The Lamentation*)

p.215 Detail of cat.56
(Nicolas Poussin, *The Lamentation*)

p.216 Detail of cat.57
(Guercino, *Semiramis at her 'Toilette' Receiving the News of the Revolt of Babylon*. This and the followings two details show particles of lead white used by Guercino in the ground of his late works, which characteristically emerge from the paint surface over the course of time.)

p.217 Detail of cat.57
(Guercino, *Semiramis at her 'Toilette' Receiving the News of the Revolt of Babylon*)

p.218 Detail of cat.57
(Guercino, *Semiramis at her 'Toilette' Receiving the News of the Revolt of Babylon*)

p.219 Detail of cat.69
(Gerrit van Honthorst, *Allegory of Taste*)

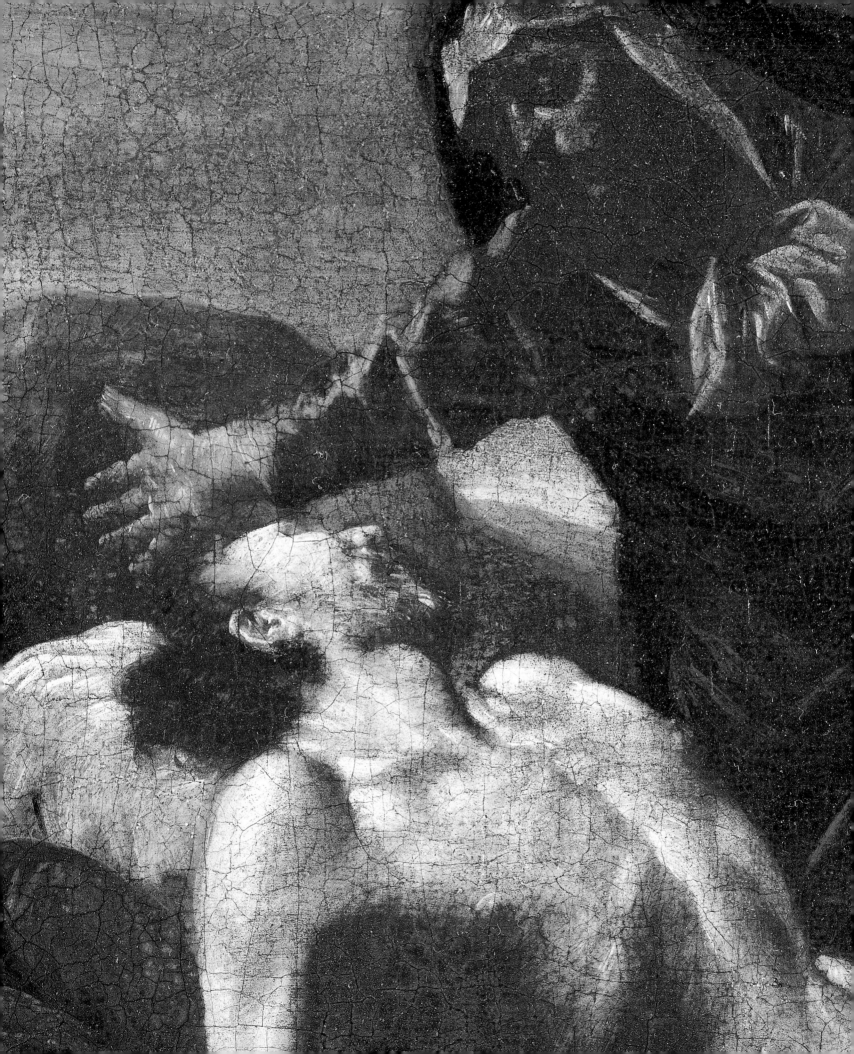

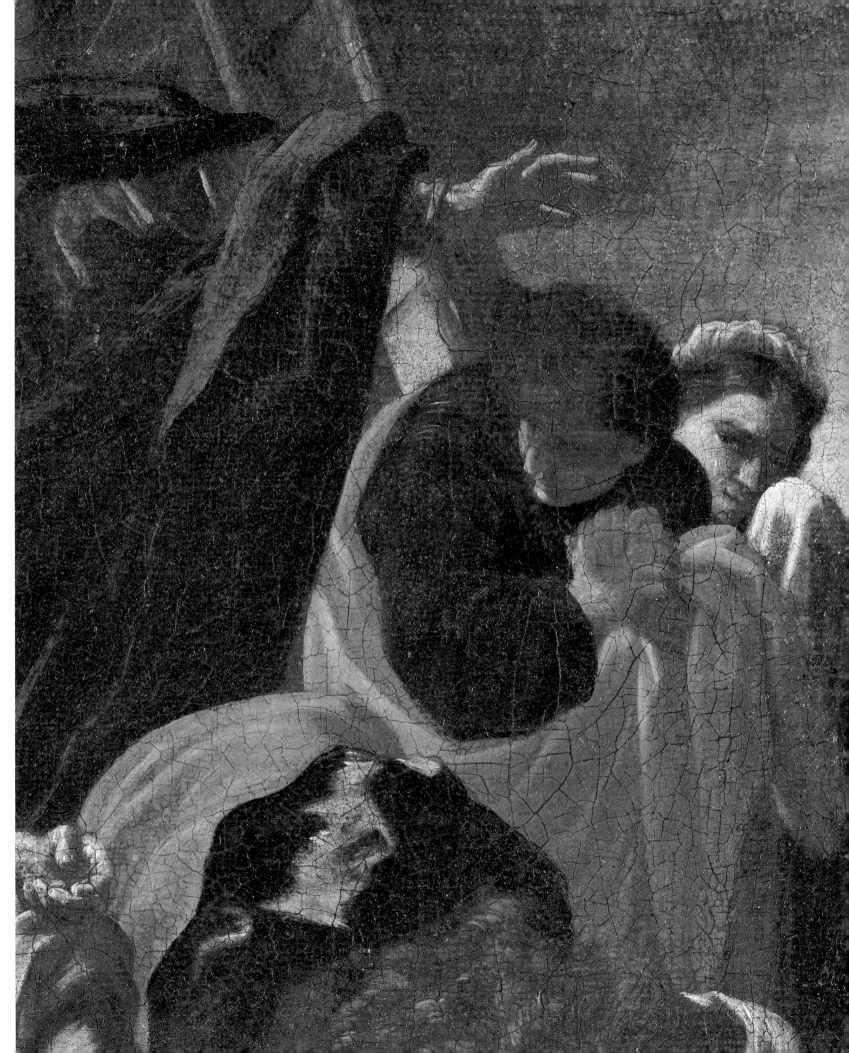

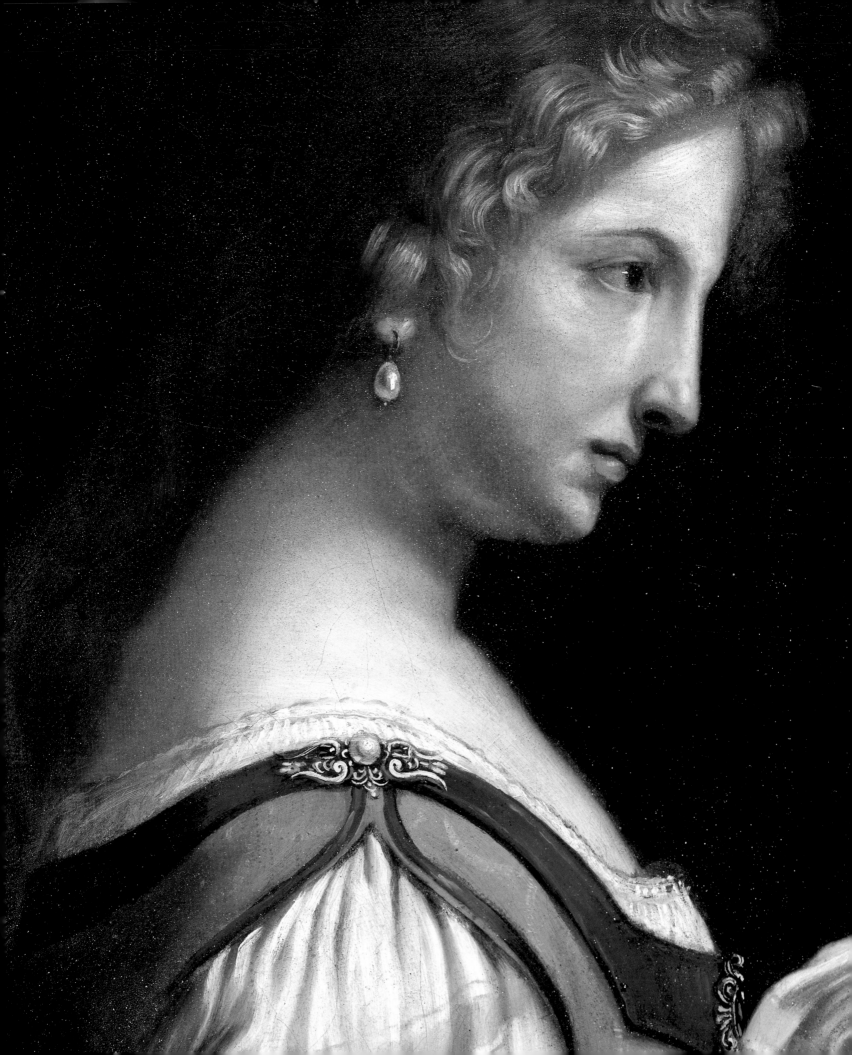

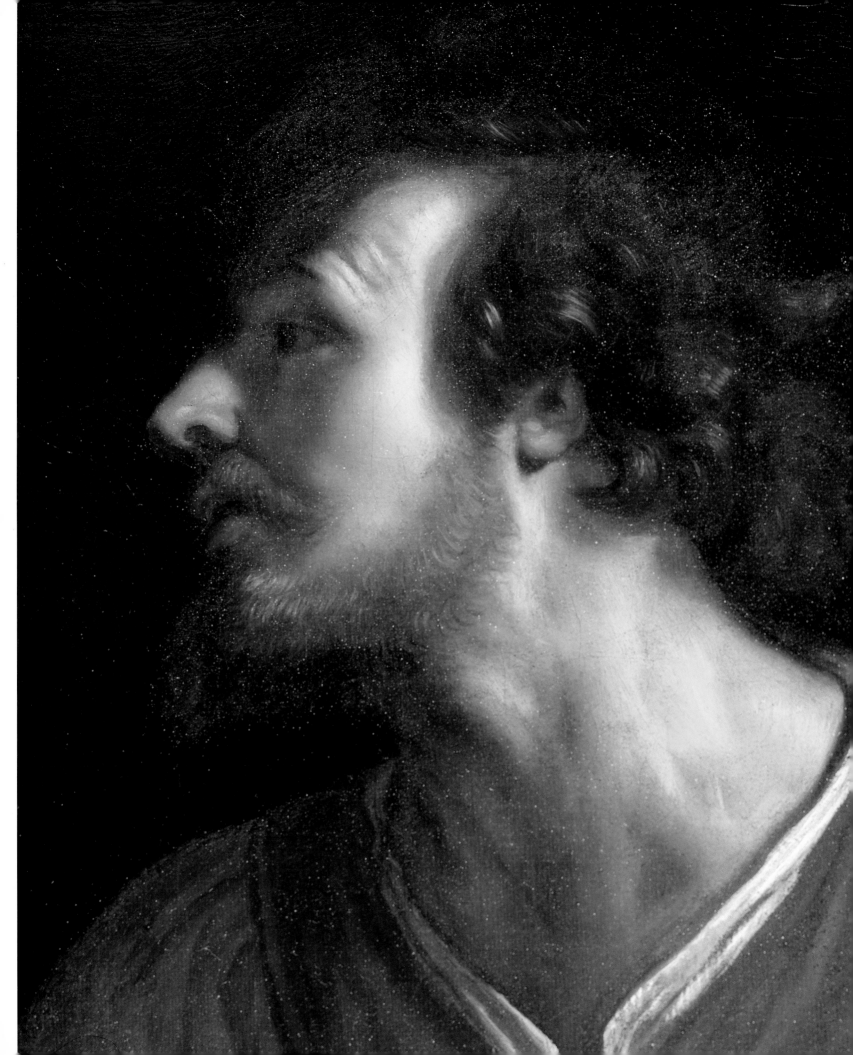

Part II

CATALOGUE OF ADDITIONS SINCE 1960

50

THE MASTER OF VOLTERRA
*fl.*Volterra *c.* 1520–30

Madonna and Child with the Infant St John the Baptist

Oil on panel, 19¾ × 13 in (50 × 33 cm)
Cobbe Collection, no.364
HISTORY acquired at sale, Christie's, London,
17 June 1988, lot 85 (as 'follower of Michele
Tosini, called Ghirlandaio')
LITERATURE Laing/Cobbe 1992, p.17, no.319
(as 'mid-16th-century Florentine')

1 Capretti 1994, pl.36.
2 Sale, London, Christie's, 3 July 1996,
lot 129, illus.
3 See, for example, another *Madonna and Child
with the Infant St John the Baptist* in the sale,
London, Christie's, 13 December 1996,
lot 345, illus. (in colour).
4 Vasari 1550 (rev.edn 1568), vol.4, p.465.
5 Ibid., p.467
6 Ibid.
7 Ibid., p.468.

Cat.50a Master of Volterra, *Madonna and Child*,
oil on panel, 38⅛ × 29¾ in (97 × 74.5 cm),
*c.*1520 (present whereabouts unknown)

'The Master of Volterra' is the name given to an anonymous follower of the Florentine painter Domenico Puligo (1492–1527). He was active mainly in Volterra, the Tuscan city southwest of Florence, and was responsible for a small group of devotional pictures that appear to have been painted around 1520–30, including the altarpiece of the *Madonna and Child with Sts Francis, John the Evangelist, Clare and Lawrence* in the Oratorio dei SS Pietro e Lino, Volterra,[1] after which he was named by Elena Capretti in 1994. His oeuvre was further expanded in the late summer of 1996 by Everett Fahy, following the appearance at Christie's, London, of a *Madonna and Child with a Female Saint* from the collection of the Marquess of Bute (cat.50a).[2] Although the Bute picture had been attributed to Domenico Puligo in the Christie's sale catalogue, it became clear immediately after that publication of it, as Fahy pointed out, that it was the work of this particular provincial follower of his. Other pictures by this same hand were subsequently identified,[3] including the Cobbe Collection picture, the attribution of which to the Master of Volterra is likewise due to Everett Fahy; this had been acquired in 1988 as by a follower of Michele di Ridolfo Ghirlandaio (1503–77).

Although pictures from the 'Master of Volterra' group share Puligo's cool, restricted colouring and outmoded classicism – which was largely based on Fra Bartolomeo (1472/5–1517), Andrea del Sarto (1486–1530) and the Florentine works of Raphael (1483–1520) – they nevertheless lack the suavity of Puligo's authentic works. Such provincial maladroitness can be seen in some passages of the present work, for example in the left leg of the Christ Child, which emerges from his body at slightly the wrong angle and the lower half of which seems too slender and short compared with his right, and in the awkward transition between the figure group and the distant landscape behind them. In spite of such structural weaknesses, other details are admirably achieved, such as the Madonna's hands, the curly blond hair of the Christ Child and the Madonna's face and headgear.

As to the career of Puligo himself, he was trained in Florence in the studio of Ridolfo Ghirlandaio and was a friend and associate of Andrea del Sarto. Vasari, in his lives of painters, devoted an entire biography to the painter, praising the sweetness of his effect in devotional subjects, as well as the softness of his contours. These last, he noted, merged imperceptibly with his backgrounds, concealing from time to time the occasional error of form.

Puligo was also expert in portrait painting, and Vasari singled out that of the courtesan Barbara Fiorentina '*…in quel tempo famosa … e molto amata da molti, non meno che per la bellezza, per le sue buone creanze, e particolarmente per essere bonissima musica e cantare divinamente*' ('famous at that time … and much loved by many, no less for her beauty, than for her good breeding, but particularly for being a very good musician and singing divinely').[4] According to Vasari, Puligo was, unfortunately, lazy, following the pleasures of the world rather than devoting himself to his painting, as he should have done.[5] Vasari implied that Puligo sometimes took advantage of the help offered him by Andrea del Sarto in designing certain compositions, '*… non volare durare molta fatica, e lavorare più per fare opere e guadagnare che per fama …*' ('not wanting to spend much time toiling, working more to carry out works for gain rather than for reputation').[6] Such a personality type might well explain his recourse to assistants, though Vasari mentioned only a certain 'Domenico Beceri fiorentino', '*fra gli altri*' ('among others').[7]

NT

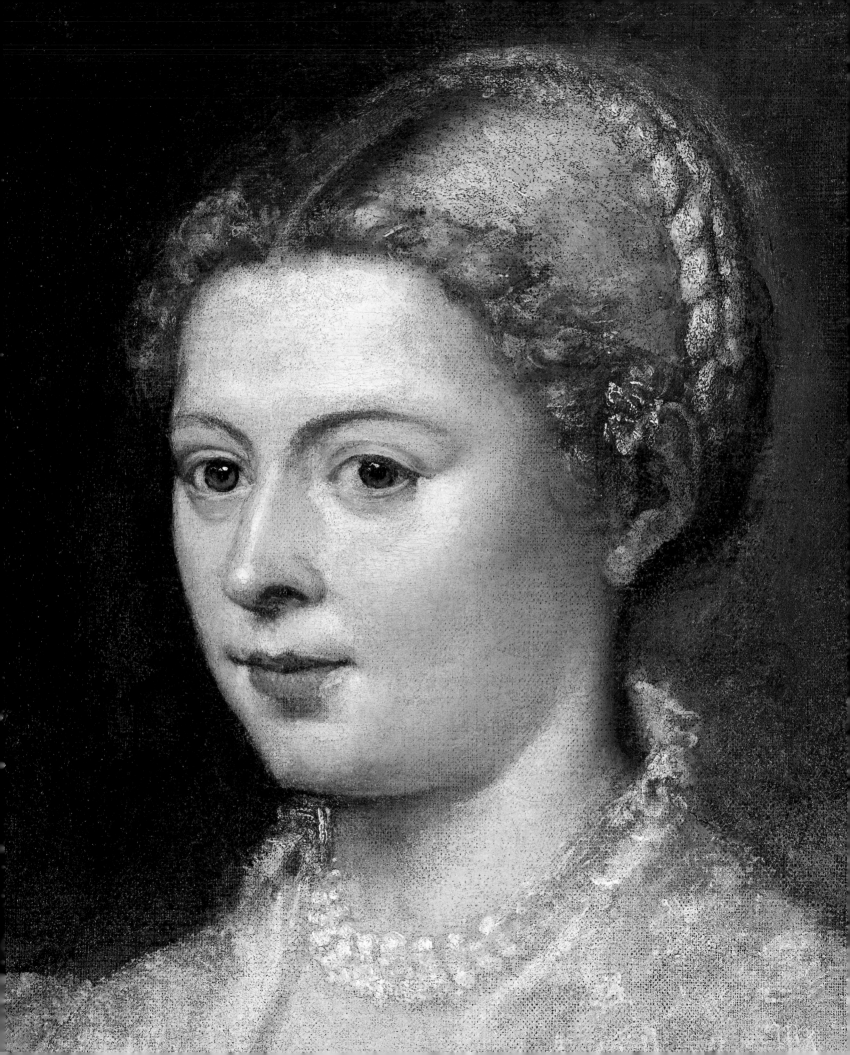

51

TIZIANO VECELLIO, CALLED TITIAN
Pieve di Cadore, *c.*1488/90 – Venice, 1576

Portrait of a Patrician Lady and her Daughter

Oil on canvas, stretcher size:
35 × 31½ in (89 × 80 cm),
canvas size: 35⅝ × 31⅛ in (88 × 79 cm)
Late 16th-century Venetian carved and gilt
cassetta frame, with bees at the corners and
eagles at the top and bottom centres, and
fleurs-de-lys at the left and right centre
INSCRIPTIONS on the reverse, on the stretcher:
inscribed with the Barbarigo Collection number
in Russian, *N. 17: Kol: bar:*
Cobbe Collection, no.403
HISTORY see p.224

This previously unknown masterpiece by Titian, an unfinished double portrait of a patrician lady and her daughter, emerged in conservation during the closing years of the 20th century. For several centuries before that, however, the image had been hidden beneath a religious composition of *Tobias and the Angel* (cat.51a).

As revealed after cleaning, the woman in the picture wears a refined costume that identifies her as a member of a Venetian patrician family. She might be about 30 years old, her child about 10. Her identity is unknown. In facial type, she is characteristic of many of Titian's blonde beauties, but her features most closely resemble those of the younger woman in the *Girl in a Fur Wrap* (Kunsthistorisches Museum, Vienna; cat.51e), a portrait by Titian that was much admired by Rubens (1577–1640). Titian's patrician subject is a mature woman, no longer a girl, captured at a moment in time when a woman's beauty is splendid and maternal. There is no comparable image of a mother and daughter in Titian's œuvre, and, furthermore, such images are extremely rare in 16th-century Venetian painting at all.

cat. 51

Cat.51a Titian and studio (or a later hand),
Tobias and the Angel Raphael
(cat.51 before restoration)

Cat.51b x-radiograph of detail of cat.51,
taken in 1948

cat. 51a *cat. 51b*

For his few female portraits, Titian favoured a three-quarter-length format, beginning with his 'La Schiavona' of *c.*1512 (National Gallery, London; cat.51d). It is one of the earliest life-size, three-quarter lengths in Italian painting and, as such, holds an important place in the history of art. Titian adopted the same format for his portrait of Alfonso d'Este's favourite and later wife, *Laura Dianti, Accompanied by her Black Pageboy*, of *c.*1527–8 (collection of Heinz Kisters, Kreuzlingen; cat.51c). The singular placement of Titian's signature on the ring on Laura's left hand suggests that he was particularly pleased with the outcome of the commission. Titian returned to this composition in the late 1540s, when he began the Cobbe *Portrait of a Patrician Lady and her Daughter*, in which he placed the woman's hand on her child's shoulder, much as Laura Dianti rests her hand on her page. But whereas Laura Dianti's gesture is one of possession, the patrician woman's is one of affectionate maternal restraint. She also resembles a female saint presenting a donor. This innovative series of three female portraits by Titian was to provide a model for many later portrait painters, a tradition that has lasted until the present day.

In Titian's surviving œuvre of nearly 120 portraits, barely 14 are of women. The same scarcity occurs in the work of other 16th-century Venetian artists, with the exception of Lorenzo Lotto (*c.*1480–1556), who worked outside Venice. Although fathers and sons are occasionally found in such paintings

HISTORY probably Titian's son, Pomponio Vecellio, from whom probably acquired in 1581 by Cristoforo Barbarigo as part of the contents of the artist's house; collection of the Barbarigo family, Palazzo Barbarigo della Terrazza, S Polo, Venice, from at least 1758 until 1850; sold, together with 102 other paintings, on 31 July 1850 by Count Nicolò Antonio Giustinian Barbarigo to Tsar Nicholas I of Russia; probably de-accessioned from the Hermitage, St Petersburg, in 1853; collection of Count Tyszkiewicz, St Petersburg, before 1913; offered to the dealer Joseph Duveen in January 1920 by Luca Comerio & C., Milan (according to an inscription on the reverse of a photograph in the Fototeca Berenson, Harvard University Centre for Renaissance Studies, Florence); Wildenstein, New York, March 1927 (according to the inscription on the reverse of a photograph sent to Berenson, now also in the Fototeca Berenson); collection of M. Maner, St-Rocque, France, before June 1936; sale, Sotheby's, London, 17 December 1947, lot 51 (as Titian, bought in); sale, Christie's, London, 1963 (bought in); sale, Sotheby's, London, 1970; acquired by the Pelican Trust during restoration as *Tobias and the Angel*, October 1996

EXHIBITIONS London 1913–14, no.49

LITERATURE Cochin 1758, p.140; Lalande 1769, pp.109–11; Bevilacqua 1845, no.17; Förster 1846, p.6; Levi 1900, pp.281–9; Wethey 1969, vol.2, no.145, pp.162–3; Wethey 1975, vol.3, pp.263–4, pls 219–20

Cat.51c Titian, *Portrait of Laura Dianti, Accompanied by her Black Pageboy*, oil on canvas, 46½ × 36⅝ in (118 × 93 cm), *c*.1527–8 (collection of Heinz Kisters, Kreuzlingen)

Cat.51d Titian, *Portrait of a Lady ('La Schaivona')*, oil on canvas, 47 × 38 in (119.5 × 96.5 cm), *c*.1512 (National Gallery, London)

as Titian's *Portrait of the Vendramin Family* (National Gallery, London), portraits of mothers and daughters are even rarer. The only other 16th-century example from Venice is by Paolo Veronese (1528–88), namely his full-length *Portrait of Countess Lucia Thiene da Porto with her Daughter Porcia* (Walters Art Gallery, Baltimore), which is usually dated *c*.1551 and is a companion piece to the full-length *Portrait of Count Giuseppe della Porta with his Son Adrian*, from the Contini–Bonacossi Collection (Uffizi, Florence). Some of Titian's female portraits were commissions from the consorts of non-Venetian rulers, such as the *Portrait of Eleanora Gonzaga della Rovere, Duchess of Urbino* of 1536–8 (Uffizi, Florence) or the *Portrait of Charles V Accompanied by his Empress* of 1548 (collection of the Duke of Alba, Madrid). On one other occasion, he depicted a tender image of a young girl, the child of a Florentine family in exile in Venice, in the *Portrait of Clarice Strozzi Feeding a Biscuit to her Dog*, dated 1542 (Staatliche Gemäldegalerie, Berlin). Titian's portraits of local Venetian doges were invariably single, unaccompanied figures.

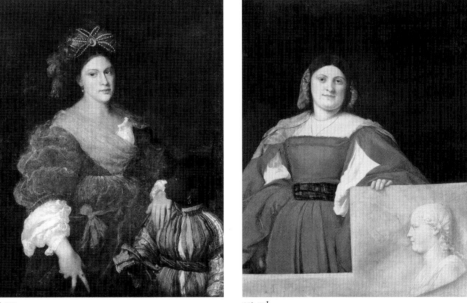

cat. 51c cat. 51d

In another form of female portraiture, Titian made pictures of beautiful women, a category that might have belonged in galleries with collections of '*le belle donne*', of which a supreme example is the painting known as '*La Bella*' (Palazzo Pitti, Florence). Portraits of women distinguished by their individual likeness began to appear in Venetian art only in the 1550s, with Paolo Veronese's *Portrait of a Lady* in the Musée Municipal, Douai, and his enchanting *Portrait of a Lady with her Infant Son and Dog*, in the Louvre, Paris. No satisfactory reason has ever been given for this late development in Venice of a genre that flourished elsewhere in Italian court culture. It may have to do with the relaxing of sumptuary laws in other parts of Italy, while in Venice the oligarchy continued, until about 1550, to prevent any patrician family from attempting to express dynastic ambition by means of displaying a family image of succession, even in architecture or in commemorative art such as portraiture or funerary monuments.

Titian's cousin, the writer Cesare Vecellio (1521–1601), in a section of his book on ancient and modern costumes, first published in 1590,[1] described the appearance of Venetian women in 1550 (*Habiti usati dalle donne di Venetia del 1550*). It was only about this date, according to Vecellio, that

1 Vecellio/ed.1859.

2 Cadorin 1833, p.113; on the palazzo, see Siebenhüner 1981.

3 Cadorin 1833, p.113.

4 Ridolfi 1648/ed. Hadeln 1914, vol.1, p.200.

5 Cochin 1758, p.140.

6 Lalande 1769, pp.109–11.

7 Bevilacqua 1845, no.17.

8 Förster 1846, p.6.

9 Savini Branca 1964, pp.183–6.

10 Levi 1900 reproduces the inventory of the entire sale, of which the *Tobias* is no.17.

11 Mündler 1855, p.79.

12 Wethey 1969, vol.1, pp.162–3.

13 Wethey 1975, vol.3, Addenda, pp.263–4, pls 219–20.

14 Ruhemann's unpublished report on his restoration.

15 Unpublished report on pigment analysis.

16 Longhi 1946/ed.1978, vol.10, p.21.

Cat.51e Titian, *Girl in a Fur Wrap*, oil on canvas, 37½ × 24¾ in (95 × 63 cm), *c*.1535 (Kunsthistorisches Museum, Vienna)

Cat.51f Titian, *Venus with a Mirror*, oil on canvas, 49 × 41 in (124.5 × 104 cm) (National Gallery of Art, Washington, DC)

women began to dress more richly, wearing earrings and other ornaments to make their face beautiful. Women, he argued, were proud to bleach their hair, making every effort to achieve the colour of gold, a colour that Italians even today call '*oro Tizianesco*' ('Titianesque gold'). They wore ornaments of flowers – lilies and other blossoms – in their hair.

The appearance of the patrician woman in cat.51 coincides in some detail with Vecellio's description of what was fashionable in 1550. Her luxuriant blonde hair is curled back in a *torciglióne* across her forehead, framing her face, a fashionable form of hairstyle that is found on other women represented by Titian at this date, notably the Barbarigo *Venus with a Mirror* (National Gallery of Art, Washington, DC; cat.51f). Her thick hair is also braided in a demure plait that crowns the back of her head. She has an ornament in her hair, a coquettish red carnation above her left ear. Her jewellery consists of two prominent strands of pearls, a third string hinted at between the two. Her daughter wears a magnificent amethyst earring, as well as a decoration of seed pearls entwined in her hair. At

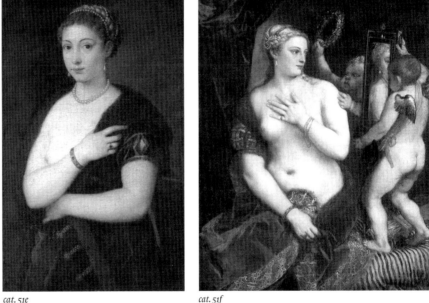

cat. 51e cat. 51f

the top of her head is a clasp. The mother's dress is rich and refined. She wears a white undergarment, a chemise of fine, delicately patterned white linen, and a golden brown velvet overdress, a *camora*. Across her bodice, or *corsetto*, are delicate white ties, in a *chiusura intrecciata*, the laces held by small buttons. The ample sleeves of her over garment are defined in varying browns. Over these, larger transparent white sleeves are lightly sketched. Venetian dresses had evolved as separate pieces, and attachable sleeves were fashionable and could be extremely elaborate. Her left sleeve has three buttons on the shoulder strap.

The unfinished state of the picture provides a precious glimpse into Titian's working method and technique. Like many portrait painters, he began by concentrating on the heads, bringing the features of mother and child to a high degree of finish. It is likely that Titian usually began his portraits in this way, quickly capturing his sitters' likeness before they tired of the session. Titian certainly appears to have been sketching from life for this work, and he had yet to come to a final decision about several passages when he abandoned the canvas. Even where the picture is incomplete, however, there is a mastery of touch that defines what is there and hints at what will emerge with an enviable brilliance.

Cat.51g Joseph Nash, *The Gallery in the Palazzo Barbarigo della Terrazza, known as the 'School of Titian'*, lithograph from Lake Price's *Interiors and Exteriors in Venice* (London, 1843)

Despite the variation in finish on different areas of the surface, the overall composition has an integral harmony and overall coherence, revealing the hand of the master throughout.

Originally, the canvas around the figures was unpainted, but it did have the preparatory ground layer on the background. Parts of the clothing have been taken to a relatively advanced stage, while other areas are hardly resolved. The woman's right hand is indicated by only a few sketched strokes: between her thumb and index finger she holds a stem and leaf, culminating in a flower with many petals, but also emerging from her hand is a series of white and grey brushstrokes, ending in an impastoed flourish, which nearly approaches the object of the child's gaze. A possible interpretation of this striking passage could be that it is the beginning of an ostrich feather fan, as seen in many of Cesare Vecellio's costume plates, or in other Titian portraits, such as the one known as *Lavinia as Matron* (Staatliche Gemäldegalerie, Dresden). Alternatively, it may be read as the beginning of fur-

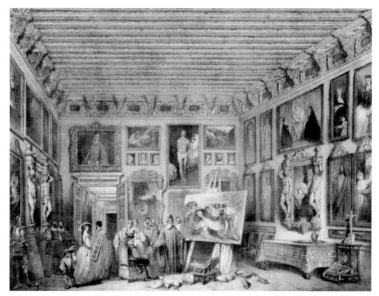

cat. 51g

ther flowers, perhaps a cluster of lilies. The apparent indecision as to whether the representation should be of a woman holding a fan or flowers is one of the many ambiguities that capture Titian's working process in a fascinating way.

There could be a number of explanations as to why the portrait was not finished. Besides the possibility that its imagery contravened the complex sumptuary laws, it could be that one or other of the sitters died in one of the many outbreaks of plague, which decimated entire families, and eventually killed Titian himself. It may represent a member of the artist's family (perhaps even his daughter Lavinia with one of her six children) and, having thus not actually been commissioned, may have been put aside constantly in order to complete other, more urgent work. It may quite simply have failed to please the patron. Rejection is always a sensitive issue for a portrait painter, which may explain both the absence of any early documentation about the picture and its later metamorphosis.

The date of the Cobbe portrait is a complex issue, as there are highly finished areas, characteristic of Titian's art in the late 1540s, and loosely sketched areas, which resemble Titian's late style in the 1560s. After 1550, Titian, then in his late sixties, began to develop a 'less finished' style of execution, which had a profound effect on his younger contemporaries. It occurred only in 1556, after the death of Aretino (who had always encouraged Titian to subscribe to Central Italian notions of finish).

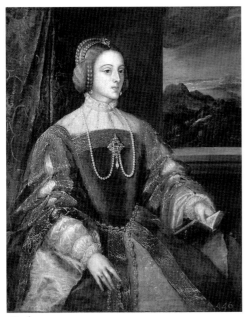

cat. 51h
Cat.51h Titian, *Portrait of the Empress Isabella*,
oil on canvas, 46¼ × 37 in (117 × 98 cm), 1548
(Prado, Madrid)

Cat.51i Titian, *Portrait of the Empress Isabella*
(reversed detail of sitter's head)

Cat.51j Titian, detail of cat.51

Easily readable brushstrokes on loosely woven canvases with large threads became increasingly apparent in this late style. The means became sparer, the risk-taking a pleasure. Whatever the cause, Titian's late style (like the compositions of his portraits) was to influence generations of later artists, especially in the 17th century – among them Velázquez (1599–1660), Rubens (1577–1640) and Van Dyck (1599–1641) – for Titian's late, fluid, painterly style has always had enormous popular appeal. It was also of seminal importance in the subsequent development of modernism, making Titian, in effect, the forerunner of both Monet (1840–1926) and Renoir (1841–1919).

At a very early stage in its existence, probably shortly after Titian's death, the unfinished Cobbe portrait was radically changed, presumably either by one of Titian's pupils or by a 17th-century artist. It was transformed into an image of the Archangel Raphael guiding the young Tobias (cat.51a), both of whom are clearly identifiable by the elements that cured Tobias's father's blindness (*Book of Tobit*, 6). The portrait heads were refashioned, their gender changed. Wings were given to the mother so that she became an angel, and her daughter acquired a boy's hairstyle to become Tobias. To complete their new identity, two rather clumsy forearms were added, with Raphael holding a medical vase containing the fish-gall that cured blindness, and Tobias a large fish, from which the gall had been taken. This was possibly done to create a more saleable religious devotional composition. Even thus disguised, the painting continued to be attributed to Titian for several centuries, occasionally with reservations expressed about the details of the execution or about a certain unevenness between the different parts of the painting.

Thus, as *Tobias and the Angel*, the painting was recorded from the mid-18th century in the gallery of the Palazzo Barbarigo della Terrazza, S Polo, Venice, on the Canal Grande. The Barbarigo collection had been dramatically enriched in 1581, when Cristoforo Barbarigo purchased Titian's house in the Biri Grande and its contents, including all of his remaining pictures, from the artist's son Pomponio Vecellio.[2] In his will of 1600, Cristoforo referred to only four pictures by Titian that he deemed important: 'I leave my paintings [of] the Christ carrying the Cross, with Joseph of Arimathea behind, who helps him carry the Cross, the Magdalene, the Madonna furnished with an ebony frame, the Venus, in all numbering four very famous paintings by the hand of the excellent painter Titian,

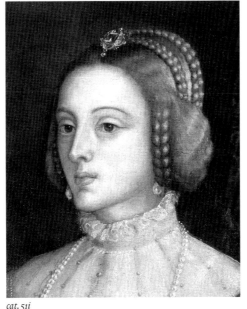

cat. 51i

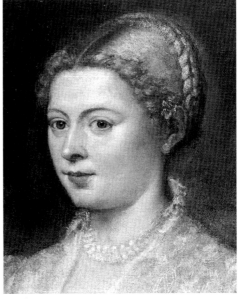

cat. 51j

Cat.51k x-radiograph of detail of fig.51l

Cat.51k Titian, *Tarquin and Lucretia*,
oil on canvas, 74¼ × 57¼ in (191 × 145.5 cm),
*c.*1570 (Fitzwilliam Museum, Cambridge)

which should be inherited from first born son to first born son.'[3] Three of these pictures are now in the Hermitage, St Petersburg, while the celebrated *Venus with a Mirror* (cat.51f), de-accessioned from the Hermitage in 1931, is now in the National Gallery of Art, Washington, DC. Other paintings must surely have been included in the initial sale to Cristoforo Barbarigo, but were not recorded in his will, such as the magnificent unfinished late *St Sebastian*, also in the Hermitage). When Carlo Ridolfi described the Barbarigo collection in 1648, eleven pictures by Titian were listed.[4] By the mid-18th century, descriptions included at least 22 paintings by the artist, most of which were from his last years. From the late Cinquecento any traveller to Venice interested in Titian visited the Barbarigo collection, which came to be known as the 'Scuola di Tiziano', and their accounts of what they saw became progressively more detailed.

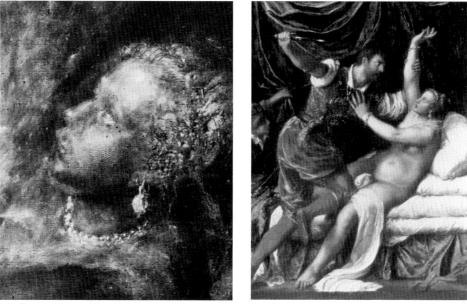

cat. 51k *cat. 51l*

Tobias and the Angel was first described, in detail and indeed rather accurately, in the earliest extensive account of the Barbarigo collection, that made in 1758 by Charles-Nicolas Cochin II (1715–90) in his *Voyage d'Italie*. Among the 12 works by Titian that he recorded was: '*L'Ange Gardien & Tobia, deux figures en bustes. Les têtes ne sont pas peintes d'un pinceau si gras que les autres; elles ont même quelque chose de plat, & les ombres, qui sont presqu'égales aux demi-teintes, ne leur donnent pas de rondeur, & d'autant moins que les draperies ont beaucoup de vigueur, & ont encore noirci.*'[5] In successive years, the painting was always included in accounts of the collection. In 1765 it was mentioned by Joseph-Jérôme de Lalande, who described 13 pictures by Titian;[6] in 1845 by Bevilacqua, who described 15;[7] and a year later, in 1846, by Ernst Förster, who also described 15.[8]

Most scholars today consider that the Barbarigo collection remained intact from the time of Cristoforo Barbarigo until 1850, when it was bought by Nicholas I, Tsar of Russia.[9] The charming appearance of the interiors of the Palazzo Barbarigo before this latter sale took place is documented in a lithograph dated 1843 by Lake Price, who fancifully included a figure of Titian at work in the principal gallery (cat.51g). The pictures in the collection are shown in very elaborate frames, which were later retained by the Barbarigo family. That the Cobbe painting was one of the items included in the 1850 sale of more than a hundred paintings to the Russian Tsar is documented.[10] However,

some unfinished pictures and *abbozzi*, as well as sketched prototypes for portraits of monarchs such as Francis I, Philip II and others, proved unacceptable to the Czar, and these remained with the Barbarigo family in Padua.[11] The Czar was evidently unimpressed by Titian's late style, consigning the *St Sebastian* to store and selling many of the other Barbarigo pictures, including the *Tobias*. By 1913 the painting was in the collection of a Russian aristocrat, a Count Tyszkiewicz from St Petersburg, who lent it to an exhibition in London.

In his *catalogue raisonné* of Titian's work, Harold Wethey included the Cobbe *Tobias*, as a 'free partial copy' from the 16th or 17th century after Titian's *Tobias and the Angel*, in the Sacristy of S Marziale, Venice.[12] When Wethey later saw an x-radiograph, taken by the restorer Helmut Ruhemann at the Courtauld Institute in 1948 (cat.51b), he revised his opinion, noting the characteristic vigorous underdrawing of the woman's head. He published the x-radiograph showing the underlying female portrait and concluded that the underpainting was by Titian and that the canvas had been re-used in Titian's workshop.[13] He further observed that the hairstyle in the portrait of a lady, with her braided hair framing her forehead, was similar to that of the sitter in the 1548 *Portrait of Empress Isabella* (Prado, Madrid; cat.51h and i). The similarity between the radiographs of the child's head (cat.51b) and that of the radiograph of the head of Lucretia (cat.51k) from the *Tarquin and Lucretia* (Fitzwilliam Museum, Cambridge; cat.51l) was pointed out by Ruhemann and Stephen Rees-Jones.[14] In 1948, when Ruhemann restored the painting, he uncovered the pearl necklace worn by the patrician women, only to cover it over again.

Pigment analysis carried out in the 1990s[15] revealed that the paint of the double portrait was laid on in just one or two solid layers, without the glazes that Titian usually applied as a final coat to enrich and intensify the colour of draperies. Moreover, it was concluded that the unfinished double portrait had never been displayed as such (i.e. in the state in which it was when abandoned by Titian), for there is no trace of varnish between the paint layers of the double portrait and those of the later alterations. The analysis also showed that its alteration took place in two successive stages, with smaller wings added in the first instance. The painting had been relined during the 19th century while it was in Russia, and the bottom edge was slightly trimmed during relining. By the late 20th century, the attribution to Titian of the *Tobias* composition had also been convincingly refuted. This, taken together with the evidence of the radiograph and analytical results, encouraged the bold decision to uncover the original double portrait lying beneath.

The resulting rediscovery of a beautiful late portrait by Titian is destined to play a part in future discussions about the nature of the artist's late style, which Roberto Longhi felicitously defined as 'magic impressionism'.[16] It confirms that this late style, as shown in the rich browns and open brushwork of the gorgeous late *Tarquin and Lucretia* (Akademie der Bildende Kunste, Vienna) or the *Annunciation* (S Salvatore, Venice), in fact evolved from the preliminary stages of his earlier painting technique. As an undoubted example of an unfinished work by Titian, the Cobbe canvas will also make an important contribution to the debate about the nature of 'finish' in his late pictures. In fact, the re-emergence of this double female portrait from its physical cocoon – the uncovering of an image that has not been seen since Titian's lifetime – opens up many new perspectives for historians of Venetian painting and especially for those interested in Titian's late style.

JA

52

LAMBERT SUSTRIS
Amsterdam *c*.1510/15– (?) Venice after 1560

Judith with the Head of Holofernes

Oil on canvas, 47¾ × 39½ in (121 × 100 cm)
Cobbe Collection, no.356
HISTORY possibly Anton Fugger I, Augsburg;
possibly sale of his descendants, 1650; possibly
acquired at the Fugger sale of 1650 and taken
from Germany to Sweden by either Anthony
Grill or Vollrath Tham; probably one of 80
paintings inherited by their respective children,
Claes Grill and his wife, Anna Johanna (*née*
Tham), Österby Estate (which they had acquired
in 1750 after their marriage); included in the
inventory made at the time of Anna Johanna
Grill's death in 1778 (as 'Judith'); by descent to
their daughter Anna Johanna Peill (*née* Grill)
and her husband, Henrik Wilhelm Peill, Österby
Estate; included in the inventory made at the
time of Henrik Wilhelm Peill's death in 1797 (as
'Italian, "Judith with the head of Holofernes"');
the entire Österby Estate, including the collec-
tion of pictures, sold at the time of the death of
Anna Johanna Peill to her cousin Anna Johanna
Grill (Claes Grill's niece); half of the estate sold
in 1802 to Per Adolf Tamm, husband of her
daughter, Anna Margareta Tamm; the remain-
ing half inherited in 1809 by Per Adolf and Anna
Margareta Tamm on the death of Anna Johanna
Grill; sold in 1876 by Per Adolf Tamm to his
grandson, Hugo Tamm, Fårnöö Estate, for 3,500
Crowns; thence by descent to his granddaughter
Miss Gunilla Tamm; acquired at sale (including
property of Miss Tamm), Sotheby's, London, 11
December 1985, lot 7
EXHIBITIONS Österbybruk 1981, no.7
(as attributed to Paris Bordone)
LITERATURE *Cat. Österby* 1841, no.30
(as by Titian); Laing/Cobbe 1992, pp.2, 12–13,
no.303, illus.; Mancini 1993, pp.103, 144, n.26,
fig.88; London 1996b, p.34

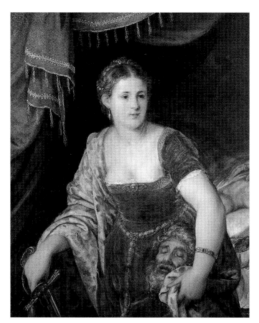

After initial training in Amsterdam, Lambert
Sustris, some time in the early to mid-1530s,
moved to Italy, where he is documented initially
in Rome. He was probably in Venice by *c*.1535,
working in the studio of Titian (*c*.1488/90–1576).
By the end of the decade he was one of the lead-
ing exponents of Mannerism in the Veneto.

The Cobbe picture – first attributed to
Sustris at the time of its sale in 1985 – belongs to
a small group of pictures assigned to the period
1548–52, when the artist was in Swabia, much
of the time with Titian. These include the *Venus*
in the Rijksmuseum, Amsterdam (cat.52a),[1]
the '*Noli me tangere*' in the Musée des Beaux-Arts,
Lille,[2] and the *Mars, Venus and Cupid* in the
Louvre, Paris (cat.52b).[3]

The style and composition of Sustris's paint-
ings, even at this relatively mature point in his
career, are still fundamentally dependent on
works by Titian, as is evident from a comparison between the Amsterdam *Venus* and Titian's famous
Venus of Urbino (mid- to-late 1530s; Uffizi, Florence).[4] Sustris must have seen the *Venus of Urbino* before
it was shipped in 1538 from Venice to the patron, Guidobaldo II della Rovere (1514–74), Duke of
Urbino, and it has even been suggested that he collaborated with Titian on that picture, painting the
room in the right background. Yet, as Stefania Mason Rinaldi observed,[5] '[Sustris's] use of colour is
different from Titian's: [he] defines areas with clear outlines and enhances his fine tonal range and
sensitive draughtsmanship with silvery highlights'. These diversities have been attributed to the
probable influence of his fellow Titian pupil Paris Bordone (1500–71). Sustris's artistic formation,
under the auspices of both Titian and Bordone, is indeed reflected in the previous attribution his-
tory of cat.52 – published as by 'Titian' in 1841 and exhibited as 'attributed to Paris Bordone' in 1981.

The refined chromatic range of the Cobbe picture – complete with the silver-toned highlights –
is entirely characteristic of Sustris and most closely resembles the palette of his Amsterdam *Venus*,
where a similar olive green curtain, edged with gold brocade trim and tassels, is knotted up at the top
left. Not only are the two pictures close in colouring, style and date, they also share the same model
and many of the same stage props. The young woman who posed for both works has widely set blue-
grey eyes, pinched rosebud lips and the same protruding ears. Her hair is arranged in the same fashion,
with a central parting and plaits wound on top of her head (with strings of pearls in the Cobbe paint-
ing). She is wearing the same jewel-encrusted gold bracelet in both compositions (see detail, p.212),
and behind her is the same bed, with a large cushion or pillow trimmed in gold brocade.

Also similar in style and date to the Amsterdam *Venus* is the Lille '*Noli me tangere*', as was first noted
by Ballarin.[6] The Lille composition was painted for Anton Fugger I (1493–1560), head of the great
Augsburg family of merchants, bankers, patrons and collectors, and it bears the family coat-of-arms.
It is possible, according to Mancini, that the Cobbe *Judith with the Head of Holofernes* might also once
have adorned the walls of the Fugger House, along with the Lille picture. Anton Fugger took over
the running of the family textile, banking and mining businesses after the death of his uncle, Jakob
Fugger (1459–1525), having first trained in various international branches of the firm, including
that in Rome, where he was knighted and made a count of the papal court by Pope Leo X. Despite the

1 London 1983–4, no.98, illus.

2 Mancini 1993, fig.87

3 Brejon de Lavergnée and others 1979, p.134, illus.

4 Venice and Washington, DC, 1990, p.532, illus.

5 London 1983–4, p.211.

6 Ballarin 1968, p.122.

7 The passing reference to the Cobbe picture in Mancini's book was brought to my attention by Mark Broch, to whom I am most grateful. However, some caution regarding Mancini's suggestion is advisable, since if Fugger owned a composition of *Judith with the Head of Holofernes* by Sustris, it is possible – even more likely – that it is another version of the subject by the artist (oil on canvas, 113×95 cm), which was together with the '*Noli me tangere*' in the French royal collection in the 17th century and is now also in the Musée des Beaux-Arts, Lille (see Brejon de Lavergnée 1986, p.134, no.56).

8 Venice and Washington, DC, 1990, no.69, illus.

9 Suida 1933, pp.130, 172.

10 *Cat. Detroit Institute of Arts* 1944, p.134.

11 Tietze 1936, vol.2, p.286.

12 Tietze 1950, p.369.

13 Venice and Washington, DC, 1900, p.352.

14 Paris 1993, p.676.

Cat.52a Lambert Sustris, *Venus*, oil on canvas, 45½×73 in (116×186 cm), *c*.1548–50 (Rijksmuseum, Amsterdam)

Cat.52b Lambert Sustris, *Mars, Venus and Cupid*, oil on canvas, 51¾×72½ in (132×184 cm), *c*.1548–52 (Musée du Louvre, Paris)

spread of Lutheranism in Augsburg in the 1530s, he remained a devoted Roman Catholic and had close ties to the Holy Roman Emperor Charles V (1500–58). Anton's major project as a patron was the embellishment of his house at no.36 Weinmarkt, Augsburg, where Charles V resided during the Imperial Diet of 1530. The sumptuously decorated house, with gilt ceilings and marble columns and chimneypieces, was filled with paintings, according to contemporary descriptions.

Unfortunately, no inventory of Anton Fugger's collection of paintings survives, but the provenance of cat.52 – which is thought to have been taken from Germany to Sweden in 1650 – lends further support to Mancini's hypothesis.[7] The holdings of the Fugger family were dispersed in that year, and it may have been then that it was bought by either Anthony Grill (*d*.1675) or Vollrath Tham, father-in-law and father respectively of Anna Johanna Grill (*née* Tham), the picture's first certain owner, who died in 1778. The painting descended in the family until its sale by Miss Gunilla Tamm in 1985.

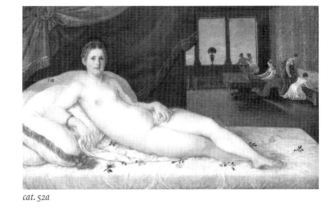

cat. 52a

For the concept of the Cobbe picture, Sustris seems to have been indebted to Titian's apparently unique depiction of the same subject, now in the Detroit Institute of Arts (cat.52c).[8] Considerable controversy surrounds the dating of the Detroit picture, as it embodies two distinct styles of Titian's work. Thought by Suida (1933) to be a late version (from the 1560s or 1570s) of a prototype from the 1530s,[9] it was catalogued by the curators at Detroit (1944) as having been begun by Titian in 1550 (starting with the figure of Judith), then abandoned and finished by him some 20 years later.[10] Tietze accepted the two-stage execution of the painting (1936),[11] but later came to believe

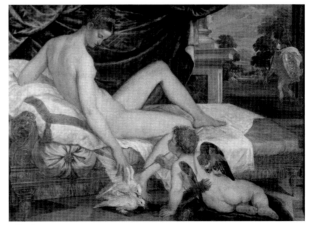

cat. 52b

Cat.52c Titian, *Judith with the Head of Holofernes*, oil on canvas, 44¼×37¼ in (113×94.5 cm), ? *c.*1550 and 1570s (Detroit Institute of Arts)

that the composition, in the form of an autograph *ébauche*, was completed by Titian's studio (1950).[12] Marandel[13] and Valcanover[14] analysed but ultimately questioned the idea of a 20-year interval between two periods of execution. They concluded that it was a wholly autograph late work and that the discrepancies were a stylistic conceit on the part of Titian – who would have deliberately painted the head of Judith in a light, finished style in order to contrast it with the dark, '*non-finito*' manner applied to the head of Holofernes.

While there is no doubt that the lower portions of the Detroit painting are executed in the 'impressionistic' style associated with the last decade of Titian's life, further evidence for the possibility that the figure of Judith was painted much earlier is provided both by the new revelations of Titian's preliminary manner of painting around 1550, as in the Cobbe *Portrait of a Patrician Lady and her Daughter* (cat.51), and by the striking similarities between it and the figure of Judith in the Cobbe picture. Sustris's Judith seems inconceivable without the Titian figure as a source (note especially the dangling pearl earring). Assuming that only the head, arms and main part of Judith's torso in the Detroit picture were completed by Titian around 1550 (when he was in Augsburg), it would also explain why Sustris's composition differs in most other respects from that of his former master.
NT

53

BERNARDINO CAMPI
Cremona 1522–Reggio Emilia 1591

St Jerome Kneeling in a Landscape

Oil on canvas, 39 × 30 in (99 × 76 cm)
Cobbe Collection, no.304
HISTORY acquired from R. McDonnell's shop,
Kildare St, Dublin, c.1979

1 Ferrari 1974, pp.114–15, figs 130–31 (in colour).
2 Sale, Sotheby's, New York, 23 January 2001,
lot 185, illus. (in colour).
3 Lamo 1584; see also Ferrari 1974, p.94.
4 For *St Cecilia and St Catherine*, see Ferrari 1974.
5 Ibid.
6 Zaist 1774, p.197: '*nell'una* [of the "*due Tavole*"]
*vi espresse S. Girolamo ignudo, che sta genuflesso
innanzi al Crocifisso, e S. Antonio Abate, colla soscritta
del suo nome, ed anno 1566*'.
7 Cremona 1997–8, no.109, illus.
8 Ibid., no.108, illus.
9 Documented in a letter dated 30 July 1568 to
Campi; see Sacchi 1872, p.72.
10 Alisio, Carughi, Di Stefano and Miccoli 1976,
pp.115, 117, fig.60.
11 Bora in Cremona 1997–8, p.292.
12 Guazzoni 1985, p.232.

Cat.53a Bernardino Campi, *St Jerome and
St Anthony Abbot*, oil on canvas, altarpiece (1566)
in the chapel of Sts Jerome and Anthony Abbot,
S Sigismondo, Cremona

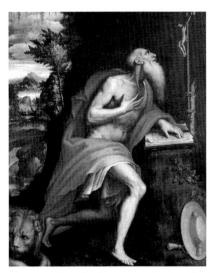

As Prof. Mario Di Giampaolo has kindly confirmed (on
the basis of a photograph), this unpublished picture is an
autograph, partial replica of Bernardino Campi's altar-
piece of *St Jerome and St Anthony Abbot* (cat.53a) in the abbey
church of S Sigismondo, c.2.5 km to the east of Cremona.[1]
The connection between the Cobbe Collection picture
and the S Sigismondo altarpiece was recognized by Alec
Cobbe and David Mees, when a drawn *modelletto* for the
altarpiece was offered for sale earlier this year at Sotheby's,
New York (cat.53b).[2]

The building of the new church of the abbey of
S Sigismondo was commissioned in 1463 by Bianca
Maria Visconti (1425–68) to commemorate her marriage
there in 1441 to Francesco I Sforza (1401–66), later Duke
of Milan. In 1546, over a century after the wedding had
taken place, Campi executed frescoes, including figures
of the *Prophets*, in the nave of the church. Sixteen years later, in 1562, at the instance of Giulio Claro
(1525–75), who was then *podestà* of Cremona, the *Fabbriceri* of the church also commissioned him to
provide altarpieces for two chapels, one dedicated to St Jerome and St Anthony Abbot and the other
to St Cecilia and St Catherine.[3] Both altarpieces are still *in situ*.[4] The commission for the altarpiece
for the first of these two chapels seems initially to have been allocated to Bernardino Gatti, called Il
Soiaro (c.1495–1576), who had painted the fresco of the *Ascension* in the vault of the church in 1549.[5]
Gatti, however, must have been too busy in 1562, for between 1560 and 1572 he was working on the
prestigious commission for the decoration of the cupola of S Maria della Steccata, Parma. Much of
Campi's decoration in the two chapels in S Sigismondo was carried out in 1562–4, when he was again
in his native Cremona, but neither of the altarpieces was completed until 1566,[6] when he signed and
dated the *St Cecilia and St Catherine*. By this time he had returned to Milan (to where he had transferred
in the 1550s). He was back in Cremona in 1570, when he decorated the main dome of the church.

Besides the ex-Sotheby's *modelletto*, which is undoubtedly a presentation drawing for the patron
or *Fabbriceri*, there are two surviving compositional studies by Campi for the altarpieces, both executed
in pen and brown wash, heightened with white. That of *St Cecilia and St Catherine* is in the Ambrosiana,
Milan,[7] while that of *St Jerome and St Anthony Abbot*, which is squared for transfer, is in the Kunsthalle,
Hamburg (cat.53c).[8] All three preparatory drawings show few differences from the finished pictures.

The two altarpieces by Campi in S Sigismondo were among his most celebrated works. Several
replicas of the *St Cecilia and St Catherine* are known to have been ordered from the artist, two by
Vespasiano Gonzaga (1531–91), Duke of Sabbioneta, and one by the Ambassador of Venice.[9] One of
these may be the signed and dated version of 1568 – interestingly enough, representing only the
main figure of *St Cecilia* – preserved in the church of SS Trinità dei Pellegrini, Naples.[10] It seems likely
that cat.53 once formed a pair with this or another partial autograph replica painted for a contempo-
rary collector. The S Sigismondo compositions also clearly influenced other Cremonese artists. Andrea
Mainardi, called Il Chiaveghino (c.1550–c.1614), faithfully reproduced in the parish church of Ostiano
the figure of St Jerome in an altarpiece, of which there is an exact copy in abbey church of Ospedaletto
Lodigiano, probably by Luca Cattapane (fl.1575–99), according to Valerio Guazzoni;[11] also preserved
in the latter church is Mainardi's copy, with minor variations, of Campi's *St Cecilia and St Catherine*.[12]

The Cobbe picture appears to be the only painting by Bernardino Campi extant in the British Isles.
It is a typical example of the mid-16th-century Cremonese school of painting, the slender proportions

Cat.53b Bernardino Campi, *St Jerome and St Anthony Abbot*, pen and brown ink and wash, over black chalk, 20⁹⁄₁₆×14⁷⁄₈ in (524×382 mm), *c*.1562–4 (present whereabouts unknown)

Cat.53c Bernardino Campi, *St Jerome and St Anthony Abbot*, pen and brown wash with traces of white heightening, on prepared paper, 4⅝×3³⁄₁₆ in (118×80 mm), *c*.1562–4 (Kunsthalle, Hamburg)

of the figure and the strong colouring revealing the powerful influence of nearby Emilian painting, particularly of the work of Parmigianino (1503–40). Especially characteristic of Bernardino's work is the delicate lighting of St Jerome's emaciated body, with its taut facial features, straggly white beard and attenuated fingers, which are fittingly contrasted with the potent scarlet of his robe and cardinal's hat.

Bernardino Campi received his earliest training in Cremona from his father, Pietro Campi, a gold-smith, and later studied in Mantua. He was almost certainly not related to the famous Campi family of artists in Cremona – of which Giulio Campi (*c*.1508–73) is the best-known member – although his niece later married Claudio Campi, the nephew of Giulio and the son of the painter Antonio Campi (1523–87). Like the work of his namesakes, Bernardino's paintings are distinguished by the use of

cat. 53b cat. 53c

brilliant colour and an openness to outside artistic influences from other regions of Italy, most notably Parma and Bologna, but also Ferrara and the Veneto, as well as from Germany and the Netherlands. The impact of Northern art is especially evident in the present work, where the space occupied by the figure of St Anthony in the S Sigismondo altarpiece has been given over entirely to a mountainous landscape with a lake, a vignette that is inconceivable without precedents by artists such as Joachim Patinir (*c*.1480–1524) and Albrecht Dürer (1471–1528). Even the fluffy, white clouds of the Cremona picture have been replaced by a stormy, grey sky.

NT

54

TOMMASO MANZUOLI, CALLED MASO DA SAN FRIANO
Florence 1531–Florence 1571

Portrait of Ottavio Farnese (1525–86), 2nd Duke of Parma and Piacenza

Oil on panel, 36½ × 29 in (92.5 × 73.5 cm)
Late 16th-century Central Italian gilt and
black-painted frame
Cobbe Collection, no.446
HISTORY P. & D. Colnaghi & Co., London;
private collection, France; acquired at sale,
Sotheby's, New York, 30 January 1998,
lot 26, illus.
EXHIBITIONS Florence 1989, pp.54–5, illus.
LITERATURE Pace 1976, fig.3; Vertova 1991,
pp.116–20

1 For the complete history of the picture,
see *Cat. Farnese* 1994, pp.99–100, illus.
2 Vasari 1550 (rev. edn 1568)/ed. de Vere 1996,
vol.2, p.62.
3 Ibid., p.61.
4 The owner and I are grateful to my wife,
Jane Turner, for calling our attention to the
up-to-date information concerning the Naples
picture that is available (through web links)
in the biography of Maso da San Friano on the
online version of *The Grove Dictionary of Art* – a
discovery that prompted a total reassessment
of the Cobbe Collection picture and its art-
historical significance.
5 See n.1 above.
6 Bertini 1994, pp.149–55.
7 Pronti 1988, no.61, repr.
8 See Robertson 1994 and the entries on
individual family members by Robertson and
Verellen in Turner (ed.) 1996, vol.10, pp.807–12.
9 *Cat. Farnese* 1994, p.59.
10 Ibid., p.100.
11 Adorni in Turner (ed.) 1996, vol.23, p.745.
12 Vasari/ed. de Vere, vol.2, p.879.
13 Borghini 1584/ed. Rosci 1967, pp.202, 539.
14 Archival documents in the church kindly
brought to our attention by M. Jean-Pierre Selz
of Paris, to whom we are grateful for the infor-
mation about the activities of Maso's father.
15 Letter of 27 June 2001 to the owner from
Giuseppe Bertini, to whom we are most grateful
for his helpful comments and minor corrections.
16 Pace 1976, fig.4.

The extraordinary importance of this sober, yet refined, portrait has only recently become apparent in the course of research for the present exhibition. The picture has long been associated with Maso da San Friano's earliest known surviving picture, the so-called *Portrait of Two Architects*, signed and dated 1556, formerly in the Galleria di Palazzo Venezia, Rome, and since 1978 in the Museo e Gallerie Nazionali di Capodimonte, Naples (cat.54a).[1] From the ground-plan drawn on the partly unrolled sheet of paper held in the Cobbe figure's right hand, it had generally been assumed that he, too, was an architect – although Alastair Laing (rightly, as it turns out) had always maintained pri-vately that the sitter's aristocratic appearance cast some doubt on such an identification.

The identity of the two 'architects' in the Palazzo Venezia picture had never been firmly established. How-ever, in 1991 Luisa Vertova tentatively suggested that they represented the deceased Florentine Renaissance architect Baccio d'Agnolo (1462–1543) and the youngest of his three sons, Domenico di Baccio d'Agnolo, also an architect. Vertova went on to propose that the Cobbe Collection picture also depicted Domenico di Baccio d'Agnolo, and it was sold as such by Sotheby's in 1998. When the picture was on the art market with Colnaghi's some years earlier (see Florence 1989), Donald Garstang, apparently the first to note the connection with the ex-Palazzo Venezia double portrait, had dated it a decade later (*c*.1565), on the basis of the sitter's costume.

There are several serious problems with the identifications proposed by Vertova, not least of which are the ages of the sitters, the disparity in the clothing of the two figures in the Naples double portrait, and the possible date of the Cobbe painting. The birth and death dates of Domenico di Baccio d'Agnolo are not known, but he must have been born around 1500 and cannot have lived long, for Giorgio Vasari (1511–74) stated that 'it is the common belief that, if he had not died so young, he would have surpassed by a great measure both his father and his brother Giuliano'.[2] Vasari – who claimed that Domenico was better at wood-carving than his brother and 'very ingenious in matters of architecture' – provided the precise death dates for both Baccio d'Agnolo (1543) and Giuliano di Baccio d'Agnolo (1555), thus implying that Domenico had died well before 1555.[3] Even if one assumes that the portraits were all three posthumous images – painted in the mid-1550s but intended as homages to honour architectural achievements from the 1530s or early 1540s – this does not explain the fact that the young man in the Cobbe portrait is obviously younger than the same sitter in the Naples painting. The sitter was clearly alive, and his likeness was captured by the artist at two different moments of his early adulthood!

That both pictures represent the same young man and that both are by Maso da San Friano is beyond dispute. Note the identical receding hairline, the same high cheekbones and profile, the long, straight nose, and what looks like the same gold ring with a black hardstone. For the correct identification of the young man in the present painting, one must turn to the latest scholarly opinion concerning the sitters in the Naples picture.[4]

Maso's double portrait of 1556 has a distinguished provenance. Recorded in the Palazzo Farnese, Rome, in 1644, its whereabouts can be traced without interruption thereafter, as it moved from one Farnese property to another (Palazzo del Giardino, Parma; Ducale Galleria of the Palazzo della Pilotta, Parma; Palazzo Reale, Naples; Palazzo di Capodimonte, Naples), was looted by the French,

Cat.54a Maso da San Friano, *Portrait of Ottavio Farnese, 2nd Duke of Parma and Piacenza, and Francesco de Marchi* (known as the '*Portrait of Two Architects*'), oil on panel, 43¾ × 34 in (115 × 90 cm), 1556 (Museo e Gallerie Nazionali di Capodimonte, Naples)

returned to Naples, was exhibited with the Bourbon collections in Palermo, again returned to Naples, then went to Rome, where it was exhibited in the Palazzo Venezia until 1978, when it finally rejoined the Farnese collections at the Museo e Gallerie Nazionali di Capodimonte, Naples.[5]

The earliest documented reference to the Capodimonte picture (1644) attributes it to Andrea del Sarto (1486–1530), but gives no clue as to the identity of the two figures portrayed. The very first mention of a name for one of the sitters occurs in 1725, when the painting (still attributed to del Sarto) was singled out among the 100 most famous paintings in the Ducale Galleria in the Palazzo della Pilotta, Parma. In this 1725 description, the young man on the right is identified as Ottavio Farnese (1524–86), 2nd Duke of Parma and Piacenza. In 1994 Giuseppe Bertini pursued this traditional identification,[6] remarking that the portrayal coincided perfectly with the age of Duke Ottavio in 1556 (31) and with a contemporary portrait of the Duke, attributed to Giulio Campi (*c.*1508–1573), in the Museo Civico, Piacenza.[7] He further proposed that older man shown with him was Francesco de Marchi (1504–77), a military architect in Ottavio's service throughout the War of Parma (1551–2).

Compared with the activities of other members of the Farnese family,[8] little is known about Ottavio as a patron or collector of art. He was greatly eclipsed both by his ambitious grandfather, Alessandro Farnese (1468–1549), who in 1534 was elected Pope Paul III (the great patron of Michelangelo who was also responsible for the large-scale urban restructuring of Rome that unearthed many of the great monuments of antiquity), and by his older brother, Cardinal Alessandro Farnese (1520–89), who became the most important private patron in mid-16th-century Rome (commissioning, among other things, the church of Il Gesù and the magnificent Palazzo Farnese in Rome, as well as the Villa Farnese at Caprarola). Even Ottavio's own son, Alessandro Farnese (1545–92), the only survivor of a set of twins, who succeeded as 3rd Duke of Parma and Piacenza in 1586, outshone him in political and military affairs, becoming the Catholic hero of the wars in the Low Countries.

The fortunes of the Farnese family were made entirely by Ottavio's grandfather, Pope Paul III. As a young cardinal in Rome, he had risen rapidly at the papal court, due in some measure to the fact that his sister Giulia was one of the mistresses of the Borgia pope Alexander VI (1431–1503). Alessandro Farnese's career prospered and he accumulated 16 bishoprics before succeeding as pope. Along the way, he fathered at least four illegitimate children, and for one of these, Pier Luigi Farnese (1503–47), he created in 1545 the new duchy of Parma and Piacenza. Two of Pier Luigi's four sons were made cardinals by their grandfather: the eldest, Cardinal Alessandro Farnese, already mentioned above, and the third son, Cardinal Ranuccio I Farnese (1530–65). Meanwhile the Pope arranged ambitious marriages for the other two sons. In 1538 the 13-year-old Ottavio was married to Margaret of Austria (1522–86), the illegitimate daughter of Emperor Charles V (1500–58) and the widow of Alessandro de' Medici (?1511–1537), while in 1552 the youngest son, Orazio Farnese (*c.*1531–53), was married to Diane de Valois, the illegitimate daughter of the French king Henry II (1519–59).

In 1547, when Ottavio was only 22, his violent-tempered father – a professional soldier who was later responsible for many military architectural projects – was murdered in Piacenza, only two years after he had become the 1st Duke of Parma and Piacenza. It took three years before Ottavio succeeded as 2nd Duke, and, not surprisingly, he moved the capital to Parma. It may have been in connection with this change in status in 1550 that the present portrait was commissioned. Ottavio would have been 25 years old, the artist a young man of 19 or 20. If there is an air of modesty or slight anxiety about the sitter's demeanour, it would not have been out of place. Not only had he inherited the title and duchy as a result of his father's murder, he had also acquired a rich and well-connected wife (half-sister of the Spanish monarch Philip II, who later appointed her Regent of the Netherlands) a year after her first husband was assassinated (within a few short months of their marriage).

In terms of the apparent age of the sitter in the Cobbe Collection portrait, a date of *c.*1550 or 1551

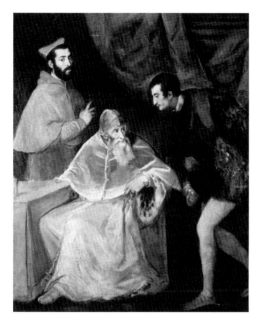

Cat.54b Titian, *Portrait of Pope Paul III and his Grandsons*, oil on canvas, 41¼ × 31¾ in (105 × 81 cm), 1546 (Museo e Gallerie Nazionali di Capodimonte, Naples)

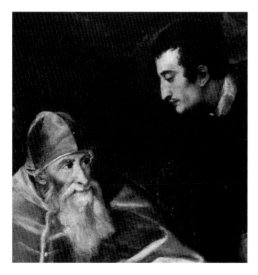

Cat.54c Detail of cat.54b

would seem appropriate. This would make it Maso's earliest surviving work by half a decade. Iconographically, it belongs midway between the earliest known depiction of Ottavio, on the right side of Titian's famous *Portrait of Paul III and his Grandsons* of 1546, also in the Capodimonte, Naples (cat.54b),[9] and Maso's double portrait of 1556. In the first, he is aged 21 (and already the victim of a receding hairline; cat.54c), while a decade later, the more elegantly dressed 31-year-old Duke, who seems to have grown in confidence and maturity, has added a beard and fuller hairstyle, perhaps to compensate for continuing losses at the hairline. In the double portrait he is shown holding an architect's compass, obviously deeply involved in the development of some architectural project. It was a normal part of a cultured Renaissance gentleman's education to have a general understanding of art and architecture, as well as the ability to draw, and, as Bertini pointed out in his article about the Capodimonte double portrait,[10] an understanding of military architecture and engineering was especially important for someone like Ottavio busy fighting wars to preserve his duchy. By 1558, within two years of this double portrait, work had begun on the Palazzo Farnese in Piacenza for Ottavio's wife, Margaret of Austria, designed jointly from 1556 by de Marchi and Francesco Paciotto (1521–91). Paciotto, another important military architect in Duke Ottavio's service, was also on confidential terms with his patron, as is demonstrated, for instance, in the 'scurrilous language' of his numerous letters to Ottavio, which were adorned with 'pornographic sketches'.[11]

What remains to be explained is how Maso da San Friano, a young Florentine painter, managed to land such a prestigious commission for an Emilian nobleman. Accounts of his initial training differ from one source to another, but it is always situated in Florence. According to Vasari (1550),[12] his teacher was the Florentine Pier Francesco Foschi [Toschi] (1502–67), also known as Pier Francesco di Jacopo di Sandro, who was himself a pupil of Andrea del Sarto. The style of both early portraits of Ottavio Farnese lends support to this tradition. Alternatively, in 1584 Raffaele Borghini (*c*.1537–1588) claimed that 'Tommaso Manzuoli' (the real name of Maso da San Friano) was the pupil of Carlo Portelli (before ?1510–1574), whose paintings Borghini considered inferior to those of his student.[13]

Maso may not have painted his portrait of Ottavio in Piacenza or Parma, but perhaps in Rome. The artist's father, Antonio Manzuoli, a mason and carpenter, was listed as a member of the Carpenters' Guild in Rome in 1544, 1546, 1552 and 1553. He must have taken his son with him some of the time, for there are bills dated 1563 from both father and son for a tabernacle in the Church of the Florentines in Rome.[14] Ottavio certainly went to Rome in 1556, though it is uncertain – as Bertini has kindly indicated[15] – that he would have been there between 1550 and 1556 since he was politically at odds with the papacy, which was trying to reclaim the duchy of Parma and Piacenza.

Maso da San Friano is today recognised as one of the principal exponents of a Tuscan revival in the late 1560s and the early 1570s of the proto-Mannerist styles of del Sarto and Jacopo Pontormo (1494–1556). At the height of his career, he was among the many artists who worked with Vasari on various Medici projects, including the famous *studiolo* of Francesco I de' Medici (1541–87) in the Palazzo Vecchio, Florence (1570–74). His formal state *Portrait of Francesco I de' Medici*, dated 1570 and now in the Sala del Consiglio, Museo Comunale, Prato,[16] illustrates the growing tendency in Florentine court portraiture towards a more naturalistic style in the third quarter of the 16th century. This trend – which seems already latent in the Cobbe portrait, except for the artificially enlarged hands – was no doubt a reaction to the refined elegance (the *maniera* style) that had dominated Florentine art during the two decades (1539–60) that Agnolo Bronzino (1503–72) was court painter to Cosimo I de' Medici (1519–74).

NT

ALESSANDRO ALLORI
Florence 1535–Florence 1607

Madonna and Child with St Catherine of Alexandria and St Francis of Assisi

Oil on canvas, 90¼ × 65¾ in (229 × 167 cm)
Mid-16th-century Venetian carved and gilt
'Sansovino' style frame (originally on Veronese's
Dream of Jacob)
INSCRIPTIONS on the frame, in black paint,
Venus & Adonis / Paolo / Veronese / Gallerie d'Orléans.
Cobbe Collection, no.358
HISTORY Cardinal Silvio Valenti Gonzaga
(1690–1756), Rome; by bequest to his nephew
Luigi Valenti Gonzaga (1725–1808), who sold his
uncle's villa (perhaps with some pictures still *in
situ*) to Cardinal Prospero Colonna (1707–65),
Rome; the villa and its contents possibly sold or
bequeathed to Agnese Colonna (1702–80) or to
her eldest son, Marcantonio IV Borghese (1730–
1800), Rome; possibly his son Camillo Borghese
(1777–1832), Rome, who in 1803 married Pauline
Bonaparte (1780–1825); the villa (and possibly
some of the former contents) definitely in her
possession *c*.1803–4, when it was known as the
Villa Paolina; some of the pictures from the villa
possibly sold by Camillo Borghese to Pauline's
brother Lucien; Lucien Bonaparte (1775–1840),
Prince of Canino, Rome; a portion of his collec-
tion of Old Master paintings given to or bought
by his mother, Mme Maria-Letizia Ramolino
Bonaparte (1750–1836), Rome; her collection of
paintings from Lucien Bonaparte bought in its
entirety by John Talbot (1791–1852), 16th Earl
of Shrewsbury, Alton Towers, Staffordshire;
the picture bequeathed by the Talbot family
(probably the 16th or 17th Earl of Shrewsbury)
to the Order of St Benedict, St Mary's Abbey,
Oulton, Stoke-on-Trent, Staffordshire; sale
[including property from St Mary's Abbey],
Christie's, London, 31 October 1980, lot 139
(to P. & D. Colnaghi and Co., London); offered
by them, unframed, at sale, Sotheby's, London,
3 July 1985, lot 11 (bought in); acquired when
re-offered at sale, Sotheby's, London, 29 October
1986, lot 26
LITERATURE Waagen 1837–9, vol.3, p.250;
Lecchini Giovannoni 1991, no.149, fig.350;
Laing/Cobbe 1992, pp.2, 12, no.302; London
1996b, pp.33–4, fig.27

The full name of the artist – Alessandro di
Cristofano di Lorenzo del Bronzino Allori
– reflects his parentage and his artistic
heritage. He was only five years old when
his father, Cristofano di Lorenzo, a sword-
maker, died in 1540, and he was adopted
by his father's friend, Agnolo Bronzino
(1503–72), in whose studio he trained. By the
age of 14 Allori was already an independent
assistant in Bronzino's workshop.

Both the patron of this fine altar-
piece by Allori and its original location are
unknown, but its relatively small size
would suggest a private chapel rather than
a place of more public devotion as its
destination. The style belongs to Allori's
middle Counter-Reformation period
(*c*.1580–90), when he increasingly adopted
the aesthetic values favoured during the
High Renaissance, then much championed
by his fellow Florentine painter Santi di
Tito (1536–1603). The picture also shows
the influence of Federico Barocci (*c*.1535–
1612), especially in the choice of the attractive young woman with a sweet expression to play the part
of the Madonna.

The same model frequently appears in other works by Allori, such as the figure of Mary in the
altarpiece of *Christ in the House of Martha and Mary* in the chapel of the Palazzo Portinari–Salviati (now
Banca Toscana) in Florence, painted in 1580.[1] This connection implies a date of around 1580 for the
Cobbe picture, an idea that receives further support from the fact that the pose of St Catherine is bor-
rowed from that of the Magdalen in the '*Noli me tangere*' (cat.55a), in one of the compartments of the
ceiling fresco in this same chapel.[2] Among the differences between the two figures are the angle of the
body, which is directed slightly further into space in the fresco, and the position of the arms and hands.

The Cobbe Collection picture is rich in *pentimenti*. In the figure of the Christ Child, for instance,
the upper edge of the left shoulder and the upper line of the arm and forearm have been altered, as
has the right profile of his left hand. The figure of the Madonna was reworked even more extensively:
in the upper hairline (extended by ½ in) and in her forehead (extended by ¼ in); in both hands; in
three different positions for the lower edge of the right forearm; and in the position of the belt
(lowered by 1¼ in). Further *pentimenti* occur in the Madonna's drapery and in the head and hands
of St Catherine, as well as in the figure of St Francis and in the architectural background.

The arrangement of the principal figures of the Madonna and Child, with Christ standing on her
lap and placing a garland of flowers on her head, proved to be one of Allori's most successful inventions.
The same grouping was featured alone in a number of painted variants by Allori, including examples
in the Hermitage, St Petersburg,[3] the Koninklijk Museum voor Schone Kunsten, Ghent,[4] the Museum
voor Schone Kunsten, Antwerp (this version including the figure of the young St John the Baptist at
lower right),[5] and a signed and dated version of 1586, formerly on the art market in London (cat.55b).[6]
The extensive changes in the figures of the Madonna and Child in the Cobbe picture and its date in

1 Ginori Lisci 1972, vol.1, p.475, fig.383.

2 Lecchini Giovannoni 1991, fig.146

3 Ibid., fig.347.

4 Ibid., fig.348.

5 Ibid., fig.349.

6 Ibid., fig.346.

7 M. Dunn in Turner (ed.) 1996, vol.26, p.775, fig.16.

8 Kiene 1992, p.75, fig.58.

9 Getty Provenance Index, inv.no. I-397 (*Inventario dei quadri, suppellettili, beni stabili e non*, 1756, Archivio Centrale dello Stato, Rome).

10 Manuscript catalogue dated 1760 in the Biblioteca Comunale, Mantua.

11 A. Wedgwood in Turner (ed.) 1996, vol.30, p.267; and Gardner 1998, p.126.

12 Waagen 1837–9, vol.3, p.249. Other pictures from the Earl of Shrewsbury's collection that may also have once been in the Valenti Gonzaga collection include the *Adoration of the Magi* by Garofalo (1481–1559), no.362 in the Valenti Gonzago inventory, and the pair of fruit still lives by 'Gobbo dai Frutti' (Pietro Paolo Bonzi, c.1576–1636), of which there were three examples in the Cardinal's collection (inv.nos 365–6 and 670).

13 Ibid., p.250.

14 Pignatti 1976, nos 243 and 245, both illus.

15 Ibid., no.248, illus.

16 Ibid., no.247, illus.

17 Ibid., no.252, illus.

18 Couché 1786–1808.

19 Ottley 1818.

Cat.55a Alessandro Allori, '*Noli me tangere*', fresco (1580), ceiling compartment (detail) in the chapel of the Palazzo Portinari–Salviati (now Banca Toscana), Florence

the early 1580s suggest that it was probably the point of departure for the other devotional variations.

The present painting is almost certainly the autograph composition that once belonged to the voracious collector Cardinal Silvio Valenti Gonzaga (1690–1756), who was elected cardinal in 1738 and Secretary of State in 1740. For his extensive art collections, the Cardinal had commissioned in 1728 a purpose-built villa in the area of Vigna Cicciaporci near Porta Pia in Rome; the villa, later known as the Villa Paolina (now the French embassy to the Holy See), included a gallery for the more than 800 pictures in his collection. Among the artists responsible for the villa was Giovanni Paolo Panini (1691–1765), who served as architect, designer, *tapissier* and general art 'expert'. He also recorded the Cardinal's collection in a number of works from different aspects, including the painting of 1749, *The Gallery of Cardinal Silvio Valenti Gonzaga* (Wadsworth Atheneum, Hartford, CT),[7] and a watercolour formerly on the Paris/London/New York art market with Didier Aaron (cat.55d).[8] In the latter, the Cobbe Allori appears as the centrepiece, as was spotted by Alastair Laing. It is not known whether the drawing – not previously connected with the Valenti Gonzaga collection – reflects an actual view in the villa or merely a proposed hang for the Cardinal's approval.

On the Cardinal's death in 1756, an inventory of the collection was made, in which the Cobbe painting by Allori features as item no.762 on fol.69: '*Quadro alto palmi 10., largo palmi 7., e mezzo, rappresentante la Vergine, col Bambino, che sta a sedere, in un Pilastro, in mezzo di due Colonne S. Francesco d'Assisi in ginocchio, e S. Caterina V., e M., in tela, di Alessandro Allori*'.[9] There is also a catalogue of the collections dating from 1760.[10] The Cardinal's estate was inherited by his nephew Luigi Valenti Gonzaga (1725–1808), who sold the villa to Cardinal Prospero Colonna (1707–65). Portions of the art collections were dispersed in two sales held in Amsterdam on 18 May and 28 September 1763.

Where the picture was for the next three-quarters of a century is not certain. It did not feature in either of the Amsterdam sales, and chances are strong that it never left Rome or possibly even the Valenti Gonzaga villa. By the early 1830s it was in the collection of John Talbot (1791–1852), 16th Earl of Shrewsbury, at Alton Towers, Staffordshire. During the 1820s, Talbot and his wife, both of whom were Roman Catholics, had lived alternately in England and Rome. Once he inherited the title from his uncle, Charles Talbot (1753–1827), 15th Earl of Shrewsbury, John Talbot continued the work started by him on the garden and house at Alton Towers, particularly the house, to which he added state apartments and a Roman Catholic chapel. From 1837 he was advised by A.W.N. Pugin (1812–52), whose Gothic Revival architectural and decorative work for the Roman Catholic Church he generously supported both at Alton Towers and elsewhere.

In Rome in 1829, the 16th Earl of Shrewsbury had purchased an entire collection of paintings from Mme Maria-Letizia Ramolino Bonaparte (1750–1836), the mother of Napoleon; *Madame Mère*, as she was also known, was the half-sister of the great art collector Cardinal Joseph Fesch (1763–1839), who settled permanently with her in Rome in 1815 (three years after he had lost his position following a quarrel with Emperor Napoleon). It is thought that most of the paintings in the 16th Earl's collection came from Mme Bonaparte and, furthermore, that the large group of paintings she sold to him had all come to her from her son Lucien Bonaparte (1775–1840), Napoleon's brother and another great collector of antiquities and paintings. (The residue of Mme Bonaparte's own personal collection of pictures – mostly family portraits by Jacques-Louis David (1748–1825) and François Gérard (1770–1837), etc – were left to Cardinal Fesch.).[11] Since the Allori does not feature either in the 1808 inventory of Lucien Bonaparte or in any of the famous sales of his pictures that took place in England in 1814, 1815 and 1816 in the galleries of William Buchanan, it could be that he replaced some of the pictures he had sold with new acquisitions made between 1816 and 1829 (when his mother sold pictures from him to the Earl of Shrewsbury). Lucien would not have been the first or the last collector to form a second collection after de-accessioning an earlier group of works.

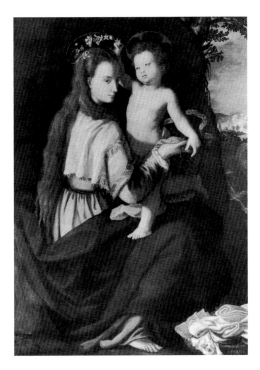

Cat.55b Alessandro Allori, *Madonna Crowned by the Christ Child with a Garland of Flowers*, oil on canvas, 39½ × 30⅜ in (100.5 × 77 cm), 1586 (formerly with P. & D. Colnaghi, London)

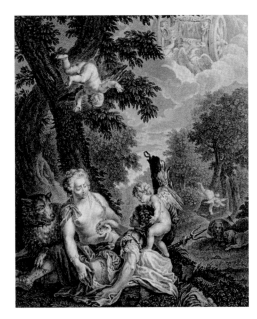

Cat.55c Charles-Emmanuel Patas after Veronese, *Dream of Jacob*, engraving from *Galerie du Palais royal* (Paris, 1786–1808)

In any case, the Bonaparte connection may still provide the clue for the possible whereabouts of the Cobbe Collection picture between the death of Cardinal Valenti Gonzaga in 1756 and the acquisition of the canvas by the 16th Earl of Shrewsbury in Rome in 1829. Valenti Gonzaga's villa came to be called the Villa Paolina because it was subsequently lived in by Pauline Bonaparte (1780–1825), Maria-Letizia's daughter and the sister of Napoleon and Lucien. Following her (second) marriage in 1803 to Prince Camillo Borghese (1775–1832), Pauline was also known as Paolina Borghese. Unfortunately, the marriage was not at all successful, there were no heirs, and Pauline returned to France after only a year. Although the marriage was not a happy union and effectively came to an end in 1804, Camillo continued to take advantage of the matrimonial connection to sell portions of his Borghese inheritance to members of her family. To ease his financial embarrassment in 1807, he sold the famous collection of Borghese antiquities to Napoleon, and perhaps some of the family pictures were later sold to Lucien (something his father, Marcantonio IV Borghese [1730–1800], had already done in 1800). One could well imagine Camillo's willingness to part with pictures from a villa that was no longer being enjoyed by his wife Pauline, while he concentrated his dwindling resources on the two principal family residences, the Palazzo Borghese and the Villa Borghese.

If the Allori did come to Lucien Bonaparte from Camillo Borghese, it is possible that the latter had acquired it along with the former Valenti Gonzaga villa, renamed after his wife, through his father, Marcantonio IV Borghese. Marcantonio IV was one of three sons of another Camillo Borghese (1693–1763) and Agnese Colonna (1702–80), the daughter of Fabrizio Colonna, Prince of Paliano. If one assumes some family connection between Agnese Colonna and Cardinal Prospero Colonna, perhaps through his father Francesco Colonna, then it is not inconceivable that on the death of Cardinal Prospero (to whom Luigi Valenti Gonzaga had sold the villa), his estate passed either to Agnese or directly to her eldest son, Marcantonio IV (then 35 years old). This hypothetical provenance – yet to be confirmed (owing to lack of time) – is cautiously presented in the 'HISTORY' section that accompanies this entry.

Returning from speculation to known facts, it was while the Cobbe painting was in the collection of the 16th Earl of Shrewsbury that it was noticed by the German art historian Gustav Waagen (1794–1868), then Director of the new Altes Museum in Berlin, who rated it among the 'higher works of art' in the collection.[12] Waagen recalled how 'accompanied by the ladies and the chaplain, I went to view the gallery of pictures'. Among the works by Florentine artists on which he remarked was the Allori, done 'in a clear tone, highly finished in the details'; but at the same time he considered it to be 'very affected: a proof of how low this master stood as an historical painter'.[13] Waagen's comments reflect the tastes of the period, when devoutly religious paintings by Italian late Mannerist artists such as Allori were out of favour with European connoisseurs and collectors.

Whether or not Waagen's rather disparaging views were taken seriously by his contemporaries, it is known that the picture and other religious paintings from Alton Towers were subsequently bequeathed by the Talbot family to the nearby Order of St Benedict, St Mary's Abbey, Oulton, Stoke-on-Trent, Staffordshire. The Allori painting remained at the Roman Catholic abbey, which was designed in 1853–4 by the 19-year-old E.W. Pugin (1834–75), carrying out a commission from the late Earl to his late father, A.W.N. Pugin – both of whom had died in 1852. In 1980 the present picture and various others formerly at Alton Towers and St Mary's Abbey were sold on behalf of the Order at Christie's, London.

The Allori's magnificent, Venetian 'Sansovino' frame, which must date from the late 16th century, was added to the picture by Alec Cobbe following its acquisition in 1986. In spite of their difference of subject-matter, the inscription on the frame (*Venus & Adonis / Paolo / Veronese / Gallerie d'Orléans*) was once thought to refer to one of the two paintings by Veronese formerly in the collection of the Duc

Cat.55d Giovanni Paolo Panini, *The Gallery of Cardinal Silvio Valenti Gonzaga*, watercolour (present whereabouts unknown)

cat. 55d

d'Orléans (1747–93) and now in the Frick Collection, New York, the *Allegory of Wisdom and Strength* and the *Allegory of Virtue and Vice (The Choice of Hercules)*, both of which are upright compositions.[14] The Frick Collection pair were among several grandly conceived mythological paintings commissioned from Veronese by Emperor Rudolf II (1552–1612), which also included the *Mars and Venus* in the Metropolitan Museum of Art, New York,[15] and the *Mercury, Herse and Aglauros* in the Fitzwilliam Museum, Cambridge.[16] But as Alec Cobbe has recently discovered, the picture to which the title-placard on the present frame seems to refer is the *Venus and the Dying Adonis with Cupids* by Veronese and studio, a picture now in the Nationalmuseum, Stockholm, that was originally upright but was trimmed at the top to its present format (56 ¼ × 68 ⅛ in [145 × 173 cm]).[17] Its original appearance while still in the Orléans Collection, full-size (cat.55c), is preserved in an engraving by Charles-Emmanuel Patas (1744–1802) published in the *Galerie du Palais royal* (Paris, 1786–1808).[18] Within a decade of the completion of the latter publication, the picture had already been cut down, as is clear from the reproductive print in William Young Ottley's four-volume series of facsimile prints after pictures in the Stafford Gallery (London, 1818).[19]

NT

56

NICOLAS POUSSIN
Les Andelys 1594–Rome 1665

The Lamentation

Oil on canvas, 17 5/8 × 13 5/8 in (44.5 × 34.5 cm)
INSCRIPTIONS on the reverse, on the lining
canvas, inscribed in red paint, *17*
Cobbe Collection, no.363
HISTORY sale, Sotheby's, Billingshurst, 26
October 1987, lot 194 (as attributed to Paul Troga
[*sic*]; bought in); acquired by private treaty,
December 1987

1 See Blunt 1966, no.71; Thuillier 1974, no.147;
Wright 1985, no.132; Mérot 1990, no.70;
Thuillier 1994, no.170; and Paris 1994–5, no.172.
2 Poussin/ed. du Colombier 1929, no.135
(13 Sept.1648), p.253, and no.138 (19 Dec. 1648),
p.257.
3 See Blunt 1966, no.88; Thuillier 1974, no.134;
Wright 1985, no.132; Mérot 1990, no.70; and
Thuillier 1994, no.154. Poussin had made no
difficulties over accepting this commission, but
two years later he wrote: 'I swore that I would
not undertake anything so small [again] (this
little work having appreciably troubled my
sight)' (Poussin/ed. du Colombier 1929,
no.103 [20 August 1645], p.194).
4 Thuillier 1974, nos 218–21; Rome 1977–8,
nos 43–5; Wright 1985, nos 192–5; Mérot 1990,
nos 53, 55, 83 and 84; Thuillier 1994, nos 208,
209, 224 and 225; and Paris 1994–5, nos 215–17.
5 Pierre Rosenberg (Paris 1994–5, *sub* no.215)
speculates that the lost *Lamentation* might, like
the *Noli me tangere*, have found its way to Spain,
but, unlike that picture, it was not recorded at
La Granja in 1746. What may have been it,
described as *Our Saviour taken down from the Cross*
and as measuring 15 × 20 ½ inches, was lot 125 on
the third day of Robert Strange's sale, Christie's,
London, 7–9 February 1771 (bought by Mr Stuart
for £42). For this to have been so, however,
the measurements would have to have been
transposed, and the foreground extended
(as Pietro del Po's print of the *Noli me tangere*
appears to show that it was, at that point). It
might only have been a copy, on the other hand,
since an *Annunciation* ascribed to Poussin, with
the improbable-sounding measurements of
20½ × 10½ inches (supporting the idea that the
measurements of the *Deposed Christ* were trans-
posed, and assuming that a typo substituted a
'0' for a '5' in the width), was lot 88 on the second
day of his sale.
6 Oberhuber 1988, no.40; Thuillier 1994, no.88;
Jerusalem 1999, pp.27–8 and figs 17 and 19.
7 Standring 1985, pp.614–17; Oberhuber 1988,
no.39; Mérot 1990, no.77; and Thuillier 1994,
no.27. A third autograph version, on canvas,
formerly in the collection of Sir Anthony Blunt,
who dismissed it as a copy, is currently on the
London art market.

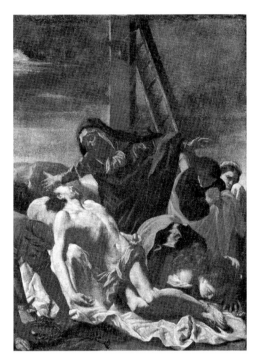

Some 20 years later than this little picture would
have been painted, Poussin wrote to Jean Fréart
de Chantelou, known as Chantelou *l'aîné*, to tell
him that he had finished and sent via Paul Fréart
de Chantelou (his younger brother, and Poussin's
habitual correspondent) a little picture of *The
Baptism of Christ*[1] that Chantelou *l'aîné* had asked
him to paint some three years before. Initially,
he had been very reluctant to undertake the com-
mission, having 'reflected upon the little room
that [he] had to depict so great a subject, and ... at
the same time considered the weakness of [his]
eyesight, and the infirmity of [his] hand ...'. How-
ever, once Chantelou had written to express his
delight on receipt of the little painting, Poussin
wrote again, to say: 'I have dedicated it to you only
after the fashion of Michel de Montaigne: not
because it is good, but as the best that I could do'.[2]

Nonetheless, five years earlier (and it was this
that had prompted Jean Fréart de Chantelou's
request), in 1643, Poussin had painted a small-
scale *Ecstasy of St Paul* for Paul Fréart de Chantelou himself (Ringling Museum of Art, Sarasota),[3] as
a pendant to a version that the latter owned of Raphael's *Vision of Ezechiel*; and a decade later he was
to paint for Jean Pointel (or for him and another client) four small panels of just two-figure or three-
figure subjects from the New Testament (two now in the Bayerische Gemäldesammlungen, one in
the Prado, and one still lost).[4] One of these (the lost picture, known, however, from prints by Pietro
del Po and an anonymous engraver, and from two good, early copies) was, like the present picture,
of a *Lamentation*, albeit one reduced simply to the figures of the dead Christ, the Virgin, and St John
(with a fourth figure half-glimpsed at the entrance to the tomb).[5]

In these, later, pictures it is evident that Poussin sought to compensate for the difficulty in
portraying facial expression on a small scale, occasioned by the 'infirmity' of his hand, by reducing
the *dramatis personae* to a minimum, and by making them take up most of the picture-space. Much
earlier in his career, however, around 1630, when he painted the two small variant coppers of the
Agony in the Garden for Cardinal Francesco Barberini (private collection, Paris, on loan to the National
Gallery, London)[6] and his secretary Cassiano del Pozzo (formerly with Wildenstein, New York),[7]
he was under no such constraints. Nonetheless, these two pictures, themselves both rediscovered
only recently, appeared to have been unique in Poussin's oeuvre, in terms of both support and
format, with the former conditioning the latter. A small whole-figure painting on canvas might
seem, not just unique, but implausible. After all, even when painting a *modello*, that for the
Martyrdom of St Erasmus (National Gallery of Canada, Ottawa),[8] did not Poussin employ a full-size
canvas (39 ¼ × 29 ¼ in [100 × 74.5 cm])?

However, as these two coppers themselves indicate, at the outset of his career Poussin was much
more at the bidding of his clients than in later years, when, even so, he was prepared to depart
from his usual practices for those whom he also regarded as friends. It is surely no coincidence that
his *Pietà* (Musée Thomas Henry, Cherbourg; cat.56a)[9] and his *Madonna and Child* (Preston Manor,
Brighton,[10] exceptional in being paired ovals of less than complete figures, also on a small scale

8 Blunt 1966, no.98; Thuillier 1974, no.53; Wright 1985, no.27; Mérot 1990, no.90; Thuillier 1994, no.68; Paris 1994–5, no.27; and Jerusalem 1999, no.37.

9 Blunt 1966, no.81; Thuillier 1974, no.20; Rome 1977–8, no.7; Wright 1985, no.8; Oberhuber 1988, no.25; Mérot 1990, no.80; Thuillier 1994, no.41; and Jerusalem 1999, no.17.

10 Wright 1974, pp.755–6; Rome 1977–8, no.8; Wright 1985, no.9; Oberhuber 1988, no.26; Mérot 1990, no.34; Thuillier 1994, no.40; and Jerusalem 1999, no.16.

(23 × 19 ½ in [58.5 × 49.5 cm]), and in being set in garlands of flowers painted by another hand, Daniel Seghers (1590–1661), should also apparently have been painted for Cardinal Francesco Barberini, but then have passed into the hands of Cassiano del Pozzo. Then there is the unique pair of gouaches of *Putti Bacchanals* (Galleria Nazionale d'Arte Antica, Palazzo Barberini, Rome),[11] painted very soon after his arrival in Rome in 1624. And even in oil on canvas, there are, on a smaller scale (albeit not so small as that of the present picture), the *Midas at the Source of the Pactolus* (Musée Fesch, Ajaccio; 19¾ × 26 in [50 × 66 cm])[12] that he painted for the dealer Stefano Roccatagliata; and the *Mercury, Herse and Aglaurus* (Ecole Nationale Supérieure des Beaux-Arts, Paris; 21 × 30 ¼ in [53 × 77 cm]),[13] of unknown origin.

One can only speculate as to why Poussin might have painted such an unwontedly small-scale canvas as the present *Lamentation*, and for whom. It does not have the air of being a *modello* for something else. Rather it has the character of an image intended for private devotion – particularly through the way in which the stark, geometric elements of the foot of the Cross and the ladder are placed

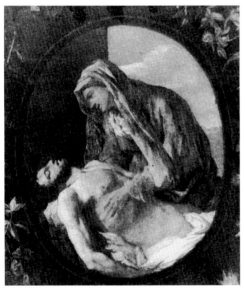

cat. 56a

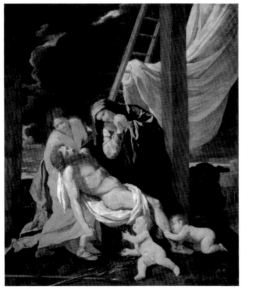

cat. 56b

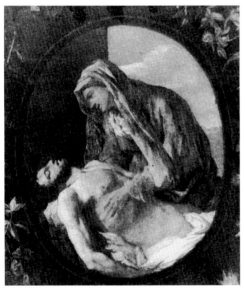

cat.56 c

Cat.56a Nicolas Poussin, *Pietà*, oil on canvas, 22⅝ × 19⅛ in (57.5 × 48.5 cm), *c*.1626 (Musée Thomas-Henry, Cherbourg)

Cat.56b Nicolas Poussin, *Lamentation*, oil on canvas, 47½ × 39 in (120.5 × 99 cm), *c*.1626 (Hermitage Museum, St Petersburg)

Cat.56c Michelangelo, *Pietà*, marble, h.1.14 m, 1497–1500 (St Peter's, Rome)

behind the group of figures, so as to situate this Lamentation in the contemplative sequence of events, immediately after the Crucifixion and Deposition (the former, interestingly, a subject that Poussin tackled but once, and the latter never at all; whereas three other Lamentations by him are known).

That the picture belongs early in Poussin's career emerges from comparisons with the aforementioned *Pietà* in Cherbourg – for which Seghers's departure from Rome in 1627 provides a *terminus ante quem* – and with the two early *Lamentations*: one (which first suggested the attribution of the picture under discussion to Alec Cobbe), in the Hermitage, St Petersburg (cat.56b),[14] datable close in time to the *Pietà*; and the other in the Alte Pinakothek, Munich, most commonly dated a little later, to 1628/29.[15] The present picture is closer to the *Lamentation* in the Hermitage than to the one in Munich, in terms of both the moment represented (at the foot of the Cross [i.e. immediately after the Deposition] rather than at the mouth of the tomb [i.e. just before the Entombment]) and the starkness of the representation and simplicity of the handling. The Cobbe picture lacks, however, the Venetian-inspired richness of tone, and finely gathered drapery, even of the St Petersburg picture. It recalls more of the handling of the picture with the dead body in which that of the Hermitage *Lamentation* is often compared – the yet earlier *Venus Tending the Dead Adonis* (Musée des Beaux-Arts,

Cat.56d French School, *Entombment Group*, marble, early 16th century (church of Notre-Dame-des-Andelys, Les Andelys)

11 Blunt 1966, nos 192–3; Thuillier 1974, nos 27–8; Rome 1977–8, nos 3–4; Wright 1985, nos 47–8; Oberhuber 1988, nos 56–7; Mérot 1990, nos 174–5; Thuillier 1994, nos 36–7; and Jerusalem 1999, nos 10–11.

12 Blunt 1966, no.166; Thuillier 1974, no.36; Rome 1977–8, no.12; Wright 1985, no.10; Oberhuber 1988, no.34; Mérot 1990, no.151; Thuillier 1994, no.48; and Jerusalem 1999, no.23.

13 Blunt 1966, no.164; Thuillier 1974, no. B13 (as doubtful); Rome 1977–8, no.6; Wright 1985, no. A26 (as uncertain); Oberhuber 1988, no.38; Mérot 1990, no.150; and Thuillier 1994, no.29.

14 Blunt 1966, no.80; Thuillier 1974, no.17; Wright 1985, no.19; Mérot 1990, no.79; and Thuillier 1994, no.39. For a good colour reproduction, see Leningrad 1990a, vol.1, pl.34, and Leningrad 1990b, no.7 (with a catalogue entry by Nadezhda Petrusevich).

15 Blunt 1966, no.82; Thuillier 1974, no.18; Wright 1985, no.40; Oberhuber 1988, no.64; Mérot 1990, no.81; Thuillier 1994, no.38; and Paris 1994–5, no.12.

16 Blunt, 1966, no.186; Thuillier, 1974, no.19; Rome 1977–8, no.14; Wright 1985, no.13; Oberhuber 1988, no.33; Mérot 1990, no.161; Thuillier 1994, no.26; Paris 1994–5, no.17; and Jerusalem 1999, no.25.

17 Mahon 1965, pp.196–205; Thuillier 1974, no. B18; Wright 1985, no.32; Oberhuber 1988, no.42; Mérot 1990, no.4; Thuillier 1994, no. B13; London 1995, no.5; and Jerusalem 1999, no.26.

18 For the little that appears to be known about the history of this sculpture, see de Ruville 1863, vol.1, p.431, partly quoting Millin 1792, vol.4, p.8.

19 Forsyth 1970, p.152 and fig.243.

20 Schnapper 1974, nos 122, 126, 142 and 143. For the 1709 picture in Toledo, see Rochester 1987, no.28, with earlier bibliography. One of the apparently autograph or at least studio replicas of this composition is in the Högalids church in Stockholm, where it was, until seen by the present writer, attributed to Piazzetta!

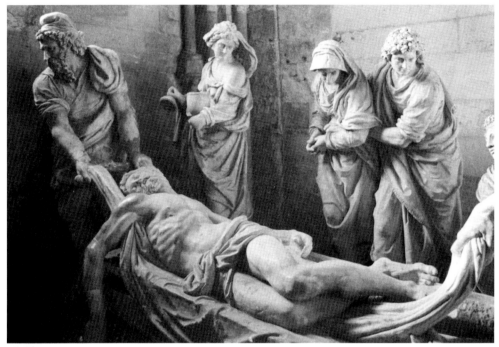

cat. 56d

Caen),[16] and the latterly rediscovered *Eliezer and Rebecca* (private collection).[17] It must, however, be remembered that all these pictures are on a substantially bigger scale than the present one, and that (as in the two small coppers of the *Agony in the Garden*) Poussin will have had to modulate his handling to work on this smaller scale, particularly for a devotional image in which the character and role of each participant needed to be lucidly and soberly expressed.

Sir Denis Mahon, who has examined this picture for himself (August 2001) and fully accepts it as an autograph work by Poussin, would date it to 1625 – in other words to the year after Poussin's arrival in Rome, for nine months of which two of his key early patrons, Cassiano del Pozzo and Cardinal Francesco Barberini, were absent on a mission to Paris. It seems to have been during this period that Poussin's ability to earn a living was seriously compromised by illness; that he painted at least three battle-paintings, two of which (probably those now in the Hermitage and in the Pushkin Museum) he was forced to sell for a mere 7 *scudi* apiece; and that he wrote to Cassiano (presumably on the latter's return) to say that he was desperately short of money. Sir Denis further draws attention, in the third known battle-painting of this period, the *Battle of Gideon with the Midianites* (Pinacoteca dei Musei Vaticani, Rome), to the bodies of the two dead and half-naked combatants towards the bottom left of the painting, the uppermost of which, in its torsion, colouring and lighting, has many affinities with that of the dead Christ in the present *Lamentation*.

The expressive contortion of the body of Christ's body is taken even further – above all in the bold distortion of his half turned-away head – to such a baroque degree, that at one point the picture attracted an attribution to Paul Troger (1698–1762)! It is, however, precisely this feature that provides further grounds for dating this picture to very soon after Poussin's arrival in Rome, when images of his native land were still fresh in his memory. For, in all but the turned-away head, it is strikingly reminiscent of the dead Christ in the early 16th-century sculpted *Entombment Group* now in the church of Notre-Dame-des-Andelys (cat.56d).[18] Described by William Forsyth as 'the most dramatic of all

French monumental Entombments',[19] this was in Poussin's day not in the church of Notre-Dame, but was an object of veneration in the Chartreuse de Gaillon nearby: Poussin cannot have failed to know it. And, as if this reminiscence of a sacred image – and an impressive work of art – from near his native town were not enough, the white cliffs that seem to accentuate the chill of the dawn light spreading above them, also seem to recall those that rise above the Seine at Les Andelys.

Timothy Clifford (orally) has also pointed to a striking early indication of the impact of Rome on Poussin, in the shape of reminiscences of Michelangelo's celebrated *Pietà* in St Peter's (cat.56c), above all, in the way in which Christ's head is flung back (albeit here facing away), his limp arm is remote from his body, and in the way in which the heavily-draped body of the Virgin is brought into close relation with the body of her son. Finally, there is an echo of this *Lamentation* in a composition that dates from many years after its creation, which also seems to anchor it in the soil of Normandy: what seem to be reminiscences of it can be detected in the many treatments of the *Deposition and Lamentation* by his fellow-Norman and great admirer, Jean Jouvenet (1644–1717; his first, exhibited in the Salon of 1704, is lost; but there is a signed and dated version of 1708 in St Maclou, Pontoise, and another of 1709 in the Toledo Museum of Art; along with many repetitions by the artist and his studio).[20]
ADL

57

GIOVANNI FRANCESCO BARBIERI, CALLED IL GUERCINO
Cento 1591–Bologna 1666

Semiramis at her 'Toilette' Receiving the News of the Revolt of Babylon

Oil on canvas, 50½ × 60½ in (128.5 × 153.5 cm)
INSCRIPTIONS on the reverse, on lining canvas:
inscribed in white chalk, 69
Cobbe Collection, no.353
HISTORY painted for Cardinal Federigo
Cornaro as an overdoor for the Palazzo Cornaro,
Rome (the artist's account book documents a
payment of 150 ducats on 22 December 1645); by
descent in the Palazzo Cornaro, Rome; possibly
identical with one or two versions of Guercino's
Semiramis sold in London around the turn of the
19th century: (1) that included in a sale ['A cata-
logue of the Genuine and Capital Collection of
Pictures Formed by a Gentleman during his
Residence Abroad, and who is returning to the
Continent', containing pictures acquired in
Rome by James Irvine (?1759–1831) and Orlando
Manley], Christie's, London, 24 March 1792, lot
106 (bought by 'Fagan' for 44 guineas); the
dealer Robert Fagan; his sale, Christie's,
London, 1 June 1801, lot 66 (to Charles Birch for
15 guineas); OR (2) that offered for sale [the prop-
erty of George Graves], Christie's, London, 6–7
May 1803, lot 31 (bought in for 105 guineas);
re-offered [presumably by George Graves again]
at sale, Peter Cox, London, 4 June 1812, lot 39
(bought in for 98 guineas); private collection,
Scotland; from which purchased by the dealer
Rafael Valls, London; acquired at sale, Christie's,
London, 25 October 1985, lot 241
LITERATURE Malvasia 1678, vol.3, p.374;
Malvasia 1841, vol.2, p.266; Salerno 1988, p.301,
sub no.227 (as copy after Guercino); Laing/Cobbe
1992, p.18, no.325, illus.

1 Salerno 1988, no.102, illus.
2 Ibid., no.121, illus.
3 Mahon 1949, pp.217–23.
4 Salerno 1988, no.227, illus.
5 Collins Baker 1920, p.52, no.155.

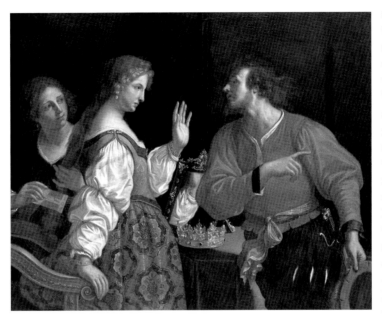

Semiramis was one of
the mythical founders
of the Assyrian empire
of Nineveh, and a
woman of surpassing
beauty. She was the
daughter of the fish-
goddess Derceto, by
a Syrian youth, and
was abandoned by her
mother in the wild as
an infant. Miraculously
kept alive by doves
until her discovery by
shepherds, she was
adopted by the family
of Simmas, chief shep-
herd of the royal herds,
whose name she took.

The incident of Semiramis being interrupted at her '*toilette*' by a messenger announcing the
revolt of Babylon is told by the Roman moralist Valerius Maximus (*fl*.AD 14). According to his unique
report of the event (Valerius Maximus, IX, p.3, ext.4), so concerned was she at the news of the rebel-
lion that she ran out immediately to try to put matters to rights, before she had even finished her
coiffure ('*nec prius decorem capillorum in ordinem*' ['not even putting the decoration of her hair in order
beforehand']). In Valerius Maximus' text, the Semiramis story appears under the heading '*De Ira
aut Odio*' ('Of Anger or Hatred'), presumably as an instance of anger. Later commentators, however,
interpreted her response as an embodiment of virtue. Here was a woman who took prompt action,
despite her preoccupation with a routine that is thought sacrosanct even today. Guercino's represen-
tation implies such an interpretation. His protagonist gives a start, but remains fundamentally
composed. The seriousness of her predicament is conveyed by her facial expression and by her rising
up from her seat and lifting her hand in dismay.

Guercino painted three half-length pictures of Semiramis at her '*toilette*': one in 1624, now in
the Museum of Fine Arts, Boston;[1] another of *c*.1627–8, formerly in the Dresden Gallery, destroyed in
1945;[2] and the third, commissioned in 1645 by Cardinal Federigo Cornaro (1579–1653). In an article
entitled 'Guercino's Paintings of Semiramis' published in 1949,[3] (Sir) Denis Mahon discussed all
three compositions, proposing the picture formerly in the collection of the Earl of Northbrook as
Guercino's 1645 picture painted for Cardinal Cornaro.[4] The ex-Northbrook canvas (cat.57a) has not
been seen since its sale in 1919 (Christie's, London, 12 December, lot 126), and at the time of Sir Denis's
article the Cobbe Collection picture – which appeared in a sale only in 1985 (London, Christie's, 25
October, lot 241) – was still unknown. Thus the only version of the composition seen by Sir Denis
in the flesh was yet a third version, at Petworth House, Sussex (cat.57b), where it has been since the
beginning of the 19th century.[5] At the time Sir Denis examined the Petworth version in the late 1940s,
it was so obscured by heavily discoloured varnish layers that it led him to conclude that it was simply
an old, studio copy. When the Cobbe Collection painting surfaced in the mid-1980s, it turned out to
be identical in design to both the ex-Northbrook and Petworth pictures, except in some minor details,
which vary between the three versions. In preparation for the present publication and exhibition,

Cat.57a ? Guercino, *Semiramis at her 'Toilette' Receiving the News of the Revolt of Babylon*, oil on canvas, 45 ½ × 60 ½ in (116 × 154 cm) (ex-collection of the Earl of Northbrook)

Cat.57b ?Bartolommeo Gennari after Guercino, *Semiramis at her 'Toilette' Receiving the News of the Revolt of Babylon*, oil on canvas, 51 × 62 in (129.5 × 157.5 cm), *c.*1645–6 (Petworth House, Sussex)

both the Cobbe and Petworth pictures were cleaned and revarnished. A close comparison between the two works was carried out, and tiny paint samples were taken from both and analysed.

In spite of surface abrasion in some areas of the present painting – such as in the orange jerkin worn by the messenger – the superlative painting of other passages, such as the face of Semiramis, her upper garment and sleeve, the head and hand of her maidservant and the head and sash of the messenger (see details, pp.216–18), make it clear that it can only be by Guercino himself. Having inspected it in April 2001 after its recent cleaning, Sir Denis is also enthusiastically of the opinion that the Cobbe picture rather than the ex-Northbrook picture is Guercino's original.

cat. 57a

cat. 57b

Cat.57c Guercino, *Semiramis at her 'Toilette'*
Receiving the News of the Revolt of Babylon, pen and
brown ink, 6⅞×9¾ in (175×249 mm), *c*.1645
(Royal Library, Windsor Castle)

6 For a summary of Paolo Antonio's activity,
see Bagni 1986, pp.287–94.

7 Other examples include details in the following
eight works: the flowers in the floral crown of
the angel and the basket of bread in *St Francesca
Romana* (1638), S Maria in Organo, Verona; the
crown jewellery and some of the costume in
Esther before Ahasuerus (1639), the University
of Michigan Museum of Art, Ann Arbor, MI;
the flowers, including those in the floral crown
on the figure's head, in the *Flora* (1642),
Federazione dei Consorzi Agrari, Palazzo
Pallavicini Rospigliosi, Rome; the flowers scat-
tered by putti from the heavens in the *Madonna
del Rosario* (1642), S Marco, Osimo; the floral
crown in the *Sts Gertrude and Lucrezia* (1645),
Galleria Sabauda, Turin; Saul's crown and spear
and David's harp in *Saul Attempting to Kill David
with a Lance* (1646), Galleria Nazionale d'Arte
Antica, Rome; the bishop's mitre and crozier in
the foreground of the *Madonna and Child with St
Bruno* (1647), Pinacoteca Nazionale, Bologna;
and the flowers on the floral staff held by the
saint in the *St Joseph* (1649), Pinacoteca
Nazionale, Bologna, which is presumably
among the last of his interventions (Salerno
1988, nos 173, 180, 200, 202, 225, 228bis, 241
and 259 respectively, all illus.).

Although there are no major *pentimenti*, their absence is a feature of pictures by Guercino from the
1640s onwards, when the salient outlines of a given composition were carefully worked out before-
hand in sequences of drawings. Nevertheless, numerous minor changes are to be found, showing
that the creator of the composition was also the painter who worked on the canvas, arriving at fresh
insights as to possible improvements with his brush and palette in hand. Among the adjustments
that Guercino made while he was engaged on painting the Cobbe picture are those to the right hand
of the maidservant, which has been shifted slightly to the right, and to the thumb of the left hand
of the messenger, which has been re-sited upwards. There are further minor modifications to the
profiles, most notably at the forehead and chin of the maidservant and at the forehead of Semiramis.
Moreover, the left profile of her left thumb has been shifted, as too has the upper edge of the arm of
the chair.

Equally clear from the Cobbe picture is the intervention of Guercino's younger brother Paolo
Antonio Barbieri (1603–49) in the painting of the ornament. Having joined Guercino's studio early
in his youth, Paolo Antonio seems to have first worked for his brother on routine tasks, finally taking
responsibility for painting the sections of still life and ornament in the 1630s.[6] He was also the studious
keeper of Guercino's accounts (the '*esatto Economo*', as he is called by Guercino's biographer Count
Carlo Cesare Malvasia [1616–93]), maintaining them in good order from 1629 until his death, aged
46, in 1649. In this same account book, Paolo Antonio also kept a record of payments that he himself
received for the 50 or so autonomous still-lifes that he painted.

The extent of Paolo Antonio's contribution to Guercino's pictures during the 1630s and 1640s
remains to be fully defined. What is beyond doubt is that his precise, full-bodied brushwork, which
is very often seen in such foreground details as flowers, costume decoration, jewellery and the like,
provided a pleasing contrast in texture to the more thinly painted, luminous passages of the rest of
the canvas, which were painted by the master himself. The collaboration seems to have been fully
underway by the late 1630s, when Paolo Antonio's intervention can readily be observed in numerous
works by the master.[7]

The decorative details by Paolo Antonio in the present picture, which are strikingly different in
treatment from the rest of the canvas, are nonetheless exquisitely wrought, as is shown by a glance
at the magnificent golden crown. His handiwork may also be seen in the mirror-stand, with its finely
ornamented frame and leg; in the decoration of the side of the scroll-shaped chair arm; the gem-
studded crown as well as the jewellery Semiramis wears – comprising two bracelets, a brooch and a
clasp at the shoulder of her bodice. The snarling lion's head surmounting the handle of the sword,
however, can only be by Guercino himself.

Taken together, Guercino's three autograph compositions of *Semiramis* from 1624, *c*.1627–8
and 1645 demonstrate the artist's change in style over a 20-year period - from his robust, sombrely
coloured naturalism to a staid, elegant classicism. Interestingly, many of the 'props' in the three
pictures are the same, such as the double-edged comb, '*all'antica*', held by the maidservant, and the
throne-like chair with scrolled arms at which Semiramis is seated. Also unvaried is the quota of
figures: two half-lengths (Semiramis and the messenger) and one head-and-shoulders (the maid-
servant). The different way in which this repertoire is orchestrated in each reveals the artist's chang-
ing outlook. The *Semiramis* painted in 1645 for Cardinal Cornaro is, of course, the most classical, with
the protagonists directly face-to-face, in profile, their bodies parallel to the picture plane. To reinforce
the frieze-like arrangement of the figures, Guercino has also located some of his stage properties
along the same axis, such as Semiramis's throne and the brim of the messenger's hat, while Semiramis's
crown confronts the viewer 'head on' in the centre of the space. In a well-calculated conceit, the
crown is placed dangerously close to the edge of the dressing-table, as if it could fall off at any moment.

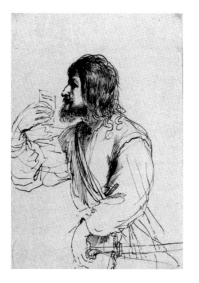

Cat.57d 'School of Guercino', *Study for the Figure of a Messenger*, pen and brown ink, 9³⁄₁₆×6 in (234×153 mm), *c.*1645 (Royal Library, Windsor Castle)

8 Oral communication to Alec Cobbe, March 2001.
9 Edinburgh, London and Vienna, 1978–9, no.33, illus.
10 Inv.nos 2575 and 2877; Mahon and Turner1989, nos114 and 434.
11 An impressions of the print filed with he 'Prints after paintings' in the Master Series in the Department of Prints and Drawings, British Museum, London.

Yet it is the symmetrical disposition of so many of the principal forms that allows other elements placed at an angle to the main picture plane to resonate in a way that they would not otherwise have done. This is true of the mirror, with its beautifully painted reflection of Semiramis's wrist and sleeve, and the corner folds of the azure cloth covering the dressing-table on which both it and the crown stand.

The reasons for the pronounced classical bias of Guercino's later picture are complex and many. The tendency first emerged in his work around the mid-1620s, partly in deference to the success of the style of his Bolognese rivals, principally Domenichino (1581–1641) and Guido Reni (1575–1642). It was the latter's work that affected him more deeply during his mid-career: older than Guercino by several years, Reni enjoyed a towering reputation, and the younger painter must have grown tired at having to play second fiddle to him. In 1642, Guercino moved from his native Cento, where he had been settled for nearly 20 years, to Bologna, in order to avoid the fighting of the War of Castro that was then raging nearby. When Reni died within weeks of Guercino's arrival, the latter decided to remain in Bologna, purchasing there two years later the family house, subsequently known (after his nephew's family) as the Casa Gennari.

The Cornaro *Semiramis* was therefore painted only three years after Guercino's transfer to Bologna. Not surprisingly, the reminiscences of Guido's work are potent – from Semiramis's physical type, with her golden blond hair and classical profile, to the turn of the head and demure expression of her tranquil maidservant; the flesh-painting in Semiramis's face, in particular, is uncannily redolent of the older artist's handling. Also unthinkable without Reni's model is the beautiful colouring of Semiramis's costume – her light pink bodice, with its ultramarine border, her pure white blouse with its light purple and yellow striped sleeves, and her skirts brocaded in gold and blue. From elsewhere, however, comes the inspiration for the pose of the messenger. As Julius Bryant has acutely observed,[8] this figure's action, except for the placement of his right arm, is reminiscent of the famous bronze *Mercury* by the Flemish-born Florentine Mannerist sculptor Giambologna (1529-1608), which was known then, as now, from numerous versions.[9] Thus another of the artist's conceits is revealed, for what more suitable prototype could there be for Guercino's excited envoy than the messenger to the gods himself?

Two drawings by Guercino in the Royal Library, Windsor Castle, are studies for the 1645 *Semiramis* – one a compositional study and the other a rapid sketch for the figure of the messenger.[10] In the first drawing (cat.57c), Semiramis is seated with her body directed towards the spectator, as if she has only just turned away from her dressing-table and mirror, her head looking to the right to listen to the messenger. At this early stage of the composition, her dressing-table was presumably intended to appear on the far left. In the drawing, both Semiramis and the messenger are radically different from their painted counterparts, except for the bearded profile of the messenger and the angle of his head, which reappear unmodified in the final result. In the drawing, Semiramis raises her right hand, though it is unclear whether this gesture is meant to convey alarm or whether she is merely putting her flowing locks in order – possibly both. In the 1624 and *c.*1627–8 versions, at Boston and formerly at Dresden, Semiramis similarly holds up her hair with one hand, but with the difference that her crown is already in place on the top of her head in both paintings.

The second Windsor drawing (cat.57d), a slight study for the messenger, must have been made first, since the messenger is even further removed in appearance from his painted equivalent. He is shown bringing his bad tidings in the form of a written despatch – a bit of paperwork that would inevitably have slowed down the main action, as Semiramis would have needed to read it before grasping the perilousness of the situation. Guercino seems to have realised this flaw in the midst of drawing the figure, and this may well explain why the sketch was so quickly abandoned. In the 1989

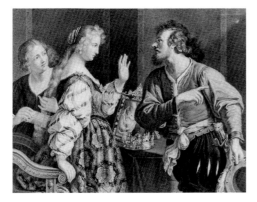

Cat.57e Catarina Piotta-Pirola, *Semiramis at her 'Toilette' Receiving the News of the Revolt of Babylon*, engraving, 12⁷⁄₁₆ × 16⅜ in (312 × 417 mm), 2nd quarter of the 19th century (British Museum, London)

12 Wheale and Richter 1889, p.135.
13 Malvasia 1678 (2nd edn, 1841), vol.2, p.266.
14 Ghelfi 1997, p.127.
15 Wittkower 1966, no.48, illus.
16 Salerno 1988, no.218, illus.
17 Ghelfi 1997, p.124.
18 Fol.220*r*, entry 438b, of manuscript quoted in forthcoming book by Spezzzaferro.
19 Ibid., fol.221*v*, entry 451a.
20 Inv.no.40086 (purchased 1999); pen and brown ink on laid paper, 4⅝ × 5⁷⁄₁₆ in (117 × 138 mm).
21 Sutherland Harris 1977, pp.95–7, no.72, and figs 144–7.

Windsor catalogue, the drawing was catalogued as 'School of Guercino', but the existence of *pentimenti*, in the raised right hand and in the sword, and the sheet's stylistic coherence with other pen studies by Guercino of the mid-1640s are strong arguments in favour of its being autograph.

The ex-Northbrook picture had belonged to the *marchand-amateur* W. Haldimand Esq. at some time in the second quarter of the 19th century, and his ownership is cited in the letterpress of an undated engraving after it by Caterina Piotti-Pirola (*b*.1800), a proof state of which, before letters, is in the British Museum Print Room (cat.57e).[11] The final state, which is dedicated to Franz Hartig, Chamberlin and Councillor to the Austrian emperor (*'Sua Maestà Imperiale e Reale Austriacò'*), is entitled *'Semiramide risponde al nunzio: la mia bellezza calmera la sedizione'* ('Semiramis replies to the messenger: my beauty will calm the uprising'). Also, at the bottom left, is the inscription giving the picture's then whereabouts *'il dipinto esiste nella Galleria del Sig. W. F. Haldimand di Londra'* ('the picture exists in the Gallery of W. F. Haldimand of London'). Following Haldimand's death, it passed into the possession of Richard Sanderson of Belgrave Square, London, at whose sale, on 20 March 1858 (lot 19), it was sold for £210 to 'Bentley', presumably acting on behalf of Sir Francis Thornhill Baring (1796–1866), 3rd Baronet and 1st Baron Northbrook of Stratton, Hants.

Unfortunately, the earlier history of the ex-Northbrook picture remains unknown, and, to date, no further information can be given as to its provenance prior to Haldimand. Thus Haldimand and Sanderson are the only owners mentioned in both J. P. Richter's entry in the catalogue of the Northbrook pictures[12] and the 1919 Christie's sale catalogue, where the measurements of the canvas are cited as 50 × 58½ and 51 × 59 in (127 × 148.5 and 129.5 × 150 cm) respectively. Although given unequivocally to Guercino by Richter, the picture, perhaps significantly, is listed as by 'Guercino' in the Christie's catalogue, without the artist's name being given in full, signifying that it was not thought to be an autograph work. It was bought at the sale by the dealer Clifford Duits for the insignificant sum of 18 guineas and has since disappeared.

A reproduction in Wheale and Richter's 1889 catalogue records the appearance of the lost Northbrook picture, which would have been fractionally smaller than that now in the Cobbe Collection. Few differences between the two come readily to view, yet some variations between them may be found in the central cluster of scrollwork at the side of the mirror frame and in the patterning at the top of Semiramis's skirt. While the messenger's mouth is closed in the ex-Northbrook picture, his lips are parted in both the Cobbe Collection and Petworth pictures, as if he were announcing the news. Finally, close scrutiny of the reproduction of the ex-Northbrook picture shows that the facial features of the protagonists seem slightly swollen and the contrasts between the lights and darks over emphatic, as in the messenger's sleeves.

For two such close variants of the same composition to exist presupposes that a tracing was taken from one canvas and copied onto another, a method of transfer that was achieved in the 17th century by impregnating paper with oil so that it became transparent, and marking the principal outlines from the work below onto the wet surface of the paper with charcoal, or an equivalent dry material. A tracing done in the studio would explain the existence of the Petworth version, for the sample analysis of the Cobbe and Petworth pictures establishes beyond doubt that they were both painted at the same time and with the same paint mixtures, even down to the same layering of glazes. The very different qualities of the two pictures rest solely in the handling of the paint, which in the Petworth version may be attributable to Guercino's kinsman Bartolomeo Gennari (1594–1661), the artist's most competent helper during the 1640s.

In the biography of Guercino published in 1678 by Count Carlo Cesare Malvasia, the Cornaro *Semiramis* is mentioned as one of the items in the list of the artist's commissions, under the year 1645, where it is described as follows: *'All'Eminentissimo Cornaro … una Semiramide quando ebbe la nova della*

Cat.57f Guercino, *Absalom and Tamar*, oil on canvas, 50¹⁄₁₆ × 58½ in (127.5 × 149 cm), 1644–5 (National Trust, Tatton Park, Cheshire)

Cat.57g Pietro da Cortona, *Elijah Reviving the Son of the Widow*, pen and brown ink on laid paper, 4⅝ × 5⁷⁄₁₆ in (117 × 138 mm), late 1630s or early 1640s (National Gallery of Canada, Ottawa)

presa di Babilonia …' ('For the Most Eminent Cornaro … a Semiramis, when she had the news of the taking of Babylon …').[13] An entry in Guercino's account book for 29 December 1645 (written in Paolo Antonio's hand) records the Cardinal's payment of 150 ducats (approximately 200 *scudi*) for the picture: '*Dall'Em.ᵐᵒ Sig.ʳ Cardinale Cornaro, si e riceuto per il Quadro della Regina Semiramiss [sic], ducat.ⁿⁱ 150 … è questi per mano dell.ᵐᵒ Sig.ʳ Gio Lupari …*' ('From the most Eminent Signor Cardinal Cornaro, 150 ducats received for the picture of Queen Semiramis … these moneys from the hand of Signor Giovanni Lupari').[14] This price tallies with the artist's standard charges of 25 ducats for a head, 50 for a half-length and 100 for a full-length figure.

The Cornaro, or Corner, family of Venice was one of the city's most powerful noble families, holding office from the Middle Ages until the 18th century. Some of its members were doges, while others were senior members of the Church, a calling that often required a presence in Rome (though none was appointed pope). There were three main branches of the family, and Cardinal Federigo Cornaro was from that known as the Cornaro di San Polo branch, which had also counted Cardinal Alvise Cornaro (1517–84) among its members. Cardinal Alvise had transferred to Rome in the middle of the 16th century and there commissioned the Sicilian architect Giacomo del Duca (*c*.1520–after 1601) to build him a palace on property behind the Trevi Fountain, in the Venetian quarter of the city, and construction took place between 1551–82. It was there that Cardinal Federigo was to live, housing in its rooms his fine collection of pictures, mostly by contemporary Roman and Bolognese artists.

The former Cornaro palace, now the Palazzo della Stamperia, still stands to this day, adjacent to the Palazzetto della Calcografia. Its main façade is at a slight angle to that of the Palazzetto and gives on to the Via and Piazza della Stamperia; one of its short sides faces the Via del Tritone; and the Palazzo Poli stands directly behind, within the same street 'block'. Following the death of Cardinal Federigo, his habitation became the Roman residence of the powerful Cardinal Mazarin (1601–62), and later the property of the Pamphilj. In 1777, the building was acquired by the Vatican and was altered by Pope Pius VI (1775–99) to accommodate the offices of the Papal Printing Press.

Cardinal Federigo was an important patron of the arts, best known for commissioning what has been described as 'the family's most famous masterwork', the family chapel, the Cappella Cornaro, designed and erected by Gianlorenzo Bernini (1598–1680), from 1647–52, in the church of S Maria della Vittoria, Rome. Over the altar is *The Ecstasy of St Teresa*,[15] the most famous piece of Baroque sculpture in Rome, while at the balconies in the two side walls, watching the religious mystery, are eight members of the Cornaro family. Of these spectators, there are seven Cardinals: six from the 16th century, including Cardinal Alvise, the builder of the family palace in Rome; and one from the 17th, the so-called 'last Cardinal', Federigo.

At the end of 1644, the Cardinal had commissioned another half-length picture from Guercino. The *Absalom and Tamar* at Tatton Park, Cheshire (cat.57f),[16] shares many features of technique and composition with the Cobbe picture. The *Absalom and Tamar* was bought by William Egerton for £315 at the sale of Sir George Warrender, Bt, of Bruntisfield (Christie's, London, 3 June 1837, lot 20), who in his turn had acquired it, presumably via an agent, 'from the Cornaro Palace in Venice'. Cardinal Cornaro's payment of 150 *scudi* for the picture, a little less than he was to later pay for the *Semiramis*, was registered in Guercino's account book on 6 February 1645.[17]

At Cardinal Federigo's death in 1653, an inventory was drawn up of his possessions. I am most grateful to Prof. Luigi Spezzaferro for allowing me to consult his transcript of this inventory and to quote from it here. It describes how the Cardinal's two large Guercino pictures were displayed in his palace, and since this information is not published in the Guercino literature, the relevant passages are worth quoting here in full.

In the sixth room of the palace, the so-called '*camerone*', which was in effect the picture gallery,

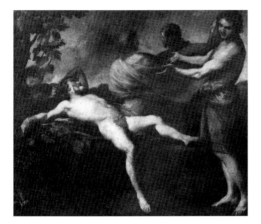

Cat.57h Andrea Sacchi, *The Drunkenness of Noah*,
1644–8 (Museo Provinciale, Catanzaro)

there are described: '*Due quadri, che servono per sopraporta dipinti in tela in uno è l'Absalone, che rende i capelli mezzo finito di mano di Guido Reni e nell'altro vi è l'istesso Absalone con Tamar, che la minaccia di mano del Guercino da Cento, guarniti di cornice di legno alla romana lavorate tutte intagliate, et indorata lunghi palmi 7½ larghe palmi 7*' ('Two pictures that serve as overdoors, painted on canvas, in one is Absalom who rends his hair, half finished, from the hand of Guido Reni and in the other the same Absalom with Tamar, who threatens her [sic], from the hand of Guercino, decorated with wooden frames, Roman style, carved and gilded, 7½ palms long and 7 palms wide').[18] The subject of the Guido Reni picture, evidently late and now lost, must have been the Death of Absalom, who was killed while caught and suspended from the branches of a tree by his hair when fleeing from David's forces on his mule.

In the eighth room, which is said to have been towards the courtyard, '*cioè quella dove dava udienza, acanto allo stanzino dove sentiva messa*' ('this is the chamber where he gave audiences, alongside the room where he heard mass'), three further overdoors are mentioned: '*Tre quadri per soraporte grandi, uno del Guercino, che è la Regina Semiramis e l'altro di Pietro da Cortona, che è l'Eliseo, che ravviva il figlio alla vedova, et il 3.o è Noè d'Andrea Sacchi con suoi cornici alla romana intagliate e indorate*' ('Three pictures for large overdoors, one by Guercino, which is Queen Semiramis, and the other by Pietro da Cortona, which is Elijah who revives the son of the widow, and the third is Noah by Andrea Sacchi, with their Roman frames carved and in gilt').[19]

The Pietro da Cortona picture is unfortunately lost, but a hint of its composition may well survive in a drawing recently acquired by the National Gallery of Canada, Ottawa (cat.57g).[20] Sacchi's '*Noè*' is very likely to have been a version of the painter's well-known *Drunkenness of Noah*, which exists in a number of versions, including those in Berlin, the Kunsthistorisches Museum, Vienna, and the Museo Provinciale, Catanzaro (cat.57h).[21] Which of the lost or surviving versions of Sacchi's composition was the one that belonged to Cardinal Federigo has yet to be established, but it would have made a good accompaniment to the Cortona painting, if the Ottawa drawing is an indication of its appearance.

Thus the Cortona and Sacchi overdoors were almost certainly pictures containing full-length figures. But how, it might be asked, would these two compositions have been combined harmoniously with Guercino's *Semiramis*, which is of half-lengths? A possible solution may reside in the disposition of the doors in the Cardinal's audience chamber. For example, the Sacchi and Cortona pictures could have been paired over doors at either end of the same wall, while the Guercino could have occupied a place on its own, over a central opening, on the opposite side of the room. This suggestion is pure guesswork, however, and an explanation of the actual arrangement remains to be discovered, as no doubt it will be one day.

NT

58

ATTRIBUTED TO GIAN LORENZO BERNINI
Naples 1598–Rome 1680

Head of a Bearded Man, Seen Full Face

Oil on canvas, 17×13 in (44×33 cm). The surface is slightly abraded in parts.[1]

INSCRIPTIONS on the reverse, on the canvas: inscribed in an 18th-century hand, in brown ink, *Belonging to General / Cam*[pbell] / *July ... / 1759*; on a label attached to the canvas, also in a late 18th-century hand, in brown ink, *The head of augustin Carracci / by Annibal 8-8 / Bought at Sir Luke Schaube / Sale* -; on the stretcher: inscribed illegibly in an 18th-century hand, in brown ink; two printed labels, one of them from an exhibition; stamped in brown ink on the canvas, stretcher and frame by the Italian Customs, dated 29 May 1961 Cobbe Collection, no.374

HISTORY Sir Luke Schaub (*d*.1758), possibly acquired in Spain; his sale, Langford's, London, 26–8 April 1758, second day's sale, lot 32: 'Ann. Carracci. The Head of Augustin Carracci' (sold for £8.0s.0d); in 1759 in the collection of General John Campbell (*c*.1693–1770), later 4th Duke of Argyll (according to inscription on the reverse); probably his third son, Lord Frederick Campbell (1729–1816), London and Comb Bank, Kent; probably bequeathed by him to William Pitt (1773–1857), 1st Earl Amherst, Montreal, Sevenoaks, Kent; his son William Pitt (1805–86), 2nd Earl Amherst; his son William Archer (1836–1910), 3rd Earl Amherst; his brother Hugh Archer (1856–1927), 4th Earl Amherst; his son Jeffery John Archer (1896–1946), 5th Earl Amherst, until at least 1942; Ian Greenlees, Florence (according to 1983 Christie's sale catalogue); private collection; sale ['the property of a gentleman'], London, Christie's, 2 December 1983, lot 51; acquired at sale, Christie's, London, 31 March 1989, lot 11, illus.

EXHIBITIONS London 1980, no.7 (as a portrait of Agostino by Annibale Carracci); London 1982, no.10 (as attributed to Bernini); Edinburgh 1998, no.36, (as attributed to Bernini)

LITERATURE Laing/Cobbe 1992, pp.2, 13, no.304, illus. on back cover (as Bernini); London 1996b, p.34 (as Bernini); Sutherland Harris 1998, p.641, fig.56 (as attributed to Simon Vouet)

1 The condition is more fully described by Christopher Baker in Edinburgh 1998, no.36.
2 Fréart de Chantelou/ed. Corbett 1985, p.165.
3 Wittkower 1966, no.31, illus.
4 Sutherland Harris 1992, pp.192–208.
5 Turner 1978, pp.388, 391 and 392, figs 1 and 5.
6 Ibid., fig.6.
7 Ibid., pl.7b.
8 *DNB*, vol.17, p.901; see also Vertue/ed. Walpole Society 1938, vol.5, p.76 (incidentally noting 'portraits few').
9 Ibid., pp.901–2.

For much of its existence, this haunting and extraordinarily life-like portrait of a young man was believed to represent the Bolognese painter Agostino Carracci (1557–1602) and was thought to have been painted by his brother Annibale Carraci (1560–1609). Such an identification appears in an 18th-century inscription on the back of the canvas, presumably taken from the description of the picture in the catalogue of the 1758 sale of the collection of Sir Luke Schaub (*d*.1758), and was maintained as recently as 1980, when the picture was included in *The Seventeenth Century* exhibition at Agnew's, London.

The idea that the portrait might enshrine a moment of peaceful union between the two brothers held an undoubted appeal. It was never an easy fraternal relationship; Agostino and Annibale Carracci quarrelled bitterly in 1599, when Agostino had briefly joined Annibale in Rome in order to help him complete the decoration of the Galleria Farnese. Following this rupture, which turned out to be final, Agostino transferred to Parma, where he died three years later. The identification of the sitter as the slightly plump and bearded Agostino is not absurd. His appearance is recorded in a number of securely documented portraits – painted and engraved – including the print (a late impression of which is illus. as cat.58a) by the Flemish printmaker Albert Clouwet (1636–79), which was included as one of the portraits that illustrate Giovanni Pietro Bellori's lives of painters, published in 1672. The similarity between Agostino's appearance, as diffused in the widely circulated portrait print from Bellori's book, and the features of the sitter in this portrait would explain the persistence of the traditional identification. Critical to its dismissal as a portrait of Agostino, however, was the ever-increasing certainty, on the grounds of style, that Annibale Carracci could not possibly have painted the picture, his rugged impasto and daring touch being quite foreign to the suavity of surface in the Cobbe picture.

The first to propose Bernini's authorship of the *Head of a Bearded Man* was Sir Denis Mahon, whose opinion is cited in the entry for the picture in the 1983 Christie's catalogue in which it was included for sale. In Mahon's opinion, it is 'associable with the small group of portraits painted by Bernini, of which examples exist in the Borghese Gallery, Rome, and the Ashmolean Museum, Oxford'. Bernini, the great sculptor and architect of the Roman Baroque period, who not only lived to a great age but was also immensely productive throughout this long span, occasionally turned his hand at the beginning of his career to painting spontaneous portrait sketches in oil on canvas – in the style of Annibale Carracci. These experimental works were undertaken in order to capture as accurately as possible the 'true' likeness of an individual, rather than as a formal record of the persona that the particular sitter wished to project. The living, breathing human being, shorn of the accretions that resulted from birth or office, was therefore the focus of his attention.

During Bernini's visit to France in 1665, his remarks on his artistic practice were carefully recorded by his guide and companion, the French courtier Paul Fréart, Sieur de Chantelou (1609–*c*.1694). When talking of portraiture, Bernini observed to Chantelou that the sitter should engage the viewer as if he were actually speaking to him: 'To be successful in a portrait ... a movement must be chosen

10 Washington, DC, London and Haarlem 1989–90, no.71, illus.

11 It is probable that Lord Frederick inherited it, through his father, from his father's cousin, Archibald Campbell (1682–1761), 3rd Duke of Argyll, whose namesake, General Sir Archibald Campbell (1739–91) of Inverneil, later Governor of Jamaica and Madras, has mistakenly been credited with having owned the Cobbe picture. (The picture cannot have been bought by the latter General Campbell at the Schaub sale, for in 1758 he was still a young soldier, busy fighting in North America, where he was wounded in General Wolfe's taking of Quebec.) I am grateful to Alastair Laing for rectifying this confusion.

12 Vertue/ed. Walpole Society 1938, vol.5, p.67. Even earlier than that, a General (James?) Campbell was given as the owner of drawings etched by Arthur Pond (c.1705–1758) and George Knapton (1698–1778) in their publication of *Prints in Imitation of Drawings* (London, 1735–6); see Lippincott 1983, pp.129 and 205 (index).

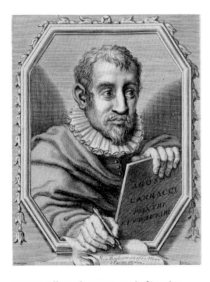

Cat.58a Albert Clouwet, *Portrait of Agostino Carracci*, engraving, 6½ × 5 in (166 × 127 mm), before 1672 (private collection)

and then followed through. The best moment for the mouth is just before or just after speaking.'[2] Cat.58 seems to fit perfectly with such a prescription. The sitter's slightly tilted head, his steady gaze directed straight at the spectator, his lips that seem on the point of speaking, even the shock of dark untidy hair and the wispy reddish brown beard, conform with late 20th-century perceptions of what Bernini's portraiture is all about. The archetype of these so-called speaking likenesses is the marble bust of *Scipione Borghese* in the Galleria Borghese, Rome,[3] in which the Cardinal turns his head vivaciously, opening his mouth as if issuing an instruction.

Recently, Ann Sutherland Harris has claimed that the originator of the *ressemblance parlante* portrait type was Simon Vouet (1590–1649), the French painter active in Rome from 1614 to 1627.[4] After questioning the attribution to Bernini of the Cobbe *Head of a Bearded Man* in her review of the 1998 Edinburgh exhibition, she went on to suggest that the artist responsible for the present painting could have been Vouet, an idea already tentatively proposed in the 1989 Christie's catalogue. One of her arguments was that none of Bernini's painted or drawn portraits show the sitter positioned frontally, as here, but only in three-quarter view. This observation may well be correct, but in my opinion there is little resemblance in handling between the careful, porcelain-like finish of Vouet's early painted portraits, which tend to favour bright pastel colours, and the 'Carraccesque' handling and reddish browns and creams of the present picture. Moreover, the Cobbe portrait seems to be datable to c.1650, possibly after Vouet's death and certainly long after 1627, when he left Rome for good.

If not by Bernini – and I am by no means certain that his authorship can be excluded – cat.58 could be by a Roman painter who modelled his oeuvre unashamedly on that of Annibale Carracci, the little-known Giovanni Angelo Canini (1617–66). The suggestion is made solely on the basis of the similarity to heads in some of his painted works, there being no known portrait by him to date. The slightly abstract simplification of the face, the broadened features and the rather swollen lips find a parallel in three of Canini's representations of the head of Christ: in the *Trinity with Sts Bartholomew and Nicholas of Bari* in S Martino ai Monti, Rome;[5] and in the *Christ's Charge to St Peter* and the *Conversion of St Paul* in S Giovanni dei Fiorentini, Rome.[6] The resemblance is perhaps most clearly seen from a comparison with a drawing in the Ambrosiana, Milan,[7] for the head of Christ in the *Christ's Charge to St Peter*, in which the typological qualities just remarked upon seem to be identical.

The picture's first documented owner was Sir Luke Schaub, the much-travelled Swiss-born diplomatist, deeply involved in the foreign policy intrigues of the Hanoverian period, He is said to have been secretary to King George I (1660–1727), and a favourite companion of George II (1683–1760). He enjoyed considerable influence with Queen Caroline (1683–1737); yet he subsequently managed to become adviser on pictures to their estranged son, Frederick, Prince of Wales. Schaub lived in Bond Street, London, and was renowned for the 'admirable collection of pictures' that he kept on show there.[8] However, according to Sir Horace Walpole (1717–97), son of Schaub's rival, Sir Robert Walpole (1676–1745), these pictures were bought cheaply when he was in Spain, in 1718–19, and included 'some good old copies [i.e. of famous pictures], some fine small ones and a parcel of Flemish, good in their way'.[9] The Cobbe picture later belonged to the Earls of Amherst. Another picture that descended within the same family, the *Portrait of a Gentleman* by Frans Hals (1582/3–1666) in the National Gallery of Art, Washington, DC,[10] is said to have been bequeathed c.1820 to the 2nd Baron (later 1st Earl of) Amherst (1773–1857) from the estate of Lord Frederick Campbell (1729–1816), third son of the 4th Duke of Argyll. It is surely this last who is intended by the inscription on the back of the Cobbe picture: for he was plain 'General Campbell' before succeeding his cousin Archibald Campbell (1682–1761), 3rd Duke of Argyll, as 4th Duke in 1761.[11] This General Campbell had already been described by Vertue in 1748 as 'a great Collector of valuable pictures'.[12]

NT

59

GASPARD DUGHET, CALLED GASPAR POUSSIN
Rome 1615–Rome 1675

Valley Landscape with a Tempest

Oil on canvas, 38 ⅜ × 52 ⅞ in (97.5 × 134 cm)
INSCRIPTIONS on the reverse: inscribed on an
old label, … *John Dunn* [Gardner]: (torn off since
the sale of the picture in 2000)
Cobbe Collection, no.461
HISTORY Jeremiah Harman (*c.*1764–1844); his
sale, Christie's, London, 17–18 May 1844, lot 89
(bought by Gardner for 205 guineas); John
Dunn Gardner, 14 Lower Grosvenor Place,
London, and Bottisham Hall, Cambridgeshire;
his sale, Christie's, London, 25 March 1854, lot
70 (bought in for 185 guineas); re-offered in his
subsequent sale, Christie's, London, 3 June
1876, lot 23 (bought in for 70 guineas); Capt.
Sir Everard Radcliffe (1910–75), 6th Bt, MC,
Rudding Park, Yorkshire;[1] acquired at sale,
Christie's, London, 19 April 2000, lot 49
LITERATURE Boisclair 1986, p.247, no.243 and
fig.282

1 Presumably sold privately by him, since not
included in either of his picture sales at
Christie's, London, 17 November and 8
December 1972 , nor in the sale of the remaining
contents of Rudding Park, Christie's, London,
16–17 October 1972.
2 See Thuillier 1976, pp.345–55, nos 5–6, and
Whitfield 1977, pp.4–12; Paris 1994, nos 200 and
201; and London 1995, nos 73 and 74.
3 Paris 1994–5, no.203 and London 1995, no.75.
4 *Vide* the crescendo-like presentation of
Boisclair 1986, p.60.
5 Boisclair 1986, p.175, no.22 and fig.30, and
pp.185–6, no.61 and fig.84.
6 Ibid., p.201, no.101 and fig.142.
7 Ibid., pp.247–8, nos 243–5 and figs 282–4.
8 Ibid., pp.201–3, nos 300–13 and figs 144–7.
9 Ibid., pp.263–6 and figs 340–46, and pp.278–
82, nos 351–62 and figs 386–403.
10 Ibid., pp.283–4, nos 371–8 and figs 405–14.
11 See Brigstocke 1982, pp.395, 421 and 468.
Harman obtained his Salvator Rosa, in the
shape of a so-called *View of the Appenines*, that
was also bought (for 570 guineas) by John Dunn
Gardner in his posthumous sale, but bought in
at both of Gardner's own sales.
12 See Kauffman 1973, no.271 (unaware of
Harman or Gardner provenance).
13 See Lees-Milne 1996, pp.179–93 (esp.p.186).

Acquired as a kind of surrogate for the Newbridge Dughet that was sold in 1839 (cat.40), this picture could instead almost be the contrasting pendant to it, in the manner of the contrasting pair by Gaspard's brother-in-law and former master, Nicolas Poussin (1594–1665), the *Temps calme* (Sudeley Castle) and the *Orage* (Musée des Beaux-Arts, Rouen).[2]

Significantly, indeed, each of the latter pictures was attributed to Dughet, before their recent rediscovery. They were painted for Jean Pointel in 1651, the same year as the *Landscape with Thisbe Discovering the Body of Pyramus in a Storm* was carried out for Cassiano del Pozzo.[3]

Whether autonomously, or from the lead given by Nicolas Poussin's examples, Gaspard went on to make something of a speciality of stormy landscapes. Indeed, as Marie-Nicole Boisclair presents it, it is almost as if the wind in his landscapes, once got up, proceeded to gain in intensity, until it had become a full-scale tempest.[4] Beginning with a *bourrasque*, or squall, in the early canvas in the Fondazione Roberto Longhi in Florence, and in a picture formerly in the Baring and Holford[5] collections, by about 1650/51 it had developed into an *orage*, or proper storm, in the picture in the Musée de Chartres,[6] and by the mid-1660s: in the present picture, in another at Holkham Hall, and in the *Landscape with Dido and Aeneas Seeking Shelter in a Cave*, in the National Gallery, London, into a full-scale *tempête*.[7]

It must, however, be questionable as to whether Mme. Boisclair ever saw the present picture with her own eyes (she devotes no discussion to it), since, despite the evidence of the broken branch on the right, the wind does not appear to have risen beyond force 7 or 8 on the Beaufort Scale, and the worst seems past, with the sky brightening in the west. More seriously, one might also challenge her dating of the picture: there is a robustness to its handling that suggests an earlier date than the mid-1660s, closer to Dughet's frescoed landscapes in the Palazzo Pamphilj,[8] than to the frescoes and tempera paintings of the Palazzo Colonna[9] or to the frescoes of the Palazzo Borghese[10] (i.e. to *c*.1650 rather than to the early 1670s). But these comparisons immediately indicate the difficulty inherent in trying to date Dughet's oil paintings at all: his only datable productions are in other media, comparisons with which can be misleading. His physical handling of paint thus becomes of the essence – but differences in condition can severely affect one's judgement of that, and it is an aspect that is impossible to assess on the basis of photographs, particularly when they are of whole paintings only.

The first recorded owner of this picture, Jeremiah Harman, was the city merchant and banker who played a key role in getting the Italian pictures from the Orleáns collection to Britain; he bought them from the French *financier* Laborde de Méréville and then sold them to the picture-dealer Michael Bryan, who was acting for a consortium formed by the Duke of Bridgewater, the Earl of Carlisle and Earl Gower. But Harman himself was a patron (of the young Charles Eastlake) and collector, whom

William Buchanan specifically records as having the first refusal of a 'fine Gaspar Poussin' and as wanting a 'fine Salvator [Rosa] … for which he would give from 600 to 1,000 Guineas, according to its quality'.[11]

John Dunn Gardner had a good collection of pictures at Bottisham Hall (the seat of the Jenyns family, which was evidently long let to his own), a number of them bought at Harman's posthumous sale, including not only the present picture, but also Perino del Vaga's detached fresco of the *Raising of Lazarus*, now in the Victoria & Albert Museum.[12]

The last recorded owner of this picture, Sir Everard Radcliffe, 6th Bt, of Rudding Park, also merits a word. Vested by his grandfather with the austerely detailed and sparsely furnished late Georgian house of Rudding Park, near Harrogate, shortly after his return from World War II, he set about redecorating and furnishing it with – above all – exquisite, gorgeous, and often Baroque, works of art. His pictures included a *Madonna in Adoration* by Verrocchio (1435–88), a *Madonna and Child with Angels and Saints* by Marco Basaiti (*fl.*1496–1530), as well as other religious paintings (for he was a devout Old Catholic) by Guercino, Rombouts, Bassano, Reni and Ribera. In the words of James Lees-Milne: 'He was a forerunner of Alec Cobbe, who has lately done for the National Trust's Hatchlands what Everard, anticipating him, did at Rudding.'[13]

Like Hatchlands before it, Rudding Park should have come to the National Trust, but – unlike Hatchlands – with its contents too. After lengthy negotiations, a complex agreement had been drawn up, formal acceptance had been passed by the Council of the National Trust, and Sir Everard's Memorandum of Wishes had been endorsed and sealed. And then suddenly, in March 1972, Robin Fedden, the Historic Buildings Secretary who had handled the negotiations, learnt from a cutting from the *Yorkshire Evening Post* that the baronet was selling up estate, house and contents. (He had, however, already sold some books at Christie's in London in December 1971.) The reason given was the weight of charges and taxation. Yet he went on to buy a beautiful house in Switzerland, the château de Cheseaux in the Canton de Vaud, and furnished that with the possessions that he had not sold; and this, with a second wife, and a late-born son in place of a cherished only son who had died at the age of 23, apparently brought him the happiness that had always eluded him before, because of the weight of his felt obligations in England. The National Trust must hope that Lees-Milne's parallel between Sir Everard Radcliffe and Alec Cobbe does not extend to a similar sudden withdrawal!

ADL

60

FILIPPO LAURI

Rome 1623–Rome 1694

Apollo with Nymphs and Satyrs, and Mercury Stealing the Cattle of Admetus

Oil on canvas, 16⅜ × 26¾ in (41.5 × 68 cm)
INSCRIPTIONS signed with the artist's
monogram at lower left, on the stone slab
on which the two satyrs are reclining, *FL*
Cobbe Collection, no.441
HISTORY acquired at sale, Christie's, London,
31 October 1997, lot 85, illus. (in colour)

1 Oil on canvas, 30.5 × 49 cm); see *Walpole
Society*, vol.60 (1998), p.10.
2 The print, of which there is an impression in
the Witt Print Collection, Courtauld Institute
Galleries, London (neg.no.993/53(15)), is a com-
panion to the reproductive print after Lauri's
Diana and Actaeon by William Woollett (1735–85).
3 *Cat. Burghley House* [n.d.] no.25; photo in the
Witt Library, London.
4 Ibid., no.26; photo in the Witt Library,
London.
5 Photo in the Getty Photograph Study
Collection, Los Angeles, CA.
6 Inv.no.337; see Brejon de Lavergnée and
Thiébaut 1981, p.191, illus.
7 London 1983b, no.29, illus.
8 Ibid., *sub* no.29, fig.2.
9 Sale, Sotheby's, London, 31 October 1979,
lot 53, illus.
10 London 1965, no.19, illus.
11 Inv.no.812; see Antwerp and Münster 1990,
no.30, illus.
12 Inv.no.1952.50 (as 'anonymous French
school, *c*.1650).

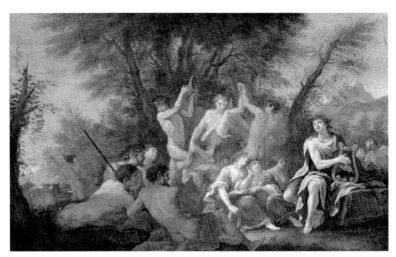

Another auto-
graph version of
this composition,
in the collection of
the late Sir Brinsley
Ford, London,[1]
was engraved, in
reverse (cat.60a),
by William Byrne
(1743–1805).[2] There
are minor differ-
ences between
the two paintings,
including the
presence of a dog
scratching its chin with its back leg at the lower right of the Ford picture, and the smaller scale of
the vignette of Mercury stealing the cattle of Admetus in that version.

The subject is taken from Ovid's Metamorphoses (2:678–709). As a punishment for killing the
Cyclopes, Apollo was sent by Jupiter to serve King Admetus as a shepherd. However, after receiving
the gift of a lyre from Mercury (its apparent inventor), the pastoral god became distracted from his
duties as herdsman; as he sat playing the instrument in front of a gathering of nymphs and satyrs,
he failed to notice Mercury stealing the King's herd of cattle in the background.

The Cobbe and Ford pictures belong to a choice group of small-scale landscapes with Ovidian
subjects. Considered among the most charming late 17th-century examples of this format and
genre, such works anticipate the idyllic pastoral scenes that were to become so fashionable during
the 18th century. Lauri's numerous small-scale cabinet pictures – which were particularly popular
with private collectors from northern Europe – complement the large-scale decorative works
and frescoes that he carried out with such success for princely Roman families. For the most part,
his large-scale work consisted of religious, historical and allegorical subjects, but small *tondi* with
charming Ovidian scenes feature over the windows in what is thought to be his most perfect surviv-
ing commission, the decoration of a small room in the Palazzo Borghese, Rome, with a painting
of the *Marriage of Bacchus and Ariadne* on the ceiling and mythological scenes (*Latona with the Sun and
Moon*, *Diana and Actaeon*, the *Birth of Adonis* and *Venus and Mars*) on the walls.

Other examples of small-scale, independent cabinet pictures with Ovidian themes include a
dated pair in the collection of the Marquess of Exeter at Burghley House, depicting the *Judgement of
Midas*[3] and the *Flaying of Marsyas*,[4] the latter of which is signed with the artist's monogram on a stone
slab at lower left centre (on which a satyr is reclining), in an identical fashion to the monogram on
the Cobbe picture. Both of the Burghley House pictures were no doubt among the works purchased
directly from the artist in Italy in the 1690s by John Cecil (*c*.1648–1700), 5th Earl of Exeter.

The two Burghley House compositions also exist in other versions: the *Judgement of Midas* in an
American private collection in Santa Barbara (10 × 11 in [25.5 × 28 cm]),[5] and the *Flaying of Marsyas* in
a small-scale gouache version (6⅝ × 8⅝ in [17 × 22 cm]) in the Louvre, Paris,[6] which is also signed
with the artist's monogram. In the case of the latter, Lauri is documented as having made at least
two versions of this composition, one of which was purchased by the Roman innkeeper Francesco
Amiconi, and the other a replica made for Antonio Botti. Another instance of multiple autograph
versions, in both gouache and oils, are the two compositions of *Dancing Nymphs and Satyrs*, of which

Cat.60a William Byrne after Filippo Lauri,
*Apollo with Nymphs and Satyrs, and Mercury
Stealing the Cattle of Admetus*, engraving
(Witt Print Collection, Courtauld Institute
Galleries, London)

the gouache version was formerly with the Trafalgar Galleries, London, in 1983,[7] and the version in oils is in a private collection, Rome.[8] Two further examples in a format roughly equivalent to the Cobbe Collection painting are the *Bacchic Scene*, with nymphs and satyrs dancing in a wooded landscape (15¾ × 24 in [39 × 61 cm]), sold at auction in London in 1979,[9] and the *Nymphs and Satyrs* (17¾ × 26 in [45 × 66 cm]), formerly with the Hazlitt Gallery, London, in 1965.[10]

Finally, it is worth mentioning the uncanny resemblance in conception between the Cobbe Collection picture and two different compositional sketches of *Apollo and the Muses* by the Flemish painter Jan Boeckhorst (*c.*1604–1668), one in the Stedelijk Prentenkabinet, Antwerp,[11] and the other, recently recognised as Boeckhorst by Pierre Rosenberg, in the Ashmolean Museum, Oxford,[12] both presumed to be designs for tapestries. Though perhaps no more than pure coincidence, it reminds us that Lauri received his first training from his father, Balthasar Lauwers (1578–1645), a Flemish landscape painter who, by *c.*1602, had settled in Rome, where he adopted an Italianised form of his name, Lauro or Lauri. In 1604 he was recorded as an assistant in the Roman workshop of fellow Flemish artist Paul Bril (1554–1626). After serving Cardinal Albornoz, appointed Governor of Milan in 1635/6 by the King of Spain, Lauwers was back in Rome by 1637, when he was listed as destitute and in need of financial support from the Brotherhood of S Maria in Campo Santo. The same year that Lauwers was declared insolvent, his elder son, Francesco Lauri (1612–37), who was also a painter (trained by Andrea Sacchi) and was Filippo's second teacher, died at the young age of 25 (some 15 years before Filippo achieved any real success as an artist). The community of Northern artists active in Rome in the first half of the 17th century was small and closely-knit, so when Boeckhorst made his first visit to Rome in 1639 it is not inconceivable to imagine some contact – direct or indirect – between him and the surviving members of the Lauri family.

Overcoming the family tragedies of the late 1630s, Filippo went on to study with his brother-in-law, Angelo Caroselli (1585–1652), for whom he worked as a copyist until at least 1652 when Caroselli died. Filippo Lauri's subsequent success, especially with noble and aristocratic patrons, is all the more remarkable, given his unfortunate physical appearance, which was commented upon in several old sources. The English connoisseur and collector Charles Rogers (1711–84), in his two-volume work, *A Collection of Prints in Imitation of Drawings* (London, 1778), described him as follows (vol.1, p.146), an account that was based, in turn, on the report in L. Pascoli, *Vite de' pittori, scultori ed architetti moderni* (Rome, 1730–36, vol.2, pp.138–9): 'He was low of Stature, deformed, and rendered lame by a fall; his Visage was long and wrinkled; his Complexion olive-coloured, and his Eyes chestnut; his Nose was big and flat, and he whore [*sic*] whiskers; his Forehead was large, furrowed, and bald, and his Hair white, and bristling up: but his Dress was gentile [*sic*], and generally black. Notwithstanding his disadvantageous figure, he had a peculiar talent to conduct himself properly with the Nobility.'
NT

61

CARLO DOLCI
Florence 1616–Florence 1686

St John the Baptist

Oil on canvas, oval, 53 × 38 in (134.5 × 96.5 cm)
INSCRIPTIONS on the scroll held by the figure
of St John the Baptist, *PARATE … [II] …DOMINI*
Cobbe Collection, no.381
HISTORY acquired at sale, Sotheby's, London,
11 April 1990, lot 56
LITERATURE Laing/Cobbe 1992, pp.2, 15, no.311;
Baldassari 1995, p.92, no.29w (as copy after
Dolci); London 1996b, p.34

1 Inv.no.41; Baldassari 1995, no.59, illus.
2 Inv.no.33; Baldassari 1995, no.60, illus.
3 A.S.F. *Guardaroba Medicea* 1185, l, c. 36 r.,
nos 37–8.
4 Chiarini 1975a, p.87, and Chiarini 1975b, p.83.
5 Baldassari 1995, p.92: '… *tra le tele citate più
ricorrentemente come autografe – ma che invece non lo
sono – ricordo il "San Giovanni Battista" in ovale già
Londra, Sotheby's, 11-4-1990, n. 56 … .*'
6 Inv.no.1134; Baldassari 1995, fig.59a.

cat. 61a

Cat.61a Carlo Dolci, *Study for the Figure of
St John the Baptist*, red chalk, 11½ × 9¼ in
(292 × 236 mm), *c.*1645
(Musée du Louvre, Paris)

Cat.61b Carlo Dolci, *St John the Baptist*, oil on
canvas, 47⅛ × 38⅛ in (120 × 94.5 cm), *c.*1645
(Museo Nazionale di Palazzo Mansi, Lucca)

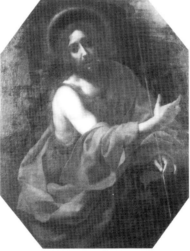

cat. 61b

St John the Baptist stands over half-length, draped in a
magnificent red cloak, beneath which his animal-skin tunic
may be glimpsed at his right shoulder and waist. His left
hand, in which he holds his reed cross decorated with a
scroll inscribed *PARATE … [II] … DOMINI*, rests on a rocky ledge,
while with his right hand he gestures towards a bright
aura behind him.

This is a version, with many minor differences, of Dolci's
upright, octagonal canvas of the same subject in the Museo
Nazionale di Palazzo Mansi, Lucca (cat.61a).[1] The Lucca
picture can be dated to 1645, owing to the signature and
date that appear on its pendant, the *St Anthony Abbot*, in the
same museum.[2] Both the Lucca pictures were formerly
in the Medici collections and are cited in an inventory of
pictures in the Palazzo Pitti drawn up in 1710,[3] and again
in 1713 among those kept in the apartment of the Gran
Principe Ferdinando de' Medici (1663–1713).[4] They were
transferred in 1847 to the Pinacoteca di Lucca by the last
Grand Duke of Tuscany, Leopoldo II of Habsburg-Lorraine
(1797–1870).

In her monograph on Carlo Dolci, Francesca Baldassari
dismissed the present picture as a copy, in spite of the fact
that it had previously been accepted as autograph.[5] Yet the
variations between the two works would seem to preclude
such a conclusion. These include the different angle of the
cross, which in the Cobbe picture is shorter and placed at
a different relationship to the hands; the inscription on
the banner; and the absence of a halo on the saint's head.
Moreover, the Cobbe picture appears to be unfinished in
the lower part of the canvas, especially in the passage where
the red drapery meets the rocks.

In her catalogue entry for the Lucca painting, Baldassari
first published a preparatory drawing by Carlo Dolci in the
Louvre, Paris (cat.61b),[6] which she connected with that painted version of the composition. However,
the configuration of the drapery in the drawing is closer in several respects to the Cobbe Collection
picture, especially in the passage near the lower edge and in the area between the two hands. Further-
more, like the present painting, the drawing shows the composition extending further downwards,
with the junction between the drapery and the rocky outcrop ill defined. The possibility that the
Cobbe picture is an autograph replica – one conceived especially for an oval format – seems worthy of
reconsideration. According to Baldassari, the deep *chiaroscuro* of the Lucca *St John the Baptist* illustrates
the change in style seen in the artist's work of the mid-1640s, as he moved towards a more sombre
and introverted manner.

NT

62

LUCA GIORDANO
Naples 1634–Naples 1705

Lamentation over the Dead Christ

Oil on canvas, 46 × 62¾ in (117 × 159.5 cm)
INSCRIPTIONS on the reverse, on the stretcher:
inscribed on label, attached with a red lacquer
seal, *EIGENTÜMER: / DR. ING. MICHEL ENGELHART /
WIEN III / 40 STEINGASSE 13 / AUS DEM NACHLASSE
VICTOR VON MAUTNER / MARKHOF, 1928*; printed
number, *25*; inscribed on another label, attached
with two red lacquer seals, *Carragi Ludovica /
Ehemals Galleria Contarini degli / Scrigni Palazzo. - /
Gegenwärtig. Besitzer Gräfin Mathilda / Berthold
Strachan*; numbered three times, in black chalk,
322; numbered, also in black chalk, *143* (encir-
cled); on the frame: inscribed on label, *Carracci
(Lodovico) / 1555–1619 / Cristo (in raccorciato) dopo la /
disceso della Croce*; inscribed on another label, *Graf
Be … d Arthur / tula … ma*; printed number, *59*;
another printed number, *S 342*; stamped in black
ink, *50*; inscribed on yet another label, *… Conta /
rini delle Scrigni … / Berchtold Strachan Mathilda / …*
Cobbe Collection, no.380
HISTORY Contarini family, gallery of the
Palazzo Contarini degli Scrigni, Venice (as by
Ludovico Carracci); Graf Arthur Berchthold
and by descent to Gräfin Mathilda Berchthold
Strachan; Victor von Mautner-Markhof, before
1928; Michel Engelhart, Vienna, thence by
descent; acquired at sale, Christie's, London,
9 April 1990, lot 76
LITERATURE Laing/Cobbe, 1992, pp.2, 16,
no.317, illus.

1 Orally, to Alec Cobbe, in January 2001.
2 Baldinucci/ed. Ferrari 1966, pp.89–96
and 129–38.
3 Lightbown 1986, no.23, illus.
4 Ibid., no.42, illus.
5 Christiansen 1992, p.155.
6 Kristeller 1901, doc.190.
7 Luzio 1913, p.115, no.318.
8 Christiansen 1992, p.158.
9 D'Onofrio 1964, p.207, no.260.

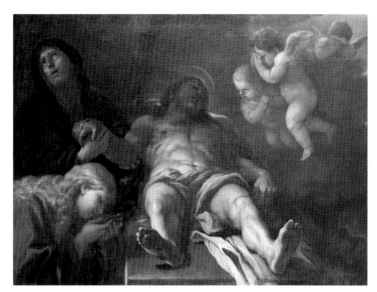

One of the most cele-
brated painters of the
Neapolitan Baroque,
Luca Giordano was
immensely prolific.
His output includes
altarpieces and mytho-
logical paintings, as
well as large-scale
fresco cycles in churches
and palaces. He experi-
mented ceaselessly
with other styles, espe-
cially in the first half
of his career.

The traditional attri-
bution to Giordano of
this powerfully conceived, but sombre composition has been recently confirmed by Prof. Nicola
Spinosa,[1] who commented that it was probably painted during the late 1660s, while the artist was
working in Venice. According to the biographer Filippo Baldinucci (1625–97), in 1665 Giordano
joined the Neapolitan painters' confraternity and in the same year travelled to Florence and from
there to Venice, where he stayed for six months.[2] His pictures from this period, such as the altar-
pieces for the church of S Maria della Salute, Venice, combine Venetian sources (e.g. Titian) with
the art of the Roman and Neapolitan Baroque.

Spinosa's proposed dating of the picture to the artist's Venetian period is supported by its early
provenance, since for many years it was in Venice in the gallery of the Palazzo Contarini degli Scrigni.
This, along with the Palazzo Contarini-Corfu, was inhabited in the early 19th century by the last
surviving members of the famous Contarini family, one of the oldest, richest and most powerful
patrician families in Venice. Over nine centuries, it had produced eight doges and numerous high-
ranking officials, who were also outstanding art patrons and collectors. (The ceiling over the Golden
or Spanish Room at Kingston Lacy comes from one of the rooms in the Palazzo Contarini degli Scrigni.)

As in Giordano's other Venetian work, the dramatic rendering of the Cobbe painting was based
on an earlier, North Italian Renaissance prototype, for it vividly recalls a composition of the same
subject of *c*.1500 by Andrea Mantegna (1431–1506), now in the Brera, Milan (cat.62a).[3] So close is it
in design – for example in the position of Christ's left forearm and hand, the angle of his head and
the humble reconciliation of his expression – that it seems impossible that Giordano should not
have seen this work, either in the original or in reproduction, the pathos and daring foreshortening
directly inspiring his own painting. It is not known for certain where Mantegna's *Lamentation over
the Dead Christ* was in the mid-17th century, but it seems to have been among the late works left in
his studio on his death in 1506. At least one other late work, the haunting *St Sebastian*, also left in the
studio when the artist died, eventually ended up and still is in Venice, in the Ca' d'Oro,[4] the most
distinguished of the 25 palaces constructed by the Contarini family.

Surprisingly little is known about Mantegna's *Dead Christ*, despite its being one of his most
expressive and memorable images. It may have been painted for Ercole d'Este (1431–1505), Duke
of Ferrara,[5] though it is generally accepted as the '*cristo in scurto*' recorded in Andrea's studio at the
time of his death by his son Lodovico Mantegna.[6] That picture was taken by Cardinal Sigismondo

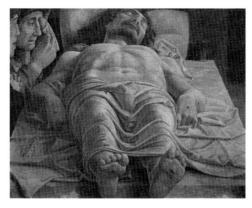

Cat.62a Andrea Mantegna, *Lamentation over the Dead Christ*, tempera on canvas, 20¾ × 31¾ in (68 × 81 cm), *c*.1500 (Pinacoteca di Brera, Milan)

Gonzaga (1469–1525), but in 1531 was installed in the apartments in the Castello di S Giorgio, Mantua, of Margherita Paleologa of Montferrat, the wife of Federico II Gonzaga (1500–40) and the new Duchess of Mantua. According to Lightbown, it is last certainly listed in 1627 in Mantua, in the Camerino delle Dame of the Palazzo Ducale.[7]

Keith Christiansen, however, has suggested that what Lightbown incorrectly assumed was another version on panel, recorded in 1626 in the collection of Giorgio Aldobrandini (*d*.1637) in the Palazzo Doria-Pamphilj in the Via del Corso, Rome, was actually the same Brera picture.[8] The apparent discrepancy in the support is clarified, as Christiansen further noted, in an inventory of 1665, when the palazzo and its collections were in the possession of Giorgio's only child, Donna Olimpia Aldobrandini (1623–81), wife of Paolo Borghese (*d*.1646) and later of Prince Camillo Pamphilj (1622–66); in this inventory the composition is described as painted 'on a canvas mounted on a panel'.[9] This picture is documented in the Palazzo Doria-Pamphilj in Roman guidebooks until the late 18th century. What is definitely the Brera picture was bought in Rome in 1806 – at a time when the Aldobrandini were selling works from their collection – by the painter Giuseppe Bossi (1777–1815), from whose heirs it was acquired in 1824 by the Accademia di Brera, Milan.

It is, therefore, probable that instead of seeing the original in Venice, Giordano took with him a powerful visual memory of a work that he had seen in Rome, either about 1652 (the date of his first journey to the Eternal City), when the 18-year-old was enthusiastically absorbing influences from countless different sources, from Pietro da Cortona (1596–1669) to Peter Paul Rubens (1577–1640), or in 1665, when he was *en route* from Naples to Florence and Venice.

According to Spinosa, a copy of cat.62 by Giordano's pupil Paolo de' Matteis (1662–1728) is in the church of Guardia Sanframondi, Benevento.

NT

63

LUCA GIORDANO
Naples 1634–Naples 1705

The Devil Tempting Christ to Turn Stones into Bread

Oil on canvas, 24 × 17 in (61 × 43 cm)
Cobbe Collection, no.367
HISTORY acquired at sale, Christie's, London,
28 October 1988, lot 9 (as by Paolo de' Matteis)
LITERATURE Laing/Cobbe 1992, p.15, no.313

1 Ferrari and Scavizzi 1992, no.A367b, illus.
2 Pigage 1778, vol.2, p.158.
3 Ferrari and Scavizzi 1992, no.A367a, illus.

Cat.63a Engraving (detail of cat.63c) after
Luca Giordano, *The Devil Tempting Christ to Turn
Stones into Bread*, oil on canvas, 99⅝ × 72¼ in
(254 × 179 cm), *c.*1685 (Bavarian State Collections,
Munich, on deposit at Schloss Schlessheim)

Cat.63b Francis Holl after Luca Giordano,
The Devil Tempting Christ to Turn Stones into Bread,
engraving, 6³⁄₁₆ × 4⁷⁄₁₆ in (152 × 113 mm)
(Witt Library, Courtauld Institute of Art,
London)

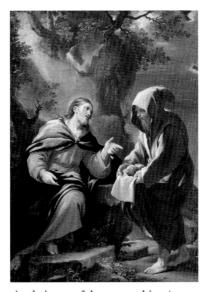

The subject of Christ's three temptations after 40 days in
the wilderness is rare in Christian iconography. Here the
first temptation is shown, when the Devil, in the cunning
guise of a hermit, invites Christ to abuse his powers by
turning stones into bread: 'If you are the Son of God, com-
mand these stones to become loaves of bread' (Matthew
4:3), to which Christ gave his oft-quoted reply: 'Man shall
not live by bread alone'. The rocks are proffered to him in
the hermit's apron, as if they were lumps of dough, the
hermit's sinister intentions being conveyed by his furtive
look – the upper part of his face is cast into shadow by the
cowl he wears over his head – and his claw-like thumb- and
toenails, traditional attributes of Satan. Christ is shown
seated at a rocky ledge discoursing politely with the impos-
tor, in an attitude akin to that he adopts in representations
of Christ and the Samaritan Woman.

The Cobbe Collection picture is related to the larger-
sized picture of the same subject (100 × 70½ in [254 × 179 cm]), formerly in the Electoral Gallery at
Düsseldorf and now in the Bavarian State Collections, on deposit at Schloss Schleissheim, Munich
(cat.63a).[1] There are only minor differences between the two versions, such as the Devil's hood (peaked
rather than rounded). As is clear from an engraving of 1778 of the pictures on the '*troisième façade*' of
the third room ('*troisième salle dite des Italiens*') in the Düsseldorf gallery (cat.63c),[2] the painting was
one of four works on that wall by Luca Giordano. It was hung as a pendant to another picture, at the
top left, also by Giordano and also now on deposit at Schloss Schleissheim, of *Christ and the Samaritan
Woman*,[3] a composition that mirrors many of its formal and figurative elements. The two pendants
have been accepted as autograph works by Giordano by Ferrari and Scavizzi, who date them to *c.*1685.

Giordano was one of several Italian artists patronised by Johann Wilhelm [Jan Willem], Elector
Palatine of the Rhine and Count Palatine of Neuburg (1658–1716), whose second wife, Princess Anna
Maria Luisa de' Medici (1667–1743), encouraged an open artistic exchange between Düsseldorf and
Italy. As a result of their marriage, the Medici collections in Florence were enriched by paintings by

cat. 63a *cat. 63b*

Cat.63c *Troisième salle, troisième façade*, engraving from part 3 of N.de Pigage, *La Galerie électorale de Düsseldorf ou catalogue raisonné et figuré de ses tableaux* (Basle, 1778), vol.2, p.158

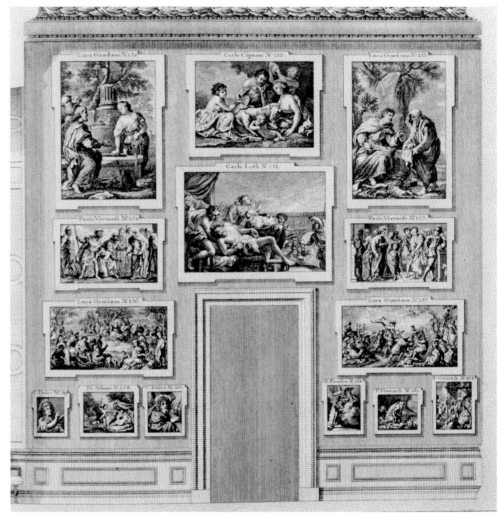

cat. 63c

Northern artists, while many examples by famous Florentine painters, such as Raphael (1483–1520), Andrea del Sarto (1486-1-530) and Federico Barocci (*c*.1535–1612), were shipped to Germany. An avid collector, the Elector was advised by Jan Frans van Douven (1656–1727), who enlarged the collection to nearly 350 pictures and also became its first director. From 1710 the paintings were housed in the Electoral Gallery, which was specially designed by the architect Jacob du Bois.

The Cobbe picture does not seem to be a *modello* for the ex-Düsseldorf picture. The most plausible explanation is that it is simply a *ricordo* or reduced replica, probably a specially commissioned reduction for a private collector's cabinet or chapel. Indeed, the slightly more saccharine visage of Christ in the present work implies a devotional function. Interestingly, the Cobbe Collection version of the composition (with Christ's sweeter expression and the Devil in a peaked hood) was engraved as by Giordano by the English reproductive printmaker Francis Holl (1815–84). Unfortunately, the print (cat.63b), a proof state of which is in the Witt Library, London, does not give the location of the painting at the time, but Holl was active in London and Milford (Godalming).

NT

64

ATTRIBUTED TO GIOVAN BATTISTA BEINASCHI
Fossano, nr Turin 1636–Naples 1688

Head of an Apostle or a Monastic Saint

Oil on canvas, mounted on board,
18 × 13¾ in (45.5 × 35 cm)
Cobbe Collection, no.357
HISTORY acquired at sale, Sotheby's, London,
29 October 1986, lot 9 (as by Gaetano Gandolfi)
LITERATURE Laing/Cobbe, 1992, p.15, no.312

1 *Cf.* the diagram in Hall 1974, p.263.
2 *Cf.* the head of St Francis of Sales in Sacchi's
altarpiece of *Sts Francis of Sales and Francis of Paula*
of *c.*1640 in the church of S Maria in Via,
Camerino (Sutherland Harris 1977, no.62, illus.),
and the figure of Zacharias in Sacchi's altarpiece
of the *Birth of the Baptist* of 1648–9 in the Lateran
Palace, Rome (ibid., no.56, illus.).
3 London 1984, nos 8 and 9, both illus.
4 Sale, Sotheby's, London, 4 July 1990, lot 41,
illus.
5 Pérez Sánchez 1964, no.257.

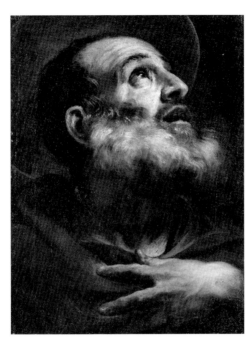

Although the figure in this painting was previously identified as an Apostle, it could have been intended to represent St Francis: the dark brown colour of the garment and the way in which it is folded about the neck suggest the presence of a hood at the back of the shoulders, much in the style of a Franciscan habit.[1]

The spirited handling of the paint, which is especially confident in the face and beard, suggests the work of two close followers of Giovanni Lanfranco (1582–1647), namely Giacinto Brandi (1621–91) and Giovan Battista Beinaschi (1636–88). Their common interest in the work of Lanfranco resulted in styles that are so similar that the paintings of one artist are often confused with those of the other. Characteristic of all three artists is the distinctive physique of the head, with the eyes ecstatically upturned, the lips slightly parted, as in wonder, and the abundant, spatulate beard.

Influences from other Roman painters, such as Andrea Sacchi (1599–1661), to whom this picture was formerly tentatively attributed,[2] and Guglielmo Cortese (1628–79), are not inconsistent with the authorship of Beinaschi, the more likely of the two Lanfranco imitators. The Cobbe head – with its 'corrugated' brow and feathery grey beard – is comparable to similar motifs in works by Beinaschi, such as the series of four pairs of saints, *Sts Matthew and Mark* and *Sts Anthony Abbot and Paul* (both formerly with the Heim Gallery, London),[3] and *Sts Peter and Paul* and *Sts Luke and John* (both now in an Italian private collection), and the figure of the elderly priest, with an equally expressive hand, in the *Vestal Virgin Tuccia*, formerly on the London art market.[4] All five of these pictures were at one time attributed to Brandi, until they were recognised as by Beinaschi by Erich Schleier. Other works that support the attribution of the present work to Beinaschi include the *Lamentation of Adam and Eve over the Body of Abel* (Madrid, Academia de San Fernando),[5] in which Adam, on the right, has the same open-mouthed expression (to signify his sense of sorrow and disbelief over the death of one of his sons at the hands of another son). Another such work is *Lot and his Daughters* (London, Buckingham Palace, Royal Collection), where the bearded, elderly figure of Lot is seen holding a cup of wine and looking up towards the right at his daughter, his eyes glazed over from the effects of alcohol – an expression not that far removed from the rapture and awe conveyed in the eyes of the present Apostle or saint.

Beinaschi received his initial training in Turin but by 1652 had settled in Rome. There he studied engraving with Pietro del Pò (1610–92), who set him the task of making copies after Annibale Carracci's frescoes in the Galleria Farnese, as well as after Lanfranco's frescoes in S Andrea della Valle and S Carlo ai Catinari. Even after moving to Naples in 1664, Beinaschi remained deeply influenced by the illusionism of Lanfranco, as can be seen in such late works as the frescoes of *Paradise* in the dome and pendentives of SS Apostoli, Naples.

NT

65

ATTRIBUTED TO GIOVANNI SEGALA
Venice 1663–Venice 1720

Pietà

Oil on canvas, 94 × 51¾ in (239 × 130.5 cm)
Cobbe Collection, no.359
HISTORY acquired at sale, Christie's, London,
11 December 1986, lot 101b
LITERATURE Laing/Cobbe 1992, p.15, no.314,
p.16, illus.; London 1996b, pp.34, 15 illus.

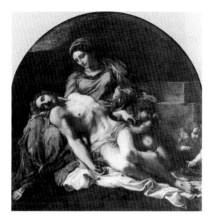

Cat.65a Annibale Carracci, *Pietà*, oil on canvas,
61¼ × 58½ in (156 × 149 cm), *c*.1599–1600 (Museo
e Gallerie Nazionali di Capodimonte, Naples)

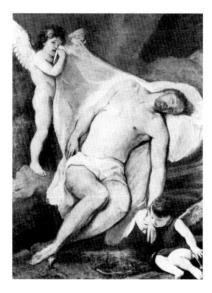

Cat.65b Giovanni Segala, *Dead Christ Mourned by
Two Winged Putti*, oil on canvas, 78½ × 57½ in
(200 × 146 cm) (Galleria dell'Accademia, Venice)

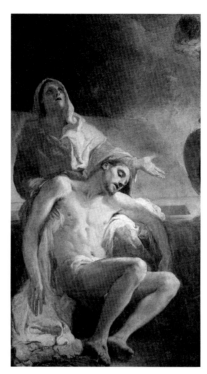

The attribution of this impressive canvas to the obscure
Venetian Late Baroque painter Giovanni Segala is due
to Charles Beddington and has been enthusiastically
endorsed by Prof. Francesco Valcanover. Long a backwater
in the history of Italian art, 17th-century Venetian painting
is still neglected by specialists; indeed, obtaining the
necessary information to pinpoint the present attribution
has proved difficult.

Segala's reputation was not always at such a low ebb.
Towards the end of the 18th century, his work was praised
by Antonio Maria Zanetti the younger (1706–78), the
important chronicler of Venetian painting from its origins
until his own day. Zanetti rated Segala one of the '*genii più
forte in Pittura all'età sua*' ('greatest geniuses in the painting
of his time'), and as the '*autore d'uno stile nuovo ed originale*'
('author of a new and original style'). Among Segala's note-
worthy qualities, Zanetti singled out his '*sapor pittoresco*'
('painterly taste'), and his clever use of pastel hues, which
contrasted with the darker shading of his backgrounds.

A revival of interest in Segala's work began around the
middle of the last century, thanks to the enthusiasm of a
small band of Italian art historians, among them Roberto
Longhi and Wart Arslan, a process that culminated in the short article on the artist published nearly
35 years ago by Nicola Ivanoff.[1] In Ivanoff's study, a handful of securely attributed paintings and
drawings was discussed and Segala's artistic personality briefly defined. Yet in spite of this contribu-
tion, our knowledge of the artist's oeuvre remains discouragingly inadequate.

As Zanetti was the first to imply, Segala's paintings occupy a significant place in the transition
between the Baroque and Rococo styles in Venice. In this respect, the artist's position is analogous
to that of his much better-known, younger contemporary, Giovanni Battista Piazzetta (1683–1754),
whose dramatic compositional inventions and bravura brushwork anticipate some of the aspects of
the later Venetian Rococo style. A penchant for a light, restricted tonal range is similarly to be found
in the work of other Venetian masters active in this watershed period, such as Gregorio Lazzarini
(1655–1730), Sebastiano Ricci (1659–1730) and Giovanni Antonio Pellegrini (1675–1741).

A particular point of departure for the lighter colouring in Segala's work are the paintings of
the Neapolitan artist Luca Giordano (cats 62–3), whose six-month visit to Venice in 1665 greatly
influenced painting in the city, and from whom Segala could have derived his strongly sculptural,
even classical conception of form, which, in Giordano's case, derived from the Roman Baroque of
Pietro da Cortona (1596–1669). Indeed, in the expression of the Virgin and the languid pose of the
dead Christ, Segala's remoulding of the Roman Baroque in the Cobbe *Pietà* goes back beyond Pietro
da Cortona to Annibale Carracci (1560–1609), and to his well-known *Pietà* in the Museo e Gallerie
Nazionali di Capodimonte, Naples,[2] a picture generally dated *c*.1599–1600, in which the figures
appear with many differences, in reverse (cat.65a).

Although the purpose of Segala's *Pietà* is not known, it must have been intended as an altarpiece.
This conclusion is supported by the narrow, upright format, and by the intense feeling that the artist
communicates through his treatment of the subject. The poor preservation of the paint in some areas,
however, makes it unclear whether or not the canvas was brought to completion.

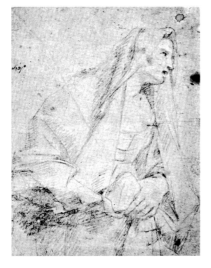

Cat.65c Giovanni Segala, *Standing Woman Seen in Profile to the Right*, red and some white chalk on grey paper, 13 ¾ × 10½ in (350 × 268 mm) (Rijksmuseum, Amsterdam)

1 Ivanoff 1966, pp.767–71.
2 Cooney and Malafarina 1976, pl.LIV.
3 Moschini-Marconi 1970, no.229, illus.
4 Cooney and Malafarina 1976, pl.LVI.
5 Ivanoff 1966, p.769, fig.505.
6 Inv.no.1955:125; see Amsterdam 1973, no.120, illus.
7 Pallucchini 1960, fig.122.

The composition of the Cobbe *Pietà* is dominated by the inert body of Christ, which occupies almost half of the picture space, the light cream colour of the corpse contributing significantly to the picture's overall lightness of key. The pallor of Christ's nude body is beautifully complemented by the pastel shades of burgundy and cobalt of the Virgin's robes. The rough finish – which is so defining a trait of Segala's work – is seen at its most emphatic in the deep folds of the blood-stained winding-sheet, which is piled up in the lower left corner, providing a suitable foil for Christ's limp right hand, with the nail wound in the middle plain to see (the prominence of the hole echoes the way in which Carracci displays the wound in Christ's foot against the winding-sheet in the Naples *Pietà*). Lying on the ground in the Cobbe picture, immediately below Christ's right hand, are the great metal nails themselves, strewn randomly over the Crown of Thorns. In contrast to the light colours are the dusky reddish browns of the sepulchre interior and the side of the tomb. It is against such a dark setting, in the top left, that the Virgin's agonised face is glimpsed as she looks heavenwards, half of her strongly featured face in shadow.

Among Segala's other painted work, the closest parallel to the Cobbe picture is the *Dead Christ Mourned by Two Winged Putti* in the Accademia, Venice (cat.65b).[3] In the Venice picture, the way in which Christ's dead body dominates the composition is very similar, as are Christ's features and the resigned attitude of his head; indeed, the same muscular young model seems to have been employed to pose for both figures. Interestingly, the Venice picture too has a prototype in Carracci's painted work, the figure of Christ depending almost directly, again in reverse, on the Christ in the *Pietà with Sts Francis and Mary Magdalen*, painted around 1602–7 and now in the Louvre, Paris.[4] Other similarities between the Cobbe and Venice pictures are Segala's 'dry' handling of the white paint in the winding-sheet; the harmonies of the creamy palette, combined with the occasional light pink or blue; and the use of a sombre brown to provide appropriate contrast.

Another parallel in composition and handling may be found with Segala's *Death of St Lorenzo Giustiniani*, one of the cycle of four canvases painted by the artist before 1712 that decorate the walls of the tribune of the church of S Pietro di Castello, Venice.[5] The way in which the figures are disposed in the lower half of the elongated upright of the canvas, and the sculptural, yet painterly treatment of the draperies, recall many of the passages found in the Cobbe picture.

Finally, mention must be made of a drawing of a *Standing Woman Seen in Profile to the Right* in the Rijksmuseum, Amsterdam (cat.65c),[6] which L. Frerichs identified as a study for one of the spectators in Segala's *Preaching of St John the Baptist* in the Scuola di S Giovanni Evangelista, Venice.[7] The pronounced and rather heavy features of the woman in the Amsterdam drawing are close to those of the Virgin in the Cobbe picture, and the possibility that they were taken from the same model cannot be excluded.
NT

66

FRANCESCO DE MURA
Naples 1696–Naples 1782

The Madonna and Child Presenting St Dominic with the Rosary

Oil on canvas, 29¾ × 20 in (75.5 × 51 cm)
Cobbe Collection, no.452
HISTORY acquired at sale, Sotheby's, London,
23 April 1998, lot 159, illus. (in colour)

1 Witt Library, London, Alinari photo no.34080.
2 Another example, on deposit at the Museo e
Gallerie Nazionali di Capodimonte, Naples,
but exhibited at the Museo 'Duca di Martina',
is the *modello* (154 × 102 cm) for the altarpiece
(450 × 220 cm) of the *Madonna Showing the
Monogram of Christ to St Luigi Gonzaga* (*c*.1758;
church of Gesù Vecchio, Naples); see Naples
1980–81, no.18, illus.; an autograph replica
of the same composition is in the Ringling
Museum of Art, Sarasota, Florida. For further
examples, see Naples 1980–81, nos 53–59b,
all illus.

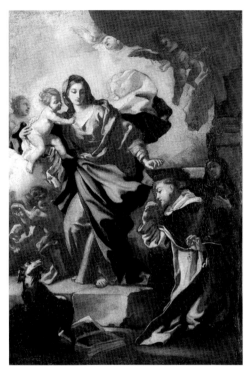

This *modello* is related in composition to a *bozzetto*
of the same subject in the Museo Nazionale di
S Martino, Naples:[1] the intended altarpiece for
which they were made appears not to have sur-
vived or indeed may never have been executed.
Prof. Nicola Spinosa has dated the commission
c.1735–40 on the grounds of style.

De Mura was first trained in his native city
in the studio of Domenico Viola (*c*.1610/20–1696),
transferring in 1708 to the workshop of Francesco
Solimena (1657–1747), where he became the
master's favourite pupil and most trusted collab-
orator. In his early independent work, de Mura
was a faithful interpreter of Solimena's monu-
mental Baroque style, but he gradually evolved
his own, slightly more disciplined style, with
gentle rhythms and light, airy colours. The pres-
ent work is a good example from this transitional
phase towards a more personal style, executed
just before the artist's stay in Turin (1741–3), where
he served the court of Savoy and where he came in
contact with Rococo paintings by other European
artists. De Mura's painted compositions often survive in multiple versions, including both *modelli*
and *bozzetti*, as well as autograph replicas, reductions and studio copies.[2]

NT

67

POMPEO BATONI
Lucca 1708–Rome 1787

Portrait of a Man, possibly the Rev. John Charles Beckingham

Oil on canvas, 29½ × 24 in (75 × 61 cm)
18th-century carved and gilt frame
Cobbe Collection, no.278
HISTORY possibly Mrs Montague, the only
child of Stephen Beckingham (the brother of
the apparent sitter); by descent to Mrs Catherine
Brickdale; sale, Christie's, London, 19 July 1985,
lot 82 (to Lord Iliffe); Langton, 2nd Baron Iliffe,
Basildon Park, Berkshire; bequeathed by him
to Alec Cobbe
LITERATURE Clark 1985, no.254

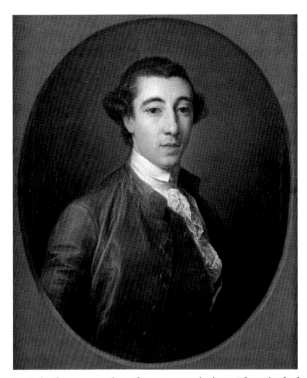

Unknown until its appearance in
1985, this is a characteristic example
of Batoni's portraiture of the 1760s
or thereabouts, which Anthony M.
Clark considered to be 'modest, but
extremely fine'. He further suggested
that the drawing of the features and
the handling of the paint point to
a date of *c.*1762. Like the portrait tra-
ditionally identified as John Hatch
(cat.43), it is of the standard Roman
size, approximately 29 × 24 in (75 ×
61 cm), which corresponds closely to
its English, so-called 'three-quarter-
length', counterpart of 30 × 25 in
(76 × 63.5 cm). While most of Batoni's
more spectacular Grand Tour portraits
are of larger format, some of his more
sensitive and direct likenesses are of
this scale. Demand for his portraits was,
however, so great that, in the 1760s and
1770s in particular, he employed assis-
tants in the preparation of most commissions. These included not only the German Johann Gottlieb
Puhlmann (1751–1826) – the extent of whose contribution to the workshop is documented in his
reminiscences – but also such passing pupils as the young Nathaniel Dance (1734–1811). Batoni was
very alert to the social standing, wealth and influence of patrons, and the degree of delegation tends
to be greater in portraits of the relatively obscure. Set in a feigned oval and with its brown costume,
this canvas represents Batoni's production at its most economical.

The identity of the sitter cannot be clearly established, although he is traditionally identified
as the Rev. John Charles Beckingham, who was a son of Stephen Beckingham of Bourne Park, Kent;
John Charles's elder brother, Stephen Beckingham (1730/31–1813), was in Rome in 1752–3 and was
one of a number of young men from Kent families on the Grand Tour who were painted by Batoni
in that decade. There is, as yet, no evidence that John Charles Beckingham made the Grand Tour,
and no particular family likeness between this portrait and that of Stephen Beckingham. While
some recorded portraits of this period by Batoni remain untraced, it seems impossible to link the
painting under discussion with any of these. Lord Iliffe, who acquired this picture in 1985, was one
the few collectors to collect in the Grand Tour tradition in the post-war years, and he also purchased
eight of Batoni's celebrated series of apostles from the Merenda Collection for his collection at
Basildon Park.

FR

68

SPANISH SCHOOL,
mid-17th century

Study of the Head of a Man

Oil on canvas, 13¾ × 12⅛ in (35 × 31 cm)
INSCRIPTIONS on the reverse, on the stretcher:
two similar red wax heraldic seals (cat.68a)
Cobbe Collection, no.437
HISTORY acquired at sale, Christie's, New York,
16 October 1997, lot 73 (as Bolognese School)

1 Naples 1992, no.1.37, illus.
2 Ibid., no.1.51, illus.
3 *Cat. National Gallery* 1973, p.497, no.74, illus.
4 Ibid., p.498, no.5931, illus.

Cat.68a Heraldic seals in red wax on the reverse
of the stretcher of cat.68

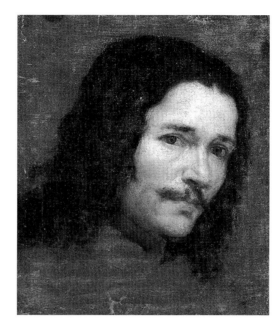

This lively, unfinished sketch was probably painted from life, possibly as a study for the head of a figure to appear in a history picture rather than as a portrait in its own right. There is no trace of underdrawing, suggesting that the sketch were done with the brush straight onto the reddish-brown prepared canvas. The sitter gives the impression of being caught unawares, his surprised expression accompanied by the vestige of a smile. Although his head is lowered and turned in three-quarter view, his eyes stare out directly at the spectator.

The handling is masterly: the darks in the hair and collar are painted freely with a thin mixture of black, while the creams and pinks of the flesh are built up more deliberately with thicker impasto. Of great sensitivity and assurance are the treatment of the mouth, including the upper lip partly covered by the young man's incipient moustache, and the area surrounding the right eye, where the modelling in mauves, pinks and creams is splendidly set off by the dark brown iris and black eyebrow.

The picture's attribution is still under debate. Although acquired as by an artist of the 17th-century Bolognese School, it is very probably Spanish, as a number of recent experts, including Simon Dickinson and David Jaffé, have pointed out. Parallels in facial type and colouring (though not in touch) may be found in the work of Jusepe de Ribera (1591–1652), the Spanish-born painter long active in Italy, as well as in that of the Sevillian Bartolomé Esteban Murillo (1617/18–82). Among the rather similar heads to be found in Ribera's paintings are those in *St James Major* of 1631 in the Prado, Madrid,[1] and *St James the Major* of *c*.1632–5 in the Patronato de Arte de Osuna, Seville.[2] The sitter's upbeat expression is, however, more like Murillo's figures, for example the *Peasant Boy Leaning on a Sill* in the National Gallery, London,[3] painted towards the end of the artist's career. Moreover, a similar physical type may be found in the young man in the left background of *Christ Healing the Paralytic at the Pool of Bethesda*, also from the painter's late period and also in the National Gallery, London.[4] In spite of these resemblances, the present *Study of a Head* does not appear to be by either artist. A convincing attribution remains to be found, probably among the many artists active in Spain in the wake of another, slightly earlier Sevillian painter, Diego Velázquez (1599–1660), whose extraordinary sense of colour and intuitive brushwork also seem to have a bearing on the style of this haunting sketch.

NT

69

GERRIT VAN HONTHORST
Utrecht 1592–Utrecht 1656

Allegory of Taste

Oil on canvas, 33 ⅜ × 26 ⅜ in (85 × 67 cm).
Cobbe Collection, no.456
HISTORY probably George Pitschaft, Mainz;
probably his sale, Paris, Jaluzot, 11 April 1811,
one of four in lot 85; estate of Marian T. Carew;
acquired at sale, New York, Sotheby's, 21 May
1998, lot 287, illus. (as 'Studio of Honthorst').

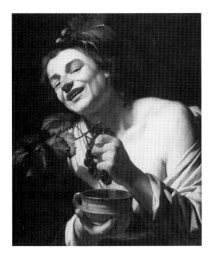

Cat.69a Gerrit van Honthorst, *A Smiling Young
Man Squeezing Grapes into a Cup (? Allegory of Taste)*,
oil on canvas, 32 ¾ × 26 ¼ in (83.5 × 66.5 cm),
1622 (Worcester Art Museum)

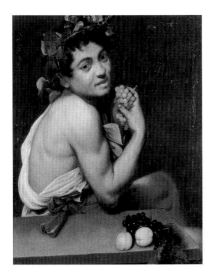

Cat.69b Caravaggio, *Young Boy with a Garland
of Ivy ('Sick Bacchus')*, oil on canvas, 26¼ × 20¾ in
(83.5 × 66.5 cm), c.1593 (Galleria Borghese,
Rome)

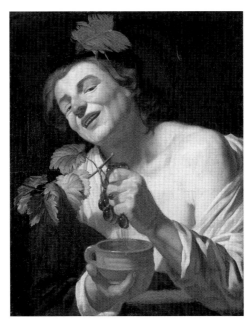

This is an apparently autograph repetition, to the same scale (32¾ × 26¼ in) but with slight differences, of the prime version of the subject by Honthorst, signed and dated 1622, in the Worcester Art Museum (cat.69a).[1] Honthorst made replicas of many of his compositions, and the numerous *pentimenti* in the Cobbe Collection painting – including changes to the contours of the youth's upper right forearm, the upper line of his shoulder, the hairline above his right eye, and the line of his nose and chin – suggest that it, too, is by the master. The sensitivity of some of the alterations and refinements, such as the position of the figure's right thumb, indicate a creative intelligence behind the changes.

After training in the Utrecht studio of Abraham Bloemaert (1566–1651), Honthorst travelled to Italy between c.1610 and 1615. There he developed a style broadly based on that of Caravaggio (1573–1610) and his Roman followers, particularly Bartolomeo Manfredi (c.1580–c.1620). While in Rome, Honthorst enjoyed the patronage of prominent collectors, such as the Marchese Vincenzo Giustiniani (in whose palazzo he lived), and Cosimo II de' Medici, Grand Duke of Tuscany. After his return to Utrecht in 1620, he became the most famous member of the group of Dutch followers of Caravaggio collectively known as the Utrecht Caravaggisti.

Like the dated Worcester version, the present picture must have been executed shortly after Honthorst's return from Italy, when he was still strongly influenced by both Caravaggio and Manfredi. The composition has been related to Caravaggio's so-called *Sick Bacchus* of c.1593, a picture still in the Galleria Borghese, Rome (cat.69b),[2] which Honthorst would certainly have known from his Italian sojourn. The Borghese picture represents a half-length figure of the young Bacchus, wearing a crown of ivy leaves and a white toga draped across his chest (leaving his right shoulder bare) and holding up a bunch of white grapes in his right hand. The motif of a half-nude figure of Bacchus squeezing grapes until the juice runs out, in that case into a glass held by a drinker, occurs in a painting in the Galleria Nazionale d'Arte Antica, Palazzo Corsini, Rome, generally attributed to Manfredi and dating from the early 1610s.[3]

In a detailed study of the Worcester picture published in 1969, Judson offered two alternative interpretations of the subject-matter.[4] In his view, it was either one of a pair of moralising pictures warning against the evil effects of excessive drinking or a secularised allegory of Taste in a series of the Five Senses. He favoured the first of these interpretations, owing to the apparent absence of embodiments of the other four senses. In his revised *catalogue raisonné* of Honthorst's work (1999), he pursued the former option still further and subtitled the painting an 'Allegory of Excess'.[5]

There is considerable evidence, however, to suggest that the more conventional identification as an Allegory of Taste is correct. Old sale records show that Honthorst must have painted several series of the Senses. Five single female portraits on panel (30 × 25 *duim* [81 × 67.5 cm]), each picture representing one of the Five Senses, were included in the sale of Johan van der Linden van Slingeland held in Dordrecht on 22 August 1785, lot 190. More significant is the reference to four pictures by Honthorst sold in Paris on 11 April 1811 from the collection of George Pitschaft, the Customs Director for the

1 Inv.no.1968.15; Judson and Ekkart 1999, pl.141.
2 Ibid., fig.62.
3 Ibid., fig.63.
4 Judson 1969.
5 Judson and Ekkart 1999, no.249.
6 Ibid., pl.111.
7 Ibid., pl.112.
8 Ibid., pl.113.
9 Ibid., no.238.
10 Ibid., pl.135.
11 Utrecht and Brunswick 1986–7, no.42, illus.
12 Baltimore, San Francisco and London 1997–8, no.43, illus.
13 Ibid.

Elector of Mainz. These four paintings, each measuring 31 by 24 *pouces* (83.5 × 65 cm), were obviously intended to symbolise the Senses – either Hearing, Taste, Touch and Sight or, alternatively, two pairs of Hearing and Taste: '*Quatre figures, de grandeur naturelle, vues à mi-corps; l'une représente un Espagnol pinçant de la guitarre; l'autre une sorte de Bacchus pressant des raisins dans une coupe; la troisième une jeune femme riant au son de pièces de monnaie qu'elle fait tomber d'une main dans l'autre; et la quatrième, l'épaule découverte, tient un vase de cristal. Ces quatre Tableaux, d'un bon ton de couleur, seront divisés.*' Because the Worcester picture is thought to have been in the collection of Count Adam Gotlob Moltke (1710–92), Copenhagen, perhaps as early as 1777 (sold by his descendants in 1931), it may well be that it is the Cobbe version of 'Bacchus' that featured as the second item in the Pitschaft sale.

There are several known versions of *A Young Girl Counting Money*, the third composition representing either Touch or Hearing from this series. An unsigned example (32⅝ × 26 in [83 × 66 cm]) of *c*.1623 in the collection of the Count von Schönborn, Schloss Weissenstein, Pommersfelden, Germany[6] – which is in too poor condition to assess its authorship – cannot have been the canvas in the 1811 Pitschaft sale since it is documented at Pommersfelden as early as 1719. Interestingly, it has long been paired in the Schönborn collection with a composition by Honthorst of a *Merry Fiddler* (31½ × 25⅝ in [80 × 65 cm]);[7] this subject is also known in at least two autograph versions, the other, signed and dated 1624, formerly in the F. Brandeis collection, Qualicum Beach, British Columbia, and later with the dealers Johnny Van Haeften and Otto Nauman (32 × 24¾ in [81.5 × 63 cm]).[8]

The fourth composition in the Pitschaft sale may well have been the bare-shouldered *Merry Toper Holding a Drinking Glass* of *c*.1623, the present whereabouts of which are unknown.[9] It survives in five recorded versions, all thought to be copies. One of these (sale, Weinmüller, Munich, 5 March 1961, lot 870, illus., as Terbrugghen)[10] is particularly close in scale (32⅛ × 25⅝ in [81.5 × 65 cm]) to the Cobbe picture. Traditionally identified as an Allegory of Taste, it might also symbolise Sight, given the prominence of the transparent, patterned drinking glass, or *roemer*, held up to the light.

In the final analysis, there is no reason to assume that an allegorical representation of Taste could not also contain a message of moral admonition to the viewer. The Cobbe figure has certainly already imbibed a substantial quantity of his own fermented grape juice, as is evident from his intoxicated demeanour and ruddy complexion, nose and bloodshot eyes. The same potential dual meaning is hinted at in a painting of the *Five Senses* (*c*.1625–30; Niedersächsiches Landesmuseum, Hanover)[11] by Honthorst's fellow Utrecht Caravaggisto Jan van Bijlert (1597/8–1671): there the allegorical figure of Taste, seen on the far right squeezing grapes into his mouth with his right hand, is so drunk that he allows the wine glass in his left hand to spill its contents.

In a painting by Hendrick ter Brugghen (1588–1629) representing a scantily dressed *Young Woman Squeezing Grapes into a Dish, with a Monkey* (1627; J. Paul Getty Museum, Los Angeles), the moralising intent is considerably more explicit, due to the motif of the monkey or ape, a traditional symbol of inebriation often associated with the antics of drunken people. Its traditional identification as an Allegory of Taste has recently been revised in favour of an Allegory of Excess. However, apes also sym-bolised appetite and gluttony and since Renaissance times have been used as an attribute of Taste in depictions of the Five Senses. Moreover, the existence of a closely related painting by ter Brugghen, *Young Woman Reading from a Sheet of Paper*, depicting the very same model (1628; Öffentliche Kunstsammlung, Kunstmuseum, Basel),[12] suggests that the older interpretation of the Getty picture should be reconsidered. While the Basel painting's traditional nickname, '*Singing Girl*', was rightly rejected by the authors of the 1997–8 exhibition of Utrecht Caravaggisti[13] – because she is holding a printed text rather than sheet music – they do not seem to have considered the possibility that she could represent an Allegory of Sight.

NT

70

CORNELIS VAN POELENBURCH
Utrecht 1594/5–Utrecht 1667

Half-length Figure of a Bearded Man Leaning on a Staff

Oil on copper, 6½ × 5¼ in (16.5 × 13.5 cm)
INSCRIPTIONS signed at lower left centre,
with the artist's monogram, *C. P.*
Cobbe Collection, no. 402
HISTORY acquired at sale, Christie's South
Kensington, London, 26 September 1996, lot 74

1 Sluijter-Seijffert 1984, nos 198 and 200.

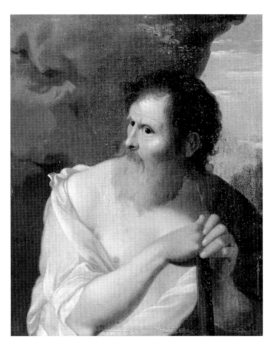

After serving an apprenticeship with
Abraham Bloemaert (1564–1651) in Utrecht,
van Poelen-burch may have been active as an
independent master for a few years in
Amsterdam. By 1617 he was in Rome, and in
1620–21 he worked for a while in Florence,
probably for Cosimo II de' Medici (*d.*1621),
Grand Duke of Tuscany (see cat.71), who was
the first of several noble and royal figures
whose patronage van Poelenburch enjoyed
throughout his successful career. Others
included Frederick V (1596–1632), Elector
Palatine (the 'Winter King' of Bohemia); the
Dutch Stadholder Prince Frederick Henry of
Orange Nassau (1584–1647); the English
king Charles I (1600–49); and Willem Vincent,
Baron van Wyttenhorst (*d.*1674), the artist's
most important patron.

This small painting of a half-length figure
of a bearded man leaning on a staff is typical
of the later work of Cornelis van Poelenburch, executed after his return from Italy. He was back in
the Northern Netherlands by April 1627 at the latest (and possibly already in 1625), at which point he
settled in his native Utrecht. On his return to the Netherlands, he continued to make small-scale
paintings on copper and panel. In addition to tiny, half-length, single figures of religious and histor-
ical subjects, van Poelenburch depicted shepherds and shepherdesses in the same format, often as
pendants, like those in the Musée des Beaux-Arts, Angers.[1] Such arcadian subject-matter had
become increasingly fashion-able in Utrecht in the 1620s, especially among the artists known as the
Utrecht Caravaggisti, for example Hendrick ter Brugghen (1588–1629), Paulus Moreelse (1571–1638)
and even van Poelenburch's teacher, Bloemaert.

The Utrecht Caravaggisti generally painted their pastoral figures on a larger scale (usually life-
size), and, like their mentor Caravaggio (1571–1610), they made a virtue of their matter-of-fact
depiction of reality (*cf.* cat.69). Their bold, naturalistic style had a profound influence on the way
in which both secular and religious themes were treated. Rejecting the elegance and artificiality of
Mannerism, Caravaggio and his followers strove for realism and stripped away the formality that
had been a customary feature of Christian iconography for centuries, emphasising, for instance,
the humanity of the martyrs, saints and apostles. Such religious figures thus began to be shown
as ordinary types, famously with dirty feet and toenails.

Although van Poelenburch's oeuvre falls largely outside these contemporary artistic develop-
ments in Utrecht, his work can be characterised by the same ambiguity that resulted from this
blurring of conventional iconographic boundaries. This is certainly true of the present example:
is the figure a saint, an elderly shepherd, a hermit in a cave or an allegory (perhaps of hearing)? The
serious gaze and pose might indicate a saint, and, indeed, traditionally he has been identified as
St John the Baptist leaning on a shepherd's staff. The problem, however, is that the only applicable
scene for St John the Baptist in a barren, rocky setting without other figures is John the Baptist
in the Wilderness (Luke 1:80), an event that occurred early in his life, at a time when he is usually
depicted as a handsome youth. Moreover, his traditional attributes – a reed cross, animal-skin

tunic, and a lamb – are all missing from the present composition.

The wrinkled visage, beard and age of the figure, his elegant, toga-like robe and simple rod or staff, his passively attentive pose (leaning forward, possibly in order to hear better) and his slightly cross expression – in short, a very different attitude to the heralding figure of John the Baptist in the Wilderness – together suggest another interpretation. If intended as a religious figure at all, the bearded man might represent either the father or husband of the Virgin. Joachim, her father, was a rich man, whose wife was barren after 20 years of marriage. Rebuked by the High Priest of the Temple of Jerusalem because he was childless, he dared not go home and instead went out and stayed with the shepherds in the desert (usually depicted as a rocky place), where the angel Gabriel announced that his wife Anne would conceive. The Virgin's husband, Joseph, is also depicted as an old, bearded man with a rod, though the latter is usually shown flowering (symbolising, since it was a spontaneous event, the Virgin's birth). Alternatively, and perhaps more plausibly, the figure in the Cobbe picture may well have been meant to be secular rather than religious – perhaps a philosopher, such as Diogenes, leading an austere and eremitic life away from the distractions of society.

Although somewhat damaged in places (erosion typical of a copper support), this well-executed little painting features the fine brushwork and subtle colour changes, especially in the transparent drapery and late evening sky, for which Cornelis van Poelenburch was so famous in his own time.
NS-S, JT

CORNELIS VAN POELENBURCH
Utrecht 1594/5–Utrecht 1667

St Joseph with the Christ Child

Oil on copper, 6¼ × 5¼ in (16 × 13.5 cm)
INSCRIPTIONS signed at lower left, with the
artist's monogram, *C.P./f*; on the reverse of
the frame: bookplate of Alec Cobbe
Cobbe Collection, no.449
HISTORY probably Willem Vincent, Baron
van Wyttenhorst (*d*.1674), Utrecht; Lord
Templemore, Dunbrody; acquired from Rafael
Valls, London, March 1998
LITERATURE Sluijter-Seijffert 1984, p.234, no.93

Cat.71a Adam Elsheimer, *St Joseph with the
Christ Child*, oil on silvered copper, 3½ × 2¾ in
(9 × 7 cm), 1605 (Petworth House, West Sussex)

1 London 1995–6, no.59(a)–(h), all illus.
2 d'Albenas 1914, p.232, no.835.
3 *Cat. Uffizi* 1979, pp.417–18, nos P1203, 1204,
and Schaar 1959, pp.34–5.
4 London 1995–6, p.162.
5 *Country Life* 23 March 1912, p.438.
6 Hollstein 1949–, vol.6, no.8. Laing is surely
correct to point out that neither of the etchings
by Wenzel Hollar (1607–77; see Parthey 1853,
nos 168 and 170) is directly after the original by
Elsheimer at Petworth (*St John the Evangelist*)
and Montpellier (*St Lawrence*).

When, early in his career, van Poelenburch started to work in Rome in 1617, he was exposed to the influence of several Northern artists active there, which had an obvious impact on both his early and later development. The Italianate landscapes of the Flemish painter Paul Bril (*c*.1554–1626), for instance, with their gently sloping hills bathed in bright sunlight, picturesque ruins and distant hill towns, had a bearing on his landscape compositions.

According to early sources (e.g. Sandrart), an important source of inspiration for van Poelenburch's figural style was the work of the German painter Adam Elsheimer (1578–1610), which was greatly admired in Rome at the time. The present picture is one of a group of exact copies that van Poelenburch made of what must originally have been a series of at least ten small-scale depictions of saints and biblical figures painted by Elsheimer around 1605. Eight of Elsheimer's originals are preserved at Petworth House, West Sussex (cat.71a),[1] and one further survivor from the series, *St Lawrence*, is in the Musée Fabre at Montpellier.[2] That there were originally at least ten images in the series is known from van Poelenburch's set of ten copies painted around 1620 and now in the Palazzo Pitti, Florence.[3] (Van Poelenburch's Palazzo Pitti set contains a representation of *Abraham and Isaac*, which is missing from the Elsheimer set.) Like Elsheimer's originals, which are painted on copper and measure 3½ × 2¾ in (9 × 7 cm), the Palazzo Pitti series by van Poelenburch is also on copper and is painted on roughly the same scale (4⅛ × 2⅞ in [10.5 × 7.5 cm]).

The Petworth series by Elsheimer seems to have been in the Grand Ducal collection in Florence by about 1619, but had been sold by 1635. The set by van Poelenburch now in the Pitti is recorded in the same collection from at least 1761, and Alastair Laing has plausibly suggested that van Poelenburch was commissioned to make the replacements for the Grand Duke just before the Elsheimers were to be sold.[4] In the case of the *St Joseph with the Christ Child*, van Poelenburch remained fairly faithful to the original, using identical postures for both the figures, and repeating the branches and leaves silhouetted against the sky, and the bare branch. However, the details are less clear, the outlines softer, the forms rounder and the colours lighter and more pastel-like.

Another large set of copies by van Poelenburch is preserved and adorns the so-called Dutch cabinet in the collection of Lord and Lady De L'Isle at Penshurst Place, Kent, as was pointed out by Laing.[5] It is this second set that implies that Elsheimer's set might once have been even larger, for although it is missing the *Abraham and Isaac*, it contains three images that are not in the Pitti series: a *St Catherine*, which does seem to reflect Elsheimer, and a *St Francis* and a *Mary Magdalene*, neither of which necessarily presupposes an original by Elsheimer.

As Laing has further noted, van Poelenburch's ten copies in the Pitti are made up of natural pairs: *St John the Baptist* and *St John the Evangelist*; *St Peter* and *St Paul*; *Abraham and Isaac* and *Tobias and the Angel*; the *Virgin and St Anne* and *St Joseph and the Christ Child*; but also *St Thomas Aquinas* and *St Lawrence*. That this last pair lacks any compositional or thematic link supports the hypothesis that the original series was still larger. Laing has suggested that Elsheimer's pairs may have flanked some central image or

object (e.g. a statue, relief or relic), and that the four images with children might point to an orphanage or infant school as the original setting.

This last idea receives further support from the additional individual copies that van Poelenburch made of what was evidently the most important pair in the series, the *Virgin and St Anne* and *St Joseph and the Christ Child*. The latter image was obviously the more significant, judging by the fact that the Cobbe Collection *St Joseph and the Christ Child* is one of two further surviving copies by van Poelenburch, and the fact that this image alone was the subject of one of Elsheimer's rare etchings.[6] The other painted version by van Poelenburch was on the Berlin art market in 1928, perhaps with the dealer Dr Schäffer, who had the picture by 1932; by 1933 it was in the possession of R. H. Ward, London, and in 2000 it was offered for sale in London at Christie's South Kensington (31 October 2000, lot 46). Like the Elsheimer original and van Poelenburch's copy in the Pitti, the present picture is painted on copper, whereas the ex-Schäffer/Ward version is on panel.

Both the Cobbe and ex-Schäffer/Ward versions are somewhat larger than van Poelenburch's earlier Pitti copy, and the figures are situated in a broader landscape. The colouring is also slightly different. In the Pitti version, Joseph is clothed in green with a yellow cloak, and the Christ Child is in blue with a little red cloak; here Joseph wears purple and yellow, while Jesus (who has darker hair) is in purple and red. The figures in both these copies show the heavy wrists and ankles typical of van Poelenburch, as well as rather round faces, with large black eyes virtually without any white. Together with the 'woolly' vegetation, these are the characteristics that date the later copies to the 1630s or even 1640s.

In 1790 a pair of pictures by van Poelenburch consisting of the *Virgin and St Anne* and *St Joseph and the Christ Child* was auctioned from the collections of the art dealer Johann Christian Kaller (1725–94) and his (?) son-in-law, Friedrich Christian Michael (1754–1813), in Frankfurt (sale, 25 August 1790, lots 393 and 394; both lots together bought by Dr Grambs for 33 fl.). Described as '4½ *Zoll* × 4 *Zoll*', the paintings' support is, unfortunately, not mentioned, so it is impossible to say whether this pair included either the Cobbe or ex-Schäffer/Ward version. What is presumably the same pair was sold at Christie's, London, in 1802 (18-19 June, lot 106 (a) and (b); the pair bought for £26.5s). Nor can one establish whether or not the present painting can be identified with the individual item that featured in any of the following sales: the picture described as '*Saint Joseph & l'Enfant jesus dans un paysage. Hauteur 4 pouces. Largeur 3 pouces*' that was in the Le Doux sale, Paris (Joullain & Saugrain), in 1782 (25 February, lot 33, bought for 52.17 *livres*); the 'small Landscape with St Joseph leading Christ' that appeared by itself, again at Christie's, London, from the collection of Clement Bellamy (*d. c*.1810 or before) in 1810 (19 June, lot 13, bought by Collins for £2.10s); or the 7 × 5 in 'Saint Joseph and Jesus' that featured in a sale in Dublin (Gernon) held 4–19 June 1832 (actual day of sale, 8 June 1832, lot 342).

It is, however, very likely that the version of the same subject that was in the collection of van Poelenburch's principal patron, Baron van Wyttenhorst, is identical to the Cobbe picture, to judge by the detailed description included in van Wyttenhorst's handwritten catalogue or inventory made in the 1650s, which mentions the painting's copper support: 'an upright landscape on a small copper plate very pleasant, where St Joseph is depicted with the Christ Child, by Corn. van Poelenburch, and have paid for it 72 guilders; it is a copy after Elshamer and is valued higher than the original ['*principael*'], that is without the frame'. This is far from the highest priced painting in Baron van Wyttenhorst's collection, but 72 guilders was at that time a very good price for a small painting.
NS-S, JT

72

CORNELIS VAN POELENBURCH
Utrecht 1594/5–Utrecht 1667

Christ on the Road to Emmaus

Oil on copper, mounted on panel,
7 × 7 in (18 × 18 cm)
INSCRIPTIONS signed at lower left, with
the artist's monogram, *cvp*; on the reverse of
the panel: printed Agnew label; of the frame:
bookplate of Alec Cobbe
Cobbe Collection, no.316
HISTORY Lord Suffield, Gunton Park, Norfolk;
acquired from Agnew's, London, 1982
EXHIBITIONS London 1982, no.23
LITERATURE Sluijter-Seijffert 1984, p.223,
no.83; Laing/Cobbe 1992, p.15, no.310

Cat.72a Cornelis van Poelenburch, *Landscape
with a Fortified Town on a Rocky Outcrop in the
Distance*, grey wash over black chalk,
233 × 316 mm (present whereabouts unknown)

1 New York 2001, no.20, illus.
2 London 1965, no.40, illus.
3 Sales, Sotheby's, London, 11 December 1996,
lot 122, illus., and Christie's, London, 13
December 1996, lot 209, illus.
4 *Cat. Burghley House* [n.d.], no.246;
photo in the Witt Library, London.

Like cat.70, this picture is a rather late composition by van Poelenburch. Although assigned to the 1660s when offered by Agnew's in 1982, it may be somewhat earlier, perhaps 1637 to 1641, the period when the artist was working in England at the court of Charles I, and the only time, after his return from Italy, that the artist was absent from Utrecht, where, in 1629, he married Jacomina van Steenre, the daughter of a notary and clerk of the court of Utrecht; she, like her husband, was a Roman Catholic.

The slightly elevated foreground, behind which the landscape slopes downwards, is a compositional formula that van Poelenburch often used. However, he usually left one side of such compositions open for a view into the far distance; only in his later work did he make use of a 'solid', cut-off composition. The view is blocked by high trees in the middle ground on the left half, which is combined with a distant high hill on the right, on top of which is a typical Central Italian hill town – a motif he frequently included in his works, long after his return from Italy.

Also characteristic of van Poelenburch's compositions are the figures cut off by the higher *repoussoir* slope in the foreground. Such figures are often the subject of detailed red chalk drawings, which are considered by some (e.g. Sluijter-Seijffert) to be copies, perhaps for use in the artist's studio, and by others (e.g. Chong) to be genuine preparatory studies, in which the focus is entirely on the staffage. The figures in such drawings are often silhouetted rather oddly against the white of the paper, with little or no indication of the landscape background. Whatever the status of these drawings, they reflect van Poelenburch's standard compositional convention of bisecting figures behind landscape ridges. This can be seen, for instance, in a study of *Cimon and Iphigenia*, recently on the New York art market and now in the Pierpont Morgan Library, New York,[1] in which the figure of Cimon, dressed as a shepherd holding a staff, is cut off on the right by the upward sloping hillock, while two cows graze behind him in the middle distance. In stark contrast to the figure drawings are the ink and silvery wash landscape studies that would have been used for the landscape background of such pictures, a good example being the ex-Esdaile *Landscape with a Fortified Town in the Right Distance* that was formerly with P. & D. Colnaghi, London, in 1965 (cat.72a).[2] Especially close is the lighting of the composition, with the empty rocky foreground elements bathed in light, a solid dark middle ground before clumps of trees, and the distant hill town lit up by sunlight streaming from the left.

The biblical subject of Christ on the Road to Emmaus (Mark 16:12, Luke 24:13–27) was a standard choice for landscape painters who wished to add figures to their landscapes. Van Poelenburch painted this same subject a number of times, for instance in a totally different, frieze-like composition that is reflected in two versions formerly on the art market (one of which was formerly in the collection of P. N. de Boer, Amsterdam),[3] as well as in a third in the collection of the Marquess of Exeter at Burghley House, near Stamford.[4]

NS-S, JT

73

SALOMON DE BRAY
Amsterdam 1597–Haarlem 1664

Agony in the Garden

Oil on panel, 23¼×16½ in (59×42 cm)
INSCRIPTIONS signed and dated at lower right,
S. Bray 1639
Cobbe Collection, no.365
HISTORY probaby by descent from the late
18th century to J. E. Maryon-Daulby, early 20th
century (as Rembrandt); art market, Amsterdam,
1935; with the dealer Katz, Dieren, 1937; possibly
Prof. Dr Usener, Marburg-Lahn, 1961; sale,
Mak van Waay, Amsterdam, 5 October 1965,
lot 71; sale, Christie's, London, 25 November 1966,
lot 45; acquired at sale, Christie's, London, 17
June 1988, lot 99 ('the property of a gentleman')
LITERATURE von Moltke 1938–9, p.318, fig.7,
pp.319, 383, no.48; Laing/Cobbe 1992, pp.2, 16,
no.315

Cat.73a Salomon de Bray, *Agony in the Garden*,
pen and brown and grey wash, 127×92 mm, 1635
(Prentenkabinet der Rijksuniversiteit, Leiden)

1 Matthew 26:36–46; Marc 14:32–42; Luke
22:39–46; Luke is the only evangelist to refer
to the angel.
2 Leiden, Prentenkabinet der Rijksuniversiteit,
inv.no.123; pen and brown and grey wash,
127×92 mm, dated *1635 5/12*.
3 von Moltke 1938–9, p.318, fig.5, p.319.
4 This composition has survived in two
versions, the best of which, monogrammed
and dated 1640, was auctioned from the Delaroff
collection in 1914 and re-appeared on the art
market in 1983 (von Moltke 1938–9, no.46); the
second version is in the Gemäldegalerie in
Kassel (von Moltke 1938–9, no.47, p.319, fig.8).

Painter, draughtsman, architectural designer, innovator
of large-scale urban planning, writer on contemporary
architectural developments and poet, Salomon de Bray
was an *uomo universalis* of considerable talent. He was
influenced by various schools of painting throughout
his career. Indebted to Rembrandt (1606-69) and to the
Utrecht Caravaggisti in early years, de Bray's decorations
of *c.*1650 for the Oranjezaal in Huis ten Bosch, The Hague,
were orchestrated by Constantijn Huygens (1596–1687)
and Jacob van Campen (1595–1657) and show an awareness
of Flemish painting. Towards the end of his career, Salomon
de Bray reverted to the idiom of early 17th-century Pre-
Rembrandtist painters, most notably Rembrandt's teacher,
Pieter Lastman (*c.*1583–1633).

The Cobbe *Agony in the Garden* depicts Christ praying
in the garden of Gethsemane on the Mount of Olives near
Jerusalem on the eve of his imprisonment. The lighting
is dramatic and issues from behind the angel's outstretched arms.[1] Painted in 1639, the deeply emo-
tional *Agony in the Garden* is among de Bray's rare dated early works and is Rembrandtesque in both
conception and lighting. A surviving preparatory drawing (cat.73a) predates the picture by four years.[2]
The painting follows the *modello* exactly, though the olive tree and the figures in the background,
clearly delineated in the drawing, can be seen only dimly in the finished painting.

The subject was popular among Haarlem and Amsterdam painters of the time and was explored
by Lastman as early as 1608. It is likely that his interpretation was known to de Bray through prints.[3]
In 1640, one year after the present picture, de Bray returned to the subject. Christ's posture in the
second treatment is reminiscent of Lastman's composition of 1608.[4]

The picture evokes an atmosphere of controlled despair and loneliness, which is heightened by
the ominous presence of the approaching soldiers and the gesture of the angel, showing Christ the
cross on which he would shortly suffer.

MB

74

WILLEM SCHELLINKS
Amsterdam 1627–Amsterdam 1678

The Angel Appearing to the Shepherds

Oil on canvas, 16¼ × 16⅞ in (41 × 43 cm)
INSCRIPTIONS signed at lower right,
W:Schellincks f; on the reverse, on the stretcher:
inscribed in brown ink, *Rembrant*; numbered, *8*;
two red lacquer seals; on the frame: two printed
exhibition labels
Cobbe Collection, no.414
HISTORY Mayor W. E. Hallin; acquired at sale,
Christie's, London, 1 November 1996, lot 43

Cat.74a Rembrandt, *The Angel Appearing to the
Shepherds*, etching, 10⅜ × 8 ⅝ in (265 × 220 mm),
1634 (Rijksprentenkabinet, Amsterdam)

1 See Amsterdam and London 2000–01,
pp.129–31, no.21, and Berlin, Amsterdam and
London 1991–2, pp.190–91, no.9.
2 Musée du Louvre, Paris, inv.no.1291;
see Sumowski 1983, vol.2, p.1020, no.615.
3 Hermitage Museum, St Petersburg;
see *Cat. Hermitage* 1958, p.136, no.1925.
4 See Turner (ed.) 1996, vol.28, pp.73–4.
5 For a more detailed discussion of Asselijn's
influence, see Steland-Stief 1964, pp.99–109.

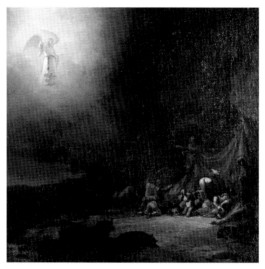

This painting tells the story of the Annunciation to the Shepherds. It is based on the biblical account of Luke 2:8–10 and 13: 'And there were in the same country shepherds abiding in the field, keeping watch over their flock by night. And, lo, the angel of the Lord came upon them, and the glory of the Lord shone round them: and they were sore afraid. And the angel said unto them, fear not: … And suddenly there was with the angel a multitude of the heavenly host.'

Schellincks's interpretation of the subject was evidently inspired by Rembrandt's etching of 1634 (cat.74a). Emerging from the blinding light behind the angel on a cloud is a group of putti, the 'heavenly host'. The shepherds and animals are taken by surprise and take flight in different directions. The print is Rembrandt's first etching of a nocturne, and he emphasised the contrasts between the black night and the bright light emanating from behind the angel, which has the effect of throwing a 'spotlight' onto the clearing with the panic-stricken shepherds and animals.[1] The composition, with its diagonal sweep from the heavenly light and the dominant angel down to the tumultuous scene on Earth, underscores the drama. The etching greatly influenced a number of Dutch artists. In a painting of 1639 Rembrandt's pupil Govert Flinck (1615–60) chose a horizontal format and brought the figures closer to the viewer, thereby somewhat diminishing the grandeur of the scene.[2] The fear expressed by the shepherds is also much more muted. Ten years later the Dutch Italianate painter Nicolaes Berchem (1620–83) also painted the subject, following Rembrandt's composition.[3] Here, the shepherds, shown praying and listening, appear much less fearful (and, as in Flinck's painting, some are still sleeping).

Schellincks seems to have stayed more faithful to the model of Rembrandt's etching. The format is upright, and the proportions of the figures relative to the size of the picture are more in keeping with the prototype. The angel is shown alone – it is the moment before the 'heavenly host' suddenly appeared – and is engulfed by the bright heavenly light. Some of the shepherds are either fearful or praying, but, once again, not all of them have woken up to the drama that is unfolding. As with other artists who were influenced by Rembrandt's image, Schellincks put none of the drama that Rembrandt was able to convey into his interpretation of the biblical story.

Schellincks was an Amsterdam artist. He is said to have been a pupil of Karel Dujardin (1626–78), but there is not much evidence for this, stylistic or otherwise.[4] His earliest-known works are drawings of Amsterdam houses that betray an interest in topographical subjects. In 1646 he travelled through France with the painter Lambert Doomer (1624–1700) – a diary of the journey survives – and soon afterwards he departed for Italy. Much of his work is influenced by the Dutch Italianate painters Jan Asselijn (after 1610–1652) and, to a lesser degree, Jan Both (*c.*1618–1652) and Jan Baptist Weenix (1621–1660/61).[5] On another journey to France, England, Italy, Malta and Germany, between 1661 and 1665, Schellincks produced many topographical sketches that he later turned into large, finished drawings. Judging by the similarity of the composition and figure types of the present picture to Rembrandt's etching, and by the absence of any Italianate traits in it, it is tempting to think that it may date from the early part of Schellinks's career in Amsterdam, possibly before he left for France.

AR

75

HENDRICK MUNNICKS

fl. Utrecht 1622–Stockholm 1664

Democritus

Oil on canvas, 28 × 23½ in (71 × 59.5 cm)
INSCRIPTIONS signed at upper left, *HMunnickx
fe*; inscribed at upper left, possibly by a later
hand, DEMOCRITE / *Ce Sage Abdéritain / qui se
moquoit des Hommes / Ce Philosophe réjouï / Que n'a-
t'il vû le jour / dans le Siècle, où nous sommes! / Il auroit
bien autrement ri*; on the reverse: inscribed on
label, *Hendrik Munniks / 1633 Men ... in Utrecht /
Democrite / Bezeichnet links Mi / ... Democrite /
H. Munniks / 72 × 60 cm.*
Cobbe Collection, no.371
HISTORY acquired at sale, Sotheby's, London,
15 February 1989, lot 103
LITERATURE Nicolson 1989, vol.1, p.151, no.1361;
vol.3, fig.1361; Laing/Cobbe 1992, pp.11–12, no.301;
London 1996, p.34; Buijsen (ed.) 1998, p.331,
illus.

1 Much of this and what follows relies on
the entry in Baltimore, San Francisco and
London 1997–8 (pp.201–3, nos 23–4) for a
pair of paintings of the two philosophers by
Hendrick ter Brugghen dated 1628, both in
the Rijksmuseum, Amsterdam (inv.nos A2783
and A2784) and the exhaustive account on this
subject in Blankert 1967.
2 Laing/Cobbe 1992, pp.11–12, no.301.
3 Blankert 1967, p.56, fig.14, and p.95, no.25.
4 See, for example, the depictions by Hendrick
ter Brugghen (details in n.1).
5 Turner (ed.) 1996, vol.22, pp.311–12.
6 Buijsen (ed.) 1998, p.331.

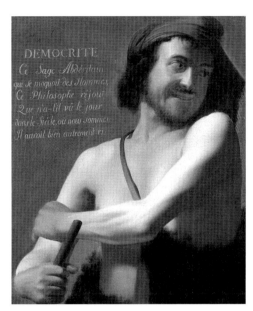

The inscription on the painting identifies the
young man in a herdsman's costume as Democritus
of Abdera (*c*.465–*c*.360 BC), often referred to as the
'laughing philosopher'.[1] He frequently ridiculed
the follies of humankind and thus represents the
counterpart to the philosopher Heraclitus (*c*.540–
c.480 BC), who was driven to tears by humans and
their shortcomings. Both were among the most
important philosophers of pre-Socratic times,
and Democritus is considered to be the father of
experimental science and of the theory of atoms.[2]

The legends of the two philosophers derive
from the accounts of ancient writers such as Cicero,
while the theme of the laughing and weeping
philosophers began with the writings of Marsilio
Ficino (1433–99). Throughout the 15th and 16th
centuries the theme remained rare and was con-
fined mostly to prints and book illustrations.
It was revived suddenly in 1599 by Cornelis Ketel (1548–1616) from Gouda, who painted the subject
three times. It quickly became popular in Haarlem and Amsterdam, and, a short while later, in
Utrecht. The earliest depiction in Utrecht of the two figures dates from 1622, in a pair of paintings
from the joint workshop of Hendrick ter Brugghen (1588–1629) and Dirck van Baburen (*c*.1595–1624).[3]
The reason for the subject's popularity in the 17th century, particularly with painters in Utrecht, was
probably related to the contemporary interest in the convincing depiction of human emotions and
passions. Influenced by the Italian painter Caravaggio (1571–1610) and his circle, the Utrecht painters
were fascinated by the portrayal of different physiognomic expressions, and there is hardly a more
suitable subject for this than the laughing and weeping philosophers.

In his representation, Munnicks clearly followed the style of the Utrecht Caravaggisti. The single
figure is shown half-length, against a plain grey background (*cf*. cat.69). Sharp contrasts between
light and shadow are used to model the smoothly painted figure – even going so far as to throw the
face, arguably the most important aspect of the laughing figure, into shadow. Democritus is shown
in a *contrapposto* pose, as if he has just turned around to look over his left shoulder. This suggests that
the painting must have had a pendant depicting a melancholic or weeping Heraclitus. Democritus
is, however, not pointing towards his counterpart, a disparaging gesture that is often employed
in paintings by Munnicks's contemporaries.[4] Munnicks has also chosen to depict Democritus as a
young man, as a contrast to an older Heraclitus.

There is no certain indication as to whether Munnicks painted the picture while he lived in Utrecht.
He is documented there from 1622 and became dean of the painters' guild in 1643.[5] In 1644 he joined
the painters' guild in The Hague,[6] and in November 1648 he is recorded in Prague. Two years later he
went to Stockholm, where he entered the service of Queen Christina. It has been assumed that there
are no works from his Utrecht period and that none of his works is signed. His inventory, drawn up in
the year of his move to Sweden, records mythological works characteristic of the Utrecht Caravaggisti,
but otherwise his only known paintings are the portraits he produced for the Swedish court and
aristocracy. The present picture, however, carries a signature in the upper left corner, and it seems
possible that it may indeed have been executed while he was living in Utrecht.
AR

CASPAR NETSCHER (AND STUDIO?)

Heidelberg (?) 1639–The Hague 1684

Portrait of a Lady Playing a Viola da Gamba

Oil on canvas, 19 × 15 ¾ in (48 × 40 cm)
INSCRIPTIONS signed and dated, *CNetscher 167 …*
(strengthened by a later hand)
Cobbe Collection, no.460
HISTORY sale ('*Sammlung aus altem Adelsbesitz*'
['an ancient noble collection']), Lepke, Berlin,
21–2 March 1934, lot 666, illus. (bought by
v. d. Wense for 200 *Reichsmark*); sale, Christie's,
Amsterdam, 6 May 1993, lot 61, illus. (as Caspar
Netscher); acquired at sale, Christie's,
Amsterdam, 4 May 1999, lot 60
LITERATURE Wieseman 1991, p.560, no.C337
(as by studio or follower and dated to *c*.1675–80)

1 For a detailed biography, see Turner (ed.)
2000, pp.233–5.
2 See, for example, his famous *Lacemaker*
of 1664 in the Wallace Collection, London.
3 For details on these artists, see Buijsen (ed.)
1998.
4 See, for example, Johannes Vermeer's *Woman
Standing at a Virginal* of *c*.1670–72 in the National
Gallery, London (inv.no.NG 1383), and Jan Steen's
Young Woman Playing a Harpsichord to a Young Man,
probably from 1659, also in the National Gallery,
London (inv.no.NG 6856).
For more on the subject of music in Dutch
painting, see The Hague and Antwerp 1994.
5 See, for example, Johannes Vermeer's *Woman
Seated at a Virginal* of *c*.1670–72 in the National
Gallery, London (inv.no.NG 2568).
6 See Sadie (ed.) 1984, vol.3, p.736, fig.1C. I
should like to thank Mark Broch for providing
me with this reference.
7 See Wieseman 1991, p.560, no.C337.
8 Communicated in a letter to Alec Cobbe,
dated 19 November 1998.

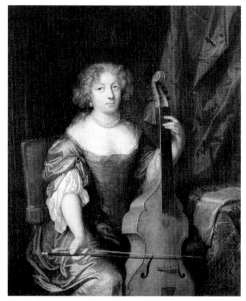

This painting by Caspar Netscher is a three-quarter-length portrait of an elegant young woman playing a viola da gamba or bass viol. Wearing a low-cut blue satin dress and a pearl necklace and earrings, she is seated in a red velvet chair. To her right is a table covered by an oriental carpet, with a musical score on top. Behind the table, the otherwise dark background is enlivened by a heavy red curtain.

This type of portrait is characteristic of the approach favoured by courtly circles in The Hague. Netscher, apparently a native of the German town of Heidelberg who had been apprenticed to Gerard ter Borch (1617–81) and had travelled to France, registered with the painters' guild in The Hague in 1662.[1] Having painted genre scenes,[2] from 1667 onwards he concentrated on portrait painting. Netscher's portrait style derives mainly from the international court style introduced by the aristocratic portraits of Anthony van Dyck (1599–1641), characterised by life-size figures, bright colours, and grand architectural and landscape settings. In The Hague, this tradition was taken up by Jan de Baen (1633–1702), Adriaen Hanneman (*c*.1604–1671) and Jan Mijtens (*c*.1614–1670).[3] At the time of Netscher's arrival in The Hague, all of these artists were still active, and there must have been a great demand for portraits by them from aristocrats and wealthy, aspiring burghers. After the deaths of Hanneman and Mijtens, Netscher became the most sought-after portrait painter in the city. However, he chose smaller formats, as compared with the life-size portraits painted by his contemporaries. But his works are equally highly finished, and include elegant decorative details such as draperies, sculpture and architectural features, and background views of fountains, country houses and parks. The present picture is, therefore, somewhat unusual in this respect, since the sitter is presented in front of a uniform dark background, without any indication of a space beyond. Usually the sophisticated background setting was meant to underscore the sitter's elevated social position.

The subject of women playing musical instruments is not uncommon in Dutch art – albeit less frequent in portraits than in genre scenes, in which it is often meant to symbolise love and harmony – but the playing of a viola da gamba is rarely featured.[4] The instrument can be found, of course, in a number of paintings by Vermeer (1632–75), most often lying on the floor or leaning against a chair,[5] but one rarely finds a character in a picture playing it. Particularly unusual is the double-curved shape of the example in this picture, which is similar to a surviving instrument of 1600 attributed to the great viol-maker John Rose of Bridewell, London (*d*.1611). Rose's instruments were well known in The Hague: in 1759 one was listed in a local sale catalogue.[6]

In her dissertation of 1991 on Netscher, Marjorie Wieseman doubted the authorship of the picture, cataloguing it as by 'studio or follower'.[7] However, more recently she has revised her opinion and now accepts the work as autograph, with assistance from the artist's studio.[8] While the date on the painting is not fully legible, the style suggests that it was painted between 1675 and 1680.

AR

77

SIR ANTHONY VAN DYCK
Antwerp 1599–London 1641

Oval Portrait of a Man in a Ruff, in Profile to the Right

Oil on canvas, 46 × 45½ in (117 × 115.5 cm)
INSCRIPTIONS inscribed at the top right,
presumably in the hand of the artist, in
graphite, on the ground beneath the brown
paint of the oval frame, *A ... R ... Schut[t] (?) /
Schepen / 4. Schepen*
Cobbe Collection, no.434
HISTORY Jules Strauss; Thos Agnew's,
London, 1968; from whom acquired in 1997
EXHIBITIONS London 1968a, no.13 (as Van
Dyck); London 1968b, no.12 (as Van Dyck);
Yokahama, Shizuoka and Osaka 1990, no.5
(as Van Dyck, c.1617–19)
LITERATURE Larsen 1980, no.A22 (not by Van
Dyck); Larsen 1988, no.A16 (not by Van Dyck)

Cat.77a Anthony van Dyck, *Oval Portrait of a
Man in a Lace Collar, in Profile to the Right*, oil on
panel, 23¾ × 23 in (60.5 × 58.5 cm), c.1628–32
(Iford Manor, Wiltshire)

1 His observation was made orally to Alec
Cobbe, on a visit to Hatchlands Park this
summer.
2 Vey 2001, pp.65–75.
3 The composition of the council is set out
by Vey 2001, p.68.
4 Ibid., pp.69–70, with what appear to be
three citations of such a sketch: (1) the panel auc-
tioned with the collection of Philips de Flines
in Amsterdam on 20 April 1700; (2) possibly
the same panel, sold as Van Dyck at the auction
of the Nourri collection in Paris in 1785; and (3)
again possibly the same sketch, sold with the
Slade collection, London, in 1801.
5 Ibid., p.71.
6 Other works in the series mentioned by
Vey are at Highnam Court in Gloucestershire.

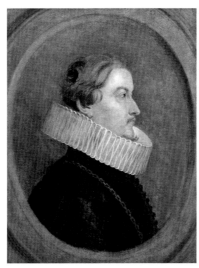

As Sir Oliver Millar has recently pointed out, the present
picture belongs, in both style and format, to a series of
portrait sketches of civic dignitaries, shown bust length
in feigned oval stonework frames, which Van Dyck painted
c.1630 in order to prepare a group portrait of the 1627/8
Brussels city council.[1] The latter was one of two group por-
traits that were commissioned from the artist for the Town
Hall, Brussels. The first was probably painted in 1628–32,
in the period immediately preceding Van Dyck's first visit
to England, the second in 1634–5, during his short return
to the Netherlands, when he is documented as being in
Brussels.

Sadly, neither group portrait survives. They were both
destroyed in 1695, during the French bombardment of
Brussels, when other important ceremonial portraits from
the Town Hall also perished. The final appearance of Van
Dyck's two lost group portraits is not known, but the reconstruction of their design has moved for-
ward, thanks to the recent, lucid account of the commissions by Horst Vey,[2] who has also brought
together the published references made to them before they were destroyed.

The first group portrait represented the annually elected members of the Brussels city coun-
cil for the year 1627/8, showing them seated life size, as if in deliberation. The old sources are not
consistent in giving the number of councillors, but a total of 23 is cited by two authorities. In any
one year, membership of the Brussels city council was comprised of mayors, '*schepenen*' (lit. 'sheriffs',
the Flemish term used for magistrates or aldermen), '*rentmeesteren*' (city accountants) and treasurers,
as well as other officials.[3] The council elected to serve for 1627/8 ordered their group portrait from
Van Dyck on 15 April 1628 and resolved to pay him 2,400 guilders for the work, an immense sum
for the time. Van Dyck had returned to Antwerp from Italy the previous year, his reputation greatly
enhanced, and he must have furnished the council with a sketch for his design beforehand.[4] This
would have been painted only a few months following his return. Vey has argued that Van Dyck
would have executed the first group portrait almost immediately after the council session had
met and that the great canvas would have been finished by March 1632, when the painter set out
for London.

Vey has further surmised that a series of portraits of dignitaries in feigned oval frames, painted in
a 'strikingly spontaneous manner', with none of the sitters 'looking at the viewer', were made from
life as *modelli* for the officials to be included in this first group portrait.[5] The sketches comprise, among
others, two portraits in the collection of Mrs Cartwright-Hignett of Iford Manor, Wiltshire, one of
which shows the sitter in profile to the right (cat.77a); another in the Methuen Collection, Corsham
Court, Wiltshire; and a fourth in the Fitzwilliam Museum, Cambridge (cat.77b).[6] According to Sir
Oliver, another picture from the series, one of the finest, though unknown to Vey, was formerly in
the collection of the Earl of Ancaster at Grimesthorpe. Vey also omitted the present picture from his
group, but the similarity in composition, costume and handling bears out Sir Oliver's view that it,
too, is part of the series (though, admittedly, it is larger and painted on canvas rather than panel).
There are, indeed, striking parallels in handling between the Cobbe picture and many of the oval
portraits from the series. For instance, the accomplished way in which the ruff is painted – with its
subtle gradations of a grey-tinged white in the shadows of the interstices, beautifully juxtaposed
with the thick, pure white impasto of the looped edging – compares well with the treatment of the

A copy of a lost oval portrait is at Hampton
Court, while what Vey believes to be another
such copy after another lost example is at
Poznan.

7 Oil sketch, 26 × 58 cm; Vey 2001, p.71.

8 White 1999, pp.38–41, nos A175–6.

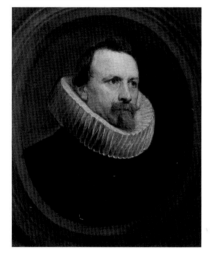

Cat.77b Anthony van Dyck, *Oval Portrait of
a Man in a Ruff*, oil on panel, 25⅝ × 23⅜ in
(65 × 59.5 cm), *c*.1628–32 (Fitzwilliam Museum,
Cambridge)

ruff in the Fitzwilliam picture. Also, the painting of the ear and eye, as well as the lighting of the
hair and forehead, is echoed in the profile portrait at Iford.

The connection of the present picture with this series of portraits of magistrates is further con-
firmed by the old inscription at the top right, which includes the designation of the sitter's office as
'*schepen*' or magistrate. This inscription, partly obscured by the light brown-grey paint in which the
oval surround is painted, also indicates that the sitter's name may have been A. R. Schut, or Schutt
(though the precise form of the name is not clear). In the last line of the inscription, the word '*schepen*'
– which, unlike the proper name, is completely legible – is repeated and preceded by the number '*4*',
possibly signifying that the subject of the Cobbe portrait was fourth in the bench of seven '*schepenen*'
that sat in Brussels at the time. Alternatively, he could have been the fourth '*schepen*' in a sequence of
portraits of '*schepenen*' on which Van Dyck was then at work in his first group portrait: in other words,
this could be Van Dyck's own ordering of these officials for the purposes of their arrangement in his
picture. The gold chain about the sitter's neck is presumably his badge of office. The Cobbe magistrate
was probably destined to appear on the left of the group portrait, looking in to the picture space, on
the same side as the man shown in the Iford picture.

Thanks to Vey's research and an unambiguous description by the English writer John Elsum,
published in 1700, we know that the composition of the second group portrait, *The Brussels 'Schepenen'
Seated to either side of Justice Enthroned*, probably a private commission from the '*schepenen*' themselves,
was destined for another chamber in the Town Hall, not the Mayor's Chamber. Its appearance is
preserved in a grisaille sketch in the Ecole des Beaux-Arts, Paris.[7] In the Paris sketch, the allegorical
figure of Justice is seated on an elaborate throne at the centre of a long, rectangular space, with three
'*schepenen*' seated to either side of her and with the seventh standing to her side. The style of the sketch
points to a date of 1634–5. Two portrait studies in the Ashmolean Museum, Oxford, which have
long been related to the Ecole des Beaux-Arts sketch, are very different in style from the series of oval
portraits that occupy us here.[8]

When the present picture was in the collection of Jules Strauss, its attribution to Van Dyck
was rejected by Larsen, who suggested that it might be by another master, such as Jan Boeckhorst
(*c*.1604–1668). Noting its strong resemblance to Van Dyck's portraiture, he seems to have misunder-
stood its place in the artist's development, comparing it to the painter's work of 1617–18.

NT

78

DAVID TENIERS II Antwerp 1610–Brussels 1690

AFTER LORENZO LOTTO Venice *c*.1480–Loreto 1556

Man in a Fur-lined Coat Holding a Lion's Claw

Oil on canvas, laid onto panel, 6⅝ × 4⅝ in
(17 × 12 cm)
English 18th-century gilt livery (Blenheim?)
frame
INSCRIPTIONS on the reverse of the frame:
inscribed by the Rev. Vaughan Thomas, *No 91*
Cobbe Collection, no. 425
HISTORY possibly acquired by John, 1st Duke
of Marlborough (1650–1722); Charles, 3rd Duke
of Marlborough (1706–58), Blenheim Palace, by
1740; recorded in the MS. *Inventory of the pictures,
&c. The property of The Duke of Marlborough*, July
1857, p.1 (among the 'collection of 120 cabinet
pictures' by Teniers in the Duke's Sitting or
Teniers Room); recorded in the catalogue made
by the Rev. Vaughan Thomas, no.91 (see Scharf
1862, p.145); recorded among the 'series of 120
paintings by D. Teniers' in the Billiard Room
in 1862 (Scharf 1862, p.144); by descent to
George Charles, 8th Duke of Marlborough;
sale, Christie's, London, 26 July 1886, lot 109
(as 'Ulysses Aldovrandi, The Naturalist, Copied
from Titian', bought by Wickham for 16 guineas);
John Edwards; sale, Christie's, London, 4 May
1936, lot 137 (bought by Asscher & Welckerfor
5 guineas); probably Henry George Charles, 6th
Earl of Harewood (1882–1947); his wife, HRH the
Princess Mary, the Princess Royal (1897–1965);
sale, Christie's, London, 26 November 1976,
lot 11; acquired at sale, Christie's, London, 18
April 1997, lot 45
EXHIBITIONS London 1972, no.13
LITERATURE Scharf 1862, pp.154–5, no.34
(as a portrait of Ulysses Aldrovandi copied
from Titian); Borenius 1936, p.68, no.VIII

1 The Lotto remains in Vienna, in the
Kunsthistorisches Museum; see Pallucchini
and Canova 1975, p.110, no.177, pl.XLVI.
2 Pilkington 1770, p.603.
3 Now in the Wallace Collection, London.
Fourteen other copies are in the Courtauld
Institute Galleries, London, formerly in the
Princes Gate Collection; see London 1981,
nos 91–104.

Cat.78a Lucas Vorsterman the younger,
Man in a Fur-lined Coat Holding a Lion's Claw,
engraving from the *Theatrum Pictorium*,
Brussels [1660], no.75

possibly purchased by the 1st Duke of Marlborough.

Cat. 78a

One of an extensive series of 243 miniature oil copies,
this copy of Lorenzo Lotto's *Man in a Fur-lined Coat
Holding a Lion's Claw* of 1527 was painted by David Teniers
the younger for the engravers of his *Theatrum Pictorium*
(1660) (cat.78a). The project to engrave a selection
of Italian masterpieces from the magnificent collection
of Archduke Leopold William of Habsburg was
designed to serve a public of international connois-
seurs. It was one of the earliest illustrated catalogues
of its kind and had a preface in four languages. The
plan was undertaken by Teniers at his own expense,
during his curatorship of the collection, which was in
Brussels at the time. As court painter to the Archduke,
Teniers had curatorial responsibilities, supervising the
acquisition and hanging of pictures in the arch-ducal
palace. It is not known when the painted copies for the
Theatrum were dispersed, but 120 of them (inclu-ding
the present picture) were at Blenheim Palace by 1740,

The Lotto was acquired while the Archduke was Governor of the Southern Netherlands (1646–56),
during which time he acquired around 1,500 important Italian and Netherlandish pictures. Many
of these originated from the dispersed collections
of Charles I, the Duke of Buckingham, the Duke of
Hamilton, and the Venetian merchant Bartolomeo della
Nave. In 1656 Leopold William's collection (today the
nucleus of the Kunsthistorisches Museum in Vienna)
was transported from Brussels to Vienna, where Jan
Anthonie van der Baren, director of the imperial picture
gallery, recorded the original *Man in a Fur-lined Coat*, in
his inventory of 1659, as by Correggio (*c*.1489–1534). In
the following year, the *Theatrum pictorium* had changed
the attribution to Titian (*c*.1488/90–1576), which was
accepted (with the sitter wrongly identified as Ulysses
Aldrovandi) until Morelli attributed the picture to
Lotto in 1893.[1]

Teniers was a fashionable artist, and his pictures
were widely collected throughout the Netherlands in
the 17th and 18th centuries. He was also popular with
collectors in 18th-century England ('incredible prices
which are at this day given for the paintings of this
master').[2] This continued in the 19th century among collectors such as the Marquess of Hertford,
who acquired several of the *Theatrum* copies.[3]

MB

JOANNES MEYSSENS
Brussels 1612–Antwerp 1670

Portrait of Dirck Volckertsz. Coornhert (1522–90)

Oil on panel, 5¼ × 3⅞ in (13.5 × 10 cm)
Cobbe Collection, no.442
HISTORY acquired at sale, Christie's, New York,
13 November 1997, one of a pair in lot 93 (as 17th-
century Flemish School, *Portrait of a Gentleman*)

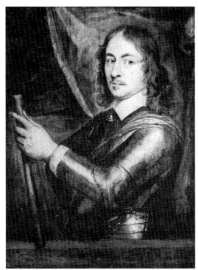

cat.79a above, cat.79b below

THEODOR CORENHERT

Cat.79a Joannes Meyssens, *Portrait of 'Hendrick,
Count of Nassau-Siegen'*, grisaille on panel,
9¾ × 7½ in (25 × 19 cm) (Historic Collections
Trust, House of Orange-Nassau, The Hague)

Cat.79b Franciscus van der Steen, *Portrait of
Dirck Volckertsz. Coornhert*, engraving, 6¾ × 4⅝ in
(170 × 117 mm), before 1649 (private collection)

Cats 79 and 80 – both previously unattributed and their
sitters unrecognised – can now be identified as the oil *modelli*
that served as preparatory studies for two of the famous
series of portrait prints published by Joannes Meyssens, a
Flemish artist who spent much of his career in the Northern
Netherlands, where he was active primarily as a portrait
painter and print publisher. The engravings, to the same
scale as, but in reverse to, the grisaille *modelli*, appeared for
the first time in Meyssens's own *Image* [sic] *de divers hommes
d'esprit sublime qui par leur art et science debvroyent vivre eternelle-
ment et des quels la louange et renommé faict estonner le monde*
(Antwerp, 1649), which was dedicated to Michel Le Blon
(1587–1656), Queen Christina of Sweden's agent in England.

Many of the engravings from this series of 99 prints[1]
were re-used in Cornelis de Bie's *Het gulden cabinet van de
edele vry schilder const* (Antwerp, 1661), a collection of lives of
artists that was almost certainly the brainchild of Meyssens,
who published it. That Meyssens was the mastermind behind this undertaking emerges from de
Bie's introduction to Book II,[2] where he excuses the absence of certain artists by explaining that he
was constrained by the selection of portraits provided him by the 'engraver'.[3] The same engraved por-
traits appeared again in 1705, in an English edition entitled *The true effigies of the most eminent Painters,*
published by D. & T. Brown, London.

More than 20 different reproductive engravers were commissioned by Meyssens to work on the
project(s), and there was just as large a number of original sources for the portrait images. It there-
fore makes sense that Meyssens – in order to ensure a level of coherence to the enterprise (what would
today be called a 'consistent house-style') – would have made grisaille *modelli* as intermediaries, from
the wide range of prototypes, to pass on to his team of engravers.

Meyssens must have been familiar with this working method through his contact with Sir
Anthony van Dyck (1599–1641) or with members of his studio. On Meyssens's gravestone in the Onze-
Lieve-Vrouwenkerk in Antwerp, he is described as an accomplished copier of van Dyck, an activity
that is also documented in the biography that accompanies his own portrait in de Bie ('*ooch met eenen
vlijtighen jever naer d'Originelen van van Dijck ghecopieert*' ['also, with diligence and industry, [he] copied
originals by van Dyck']).[4] Van Dyck is known to have provided grisaille oil sketches for some of the
engravings in his famous portrait series known as *The Iconography*, published in Antwerp by Martinus
van den Enden (*fl.*1630–54) between 1636 and 1641. A large group of grisaille oil sketches connected
with the *Iconography* portraits has been preserved, including some 40 examples in the collection
of the Duke of Buccleuch at Boughton House, formerly in the collection of Sir Peter Lely (1618–80).
Their authorship has been disputed, but, in the opinion of Christopher Brown, Julius Held and Ger
Luijten, at least some of these oil *modelli* are good enough to be by van Dyck himself, while others are
by assistants working under his close supervision.[5]

The whereabouts of other oil *modelli* related to the Meyssens artist portrait series are not known
at present (a fact kindly confirmed by Ger Luijten). However, another grisaille portrait panel by
Meyssens, executed in exactly the same style and technique as the Cobbe pair, but to a slightly larger
scale (9⅞ × 7½ in [25 × 19 cm]), is in the Historic Collections Trust, House of Orange-Nassau, The
Hague (cat.79a).[6] Said to represent '*Hendrick, Count of Nassau-Siegen*', it is more likely to be a portrait
of Stadholder Willem II (1626–50), Prince of Orange, as can be seen from a comparison with the

1 Hollstein 1949–, vol.14, nos 5–104.

2 de Bie 1661, p.183.

3 de Bie/ed. Lemmens 1971, p.4.

4 de Bie 1661, p.386.

5 New York 1991, pp.192–3, and Amsterdam and Antwerp 1999, pp.81–2.

6 De Maere and Wabbes 1994, vol.3, p.820, illus.

7 New York 1979, no.35, illus.

8 Judson and Ekkart 1999, pl.186.

9 Hollstein 1949–, vol.28, no.46.

10 Ibid., vol.8, no.180.

miniature of the prince by Jean Petitot (1607–91) of *c*.1650, also in the Historic Collections Trust, House of Orange-Nassau;[7] the latter is itself based on a double portrait by Gerrit van Honthorst of *Willem II and his Wife, Henrietta Maria Stuart*, signed and dated 1647, in the Rijksmuseum, Amsterdam.[8]

Like van Dyck, Meyssens is also documented as having made preparatory drawings in addition to oil *modelli* for some of his prints. A signed and dated (1663) example in pen and brown ink, depicting *Mary Magdalene*, was on the art market in 1926 (sale, Sotheby's, London, 3 June 1926, lot 70) and again more recently, and another five unsigned sheets, also in pen and ink, appeared in a sale late last year (sale, Phillips, London, 13 December 2000, lot 13, as 'Circle of Sir Peter Paul Rubens'), where they were recognised as Meyssens's work by Martin Royalton-Kisch and purchased for the British Museum.

The present painting depicts Dirck Volckertsz. Coornhert, the great Dutch humanist, poet, engraver and teacher of Hendrick Goltzius (1558–1617). Indeed, in the engraving (cat.79b) by Frans van der Steen (1624–72)[9] after the Cobbe *modello*, it is Goltzius who is credited with the invention. Although Meyssens's oil sketch may ultimately derive from Goltzius's large and impressive engraved portrait of his master (21 × 16 ¾ in [53.2 × 42.5 cm]),[10] Meyssens altered the design, making the sitter, for instance, appear somewhat younger. The costume is largely the same, but Meyssens extended the figure's torso, added his left hand poised above a piece of paper (which, when reversed in the print, shows Coornhert writing with his right hand), a cloak over his right shoulder, and an architectural stonework background.

Coornhert was a resident of Haarlem until 1588, but he spent his last years before he died on 29 October 1590 in Gouda. Goltzius left for Italy within days of his elderly mentor's death, and it is thought that he may have visited him and recorded his likeness before setting off on his journey south. Whether or not such a portrait sketch was made in Gouda or earlier in Haarlem, it is certain from the inscription on the print that it was based on a study *ad vivum*. (No such portrait drawing by Goltzius is known today, although a drawing, presumably in the artist's preferred portrait medium of black and red chalks, was described in the Amsterdam sale of J. G. Cramer, 13 November 1769, lot 202 as: '*Dirk Volkertsz. Koornhart. Gekleurd*' ['Dirck Volckertsz. Coornhert. Coloured'].) It is, in any case, likely that Meyssens based his *modello* on Goltzius's print, which is in the same direction, rather than on the missing drawn prototype.

It is possible that the Cobbe *modello* is identical to an anonymous painted portrait of Coornhert, 'vigorously and freely painted on panel' ('*krachtig en fraai op Paneel geschilderd*'), that was formerly in the collection of the Rev. Engelbertus Matthias Engelberts (1732–1807), father of the well-known art dealer Engelbert Michaël Engelberts (1773–1843), and included in his sale in van der Schley, Amsterdam, 13–14 June 1808, lot 248 (bought by Otto Willem Johan Berg for 1.5 fl.). It is interesting to note that the same picture had previously appeared as by 'Hendrick Goltzius' in the sale of the collection of Daniel Mansveld (1726–1806) of Amsterdam and others, held at the same auction house on 13 August 1806, lot 246 (consigned by the dealer Willem Gruyter and bought by the dealer IJver for 0.16 fl.).

NT

JOANNES MEYSSENS
Brussels 1612–Antwerp 1670

Portrait of Jacob Matham (1571–1631)

Oil on panel, 5¼ × 3⅞ in (13.5 × 10 cm)
Cobbe Collection, no.443
HISTORY acquired at sale, Christie's, New York,
13 November 1997, one of a pair in lot 93 (as 17th-
century Flemish School, *Portrait of a Gentleman*)

Cat.80a Anthony van der Does, *Portrait of Jacob
Matham*, engraving, 7⅝ × 5⅜ in (195 × 138 mm),
before 1649 (private collection)

1 Hollstein 1949–, vol.5, no.24.
2 Gernsheim Corpus photo, no.44 192.

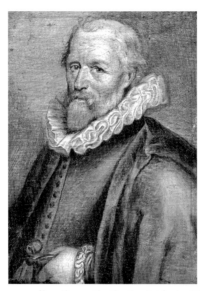

For details of the print series published by Joannes
Meyssens to which this portrait belongs, see cat.79.

Like the Cobbe grisaille of Coornhert, the present
painting also has a Haarlem connection, for it depicts
Jacob Matham (1571–1631), the stepson, apprentice and
collaborator of Hendrick Goltzius (1558–1617), who mar-
ried Matham's mother in 1579. Matham worked closely
with his stepfather and others in his circle of Haarlem
Mannerists, engraving many of his teacher's drawings
and paintings, and, in turn, taught his three sons,
Adriaen, Jan and Theodor Matham, to engrave, using
the techniques he had learnt in Goltzius's studio.

Meyssens's oil *modello* of Matham was engraved by
Anthony van der Does (1609–80)[1] and, according to the
inscription on the print (cat.80a), was based on a por-
trait by Matham's pupil Pieter Soutman (*c*.1580–1657).
A pen-and-ink portrait of Matham by Soutman, in the
same direction as the final print but with differences, is in the Prentenkabinet der Rijksuniversiteit,
Leiden (inv. no. 1100).[2] This drawing seems to have served as the preparatory study for the more closely
related engraving, in reverse, by Jan van de Velde II (*c*.1593–1641), which must have been made *c*.1630,
since it gives Mathams age as 59.[3] Meyssens seems to have based his portrait on the van de Velde
print rather than the original by Soutman. But, as with the portrait of Coornhert, the grisaille *modello*
reveals changes from the original prototype, the most significant of which are again the addition of
the figure's left hand (right, once reversed in the print) and the lengthening of the torso.

From 1615/16 to 1628 Soutman was active in Flanders in the circle of Rubens (1577–1630), but he
was born in Haarlem and spent the end of his career there. His portrait of Matham in the Leiden
Prentenkabinet probably dates from the early 1640s. In 1643 and 1644 Soutman published two series
of engraved portraits, important precedents, like van Dyck's *Iconography*, for the Meyssens project.

If the other Cobbe grisaille (cat.79) is indeed the anonymous portrait of Coornhert that figured
in the sale of the Rev. Engelbertus Matthias Engelberts (1732–1807), then its present companion may
well have been the anonymous portrait of a man '*in den stijl van A. van Dijk*' that featured as lot 191 of
the same sale.

NT

81

JOHANN GEORG PLATZER
St Michael in Eppan 1704–St Michael in Eppan 1761

The Crucifixion

Oil on copper, 6 × 4 in (15 × 10 cm)
Cobbe Collection, no.418
HISTORY acquired at sale, Sotheby's, London,
19 November 1996, lot 124

1 The artist's name is occasionally also spelt
'Plazer'. For biographical information, see
Agath 1955; Baum 1980, p.556; Plunger 1986;
Salzburg 1996, pp.16ff; Turner (ed.) 1996, vol.25,
p.34 and Schubert 2000, p.40. To date, no com-
prehensive catalogue of his oeuvre has been
compiled.
2 See the essay by Michael Krapf in Salzburg
1996, pp.16–28 (esp.p.16, quoting the influential
critic and theorist Frans Christoph von Scheyb,
who in 1774 claimed that 'all painters from Tyrol
want to be Platzer').
3 One of the innumerable examples is Rubens's
*Christ on the Cross, Addressing his Mother, St John the
Baptist and Mary Magdalene* in the Rockoxhuis,
Antwerp; see Judson 2000, no.34.
4 See, for example, the oil sketch by Rubens
of the '*Coup de lance*' in the National Gallery,
London (inv.no.NG 1865).
5 The subject showing the Virgin collapsing
under the weight of her grief derives from the
writings of late medieval monastic writers and
mystics who dwelt on the sorrows of the Virgin.
For more on this subject, see Judson 2000, p.134,
no.34; Knipping 1974, vol.2, pp.277–8; and Hall
1974, pp.83–4.
6 See also Schubert 2000, p.45, and Salzburg
1996, p.19, where the author refers to a 'thunder-
storm of form and colour' ('*ein Gewitter aus
Formen und Farben*').
7 Quoted by Schubert 2000, p.40, from Baum
1980, p.556.
8 Schubert 2000, p.40.

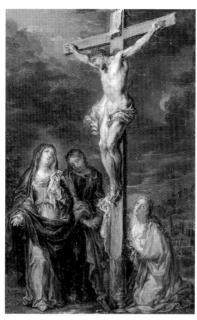

Johann Georg Platzer was born into a family of artists in
St Paul, Eppan, near Meran in the south Tyrol.[1] His father
was the painter Johann Viktor Platzer. He studied, how-
ever, with his stepfather, Josef Anton Kessler (*d*.1721), and
later with his uncle Christoph Platzer, who was court
painter in Passau. His earliest-known painting, the altar-
piece for the church of St Helena in Deutschnofen of 1723,
was executed during this period. The decisive phase of his
artistic training, however, occurred in the years following
his entry into the re-opened Academy in Vienna in 1726.
Not only did he befriend the painter Franz Joseph Janneck
(1703–61), but he also drew much inspiration from the
imperial art collections, as well as the Academy's collection
of prints and drawings. Both Janneck and Platzer were
much influenced by 16th- and 17th-century Flemish and
Dutch painters such as Jan Brueghel the Elder (1568–1625),
Frans Francken II (1581–1642) and Caspar Netscher (1636–
84). By 1755 Platzer had permanently returned to the South
Tyrol, possibly owing to health problems. Besides histori-
cal subjects he also painted genre scenes. He has been celebrated as the most important master of the
conversation-piece in 18th-century Austria.[2]

This delicate, small painting is a devotional picture that must have been painted for a private
patron who would either have placed it on an altar in the home or have used it as a portable altar.
Compositions of this subject usually show Christ addressing his Mother at the moment immediately
before he dies, entrusting her into the care of St John the Evangelist (John 19:25–7),[3] followed by the
scene of the Roman soldier stabbing Christ with his lance (John 19:34).[4] Here, however, one can see
the lifeless body of the dead Christ with the wound already in his side. In keeping with 17th-century
tradition, the Virgin is shown standing erect rather than swooning, overwhelmed by her grief.[5] In
the sky the clouds that had obscured the Sun before Christ died (Luke 23:44–5) are about to disperse.
Beyond the figure group one glimpses a few faintly outlined buildings and mountains that seem
intended to evoke the landscape around Jerusalem in biblical times.

In this composition, the figures are placed close to the picture plane. To add depth to the scene
and to enliven the composition, the Cross has been placed at an angle with the figures grouped
tightly around it. Through the use of colour, the artist has underscored the contrast between the
brightly clothed living figures on Earth and Christ's dead body silhouetted against the darkened
sky. Luxurious fabrics, bright, contrasting colours and lively patterns created by folds and by the
resulting *chiaroscuro*, combined with dramatic figures, and rich decorations and accoutrements, are
characteristic of Platzer's works.[6] Executed mostly on copper, which enhances their air of refine-
ment and artistic virtuosity, they often evoke a 'paradise of the senses'[7] that invites the viewer's
close attention. The consistent style of his paintings and the small number of dated pieces have so
far made it difficult to formulate a convincing chronology of his oeuvre. Although on occasion his
predilection for drama and embellishment threatens to overwhelm the subject of the picture, gener-
ally Platzer's idiosyncratic style reveals a sense of composition and delicate execution that made
him one of the most sought-after and successful artists in the 18th century, both at home and abroad.[8]
AR

82–83

BALTHAZAR BESCHEY
Antwerp 1708–Antwerp 1776

Adoration of the Shepherds / Adoration of the Magi

Both oil on copper, oval, 7⅛×6 in (18×15 cm)
Both in an 18th-century Irish (?) carved and gilt frame
Cobbe Collection, nos 454 and 455
HISTORY Mr Sweetman; his sale, Vallance, Dublin, 26 November 1798, lots 10 ('The wise Men offering. Besch … An original composition, which for expression, neatness of Pencil and the charms of Colouring, is entitled to rank in the first class of Cabinet Pictures') and 11 ('The Companion, a Nativity. By the same Master. Equally brilliant and interesting. They are both on copper, each 7i. by 6i.'); sale, Christie's, London, 17 March 1950, lot 98; acquired at sale, Christie's, Amsterdam, 6 May 1998, lot 149

1 This auctioneer was also used by Thomas Cobbe in the disposal of Archbishop Cobbe's library in 1800.
2 Now in the Louvre, Paris; see Roethlisberger 1993, vol.1, pp.186–90, no.222; vol.2, fig.333.
3 Oil on copper, 35.5×29 cm, sale, Phillips, London, 16 April 1991, lot 114.
4 Possibly the etching by Rombout Eynhoudts (1613–79/80).

By end of the 18th century, both these delicate scenes of the *Adoration* were in Ireland, where in 1798 they appeared in a sale organised by the leading Dublin auctioneer, James Vallance of Eustace St. They were described in the catalogue as 'in the first class of Cabinet Pictures'.[1]

Balthazar Beschey's interest in Dutch and Flemish art of the 17th century influenced his work generally, and in these pictures he has drawn from two celebrated altarpieces. The central group of figures in *The Adoration of the Shepherds* (cat.82) is loosely based on the altarpiece that the Utrecht Mannerist Abraham Bloemaert (1566–1651) painted in 1612 for the main altar of the church of the Monastery of the Poor Clares in 's Hertogenbosch.[2] Around 1654 the Poor Clare nuns moved the altarpiece to Mechelen (Malines), where it would have been available for study. Another picture by Beschey of the same subject, but of rectangular shape, corresponds more closely to Bloemaert's altarpiece and may have served as an intermediate stage between Bloemaert's painting of 1612 and the Cobbe oval.[3]

The two camels and a number of the background figures in *The Adoration of the Magi* (cat.83), on the other hand, correspond to elements in Rubens's *Adoration of the Magi*, one of the icons of 17th-century art in the Southern Netherlands. Painted in 1624 for the Abbey of St Michael and now in the Koninklijk Museum voor Schone Kunsten, Antwerp, this famous work would undoubtedly have been known to Beschey at first hand; however, the quotations from Rubens in the Cobbe picture are in reverse, which indicates Beschey's use of a print as his immediate source.[4]

MB

84

ATTRIBUTED TO JOSEPH-MARIE VIEN
Montpellier 1716–Paris 1809

Head of an Old Bearded Man, Looking down to the Right

Oil on paper, laid down on board,
17½ × 14⅛ in (44.5 × 35.5 cm)
Cobbe Collection, no.440
HISTORY acquired at sale, Sotheby's, New York,
16 October 1997, lot 105

1 See de Montaiglon 1853; Vitet 1861; and Duro
1997. The *têtes d'expression* were also customarily
drawn, rather than painted. It was only in 1759
that the Comte de Caylus instituted the *prix d'expression* for students of the Academy.
2 Gaehtgens and Lugand 1988, pp.60–62, 136–7,
294–5, 300 and figs 29–34.
3 The *Mémoires* remained in manuscript
(preserved in the Fonds Vien in the Musée des
Beaux-Arts in Béziers), but have now been
published by Gaehtgens and Lugand 1988,
pp.287–319 (esp.pp.295–6).
4 Gaehtgens and Lugand 1988, pp.136–7
and fig.32.
5 Ibid., pp.139–40 and fig.51. It was subsequently triumphantly exhibited in Rome,
Marseilles, Montpellier and Paris.
6 Ibid., pp.140–41 and fig.52.
7 Ibid., p.295.
8 Ibid., pp.22, 146–7 and 304–5. This may
sound, on first hearing, an unimportant commission – until one realises that it was given
to Vien by the *surintendant des Bâtiments du Roi*,
the Marquis de Vandières (later Marigny), and
was for his sister, Mme de Pompadour, to give
to the parish church of the village in which she
had the *château*.
9 Ibid., pp.22, 71 and 146.
10 Ibid., p.147 and fig.74.

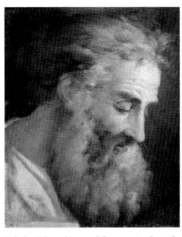

The *tête d'expression* – a study of a human head in the grip of some defined emotion – had been one of the official requirements of the artistic education at the Académie Royale de Peinture et de Sculpture since the 17th century.[1] Studies of old mens' heads had no such official status, but seem, if anything, to have been even more popular. Whereas *têtes d'expression* were student productions aimed at winning academic honours, heads of old men were virtuoso demonstrations of painterly skills – sometimes even by mature artists – collected by, if not necessarily originally aimed at, discerning lovers of art.

The present head would appear to have been just such a thing. Painted on paper, which suggests a genuinely spontaneous exercise, it has subsequently been laid down on board and framed, to give it greater permanence in a collection. If it is by Vien, it would seem to date from a period when, though still a student (on a scholarship at the French Academy in Rome), he was already a fully formed artist, accepting commissions for altarpieces, including six for the Capuchin church of Ste-Marthe in Tarascon, in his native Provence.[2]

The model for this head seems to have been the picturesque old hermit whom, Vien relates in his *Mémoires*, he found when walking about Rome and who, having taken a vow of poverty, sat for no fee, so long as he was fed.[3] He was first used for the altarpieces devoted to the *Life of St Martha*, most obviously for two heads, seen at different angles, among the audience of *St Martha Preaching the Gospel at Tarascon* (1748).[4] But it was the picture in which the model sat in his own guise as a hermit, having fallen asleep from exhaustion while playing the fiddle, *L'Hermite endormi* (1750; Louvre, Paris), that won Vien the approbation of the Director of the Academy, Jean-François de Troy (1679–1752).[5] A variant study for the head of that figure is in the Musée des Beaux-Arts in Orléans.[6] Vien so often used the head of this model that one could re-interpret the exchange related in his *Mémoires*, between the Capuchin who kept on exclaiming, after his delivery of the six pictures for Tarascon: '*Monsieur, vous êtes bien jeune*' ('Sir, you are very young'), and Vien, who responded in exasperation: '*Mon Père, ce n'est pas la barbe qui fait les tableaux, c'est la tête*' ('Reverend Father, one doesn't paint pictures with one's beard, but with one's head').[7]

The present head appears to have been exploited in a picture painted by Vien shortly after his return from Rome, the altarpiece of the *Visitation* (1752) in the church of St-Éloi at Crécy.[8] Somewhat improbably, Gaehtgens and Lugand claimed that, for the hands of the Virgin, he had employed those of Boucher's supposedly favourite model, Louise Murphy, and for her face, that of one of the sisters who had preceded her as mistress to Louis XV! Vien, in his *Mémoires* leaves the matter much more open.[9] Whether because of the rumour of this after the fall of the monarchy, or for some other reason, though the altar itself survives, with Vien's ovals of the patron saint of the church, *St Eligius*, and Mme de Pompadour's name-saint, *St John the Baptist*, in its upper parts, the *Visitation* is no longer in it, an inferior *Annunciation* by another hand having taken its place since at least 1830. Vien's oil sketch for the painting is, however, in the Musée des Beaux-Arts in Rouen.[10] The head of Zacharias behind St Anne in this was patently taken from another of Vien's sketches of his Roman hermit, seen in a very similar view to the present study; it would only have required Zacharias to have been raised a little higher than Elizabeth in the actual altarpiece, to avoid his appearing to be dwarfed by her, for his gaze to have been directed so far downwards as well.

ADL

85

ATTRIBUTED TO JEAN-JOSEPH-XAVIER BIDAULD
Carpentras 1758–Montmorency 1846

View from Vallombrosa (?)

Oil on canvas, 9¼ × 12½ in (23.5 × 32 cm)
Cobbe Collection, no.340
HISTORY John Cooper, Paris; from whom
acquired *c*.1970/75 by [Sir] Jack Baer, of Hazlitt,
Gooden & Fox, London; by whom sold to John
Tillotson (1913–84); his posthumous sale,
Christie's, London, 2 February 1985, lot 46 (as
View from Vallombrosa, attributed to F.-X. Fabre).
LITERATURE Laing/Cobbe 1992, p.17, no.322,
illus. (as by Fabre); London 1996, p.34

1 *Cf*. London 1986c. The decision was taken to
focus the Bequest around his sketches from the
Barbizon School.
2 Laure Pellicer's doctoral thesis, *Le peintre
François-Xavier Fabre*, University of Paris IV, 1982,
regrettably remains unpublished, but she has
derived a number of articles and entries from
it, most notably in Spoleto 1988. Sir Jack Baer,
through whom John Tillotson bought most of
his pictures, has kindly informed me that he
bought this picture with an attribution to that
artist from the late John Cooper, but himself
catalogued it simply as 'French School, *c*.1800'.
3 There is as yet no monograph on Bidauld, but
see the comprehensive exhibition catalogue by
the late Suzanne Gutwirth (Carpentras 1978).
4 Inv.nos 2600 (oil on paper, laid down on can-
vas) and 2601 (oil on canvas); Carpentras 1978,
nos 12 and 10. *The View from Subiaco* first gained
wider exposure from its exhibition in London
1959, no.18 and was subsequently shown in
Cambridge and London 1980–81, no.39.
5 Carpentras 1978, no.7; Gutwirth 1977, fig.6.
6 Gutwirth 1977, pp.147–52. Another version
of the landscape in Boston was auctioned at
Sotheby's, New York, 2 November 2000, lot 106.
7 Sales, Christie's, London, 14 December 1984,
lot 12, and 4 April 1986, lot 187.
8 Buildings do, however, appear in close-up
at the top of Bidauld's *Gorge at Civita Castellana*,
of 1787 (private collection; see Carpentras 1978,
no.8, and Cambridge and London 1980–81,
no.38).
9 *Cf*. New York 1990, no.57.
10 Inv.nos 825-I-112–15; d'Albenas 1914, nos 256
(on panel), 257, 258 and 260 (all on canvas). One
of these, *Vallombrosa and the Valley of the Arno Seen
from the Paradisino* (inv.no.825-I-115) was exhibited
in Paris, Detroit and New York 1974–5, no.65.
11 Lefuel 1934, p.147, no.602; *cf*. Marmottan
1926, p.298, and London 1976, p.58 and p.36,
illus.
12 Inv.no.1837-I-837.
13 Castellan 1819, vol.3, p.316.

When this picture was, with
some regret, weeded out of the
John Tillotson Bequest to the
Fitzwilliam Museum (his tax
dispositions not having been
quite as intended, making it
necessary to sell some items
from his collection),[1] it was sold
with an attribution to François-
Xavier Fabre (1766–1837) and
described as a '*View of the Valley
of the Arno from Vallombrosa*'. The
source of this attribution and
location remains mysterious,
since no written justification
for either ever seems to have been produced, and it is hard to find anything in Fabre's known oeuvre –
even in the landscape backgrounds to his Florentine portraits – that would justify it.[2] Nonetheless
it does have the merit of locating this picture in the output of one of those French artists in Italy for
whom Florence – and Tuscany – was as important a part of their artistic itinerary as Rome.

After the violent reaction to the execution of Louis XVI had driven the French out of Rome, some
French artists, such as Fabre himself, Nicolas-Didier Boguet (1755–1839) and Louis Gauffier (1762–
1801), retreated to Florence, their lack of sympathy with the Revolution inclining them to remain in
Italy rather than to return home. The artist to whom this evocative study is here attributed, however,
Jean-Joseph-Xavier Bidauld, simply took in Tuscany in a five-year sojourn in Italy (1785–90), which,
being at the expense of Cardinal de Bernis and a picture-dealer called Dulac, rather than a product
of the so-called *prix de Rome*, allowed him to roam the peninsula practising his specialty, landscape,
instead of following an academic course of instruction and practice in the papal city.[3]

In the course of his rovings, Bidauld produced a number of highly distinctive landscapes, marked
by an unusual clarity of focus and by a particular pleasure in the light effects of morning haze lifting
from over densely wooded hills. Two of these are in the Louvre, Paris: the *View from Subiaco*, and the
View from Avezzano, both of 1789.[4] Two others, *Rocks near Narni* of 1787 and a *View of Mt Soracte* of *c*.1789,
are in the Musée Duplessis of his native Carpentras[5] (then still in the comtat Venaissin, and so part of
the Papal States). Another two are in American museums: a *View of the Sabine Mountains* in the Detroit
Institute of Arts and a *View of Monte Cavo from Lake Albano* in the Museum of Fine Arts in Boston.[6] And
an unidentified view of a *Landscape with a Tower and Ruined Antique Tomb* has twice passed through
Christie's in London.[7]

What sets the present picture somewhat apart from all of these is the prominence given to the
tile-roofed buildings in the foreground.[8] On the one hand, this associates them with a number of
the sketches of Italian sites by Valenciennes (1750–1819); on the other, it lends them some affinity
with the four *Views of and from Vallombrosa* painted by Louis Gauffier in 1797, which were picked up
by the Prior of Glenstall Abbey, Co. Limerick, from a store in Dublin around 1930 and subsequently
sold at Christie's, London, on 13 December 1974 (two of them subsequently being acquired by the
Philadelphia Museum of Art).[9] Four studies for these belonged to Fabre and were given by him to
the museum named after him in Montpellier,[10] and two later variants are in the Musée Marmottan
in France[11] and in a private collection in Michigan. But these views by Gauffier tend to be more ver-
tiginous and to have a broader sweep than the present picture. It must, however, be wondered – since

he was not primarily a landscape painter – whether it was purely his encounter with the site in 1796 (the date on a large black chalk drawing of one of the views, also in the Musée Fabre)[12] that stimulated Gauffier to paint his views of Vallombrosa, or whether he was not encouraged to do so by having encountered some of Bidauld's landscapes, including the present picture.

As to Vallombrosa itself, and its treatment by these two artists, Jean-François Méjanès quoted some very pertinent lines from a friend of Fabre's, who visited the Camaldolese abbey with him in 1798, apropos of one of Gauffier's views of it, when it was exhibited in Detroit and Paris in 1974: 'This wild spot, which was originally called Aqua Bella [beautiful water], has since been called Vallombrosa [shady valley]. And indeed, the thick black foliage of the beeches and pines, the sheer rocks that prevent the sun from penetrating the depths of the valley until long after it has lifted, the clouds and mist with which it is often covered: all these give it a sombre, wild, and melancholy character, that chimes with the retreat and meditations of the monks that inhabit it.'[13]

ADL

JEAN-LAURENT MOSNIER
Paris 1743/4–St Petersburg 1808

Portrait of Catherine Cobbe, the Hon. Mrs Henry Pelham (1761–1839)

Oil on canvas, 45 × 34¾ in (114 × 88 cm)
INSCRIPTIONS signed and dated at centre right,
on the wall, *J.L. Mosnier / f.1792*; on the reverse:
inscribed on a label on the canvas, in brown ink,
*Hon. Mrs. Pelham / Daughter of Lady Betty Cobbe /
1793*; and on the stretcher, also in brown ink, *The
Hon^ble Mrs Pelham / Daughter of Lady / Betty Cobbe*.
Cobbe Collection, no.462
HISTORY presumably the sitter, until her
death in 1839; be descent to her elder daughter,
Catherine Pelham, until her death in 1876; A.
Stewart Walker, New York; his sale, Parke-
Bernet, New York, 26–8 April 1956, lot 319; sale,
Sotheby's, New York, 2 December 1976, lot 155;
with P. & D. Colnaghi, London; with Didier
Imbert, Paris; Karl Lagerfeld, Paris; acquired at
his sale, Christie's, New York, 23 May 2000, lot 14
EXHIBITIONS London 1793, no.182 (as *Portrait of
a Lady*; identified in Horace Walpole's copy of the
catalogue).

Cat.86a Gold thimble given to the
Hon. Mrs Pelham by the future George IV
(private collection)

1 *Cf.* FitzGerald 1950, p.109.
2 Quoted by Stirling 1918, vol.2, p.179.
3 The details of this story are taken from a note
accompanying the thimble, with certain small
errors – such as calling the Bedchamber Women,
Maids of Honour, and locating the episode at
Hampton Court, rather than Windsor – corrected.
4 See George, Prince of Wales/ed. Aspinall 1965,
vol.3, Walpole/ed. Yale, vol.15, p.328 and nn.83–4
(mistakenly supposing that Mrs Pelham's
offence, a remark made in front of the Princess,
that 'all crooked people stunk', was directed
at the Prince's friend Lord Jersey rather than
against someone cherished by the Princess). See
also Farington/ed. Garlick and Macintyre 1978,
vol.2, p.615.
5 Walpole/ed. Yale, vol.12, pp.200–01 and no.10

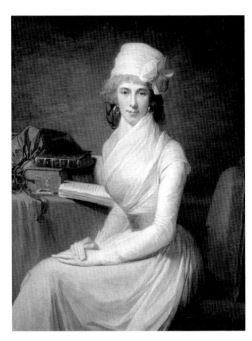

The directness of this portrait of the Hon. Mrs
Henry Pelham seems to have been as characteris-
tic of the sitter as it was of the artist. Second of the
children of Thomas and Lady Betty Cobbe (she
was painted with her elder brother Charles, at the
age of four, by Strickland Lowry: see cat.12), she
made her debut as the *belle* of the last two balls of
the season at Dublin Castle in November 1777,
when she was described by Lady Louisa Conolly
as 'not so beautiful as, but vastly in the style of' the
celebrated Georgiana, Duchess of Devonshire.[1]
The next year, the newish Lord-Lieutenant, John,
2nd Earl of Buckinghamshire, wrote that she: 'is
a very fine young woman; but her judgment does
not do honour to her figure: she has repeatedly
assured me she had rather be a Lord-Lieutenant
of fifty-three, than the handsome accomplished
Miss Cobbe of seventeen!'[2] Her *belle*-hood was
not achieved without some cost: to this day an
iron staple may be seen fixed to a beam across the
ceiling of the room at the end of the North Corridor at Newbridge; from this she used to hang, to
enable her maid to lace her bodice yet tighter. Nonetheless, it was not until November 1788 that she
was married in Bath to the Hon. Henry Pelham (1759–97), second son of Sir Thomas, 6th Bt and 3rd
Baron Pelham, later 1st Earl of Chichester, to whom she had probably been introduced through the
appointment of his elder brother, Thomas, as Secretary to the new Lord-Lieutenant of Ireland, the
2nd Earl of Northington, in 1783–4.

It was doubtless to the Hon. Mrs Pelham's half-uncle, Francis Rawdon-Hastings (1754-1826),
2nd Earl of Moira (and later 1st Marquess of Hastings), former *aide-de-camp* to George III, and bosom
friend of the Prince of Wales, that she owed her appointment as one of the Bedchamber Women to
Princess Caroline of Brunswick-Wolfenbüttel, following the latter's marriage to the Prince in April
1795. Catherine's fearlessness of response earned her a gold thimble from the future George IV, who,
while walking along the Terrace at Windsor Castle, came across the Bedchamber Women sewing at
an open window and noticed that Catherine Pelham was the only one to be wearing a silver, rather
than a gold, thimble; when he asked her why, he was given the unvarnished reply that she possessed
no other. The gold thimble that he thereupon bought and gave her remains in the family (cat.86a).[3]

Catherine was dismissed by the Princess in July 1796, for having taken sides with the Prince of
Wales's Master of the Horse, George, 4th Earl of Jersey, and his wife, *née* Frances Twysden, the daugh-
ter of the Bishop of Raphoe and a former mistress of the Prince, whom the Princess was determined
to dismiss from her post as one of her three Ladies of the Bedchamber.[4] Not wishing to disrupt her
household arrangements for the season because of her dismissal, Catherine coolly enquired of the
Prince whether her former mistress planned to come to Brighton; on being told that she did not,
she simply remained there.[5] Catherine bore Henry Pelham two daughters: Catherine (*d.*1876), who
remained unmarried, and Fanny (*d.*1860), who was married in 1834 to Capt. James Hamilton Murray,
RN (*d.*1841). She spent her own widowhood at Cheltenham, where she died.

Mosnier was, like the older and better-known Henri-Pierre Danloux (1753–1809), forced into
exile in England in 1790 by the French Revolution.[6] His initial career was one of great *éclat*, aided,

(letter to Mary Berry, 9 August 1796, also making it clear that it was the Princess who insisted on Mrs Pelham's dismissal).

6 Very little study has been made of Mosnier or of his time in England (for which, however, see the abstract of Marlier 1958, pp.121–2).

7 A second portrait, painted in 1791 for the sitter to present to Baron von Schlaffen, was, after a period in family ownership from 1949, auctioned at Christie's, 11 November 1994, lot 16.

8 Lord Armstrong's sale, Christie's, London, 14 March 1924, lot 23; sale, Parke-Bernet, New York, 21 February 1945, lot 41; see Buenos Aires 1948, no.12.

9 *Cat. National Maritime Museum* 1988, p.281, inv.no. BHC 2970 and fig.C, and *Cat. Paintings in British Collections* 1993, vol.1, p.325, no.965.

10 Reproduced in Waterhouse 1981, p.250.

no doubt, by the fact that the francophile former Prime Minister, William, 2nd Earl of Shelburne (by then, 1st Marquess of Lansdowne), sat to him in that year (the portrait now in the Art Museum, University of Michigan, Ann Arbor).[7] One of his earlier portraits, a three-quarter-length of *Lady Boyd* (1791; formerly in Lord Armstrong's collection),[8] still appears very French and Mme Vigée-Lebrun-like in character, but his portrait of the great naval hero and victor over the French, *Lord Rodney* (1791; National Maritime Museum, a copy of which is in the City of London's collection)[9] is already much less so.

Mosnier went on to paint a number of striking whole-lengths in the English taste, notably those of *George, 7th Marquess of Tweeddale* (1794; private collection),[10] *Anne Powys, Viscountess Feilding* (1794; cut down between 1938 and 1983; private collection), and *Lady Callender with her Son* (1795; Breadalbane), but, despite exhibiting portraits at the Royal Academy between 1791 and 1796, he did not make a sufficient livelihood and so left in the latter year for Russia. There he was appointed court painter to the Tsar, and professor at the Academy, and thrived until his death.

The present portrait shows Catherine Pelham in a French-inspired white dress, with a white muslin shawl with red candy stripes tied tightly round her bodice, and another forming a turban with a bow. Behind her, on the table covered with a scarlet cloth, sit books and a red leather wallet with a piece of paper emerging from it – possibly a letter-case (it was her younger sister, Elizabeth, Lady Tuite, who was a published author). But behind them is a dark blue work-bag, its draw-strings falling over the front of the table, as if to emphasise that her intelligence had not cut her off from female pursuits. No trace, curiously, of a wedding-ring, her only jewellery being a pair of gold ear-rings. Her waist, despite child-bearing, looks as slender as when it was tightened from the sling at Newbridge. ADL

ATTRIBUTED TO JEAN-VICTOR BERTIN
Paris 1767–Paris 1842

Landscape with Classical Figures on and beside a Lake

Oil on canvas, 15 ¾ × 12 ½ in (40 × 32 cm)
INSCRIPTIONS signed and dated at bottom
right, *Bertin / 1828*; on the reverse of the canvas:
inscribed, *106 m Bertin*
HISTORY acquired at sale, Sotheby's, New York,
30 January 1998, lot 189

1 See the accusation made by Théophile
Gautier, quoted in Paris 1968, unpaginated.
2 For the modes of landscape painting in
France at this period and Bertin's place within
it, see Galassi 1991, and his essay, adapted
from his book, in New York 1990, pp.233–49.
3 A comparable picture, but with a more
definite Classical subject, is the *Landscape Roundel
with Echo and Narcissus*, signed and dated 1825
(see London 1978, no.11).
4 The picture (40.5 × 32 cm) is signed, *J.V. Bertin*;
don Lemonnier, 1862. See Gutwirth 1974, p.348,
no.69, dating it to *c.*1810 and saying that it is: '*fort
représentatif de la manière néo-classique à laquelle
aboutit l'art de J.V. Bertin sous l'Empire*'. Not having
seen that picture – and her illustration of it
being too small for meaningful comparison –
the present writer is unable to say whether her
dating of it is correct, or how it relates to the
present picture. If Gutwirth's dating of the
Rouen picture is right, then the present paint-
ing is either a later autograph repetition of it,
or a looser copy with a spurious signature
and date. It is conspicuous, however, that she lists
only one painting – also dated 1828 – of between
1827 and 1830, suggesting that there is a void
in Bertin's oeuvre crying out to be filled. In the
absence of fresh commissions, he may well
have responded to requests to repeat earlier
compositions.

It is the misfortune of Bertin to have been
the pupil of the most revolutionary of the
pioneers of the *plein-air* landscape sketch in
oils, Pierre-Henri de Valenciennes (1750–
1819), and one of the teachers of its best-loved
exponent, Camille Corot (1796–1875); more-
over, in later life he came to be excoriated,
along with Bidauld (see cat.85), as one of the
reactionaries blocking the path of the painters
of the Barbizon School, such as Théodore
Rousseau (1812–67), who would carry this
naturalism over into their finished Salon
exhibits.[1] In the revival of Bertin's reputation,
his studies of actual or imagined sites in Italy
have regained favour much more easily than
such *paysages composés* as the present one.[2]

This kind of picture, with nature carefully
selected and refined, and peopled by classical
figures doing nothing in particular, represents
the final French manifestation of a universal
European tradition, one that had obtained since the days of Claude (who, it should be remembered,
was not a Frenchman, but an artist from the then still autonomous Lorraine, whose whole career
was spent in Rome). Even within this idiom, Bertin had two modes of working: one that of the true
paysage historique – generally a large landscape, of classic oblong shape, with a repertoire of set motifs
carefully carpentered into place – and the other that of the less formal *tableautin*, prefiguring in
character – but not in handling – the later idylls of his pupil Corot.[3]

The present painting, which is in the latter mode, is evidently one that struck a chord, since there
is another version of it, signed but not dated, in the Musée des Beaux-Arts in Rouen.[4]

ADL

88

FRENCH SCHOOL,
Early 19th century

Study of Drapery

Oil on canvas, laid on board,
8½ × 11 in (21.5 × 28 cm)
INSCRIPTIONS inscribed at bottom left, *N°371*,
and in black ink, within a stamped oval in red
ink, *Vente Atelier*
Cobbe Collection, no.391
HISTORY acquired from the Galerie de Staël,
Paris, 1992

1 See Paris 1991–2.
2 Paul Delaroche (1797–1856) made a number
of studies of the heads of Camaldolese monks
(mostly now in the Musée des Beaux-Arts in
Nantes), when he spent ten days at Vallombrosa,
in the company of Odier, Delaborde and Édouard
Bertin, in the summer of 1834, but these do not
appear to have been intended for use in any
composition requiring studies of their habits
too (see Ziff 1977, pp.138, 282–3, nos 61–5 and
p.357, fig.61).

When this study of a piece of cream-coloured drapery was acquired, it bore an attribution to Théodore Géricault (1791–1824), but the stamp is not that of his studio sale. There was such a sale, held in the Hôtel de Bullion, Paris, on 2–3 November 1824, but no *cachet d'atelier* was applied to either paintings or drawings in that sale, with the result that many of its lots can be identified only tentatively with surviving works.[1]

A study such as this, being one of the traditional aids in the creation of a history painting by an academically trained artist, is particularly difficult to attach to a specific name, unless one can either identify the finished picture for which it served, or unless the *cachet d'atelier* on it can be identified, thanks to its occurrence on a securely identified work elsewhere.

Stylistically, the previous attribution to Géricault would not seem to have been so wide of the mark: the vigorous, but solid handling of the paint of the drapery itself, thrown into relief by the sketchier indication of the greenish-brown background, would appear to point to a dating to the first third of the 19th century. It is evidently the study for the nether parts of a semi-prostrate figure, possibly that of a Cistercian, Olivetan, Carthusian or Camaldolese monk[2] – although the figure's feet are shod, rather than barefoot or be-sandalled, and the heavy cloth, though appropriate for a monastic habit, seems almost too copious for such a garment. That, and the smallness of the feet, might even suggest the gown of some medieval woman.

The *cachet d'atelier* appears to contain two conflicting clues to its dating: on the one hand, the existence of such a stamp, devoid of any artist's name, points to a time reasonably advanced in the 19th century, when such studio sales were sufficiently frequent for an auctioneer to have had such a stamp made, for multiple use – before realising that something specific to each sale was required. On the other hand, the use of an uncrossed '7' would indicate a writer brought up under the *ancien régime*, before the Napoleonic system of universal education standardised the use of the crossed '7' across Europe.

Thus, until either a finished painting or the *cachet d'atelier* can be identified, the attribution of this attractive study must remain unresolved.

ADL

WILLIAM ASHFORD
Birmingham 1746–Dublin 1824

Landscape with a Castle above a River

Oil on unlined canvas, on original stretcher,
24⅛ × 20⅛ in (61 × 76.5 cm)
INSCRIPTIONS on the reverse: stamped on linen,
413 1775; and the bookplate of Alec Cobbe
Cobbe Collection, no.323
HISTORY acquired from the Sean Collins
Gallery, Dublin, *c*.1984 (as by Thomas Sautelle
Roberts)

Cat.89a Claude Lorrain, *Landscape with
Narcissus and Echo*, pen, grey-brown wash, over-
laid with areas of brown wash, 7¾ × 10¼ in
(195 × 260 mm), 1644, from the *Liber Veritatis*
(British Museum, London)

1 Formerly with Aldric Young Antiques,
Edinburgh; photograph in the Witt Library,
London.
2 See Wynne 1994, p.139.
3 See McEvansoneya 1999, pp.159 and 172, n.44.

The present work seems to be one
of the earliest surviving landscapes
by William Ashford. This artist was
born in Birmingham and came to
Dublin in 1764 to take up a position
as clerk to the comptroller of the
Laboratory of the Ordnance, which
involved travelling around Ireland
checking on the armaments and
ammunition in the garrisons. He
started to exhibit still-lifes, such as
the *Vase of Flowers* (National Gallery
of Ireland, Dublin), at the Society
of Artists in Dublin, but it was not
until 1772 that he turned his hand
to landscape, a genre in which from
that date he worked exclusively. Particularly after the death of Thomas Sautelle Roberts (1748–78),
Ashford dominated the Irish market for topographical views of estates and was patronised by the
Duke of Leinster, Viscount Fitzwilliam and the Earl of Drogheda. In 1813 he was elected president of
the Irish Society of Artists and was instrumental in the foundation of the Royal Hibernian Academy,
of which he was voted the first president.

In the present painting, Ashford was clearly still experimenting with landscape. The picture can be
compared with a signed work of similar composition, but in reverse, in which the castle is repeated
almost identically.[1] There is a certain awkwardness to the composition, and the figures and cattle
are not as well integrated into the picture, as is the case in his later work. Ashford, like George Barret
(*c*.1728/32–1784) early in his career (see cat.11), took Claude (?1604/5–1682) as his model.[2] Indeed,
collections of landscapes such as that at Newbridge House, which included works by Dutch masters
such as Hobbema (see cat.24) and others in the classical tradition of Gaspard Dughet (see cat.40), were
instrumental in the creation of the distinctive landscape school that arose in Ireland in the second
half of the 18th century. In the present context, it is worth noting that the Earl of Moira, Thomas
Cobbe's stepbrother, had on display in his house in Dublin a picture by Claude which we know was
available to artists for study.[3] The composition in the Cobbe picture by Ashford is modelled on Claude's
celebrated *Landscape with Narcissus and Echo* (National Gallery, London). He replaced the mythological
story in the foreground with a more prosaic genre element. However, the essential disposition of
the trees and the placement of the castle remain the same. Claude's work was frequently reproduced,
and indeed Ashford's landscape is rather closer to Earlom's aquatint from the *Liber Veritatis* (cat.89a)
than to the National Gallery oil. Interestingly, Narcissus and Echo had been engraved as early as 1743
by François Vivares (1708–80), who in 1770, around the date of Ashford's landscape, exhibited at the
Society of Artists in Dublin.

WL

90

CORNELIS JONSON VAN CEULEN
London 1593–Utrecht 1661

Portrait of Sarah Harington, Lady Edmondes

Oil on panel, oval, 23¾ × 19 in (60.5 × 48.5 cm)
INSCRIPTIONS inscribed along the upper edge,
in paint, *Spes Supra* and *ÆTATIS SUÆ 63*
Cobbe Collection, no.339
HISTORY Jephson-Norreys family, Mallow
Castle, Co. Cork; J. Hare; his sale, Christie's,
London, 16 April 1937, lot 62 (the catalogue
illustration showing the corners made up to a
rectangular shape); acquired at sale, Christie's,
London, 13 July 1984, lot 88
LITERATURE London 2000a, *sub* no.15, n.5

1 I am grateful to Mark Weiss for drawing
my attention to the findings of Dr Rosalind
K. Marshall and Dr Athol Murray (corres-
pondence with Mark Weiss, 13 June 2000).
The inventory in the Public Record Office of
Scotland, Bohemia 2, RD 1/508 s.d. 23 August
1637, the jewel being item no.7.
2 Oil on panel, 30 × 24 in (76 × 61 cm), with the
Weiss Gallery, London; see London 2000a, no.15.

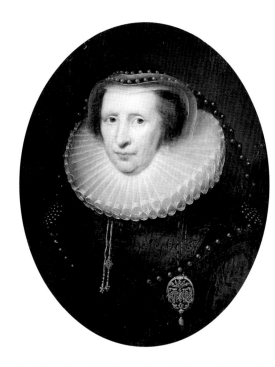

When the 63-year-old Sarah (*née* Harington),
Lady Edmondes, was painted by Cornelis
Jonson in 1628, she was in the second year of
marriage to her fourth husband, Sir Thomas
Edmondes, then Treasurer of the Household.
Her first husband, whom she had married in
1586, was Francis, Lord Hastings, the eldest
son of the 4th Earl of Huntingdon. Their son,
Henry, succeeded his grandfather as 5th Earl
in 1604. His descendant the 9th Earl married
Selina Shirley, one of three daughters of Mary
(*née* Levinge), Countess of Ferrers (see cat.2),
and the founder of the famous evangelical
'Countess of Huntindon Connexion'; the
celebrated Methodist Countess was a niece of
Archbishop Cobbe (see cat.7), through his
marriage to Mary's sister, Dorothea Rawdon
(*née* Levinge).

Lady Edmondes is depicted as a sympa-
thetic old lady, wearing an important oval gold
pendant jewel set with diamonds and a dress
lavishly adorned with pearls. The form of the jewel corresponds to a description of a monogram
on the cover of a gold 'pictour box' in an inventory dated 1637 in the papers of Princess Elizabeth
(the 'Winter Queen'), daughter of King James I and wife of Prince Frederick, Elector Palatine, who
in 1619 was created King of Bohemia (the 'Winter King'). That monogram was 'sett with diamondis
efter this forme ΦΦ containing twa eyes decephered with twa OO resembling twa greek letters F for
Frederik the king his name with ane croune upone the heid of the same'.[1] Sarah's brother, John, 1st
Baron Harington of Exton (1540–1613), was Princess Elizabeth's guardian during her childhood, and
it seems likely that the Elector Palatine honoured her with this token of gratitude, perhaps on the
occasion of his marriage in 1612.

The execution of the face, stiff-pressed ruff, pearls and jewellery is very detailed and painterly.
The picture has been cut down, resulting in the loss of its original fictive architectural surround.
The original form of the work can be seen in a second version, which is monogrammed and dated
C. J. fecit 1628 and which was on the London art market last year.[2] The architectural surround of the
latter version is marbled, and the face is painted in the same sensitive manner.

MB

Antwerp 1599–London 1641

Portrait of Rachel Wriothesley (née de Ruvigny), Countess of Southampton (1603–40), as Fortune

Oil on canvas, 50¾ × 41¼ in (129 × 105 cm)
Cobbe Collection, no.467
HISTORY acquired at sale, Christie's South
Kensington, London, 7 June 2001, lot 10, illus.
(in colour)

Cat.91a Anthony van Dyck, *Portrait of
Rachel Wriothesley (née de Ruvigny), Countess
of Southampton, as Fortune*, oil on canvas,
87¾ × 52 in (223 × 132 cm), c.1638–40 (National
Gallery of Victoria, Melbourne)

1 A third full-length version, corresponding to
the Melbourne design, is in the collection of the
Duke of Portland, Welbeck Abbey. Good head
and shoulder copies are in the Buccleuch and
Sutherland collections and in a private collec-
tion in New York. Among later derivations is
one at Woburn Abbey. An enamel miniature
copy by Jean Petitot (1607–91), signed and dated
1643 and based on the Melbourne version, is in
the Devonshire Collection, Chatsworth House,
Derbyshire. An equally fine enamel of the head
and shoulders is at Sherborne Castle.
2 Hoff 1995, pp.96–8; Antwerp and London
1999, p.336, no.104 (entry by Judy Egerton), illus.
3 The picture was discussed by Jaffé 1984,
pp.603–9; see also London 1992–3, no.7, illus.

This hitherto unknown three-quarter
length portrait from the studio of Van
Dyck depends for its design on the full-
length *Portrait of Rachel Wriothesley, Countess of
Southampton, as Fortune*, a composition that
survives in two main versions, both datable
1638–40.[1] What is now considered to be the
prime version is that in the National Gallery
of Victoria, Melbourne (cat.91a),[2] which is
palpably superior to the second version, in
the Fitzwilliam Museum, Cambridge.[3] The
latter is now thought to be a second version
painted slightly later in the studio (possibly
while the original was still being worked
on), to which two important amendments
were made by Van Dyck himself or by a par-
ticularly skilful assistant. It is in less good
condition than the first, with abrasions
throughout much of the surface from the
over-zealous cleaning that occurred while
the picture was at Althorp House, Northamptonshire. The recent appearance of the Cobbe picture,
which is well preserved and whose impressive handling seems at least equal, in part, to the Fitzwilliam
version, raises further questions about the relationship and sequence of the known versions of the
composition. The Cobbe picture, moreover, is clearly to be associated with the Melbourne and not
with the Fitzwilliam version.

In the catalogue to the 1999 Antwerp and Royal Academy exhibition on Van Dyck, Judy Egerton
gave an excellent appreciation of the Melbourne *Countess of Southampton as Fortune*, including the
probable significance of the allegory of the composition. Only rarely did Van Dyck cloak his por-
trait subjects with symbolical meaning, preferring to represent them in their unalloyed, everyday,
aspect. But, in this instance, the Countess plays the part of Fortune, the fickle goddess of antiquity
who bestowed her favours at random. Appearing on a cloud, as is the goddess's wont, the Countess is
dressed in 'heavenly' blue. With a detached expression on her face, she glances down at the spectator
contemplating her next move. The globe on which she rests her left arm indicates her ability, with
a mere movement of her hand, to intervene at whim in earthly goings-on (at an early stage, the sceptre,
which is present in the Fitzwilliam picture, was removed from the Melbourne version and the era-
sure then covered up). With her right foot, she treads on a human skull, a reminder of the Countess's
premature death at the age of 37, itself a sleight of Fortune's hand.

Since the Melbourne picture's showing at the Royal Academy exhibition, Alastair Laing has sug-
gested (orally) that the original idea for the commission could have been to portray her as *Bellezza*
(Beauty), one of the properties of which, according to Ripa's *Iconologia* (an influential contemporary
handbook on signs and symbols), was a sun-burst, such as is seen behind the sitter in the principal
versions of the subject. Following the Countess's untimely death in childbirth in February 1640,
the iconography was then changed to Fortune in order to reflect the sad event that had occurred.

The question of which of the full-length compositions is the canvas on which Van Dyck worked
first has been debated, and the problem is compounded by the fact that the Melbourne and Fitzwilliam
pictures are of slightly different designs. In the Fitzwilliam version, apart from the presence of the

sceptre, a pentiment shows that the hem of the gown originally followed the Melbourne design but was raised to show the sitter's right foot (covered in the Melbourne version) treading on the skull. This suggests that the Melbourne picture preceded that in the Fitzwilliam but is also evidence of the artist's involvement in the latter. The two versions were placed side-by-side at the Royal Academy before the exhibition opened – an experience that showed conclusively that the version in Australia is the finer of the two. The primacy of the Melbourne picture is also supported by the respective provenances of the two paintings. Whereas the Melbourne picture can be traced back to the family of the sitter's second husband, Thomas Wriothesley, 4th Earl of Southampton (1607–67), the likely commissioner of the picture, the Fitzwilliam version may have first belonged to Lady Spencer, Lord Southampton's sister; it was probably later in the collection of her grandson, the 2nd Earl of Sunderland.

The history of the Cobbe picture is, as yet, unknown, but its position in the sequence is defined by a substantial pentiment of drapery above and to the right of the sitter's left hand, an area in which a comparable pentiment occurs in the Melbourne version, but not in the Fitzwilliam picture. This suggests that it is dependent on the Melbourne picture, the design of which it largely follows. The fluid drawing of the contours of the face, the nobility of her countenance and the vigorous brushwork of the drapery, which has not suffered the same extent of simplification as in the Fitzwilliam picture, hints at a closeness to Van Dyck. Besides combining elements from both the Fitzwilliam and Melbourne versions, there are passages in it that appear in neither, for example the irregular dark area in the sphere immediately below the sitter's left wrist, which is buff in the Melbourne picture and is reduced to a quarter of its size in that of the Fitzwilliam because of the knot of drapery that touches the tip of her left thumb.

Rachel de Ruvigny (1603–40) was born in Paris, daughter of Daniel de Massue, Seigneur de Ruvigny, and married the Earl of Southampton, as her second husband, in 1633. The Earl had inherited his title and estates in 1624 on the death of his father, the 3rd Earl, Henry Wriothesley, an exceptional patron of literature, who was a close friend of William Shakespeare and the dedicatee of Shakespeare's poems *Venus and Adonis* (1593), the *Rape of Lucrece* (1594), and quite possibly the 'W. H.' of the *Sonnets*. From this colourful personality and his maternal grandparents, Viscount and Viscountess Montague, the Cobbes had purchased their Hampshire estates in the 16th century. The connection between the families remained active over generations and Michael Cobbe (1602–47), great-grandson of the original purchaser of the Cobbe lands, after graduating from Trinity College, Oxford, became steward of the 4th Earl's vast estates.

Lord Southampton was one of King Charles I's closest advisors during the Civil War. His estates were valued by Parliament at £60,000, and he maintained a firm retirement on them during the Commonwealth, deftly avoiding friendly overtures from Oliver Cromwell. The Commonwealth saw Michael Cobbe's younger brother Richard (1606–58) returned as Knight of the Shire for Southampton, representing the county in Parliament together with Richard Cromwell. He may have played a part in promoting the leniency with which Lord Southampton's estates were treated by Cromwell. After the Restoration, Lord Southampton was appointed Lord High Treasurer and remained for a considerable period a powerful minister.

OM

SIR PETER LELY

Soest 1618–London 1680

Portrait of Archbishop James Ussher (1581–1656)

Oil on canvas, 49½ × 39¼ in (126 × 99.5 cm)
INSCRIPTIONS at upper left, presumably by
the artist (though the date may have later been
changed), ANNO DOM / 1654 / ÆTATIS 74; and at
lower left (indistinctly), *Arch Bishop Usher*; on
the reverse, on the stretcher: inscribed on label,
25346; on the frame: inscribed on another label,
*Yorkshire / Fine Art and Industrial Exhibition / York /
Subject Archbishop Usher / Artist Vandyke / Exhibitor
H.S. Thompson Esq. Number of Pictures sent. 20*;
inscribed, in pencil, *J.M. Dangar 1958*; bookplate
of Alec Cobbe
Cobbe Collection, no.349
HISTORY the sitter's daughter, Elizabeth, wife
of Sir Timothy Tyrrell of Shotover; thence by
descent; sale of the Tyrrell collection, 1855;
H.S. Thompson, Esq., 1866; Lord Knaresborough,
1923; J.M. Dangar, 1958; thence by descent to
Mrs Dangar; acquired at sale, Sotheby's, London,
10 July 1985, lot 27 ('the property of a Lady')
EXHIBITIONS York 1866 (as 'Vandyke')
LITERATURE Parr 1686, p.79; Vertue/ed. Walpole
Society 1935–6, vol.2, p.60, vol.4, p.126; Beckett
1951, p.64, no.542; Piper 1963, p.355; Ingamells
1981, p.394; Laing/Cobbe 1992, p.19, no.400

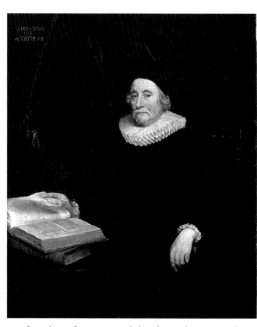

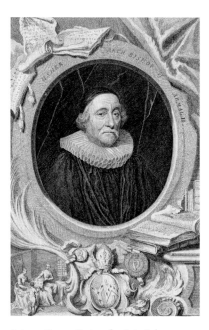

Cat.92a George Vertue after Peter Lely,
Archbishop James Ussher, engraving, plate size:
14½ × 9½ in (365 × 240 mm), 1736

James Ussher, born in Dublin in 1581, was
considered one of the most learned men of
his generation. He entered Trinity College,
Dublin, as one of its first scholars in 1594;
was appointed Professor of Divinity in 1607
and Vice-Chancellor in 1615; and in 1615 was
also entrusted with drawing up Ireland's
new Articles of Faith. In 1607 he had taken
holy orders, and in 1621 he was appointed
Bishop of Meath and four years later, in 1625,
he became Archbishop of Armagh.

It was for his scholarship that Ussher was
most renowned. According to his biographer,
his chaplain Richard Parr, he led 'a life of
incessant study', rising at five in the morning
in summer and at six in winter. It was to pur-
sue his studies that he began making regular
journeys to England, habitually spending
one month each at Oxford, Cambridge and
London, in order to consult books and manuscripts and to collect material for his personal library.
He hoped to compile an accurate version of the Bible, and, to this end, with the help of agents abroad,
he sought out old Hebrew, Greek, Syriac and Ethiopic texts. Another of his intellectual tasks was the
formulation of a historical chronology based on biblical evidence: his estimation of a 4,004-year
elapse from the Creation to the coming of Christ was repeated with authority until relatively recently.

Lely's fine portrait of the Archbishop was painted in the last decade of his life, when he was an
exile in England. He had left Ireland on 5 May 1640 on one of his usual research visits, but his plans
for return were overtaken by the outbreak of the Irish Rebellion and the English Civil War. He was
never to return to Ireland, the words of David, 'Thou tellest my wanderings: put thou my tears into
thy bottle' (Psalms 56:8), apparently often in his thoughts.[1]

George Vertue (1684–1756) knew the present work intimately, as it had been sent to him in
November 1737 by Ussher's descendants, the Tyrrell family, for him to engrave (cat.92a). He identified
the work as an early one by Lely, 'by the pencilling of the Face &c. done expeditiously not painted
over more than once I think, but masterly and with spirit'. He thought the inscribed date had been
altered, however ('on one Corner is writ Anno Dom the date scratched out and the ætat alter'd'),
preferred a dating of 1644, and he lamented the overpainting of the drapery, originally a bishop's
habit with white lawn sleeves but transformed to a uniform black: 'its plainly to be seen on the
picture, the body is painted all over black by an indifferent hand', he says, 'absolutely not Sr. Peter
Lilly'. He presumed that the change had been made 'at the Time of the Rebellious Civil Warrs', when
Episcopal church government had been abolished, and he regretted 'their Squeemish Stomachs
coud not leave it, as it was by him'.[2]

Vertue's reason for an earlier dating of the portrait was his knowledge of the 1644 decision by the
Convocation of Oxford University to pay tribute to Ussher by commissioning an engraving of him,
with an inscription. Ussher had been in retirement at Oxford since 1642, lodging at Jesus College
and working daily among the Bodleian Library's manuscripts. The engraving was supposed to have
been prefaced to his recently completed, corrected edition of the Epistles of St Ignatius, but was
delayed until 1647.[3] Vertue was aware of the engraving, with a eulogistic inscription composed by

Cat.92b x-radiograph of cat.92

1 Bernard 1656, p.99.
2 Vertue/ed. Walpole Society 1935–6, vol.24, p.126.
3 Elrington 1847, vol.1, pp.235–6.
4 See the documents cited in Poole 1912, vol.1, p.51, no.125.
5 Parr 1686, p.79.
6 Ibid., p.72.
7 See Knox 1967.
8 Crookshank and Webb 1990, p.136.

the university Vice-Chancellor, Robert Pinck, which first appeared in Ussher's *De Romanae Ecclesiae Symbolo Apostolico Veterae* (London, 1647) and which he attributed to William Faithorne (1616–1691). He supposed it to have been taken partly from life and partly from the portrait by Lely. In fact, the 1647 engraving is by William Marshall (*fl.c.* 1617–50) and is probably based on the portrait of Ussher by William Fletcher, commissioned and paid for (£2) by the university in 1644 and now in the Bodleian Library.[4] Another portrait of Ussher is at Jesus College (inscribed *1641*). As in the portrait by Fletcher, Ussher appears younger in the Jesus College picture than in the Lely portrait, his hair less grey. Marshall produced at least four engraved types of Ussher, similar to one another but with differing accessories. A more accomplished engraving, attributed to Faithorne, was not published until 1656, facing the title-page to Ussher's funeral sermon.

Parr described Ussher as 'indifferent tall, and well shaped', someone who 'went always upright to the last; his Hair naturally Brown, when young; his Complexion Sanguine; his Countenance expressed Gravity, and good Nature; his Carriage free; a presence that commanded both Respect, and Reverence'.[5] 'Though many Pictures have been made of him', he continued, 'that I never saw but one (drawn by Mr Lilly) that was like him'. Lely's expressive image is, indeed, far more sophisticated than other portraits of Ussher, the handling more lively and the figure with a relaxed ease absent from the two works at Oxford. The portrayal of Ussher seated in a chair, his face displaying a sensitive intelligence, and his books, evidence of his eminence and learning, piled on a table to the left, is one inspired by Van Dyck, and is a pattern to which Lely returned, for professionals and divines, throughout his career. Although this portrait is undoubtedly an early work, 1644 is perhaps an unlikely date, as Lely had arrived in England only towards the beginning of the decade. It seems more plausible as a slightly more mature work, done when Ussher was in London between 1647 and 1656 – thus lending credibility to the date of 1654 inscribed at the upper left of the picture.

Ussher had left Oxford in 1645, when he accompanied the Prince of Wales to Bristol. He proceeded to Cardiff, where he lived briefly with his daughter, Elizabeth, and her husband, Sir Timothy Tyrrell, the Royalist governor of that city; in 1646 he was at St Donat's, Glamorganshire, at the invitation of Lady Stradling; and from 1647 he lived in London as the guest of the Dowager Countess of Peterborough. It was from the leads of her house near Charing Cross that he witnessed the execution of Charles I, falling unconscious as the axe was raised.[6] Although Ussher remained loyal to the king (he frequently preached before him at Oxford, and at Carisbrooke in 1648) and was in favour of a moderate episcopacy,[7] he nevertheless retained the respect of Oliver Cromwell, who ordered a public funeral for him at Westminster Abbey, a service at which the banned Book of Common Prayer was used.

The reason for the alteration of the portrait's drapery, which x-ray examination confirms was carried out (cat.92b), is, therefore, unknown; possibly it was done after Ussher's death. A head-and-shoulders version of the portrait, with white lawn sleeves (National Portrait Gallery, London), possibly records its original appearance. Versions at Chatsworth and Stanford Park show black drapery, while that at Trinity College, Dublin, is possibly a work of *c.*1744, taken from an engraving.[8]

TB

SIR PETER LELY

Soest 1618–London 1680

Portrait of a Man

Oil on canvas, 49 × 39 ¾ in (124.5 × 101 cm)
Cobbe Collection, no.431
HISTORY sale, Sotheby's, London, 9 July 1997,
lot 20 (unsold, acquired after sale)

1 For Browne, see London 1998, p.126, no.146,
and London 2000b, p.57, no.34.

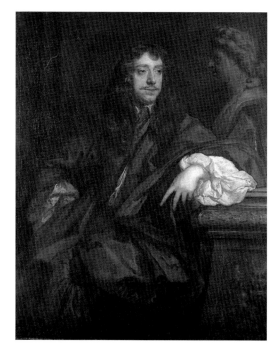

Although this painting was described as a
Portrait of Lawrence Hyde, Earl of Rochester, when
sold at Sotheby's in 1997, this proposal cannot
be sustained and hence the identity of the sitter remains unknown. The informality of his
pose – seated with his legs crossed, relaxing
against a classical plinth – suggests that he
was well known to Lely, perhaps a friend connected with the professional world of art. The
presence of the bust does not necessarily indicate that he was an artist or a sculptor, but it
has presumably been copied or adapted from
a work known to Lely. Background pieces of
sculpture, for which he looked for inspiration to his own famous collection of antique
sculptures and casts and Old Master drawings, are common in his portraits. He owned,
for example, the ancient Roman *Crouching
Aphrodite Bathing* (2nd century AD; Royal
Collection, on loan to the British Museum,
London), and the relief sculpture in his
Portrait of Lady Charlotte Fitzroy, later Countess of Litchfield (York City Art Gallery) was taken from a
Parmigianino drawing he owned. He also made sketches of sculpture elsewhere: for instance, elements of Francesco Fanelli's *Diana Fountain*, then in the Privy Garden at Hampton Court, appear
in several portraits from the early 1660s onwards.

Although not a dominant feature, the crumpled piece of paper lying at the sitter's elbow adds
weight to the theory that he is connected with the world of art. On it is a drawing, albeit rather summary, of the bust above it (the drawing lies on its side, the top of the head facing left). Making copies
after prints, casts and Old Master drawings was widely acknowledged as an important discipline in
the mastery of drawing, for professionals and amateurs alike. It was stressed by Alexander Browne
(*fl.*1659–1706), for example, in his publication *Ars pictoria, or an Academy Treating of Drawing, Painting,
Limning, Etching* (1669), the second edition of which (1675) had an additional section, containing
recipes for artists' colours, dedicated to Lely. Browne was active as a colourman in Long Acre, Covent
Garden, London; was a drawing instructor (in the 1660s he taught Pepys's wife, among others); and
in 1660 had published a drawing manual, *The Whole Art of Drawing, Limning, Painting and Etching*, based
largely on Fialetti.[1]

It would be taking it a stage too far to identify the sitter as Browne himself. Although there are
similarities, Browne appears too young in the engraving by Arnold de Jode (*c*.1638–1662) after Jacob
Huysmans (*c*.1630–*c*.1696), facing the title-page to *Ars pictoria*, to have been the sitter in the present,
slightly earlier portrait. However, the subject of the portrait was probably well known to Lely through
similar professional connections. The Cobbe portrait is painted with a casual familiarity, the face
apparently *ad vivum*, and is dateable to *c*.1660–65.

TB

94

JACOB HUYSMANS
Antwerp *c*.1633–London *c*.1696

Portrait of a Lady as Diana

Oil on canvas, 50 × 40 in (127 × 101.5 cm)
Cobbe Collection, no.457

HISTORY Harold Arthur, 17th Viscount Dillon
of Ditchley; sale, Sotheby's, London, 24 May
1933, lot 70 (as Sir Peter Lely); sale, Sotheby's,
New York, 9 January 1980, lot 64 (as Lely);
acquired at sale, Christie's, New York,
15 October 1998, lot 11
LITERATURE *Cat. Ditchley* 1908, no.15 ('A Lady');
Waterhouse 1988, p.137, illus.

1 Vertue/ed. Walpole Society 1931–2, vol.20,
p.124.
2 Inv.no.T00901.
3 See Boswell 1932, pp.214ff.

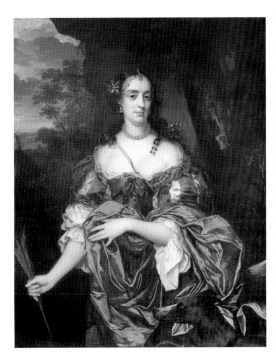

This unknown lady in the guise of Diana, goddess of the hunt, was identified previously as Catherine of Braganza, queen consort of King Charles II. Huysmans was a Roman Catholic artist from Antwerp, first recorded in England in 1662. He is particularly associated with Catherine and her court, painting religious works for her (the most important being an altarpiece for her Roman Catholic chapel at St James's Palace), as well as portraits of her – most spectacularly as a holy shepherdess seated on a river bank surrounded by ducks, lambs and putti (Royal Collection). On a visit to Huysmans's studio in 1664 the diarist Samuel Pepys saw that painting, or a version of it, as well as portraits of her maids of honour, and was 'mightily pleased with this sight endeed'. According to Vertue, Huysmans styled himself 'her Majesty's Painter';[1] whether his position was actually as formal as this is not known.

Huysmans frequently painted court ladies in the mythological role of Diana, a representation that was seen to compliment their beauty, purity and chaste virtue. The sitter in the *Portrait of a Lady as Diana* (Tate Britain, London),[2] also by Huysmans and in spirit very similar to this work, was formerly considered to be Margaret Blagge, later Lady Godolphin; this was because of an old label pasted on the back (no longer extant, date unknown) that was inscribed '*Calisto*', the name of a play, or masque, by John Crowne, performed at court in 1675, in which Blagge (at the time one of Catherine of Braganza's maids of honour) played the part of Diana and the Countess of Derby, the Countess of Pembroke, Lady Katherine Herbert, Katherine Fitzgerald and Mrs Carey Frazier (also a maid of honour) her attendant nymphs. Each nymph wore a rich costume valued at £300 (paid for by herself), and they were all provided with 'plain quivers and arrows' by the Great Wardrobe.[3]

In fact, there seems no need to equate Huysmans's images of ladies as Diana with court stage productions: those painted in such guise are never known to have performed on stage, for example *Anne Scott, Duchess of Buccleuch and Monmouth* (private collection, Scotland) and *Elizabeth Cornwallis* (Canons Ashby, the National Trust). In these two portraits, both sitters appear in the same pose, with the same dogs (suggestive of Diana's hunting pack), and in very similar costume to the sitter in the Tate's picture – evidently it was a pattern that Huysmans had in the studio, which he repeated for various sitters, devoid of a particular context.

The vivid colouring and the vigour and freedom of handling evident in this portrait are typical of Huysmans. The sitter's dogs – the head of one by her side, the nose of another jutting into the picture on the right (revealed during recent cleaning) – are also studio patterns and appear in all three portraits mentioned above.

TB

MICHAEL DAHL

Stockholm *c*.1659–London 1743

Portrait of Mary Corbyn, Lady Levinge (d.before 1722)

Oil on canvas, 49½ × 40½ in (125.5 × 103 cm)
INSCRIPTIONS inscribed at lower left
(incorrectly and by a later hand), *G.KNELLER.fe*;
and below the marble slab (also by a later hand),
Lady Levinge Wife to / Lord Chief Iustice / Levinge;
on the reverse: printed label of William Cowlin
& Son, Ltd, Clifton; inscribed in pencil, *Mitchell*;
and with printed number, *3502*
Cobbe Collection, no.421
HISTORY W. R. Vaughan, OBE; sale, Christie's,
London, 14 July 1961, lot 115 (bought, together
with a portrait of Col. George Bate, for 70
guineas); acquired at sale, Christie's, London,
11 April 1997, lot 63

1 Luttrell 1969, vol.4, p.604.
2 [Anonymous] 1853, p.13.

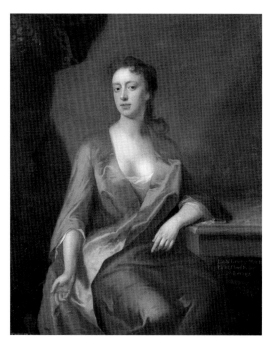

Mary Corbyn married Sir Richard Levinge
(1656–1724), originally of Parwich, Ashbourne,
Derbyshire, in 1680. Their daughter Dorothea
married, as her second husband, Charles
Cobbe, later Archbishop of Dublin (see cat.7).
Dorothea inherited and commissioned sev-
eral Levinge family portraits, but this image
of her mother, by the fashionable Swedish
portrait painter Dahl, who had settled per-
manently in England in 1689, was actually
purchased for the Cobbe Collection in 1997:
presumably it had been inherited by another
family member, while the secondary version
of it at Newbridge (Cobbe Collection, no.98)
had passed to Dorothea.

Sir Richard Levinge was an eminent law-
yer and was appointed Solicitor-General of
Ireland in 1690. He continued to hold promi-
nent public positions there for the rest of his
life, becoming Speaker of the Irish House of
Commons in 1692, Attorney-General in 1711 and Lord Chief Justice in 1720. In 1699 he was one of the
Commissioners appointed to enquire into forfeited estates, but he quarrelled with his four fellow
Commissioners and was committed to the Tower of London in January 1700 for 'aspersing the afore-
said 4 [Commissioners] with what he could not prove'.[1] He purchased estates in Ireland, chiefly in
Westmeath from Lord Albemarle, and four of Sir Richard and Lady Levinge's six children were to
marry into Irish families.

Dahl's *Portrait of Lady Levinge* most likely dates from the early 1700s, possibly from 1704, when her
husband was created a baronet. Her languorous, yet dignified pose is typical of Dahl. Equally charac-
teristic is the involved use of colour: both the rich orange used for her silk robe and the mauve pink
of its lining appear elsewhere in the canvas (the pink highlighting her cheeks is darkened to a purple
for the cast shadow on the wall behind, while the orange is used in areas of dark shading). Areas of
the canvas are rubbed – for instance, Lady Levinge's hair should be more dense, forming a rich sweep
down her neck, with a dark emphasis at the top of her head to help control the composition.

The date of Lady Levinge's death is not certain, but it was before 1722, when Sir Richard married,
as his second wife, Mary, daughter of the Hon. Robert Johnston, Baron of the Exchequer of Ireland.[2]
TB

96

SIR JOSHUA REYNOLDS, PRA (AUTOGRAPH REPLICA?)
Plympton 1723–London 1792

Mrs Siddons as the Tragic Muse

Oil on canvas, unlined, dimensions of present stretcher: 93¾×57½ in (the painted surface extends round the right edge, and original width was 58 in)(238×146 cm)
INSCRIPTIONS signed and dated, on the hem of the shawl on the sitter's lap, *Joshua Reynolds pinx1784*
Cobbe Collection, no.383
HISTORY Robert Bateson Harvey, Langley Park, Stowe, Buckinghamshire (stated to have been exchanged by Reynolds for a large *Boar-hunt* by Frans Snyders, which had hung in his collection at Langley Park); by descent to his grandson, Mr Harvey, MP, by 1865; by descent to Lady Harvey, 1931; acquired at sale, Christie's, London, 12 July 1990, lot 82
LITERATURE probably referred to in *The World*, 15 April 1789, p.3; Leslie and Taylor 1865, vol.2, p.424, note; Graves and Cronin 1899–1901, vol.3, p.898; Collins Baker 1936, p.77; Broun 1987, vol.2, p.173; Asleson (ed.)1999, p.140, n.84; Mannings 2000, vol.1, p.415, no.1621 (as studio replica); vol.2, fig.1569

Cat.96a Joshua Reynolds, *Mrs Siddons as the Tragic Muse*, oil on canvas, 93×57½ in (236×146 cm), 1784 (Huntington Art Gallery, San Marino, California)

1 Quoted in Asleson (ed.)1999, p.52.
2 Ibid., p.46.
3 Aileen Ribeiro in London 1986b, p.325.
4 Reynolds/ed.Hilles 1929, p.103.
5 As pointed out in Merz 1995, pp.516–17.

Sarah Siddons was the most famous actress of her day. Born in 1755, she was the eldest child of Roger Kemble, an actor and playhouse manager. Her brothers John Philip, Stephen and Charles were also well-known actors, and she married an actor, William Siddons, in 1773. She retired in 1812, died in 1831 and was buried in St Mary's Church, Paddington, London, where a white marble seated statue of her, the pose loosely based on Reynolds's picture, now silently contemplates the roar of traffic on the Marylebone flyover.

After a false start as a comedy actress, Mrs Siddons established herself as a great tragic heroine by her astounding performance in the title role of Thomas Southerne's play *Isabella*, at the Drury Lane Theatre, London, in October 1782. 'There was scarce a dry eye in the whole house, and … two Ladies in the boxes actually fainted'.[1] Her appearance was striking. Contemporaries admired her commanding height and piercing, dark brown eyes; painters struggled to capture her dramatic presence. Her prominent nose and chin, and her expressive brows feature in hundreds of paintings, drawings, prints and sculptures, as well as in images on porcelain and other artefacts. As Robyn Asleson has shown, Siddons quickly grasped the publicity benefits to be gained from her portraits and 'devoted herself as assiduously to posing for pictures as she did to performing'.[2] In Reynolds's original picture, which appears to have been commissioned by the Irish playwright and impresario Richard Brinsley Sheridan, she wears an imaginary costume and (probably) false hair, including long plaits considered appropriate for a tragic heroine; only the fairly pointed and corseted bodice and the slightly puffed-out hairstyle acknowledge the fashions of the early 1780s.[3] She is flanked by figures representing Pity and Terror (*cf*.Aristotle's classic definition of tragedy) holding a cup and a dagger: these were traditional attributes of Melpomene, the Muse of Tragedy, as illustrated in standard emblem-books.

At least four full-size versions of this portrait exist, only three of which, those in the Cobbe Collection, the Huntington Art Gallery, San Marino, California (cat.96a), and the Dulwich Picture Gallery, London (cat.96b), will be discussed here. There is good evidence that the prime version, the Huntington picture, was painted mostly in 1783, though it is dated 1784 on the hem of Mrs Siddons's gown. Reynolds's Pocket Book for 1783, in which he would have recorded the dates and times of the actress's sittings, is lost, but in a letter to the engraver Valentine Green (1739–1813), written on 6 May 1783, he refers to the picture as 'just begun'.[4] This must have been the Huntington version, and it was probably the same version that was exhibited at the Royal Academy the following year. However, the status of the Cobbe version, which is also dated 1784, is surely due for reconsideration.

Recent technical examination has confirmed that the Huntington picture is the result of many changes and extensive reworkings by the artist himself. The drapery across Mrs Siddons's knees in that painting was originally a deep blue-violet hue; this was subsequently changed, but the original choice of colour is preserved in the Cobbe version. The figure of Mrs Siddons, whose affinity with Michelangelo's *Isaiah* from the Sistine Ceiling was remarked by early admirers such as Sir Thomas Lawrence (1769–1830), was originally accompanied by a kneeling putto at her feet, holding a scroll, apparently inspired by Domenichino's *St John the Evangelist* now at Glyndebourne.[5] Nor was Reynolds's reworking limited to the foreground. Dissatisfied with the original form of 'Terror' holding the cup,

305

Cat.96b Joshua Reynolds, *Mrs Siddons as the Tragic Muse*, oil on canvas, 94½ × 58 in (239.5 × 147.5 cm), 1789 (Dulwich Picture Gallery, London)

Cat.96c Frances Hayward after Joshua Reynolds, *Mrs Siddons as the Tragic Muse*, mezzotint, 22 × 16 in (560 × 405 mm), 4 June 1787 (Alec Cobbe)

6 The connection with Le Brun was noticed by Robert Wark; see Plymouth 1992, no.21.
7 Harvey, born Robert Bateson, took the additional name of Harvey on inheriting the estates of his uncle David Harvey in July 1788; he bought Langley Park, Buckinghamshire, the same year, and was created a baronet in 1789.
8 Leslie and Taylor 1865, vol.2, p.424, note.
9 Graves and Cronin 1899–1901, vol.3, p.898.

Reynolds selected the figure of 'Fright' in John Williams's 1734 translation of Le Brun's treatise on the passions, and then made a drawing (now in the Tate Collections) of a figure pulling a similar face in the mirror:[6] a fusion of convention and observation – and not without a dash of humour – which might be taken to symbolise much of his work. The Cobbe version shows no such reworking, though x-rays show slight alterations to the placing of Siddons's right hand and to the profile of her face. This is consistent with its being an autograph or near-autograph replica, painted by Reynolds, either alongside or immediately after the completion of the Huntington picture – i.e. a 'fair copy' made after many changes and refinements (rather as a poet might, after numerous alterations and crossings out, make a fair copy of a poem).

Indeed, close comparison strongly suggests that it was the tidy Cobbe version, not the messy Huntington one, that was used by Francis Haward (1759–97) for his engraving, published on 4 June 1787 (cat.96c). The near certainty of this is confirmed by such details as the lowest pendant pearls at Mrs Siddons's bosom – only three strands are clearly visible in the Cobbe picture and in the engraving, but there are four in the Huntington version. Similarly, the patch of light on the cloud beneath her feet in the engraving matches that in the Cobbe picture very closely, whereas the same detail in the Huntington version is somewhat amorphous. In general, Reynolds seems to have simplified and sharpened up such minor details, almost certainly with the engraving in mind, which reflects his long-standing awareness of the importance of engravings in the wider publication of his work. The intriguing question remains as to which picture of Mrs Siddons was actually in the studio at the time the engraving was made. It should be remembered – as is revealed by Reynolds's exchange of letters with Valentine Green, discussing the engraving of the picture, which had been entrusted to Haward rather than to him – that the original prime version, assumed to have been painted for Sheridan, had never been paid for, nor collected by him. It thus remained in Reynolds's hands until sold to Calonne in 1790. The Dulwich copy, acquired by Noël Desenfans at an unknown date, bears the date 1789.

It was this same year, i.e.1789, two years after Haward's engraving, that the Cobbe version was exchanged by Reynolds for an Old Master belonging to a newly rich landowner, Robert Bateson Harvey.[7] This transaction attracted the following comments in the newspaper *The World* (15 April 1789): 'Sir Joshua has agreed to copy his Picture of Mrs Siddons; his payment a Reubens, valued at 500£. The original Sir Joshua values at 1000£'. (The report was not quite accurate; as noted above, the 'copy' of Mrs Siddons already existed, and the 'Rubens' was actually a large boar-hunt by Snyders.)

After this date, all interest focused on the Huntington version of *Mrs Siddons* (and to a lesser extent on the inferior copy at Dulwich). The former was recognised as an outstanding document of early

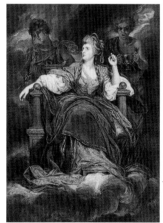

Romanticism, being extravagantly praised when first exhibited and for many years afterwards. Meanwhile the Cobbe version, although noted by 19th-century writers such as Tom Taylor[8] and Algernon Graves,[9] was rarely mentioned and never discussed. It remained in relative obscurity, descending in the Harvey family, but was not included in the sale of the contents of Langley Park in 1946. The present writer first saw and studied it in 1990 when it was sold at Christie's and described it in his *catalogue raisonné* on the basis of that; since then, the painting has been restored, and he has had the opportunity to re-examine it thoroughly.

DM

cat. 96c

97

THOMAS GAINSBOROUGH
Sudbury 1727–London 1788

Portrait of Mrs Letitia Townley Balfour (1746–1838)

Oil on canvas, 30 × 24¾ in (76 × 63 cm)
The gilt livery frame is contemporary with
the picture and is of a most unusual, almost
certainly Irish, design. The corner spaces,
corresponding to the feigned oval in the paint-
ing, are filled with spirited carved and gilded
Rococo traceries that impart a very decorative
effect (for a Gainsborough frame supplied in
Bath, see cat.45)
INSCRIPTIONS on the reverse, on a cross
member of the stretcher: inscribed in ink,
Letitia Mrs Townley Balfour; stamp on a cross
member of the stretcher and again on the right
member of the frame: *M. Gernon & Sons / Picture
Cleaners &c &c /34 Molesworth St / Dublin*
Cobbe Collection, no.350
HISTORY the sitter's son, who built the new
Townley Hall, nr Drogheda, Co. Louth, where
the picture remained with the Balfour family
until the 20th century; David Crichton; his sale,
Christie's, London, 25 October 1957, lot 58
(presumably bought in); D.G. Crichton, Esq.;
acquired at his sale, Christie's, London, 19 July
1985, lot 89
LITERATURE Waterhouse 1958, p.53, no.38a;
Laing/Cobbe 1992, p.20, no.404

1 See Hussey 1948, p.230.
2 See Mitchell 1987, p.55.
3 Ibid., p.8, fig.2.
4 See Ford and Ingamells 1997, p.44.
5 Not in Garlick 1989.
6 See Hussey 1948, p.230, fig.6.

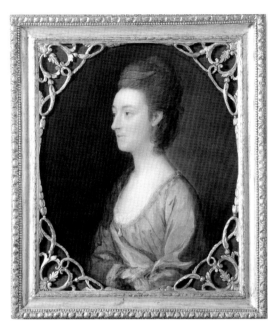

This portrait of a neighbour of the Cobbes
was purchased for the Cobbe Collection in
1985 to hang as a pendant to Gainsborough's
Portrait of Col. Thomas Alexander Champion
(cat.45), the portrait of Champion's wife
(cat.45*) having been sold from Newbridge
in 1913.

Letitia Leigh, daughter of Francis Leigh,
MP for Drogheda, Co. Louth, had a personal
fortune of £10,000, which provided much-
needed security when she was left a widow
with three infant children at the age of
only 25. She had married Blayney Townley
Balfour (1744–71) on 20 February 1768, and
the couple lived at Townley Hall, Co. Louth,
and Granby Row, Dublin. Their eldest son,
Blayney Balfour (1769–1856), employed
Francis Johnston to build a remarkable Neo-
classical country seat for the family, the new
Townley Hall, in 1794. He was probably encouraged in this project by his mother: an architectural
drawing by Letitia Balfour of a Georgian country house in Hertfordshire may have been made at the
time when a replacement for the old Townley Hall was being contemplated.[1]

Mrs Balfour's portrait by Gainsborough was probably painted some time between her marriage
and her husband's death in December 1771. It is possible that the Balfours visited Bath for the sake of
his health. Mrs Balfour's portrait must have hung alongside the 18 Balfour family portraits that had
been brought to the old Townley Hall from Castle Balfour in 1741. By 1773, when the old Townley
Hall had been enlarged by Letitia's father-in-law, there were about 30 portraits and many landscapes
on the walls.[2] Old Townley Hall can be seen in the background of a view of *The Boyne Obelisk* by Paul
Sandby (1725–1809).[3]

Letitia Balfour's son Blayney inherited Townley Hall from his grandfather in 1788, and in 1791
he set out on an extended Grand Tour, together with his mother and sisters.[4] In Rome in 1792 (by
which time his mother had returned home) he met the Scottish architect James Playfair (1755–94),
who made the first drawings for a new Townley Hall; Francis Johnston took over the project two
years later. A portrait of Blayney Balfour was painted by Thomas Lawrence (1769–1830) about 1810.[5]
The Gainsborough *Portrait of Letitia Balfour* can be seen in the new Townley Hall in a photograph of
c.1948.[6] At that time, it hung over a fireplace in the 'prettily domed little boudoir', a ground-floor
room containing satinwood and rosewood furniture.

In the early 19th century, the picture suffered somewhat from the attentions of the restorer
Michael Gernon, who was established as a Picture Cleaner and Valuator at 17 College Green, Dublin,
by 1830. He was involved in restoration work on the Newbridge pictures from 1822 and with the
sale of the Hobbema from the Cobbe Collection in 1839. The background of the Balfour portrait was
entirely scumbled over by Gernon, and the face and drapery have lost some glazes.
ss

JOHN OPIE
St Agnes 1761–London 1807

Self-portrait

Oil on canvas, 23×19¾ in (58.5×50 cm)
Cobbe Collection, no.336
HISTORY Col. Carleton Cowper; Sir Harold
Parkinson, KBE, Hornby Castle, Lancaster;
sale, Christie's, London, 20 June 1969, lot 44
(bought by Klein for 55 guineas); acquired at
sale, Sotheby's, London, 24 October 1984, lot 238
LITERATURE Laing/Cobbe 1992, pp.2, 21, no.407

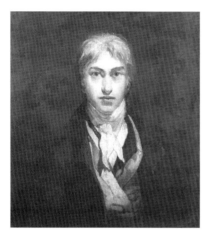

Cat.98a J.M.W. Turner, *Self-portrait*, oil on
canvas, 29¼×23 in (74.5×58.5 cm), *c*.1799
(Tate Gallery, London)

1 Wilton 1987, p.42.
2 Opie 1809, preface, p.15.
3 Earland 1911, pp.297–302.
4 Opie 1809, p.100.

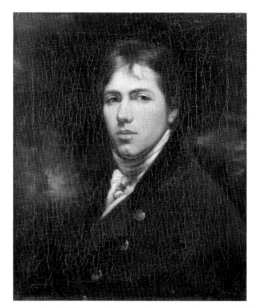

John Opie was the son of a tin-mine carpenter in Cornwall. From an early age, he was encouraged in the arts by a cultivated neighbour, the itinerant doctor John Wolcot, who published satirical verses under the pseudonym of Peter Pindar and who provided appendices for the first important new edition of Pilkington's *Dictionary of Painters*, published in 1798 (see p.60). The young artist frequented Wolcot's house, where he was provided with artists' materials and tuition in the principles of drawing and painting. Strongly interested in *chiaroscuro*, Opie studied prints after Rembrandt (1606–69) and other masters, excelling in this 'requisite' of art training, and introduced such effects into his own work. Wolcot encouraged his *protégé* to pursue a career in London in 1781 and introduced him to 'Mrs. Bos', widow of Admiral Boscawen of Hatchlands Park, Surrey (see pp.206–7). Through Fanny Boscawen (1719–1805), Opie was commissioned to paint a portrait of Mrs Delany, favourite of George III, which allegedly hung in the King's Bedchamber at Windsor Castle. This, in turn, led to his being presented at court and to the King purchasing other works by him.

Within a few months of moving to London, Opie had gained the wonder and admiration of the London art establishment. Sir Joshua Reynolds (1723–92) referred to Opie as the 'Cornish boy' and likened his dramatic light and heavy impasto to 'Caravaggio and Velázquez rolled into one'. His career was consolidated by the success of his history pictures *The Assassination of James I of Scotland* and *The Assassination of David Rizzio*, exhibited in 1786 and 1787 respectively.

The present *Self-portrait* shows the artist in his early twenties, thus dating it to the 1780s. Its pronounced *chiaroscuro*, strongly defined features and, above all, its assured and penetrating gaze may later have inspired the *Self-portrait* of 1798 by J.M.W. Turner (1775–1851), now in the Tate Gallery, London (cat.98a). Andrew Wilton has suggested that Turner had Opie's work in mind when he painted his own self-portrait, since 'its unflinching, four-square regard, its rich impasto, its strongly contrasted lights and shadows, pay tribute jointly to Opie and to Rembrandt'.[1]

Despite the assertion of the artist's second wife, Amelia, that her late husband was entirely free of vanity of any kind,[2] Opie produced a large quantity of self-portraits; more, in fact, than any contemporary British painter other than Reynolds. Earland listed some 40 examples, ranging from early experiments of *c*.1775 to mature, sophisticated portraits done towards the end of his life.[3]

Opie became involved in the theory and history of painting. He contributed a 'life' of the recently deceased Reynolds to Wolcot's 1798 edition of Pilkington's *Dictionary* and delivered a series of lectures at the Royal Institution in 1804. In 1805 he was elected Professor of Painting at the Royal Academy. His lectures for the Royal Academy, published posthumously in 1809, contained encouragement to students to study the relationship of light and shadow by means of both the careful examination of the achievements of the Old Masters and the 'scientific observation of the … phaenomena of nature'.[4]

AC

99
GEORGE JONES, RA
London 1786–London 1869

Wellington with Frontline Artillery at Waterloo

Oil on millboard, 4¾ × 6¾ in (12 × 17 cm)
INSCRIPTIONS on the reverse: inscribed in ink
and pencil, *Wellington at Waterloo at advanced
artillery*; fragment of a printed label from
Winsor & Newton; label of Victor Brockbank,
Fine Art Dealer, Bury St, London
Cobbe Collection, no.386
HISTORY presumably Victor Brockbank,
Fine Art Dealer, London; acquired at sale,
London, Christie's, 26 October 1990, one of
a pair in lot 291

1 John Constable was particularly contemptuous
of the three artists elected as Associates that
year (the architect Jeffry Wyatt, Jones and H.W.
Pickersgill): 'Three associates are to be chosen
next Tuesday at the Royal Academy, out of forty
candidates. They are at a loss entirely. There is
not an artist among them.' (see Whitley 1930,
pp.35, 58).
2 If Constable thought George Jones was with-
out talent in 1822, he must have been even more
outraged in 1824 to see the artist (three years his
junior as an Associate) elected over him as Royal
Academician, by a margin of thirteen to three
votes, to fill the vacancy left by Raeburn.
3 The likelihood is that the sketches were made
on the spot, as is suggested by surviving pencil
sketches made from life, such as *The Duke of
Wellington Mounted on Copenhagen* and *The Duke
of Wellington in Action* (sale, Sotheby's, London,
14 March 1985, a pair in lot 36), the latter of which
is signed and dated 1806, and the fact that some
of the oil sketches are painted on a type of canvas
available only on the Continent.
4 See P. Usherwood in Turner (ed.) 1996,
vol.17, p.631.

George Jones, who painted the present pic-
ture and cat.100, was also known as 'Waterloo
Jones' because of his important depictions of
the Waterloo Campaign (15–18 June 1815) –
when an alliance between the Prussian army
led by Field-Marshal Gebhard Leberecht von
Blücher (1742–1819), Prince of Wahlstadt, and
a mixed British, German and Dutch–Belgian
force under Arthur Wellesley (1769–1852),
1st Duke of Wellington, defeated Napoleon
Bonaparte in a series of battles fought in the
area between the Franco-Belgian border and the town of Waterloo, south of Brussels. This famous
victory resulted in the French emperor's second abdication and final exile to the island of St Helena.

In 1803, the 17-year-old trainee artist George Jones interrupted his studies at the Royal Academy
Schools, London, upon obtaining a commission in a regiment of the militia. After receiving his cap-
taincy, he volunteered with his company to serve under Wellington in the Peninsular War (1808–14).
Although he continued to exhibit while in the army, during these years he showed mainly views and
domestic scenes. It was only after Napoleon's defeat at Waterloo in 1815 that Capt. Jones – who briefly
served as part of the army of occupation of Paris – returned to civilian life, resumed his artistic career
and began to specialise in the battle scenes for which he is now best known.

Jones's sketch of *Wellington Leading the British Advance* won second prize in the British Institution's
Waterloo Competition of 1820, and he was subsequently awarded the commission to paint the
composition on a large scale (*c*.119 × 109 in [350 × 300 cm]). For the finished work (now in the Royal
Hospital, Chelsea, London), he was paid a premium of 200 guineas. Two years later, the British
Institution awarded him a second premium of the same amount for a slightly altered version of the
subject. Despite the fact that the latter met with somewhat mixed reviews when it was exhibited at
the Royal Academy in 1822, it secured Jones's election as ARA.[1] In 1824 he was elected a full academi-
cian.[2] Years later, when he served as Keeper of the Royal Academy Schools (1840–50), he applied his
military training to his nightly inspection of the premises, touring the building with a drawn sword
and accompanied by two night porters with lanterns.

It is not clear whether or not Jones was actually present at the Battle of Waterloo with Wellington,
to whom he bore a distinct resemblance (and of which he was supposedly very proud). Nor can one
say with certainty whether sketches such as the Cobbe Collection pair were made on the spot – though
they have that sense of immediacy[3] – or in the studio years later from memory. They nonetheless
reveal Jones's military background and his first-hand experience of battle. He has been particularly
praised for his intimate understanding of the disposition of troops on the battlefield, 'avoiding the
standard convention of the large-sized portrait group set against a distant battle'.[4]
NT

100

GEORGE JONES, RA
London 1786–London 1869

The Meeting of Wellington and Blücher at Waterloo

Oil on millboard, 4½ × 6¾ in (11.5 × 17 cm)
INSCRIPTIONS on the reverse: inscribed in ink
and pencil, *By Jones R.A. The meeting between*
Wellington and Blücher; fragment of a printed
label from Winsor & Newton; label of Victor
Brockbank Fine Art Dealer, Bury St, London
Cobbe Collection, no.387
HISTORY presumably with Victor Brockbank,
Fine Art Dealer, London; acquired at sale,
Christie's, London, 26 October 1990, one of
a pair in lot 291

1 Sale, Sotheby's, London, 17 May 1989,
lot 252, illus.

For general information about the artist
and the series of studies to which this small
picture belongs, see cat.99.

The present painting represents the meeting in front of La Belle Alliance, just south of
Waterloo, now in Belgium, that occurred at
9.15 p.m. on 18 June 1815 between the Duke of
Wellington and Field-Marshal von Blücher,
the respective commanders of the allied British
and Prussian forces that had successfully
converged against Napoleon and his highly
skilled, veteran French army. The scene is bathed in bright moonlight, as dusk begins to fall on what
would have been the fourth longest day of the year. Another oil sketch of the meeting (oil on canvas,
9½ × 11¾ in [24 × 30 cm]), from a closer viewpoint and showing the two protagonists after they had
dismounted, was on the London art market in 1989.[1]

Blücher was a career soldier who had enlisted, against his parents' wishes, in a Swedish cavalry
regiment at the age of 14. Ironically, his first campaign was against the Prussians. Despite the fact
that they took him prisoner, he later joined the Prussian army and served with the regiment that had
captured him. Described by contemporaries as rough and ill-educated, with 'little knowledge of
the higher art and science of war', he nonetheless displayed immense common sense, determination
and personal courage on the battlefield, qualities that earned the respect of his troops. He also appreciated the value of a good chief of staff to advise him.

Already aged 71 when war between France and Prussia broke out again in 1813, Blücher came
out of retirement, and for his success at the Battle of Leipzig (16–18 October 1813) he was made field-
marshal. He led Prussian troops across the Rhine on 1 January 1814 and, after five months of heavy
fighting, entered Paris, along with other allied troops. Once again the victorious field-marshal retired
to his estates, but when he heard of Napoleon's escape from Elba and return to Paris in March 1815,
he resumed command of the Prussian army, this time in Belgium, co-ordinating his efforts with
Wellington. In the late afternoon of 18 June 1815, at a critical stage in the Battle of Waterloo, Blücher
and his exhausted troops (who had been marching for 11 hours through difficult terrain) attacked the
right flank of the French cavalry screen. This diverted Napoleon's attention at a time when Wellington
was vulnerable at the main front. By the time the Emperor turned back to the main front, Wellington
had regrouped his defences and, in less than an hour, defeated six battalions of the French Guard.
Some 15 minutes later, at around 8.15 p.m., Wellington ordered a general advance, and an hour later
the two victorious commanders met to celebrate their decisive rout of the French. Each is said to
have greeted the other as the victor. It was then decided that the Prussian army should continue the
pursuit of the French soldiers retreating towards Paris. With his second taking of Paris, Blücher
wanted to inflict on the city the kind of damage suffered by other European capitals at the hands of
Napoleon and his soldiers, but he was restrained by Wellington. Napoleon arrived in Paris on 21 June
1815, humiliated by his overwhelming defeat at Waterloo, and abdicated the following day. He spent
the rest of his life on the island of St Helena.

NT

101

GEORGE JONES, RA London 1786–London 1869

AFTER BARON FRANÇOIS GÉRARD Rome 1770–Paris 1837

Portrait of Field Marshal William Carr Beresford, Viscount Beresford (1768–1854)

Oil on canvas, unlined, 35½ × 28½ in
(90 × 72.5 cm)
INSCRIPTIONS on the reverse, on the stretcher:
inscribed, *Field Marshall Viscount Beresford copied
by Mr Jones from picture in Charles Street* [with]
permission of the Primate [presumably Lord John
George Beresford, Archbishop of Armagh,
1822–62]; on the canvas: colourman's stencil,
C. Davy 83 Newman Street Established 1795; on
the frame: inscribed in pencil, *Mr Beresford*
Cobbe Collection, no.465
HISTORY the original picture may have been
bequeathed or given by the sitter to his half-
brother ('the Primate') and copied by George
Jones for another member of the family;
acquired at sale, Sotheby's, London, 21 March
2001, lot 50

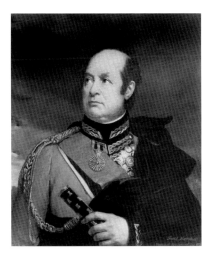

Cat.101a Baron François Gérard, *Portrait of Field
Marshal William Carr Beresford, Viscount Beresford*,
oil on canvas, 35¼ × 27½ in (90 × 70 cm)
(collection of the Marquess of Waterford,
Curraghmore, Portlaw, Co. Waterford)

1 Baird gave him permission to sail from South
Africa to South America, where, as brigadier-
general commanding a mere 1,200 troops, he
surprised and captured the Spanish colonial city
of Buenos Aires (Spain at the time being an ally
of France). The city, however, was soon overrun,
and Beresford was taken prisoner for six months.
He escaped and returned to England, and at the
end of 1807 was sent to take Madeira on behalf
of the King of Portugal; he remained there as
governor for six months and during his time
there learnt Portuguese, which was to prove
useful in his future career.

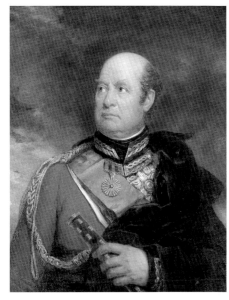

The sitter, Field-Marshal William Carr Beresford,
Viscount Beresford, played a crucial role in the career
of Thomas Cobbe's eldest grandson, Charles Cobbe
(see cat.14), and for this reason alone the picture – sold
as an anonymous copy after the noted French portrait
painter Baron François Gérard (1770–1837; cat.101a) –
was recently acquired for the Cobbe Collection by
Alec Cobbe. He is to be congratulated for deciphering
what the auction catalogue described as an 'indis-
tinctly inscribed' label on the back of the stretcher,
and consequently discovering the author of the copy,
George ('Waterloo') Jones (see cats 99 and 100).

William Carr Beresford was one of two natural
sons of George de la Poer Beresford (1735–1800), 2nd
Earl of Tyrone and 1st Marquess of Waterford (see
cat.46), and had a successful army career, fighting in
the French Revolutionary and Napoleonic wars. He
entered the army in 1785 and from 1795 commanded
the 88th Connaught Rangers. He served under Sir David Baird (1757–1829) in the expeditions to Egypt
(1801) and was with him when he recaptured the Cape of Good Hope (Cape Town) from the Dutch
in 1806.[1] During the Peninsular War (1808–14) Beresford enjoyed the most significant successes of
his career. In February 1809 he was chosen by the Duke of Wellington to restructure the Portuguese
army, a task for which he was promoted to the rank of marshal.[2]

Beresford was admired by Wellington not so much for his military prowess as for his logistical and
administrative skill: the Duke later remarked that 'he alone could feed an army'. In 1823 Beresford
was created a viscount, having been made Baron Beresford of Albuera and Cappoquin in 1814. He
served as Master-General of the Ordnance in the first cabinet of Wellington (1828–30). After 1830
Viscount Beresford retired to his estate at Bedgebury, Kent, and in 1832 he was married for the first
time, to his cousin the Hon. Louisa Beresford, fifth daughter of Lord Waterford's younger brother,
the Rev. Hon. William Beresford (d.1819), 1st Baron Decies (see cat.87); she was the widow of the banker,
patron, collector, connoisseur and designer Thomas Hope (1769–1831), who introduced the phrase
'interior decoration' into the English language in 1807.

In the early part of William Carr Beresford's career, as a colonel in charge of the 88th Regiment,
he was instrumental in obtaining a lieutenancy with the Duke of Wellington for his second cousin
Charles Cobbe, the grandson of Thomas and Lady Betty Cobbe (see cats 13 and 9). Lady Betty was
the youngest sister of Lord Waterford (who earlier, as Lord Beresford, was a trustee of her marriage
settlement). Thomas Cobbe seems to have enlisted the help of both of his brother-in-law's highly
successful illegitimate sons to further the careers of his five grandchildren (whom he supported
following the premature death of his own son Charles in 1798). Owing to the efforts of Beresford,
Charles Cobbe was shown great kindness by the Duke of Wellington who, as Colonel Wellesley, lent
him the money to purchase his lieutenancy in the 19th Dragoons in India. The young Lieutenant
Cobbe wrote to his grandfather on 16 November 1801 asking him to reimburse Wellesley the sum of
£262 10s. in payment of the lieutenancy, a bill accepted and paid by Thomas Cobbe in February 1802.

In a letter of 1803 written to his agent, Thomas Cobbe mentions the fact that his [youngest] grand-
son (William Power Cobbe [1790–1831]) had 'gone to sea under the protection of Capt. Beresford'. This
'Capt. Beresford' was Lord Waterford's other natural son, Admiral Sir John P. Beresford (?1768–1844),

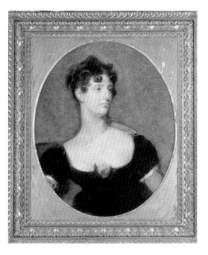

Cat.101b Thomas Lawrence, *Portrait of Harriet Elizabeth (née Peirse), Lady Beresford*, oil on canvas, 30½ × 25 ¼ in (77.5 × 64 cm) (Cobbe Collection, no.444)

2 At La Albuera in 1811 he defeated Nicolas Jean de Dieu Soult (1769–1851), the French marshal who had conquered and governed Portugal until the arrival of Wellington. A year later Beresford was present at the capture of Badajoz and also at Wellington's victory over the French at the Battle of Salamanca, where he was severely wounded in the thigh.

3 Garlick 1989, no.94, illus.

4 Sale, Knight, Frank & Rutley, Bedgebury Park, 12–19 May 1919, lot 11, illus.

5 Garlick 1989, no.95, illus.

6 Ibid., no.93(a), illus.

7 Ibid., no.93(b), illus.

8 Sale, Sotheby's, London, 31 October 1990, lot 290, illus.

9 Photo in Witt Library, London (neg.no. B69/876); the portrait is inscribed at lower right, *Field Marshall | Viscount Beresford died 1854 | by François Gérard*

10 Inv.nos 982a–c.

MP, KCB, GCH (Knight of the Tower and Sword), who was created a baronet in 1814 and who was either a full or half-brother to Viscount Beresford. A portrait of his wife (cat.101b), Harriet Elizabeth Peirse (1790–1825), by Sir Thomas Lawrence (1769–1830) is also in the Cobbe Collection (no.444).

Lawrence painted a number of other Beresford family portraits, many of which exist in two versions. A portrait of Lord Waterford's second legitimate son, *The Rev. John George Beresford (1773–1862)*, known as 'the Primate' following his appointment as Archbishop of Dublin in 1820 and Archbishop of Armagh in 1822, is in the collection of the present Marquess of Waterford, Curraghmore, Portlaw, Co. Waterford,[3] while a second (apparently inferior) version was included in the Bedgebury Park sale of the Beresford-Hope collection held on 12–19 May 1919 (the residue of Viscount Beresford's collection, as well as that of his wife's first husband and her son A. J. Beresford-Hope).[4] Also at Curraghmore is a portrait of Lord Waterford's nephew, *Marcus Beresford (1764–97)*, the elder son of another of Lord Waterford's brothers, the Rt Hon. John Beresford (1738–1805), MP (see cat.10).[5] Of Lawrence's two portraits of the present sitter, one was made for the Duke of Wellington and is now in Apsley House, London,[6] while that made for himself must also have been at Bedgebury Park, but instead of being sold in 1919 was bequeathed that year by S. J. Beresford-Hope to the Government Art Collections and is now at the British Embassy, Lisbon.[7] Finally, a portrait of Viscount Beresford's wife, *Louisa, Viscountess Beresford*, by Lawrence was sold in another Beresford-Hope sale of heirlooms held on 20 July 1917 (lot 62), while another version, now considered to be from the 'studio of Lawrence', was also included in the 1919 Bedgebury Park sale.[8]

It is, therefore, not surprising that the original *Portrait of Field-Marshal Viscount Beresford* by Baron François Gérard from which this painting was copied is also still in the collection of the Marquess of Waterford at Curraghmore (cat.101a).[9] From the inscription on the Cobbe Collection copy it seems clear that the original must also once have been in the collection of the Archbishop of Armagh ('the Primate'), who was obliged to give his permission for it to be copied. Most of the prime versions of the family portraits – by Lawrence, Gérard etc – presumably stayed with the main branch of the Beresford family and descended to the present marquess. A series of copies must have been made, probably for another member of the family.

Since so many of the replicas ended up at Bedgebury Park, it is worth speculating that the patron of the second series – the 'Mr Beresford' whose name is inscribed on the back of the frame of the present picture – was Field-Marshal Viscount Beresford's stepson A.J. Hope (1820–87), who inherited the Viscount's Kent and Staffordshire estates on his death in 1854, at which time he added 'Beresford' to his name. Hope was apparently extremely fond of his stepfather and looked after him dutifully at Bedgebury Park, especially after the Viscount was devastated by the death of his wife.

The style of the present picture supports Alec Cobbe's conclusions about its authorship, even though George Jones was known primarily as a battle, history and view painter rather than as a portraitist. The loose handling of the paint, the palette (with its Prussian blue over deep pinks) and the wiry underdrawing, evident especially in the sitter's face, hand and hair, find many parallels in the sketches and watercolours of George Jones. The artist may have been chosen to make a copy of the Waterford picture because of the series of small-scale portrait drawings and oil sketches he made of heroes of the Napoleonic Wars, including *Gen. Sir Andrew Francis Barnard (1773–1855)*, *Field-Marshal John Colborne (1778–1863), 1st Baron Seaton*, and *Col. William Light (1784–1838)*, all three of which are now in the National Portrait Gallery, London.[10] Like Viscount Beresford, some of these sitters had Irish connections (Sir Andrew Francis Barnard, for example, was the grandson of the Bishop of Derry), and Jones is known to have visited Ireland, which he recorded in drawings and oil sketches, such as *Dunmore, Waterford*, a watercolour that was with Agnew's in 1966.

NT

102

JOHN BOADEN
*fl.*1812–*d.*1839

Portrait of Fanny Kemble (1809–93)

Oil on canvas, 30⅛ × 25⅛ in (76.5 × 64 cm)
INSCRIPTIONS on the reverse: bookplate of
Alec Cobbe
Cobbe Collection, no.458
HISTORY Earl Cawdor; his sale, Christie's,
London, 22 July 1882, lot 82 (bought for 33
guineas); acquired at sale, Sotheby's, London,
25 November 1998, lot 37

1 Cobbe 1894, pp.198–200.

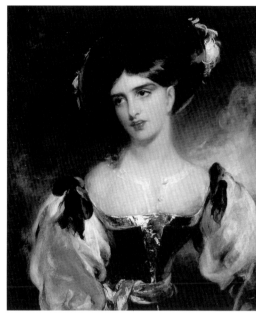

Fanny Kemble was born in 1809, daughter of
actor–manager Charles Kemble, the younger
brother of Mrs Siddons and John Philip
Kemble. Her mother, Maria du Camp, was
also an actress, and she was brought up in the
thick of theatrical life. At the age of 19, she
made her début as Juliet at Covent Garden,
London, and found herself famous overnight.
Comparisons were made with Mrs Siddons:
she had the same dramatic features and flash-
ing dark eyes, though she was shorter and
less imposing than her aunt. She was drawn
by Thomas Lawrence (1769–1830), who was
deeply moved by the resemblance; on her
twentieth birthday, a month after her début,
he presented her with an engraving of
Reynolds's portrait of *Mrs Siddons as the Tragic
Muse* (see cat.96), inscribed 'To her niece and
worthy successor'.

 In 1832 Fanny set out on a tour of America. Here her reputation was equally enthusiastic, but
two years later, at the height of her career, she abandoned the stage to marry a rich Philadelphian,
Pierce Butler. It was only after her marriage, however, that she realised that his wealth derived from
slave ownership. On a visit to his plantation in Georgia in 1840, she was appalled by the condition
of the slaves, recording her outrage in a private journal. Her hatred of his lifestyle led to the break-
up of their marriage and their eventual divorce, though under the harsh laws of the period she was
separated from her children.

 Returning to England, she began a new career giving readings from Shakespeare; their success
gave her a secure income and won her the friendship of many of the leading intellectual and literary
figures of the day. She had always refused to publish her *Journal of a Residence on a Georgian Plantation*,
for fear it would damage her children's relations with their father. But in 1862, when it seemed that
Britain might come in on the side of the South in the American Cival War, she reluctantly decided
to publish it. The book was an immediate best-seller and was widely credited with swinging British
sympathies from the Confederate to the Union side. She went on to publish several more books,
including two volumes of memoirs, and, at the age of 80, a novel, *Far Away and Long Ago*. 'Did *any* one
ever produce a first fiction at 80?', asked Henry James, a friend and admirer in her later years. She
died in 1893.

 She had been a close friend of Frances Power Cobbe, to whom she bequeathed her papers. Frances
Power Cobbe recounted the occasion of their meeting at Newbridge in her own autobiography:

 'It happened once, somewhere in the early fifties, that Mrs Kemble was paying a visit to Miss St
Leger at Ardgillan, and we arranged that she should bring her over some day to Newbridge to lunch-
eon. I was of course prepared to receive my guest very cordially but, to my astonishment, when
Mrs Kemble entered she made me the most formal salutation conceivable and, after being seated,
answered all my small politenesses in monosyllables and with obvious annoyance and disinclination
to converse with me or with any of my friends whom I presented to her. Something was evidently
frightfully amiss, and Harriet perceived it; but what could it be? What could be done? Happily
the gong sounded for luncheon, and, my father being absent, my eldest brother offered his arm to

Mrs Kemble and led her, walking with more than her usual stateliness across the two halls to the dining-room, where he placed her, of course, beside himself. I was at the other end of the table but I heard afterwards all that occurred. We were a party of eighteen and naturally the long table had a good many of dishes on it in the old fashion. My brother looked over it and asked: "What will you take, Mrs Kemble? Roast fowl? or galantine? or a little Mayonnaise, or what else?" "Thank you," replied Mrs Kemble, "*If there be a potatoe*!" Of course there was a potatoe – nay, several; but a terrible *gêne* hung over us all till Miss Taylor hurriedly called for her carriage, and the party drove off.

'The moment they left the door after our formal farewells, Harriet St Leger (as she afterwards told me) fell on her friend; "Well Fanny, never, *never* will I bring you anywhere again. How *could* you behave so to Fanny Cobbe?"

' "I cannot permit any one," said Mrs Kemble, "to invite a number of people to meet me without having asked my consent; I do not choose to be made a gazing-stock to the county. Miss Cobbe had got up a regular party of all those people, and you could see the room was decorated for it." "Good Heavens, what are you talking of?" said Harriet, "those ladies and gentlemen are all her relations, stopping in the house. She could not turn them out because you were coming, and her room is always full of flowers." "Is that really so?" said Mrs Kemble, "then you shall tell Fanny Cobbe that I ask her pardon for my bad behaviour, and if she will forgive me and come to see me in London, *I will never behave badly to her again*!"

'I did go to see her in London; and she kept her word, and was my dear and affectionate friend and bore many things from me with perfect good humour, for forty years; including (horrible to recall!) my falling fast asleep while she was reading Shakespeare to Mary Lloyd and me in our drawing-room here at Hengwrt!'[1]

LK

103

DOUGLAS COWPER Gibraltar 1817–Guernsey 1839

AFTER REMBRANDT HARMENSZ. VAN RIJN Leiden 1606–Amsterdam 1669

Copy of Rembrandt's 'Self-portrait'

Oil on canvas, 27 × 23 in (68.5 × 58.5 cm)
INSCRIPTIONS on the reverse of the canvas:
inscribed, *Copied in the Royal Academy / in the Year
1836 by Mr Cowper / from the Original Picture /
A.J.Oliver*
Cobbe Collection, no.315
HISTORY acquired at sale, Newbury, *c.*1982
EXHIBITIONS Cambridge 1988 (alongside
the original from the Royal Collection)
LITERATURE Laing/Cobbe 1992, p.22, no.416

Cat.103a Detail of the inscription on the reverse
of cat.103

1 See White 1980, pp.111–12, no.168.
2 National Gallery, London (inv.no. NG 672).
3 For a more detailed discussion of this subject,
see Marieke de Winkel's essay in London and
The Hague 1999–2000, pp.67–72.
4 On this subject, see Chapman 1990 and
Ernst van de Wetering's essay in London and
The Hague 1999–2000, pp.8–37.
5 Laing/Cobbe 1992, p.22. White (1982, p.112)
attributed the picture to an 'Imitator of
Rembrandt', possibly from the second half of
the 18th century. See also the entry by Karen
Groen in Cambridge 1988, pp.66–8, in which
this view is reiterated.
6 See the detailed discussion of the recent
findings in London and The Hague 1999–2000,
pp.177–9, no.57.
7 Dulwich Picture Gallery, London (inv.no.238).
For more information on the lending of pictures
from Dulwich to the Royal Academy in London
for the purpose of copying, see Waterfield 1988,
pp.8–11 and 31. Poussin's *Rinaldo and Armida*
was lent no fewer than three times to the Royal
Academy between 1816 and 1857.
8 For a more detailed biography, see the entry
on Cowper in the *DNB*, vol.4, p.1310.

This picture is a faithful 19th-century copy of
Rembrandt's (1606–69) well-known *Self-portrait*
of 1642, now in the Royal Collection.[1] Rembrandt
has depicted himself in characteristic old-
fashioned, or *à l'antique*, clothing, rather than the
contemporary dress of a gentleman. The beret
and the openworked doublet underneath the
dark cloak hark back to 16th-century costume. He
often chose this type of dress, most famously in
his *Self-portrait* of 1640 in London,[2] apparently in
an attempt to associate himself with the tradition
of the famous masters of the past, such as Albrecht
Dürer (1471–1528), Raphael (1483–1520) and Titian
(*c.*1485/90–1576).[3] Recently, it has been convinc-
ingly argued that Rembrandt must have painted
and etched many of his self-portraits for collectors
and patrons.[4] By the early 1640s he was a famous
and well-established artist, whom people would
have recognised. Thus, it seems likely that a self-portrait would have been a desirable item, as a col-
lector would obtain both a portrait of the famous master as well as a work by his hand.

In the past, the authorship of the original 1642 self-portrait from which this was copied has been
doubted, as Alastair Laing has noted, and in 1982 it was even considered to be an 18th-century pastiche.[5]
After taking the results of new technical research into account, this judgement has been reversed
more recently, and the work is now accepted as autograph, albeit with copious amounts of later over-
painting.[6] This research has revealed that the existing picture was painted over another self-portrait
by Rembrandt, and a faint outline of the headgear of the earlier figure is still visible. Following
Rembrandt's execution of his second self-portrait, another hand applied further paint layers, par-
ticularly in the cloak and the left hand, which are painted in a different, clumsier style. The face and
the signature, however, seem to have remained untouched.

According to an inscription on the Cobbe painting (cat.103a), Douglas Cowper copied Rembrandt's
painting in 1836 at the Royal Academy 'from the Original Picture'. The picture had evidently been
lent by the Royal Collection to the Royal Academy for the purpose of copying. Cowper, a merchant's
son, had entered the Royal Academy Schools on 2 January 1836, after having overcome 'the repugnance
of his family to his being an artist', and in the same year won a Silver Medal for his copy of Poussin's
Rinaldo and Armida from the Dulwich Picture Gallery, which had also been lent to the Royal Academy.[7]
Cowper earned his living as a portrait painter, but from 1837 onwards he regularly exhibited works
with literary and historical subjects at the Royal Academy and the British Institution. He died
prematurely in 1839.[8] His copy of Rembrandt's self-portrait follows the original very closely, with
particular attention to the sitter's facial features and to the distribution of light and shadow. Interest-
ingly, Cowper made no attempts to embellish or 'improve' the rather clumsily painted hand of the
sitter that has been pushed into his cloak, clearly the least satisfying part of the painting. Instead, he
left it equally sketchy and undefined. For a 19th-century collector interested in 17th-century Dutch
painting, it must have been similarly appealing to own a portrait of one of the most famous painters
of that time. Since original works by Rembrandt were difficult to come by, not to mention expensive,
a high-quality copy such as that by Cowper must have presented the ideal solution.

AR

Part II

COLOUR PLATES OF
ADDITIONS SINCE 1960

CAT.50 THE MASTER OF VOLTERRA *Madonna and Child with St John the Baptist*

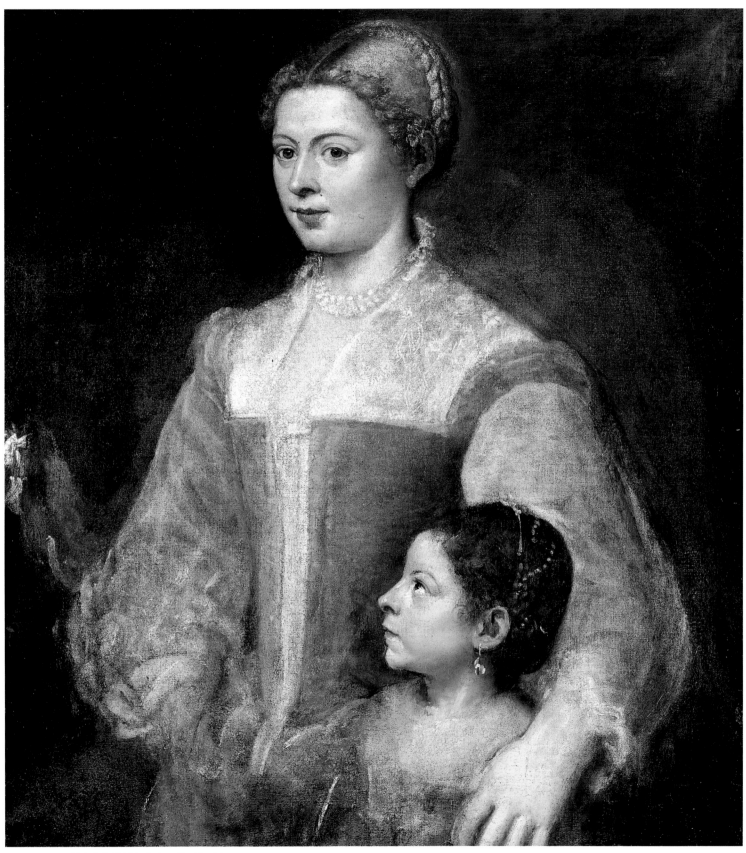

CAT.51 TITIAN *Portait of a Patrician Lady and her Daughter*

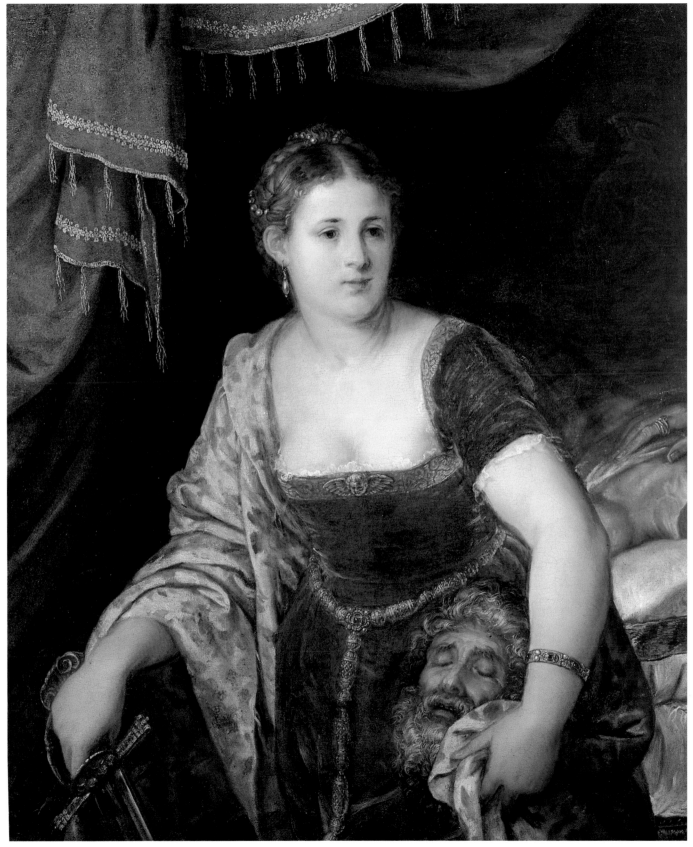

CAT.52 LAMBERT SUSTRIS *Judith with the Head of Holofernes*

CAT.53 BERNARDINO CAMPI *St Jerome Kneeling in a Landscape*

CAT.54 MASO DA SAN FRIANO *Ottavio Farnese, 2nd Duke of Parma and Piacenza*

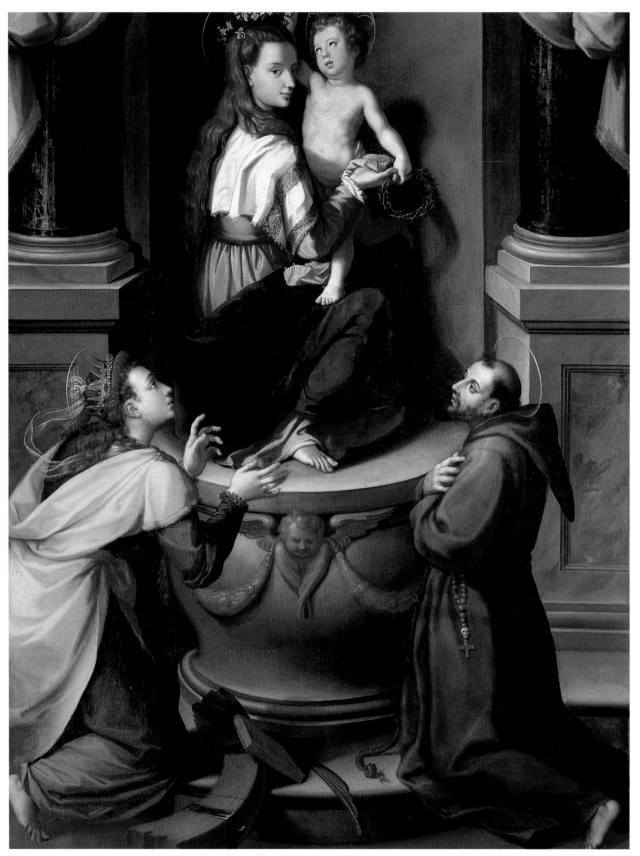

CAT.55 ALESSANDRO ALLORI *Madonna and Child with St Catherine and St Francis of Assisi*

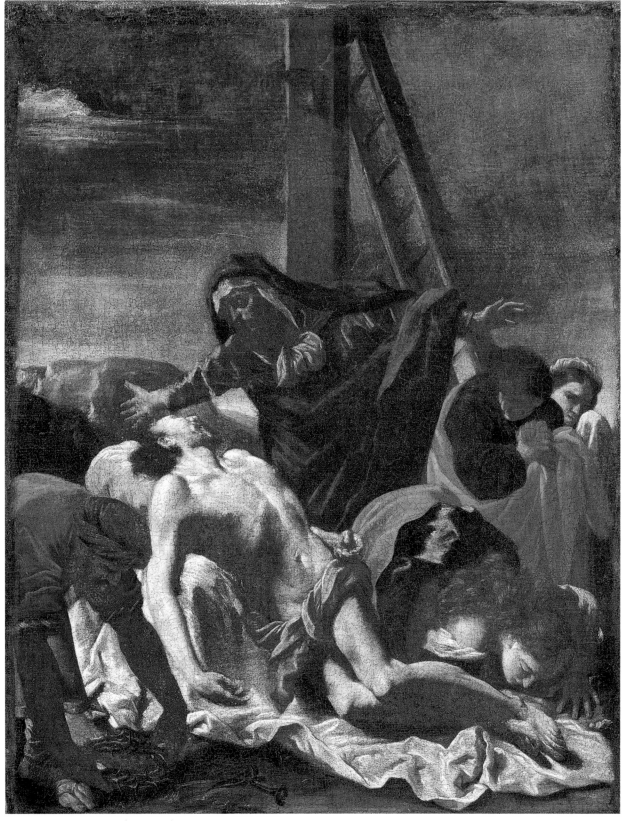

CAT.56 NICOLAS POUSSIN *The Lamentation*

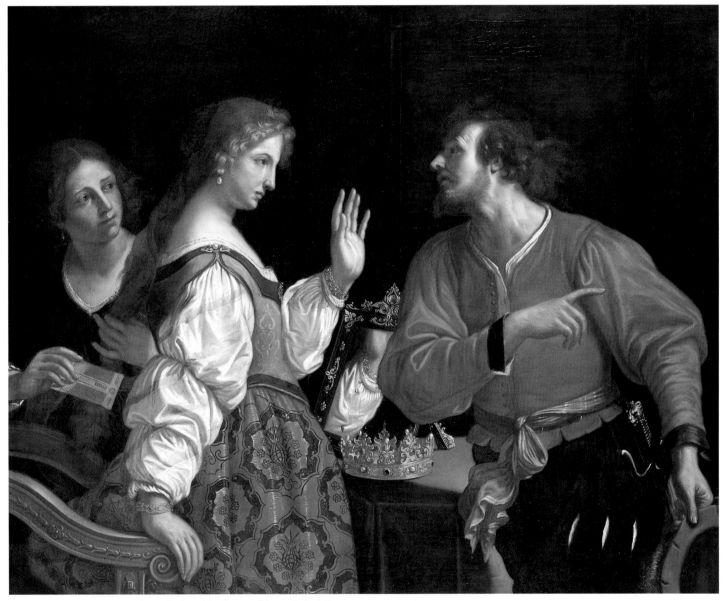

CAT.57 GUERCINO *Semiramis at her 'Toilette' Receiving the News of the Revolt of Babylon*

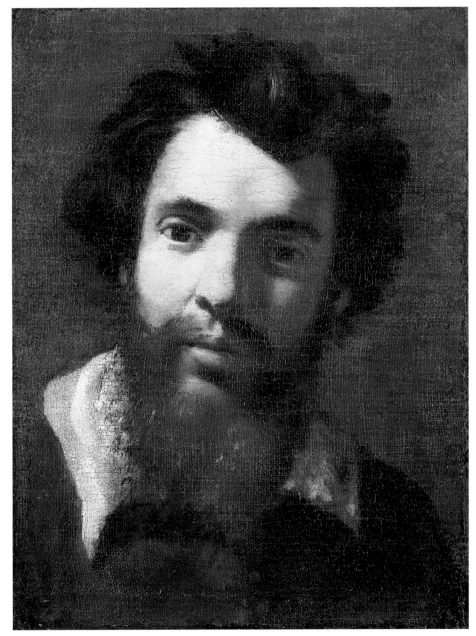

CAT.58 ATTRIBUTED TO GIAN LORENZO BERNINI *Head of a Bearded Man*

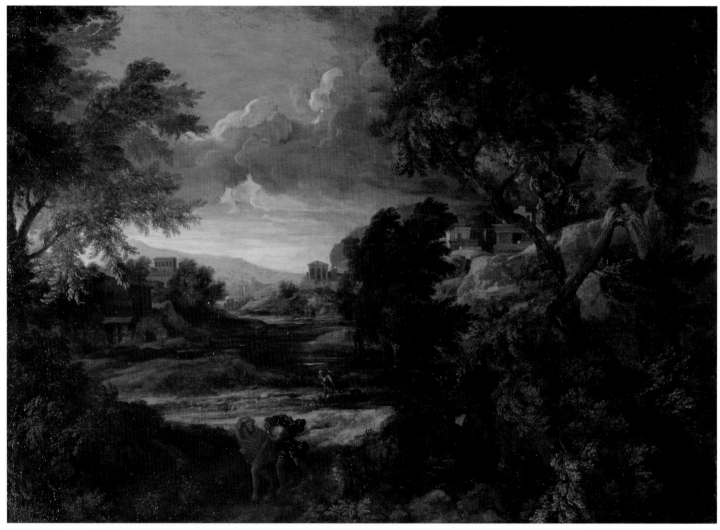

CAT.59 GASPARD DUGHET *Valley Landscape with a Tempest*

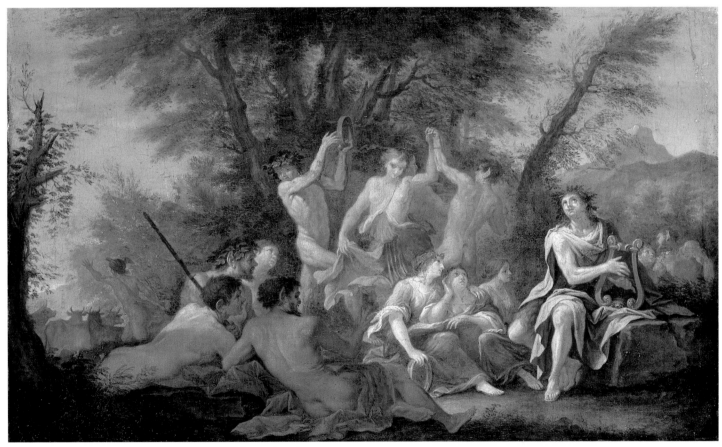

CAT.60 FILIPPO LAURI *Apollo with Nymphs and Satyrs, and Mercury Stealing the Cattle of Admetus*

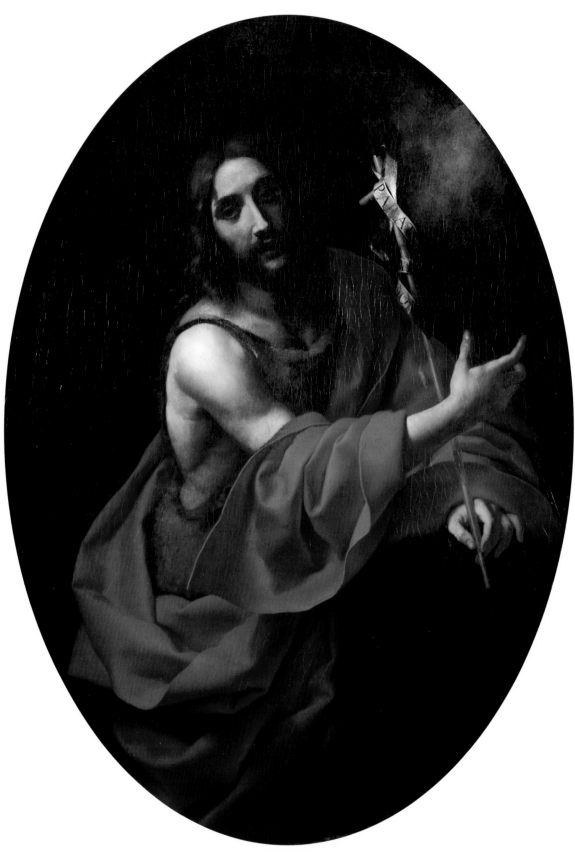

CAT.61 CARLO DOLCI *St John the Baptist*

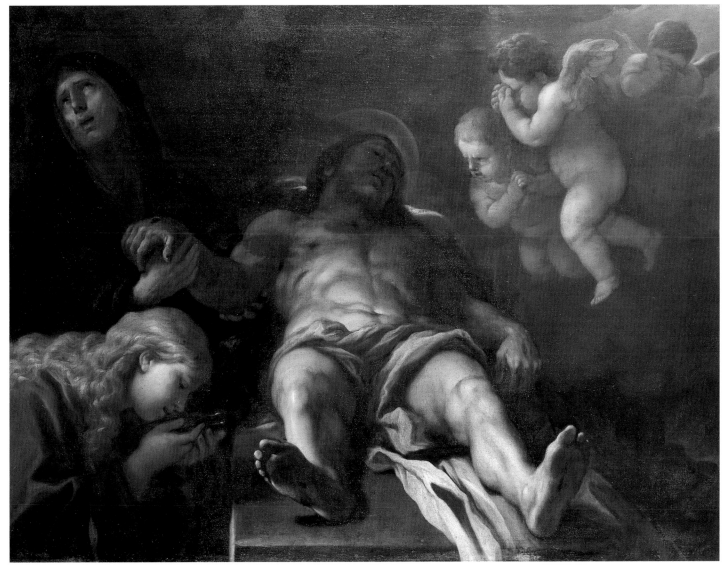

CAT.62 LUCA GIORDANO *Lamentation over the Dead Christ*

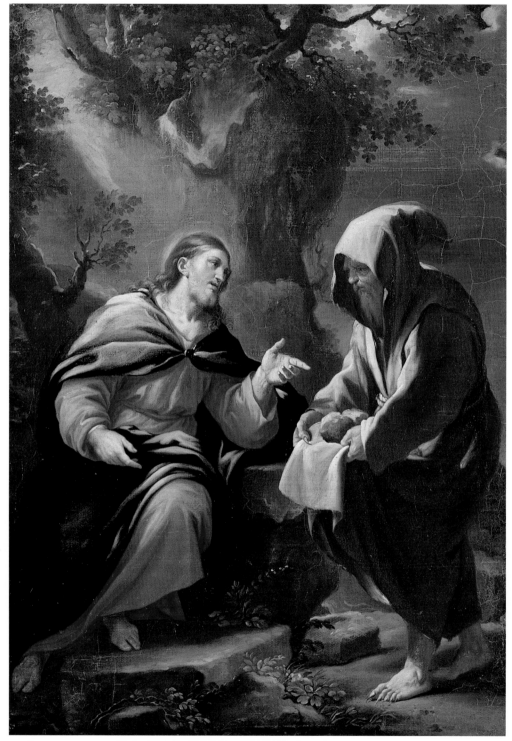

CAT.63 LUCA GIORDANO *The Devil Tempting Christ to Turn Stones into Bread*

CAT.64 ATTRIBUTED TO GIOVAN BATTISTA BEINASCHI *Head of an Apostle or Saint*

CAT.65 ATTRIBUTED TO GIOVANNI SEGALA *Pietà*

CAT.66 FRANCESCO DE MURA *Madonna and Child Presenting St Dominic with the Rosary*

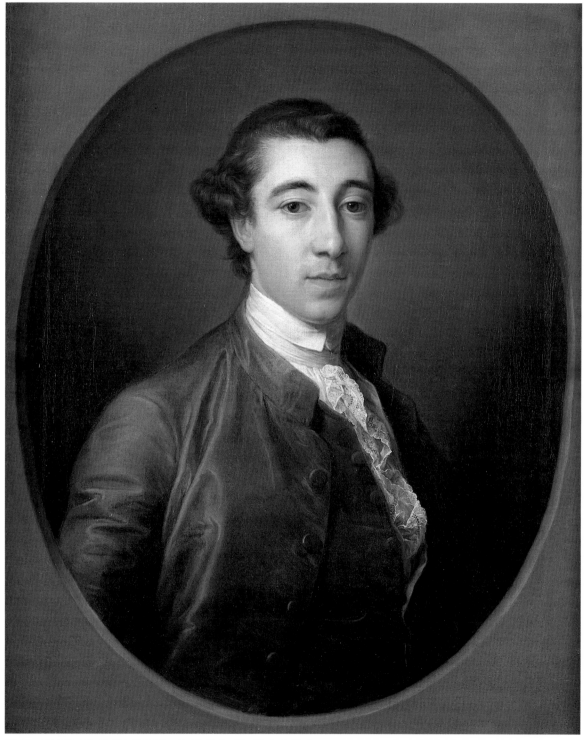

CAT.67 POMPEO BATONI *Portrait of a Man, possibly the Rev. John Charles Beckingham*

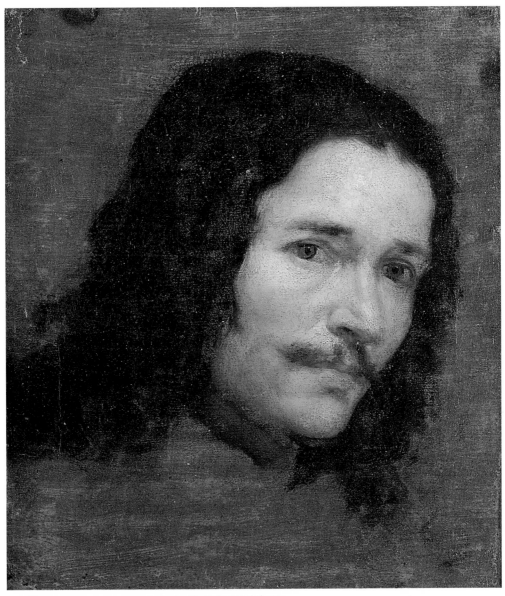

CAT.68 SPANISH SCHOOL, 17TH CENTURY *Study of the Head of a Man*

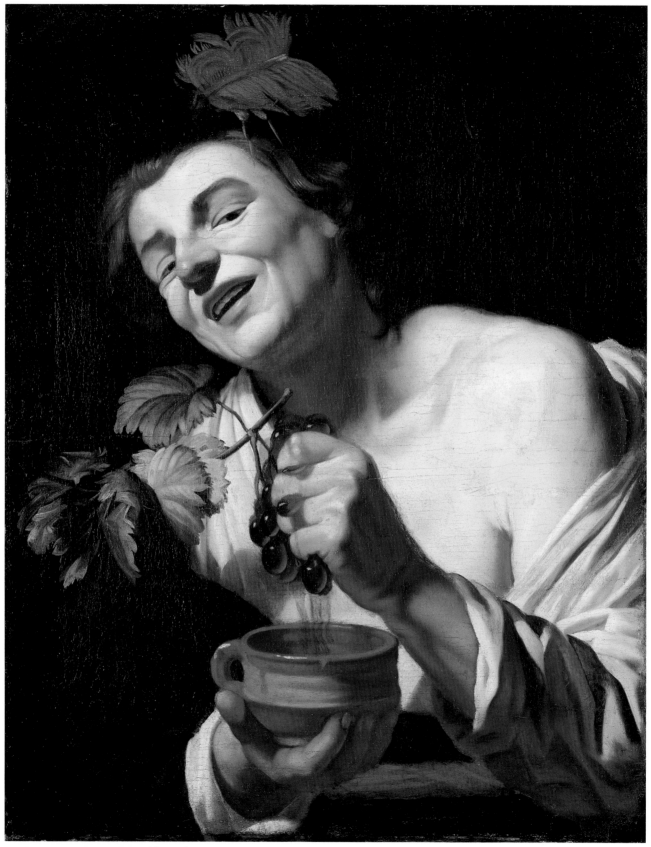

CAT.69 GERRIT VAN HONTHORST *Allegory of Taste*

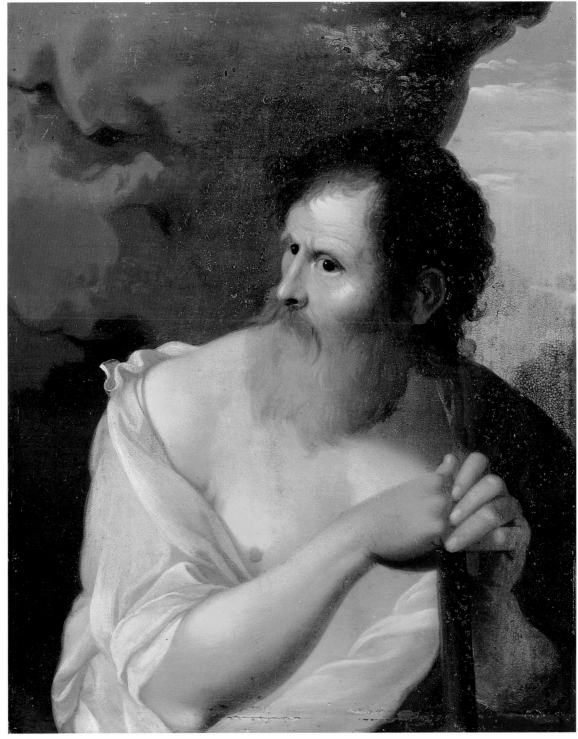

CAT.70 CORNELIS VAN POELENBURCH *Bearded Man Leaning on a Staff*

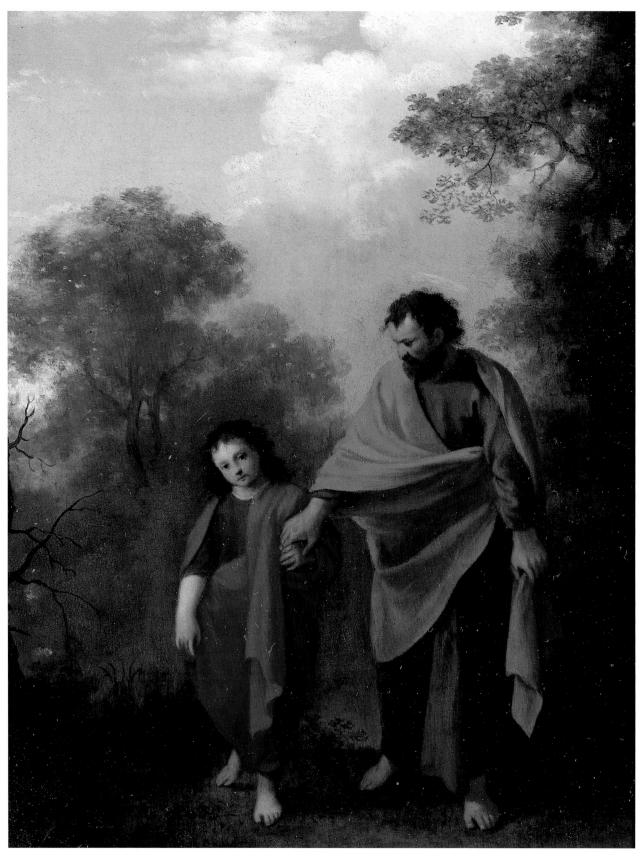

CAT.71 CORNELIS VAN POELENBURCH *St Joseph with the Christ Child*

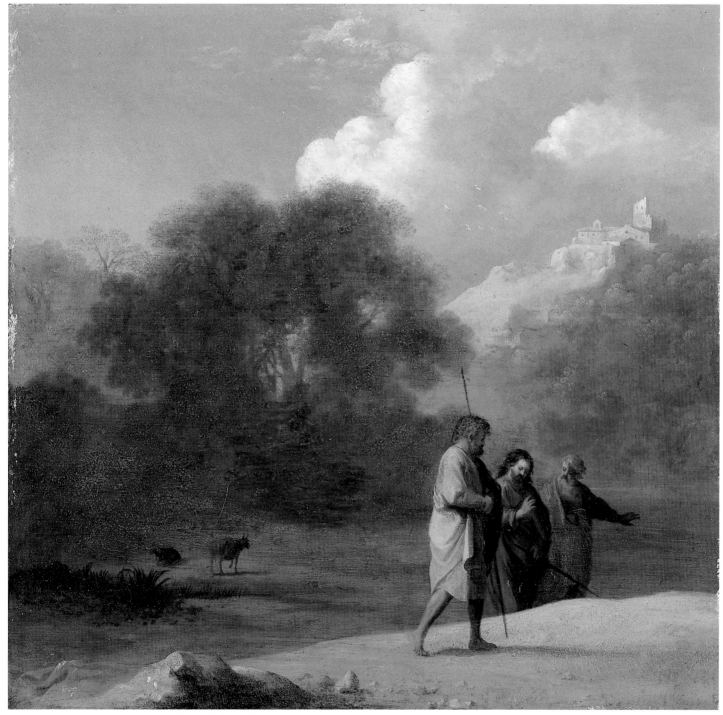

CAT.72 CORNELIS VAN POELENBURCH *Christ on the Road to Emmaus*

CAT.73 SALOMON DE BRAY *Agony in the Garden*

CAT.74 WILLEM SCHELLINKS *The Angel Appearing to the Shepherds*

DEMOCRITE

Ce Sage Abdéritain
qui se moquoit des Hommes,
Ce Philosophe réjouï
Que n'a-t-il vû le jour
dans le Siecle, où nous sommes!
Il auroit bien autrement ri.

CAT.75 HENDRICK MUNNICKS *Democritus*

CAT.76 CASPAR NETSCHER (AND STUDIO ?) *Portrait of a Lady Playing a Viola da Gamba*

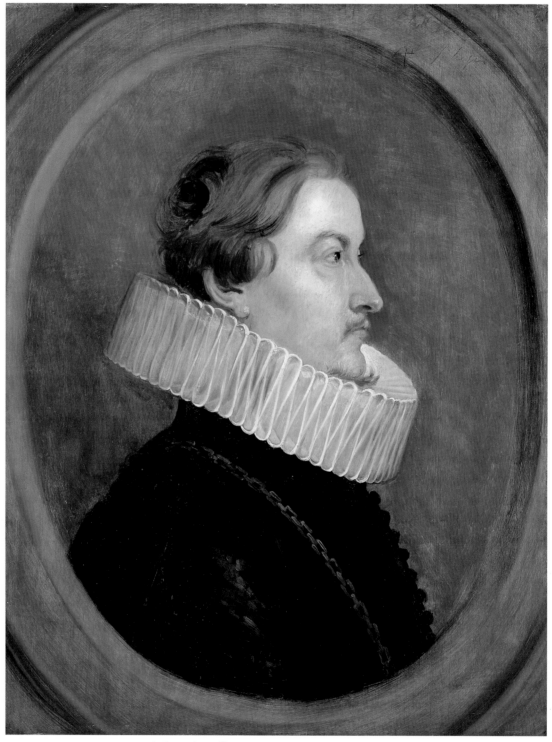

CAT.77 ANTHONY VAN DYCK *Portrait of a Man in a Ruff*

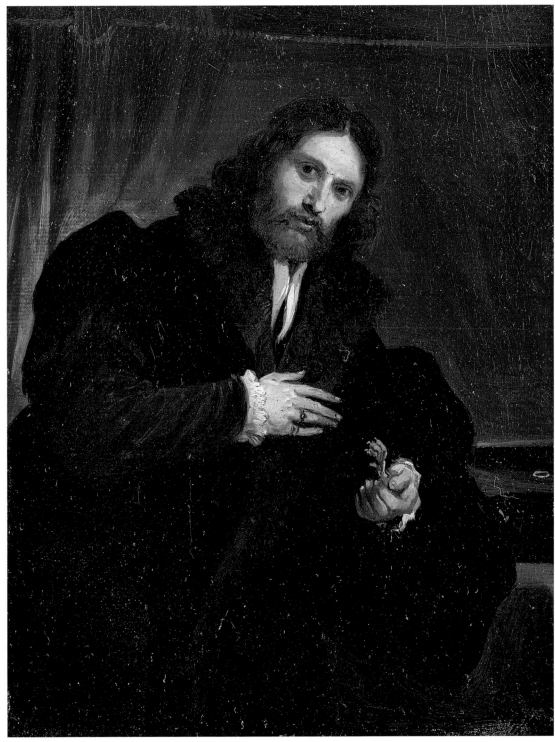

CAT.78 DAVID TENIERS II AFTER LORENZO LOTTO *Man in a Fur-lined Coat*

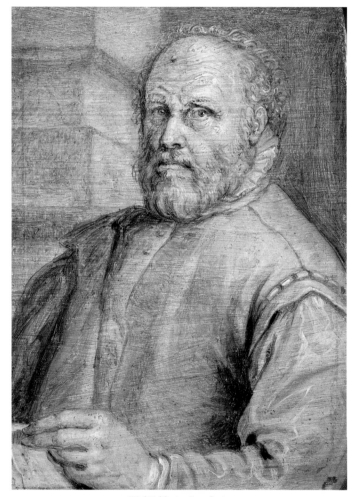

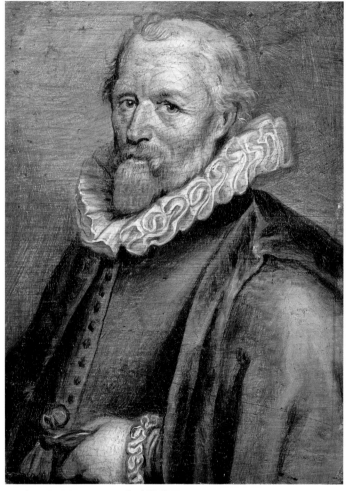

CAT.79 JOANNES MEYSSENS *Dirck Volckertsz. Coornhert*

CAT.80 JOANNES MEYSSENS *Jacob Matham*

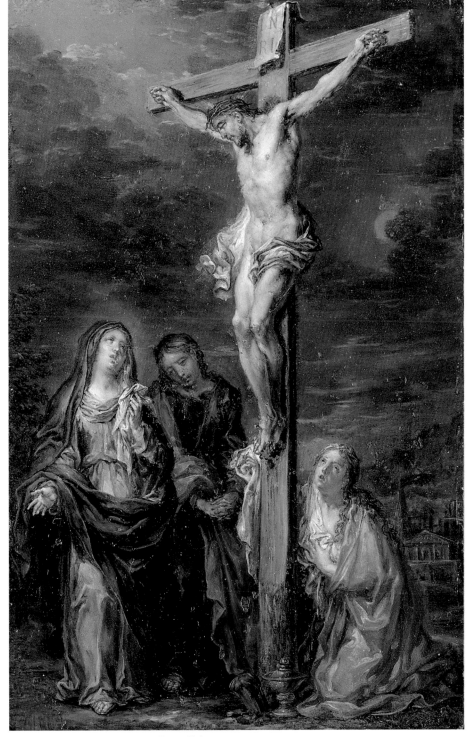

CAT.81 JOHANN GEORG PLATZER *The Crucifixion*

CAT.82 BALTHAZAR BESCHEY *Adoration of the Shepherds*

CAT.83 BALTHAZAR BESCHEY *Adoration of the Magi*

CAT.84 ATTRIBUTED TO JOSEPH-MARIE VIEN *Head of an Old Bearded Man*

CAT.85 ATTRIBUTED TO JEAN-JOSEPH-XAVIER BIDAULD *View from Vallombrosa (?)*

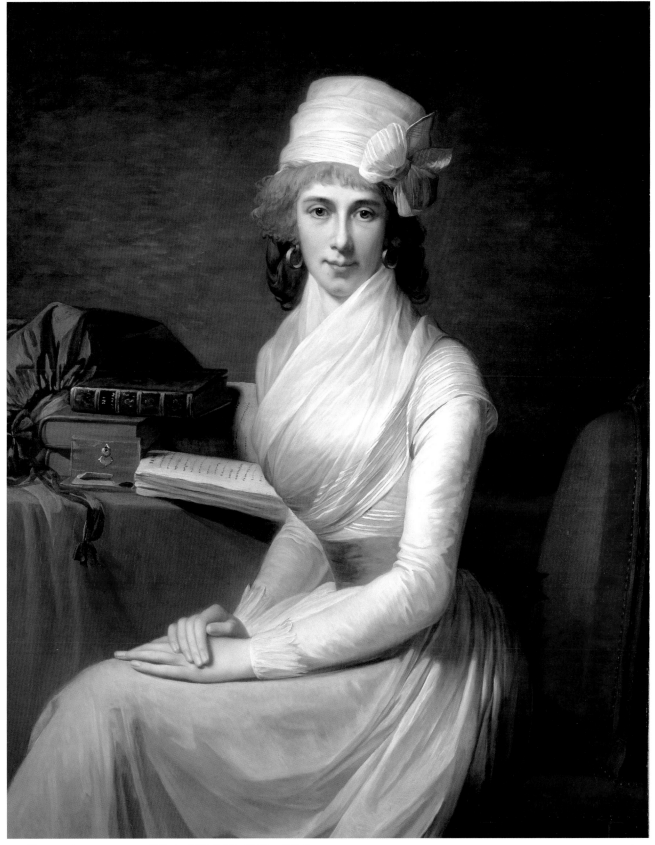

CAT.86 JEAN-LAURENT MOSNIER *Catherine Cobbe, the Hon. Mrs Henry Pelham*

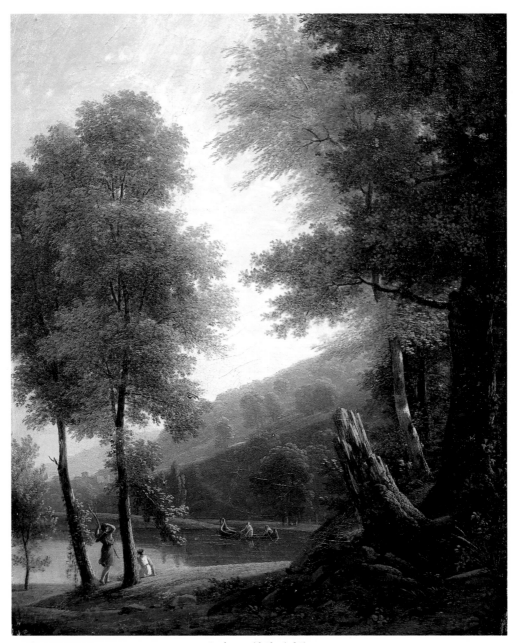

CAT.87 ATTRIBUTED TO JEAN-VICTOR BERTIN *Landscape with Classical Figures*

CAT.88 FRENCH SCHOOL, EARLY 19TH CENTURY *Study of Drapery*

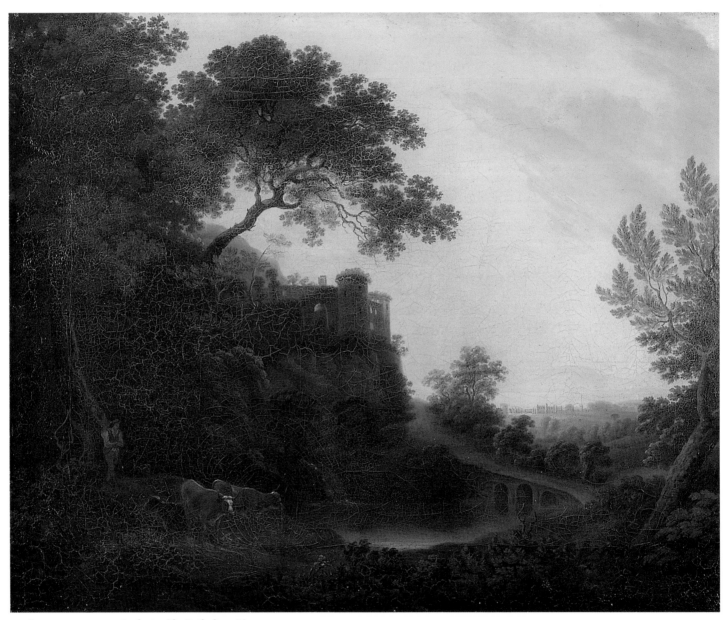

CAT.89 WILIAM ASHFORD *Landscape with a Castle above a River*

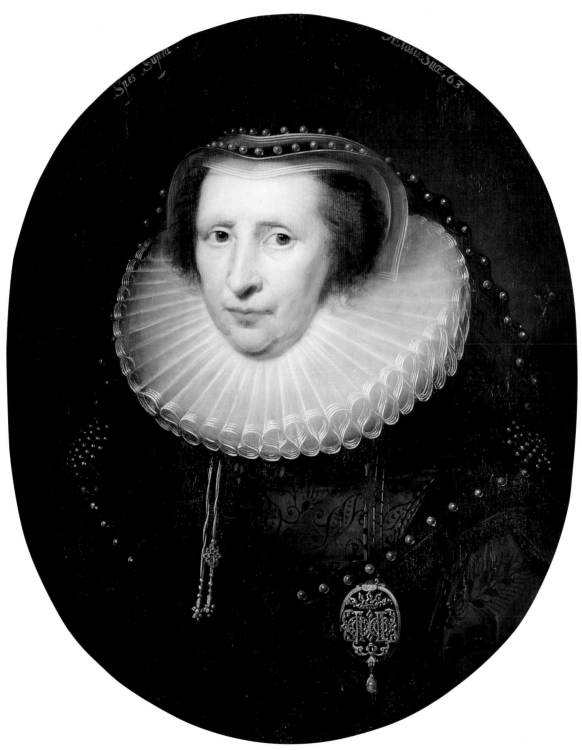

CAT.90 CORNELIS JONSON VAN CEULEN *Sarah Harington, Lady Edmondes*

—

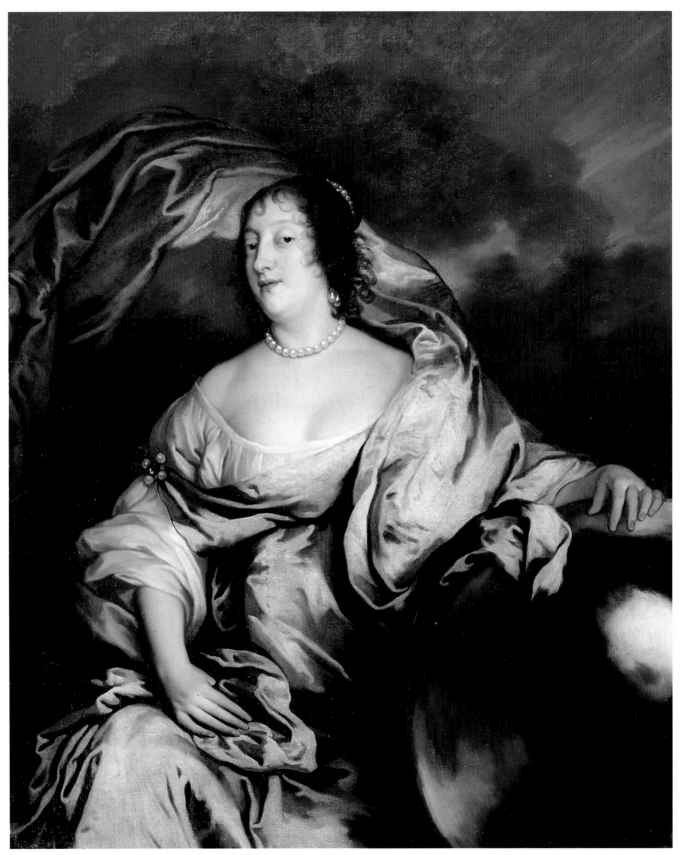

CAT.91 STUDIO OF ANTHONY VAN DYCK *Rachel Wriothesley, née de Ruvigny, Countess of Southampton, as Fortune*

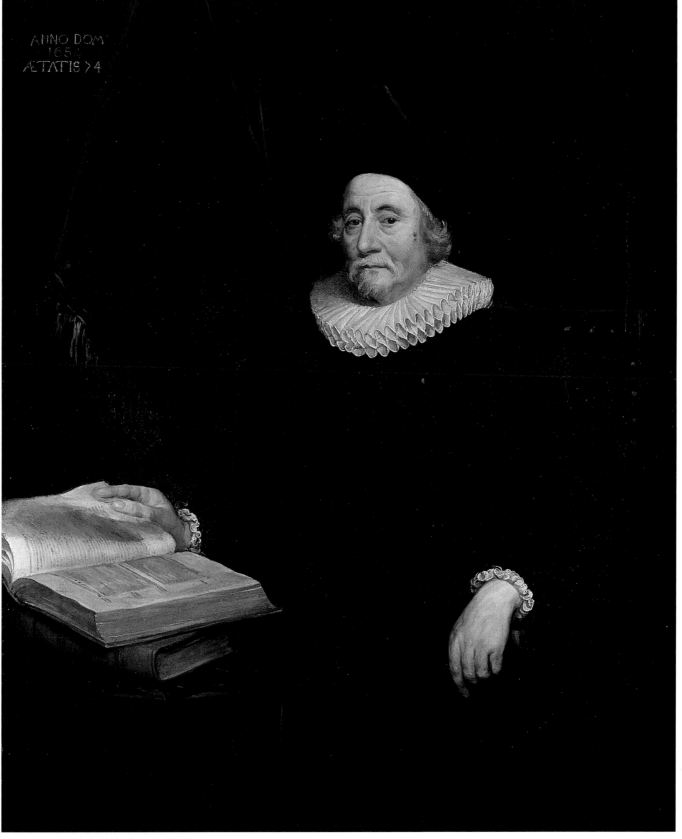

CAT.92 PETER LELY *Archbishop James Ussher*

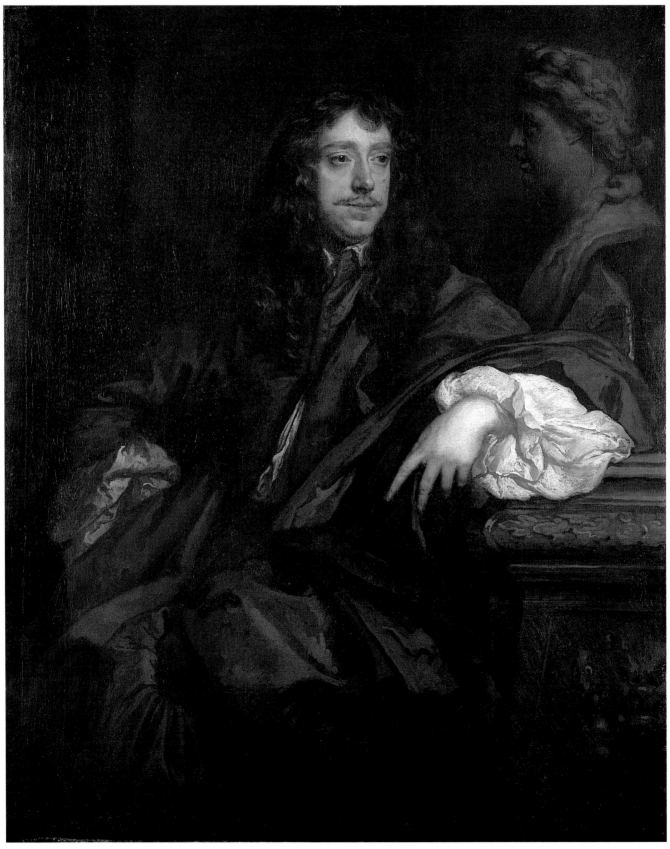

CAT.93 PETER LELY *Portrait of a Man*

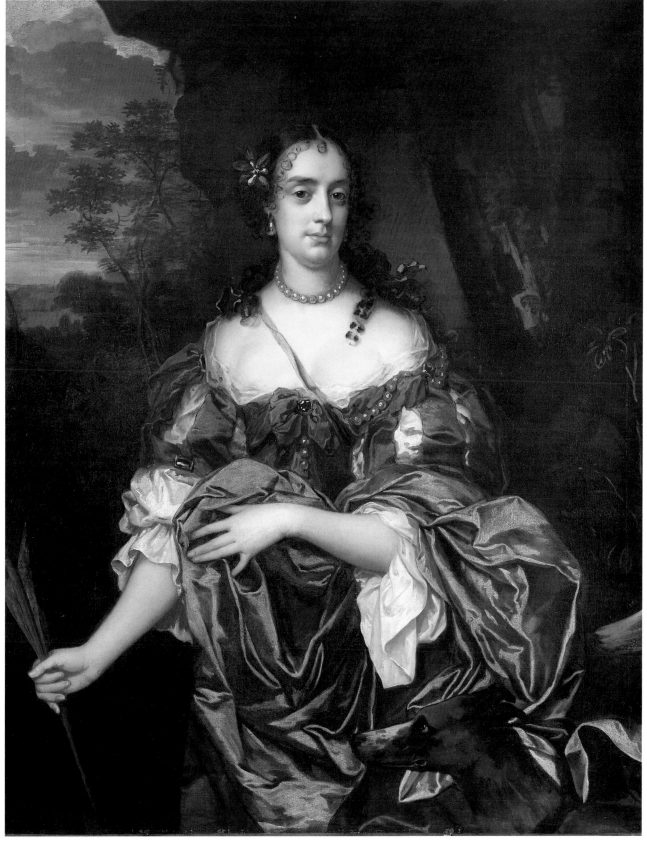

CAT.94 JACOB HUYSMANS *Portrait of a Lady as Diana*

CAT.95 MICHAEL DAHL *Mary Corbyn, Lady Levinge*

CAT.96 JOSHUA REYNOLDS (AUTOGRAPH REPLICA ?) *Mrs Siddons as the Tragic Muse*

CAT.97 THOMAS GAINSBOROUGH *Mrs Letitia Townley Balfour*

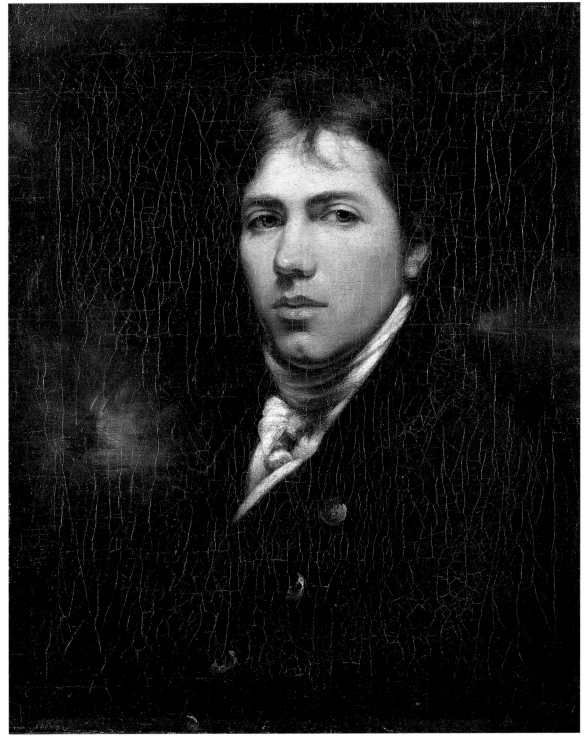

CAT.98 JOHN OPIE *Self-portrait*

CAT.99 GEORGE JONES *Wellington with Frontline Artillery at Waterloo*

CAT.100 GEORGE JONES *The Meeting of Wellington and Blücher at Waterloo*

CAT.101 GEORGE JONES AFTER FRANÇOIS GÉRARD *Field-Marshal William Carr Beresford, Viscount Beresford*

CAT.102 JOHN BOADEN *Fanny Kemble*

CAT.103 DOUGLAS COWPER *Copy of Rembrandt's 'Self-portrait'*

CONCORDANCE

Cobbe Coll.	Cat.	Cobbe Coll.	Cat.	Cobbe Coll.	Cat.	Cobbe Coll.	Cat.
1	17	66	11	336	98	421	95
4	16	70	3	339	90	425	78
5	29	71	7	340	85	431	93
6	21	73	46	349	92	432	1
10	20	80	48	350	97	434	77
13	36	83	4	353	57	437	68
14	22	85	45*	356	52	440	84
15	15	86	45	357	64	441	60
16	26	87	12	358	55	442	79
21	41	88	14	359	65	443	80
23	35	92	6	363	56	446	54
25	18	93	2	364	50	447	87
26	38	95	44	365	73	449	71
28	30	104	8	367	63	452	66
31	28	105	10	371	75	454	82
32	23	114	47	374	58	455	83
34	37	121	9	380	62	456	69
38	25	124	49	381	61	457	94
39	42	147	13	383	96	458	102
40	19	270	5	386	99	461	59
41	39	272	43	387	100	460	76
44	31	278	67	391	88	462	86
45	32	304	53	402	70	465	101
46	33	315	103	403	51	467	91
47	34	316	72	414	74		
62	27	323	89	418	81		

The Knight of Glin (pp.19–26)

1 *Georgian Society Records* (1913), p.87 and pl.cxv.

2 Cornforth 1985a, pp.1732–7 and Cornforth 1985b, pp.1808–13, pl.3 (p.1809).

3 Cobbe 1988, pp.64–9.

4 Glin 1992, pp.12 and 6.

5 Ibid., pp.8–9.

6 A. C. Elias kindly supplied me with a draft of his *DNB* entry for Pilkington (March 1999).

7 Cobbe 1894, vol.1, pp.17–19.

8 Ibid., vol.1, p.139.

9 Letter from Frances Power Cobbe to Mrs Louisa Cobbe (*née* Brooke), her sister-in-law (n.d. [*c*.1840], Cobbe Papers: Alec Cobbe).

10 Cobbe Papers: Hugh Cobbe.

11 A new, extremely well-documented study of the demise of the great houses of Ireland has just been published: see Dooley 2001 (with careful analysis of newspaper accounts, servants reports etc).

12 Pückler-Muskau 1832, vol.1, p.221.

13 *The Irish Sketch Book* (London, 1842); see William Makepeace Thackeray, vol.5, pp.306–7.

14 Woods 1889, pp.70–71.

15 Ibid., p.75.

16 Lyster (ed.) 1908, p.131.

17 Dermot and Ó Maitiú 1996, p.13.

18 Dublin 1997, with a contribution by the author of this essay on the decoration of Russborough.

19 For an excellent study of this collection through inventories and other material, see Barnard and Fenlon 2000, pp.137–59. Matthew Pilkington acquired some paintings from the Ormonde collection, including six watercolour paintings of East Indian birds and a Tintoretto sketch (see fig.63).

20 Many of the houses are illustrated in the following two books: Montgomery-Massingberd and Sykes 1999 and O'Brien and Guinness 1992. For background on Ireland's historic houses, see Pakenham 2000; Somerville-Large 1995; and Glin, Griffin and Robinson 1989.

21 A report on Newbridge and its arrangements with Fingall County Council and a summary of the conference by Hugh Montgomery-Massingberd appeared in *The Sunday Telegraph* (19 March 1993).

A. Cobbe and T. Friedman (pp.27–36)

1 Richard Castle and George Semple have been suggested as architect. *The Georgian Society Records*, vol.v (1913), p.87, pl.cxv; Guinness and Ryan 1971, pp.151–7; Bence-Jones 1978, p.223; Cornforth 1985a, pp.1732–7, and Cornforth 1985b, pp.1808–13; Jackson-Stops 1988, pp.64–9; O'Brien and Guinness 1992, pp.86–8.

2 *A Book of Architecture*, pp.xxvi, xxviii, xix–xx, pls 72–4, 84. Friedman 1984,

pp.133, 164, 301, pl.174; see also Abbotstone and Cannam Heath, pp.300–01.

3 British Library, Department of Manuscripts, Add.MS.47025, fols 81*v*–82. For Perceval's Italian visit and his friendship with Gibbs, see Friedman 1984, pp.7–8, and Ford and Ingamells 1997, pp.757–8.

4 British Library, Department of Manuscripts, Add.MS.47025, fol.114*v*, with the annotation 'Mr. Gibbs accepts my invitation to come to Ireland'; see also fol.104, Gibbs to Perceval, 24 November 1708.

5 Add.MS.47025, fols 115*v*–116, 12 February 1709, perhaps in connection with Burton Park, Co. Cork, burnt by James II's troops in 1690 (Bence-Jones 1978, p.50).

6 Perceval and his son, Philip, subscribed to *A Book of Architecture*, 1728, p.xxviii. On 30 December 1741 John Perceval 'visited … Mr. Gibbs … who promised [his] interest for my son', who was seeking a seat in the House of Commons (Perceval/ed. Historical Manuscripts Commission 1920–23, vol.3, pp.234–5).

7 In 1738 Cobbe and Perceval served together as Privy Councillors of Ireland. Rawdon travelled in Italy in 1739–40 and was a member of the Society of Dilettanti (Ford and Ingamells 1997, pp.800–01).

8 Perceval/ed. Historical Manuscripts Commission 1920–23, vol.3, pp.242–3. In 1744 Rawdon became a Fellow of the Royal Society, to which Gibbs had been elected in 1729 (Friedman 1984, p.16).

9 On 22 and 23 June 1744 and 5 and 13 February 1745; Perceval/ed. Historical Manuscripts Commission 1920–23, vol.3, pp.301 and 308.

10 Depicted on a survey for Charles Cobbe of the lands of Lanistown, Newbridge and Donabate by Thomas Cave dated March 1736 (Cobbe Papers: Alec Cobbe).

11 Account book of Dorothea Rawdon and Charles Cobbe (Cobbe Papers: Hugh Cobbe). On 21 June 1736 Cobbe, when Bishop of Kildare and Dean of Christ Church, Dublin, paid £5,526.5s.6d for the Newbridge property (fol.32*r*); in 1742, he spent a further £6,435 for the adjoining property at Corballis and Kilcreagh (fol.31*r*).

12 Friedman 1984, chapters I–II.

13 Northamptonshire Record Office, Fitzwilliam Papers, Milton, Plan 63, in 'Plans & Elevations for a House', 'Earl Fitzwilliam 1726' (Friedman 1984, pp.127, 129, 269 and 318).

14 Letter of August 1722, quoted in Guinness and Ryan 1971, pp.194–5.

15 Public Record Office of Northern Ireland, D654. According to Anne Casement, who discovered these unpublished drawings, the wealthy, politically ambitious but untitled Stewart purchased estates in Co. Down in 1744, including the

Templecrone demesne, where, according to Montgomery-Hyde (1979, p.2), he planned to build a country house. It was not until the 1770s that the family entertained building a house at Mount Stewart, which was to be designed by James Wyatt in the following decade (communication from Anne Casement, 15 June 2001).

16 Ashmolean Museum, Oxford, Department of Western Art, Gibbs Collection, vol.v, nos 1–22. Friedman 1984, pp.146, 155, 291, pls 156 and 165.

17 Friedman 1984, p.289. Gibbs left Borlach, 'many years my draughtsman', £400 in his 1754 Will (pp.18–19).

18 Letter to the Duke of Newcastle, 21 October 1746, British Library, Newcastle Papers Add.MS.32709, fol.75. Cobbe also appealed to the King (ibid., fol.294).

19 Answering objections to 'lay preachers preaching out of a church' (Curnock [n.d.], vol.3, pp.312–13).

20 *A Map of the Lands of Newbridge* etc by Roger Kendrick, *Surveyor to the Honble City of Dublin,* Dublin, 27 August 1747 (Cobbe Papers: Alec Cobbe). Kendrick's name appears with Archbishop Cobbe's in the Register of St Patrick's Cathedral, Dublin: '1765. April 18. The most Revd Dr Charles Cobbe ArchBishop of Dublin was Inter'd at Donabate, near his late Dwelling house …. He was my very great friend, I have lost many. R: Kendrick'. MS. extract, *c*.1880 (Cobbe Papers: Alec Cobbe).

21 Account book of Dorothea Rawdon and Charles Cobbe, fols 32*r*–27*v* (Cobbe Papers: Hugh Cobbe).

22 Ibid., fol.33*r*.

23 *A Map of pt of the Land of Donabate* etc by Roger Kendrick, Dublin, dated December 1752 (Cobbe Papers: Alec Cobbe).

24 Gibbs Collection, vol.II, no.54 (see n.16 above).

25 The dimensions are discussed in detail in Cobbe and Friedman [forthcoming 2001].

26 *A Map of Newbridge, Desmesne of Thomas Cobbe Esq etc* by Charles Frizell, 1776 (Cobbe Papers: Hugh Cobbe).

27 Pool and Cash 1780; Guinness 1979, pp.232–3, fig.248. In 1755 Lord Tyrone's youngest daughter, Lady Elizabeth ('Betty'), married Cobbe's only surviving son, Thomas.

28 Nos 68, 74, 78 and 79 (see n.13 above). Gibbs also used the composition in the Greenhouse at Whitton Place, Middlesex, 1725–7 (Friedman 1984, p.162, pl.171).

29 Friedman 1984, p.318. For illustrations of the features at Newbridge, see n.1.

30 Cornforth 1985b, p.1811, fig.8.

31 Jackson-Stops 1988, p.65.

32 Quoted in *The Irish Builder*, 1 June 1873, p.144. Papworth 1887, p.51, under Semple, refers to 'a mansion for the archbishop of Dublin'.

33 Pool and Cash 1780, p.84, illus., and Craig 1992, p.139.

34 Malcolm 1989, pp.39–48, illustrating Semple's signed plan and elevation, 1750. George Semple's brother, John, was paid £419.10s.0d for masonry and bricklaying (p.49); Cobbe was elected a Hospital Governor on 29 August 1746 (pp.32–3).

35 Craig 1992, pp.170–72, pl.ix; Ruddock 1979, pp.40–44, figs 42–6. Semple's clerk of works, the mason Robert Mack (Craig 1992, p.225), submitted a bill in 1777 for £153.10s.10d for building the bridge surviving in the park at Newbridge (Cornforth 1985a, p.1735). Semple consulted his own 'fine collection of books' in preparation for the Liffey commission and later in 1751 purchased others from London; these included treatises by Alberti, Palladio and Serlio, and he visited the capital in the Spring of 1752 (Harris and Savage 1990, pp.412–13).

36 Compare the Hospital and the Headfort drawings (London 1973, preface, figs 3–4, 8–9) to *A Book of Architecture*, pp.x–xi, pls 37 and 41, Kirkleatham Hall (Friedman 1984, p.296). The motif also appears on Essex Bridge. The *Book* was available from mid-century at the Dublin Society's school (Craig 1992, p.200).

37 These works, together with a more detailed account of the Gibbs house, including the likely involvement of another architect during the formative years of the 1740s, are discussed in a series of forthcoming *Country Life* articles.

A. Cobbe (pp.37–46)

1 Cobbe 1894, vol.1, p.6.

2 Cobbe 1860. Quoted from Thomas Woodcock, Norroy and Ulster King of Arms, letter of 28 February 2001 to the author.

3 He cited: 'At a Court of Chivalry held on the sands of Calais in September 1346, called to consider the case of one Sir Robert de Morley who had been bearing the arms of Lord Burnell, were gathered King Edward III, the Black Prince, Thomas de Beauchamp, Earl of Warwick and Earl Marshall, one of the commanders, William de Bohun, Earl of Northampton and Constable of England, Clarencieux and Norroy Kings of Arms, Berye Dragon and Windsor Heralds, and Robert Cobbe, knight (Miles), who testified that he had borne arms since a boy and had taken part in eleven pitched battles and he knew well the arms of Lord Burnell.' Another account of this dispute cites Robert Cobbe as deponent in a second hearing in 1395, though his evidence of participation in armed battles still shows him to have been present at Crécy. Norroy and Ulster King of Arms has pointed out that a family of the name of Cobbe would not have need of these sources

to result in a swan in their coat of arms (Norroy and Ulster King of Arms, see n.2).

4 The confirmation was to Thomas Cobbe of Swaraton in the Visitation of Hampshire, in 1575, by Robert Cooke, Clarencieux King of Arms. The original document survives (Cobbe Papers: Hugh Cobbe). Cooke was famously prone to inserting flattering allusions to ancient origins in return for hospitality and or money.

5 British Library, Department of MSS, Harleian MSS 1139, 1473 and 1544.

6 Pitman 1941; the reference given here is 'Extract from Court Rolls *vide* History of Basingstoke'. A 'tythingman' was a significant landholder.

7 Eyre 1890, p.27.

8 Pitman 1941, 1568, Oct.6 (l.T.R. Mich.10 Eliz. Record Ro.185); Eyre 1890, p.22.

9 Will of John Cobbe (1594) states 'Allso my brother Mr Myghell oweth me for all the Glasse of the Newe House.' Undated MS. extract by Charles Woodridge 'from the Registry of the Lord Bishop of Winchester at Winchester' (Cobbe Papers: Alec Cobbe).

10 Will of Richard Cobb (1597, transcription 1660), Corpus Christi College, Oxford.

11 Pitman 1941, Chan. Pro. Southampton v. Cobb C.2 Eliz. S. 16/43 and S.43/3 1598 Mar. 8; see also Stopes 1922, p.118, in which the name Richard is erroneously given for Michael Cobbe.

12 Hampshire Record Office, 1658 PC/16, 'An Inventory of the goods and chattels of Richard Cobb late of the p[ish] of St Michaell neare the City of Winchester in the County of South[h] Esq. deceased Taken & [ap]praysed the Nyneth day of July in the yeare of our Lord 1658'.

13 British Library, Add.MS.71488.

14 *Lords Manuscripts* 1912, pp.261–3.

15 The affair was embodied in 1704 under 'An Act to empower the Lord High Treasurer, or Commissioners of the Treasury, to compound with Richard Cobb Esquire, as One of the Sureties for Thomas Cobbe Gentleman, deceased, Receiver General for the County of Southampton' (*Lords Journals*, vol.xvii, p.631 [25 January 1704]; p.633 [26 January 1704]; p.640 [1 February 1704]; p.649 [5 February 1704]; p.717 [14 March 1704]; p.718 [14 March 1704]; *Commons Journals* 1803, vol.xv, p.111–12 [25 January 1705/6]; p.116 [26 January 1705/6]; p.121 [31 January 1705/6]; p.133 [8 February 1705/6]; p.154 [16 February 1705/6]; p.164 [21 February 1705/6].

16 Perceval/ed. Historical Manuscripts Commission 1920–23, vol.3, p.301.

17 Alton 1838, p.341.

18 *Pue's Occurences*, Dublin (Sunday, 14 April 1765), quoted from MS. copy, 1888 (Cobbe Papers: Alec Cobbe).

19 *Conveyance of house in Pallas Row from John*

Beresford, Theophilus Jones and Thomas Cobbe to Thomas Earl of Bective, MS., 25 September 1788 (Cobbe Papers: Hugh Cobbe). No record of its external appearance survives. That the sale of the house was to another of Semple's clients, Lord Bective, suggests that it had been built by Semple.

20 Correspondence of the Ladies of Llangollen, information verbally communicated by the Knight of Glin.

21 Cobbe 1868 (1892), *sub* no.87.

22 Ibid.

23 Cobbe 1894, vol.1, p.17.

24 Ibid.

25 Arthur Wellesley, with characteristic good will towards younger Anglo-Irishmen, assisted Cobbe with the £262.10s required to purchase his lieutenancy. Cobbe seems to have been diffident in the first instance about approaching his grandfather for the sum, perhaps because the latter, in his old age, had become increasingly conscious of the costs of living in Bath and the inconsistency of the rents coming in from Ireland. In an exceedingly considerate letter of 1802, Wellesley suggests to Cobbe, who was then in funds to repay the sum, that various sets of bills had been sent to his grandfather in the previous year and, if he was likely to pay them, that Cobbe should hold on to his money (Cobbe Papers: Alec Cobbe).

26 Cobbe 1894, vol.1, p.19.

27 Force Orders by Brigadier Gen. W.H. Manning, Commanding Somaliland Field Force, 470 Victoria Cross, dated Obbia, 9 February 1903 (Cobbe Papers: Alec Cobbe).

B. Bryant (pp.52–62)

1 The most recent reassertion of this evaluation appears in Turner (ed.) 1996, vol.10, p.206, in the entry on 'Encyclopedias and dictionaries of art' by Alex Ross. Lawrence Lipking (1970, pp.125, 192) briefly notes Pilkington as a foil to other writers. Johannes Dobai (1974–5, vol.2, p.1179ff and 1189), however, situates the *Dictionary* in the context of other writings on art. Iain Pears (1988, pp.203–4 and 268–9, n.68) sees Pilkington's as producing a 'more "Renaissance-oriented" approach' focusing on the artist. Much earlier, William T. Whitley (1928, vol.1, p.105) made passing reference to Pilkington as 'the writer of one of our earlier dictionaries of painters' biographies' in the context of discussing Laetitia and Worsdale.

2 For example, Christopher White in New Haven 1983, pp.10–11; Postle 1995, pp.285, 289; and Andrew Wilton in London 1996–7, p.42.

3 Laetitia's reputation long overshadowed that of Matthew as indicated by the greater length of her *DNB* entry in 1896. A.C. Elias

Jr has produced the definitive modern edition (1997) of her *Memoirs*, in which there is much on Matthew the clergyman (see esp. vol.2, pp.372–3).

4 Corrected by F. Elrington Ball, the editor of Swift's correspondence, who located Matthew's will and published it in 1912 (p.66), as noted by Iris Barry in her edition (1928), with introduction and bibliographical notes, of the *Memoirs of Mrs Laetitia Pilkington …* (pp.470ff). Matthew's will is a chilling document, providing ample evidence of his lack of feeling for his family: he spurned his eldest son as one who 'never felt any filial affection for me' and referred to his youngest grown children (whose legitimacy he doubted) as 'those two abandoned wretches' because they had supported their mother. He bequeathed five pounds to the eldest son and one shilling each to the younger ones.

5 As an indication of his tendency to flatter likely patrons, he dedicated the *Poems on several Occasions* in 1730 to the 19th Earl of Kildare (1675–1743/4).

6 In fact, Matthew Pilkington's poetry has always been recognized, as in O'Donoghue 1892–3 (later edn 1912; repr. 1970), p. 383 (even if it was initially unconnected with the Matthew Pilkington of the *Dictionary*), and his work has undergone recent re-evaluation as by Fagan (1989), who devotes chap.12 to Matthew Pilkington. He is also included in Hogan (ed.) 1979 (rev. and expanded edn 1996), p.1022 (entry by Aileen Douglas).

7 As quoted by Fagan 1989, p.89, from a letter of 1730 by Swift, who also called the two 'the mighty Tom Thumb and her Serene Highness of Lilliput', in reference to their stature.

8 On Worsdale, see Crookshank and Glin 1978, pp.47–51; also Waterhouse 1981, p.424. In 1741, while in Dublin, he became Deputy Master of the Revels, which suited his 'excellent mimicry and facetious spirit', as noted in the edition of the *Dictionary* of 1798 (p.826). He seesawed between Dublin and London, ending up in the latter as the saviour of Sir Edward Walpole, who rewarded him with the position of Master Painter to the Board of Ordnance. For more on Worsdale's adventures, see Pilkington 1748–54/ed. Elias 1997, vol.2, pp.445–6.

9 My thanks to Adrian Le Harivel of the National Gallery of Ireland, for providing further information about the painting.

10 Quoted in Crookshank and Glin 1978, p.49, noting that Vertue also called him 'a little cringing creature'.

11 On this painting and Hogarath's links with Sir Edward Walpole and Viscount Boyne, see Paulson 1993, pp.270–71 and p.519, n.30.

12 The assumption is that Hone produced this portrait before Laetitia and Matthew separated; once she left for London, it would seem her limited resources would not have stretched to commissioning a portrait. However, it is possible that the portrait dates from her time in London, since she opened her own pamphlet- and print-selling establishment for brief time in St James's (Lippincott 1983, p.147–8) and may have encountered Hone in London. An engraving by Richard Purcell after the portrait appeared as the frontispiece to the book by her son, also a poet: *The Real Story of John Carteret Pilkington* (London, 1760). See also Pilkington 1748–54/ed. Elias 1997, vol.2, p.359.

13 Letter by Swift of 22 July 1732 in Curll 1741, p.27.

14 Ibid., p.40.

15 Pilkington 1748–54/ed. Barry 1928, p.7 and A.C. Elias Jr in the *New DNB* article on Matthew Pilkington (forthcoming).

16 [Anonymous] 1741, p.44.

17 Noted Pilkington 1748–54/ed. Elias 1997, vol.1, p.53; vol.2, pp.430–32.

18 Gawen Hamilton's group portrait of *'A Conversation of Virtuosis at the Kings Armes'* (National Portrait Gallery, London), dating from 1734–5 (soon after Pilkington was in London), is discussed by Elizabeth Einberg in London 1987–8, pp.85–6, no.65.

19 As noted by Haskell 1985, pp.50–59.

20 The expanding art market of the 1750s and 1760s is ground well covered by Lippincott 1983 and Pears 1988. Further interesting discussions of the art market in London *c*.1750 include St John Gore 1989, pp.127ff and Sloan 1997, pp.205–27, where availability of paintings at major sales and the prices are discussed.

21 Pilkington 1748–54/ed. Elias 1997, vol.2, p.451.

22 Ibid.

23 Ibid., vol.1, p.xvi.

24 Woolf 1925 and, most recently, Thompson 2000, pp.80–122. For earlier literature, see Pilkington 1748–54/ed. Elias 1997.

25 Pilkington 1748–54/ed. Elias 1997, vol.1, p.300.

26 The reliable source of this account was Frances Power Cobbe, noted writer with proto-feminist leanings, extremely prolific and serious-minded, a friend of John Stuart Mill and Thackeray. See also Cornforth 1985b, pp.1809–10 and on Pilkington, Archbishop Cobbe and Thomas Cobbe, see pp.47–51.

27 Cobbe 1894, vol.1, p.10. The Archbishop's sister Elizabeth had died in 1749, thus freeing Pilkington from some of his responsibilities. Material on the Cobbe collection at Newbridge has been kindly

28 Newbridge, House Account Books, reference for 11 December 1761 (Cobbe Papers: Hugh Cobbe).

29 Information from A.C. Elias Jr in a letter to Alec Cobbe. Pilkington was vicar at one other parish in the Dublin area.

30 Glin (forthcoming), chap.4.

31 Pilkington 1748–54/ed. Elias 1997, vol.2, p.688.

32 Glin (forthcoming), chap.4. This chapter also contains the most up-to-date discussion of the Irish art trade in the 18th century, which concludes, 'Dublin would appear to have been a much more artistically minded Capital than has been previously thought'.

33 Algarotti's *An Essay on Painting* appeared in a translation published by Whitehouse in Dublin by 1767, priced 2s.2d. Pilkington cites this recent translation.

34 He referred to the paleness in the paintings of Poussin and Vouet, which contained 'too much of the white', and noted the violets and purples of Bassano's works (Pilkington 1770, pp. 679, 41).

35 A.C. Elias Jr has kindly provided a copy of this letter by Pilkington in the Huntington Library, San Marino, California.

36 On Richardson and the rationalisation of connoisseurship, see Gibson-Wood 2000, pp.179ff. And for the wider implications of the cult of connoisseurship, see also Brewer 1997, pp.258–9 and Brewer 1995, pp.341–61.

37 *The English Connoisseur, containing an account of whatever is curious in painting, sculpture, &c. in the Palaces and Seats of the Nobility and Principal Gentry of England, both in Town and Country* (Dublin, 1767), preface to vol.2, p.i. It does not appear that Pilkington availed himself of these lists, but the publication is symptomatic of the quest for information, as the market expanded, in the 1760s. Frank Simpson (1951, pp.355–6) has recorded that most of Martyn's information came from R. and J. Dodsley's *London and its Environs Described* (1761). Pilkington tapped into this concern for specific works of art seen in the original in many of his entries.

38 Ogden and Ogden 1947, pp.196–201. It is clear that most of these publications were akin to manuals for drawing.

39 Introduction by Ronald Lightbown to the facsimile reprint (1969) of Bainbrigg Buckeridge, *An Essay towards an English School of Painters* (1706).

40 Bignamini 1988, p.1991 on the search for a national identity in the writing of lives of British artists by Vertue.

41 As noted by Francis Russell on the collections at Wilton House in Washington, DC, 1985, p.348.

42 Among works in Irish collections, Pilkington referred to a 'Pietro de Castro' owned by William Montgomery of Dublin; a river scene by 'Jan Van Goyen' with Viscountess Kingsland; a head by Guido Reni; and a landscape by 'Franciso Mille' in the Earl of Moira's collection in Dublin.

43 As noted by J. Loughman in the entry on Hobbema in Turner (ed.) 1996, vol.14, p.603; he also noted that Hobbema was not mentioned by Houbraken. According to Loughman, 'it was well into the 19th century before he was rescued from obscurity'.

44 Christopher Brown, in Hull 1981, noted that in the first half of the 18th century the work of most Dutch painters 'fell into critical disfavour', citing Walpole on the 'drudging mimics of Nature'.

45 Alastair Laing (London 1995–6, pp.102–3, no.36) discusses the 2nd Earl of Egremont's purchase of a work by Bril in 1754.

46 As noted in the *Catalogue of the Celebrated Collection of Works of Art and Vertu … the property of the late Samuel Rogers, Esq.*, Christie's, London, 28 Apri–May 1856, lot 720.

47 Herrmann 1999, p.258 quotes from Anna Jameson's *Companion to the Most Celebrated Private Galleries of Art in London* (1844), in which she described the position of the Tintoretto near Reynolds's *Laughing Girl* ('and Sir Joshua stands it bravely'). Herrmann (p.256) also cites from an article on Rogers's collection in the *Athenaeum* (December 1855), in which she notes the 'magnificent sketch by Tintoretto … formerly belonged to Pilkington'. It remained with Rogers until purchased at a high price in the Rogers sale of 1856 by Angela (later Baroness) Burdett Coutts, who lent it to the Manchester Art Treasures exhibition; consequently it became one of the best-known works by Tintoretto in Britain in the 19th century. The painting appears in an anonymous watercolour of Rogers's dining room illustrated by Cornforth 1978, pl.165, in which its impressive size and dominant position are easily assessed.

48 Getty Provenance Index. His name remained in the public eye thanks to the regular appearance of editions from 1798 until the 1850s.

49 See n.35 above.

50 By 1767, the publishers Whitehouse of Dublin published the translation of Algarotti's *Essay on Painting*, for 2s.2d. (compared with three volumes of Smellie's *Midwifery* at 9s.9d. and two volumes of Smart's *Horace* at 5s.5d).

51 Hazen 1969, vol.3, item 3362. The *Dictionary* lent itself naturally to grangerisation and Bull, noted for his efforts in this area, transformed his copy into seven volumes of extra-illustrated text (completed in 1784; now in the London Library), linking the idea of an artist's biography with portraiture and thus tapping into the notion of the artist as personality. On Bull in general, see Pinkerton 1978, pp.41–59.

52 There is no reference in the Royal Academy Council Minutes (1770–84) to any deposit of the *Dictionary* by Pilkington or the publishers, nor does it appear in the published catalogue of the Library of 1802. But by 1805, Farington recommended the purchase of Fuseli's edition of that year (1 August 1805; see Farington/ed. Garlick and Macintyre 1978–84, vol.7, p.2600), and indeed this item was still at the Library at the time of S.A. Hart's catalogue of 1877. That particular volume is no longer there, but Mary Fedden, RA gave another copy of the edition of 1805 (bound with Fuseli's *Lectures*) to the Academy in 1988.

53 *Gentleman's Magazine*, XL (1770), p.622. In 1803 another vicar, Edward Shephard, produced an abridged version of Pilkington's work, *The Lives of the Most Eminent Painters …* and in the preface claimed that Pilkington's *Dictionary* (the edition of 1798 presumably) was too long, too verbose and too expensive.

54 Review in *Monthly Review* (July 1770), p.24.

55 The American artist Charles Willson Peale (1741–1827), a student of Benjamin West, used his own copy in Philadelphia as a source for the names of his many children (Rembrandt, Rubens etc). He even inscribed their births in Pilkington's first edition, treating it much like a family bible; see Stewart 1994, p.207.

56 Edwards 1808, p.305, confirms that Wolcot executed this edition, writing some of the lives, inadequately in the case of Richard Wilson, since Wolcot 'knew nothing of him'. According to Postle 1995 (pp.284–5), John Opie wrote the life of Reynolds. I am grateful to Alastair Laing who informed me that the entry on Wolcot in *Pubic Characters of 1798–9* ('a new edition', London, 1799), p.215, further confirms that he 'lately superintended a new edition of Pilkington's Dictionary of Painters'.

57 William Pressly (1981, pp.137–41 and 220, n.51) notes that only parts of the letter appeared and these without Barry's approval; in fact Barry denied his involvement in a letter of 4 August 1799 (published in the *Morning Post* on 3 December 1799).

58 Fuseli here took up the family tradition, as his father wrote *Geschichte und Abbildung der besten Mahler in der Schweiz* (Zurich , 1755–7).

59 Knowles 1831, vol.1, p.288.

60 John Walker, who published the editions of 1798, sold a share in July 1804; see British Library, Add.MS.38730, fol.195.

61 Letter to William Roscoe in Fuseli/ed. Weinglass 1982, p.296 (letter of 27 March 1804).

62 In the entry on 'Albert Aldegraff' [Aldegrever], Pilkington wrote: 'He was a very considerable painter', which Fuseli revised as 'He was no inconsiderable painter'; Pilkington noted: 'His design was correct', which Fuseli turned into 'His design was not without knowledge'.

63 Fuseli/ed. Weinglass 1982, p.312 (letter of 1 February 1805); see also pp.314–15.

64 Again John Wolcot may be the anonymous editor.

65 It duplicates the catalogue of West's works in *Public Characters*, but its inclusion in the *Illustrated Supplement* of 1805 has gone unnoted, while the relevance of its appearance in yet another key publication underlines how the *Dictionary* lent itself to a variety of promotional stunts, as well as re-asserting West's position in the year he had resigned the Presidency of the Academy.

66 Farington/ed. Garlick and Macintyre 1978–84, vol.9, p.3401 (1 Feb 1809).

67 The 'Memoir of the late Henry Fuseli Esq. R.A.', *Blackwood's Magazine*, vol.23 (1828), p.579, referred to his Lectures and his 'Notes upon Pilkington' as forming 'an imperishable monument of the depth of his information'.

68 Also in 1810, John Gould produced *A Dictionary of Painters, Sculptors, Architects and Engravers*, intended to be 'compact and portable size of a pocket volume'. Significantly, the author dutifully recorded Pilkington's name against every entry where he borrowed information, emphasizing that by this time Pilkington was virtually a household name in the art world.

69 *Bryan's Dictionary* became a standard issue, with many revisions, including a second edition by George Stanley in 1852 and continuing into the early 20th century, with the still valuable edition by G.C. Williamson (1903–5).

70 Similarly, the edition of 1829 produced by Thomas Tegg (based on the edition of 1824) was closely printed and on a smaller format.

71 Preface to edition of 1824.

72 Haskell 1976, pp.21–2, 182–3, n.25.

J. Bryant (pp.63–72)

1 Lewis 1837, vol.1, p.463.

2 Cornforth 1985a, pp.1732–7 and Cornforth 1985b, pp.1808–13; and Jackson Stops 1988, pp.6–9.

3 Some of the finest paintings to remain in the Cobbe family collection hang at Hatchlands in East Clandon, Surrey.

4 See the essay in this catalogue by Alec Cobbe and Terry Friedman (pp.27–36).

5 See Russell 1989; Fowler and Cornforth 1978, pp.231–47; Cornforth 1978; and Laing in London 1995, pp.117–19.

made available to me by Alec Cobbe.

6 Sykes 1985.

7 The best examples are Spencer House and, from the early 19th century, the Waterloo gallery at Apsley House.

8 See, for example, Thornton 1984.

9 Ware 1756, pp.433–4. Ware may have had in mind Houghton Hall, for the picture gallery wing features in his monograph (1735). See London and Norwich 1996, pp.14–16; 120–21; and 149–50.

10 See Washington, DC, 1985, p.354.

11 Quoted from sale catalogue, Christie's, London, 29 April 1782.

12 London 1986a, pp.30–34.

13 Rosoman 1985, pp.663–77 and Bryant 1993, pp.30–55.

14 London 1983a, pp.50–51.

15 Adam 1774, vol.1, part 2.

16 Cobbe Papers: Hugh Cobbe.

17 See the essay in this catalogue by Sebag Montefiore, pp.47–51; also Crookshank and Glin (forthcoming revised edition).

18 London 1973.

19 A further £35.8s.3d was spent on lime and stucco men in 1763. Williams began work at Newbridge in July 1763 and is probably the 'Mr Richard Williams' who was married by Pilkington to the Cobbe family nurse, Mrs Mary Carney, at the local church on 29 September 1763. She was discharged the following February. According to Cornforth, 'at least three hands are recognized in the plasterwork' (Cornforth 1985b, p.1808).

20 Roller printing of wallpaper in continuous rolls was invented in 1804 but did not become widespread until the 1840s.

21 Cobbe 1868 (1892), preface.

22 Cobbe Papers: Alec Cobbe.

23 For the choice of artists and comparison with other Anglo-Irish collections, see the accompanying essay by Charles Sebag Montefiore in this catalogue (pp.47–51).

24 For the genteel occupations pursued beneath the Rococo ceilings of drawing roms in contrast to the activities that took place in more 'masculine' dining rooms, see Jackson Stops 1984, pp.139–57.

25 Cobbe 2000, p.17. Lady Betty Cobbe also owned two harpsichords and, from 1775, a 'Forte Piano'.

26 Waagen 1854–7, vol.3, p.7.

27 Cobbe 1894, vol.1, p.8.

A. Cobbe (pp.74–9)

1 The payments in question are for 12 December 1783 and 26 May 1785.

2 See Crookshank 1991, *passim*.

3 When sold at Christie's, London, 6 July 1990, lot 92.

4 Charles Cobbe diaries (Cobbe Papers: Hugh Cobbe).

5 This is not an original Newbridge picture, but was at Townley Hall, near Drogheda, when Gernon's work was carried out.

W. Laffan (pp.80–86)

1 'Ancestral Houses, Meditations in Time of Civil War', from *The Tower* (1928).

2 I am grateful to Dr Jane Fenlon and Prof. Anne Crookshank for this suggestion; they have encountered works from the same hand in other Irish collections.

3 He is listed in Bénézit 1976, vol.9, p.830, yet he is absent from Waterhouse 1981. The attribution derives from Frances Power Cobbe's catalogue of 1868.

4 For the same practice employed, more successfully, by Richard Robinson, see Coleman 1995, p.135.

5 Quoted in Lecky 1871, p.52.

6 Trinity College, Dublin, MSS 750 N.3.8, pp.38–9. See Crookshank and Glin 1969, p.14.

7 A 'James Verney' with a floruit date of 1753 is recorded in Waterhouse 1981, p.392.

8 Perceval/ed. Historical Manuscripts Commission 1920–23, vol.3, p.229.

9 Ibid., vol.3, pp.89 and 308.

10 Crookshank and Glin 1978, p.151.

11 Lightbown (ed.) 1970, pp.26–7 (1796).

12 Sale, Christie's, London, 3 June 1977, lot 59.

13 There is a puzzling correspondence in terminology in the account books between the Verney portrait and that by Lowry some 40 years later. In both cases, pictures in the plural are noted, although only the one work by Lowry showing two children and by Verney again showing two children is known or recorded.

14 Lippincott 1983, p.67.

15 Granard Papers, Public Record Office, Belfast, 2/31/1–4. I am grateful to The Knight of Glin for bringing this reference to my attention.

16 Walpole 1872, pp. 323–4 (1798).

A. K. Wheelock and A. Cobbe (pp.87–9)

1 Van Gool, 1751, vol.2, p.490, identifies him simply as a painter of 'modern landscapes'.

2 Pears 1988, p.222, noted that two of Hobbema's paintings sold at auction in England between 1731 and 1759 fetched at least £40.

3 Pilkington 1770, p.288.

4 Inv. no.4533.

5 Letter of 18 January 1795 (Cobbe Papers: Hugh Cobbe).

6 Cobbe 1894, vol.1, p.19.

7 Ibid.

8 Cobbe Papers: Hugh Cobbe.

9 Ibid.

10 Charles Cobbe diaries, entry for 8 November 1839 (Cobbe Papers: Hugh Cobbe).

11 Brown's receipt to Holford dated 4 April 1840 (collection of Charles Sebag Montefiore).

12 Cobbe 1894, vol.1, pp.23–4. The relevant

passage reads: 'Though often hard pressed to carry out with a very moderate income all his projects of improvements, he [Charles] was never in debt. One by one he rebuilt or re-roofed almost every cottage on his estate, making what had been little better than pig-styes, fit for human habitation; and when he found that his annual rents could never suffice to do all that was required in this way for his tenants in his mountain property, he induced my eldest brother, then just of age, to join with him in selling two of the pictures which were the heirlooms of the family and pride of the house, a Gaspar Poussin and a Hobbema, which last now adorns the walls of Dorchester House. I remember as a child seeing the tears in his eyes as this beautiful painting was taken out of the room in which it had been like a perpetual ray of sunshine. But the sacrifice was completed, and eighty good stone and slate "Hobbema Cottages", as we called them, soon rose all over Glenasmoil'.

C. Rowell (pp.205–9)

1 For a general account of Hatchlands, see Rowell 1992 (rev. edn 1998); for the paintings, see Laing/Cobbe 1992.

2 In fact, there were then no pictures belonging to the National Trust in the Saloon, but there were (and are) several elsewhere. There was, however, one picture on loan to the Trust in the Saloon. The only picture in the Saloon now in National Trust ownership is the copy after Salvator Rosa in the overmantel, but that was owned by Alec Cobbe at the time of Gervase Jackson-Stops' article in 1989 and was subsequently bought by the Trust because it had become – in effect – a fixture.

3 Jackson-Stops 1989.

4 Ibid.

5 Sir John Soane's Museum; file inscribed 'Designs for Admiral the Hon. E. Boscawen', containing Adam's Hatchlands drawings and Stiff Leadbetter's plan of the ground floor dated March 6, 1757; see Spiers 1979.

6 Adam owned a drawing, dating from *c*.1644–52, of a panel of a dome at the Villa Pamphilij (now Sir John Soane's Museum, London), which is directly comparable to his design for the ceiling of the Drawing Room (now Library); see Stillman 1966, pp.96–7, figs 118–19. There is no drawing for the Saloon ceiling, but the outlines are delineated in pencil on Leadbetter's ground-plan.

7 I am grateful to Catherine Hassall for confirming this by paint analysis.

8 See King 1991, p.241 and fig.339.

9 Christopher Hussey (1956, p.54) wrote of the wall panels in the Saloon: '… beneath the silk with which they are now filled,

the rough lines have been found for some of this decoration, probably countermanded after the Admiral died in 1762 [*sic*]'. In corroboration, Christopher Beharrell, then the National Trust's Historic Buildings Representative for the Southern region, found in 1982 'marks of decorative plasterwork on many of the panels suggesting that some of Adam's work *had actually taken place*'. To the left (east) of the bay window wall, pencil outlines matched 'the design in one of the drawings in the Soane Museum' (18 October 1982; National Trust Archive, Polesden Lacey).

10 For Shardeloes, see King 1991, pp.184–5, figs 263–4. The other craftsmen documented there were Sefferin Alken and Richard Lawrence, woodcarvers; and Thomas Carter, the statuary.

11 For a photograph of the Kedleston drawing room chimneypiece, see Jackson-Stops and Antram 1988, p.24. The caryatids of the Saloon chimneypiece are also close in concept to Adam's chimneypieces in the Red Drawing Room at Hopetoun House (*c*.1756, carved by Rysbrack, to whom the Saloon chimneypiece has also been convincingly attributed by Hussey [1956, p.54]) and in the Gallery at Croome Court (1766 by Joseph Wilton). The overmantel at Croome (see King 1991, pp.179–81, fig.257 and p.229, fig.321) is also virtually identical to the one in the Saloon.

12 See Kemp (ed.) 1952, vol.IV, p.246.

13 Walpole 1764, repr. in *Walpole Society*, 1928, vol.16, p.xxxi. I am grateful to Alec Cobbe for drawing my attention to this reference.

14 James 1929, p.273.

15 Repton's 'Red Book', for the redesign of the park, is in the Pierpont Morgan Library, New York.

16 See Hussey 1953.

17 Sold from Hatchlands, Christie's, London, 7 March 1958 and subsequently resold at Christie's, London, 11 December 1987. For a photograph of the picture *in situ* at Hatchlands, see Hussey 1953, p.873, fig.11.

18 See Rogers/ed. Hale 1956, p.209.

19 See Jackson-Stops 1989.

20 See London 1991, pl.v.

21 Acquired at sale, Sotheby's, London, 17 February 1988, lot 8.

22 See Redford 1888, vol.1, p.75. The Duke paid 150 guineas for the picture, which was looted from the Imperial Collection in Prague in 1648, taken to Stockholm for Queen Christina of Sweden, and then to Rome by her after her abdication. In 1947 it was acquired by the National Gallery, Stockholm (inv. no.NM 4414).

23 Sale, Bonhams, London, 5 November, 1987, lot 163.

BIBLIOGRAPHY

Books and Articles

Adam 1774
R. Adam and J. Adam: *The Works in Architecture of Robert and James Adam* (London, 1774)

Agath 1955
G. Agath: *Johann Georg Plazer: Ein Gesellschaftsmaler des Wiener Rokoko* (Vienna, 1955)

d'Albenas 1914
G. d'Albenas: *Catalogue des peintures et sculptures exposées dans les galeries du Musée Fabre de la Ville de Montpellier* (Montpellier, 1914)

Alisio, Carughi, Di Stefano and Miccoli 1976
C. C. Alisio, U. Carughi, A. M. Di Stefano and A. Miccoli: *L'arciconfraternità della SS Trinità dei Pellegrini in Napoli* (Naples, 1976)

Alton 1838
J. d'Alton: *The Memoirs of the Archbishops of Dublin* (Dublin, 1838)

[Anonymous] 1824
The East India Military Calendar, vol.2 (London, 1824)

[Anonymous] 1853
Historical Notes of the Levinge Family, Baronets of Ireland (Ledestown, 1853)

[Anonymous] 1913a
'Gainsborough Picture Sold for £10,000', *The Times* (16 July 1913), p.5

[Anonymous] 1913b
'Sale of a Gainsborough Portrait, Mrs. Champion of Bath', *The Times* (25 July 1913), p.6

[Anonymous] 1914a
'Leaves from the President's Note Book', *Bengal Past and Present: Journal of the Calcutta Historical Society*, vol.8/nos 15–16 (1914)

[Anonymous] 1914b
'The Letters of Richard Barwell, III', *Bengal Past and Present: Journal of the Calcutta Historical Society*, vol.9/nos 17–18 (1914)

[Anonymous] 1916
'The Letters of Richard Barwell, IX', *Bengal Past and Present: Journal of the Calcutta Historical Society*, vol.12/nos 23–24 (1916)

Archer and Jackson-Stops 1988
M. Archer and G. Jackson-Stops: 'Mr Cobbe's Cabinet of Curiosities', *Country Life* (10 March 1988), pp.130-33

Armstrong 1898
Sir W. Armstrong: *Gainsborough and his Place in English Art* (London and New York, 1898)

Armstrong 1904
— *Gainsborough and his Place in English Art* (rev.edn, London, 1904)

Armstrong 1913
— *Lawrence* (London, 1913)

Ashton 1997
G. Ashton: *Pictures in the Garrick Club*, ed. by K. A. Burnim and A. Wilton (London, 1997)

Asleson (ed.) 1999
R. Asleson, ed.: *A Passion for Performance: Sarah Siddons and her Portraitists* (Los Angeles, 1999)

Bagni 1986
P. Bagni: *Benedetto Gennari e la bottega del Guercino* (Bologna, 1986)

Baldassari 1995
F. Baldassari: *Carlo Dolci* (Turin, 1995)

Baldinucci/ed. Ferrari 1966

F. S. Baldinucci: *Vita di Luca Giordano pittore napoletano*; ed. by O Ferrari: 'Una "vita" inedita di Luca Giordano', *Napoli nobile* (1966), pp.89–96, 129–38

Ballarin 1968
A. Ballarin: *Tiziano* (Florence, 1968)

Barnard and Fenlon 2000
T. Barnard and J. Fenlon: *The Dukes of Ormonde, 1620–1745* (Woodbridge, 2000)

Baum 1980
E. Baum: *Katalog des österreichischen Barockmuseums im Unteren Belvedere in Wien*, 2 vols (Vienna, 1980)

Beckett 1951
R. B. Beckett: *Lely* (London, 1951)

Bence-Jones 1978
M. Bence-Jones: *Burke's Guide to Country Houses, Ireland*, 3 vols (London, 1978)

Bénézit 1976
E. Bénézit: *Dictionnaire critique et documentaire des peintres, sculpteurs, dessinateurs et graveurs*, 10 vols (Paris, 1976)

Benson 1927
R. Benson: *The Holford Collection, Dorchester House* (London, 1927)

Bernard 1656
N. Bernard: *The Life and Death of the Most Reverend and Learned … Dr James Usher … in a Sermon at his Funeral at the Abby of Westminster* (London, 1656)

Bertini 1994
G. Bertini: 'Ottavio Farnese e Francesco de Marchi: Una proposta di identificazione del *Doppio ritratto maschile di Maso da San Friano*', *Aurea Parma*, vol.68 (1994), pp.149–55

Bevilacqua 1845
G. C. Bevilacqua: *Insigne Pinacoteca della nobile veneta famiglia Barbarigo dalla Terrazza descritta ed illustrata da Gian Carlo Bevilacqua pittore di storia I. R. Consigliere dell'I. R. Accademia Venetia di Belle Arti* (Venice, 1845)

de Bie/ed. Lemmens 1971
C. de Bie: *Het gulden cabinet van de edele vry schilderconst* (Antwerp, 1661); facs.edn with introduction by G. Lemmens (Soest, 1971)

Bignamini 1988
I. Bignamini: 'George Vertue, Art Historian, and Art Institutions in London, 1689–1768', *Walpole Society*, vol.54 (1988)

Blankert 1967
A. Blankert: 'Heraclitus en Democritus: In het bijzonder in de Nederlandse kunst van de zeventiende eeuw', *Nederlands Kunsthistorisch Jaarboek*, vol.18 (1967), pp.31–124

Blunt 1966
A. Blunt: *The Paintings of Nicolas Poussin* (London, 1966)

Bode 1913
W. Bode: *Catalogue of the Collection of Pictures and Bronzes in the Possession of Mr Otto Beit*, 3 vols (London, 1913)

Bodkin 1934
T. Bodkin: 'Orazio and the other Grevenbroecks', *Proceedings of the Royal Irish Academy*, vol.62 (1934), section C, no. 1

Boisclair 1986
M.-N. Boisclair: *Gaspard Dughet: Sa Vie et son oeuvre (1615–1675)* (Paris, 1986)

Bol 1969
L. J. Bol: *Holländische Maler des 17. Jahrhunderts nahe den grossen Meistern: Landschaften und Stilleben* (Braunschweig, 1969)

Bolton 1916
A. T. Bolton: 'Hatchlands, Surrey, the Seat of Mr. H. S. Goodhart-Rendel', *Country Life*, vol.39 (5 February 1916), pp.176–84

Borenius 1936
T. Borenius: *Catalogue of the Pictures and Drawings at Harewood House and Elsewhere in the Collection of the Earl of Harewood KG, G.V.O., D.S.O.* (Oxford, 1936)

Borghini 1584/ed. Rosci 1967
R. Borghini: *Il riposo di Raffaele Borghini* (Florence, 1584); facs.edn by M. Rosci (Milan, 1967)

Boswell 1932
E. Boswell: *The Restoration Court Stage, 1660–1702* (London, 1932)

Braun 1966
H. Braun, *Gerard und Willem van Honthorst* (diss., Göttingen, Georg-August-Universität, 1966)

Bredius 1925
A. Bredius: *Album hem aangeboden op 18 April 1925* (Amsterdam, 1925)

Breeze 1984
G. Breeze: 'Thomas Hickey's Stay in Bath', *Somerset Archaeological and Natural History Society*, vol.128 (1984), pp.83–92

Brejon de Lavergnée 1986
A. Brejon de Lavergnée: *L'inventaire Le Brun de 1683: La collection des tableaux de Louis XIV* (Paris, 1986)

Brejon de Lavergnée and others 1979
A. Brejon de Lavergnée and others: *Catalogue sommaire illustré des peintures du Musée du Louvre: Ecoles flamande et hollandaise* (Paris, 1979)

Brejon de Lavergnee and Thiebaut 1981
A. Brejon de Lavergnee and D. Thiebaut: *Catalogue sommaire illustré des peintures du Musée du Louvre: Italie, Espagne, Allemagne, Grand-Bretagne et divers* (Paris, 1981)

Brewer 1995
J. Brewer: '"The most polite age and the most vicious": Attitudes towards Culture as Commodity, 1660–1800', *The Consumption of Culture, 1600–1800*, ed. by A. Bermingham and J. Brewer (London and New York, 1995), pp.341–61

Brewer 1997
— *The Pleasures of the Imagination: English Culture in the Eighteenth Century* (London, 1997)

Brigstocke 1982
H. Brigstocke: *William Buchanan and the 19th-century Art Trade: 100 Letters to his Agents in London and Italy* (London, 1982)

Brossard de Ruville 1863
Brossard de Ruville: *Histoire de la ville des Andelys*, 2 vols (Les Andelys, 1863)

Broulhiet 1938
G. Broulhiet: *Meindert Hobbema (1638–1709)* (Paris, 1938)

Broun 1987
F. J. P. Broun: *Sir Joshua Reynolds's Collection of Paintings*, 3 vols (diss., Princeton University, 1987)

Brown 1982
C. Brown: *Van Dyck* (Oxford, 1982)

Bryan 1903
M. Bryan: *Dictionary of Painters and Engravers, Biographical and Critical*, 2 vols (London, 1903)

Bryant 1993
J. Bryant: *London's Country House Collections* (London, 1993)

Buijsen (ed.) 1998

E. Buijsen, ed.: *Haagse schilders in de Gouden Eeuw: Het Hoogsteder lexicon van alle schilders werkzaam in Den Haag, 1600–1700* (The Hague and Zwolle, 1998)

Burke 1852
J. B. Burke: 'The Grange, Hampshire: The Seat of Lord Ashburton', *A Visitation of the Seats and Arms of the Noblemen and Gentlemen of Great Britain*, 2 vols (London, 1852–3), vol.2, p.247

Cadorin 1833
G. Cadorin: *Dello amore ai veneziani di Tiziano Vecellio* (Venice, 1833)

Capretti 1994
E. Capretti: 'Intorno al maestro di Volterra', *Paragone*, vol.45/nos 529/531/533 (1994)

Castellan 1819
A.-L. Castellan, *Lettres sur l'Italie*, 3 vols (Paris, 1819)

Cat. Brussels 1984
Catalogue inventaire de la peinture ancienne: Musées Royaux des Beaux-Arts de Belgique (Brussels, 1984)

Cat. Burghley House
Guide to Burghley House, Stamford: The Seat of the most Honourable, the Marquess of Exeter (Stamford, [n.d.])

Cat. Copenhagen 1951
Catalogue of Old Foreign Paintings, Copenhagen, Royal Museum of Fine Arts, 2 vols (Copenhagen, 1951)

Cat. Detroit Institute of Arts 1944
Catalogue of Paintings, Detroit Institute of Arts (Detroit, 1944)

Cat. Ditchley 1908
Catalogue of Paintings in the Possession of the Right Honble Viscount Dillon at Ditchley Spelsbury, Oxfordshire (Oxford, 1908)

Cat. Farnese 1994
La Collezione Farnese: I dipinti lombardi, liguri, veneti, toscani, umbri, romani, fiamminghi; Altre scuole; Fasti Farnesiani, Museo e Gallerie Nazionali di Capodimonte (Naples, 1994)

Cat. Hermitage 1958
Catalogue des Peintures, Hermitage Museum, Department of Western Art, 2 vols (Leningrad, 1958)

Cat. Kimbell Art Museum 1972
Kimbell Art Museum: Catalogue of the Collection (Fort Worth, 1972)

Cat. Kimbell Art Museum 1981
Kimbell Art Museum: Handbook of the Collection (Fort Worth, 1981)

Cat. National Gallery 1973
Illustrated General Catalogue, National Gallery (London, 1973)

Cat. National Gallery of Ireland 1981
Illustrated Summary of Paintings in the National Gallery of Ireland, with preface by H. Potterton (Dublin, 1981)

Cat. National Maritime Museum 1988
Concise Catalogue of Oil Paintings in the National Maritime Museum (Woodbridge, 1988)

Cat. National Portrait Gallery 1957
British Historical Portraits: A Selection from the National Portrait Gallery with Biographical Notes (Cambridge, 1957)

Cat. Paintings in British Collections 1993
Catalogue of Paintings in British Collections (London, 1993)

Cat. Österby 1841
Catalogue of the Paintings in the Galleries at Österby (Stockholm, 1841)

Cat. Uffizi 1979
Uffizi: Catalogo generale (Florence, 1979)

Cat. Warsaw 1969
Foreign Schools, Warsaw, National Museum (Warsaw, 1969)

Charlemont/ed. Historical Manuscripts Commission 1891
The Manuscripts and Correspondence of James, First Earl of Charlemont, I: 1745–83, ed. Historical Manuscripts Commission, Twelfth Report, Appendix, Part X (London, 1891)

Chiarini 1975
M. Chiarini: 'I quadri della collezione del Principe Ferninando II', *Paragone*, vol.26/no.303 (1975), pp.95–108

Christiansen 1992
K. Christiansen: 'Devotional Works: Mantua', *Andrea Mantegna* (exh.cat. ed. by J. Martineau, London, Royal Academy of Arts, and New York, Metropolitan Museum of Art, 1992), pp.150–56

Clark 1967
A. M. Clark: 'The Portraits of Artists Drawn for Nicola Pio', *Master Drawings*, vol.5 (1967), pp.3–23

Clark 1985
— *Pompeo Batoni: A Complete Catalogue of his Works with an Introductory Text*, ed. E. Peters Bowron (Oxford, 1985)

Cobbe 1860
T. Cobbe: *An Essay on the Achievement of Cobbe formerly of Steventon & the Grange Hants, now of Newbridge in the Co. of Dublin*, MS. dated 1860 (Cobbe Papers: Alec Cobbe)

Cobbe 1863
F. P. Cobbe: 'A Day at the Dead Sea', *Fraser's Magazine*, vol.67 (1863), pp.226–38

Cobbe 1868
— 'Twelve Canons of Art and Literature', *Spectator* (6 June 1868)

Cobbe 1868 (1882)
— *Catalogue of Pictures in the Possession of Charles Cobbe at Newbridge House; Written by Frances Power Cobbe 1868 – Copied by Mabel Cobbe 1882*, MS. (the 1868 original, Cobbe Papers: Hugh Cobbe; 1882 copy, Cobbe Papers: Alec Cobbe)

Cobbe 1875
— 'The Town Mouse and the Country Mouse', *New Quarterly Magazine*, vol.4 (1875), pp.475–510

Cobbe 1894
— *Life of Frances Power Cobbe by herself, with Illustrations*, 2 vols (London, 1894)

Cobbe 1896
C. Cobbe: *A Book for Remarks & Reference Relative to Pictures - Plate - Furniture &c -&c - &c bought by Me*, MS. dated 1896 (Cobbe Papers: Alec Cobbe)

Cobbe 1970
A. Cobbe: *A Catalogue of Portrait Miniatures, Newbridge House, Co. Dublin, being the Collections Respectively of Thomas Leuric Cobbe Esquire and Joan Mervyn Cobbe*, MS. dated 1970 (Cobbe Papers: Alec Cobbe)

Cobbe 1988
— 'Newbridge Restored', *World of Interiors* (18 February 1988), pp.64–9

Cobbe 2000
— *Composer Instruments* (Great Bokham, 2000)

Cobbe and Friedman (forthcoming, 2001)
A. Cobbe and T. Friedman: 'Newbridge House, Co. Dublin', *Country Life* (forthcoming, 4 October 2001)

Cochin 1758
C.-N. Cochin: *Voyage d'Italie ou recueil de notes sur les ouvrages de peinture & de sculpture, qu'on voit dans les principales villes d'Italie* (Paris, 1758)

Coleman 1995
J. Coleman: 'Sir Joshua Reynolds and Richard Robinson, Archbishop of Armagh', *Irish Arts Review Yearbook*, vol.11 (1995)

Collins Baker 1920
C. H. Collins Baker: *Catalogue of the Petworth Collection of Pictures in the Possession of Lord Leconfield* (London, 1920)

Collins Baker 1936
— *A Catalogue of British Paintings in the Henry E. Huntington Library and Art Gallery, San Marino* (San Marino, 1936)

Commons Journals 1803
Journals of the House of Commons. From October the 25th 1705, In the Fourth Year of the Reign of Queen Anne, to April the 1st 1708, In the Seventh Year of the Reign of Queen Anne. Reprinted by the Order of the House of Commons (London, 1803)

Cooney and Malafarina 1976
P. J. Cooney and G. Malafarina: *L'opera completa di Annibale Carracci* (Milan, 1976)

Cornforth 1978
J. Cornforth: *English Interiors, 1790–1848: The Quest for Comfort* (London, 1978)

Cornforth 1985a
— 'Newbridge, Co. Dublin, I: The Home of Mrs Francis Cobbe', *Country Life* (20 June 1985), pp.1732–37

Cornforth 1985b
— 'Newbridge, Co. Dublin, II: The Home of Mrs Francis Cobbe', *Country Life* (27 June 1985), pp.1808–13

Couché 1786–1808
J. Couché: *Galerie du Palais royal, gravé d'après les tableaux des differentes écoles qui la composent: avec un abrégé de la vie des peintres & une description historique de chaque tableau par mr. l'abbé de Fontenai*, 3 vols (Paris, 1786–1808)

Craig 1992
M. Craig: *Dublin, 1660–1860* (London, 1992)

Crookshank 1989
A. Crookshank: 'Robert Hunter', *The GPA Irish Arts Review, Yearbook 1989–90* (Dublin, 1989), pp.169–85

Crookshank 1991
— 'Notes on the Cleaning and Framing of Pictures in Trinity College, Dublin', *Art is my Life: A Tribute to James White* (exh.cat. ed. by B. P. Kennedy, Dublin, National Gallery of Ireland, 1991)

Crookshank and Glin 1978
A. Crookshank and the Knight of Glin: *The Painters of Ireland, c.1660–1920* (London, 1978)

Crookshank and Webb 1990
A. Crookshank and D. Webb: *Paintings and Sculpture in Trinity College, Dublin* (Dublin, 1990)

Cundall 1891
F. Cundall: *The Landscape and Pastoral Painters of Holland: Ruisdael, Hobbema, Cuijp, Potter* (London, 1891)

Curll 1741
E. Curll: *An Impartial History of the Life, Character, Amours, Travels, and Transactions of Mr John Barber* (London, 1741)

Curnock
N. Curnock: *The Journal of the Rev. John Wesley A.M.*, [n.p./n.d.]

D'Auvergne 1696
E. d'Auverge: *The History of the Campagne in Flanders for the Year 1695* (London, 1696)

Davies 1935
A. M. Davies: *Warren Hastings: Maker of British India* (London, 1935)

De Maere and Wabbes 1994
J. De Maere and M. Wabbes: *Illustrated Dictionary of 17th-*

century Flemish Painters, ed. by J. A. Martin, 3 vols
(Brussels, 1994)

Dermot and Ó Maitiú 1996
J. Dermot and S. Ó Maitiú: The Wicklow World of Elizabeth
Smith (Dublin, 1996)

De Witt 2000
D. A. de Witt: Jan van Noordt (1624–after 1676): 'Famous
History- and Portrait Painter in Amsterdam' (diss.,
Kingston, Queen's University, 2000)

DNB
Dictionary of National Biography, 63 vols (London, 1885–
1900)

Dobai 1974–5
J. Dobai: Die Kunstlerliteratur des Klassizismus und der
Romantik in England, 2 vols (Bern, 1974–5)

Donahue Kuretsky 1979
S. Donahue Kuretsky: The Paintings of Jacob Ochtervelt
(1634–1682), with Catalogue Raisonné (Oxford, 1979)

D'Onofrio 1964
C. D'Onofrio: 'Inventario dei dipinti del cardinal
Pietro Aldobrandini compilato da G. B. Agucchi nel
1603', Palatino, vol.8 (1964), nos 1–3, pp.15–20; nos 7–8,
pp.158–62; nos 9–10, pp.202–11

Dooley 2001
T. Dooley: The Decline of the Big House in Ireland
(Dublin, 2001)

Duro 1997
P. Duro: The Academy and the Limits of Painting in
Seventeenth-century France (Cambridge, 1997)

Earland 1911
A. Earland: John Opie and his Circle (London, 1911)

Edwards 1808
E. Edwards: Anecdotes of Painters who have resided or been
born in England (London, 1808)

Elrington 1847
C. R. Elrington: The Life and Whole Works of the Most Rev.
James Ussher (Dublin, 1847)

Elrington Ball 1912
F. Elrington Ball: Notes and Queries, ser. XI, vol.6
(27 July 1912), p.66

Emmens 1973
J.A. Emmens: ' "Eins aber ist nötig": Zu Inhalt und
Bedeutung von Markt- und Küchen-stücken des
16. Jahrhunderts', Album Amicorum J.G. van Gelder, ed. by
J. Bruyn (The Hague, 1973), pp.93–101

Eyre 1890
W. L. W. Eyre: A Brief History of the Parishes of Swarraton
and Northington with Notices of the Owners of the Grange in
the County of Southampton (London and Winchester, 1890)

Fagan 1989
P. Fagan: A Georgian Celebration: Irish Poets of the
Eighteenth Century (Dublin, 1989)

Farington/ed. Garlick and Macintyre 1978
The Diary of Joseph Farington, ed. by K. Garlick and A.
Macintyre (New Haven and London, 1978)

Ferrari 1974
M. L. Ferrari: Il tempio di San Sigismondo a Cremona: Storia
e arte (Milan, 1974)

Ferrari and Scavizzi 1992
O. Ferrari and G. Scavizzi: Luca Giordano: L'opera
completa, 3 vols (Naples, 1992)

FitzGerald 1950
B. FitzGerald: Lady Louisa Conolly (1743–1821): An Anglo-
Irish Biography (London and New York, 1950)

Ford and Ingamells 1997
J. Ingamells compiled from the Brinsley Ford Archive:
A Dictionary of British and Irish Travellers in Italy, 1701–1800
(New Haven and London, 1997)

Förster 1846
E. Förster: 'Wanderungen durch einige Privatgalerien
Italiens, I: Die Galerie Barbarigo in Venedig', Kunstblatt
(1 January 1846), pp.1–3, 5–7

Forsyth 1970
W. H. Forsyth: The Entombment of Christ: French Sculptures
of the Fifteenth and Sixteenth Centuries (Cambridge, MA,
1970)

Fowler and Cornforth 1978
J. Fowler and J. Cornforth: English Decoration in the 18th
Century (London, 1978)

Fréart de Chantelou/ed. Corbett 1985
P. Fréart de Chantelou: Diary of the Cavaliere Bernini's
Visit to France, Eng.trans. by M. Corbett (Princeton, 1985)

Friedman 1984
T. Friedman: James Gibbs (New Haven and London, 1984)

Fuseli/ed. Weinglass 1982
The Collected English Letters of Henry Fuseli, ed. by D. H.
Weinglass (New York and London, 1982)

Gaehtgens and Lugand 1988
T. Gaehtgens and J. Lugand: Joseph-Marie Vien (Paris, 1988)

Gainsborough/ed. Hayes 2001
The Letters of Thomas Gainsborough, ed. by J. Hayes (New
Haven, 2001)

Galassi 1991
P. Galassi: Corot in Italy (New Haven and London, 1991)

Gardner 1998
E. E. Gardner: A Bibliographical Repertory of Italian
Private Collections, I: Abaco-Cutolo (Vicenza, 1998)

Garlick 1989
K. J. Garlick: Sir Thomas Lawrence: A Complete Catalogue
of the Oil Paintings (Oxford, 1989)

George, Prince of Wales/ed. Aspinall 1965
The Correspondence of George, Prince of Wales, 1770–1812,
ed. by A. Aspinall (London, 1965)

Ghelfi 1997
B. Ghelfi: Il libro dei conti del Guercino, 1629–1666
(Venice, 1997)

Gibson 2000
K. Gibson: 'Jan Wyck (c.1645–1700): A Painter with
"a grate deal of fire"', The British Art Journal, vol.2/no.1
(2000), pp.3–13

Gibson-Wood 2000
C. Gibson-Wood: Jonathan Richardson: Art Theorist of the
English Enlightenment (New Haven and London, 2000)

Gilbert 1972
J. T. Gilbert: A History of the City of Dublin, 3 vols
(Shannon, 1972; rev.edn of original edn, Dublin, 1854–9)

Ginori Lisci 1972
L. Ginori Lisci: I palazzi di Firenze nella storia e nell'arte,
2 vols (Florence, 1972)

Glin 1992
The Knight of Glin: A Directory of the Dublin Furnishing
Trade, 1752-1800 (Dublin, 1992)

Glin, Griffin and Robinson 1989
The Knight of Glin, D. Griffin and N. Robinson:
Vanishing Country Houses of Ireland (Dublin, 1989)

van Gool 1751
J. van Gool: De nieuwe schouburg der Nederlantsche
kunstschilders en schilderessen (The Hague, 1751)

Graves 1906
A. Graves: The Royal Academy of Arts: A Complete Dictionary
of Contributors and their Works from its Foundation in 1769 to
1904, 5 vols (London, 1906)

Graves 1970
— The Royal Academy of Arts: A Complete Dictionary of
Contributors and their Works from its Foundation in 1769 to
1904, 4 vols (Wakefield and Bath, 1970/R of London, 1906)

Graves and Cronin 1899–1901
A. Graves and W. V. Cronin: A History of the Works of
Sir Joshua Reynolds, 4 vols (London, 1899–1901)

Guazzoni 1985
V. Guazzoni: 'Andrea Mainardi detto il Chiaveghino',
I Campi e la cultura artistica cremonese del Cinquecento
(exh.cat. ed. by M. Gregori, Cremona, S Maria della
Pietà, Museo Civico and Palazzo Affaitati, 1985)

Guinness 1979
D. Guinness: Georgian Dublin (London, 1979)

Guinness and Ryan 1971
D. Guinness and W. Ryan: Irish Houses & Castles
(London, 1971)

Gutwirth 1974
S. Gutwirth, 'Jean-Victor Bertin: Un Paysagiste
néo-classique', Gazette des Beaux-Arts, 6th ser., vol.83
(1974), pp.337–8

Gutwirth 1977
— 'The Sabine Mountains: An Early Italian Landscape
by Jean-Joseph-Xavier Bidauld', Bulletin of Detroit
Institute of Arts, vol.55/no.3 (1977), pp.147–52

Haak 1996
B. Haak: The Golden Age: Dutch Painters of the Seventeenth
Century (New York, 1996)

Hall 1974
J. Hall: Dictionary of Subjects and Symbols in Art, intro.
by K. Clark (London, 1974/R 2000)

Harris and Savage 1990
E. Harris and N. Savage: British Architectural Books and
Writers, 1556–1785 (Cambridge and New York, 1990)

Harwood 1988
L. B. Harwood: Adam Pijnacker (c.1620–1673), Aetas Aurea,
7 (Doornspijk, 1988)

Haskell 1976
F. Haskell: Rediscoveries in Art: Some Aspects of Taste, Fashion
and Collecting in England and France (London, 1976/R 1980)

Haskell 1985
— 'The British as Collectors', Treasure Houses of Britain
(exh.cat. by G. Jackson-Stops, Washington, DC,
National Gallery of Art, 1985), pp.50–59

Hazen 1969
A. T. Hazen: A Catalogue of Horace Walpole's Library
(London and New Haven, 1969)

Herrmann 1999
F. Herrmann: The English as Collectors: A Documentary
Sourcebook (New Castle, DE, and London, 1999)

Hodson 1927
V.C.P. Hodson: List of the Officers of the Bengal Army,
1758–1834 (London, 1927)

Hoff 1995
U. Hoff: European Paintings before 1800 in the National
Gallery of Victoria (London, 1995)

Hofstede de Groot 1907–27
C. Hofstede de Groot: A Catalogue Raisonné of the Works of
the Most Eminent Dutch Painters of the Seventeenth Century,
8 vols (London, 1907–27)

Hogan (ed.) 1979
 R. Hogan, ed.: *Dictionary of Irish Literature* (London, 1979); rev. and expanded edn (London and Westport, 1996)

Hollstein 1949–
 F. W. H. Hollstein: *Dutch and Flemish Etchings, Engravings and Woodcuts, ca. 1450–1700* (Amsterdam, 1949–)

Houbraken 1718–21
 A. Houbraken: *De groote schouburgh der Nederlantsche konstschilder en -schilderessen*, 3 vols (Amsterdam, 1718–21)

Howe 1933
 T. Howe: 'XVIII Century England in San Francisco', *The Fine Arts*, vol.20/no.3 (1933), pp.12–15

Hussey 1948
 C. Hussey: 'Townley Hall, Co. Louth, Ireland, II', *Country Life*, vol.104 (30 July 1948), pp.870–73

Hussey 1953
 — 'Hatchlands, Surrey I and II', *Country Life*, vol.114 (17 September 1953), pp.870–73 and (1 October 1953), pp.1042–5

Hussey 1956
 — 'Hatchlands, Surrey', *English Country Houses: Mid-Georgian, 1760–80* (London, 1956), p.54

Ingamells 1981
 J. Ingamells: *The English Episcopal Portrait, 1559–1835: A Catalogue* (London, 1981)

Ingamells 1992
 — *The Wallace Collection: Catalogue of Pictures, IV: Dutch and Flemish* (London, 1992)

Ivanoff 1966
 N. Ivanoff: 'Giovanni Segala', *Arte in Europa: Scritti di storia dell'arte in onore di Edoardo Arslan* (Milan, 1966), pp.767–71

Jackson-Stops 1984
 G. Jackson-Stops: *The English Country House: A Grand Tour* (London, 1984)

Jackson-Stops 1988
 — 'Newbridge Restored', *Country Life* (18 February 1988), pp.64–9

Jackson-Stops 1989
 — 'Hatchlands, Surrey', *Country Life*, vol.183 (20 April 1989), pp.182–7

Jackson-Stops and Antram 1988
 G. Jackson-Stops and N. Antram: *Kedleston Hall* (Derby, 1988)

Jaffé 1984
 M. Jaffé: 'Van Dyck Studies, II: "La Belle & Vertueuse Huguenotte"', *Burlington Magazine*, vol.126 (1984), pp.603–9

James 1929
 C. W. James: *Chief Justice Coke, his Family and Descendants at Holkham* (London, 1929)

de Jongh 1968–9
 E. de Jongh: 'Erotica in vogelperspectief: De dubbel-zinnigheid van een reeks zeventiende-eeuwse genre-voorstellingen', *Simolus*, vol.3 (1968–9), pp.22–74 (Eng. trans. in E. de Jongh: *Questions of Meaning, Theme and Motif in Dutch Seventeenth-Century Painting*, Leiden, 2000)

Judson 1969
 J. R. Judson: 'Allegory on Drinking', *Worcester Art Museum News Bulletin*, vol.34/no.5 (February 1969) [whole issue]

Judson 2000
 — *Rubens: The Passion of Christ*, Corpus Rubenianum Ludwig Burchard, vol.6 (London, 2000)

Judson and Ekkart 1999
 J. R. Judson and R. E. O. Ekkart: *Gerrit van Honthorst (1592–1656)* (Doornspijk, 1999)

Kauffman 1973
 M. Kauffman: *Victoria and Albert Museum: Catalogue of Foreign Paintings, I: Before 1800* (London, 1973)

Kemp (ed.) 1952
 P. K. Kemp, ed.: 'Boscawen's Letters to his Wife', *The Naval Miscellany*, vol.4 (London, 1952), p.246

Kiene 1992
 M. Kiene: *Les Dossiers du Musée du Louvre, 41: Pannini* (Paris, 1992)

Kieven 1975
 E. Kieven: 'The Gascoigne Monument by Alessandro Galilei', *Leeds Art Calendar*, no.77 (1975), pp.13–23

Kinderen 1950
 J. H. der Kinderen-Besier: *Spelevaart der mode* (Amsterdam, 1950)

King 1991
 D. King: *The Complete Works of Robert and James Adam* (Oxford, 1991)

Kitz 1984
 N. and B. Kitz: *Pains Hill Park* (Cobham, 1984)

Knipping 1974
 J. B. Knipping: *Iconography of the Counter Reformation in the Netherlands*, 2 vols (Leiden, 1974)

Knowles 1831
 J. Knowles: *The Life and Writings of Henry Fuseli, M.A., R.A.* (London, 1831)

Knox 1967
 R. B. Knox: *James Ussher, Archbishop of Armagh* (Cardiff, 1967)

Kristeller 1901
 P. Kristeller: *Andrea Mantegna* (London and New York, 1901)

Laing/Cobbe 1992
 A. Laing and A. Cobbe (preface): *The Cobbe Collection of Paintings* (Cobbe Foundation, 1992)

Lalande 1769
 J. J. le Francais de Lalande: *Voyage d'un François en Italie, fait dans les années 1765 & 1766* (Venice, 1769)

Lamo 1584
 A. Lamo: *Discorso intorno alla scoltura, e pittura dove ragiona della vita, ed opere in molti luoghi … fatte dall'eccellentissimo cremonese M. Bernardino Campo* (Cremona, 1584)

Larsen 1980
 E. Larsen: *L'opera completa di Van Dyck*, 2 vols (Milan, 1980)

Larsen 1988
 — *The Paintings of Anthony van Dyck*, 2 vols (Freren, 1988)

Lecchini Giovannoni 1991
 S. Lecchini Giovannoni: *Alessandro Allori* (Turin, 1991)

Lecky 1871
 W. Lecky: *The Leaders of Public Opinion in Ireland* (London, 1871)

Lees-Milne 1996
 J. Lees-Milne: *Fourteen Friends* (London, 1996)

Lefuel 1934
 H. Lefuel: *Catalogue du Musée Marmottan* (Paris, 1934)

Leslie and Taylor 1865
 C. R. Leslie and T. Taylor: *Life & Times of Sir Joshua Reynolds*, 2 vols (London, 1865)

Levey 1964
 M. Levey: *The Later Italian Pictures in the Collection of Her Majesty the Queen* (London, 1964)

Levi 1900
 C. A. Levi: *Le collezioni veneziane d'arte e d'antichità dal secolo XIV ai nostri giorni* (Venice, 1900)

Lewis 1837
 S. Lewis: *A Topographical Dictionary of Ireland* (London, 1837)

Lightbown (ed.) 1970
 R. Lightbown, ed.: *An Authentic History of the Professors of Painting, Sculpture and Architecture who have Practised in Ireland* (London, 1970)

Lightbown 1986
 — *Mantegna with a Complete Catalogue of the Paintings, Drawings and Prints* (Oxford, 1986)

Lipking 1970
 L. Lipking: *The Ordering of the Arts in Eighteenth-century England* (Princeton, 1970)

Lippincott 1983
 L. Lippincott: *Selling Art in Georgian London: The Rise of Arthur Pond* (New Haven and London, 1983)

Longhi 1946/ed. 1978
 R. Longhi: 'Viatico per cinque secoli di pittura veneziana', *Opere complete*, vol.10 (Florence, 1946, rev.edn 1978), p.21

Lords Journals
 Journals of the House of Lords, Beginning Anno Decimo Tertio Gulielmi Tertii, 1701 (London, 1701–)

Lords Manuscripts 1912
 House of Lords Manuscripts, VI (New Series): The Manuscripts of the House of Lords, 1704–1706 (London, 1912)

Lugt
 F. Lugt: *Les Marques de collections de dessins et d'estampes* (Amsterdam, 1921); *Supplément* (The Hague, 1956)

Luttrell 1969
 N. Luttrell: *A Brief Historical Relation of State Affairs, 1678–1714*, 6 vols (R/ Farnborough, 1969)

Luzio 1913
 A. Luzio: *La Galleria dei Gonzaga venduta all'Inghilterra nel 1627–8* (Milan, 1913)

Lyster (ed.) 1908
 G. Lyster, ed.: *A Family Chronicle* (London, 1908)

McEvansoneya 1999
 P. McEvansoneya: 'An Irish Artist Goes to Bath', *Irish Architectural and Decorative Studies*, vol.2 (1999)

MacLaren and Brown 1991
 N. MacLaren: *Catalogue of the Dutch School, 1600–1900*, rev. and expanded by C. Brown, National Gallery, 2 vols (London, 1991)

Mahon 1949
 D. Mahon: 'Guercino's Paintings of Semiramis', *The Art Bulletin*, vol.31 (1949), pp.217–23

Mahon 1965
 — 'The Dossier of a Picture: Nicolas Poussin's "Rebecca al Pozzo"', *Apollo*, vol.81 (1965), pp.196–205

Mahon and Turner 1989
 D. Mahon and N. Turner: *The Drawings of Guercino in the Collection of Her Majesty The Queen at Windsor Castle* (Cambridge, 1989)

Malcolm 1989
 E. Malcolm: *Swift's Hospital: A History of St Patrick's Hospital, Dublin, 1746–1989* (Dublin, 1989)

Malvasia 1678
 C. C. Malvasia: *Felsina Pittrice: Vite de' pittori bolognesi*, 2 vols (Bologna, 1678)

Malvasia 1841
 — *Felsina Pittrice: Vite de' pittori bolognesi* (rev.edn, Bologna, 1841)

Mancini 1993
 V. Mancini: *Lambert Sustris a Padova: La Villa Bigolin a Selvazzano* (Selvazzano, 1993)
Mannings 2000
 D. Mannings: *Sir Joshua Reynolds: A Complete Catalogue of his Paintings*, 2 vols (New Haven and London, 2000)
Marlier 1958
 G. Marlier: 'Les Séjours à Londres et à Hambourg du portraitiste français, Jean-Laurent Mosnier', *XIXe Congrès International d'histoire de l'art* (Paris, 1958), pp.121–22
Marmottan 1926
 Paul Marmottan: 'Le Peintre Louis Gauffier', *Gazette des Beaux-Arts*, vol.13 (1926), pp.281–300
Mayer 1972
 D. M. P. Mayer: *Angelica Kauffmann, R.A. (1741–1807)* (Gerrards Cross, 1972)
Meehan 1901
 J. F. Meehan: *Famous Houses of Bath and District* (Bath, 1901)
Mérot 1990
 A. Mérot: *Nicolas Poussin* (Paris and New York, 1990)
Merz 1995
 J. M. Merz: 'Reynolds Borrowings', *Burlington Magazine*, vol.137 (1995), pp.516–17
Michel 1865
 E. Michel, *Hobbema et les paysagistes de son temps en Hollande* (Paris, 1865)
Miedema 1980
 H. Miedema: *De archiefbescheiden van het St Lukasgilde te Haarlem, 1497–1798* (Alphen aan Rijn, 1980)
Millar 1969
 O. Millar: *Thomas Gainsborough* (rev.edn, London, 1969)
Millin 1790–99
 A. L. Millin: *Antiquités nationales, ou Recueil de monumens*, 5 vols (Paris, 1790–99)
Mitchell 1987
 F. Mitchell: 'The Evolution of Townley Hall: A Personal View', *Bulletin of the Irish Georgian Society*, vol.30 (1987)
von Moltke 1938–9
 J. W. von Moltke: 'Salomon de Bray', *Marburger Jahrbuch für Kunstwissenschaft*, vols 11–12 (1938–9; pubd 1942), pp.309–420
de Montaiglon 1853
 A. de Montaiglon: *Mémoires pour servir à l'histoire de l'Académie Royale de painture et de sculpture* (Paris, 1853)
Montgomery-Massingberd and Sykes 1999
 H. Montgomery-Massingberd and C. Sykes: *Great Houses of Ireland* (London, 1999)
Mortari 1966
 L. Mortari: *Bernardo Strozzi* (Rome, 1966)
Mortari 1995
 — *Bernardo Strozzi* (rev.edn, Rome, 1995)
Moschini Marconi 1970
 S. Moschini Marconi: *Gallerie dell'Accademia di Venezia: Opere d'arte dei secoli XVII, XVIII, XIX* (Rome, 1970)
Moxey 1976
 K. P. F. Moxey: 'The Humanist Market Scenes of Joachim Beuckelaer: Moralising Example or "Slices of Life"', *Jaarboek van het Koninklijk Museum voor Schone Kunsten Antwerpen* (1976), pp.109–89
Neale
 J. P. Neale: *Views of the Seats of Noblemen and Gentlemen in England, Wales, Scotland and Ireland*, 11 vols, 1st series (London, 1818–23); 2nd series (London, 1824–9)
Nicolson 1989

B. Nicolson: *Caravaggism in Europe*, 2nd edn rev. and enlarged by L. Vertova, 3 vols (Milan, 1989)
Oberhuber 1988
 K. Oberhuber: *Poussin: The Early Years in Rome* (New York, 1988)
Obreen 1877–90
 F. D. O. Obreen: *Archief voor Nederlandsche kunstgeschiedenis*, 7 vols (Rotterdam, 1877–90)
O'Brien and Guinness 1992
 J. O'Brien and D. Guinness: *Great Irish Houses and Castles* (London, 1992)
O'Donahue 1892–3
 D. J. O'Donahue: *The Poets of Ireland* (Dublin, 1892–3, rev.edn, 1912/R New York and London, 1970)
Ogden and Ogden 1947
 H. V. S. Ogden and M. S. Ogden: 'A Bibliography of Seventeenth-century Writings on the Pictorial Arts in English', *Art Bulletin*, vol.29 (1947), pp.196–201
Opie 1809
 J. Opie: *Lectures on Painting, Delivered at the Royal Academy of Art: with a Letter on the Proposal for a Public Memorial of the Navel Glory of Great Britain … to which are Prefixed, a Memoir by Mrs Opie, and other Accounts of Mr Opie's Talents and Character* (London, 1809)
Ottley 1818
 W. Y. Ottley: *Engravings of the Most Noble The Marquis of Stafford's Collection of Pictures*, 4 vols (London, 1818)
Pace 1976
 V. Pace: 'Maso da San Friano', *Bolletino d'Arte*, vol.61 (1976), pp.74–99
Pakenham 2000
 V. Pakenham: *The Big House in Ireland* (London, 2000)
Pallucchini 1960
 R. Pallucchini: *La pittura veneziana del Settecento* (Venice, 1960)
Pallucchini and Canova 1975
 R. Pallucchini and G. M. Canova: *L'opera completa del Lotto* (Milan, 1975)
Papworth 1887
 W. Papworth, *The Dictionary of Architecture, Architectural Publications Society*, vol.7 (1887)
Parr 1686
 R. Parr: *The Life of the Most Reverend Father in God, James Ussher, late Lord Archbishop of Armagh, Primate and Metropolitan of all Ireland* (London, 1686)
Parthey 1853
 G. Parthey: *Wenzel Hollar: Beschreibendes Verzeichniss seiner Kupferstiche* (Berlin, 1853)
Paulson 1993
 R. Paulson: *Hogarth, III: Art and Politics* (Cambridge, 1993)
Pears 1988
 I. Pears: *The Discovery of Painting: The Growth of Interest in the Arts in England, 1680–1768* (New Haven and London, 1988, 2nd edn, 1991)
Pepper 1988
 S. Pepper: *Guido Reni: L'opera completa* (Novara, 1988)
Perceval/ed. Historical Manuscripts Commission 1920–23
 Manuscripts of the Earl of Egmont: Diary of Viscount Percival, afterwards First Earl of Egmont, Historical Manuscripts Commission, 3 vols (London, 1920–23)
Pérez Sánchez 1964
 A. E. Pérez Sánchez: *Inventario de las pinturas*, Real Academia de Bellas Artes de San Fernando (Madrid, 1964)
Pigage 1778

N. de Pigage: *La Gallerie Electorale de Düsseldorf ou catalogue raisonné et figure de ses tableaux* (Basle, 1778)
Pignatti 1976
 T. Pignatti: *Veronese*, 2 vols (Venice, 1976)
Pilkington 1748–54/ed. Barry 1928
 Memoirs of Mrs Laetitia Pilkington (1712–1750) Written by herself, ed. I. Barry (London, 1928)
Pilkington 1748–54/ed. Elias 1997
 Memoirs of Mrs Laetitia Pilkington (1712–1750) Written by herself, ed. A. C. Elias Jr (London, 1997)
Pilkington 1770
 M. Pilkington: *The Gentleman's and Connoisseur's Dictionary of Painters* (London, 1770)
Pinkerton 1978
 J. M. Pinkerton: 'Richard Bull of Ongar, Essex', *Book Collector*, vol.27/no.1 (1978), pp.41–59
Pio 1724/ed. Enggass 1977
 N. Pio: *Le vite di pittori, scultori et architetti* (MS., 1724); ed. by C. Enggass and R. Enggass (Vatican City, 1977)
Piper 1963
 D. Piper: *Catalogue of Seventeenth-century Portraits in the National Portrait Gallery* (Cambridge, 1963)
Pitman 1941
 H. A. Pitman: *Abstracts of Cobbe Family Records*, unpublished typescript dated 1941 (Cobbe Papers: Alec Cobbe)
Pool and Cash 1780
 R. Pool and J. Cash: *Views of the Most Remarkable Public Buildings, Monuments and Other Edifices in the City of Dublin* (Dublin, 1780)
Poole 1912–25
 Mrs R. L. Poole: *Catalogue of Oxford Portraits*, 3 vols (Oxford, 1912–25)
Postle 1995
 M. Postle: *Sir Joshua Reynolds: The Subject Pictures* (Cambridge, 1995)
Poussin/ed. du Colombier 1929
 Lettres de Poussin, ed. by P. du Colombier (Paris, 1929)
Pressly 1981
 W. Pressly: *The Life and Art of James Barry* (New Haven and London, 1981)
Price 1843
 L. Price: *Interiors and Exteriors in Venice: Lithographed by Joseph Nash from the Original Drawings* (London, 1843)
Pronti 1988
 S. Pronti: *Il Museo Civico di Piacenza in Palazzo Farnese* (Piacenza, 1988)
Pückler-Muskau 1832
 Prince Pückler-Muskau: *Tours in England, Ireland and France* (London, 1832)
Puglisi 1999
 C. R. Puglisi: *Francesco Albani* (New Haven and London, 1999)
Raines 1987
 R. Raines: 'Notes on Egbert van Heemskerck and the English Taste for Genre', *Walpole Society*, vol.53 (1987), pp.119–42
Redford 1888
 G. Redford: *Art Sales, 1628–1887*, 2 vols (London, 1888)
Rembrandt Research Project, *Corpus* 1982–
 J. Bruyn, B. Haak, S. H. Levie, P. J. J. van Thiel and E. van de Wetering: *A Corpus of Rembrandt Paintings*, Foundation Rembrandt Research Project (Amsterdam, 1982–)
Reynolds/ed. Hilles 1929

J. Reynolds: *Letters*, ed. by F. W. Hilles (Cambridge, 1929)

Ridolfi 1648/ed. Hadeln 1914–28
C. Ridolfi: *Le maraviglie dell'arte* (Venice, 1648); ed. by D. von Hadeln (Berlin, 1914–28)

Robertson 1994
C. Robertson: *Il Gran Cardinale: The Artistic Patronage of Alessandro Farnese* (New Haven and London, 1994)

Robinson 1958–74
M. S. Robinson: *Van de Velde: A Catalogue of the Paintings of the Elder and Younger Willem van de Velde*, 2 vols (Cambridge, 1958–74)

Robinson 1990
— *Van de Velde: A Catalogue of the Paintings of the Elder and Younger Willem van de Velde*, 2 vols (rev.edn, London, 1990)

Roethlisberger 1993
M. G. Roethlisberger: *Abraham Bloemaert and his Sons: Paintings and Prints*, 2 vols (Doornspijk, 1993)

Rogers 1878
J. J. Rogers: *Opie and his Works: Being a Catalogue of 760 Pictures by John Opie, RA. Preceded by a Biographical Sketch* (London and Truro, 1878)

Rogers/ed. Hale 1956
The Italian Journal of Samuel Rogers, ed. by J. R. Hale (London, 1956)

Rosoman 1993
T. S. Rosoman: 'The Decoration and Use of the Principal Apartments of Chiswick House, 1727–70', *Burlington Magazine*, vol.127 (1985), pp.663–77

Rowell 1992
C. Rowell: *Hatchlands Park* (E. Clandon, 1992; rev.edn, 1998)

Ruddock 1979
T. Ruddock: *Arch Bridges and their Builders, 1735–1835* (Cambridge and New York, 1979)

Russell 1989
F. Russell: 'The Hanging and Display of Pictures, 1700–1850', *The Fashioning and Functioning of the British Country House*, ed. by G. Jackson Stops, Studies in the History of Art, no.25 (Hanover and London, 1989), pp.133–74

Sacchi 1872
F. Sacchi: *Notizie pittoriche cremonesi* (Cremona, 1872)

Sadie (ed.) 1984
S. Sadie, ed.: *The Grove Dictionary of Instuments*, 3 vols (London, 1984)

Salerno 1988
L. Salerno: *I dipinti del Guercino* (Rome, 1988)

Sani 1988
B. Sani: *Rosalba Carriera* (Turin, 1988)

Saur
Allgemeines Künstlerlexikon: Die bildenden Künstler aller Zeiten und Völker (Munich and Leipzig, 1983–)

Savini-Branca 1964
S. Savini-Branca: *Il collezionismo veneziano nel'600* (Padua, 1964)

Schaar 1959
E. Schaar: 'Poelenburgh und Breenbergh in Italian, und ein Bild Elsheimers', *Mitteilungen des Kunsthistorischen Institutes in Florenz*, vol.9/no.1 (1959), pp.34–5

Schaeffer 1909
E. Schaeffer: *Van Dyck: Des Meisters Gemälde*, Klassiker der Kunst (Stuttgart, 1909)

Scharf 1862
G. Scharf: *Catalogue raisonné; or, A List of the Pictures in Blenheim Palace; with Occasional Remarks and Illustrative Notes* (London, 1862)

Schnapper 1974
A. Schnapper: *Jean Jouvenet* (Paris, 1974)

Siebenhüner 1981
H. Siebenhüner: 'Der Palazzo Barbarigo della Terrazza in Venedig und seine Tizian Sammlung, *Studien Centro Tedesco di Studi Veneziani*, vol.5 (1981) [whole issue]

Simpson 1951
F. Simpson: '"The English Connoisseur" and its Sources', *Burlington Magazine*, vol.93 (1951), pp.355–6

Slive 1995
S. Slive: *Dutch Painting, 1600–1800*, Pelican History of Art (rev. edn, London, 1995)

Sloan 1997
K. Sloan: 'Sir William Hamilton's "Insuperable Taste for Painting"', *Journal of the History of Collections*, vol.9 (1997), pp.205–27

Sluijter-Seijffert 1984
N. C. Sluijter-Seijffert: *Cornelis van Poelenburch (ca. 1593–1667)* (Enschede, 1984)

Smith 1829–42
J. Smith: *A Catalogue Raisonné of the Works of the Most Eminent Dutch, Flemish and French Painters*, 9 vols (London, 1829–42)

Somerville-Large 1995
P. Somerville-Large: *The Irish Country House: A Social History* (London, 1995)

Spence/ed. Klima 1975
J. Spence: *Letters from the Grand Tour*, ed. by S. Klima (Montreal and London, 1975)

Spiers 1979
W. L. Spiers: *Catalogue of the Drawings and Designs of Robert and James Adam in Sir John Soane's Museum* (Cambridge and Teaneck, NJ, 1979)

Standring 1985
T. J. Standring: 'A Lost Poussin Work on Copper: *The Agony in the Garden*', *Burlington Magazine*, vol.127 (1985), pp.614–17

Stechow 1959
W. Stechow: 'The Early Years of Hobbema', *Art Quarterly*, vol.22 (1959), pp.3–18

Stechow 1966
— *Dutch Landscape Painting of the Seventeenth Century* (London, 1966)

Steland-Stief 1964
A. C. Steland-Stief: 'Jan Asselijn und Willem Schellincks', *Oud Holland*, vol.129 (1964), pp.99–109

Stewart 1994
S. Stewart: 'Death and Life, in that order, in the Works of Charles Willson Peale', *The Culture of Collecting*, ed. by J. Elsner and R. Cardinal (London, 1994), p.207

Stewart 1995
A. M. Stewart: *Irish Art Loan Exhibitions, 1765–1927*, 3 vols (Jersey and Dublin, 1995)

Stillman 1966
D. Stillman: *The Decorative Work of Robert Adam* (London, 1966)

Stirling 1918
A. M. W. Stirling: *The Hothams* (London, 1918)

St John Gore 1989
R. St John Gore: 'Old Masters at Petworth', *The Fashioning and Functioning of the British Country House*, ed. G. Jackson-Stops, Studies in the History of Art, no.25 (Hanover and London, 1989), pp.127ff

Stopes 1922
C. E. Stopes: *Life of Henry, 3rd Earl of Southampton* (Cambridge, 1922)

Suida 1933
W. Suida: *Tizian* (Leipzig and Zurich, 1933; It.edn, Rome, 1933)

Sumowski 1983
W. Sumowski: *Gemälde der Rembrandt-Schüler*, 6 vols (Landau, 1983)

Sutherland-Gower 1900
Lord R. Sutherland-Gower: *Sir Thomas Lawrence* (London, 1900)

Sutherland-Harris 1977
A. Sutherland-Harris: *Andrea Sacchi: Complete Edition of the Paintings with a Critical Catalogue* (Princeton, 1977)

Sutherland-Harris 1992
— 'Vouet, le Bernin et la "ressemblance parlante"', *Simon Vouet: Actes du colloque international Galeries nationales du Grand Palais (février 1991)*, ed. by S. Loire (Paris, 1992), pp.192–208

Sutherland-Harris 1998
— 'Review of Edinburgh 1998', *Burlington Magazine*, vol.140 (1998), p.641

Sykes 1985
C. S. Sykes: *Private Palaces: Life in the Great London Houses* (London, 1985)

Thieme–Becker
U. Thieme and F. Becker: *Allgemeines Lexikon der bildenden Künstler von der Antike bis zur Gegenwart*, 37 vols (Leipzig, 1907–50)

Thompson 2000
L. M. Thompson: '"I have a Right to Choose the Weapons: a Pen is mine": Writing and Wit as Weaponry in Laetitia Pilkington's *Memoirs*', *The 'Scandalous Memoirists': Constantia Phillips, Laetitia Pilkington and the Shame of 'Publick fame'* (Manchester and New York, 2000), pp.80–122

Thoré Bürger 1857
W. Thoré Bürger: *Trésors d'art exposés à Manchester en 1857* (Paris, 1857)

Thoré Bürger 1859
— 'Hobbema', *Gazette des Beaux-Arts*, vol.4 (1859), pp.28–44

Thoré Bürger 1865
— *Trésors d'art en Angleterre* (Paris, 1865)

Thornton 1984
P. Thornton: *Authentic Décor: The Domestic Interior, 1620–1920* (London, 1984)

Thornton and Tomlin 1980
P. K. Thornton and M. F. Tomlin: *The Furnishings and Decorations of Ham House* (London, 1980)

Thuillier 1974
J. Thuillier: *Tout l'oeuvre peint de Poussin* (Paris, 1974)

Thuillier 1976
— 'Poussin et le paysage tragique: *L'Orage pointel* au Musée des Beaux-Arts de Rouen', *La Revue du Louvre*, vol.26 (1976), pp.345–55

Thuillier 1994
— *Nicolas Poussin* (Paris, 1994)

Tietze 1936
H. Tietze: *Tizian: Leben und Werk*, 2 vols (Vienna, 1936)

Tietze 1950
— *Titian: Paintings and Drawings* (London, 1950)

Turner 1978
N. Turner: 'Drawings by Giovanni Angelo Canini', *Master Drawings*, vol.16 (1978), pp.387–97

Turner (ed.) 1996
J. Turner, ed.: *The Dictionary of Art*, 34 vols (London and New York, 1996)

Turner (ed.) 2000
— *From Rembrandt to Vermeer: 17th-century Dutch Artists in the Grove Dictionary of Art* (London, 2000)

Valuation 1901a
Bennett & Son (valuers): *18th November 1901 – Valuation of Heir Looms at Newbridge House, Donabate, County Dublin*, MS. dated 1901 (Cobbe Papers: Alec Cobbe)

Valuation 1901b
Bennett & Son (valuers): *18th November 1901 – Valuation at Newbridge House, Donabate, of the Furniture, Paintings and Other Effects the Property of the late Mrs. Cobbe*, MS. dated 1901 (Cobbe Papers: Alec Cobbe)

Valuation 1914
Bennett & Son (auctioneers and valuers): *In the Matter of the Estate of Thomas Maberly Cobbe Deceased, Newbridge House, Donabate, Co Dublin, … , Made the 21, 22, 23 & 24 July 1914*, MS. (Cobbe Papers: Alec Cobbe)

Vasari
G. Vasari: *Le vite de' piu eccellenti pittori, scultori ed architetti* (Florence, 1550; rev.edn, Florence, 1568); Eng. trans. as *Lives of the Painters, Sculptors and Architects*, by G. du C. de Vere, 2 vols (London, 1996)

Vecellio/ed. 1859
C. Vecellio: *Habiti antichi et moderni di tutto il secolo* (Venice, 1590); facs. edn. (Paris, 1859)

Vertova 1991
L. Vertova: 'Domenico di Baccio d'Agnolo: Due ipotetici ritratti e un omaggio al maestro', *L'Artista*, vol.10 (1991), pp.116–20

Vertue/ed. Walpole Society 1930–50
G. Vertue: 'The Note-books of George Vertue', *Walpole Society*, vol.18 (1930), vol.20 (1932), vol.22 (1934), vol.24 (1936), vol.26 (1938), vol.29 (1942) and vol.30 (1950)

Vey 2001
H. Vey: 'Van Dyck's Two Lost Group Portraits for the Brussls Town Hall', *Van Dyck, 1599–1999: Conjectures and Refutations*, ed. by H. Vlieghe (Tunrhout, 2001), pp.65–75

Vicini 1998
D. Vicini: *Musei civici di Pavia* (Milan, 1998)

Vitet 1861
L. Vitet: *L'Académie Royale de peinture et de sculpture* (Paris, 1861)

Waagen 1837–9
G. F. Waagen: *Works of Art and Artists in England*, 3 vols (London, 1837–9)

Waagen 1854–7
— *Treasures of Art in Great Britain*, 4 vols (London, 1854–7)

Waagen 1860
— *Handbook of Painting*, 2 vols (London, 1860)

Waddingham 1960
M. Waddingham: 'Herman van Swanevelt in Rome', *Paragone*, vol.11 (1960), pp.37–50

Walker 1976
J. Walker: *National Gallery of Art, Washington* (New York, 1976)

Walpole 1872
H. Walpole: *Anecdotes of Painting in England* (London, 1872)

Walpole 1928

— 'Journal of Visits to Country Seats', *Walpole Society*, vol.16 (1928)

Walpole/ed. Yale 1948
The Yale Edition of Horace Walpole's Correspondence, 5 vols (New Haven, 1948)

Ware 1756
I. Ware: *A Complete Body of Architecture* (London, 1756)

Waterhouse 1941
E. K. Waterhouse: *Reynolds* (London, 1941)

Waterhouse 1953
— 'Portraits by Thomas Gainsborough', *Walpole Society*, vol.33 (1953), pp.1948–50

Waterhouse 1958
— *Gainsborough* (London, 1958)

Waterhouse 1981
— *British 18th-century Painters in Oils and Crayons* (Woodbridge, 1981)

Waterhouse 1988
— *A Dictionary of 16th- and 17th-century British Painters* (Woodbridge, 1988)

Wethey 1969–75
H. E. Wethey: *The Paintings of Titian*, 3 vols (London, 1969–75)

Wheale and Richter 1889
W. H. J. Wheale and J. P. Richter: *A Descriptive Catalogue of the Collection of Pictures Belonging to the Earl of Northbrook* (London and Sydney, 1889)

Wheelock 1995
A.K. Wheelock Jr: *The Collections of the National Gallery of Art Systemic Catalogs: Dutch Paintings of the Seventeenth Century* (Washington, DC, Oxford and New York, 1995)

White 1980
C. White: *The Dutch Pictures in the Collection of Her Majesty The Queen* (Cambridge, New York and Melbourne, 1980)

White 1999
— *Catalogue of the Collection of Paintings in the Ashmolean Museum, Oxford, I: Dutch, Flemish and German Paintings before 1900* (Oxford, 1999)

Whitfield 1977
C. Whitfield: 'Nicolas Poussin's *Orage* and *Temps calme*', *Burlington Magazine*, vol.119 (1977), pp.4–12

Whitley 1930
W. T. Whitley: *Art in England, 1821–1837* (Cambridge, 1930)

Wieseman 1991
M. E. Wieseman: *Caspar Netscher and Late Seventeenth-century Dutch Painting* (diss, New York, Columbia University, 1991)

Wietzman 1929
S.Wietzman: *Warren Hastings and Philip Francis* (Manchester, 1929)

Wilton 1987
A. Wilton: *Turner in his Time* (London, 1987)

Wittkower 1966
R. Wittkower: *Bernini* (London, 1966)

Woolf 1925
V. Woolf: 'Lives of the Obscure', *The Common Reader* (London, 1925)

Woods 1889
M. Woods: *Rambles of a Physician* (Philadelphia, 1889)

Wortley Montagu/ed. Halsband 1965–
The Complete Letters of Lady Mary Wortley Montagu, ed. by R. Halsband (Oxford, 1965–)

Wright 1974
C. Wright: 'A *Virgin and Child* by Poussin in Brighton',

Burlington Magazine (1974), pp.755–6

Wright 1985
— *Poussin Paintings: A Catalogue Raisonné* (London, 1985)

Wurzbach 1906–11
A. Wurzbach: *Niederländisches Künstler-Lexikon*, 3 vols (Vienna and Leipzig, 1906–11)

Wynne 1994
M. Wynne: 'Continental European Sources for George Barret', *Irish Arts Review Yearbook* (Dublin, 1994)

Young 1780
A. Young: *A Tour in Ireland; with General Observations and the Present State of that Kingdom, made in the Years 1776, 1777 and 1778 and Brought Down to the End of 1779* (London, 1780)

Zaist 1774
G. B. Zaist: *Notizie istoriche de' pittori, scultori ed architetti cremonesi* (Cremona, 1774)

Zani 1819
D. P. Zani: *Enciclopedia metodica critico ragionata delle belle-arti* (Parma, 1819)

Zeri 1965
F. Zeri: *La Galleria Spada in Roma* (Rome, 1965)

Zeri 1966
— *La Galleria Colonna a Roma* (Milan, 1966)

Ziff 1977
N. D. Ziff: *Paul Delaroche: A Study in Nineteenth-century Frence History Painting* (New York, 1977)

Exhibition Catalogues

Amsterdam 1973
Italiaanse tekeningen in de 17de eeuw (exh.cat. by L. C. J. Frerichs, Amsterdam, Rijksmuseum, 1973)

Amsterdam and Antwerp 1999
Anthony van Dyck as a Printmaker (exh.cat. by G. Luijten and C. Depauw, Amsterdam, Rijksmuseum, and Antwerp, Museum Plantin-Moretus, 1999)

Amsterdam and Cleveland 1999–2000
Still-life Paintings from the Netherlands, 1550–1720 (exh.cat. by A. Chong, W. Kloek and others, Amsterdam, Rijkmuseum, and Cleveland Museum of Art, 1999–2000)

Amsterdam and London 2000–01
Rembrandt the Printmaker (exh.cat. by E. Hinterding, G. Luijten and M. Royalton-Kisch, Amsterdam, Rijksmuseum, and London, British Museum, 2000–01)

Amsterdam, Boston and Philadelphia 1987–8
Masters of 17th-century Dutch Landscape Painting (exh.cat. ed. by P. Sutton, Amsterdam, Rijksmuseum, Boston, Museum of Fine Arts, and Philadelphia, Museum of Art, 1987–8)

Antwerp 1991
David Teniers de Jonge: Schilderijen – tekeningen (exh.cat. by M. Klinge, Antwerp, Koninklijk Museum voor Schone Kunsten, 1991)

Antwerp and London 1999
Van Dyck, 1599–1641 (exh.cat. by C. Brown and H. Vlieghe, Antwerp, Koninklijk Museum voor Schone Kunsten, and London, Royal Academy of Arts, 1999)

Antwerp and Münster 1990
Jan Boeckhorst (1604–1668): Maler der Rubenszeit (exh.cat. ed. by J. Luckhardt, Antwerp, Rubenhuis, and Münster, Westfalisches Landesmuseum, 1990)

Baltimore, San Francisco and London 1997–8
Masters of Light: Dutch Painters in Utrecht during the Golden Age (exh.cat. by J. A. Spicer, L. F. Orr and others, Baltimore, Walters Art Gallery, San Francisco,

Fine Arts Museum of San Francisco, and London,
National Gallery, 1997–8)

Belfast 1990
Kings in Conflict (exh.cat. ed. by E. Black, Belfast, Ulster
Museum, 1990)

Berlin, Amsterdam and London 1991–2
*Rembrandt: The Master and his Workshop, Drawings
and Etchings* (exh.cat. by H. Bevers, P. Schatborn and
B. Welzel, Berlin, Kupferstichkabinett, Amsterdam,
Rijksmuseum, and London, National Gallery, 1991–2)

Cambridge 1988
*The First Ten Years: The Examination and Conservation
of Paintings, 1977 to 1987* (Cambridge, Fitzwilliam
Museum, 1988)

Cambridge and London 1980–81
Painting from Nature (exh.cat., Arts Council of Great
Britain, Cambridge, Fitzwilliam Museum, and
London, Royal Academy of Arts, 1980–81)

Carpentras 1978
Jean-Joseph-Xavier Bidauld (1758–1846): Peintures et dessins
(exh.cat. by S. Gutwirth, Carpentras, Musée Duplessis,
1978)

Cremona 1997–8
I segni dell'arte: Il Cinquecento da Praga a Cremona
(exh.cat. by G. Bora and M. Zlatohlávek, Cremona,
Museo Civico 'Ala Ponzone', 1997–8)

Dublin 1816
Royal Irish Institution, Third Exhibition (exh.cat., Dublin,
Dublin Society's House, 1816)

Dublin 1818
Royal Irish Institution, Fourth Exhibition (exh.cat., Dublin,
Dublin Society's House, 1818)

Dublin 1829
Royal Irish Institution, Fifth Exhibition (exh.cat., Dublin,
Gallery of the Royal Irish Institution, 1829)

Dublin 1832
Royal Irish Institution, Eighth Exhibition (exh.cat., Dublin,
Royal Irish Institution Gallery, 1832)

Dublin 1847
Royal Irish Art Union Exhibition (exh.cat., Dublin, Royal
Irish Institution Gallery, 1847)

Dublin 1872
*Dublin Exhibition of Arts, Industries, Manufactures & Loan
Museum of Works of Art* (exh.cat., Dublin, Exhibition
Hall, 1872)

Dublin 1957
Paintings from Irish Collections (exh.cat., Dublin,
Municipal Gallery of Modern Art, 1957)

Dublin 1967
Swift and his Age (exh.cat.,Dublin, National Gallery of
Ireland, 1967)

Dublin 1997
The Milltowns: A Family Reunion (exh.cat. by S. Benedetti,
Dublin, National Gallery of Ireland, 1997)

Dublin, London and Belfast 1969–70
Irish Portraits, 1660–1860 (exh.cat. by A. Crookshank and
The Knight of Glin, Dublin, National Gallery of
Ireland, London, National Portrait Gallery, and Belfast,
Ulster Museum, 1969–70)

Edinburgh 1998
*Effigies & Ecstasies: Roman Baroque Sculpture and Design
in the Age of Bernini* (exh.cat. ed. by A. Weston-Lewis,
Edinburgh, National Galleries of Scotland, 1998)

Edinburgh, London and Vienna 1978–9
Giambologna (1529–1608): Sculptor to the Medici (exh.cat.
by C. Avery and A. Radcliffe, Edinburgh, Royal Scottish
Museum, London, Victoria and Albert Museum, and
Vienna, Kunsthistorisches Museum, 1978–9)

Florence 1989
XVI Biennale dell'Antiquario: Colnaghi a Firenze (exh.cat.
by D. Garstang, Florence, Palazzo Strozzi, 1989)

Genoa 1995
Bernardo Strozzi (Genova 1581/82–Venezia 1644) (exh.cat. by
E. Gavazza, G. Nepi Scire and G. Rotondi Terminiello,
Genoa, Palazzo Ducale, 1995)

Ghent 1986–7
*Joachim Beuckelaer: Het markt- en keukenstuk in de
Nederlanden, 1550–1650* (exh.cat. ed. by P. Verbracken,
Ghent, Museum voor Schone Kunsten, 1986–7)

The Hague and Antwerp 1994
The Hoogsteder Exhibition of Music in Dutch Painting
(exh.cat. by E. Buijsen, L. P. Grijp and others, The
Hague, Hoogsteder and Hoogsteder, and Antwerp,
Hessenhuis Museum, 1994)

Hull 1981
*Scholars of Nature: The Collecting of Dutch Paintings in
Britain, 1660–1857* (exh.cat. by C. Brown, Hull, Ferens
Art Gallery, 1981)

Jerusalem 1999
Nicolas Poussin: Works from his First Years in Rome (exh.cat.
by D. Mahon, Jerusalem, Israel Museum, 1999)

Leeds 1954
Paintings by Artists Born before 1800 (exh.cat., Leeds, City
Art Gallery and Temple Newsam House, 1954)

Leningrad 1990a
*Five Hundred Years of French Painting, 15th to 18th Centuries:
The Hermitage, Leningrad & The Pushkin Museum of Fine
Arts, Moscow* (exh.cat., Leningrad, Hermitage Museum,
1990)

Leningrad 1990b
Nicolas Poussin: Paintings and Drawings in Soviet Museums
(exh.cat., Leningrad, Hermitage Museum, 1990)

London 1793
Exhibition of the Royal Academy (exh.cat., London, Royal
Academy, 1793)

London 1840
*Catalogue of the Works of British Artists in the Gallery of the
British Institution* (exh.cat., London, British Institution,
1840)

London 1851
*Catalogue of the Works of British Artists in the Gallery of the
British Institution* (exh.cat., London, British Institution,
1851)

London 1862
*Catalogue of the Works of British Artists in the Gallery of the
British Institution* (exh.cat., London, British Institution,
1862)

London 1887
Exhibition of Works by the Old Masters, Winter Exhibition
(exh.cat., London, Royal Academy of Arts, 1887)

London 1900
*Exhibition of Pictures by Dutch Masters of the Seventeenth
Century* (exh.cat., London, Burlington Fine Arts Club,
1900)

London 1903
*Ninth Annual Exhibition on Behalf of the Artist General
Benevolent Institution* (exh.cat., London, Thos Agnew's,
1903)

London 1908
*Fourteenth Annual Exhibition on Behalf of the Artist General
Benevolent Institution* (exh.cat., London, Thos Agnew's,
1908)

London 1913–14
*A Catalogue of the Pictures and Sculptures in the IInd
National Loan Exhibition: Woman and Child in Art*
(exh.cat., London, The Grosvenor Gallery, 1913–14)

London 1959
The Romantic Movement (exh.cat., London, Tate Gallery,
1959)

London 1965a
Old Master Drawings (exh.cat., London, P. & D. Colnaghi
and Co., 1965)

London 1965b
Seventeenth and Eighteenth Century Italian Painting
(exh.cat., London, Hazlitt Gallery, 1965)

London 1968a
Old Masters (exh.cat., London, Thos Agnew's, 1968)

London 1968b
Sir Anthony van Dyck (exh.cat., London, Thos Agnew's,
1968)

London 1972
Cabinet Pictures by David Teniers (exh.cat., London,
Kenwood House, 1972)

London 1973
*Headford House and Robert Adam Drawings from the
Collection of Mr and Mrs Paul Mellon* (exh.cat. by J. Harris,
London, RIBA, 1973)

London 1976
*Consulat-Empire-Restauration: Art in Early XIX Century
France* (exh.cat., London, Wildenstein, 1976)

London 1978
From Revolution to Second Republic (exh.cat., Hazlitt,
Gooden & Fox, 1978)

London 1979
Venetian Seventeenth-century Painting (exh.cat. by
H. Potterton, London, National Gallery, 1979)

London 1980a
The Seventeenth Century (exh.cat., London, Thos Agnew's,
1980)

London 1980b
*Gaspard Dughet, Called Gaspar Poussin (1615–75): A French
Landscape Painter in Seventeenth-century Rome and his
Influence on British Art* (exh.cat. by A. French, London,
Kenwood House, 1980)

London 1981
The Princes Gate Collection (exh.cat. by H. Braham,
London, Courtauld Institute Galleries, 1981)

London 1982
*Master Paintings, 1470–1820, and a Group of Watercolours by
J. M. W. Turner, R. A.* (exh.cat., London, Thos Agnew's, 1982)

London 1983a
Mrs Howard: A Woman of Reason (exh.cat. by J. Bryant,
London, Marble Hill House, 1983)

London 1983b
Trafalgar Galleries at the Royal Academy III (exh.cat.,
London, Trafalgar Galleries, 1983)

London 1983–4
The Genius of Venice, 1500–1600 (exh.cat. ed. by J. Martineau
and C. Hope, London, Royal Academy of Arts, 1983–4)

London 1984
*Paintings and Sculpture of Three Centuries: Autumn
Exhibition* (exh.cat., London, Heim Gallery, 1984)

London 1986a
> *Finest Prospects* (exh.cat. by J. Bryant, London, Kenwood House, 1986)

London 1986b
> *Reynolds* (exh.cat. ed. by N. Penny, London, Royal Academy, 1986)

London 1986c
> *The John Tillotson Bequest: Paintings and Drawings of the Barbizon School* (exh.cat., London, Hazlitt, Gooden & Fox, 1986)

London 1987–8
> *Manners and Morals: Hogarth and British Painting, 1700–1760* (exh.cat. by E. Einberg, London, Tate Gallery, 1987–8)

London 1988
> *Rich Summer of Art: A Regency Picture Collection Seen through Victorian Eyes* (exh.cat. by G. Waterfield, London, Dulwich Picture Gallery, 1988)

London 1991
> *Carlton House: The Past Glories of George IV's Palace* (exh.cat., London, Buckingham Palace, The Queen's Gallery, 1991)

London 1992–3
> *The Swagger Portrait: Grand Manner Portraiture in Britain from Van Dyck to Augustus John* (exh.cat. by A. Wilton, London, Tate Gallery, 1992–3)

London 1995
> *Nicolas Poussin* (exh.cat. by R. Verdi, London, Royal Academy, 1995)

London 1995–6
> *In Trust for the Nation: Paintings from National Trust Houses* (exh.cat. by A. Laing, London, National Gallery, 1995–6)

London 1996a
> *Vases and Volcanoes: Sir William Hamilton and his Collection* (exh.cat. by I. Jenkins and K. Sloan, London, British Museum, 1996)

London 1996b
> *Creations and Recreations, Alec Cobbe: Thirty Years of Design and Painting* (exh.cat. ed. by R. John, London, The Prince of Wales's Institute of Architecture, 1996)

London 1996–7
> *Grand Tour: The Lure of Italy in the Eighteenth Century* (exh.cat. ed. by A. Wilton and I. Bignamini, London, Tate Gallery)

London 1998
> *The Print in Stuart Britain, 1603–1689* (exh.cat. by A. Griffiths, London, British Museum, 1998)

London 2000a
> *A Life Delineat'd: A Catalogue of Early Portraits, 1545–1690* (exh.cat., London, Weiss Gallery, 2000)

London 2000b
> *'A Noble Art': Amateur Artists and Drawing Masters, c.1600–1800* (exh.cat. by K. Sloan, London, British Museum, 2000)

London and The Hague 1999–2000
> *Rembrandt by himself* (exh.cat. ed. by C. White and Q. Buvelot, London, National Gallery, and The Hague, Mauritshuis, 1999–2000)

London and Norwich 1996
> *Houghton Hall: The Prime Minister, the Empress and the Heritage* (exh.cat. by A. Moore, London, Kenwood House, and Norwich, Castle Museum, 1996)

Manchester 1857
> *Art Treasures of the United Kingdom* (exh.cat. ed. by J. B. Waring, Manchester, 1857)

Montreal 1990
> *Italian Recollections: Dutch Painters of the Golden Age* (exh.cat. by F. J. Duparc and L. L. Graif, Montreal, Museum of Fine Arts, 1990)

Naples 1980–81
> *Pittura sacra a Napoli nel '700* (exh.cat. by N. Spinosa, Naples, Palazzo Reale, 1980–81)

Naples 1992
> *Jusepe de Ribera (1591–1652)* (exh.cat. by A. E. Pérez Sánchez and N. Spinosa, Naples, Castel Sant'Elmo, Certosa di San Martino and Cappella del Tesoro di San Gennaro, 1992)

New Haven 1983
> *Rembrandt in Eighteenth-century England* (exh.cat. by C. White, New Haven, Yale Center for British Art, 1983)

New York 1909
> *Hudson–Fulton Celebration* (exh.cat., New York, Metropolitan Museum of Art, 1909)

New York 1914
> *Loan Exhibition of the J. Pierpont Morgan Collection* (exh.cat., New York, Metropolitan Museum of Art, 1914)

New York 1939
> *Masterpieces of Art: European Paintings and Sculpture, 1300–1800* (exh.cat. by W. R. Valentiner and A. M. Frankfurter, New York, New York World's Fair, 1939)

New York 1942
> *French and English Art Treasures of the XVIII Century* (exh.cat., New York, Parke-Bernett Galleries, Inc., 1942)

New York 1953
> *An English Exhibition to Honor Queen Elizabeth II* (exh.cat., New York, M. Knoedler & Co., 1953)

New York 1979
> *William and Mary and their House* (exh.cat., New York, Pierpont Morgan Library, 1979)

New York 1990
> *Claude to Corot: The Development of Landscape Painting in France* (exh.cat., New York, P. & D. Colnaghi and Co., 1990)

New York 1991
> *The Drawings of Anthony van Dyck* (exh.cat. by C. Brown, New York, Pierpont Morgan Library, 1991)

New York 2001
> *Old Master Drawings* (exh.cat., New York, W. M. Brady & Co, Inc., and Thomas Williams Fine Art Ltd, 2001)

New York and London 2001
> *Vermeer and the Delft School* (exh.cat. by W. Liedtke, M. Plomp, A. Rüger and others, New York, Metropolitan Museum of Art, and London, National Gallery, 2001)

Österbybruk 1981
> *Gyllene Tider Österbysamlingen* (exh.cat. by L. Sjöberg and C. P. A. Tamm, Österbybruk, Österbybruks Herrgård, 1981)

Padua 1990
> *Arte fiamminga e olandese del Seicento nelle Repubblica Veneta*, Padua, Palazzo della Ragione, 1990

Paris 1967–8
> *Théodore Rousseau (1812–1867)* (exh.cat. by H. Toussaint, Paris, Musée du Louvre, 1967–8)

Paris 1988–9
> *Seicento: Le Siècle de Caravage dans les collections françaises* (exh.cat. by A. Brejon de Lavergnée and N. Volle, Paris, Grand Palais, 1988–9)

Paris 1991–2
> *Géricault* (exh.cat., Paris, Grand Palais, 1991–2)

Paris 1993
> *Le Siècle de Titien: L'Âge d'or de la peinture à Venise* (exh.cat., Paris, Grand Palais, 1993)

Paris 1994–5
> *Nicolas Poussin (1594–1665)* (exh.cat. by P. Rosenberg and L.-A. Prat, Paris, Grand Palais, 1994–5)

Paris, Detroit and New York 1974–5
> *De David à Delacroix/French Painting, 1774–1830: The Age of Revolution* (exh.cat., Paris, Grand Palais, Detroit, Institute of Arts, and New York, Metropolitan Museum of Art, 1974–5)

Plymouth 1992
> *Sir Joshua Reynolds: The Self-portraits* (exh.cat. by R. Wark, Plymouth, City Art Gallery, 1992)

Rochester, New Brunswick and Atlanta 1987–8
> *La Grande Manière: Historical and Religious Painting in France, 1700–1800* (exh.cat. by D.A. Rosenthal, Rochester, NY, Memorial Art Gallery of the University of Rochester, New Brunswick, NJ, Jane Voorhees Zimmerli Art Museum, Rutgers University, and Atlanta, GA, High Museum of Art, 1987–8)

Rome 1977–8
> *Nicolas Poussin (1594–1665)* (exh.cat. by P. Rosenberg, Rome, Villa Medici, 1977–8)

Salzburg 1996
> *Reich mir die Hand, mein Leben: Einladung zu einem barocken Fest mit Bildern von Johan Georg Platzer und Franz Christoph Janneck* (exh.cat. ed. by R. Juffinger, Salzburg, Residenzgalerie, 1996)

San Francisco 1933
> *English Paintings of the Late 18th and 19th Century* (exh.cat., San Francisco, CA, California Palace of the Legion of Honor, 1933)

Spoleto 1988
> *François-Xavier Fabre* (exh.cat., Spoleto, XXXI Festival dei Due Mondi, Palazzo Racani-Arroni, 1988)

Utrecht and Brunswick 1986–7
> *Nieuw licht op de Gouden Eeuw: Hendrick ter Brugghen en tijdegenoten* (exh.cat. ed. by A. Blankert and L. Slatkes, Utrecht, Centraal Museum, and Brunswick, Herzog Anton-Ulrich Museum, 1986–7)

Venice and Washington, DC, 1990
> *Tiziano* (exh.cat. ed. by F. Valcanover and others, Venice, Palazzo Ducale, and Washington, DC, National Gallery of Art, 1990)

Washington, DC, 1985
> *The Treasure Houses of Britain* (exh.cat. ed. by G. Jackson-Stops, Washington, DC, National Gallery of Art, 1985)

Washington, DC, and Amsterdam 1996–7
> *Jan Steen: Painter and Storyteller* (exh.cat. by H. P. Chapman, W. T. Kloek and A. Wheelock Jr, Washington, DC, National Gallery of Art, and Amsterdam, Rijksmuseum, 1996–7)

Washington, London and Amsterdam 2001–2
> *Aelbert Cuyp* (exh.cat. ed. by A. Wheelock, Washington, DC, National Gallery of Art, London, National Gallery, and Amsterdam, Rijksmuseum, 2001–2)

Washington, London and Haarlem 1989–90
> *Frans Hals* (exh.cat. by S. Slive, Washington, DC, National Gallery of Art, London, Royal Academy of Arts, and Haarlem, Frans Halsmuseum, 1989–90)

Yokohama, Shizuoka and Osaka 1990
> *Anthony van Dyck* (exh.cat. by C. Brown, E. Haverkamp-Begemann and J. Müller-Hofstede, Yokohama, Sogo Museum of Art, Shizuoka, Shizuoka Prefectural Museum of Art, and Osaka, Museum of Art, Kintetsu, 1990)

CREDITS

LENDERS TO THE EXHIBITION

National Gallery of Art, Washington, DC Cat.24
Alec Cobbe Cats 3, 11, 13, 21, 26, 29, 38, 41–2, 45, 53–5, 60, 62–3, 66–8, 70–7, 81, 84, 86–8, 90–5, 97–103
Hugh Cobbe Cats 7, 14 and 44
The Trustees of the David Drummond Settlement Cats 6, 12, 19, 25, 30–5 and 48
The Directors of the Pelican and Coronet Company Cats 1–2, 4–5, 8–10, 15–18, 20, 22–3, 27–8, 36–7, 39, 41, 43, 46–7, 49–52, 56–9, 61, 64–5, 69, 78–80, 82–3, 85, 89 and 96
Private collection Cat.40

ILLUSTRATIONS ACKNOWLEDGEMENTS

Galleria dell'Accademia, Venice Cat.65b
Mr and Mrs Russell B. Aitken, New York/photo: Sotheby's Cat.45*
Ashmolean Museum, Oxford Figs 23, 25, 27 and 38
Bavarian State Collections, Munich Cat.63a
Pinacoteca di Brera, Milan Cat.62a
Bridgeman Art Library Fig.46; and cats 37b, 41a, 51d, 51h–i, 51k, 52b, 53a, 55a, 56b–c, 57h, 69b and 96b
British Library, London Figs 64–5
British Museum, London Cats 57e and 89a
Museo e Gallerie Nazionali di Capodimonte, Naples Cats 54a–c and 65a
Chatsworth House (reproduced courtesy of the Trustees of the Chatsworth Settlement) Cat.38b
Christie's Cats 26b–c, 40, 50a, 57a and 101
Cobbe Collection Figs 2, 19, 45, 47, 49 and 50; Cats 17a and 101a
Cobbe Papers: Alec Cobbe Figs 3–5, 10, 12–14, 16–17, 24, 39, 41–2, 44, 51–3, 57–60, 67–8, 71, 74.1, 74.3–4, 75, 92 and 96; and cats 45a, 51g, 55c, 63c and 92a
Cobbe Papers: Hugh Cobbe Figs 8, 61–2, 69 and 90–91
P.&D. Colnaghi, London Cats 55b and 72a
Galleria Colonna, Rome Cat.37a
Corpus Christi College, Oxford (by permission of the President and Fellows) Figs 43.1–2
Country Life Figs 37 and 97
Courtauld Institute of Art, London, Photographic Survey Fig.85 and cats 51b, 51k, 60a, 63b, 77a and 101a
Crown copyright (NMR) Cat.45b
Detroit Institute of Arts, Detroit Cat.52c
Didier Aaron, Paris, London and New York Cat.55d
English Heritage/photo Jonathan Bailey pp.212–13; figs 7, 9, 28–9, 31–2, 34, 36–7, 70, 76 and 86; and cats 2–5, 7–8, 10, 14–16, 18, 20, 22–3, 29, 38, 41–2, 44, 50, 52–5, 59, 61, 64, 66, 68, 68a, 73–6, 81–3, 86–7, 89, 91, 96, 96c, 97 and 103
Fitzwilliam Museum, Cambridge Cat.77b
Glin Castle, Furniture Archives Fig.11
Richard Green, London Frontispiece and cat.46
Historic Collections Trust, House of Orange-Nassau, The Hague Cat.79a

Huntington Art Gallery, San Marino, California Cat.96a
Christopher Hurst pp.7, 65–6, 78, 211, 214–19, 222; figs 6, 40, 48, 77, 80–81, 87–8 and 93–4; and cats 1, 6, 9, 12, 17, 19, 21, 25–8, 30–37, 39, 43, 45, 47–9, 51, 51a, 51j, 56–8, 58a, 60, 65, 67, 69–72, 77–9, 79b, 80, 80a, 84–5, 86a, 88, 90, 92, 92b, 94–5, 98–100, 102 and 103a
Irish Times Figs 33 and 35
Kunsthalle, Hamburg Cat.53c
Kunsthistorisches Museum, Vienna Cat.51e
Musée du Louvre, Paris Cat.61a
Museo Nazionale di Palazzo Mansi, Lucca Cat.61b
David Mees pp.16, 198; figs 1, 15, 26, 30, 66, 73, 74.2, 78–9, 82–3, 89 and 98; and cats 13, 18a and 56d
National Gallery of Art, Washington, DC/*photo: José A. Naranjo* p. 8 and cats 24 and 51f
National Gallery of Canada, Ottawa Cat.57g
National Gallery of Ireland, Dublin Figs 54 (photo: Trafalgar Galleries, London) and 56; and cat.24a
National Gallery of Victoria, Melbourne Cat.91a
National Maritime Museum, Greenwich, London Cat.29a
National Portrait Gallery, London Fig.18
National Trust Cats 57b, 57f and 71a
Northampton Record Office Figs 20–22
Phaidon Publishers Cat.26a
Prentenkabinet der Rijksuniversiteit, Leiden Cats 73a and 78a
Rijksmuseum, Amsterdam Cats 36a, 52a, 65c and 74a
Royal Collection (reproduced by gracious permission of Her Majesty The Queen) Cats 38a and 57c–d
Mr and Mrs Stuart B. Schimmel Fig.63
Sir John Soane Museum, London Fig.95
Sotheby's Fig.72; and cats 53b and 93
Tate Gallery, London Cat.98a
Thames and Hudson Fig.55
Musée Thomas-Henry, Cherbourg Cat.56a
Pinacoteca Vaticana, Rome Cat.39a
Worcester Art Museum, Worcester, Massachusetts Cat.69a
Yale University Press, New Haven Cat.51c

INDEX

(Numbers refer to catalogue entries)